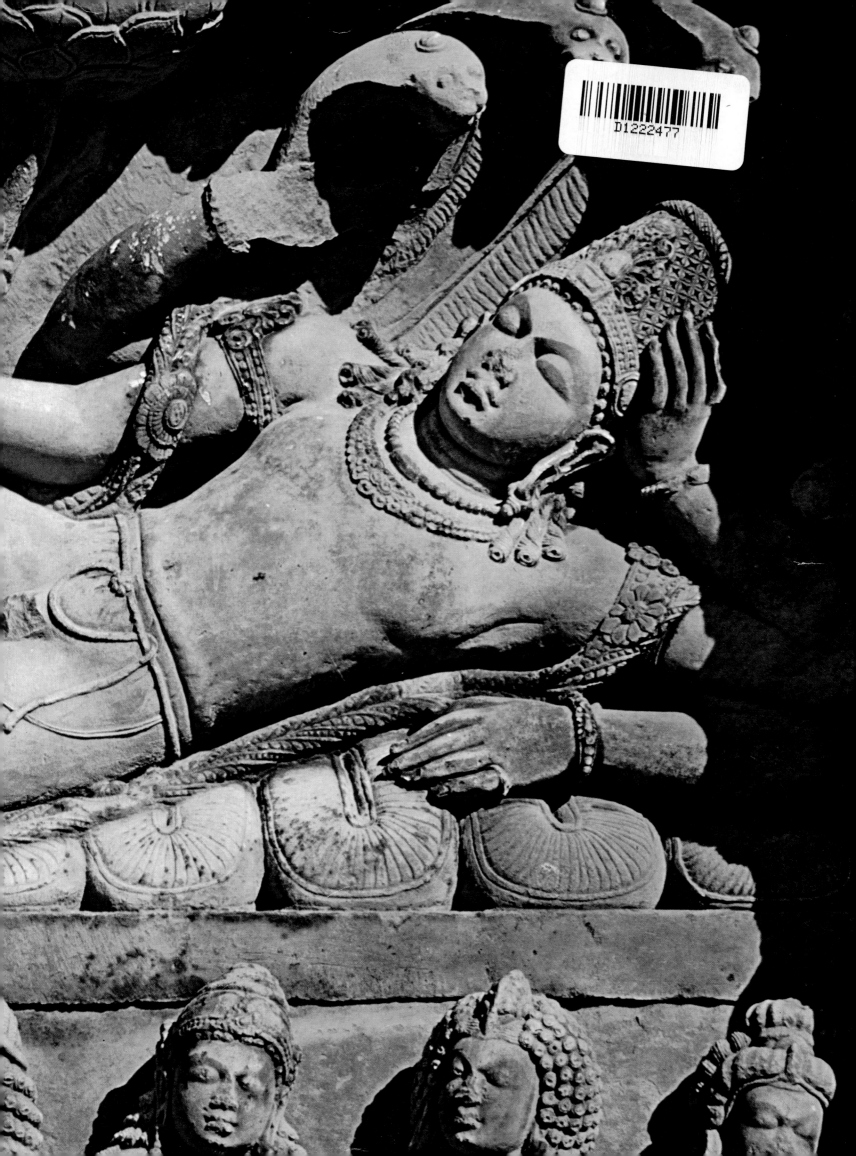

THE ART OF INDIA

THE ART

CALAMBUR SIVARAMAMURTI

OF INDIA

HARRY N. ABRAMS, INC., PUBLISHERS, NEW YORK

PHOTOGRAPHIC CREDITS

Jean-Louis Nou is responsible for all of the photographs in this volume with the exception of those plates listed below.

We are grateful to these institutions and photographers for their kind permission to reproduce their illustrations:

Archaeological Museum, Trichur—651; Archaeological Survey of India, New Delhi—209, 211, 263, 268, 282, 293, 317–19, 326, 331, 342, 345, 350, 353, 356–58, 361–62, 375–76, 384–85, 395, 406, 408, 439, 441, 451, 514, 536, 549, 556, 625–31, 639, 642–43, 664, 684–85, 697, 715–16, 725, 734–36, 739, 749, 756, 778, 781, 824, 828, 835, 841–42, 848, 850–54, 863, 883, 886, 889–91, 902–3, 905, 939, 949, 951, 955, 958–60, 963–64, 967–68, 973; Ashmolean Museum, Oxford—407; Atlas Photo—G. Boutin, 124; British Museum, London—365–66; Brooklyn Museum, New York—530; Cleveland Museum of Art—502; De Smeets—18–23, 25, 29, 141; Detroit Museum of Arts—444; Dharwar Research Institute—613; Field Museum of Natural History, Chicago—443; Louis Fréderic–Rapho—449; Government Museum, Madras—314, 392; J. C. Harle—938; Indian Office Library, London—659; Institut Français d'Indologie, Pondicherry—275; Los Angeles County Museum of Art—528; Jean Mazenod—66, 101, 103, 120–23, 136, 306, 501, 615; Metropolitan Museum of Art, New York—69; Museum of Fine Arts, Boston—529, 564; National Museum of India, New Delhi—637, 666–67; Nelson Gallery–Atkins Museum, Kansas City—348; F. Parisio—102; Karl H. Paulmann—107; Cecil Reilly—106; Scala Fine Art Publishers, New York—14–17, 108, 110, 112–14; UNESCO—Baugey, 503; David Davies, 496–97, 499; Marc Riboud, 498; Dominique Roger, 495; Roger Viollet—500; Ziolo—M. Babey, 132, 140

The drawings for figures 706–9, 786, 793, 799, 801, 816, 826, 829, 832, 855, 897, 919, 928, and 956–57 were done by Pierre Giroud and Jean Mazenod.

Library of Congress Cataloging in Publication Data

Sivaramamurti, C.
 The art of India.

 Translation of L'Art en Inde.
 Bibliography: p.
 Includes index.
 1. Art, Indic. I. Title.
N7302.S5813 709'.54 76-4569
ISBN 0-8109-0630-9

Library of Congress Catalogue Card Number: 76-4569
Published in 1977 by Harry N. Abrams, Incorporated, New York
All rights reserved for all countries, including U.S.S.R. © Mazenod, Paris 1974
No part of the contents of this book may be
reproduced without the written permission of the publishers
Printed and bound in West Germany

To my parents

C. Sundara Sastri

C. Marakatavalli

FOREWORD

Any attempt to present Indian art through Western methods and sensibility would probably be doomed to failure—the prodigious proliferation of its forms would escape an aesthetic examination based on our classical criteria.

Indian art, born in a land "teeming with gods and legends," is intimately tied to religious, literary, and mythological traditions. Thus a simple chronological treatment, ignoring symbolic and literary parallels, would give a very incomplete view of an art so rich and multiform. The true significance and exuberance of Indian art would escape us.

Moreover, during the classical period the Indian sculptor and painter adhered to a multitude of iconographic rules so stringent that they minutely defined each attitude, each expression, and each gesture (even to the position of the fingers). The garments, coiffures, jewelry, and symbolic elements all play a very meaningful role in the representation of mythic and historical personages. The artist had to express himself through extremely subtle suggestion and implication. Thus all freedom of expression would seem to be excluded by the straitjacket of convention that imprisoned the artist.

But—and this is the miracle of Indian art—despite the rigorous strictures, over the centuries the Indian artist created works whose variety, abundance, exuberance, prodigious vitality, and masterfulness demand our admiration.

Thus a valid analysis of Indian art can be undertaken only through learning (or perhaps we should say "experiencing") the innumerable sources and concepts of Indian art and the kaleidoscopic vision this art expresses. We must know India's culture—its religion, rituals, legends, metaphors, allegories—and its historic reality—its epochs, dynasties, styles, and regions.

The elements of this complex art are difficult for the Western sensibility to grasp, and only an Indian scholar is truly able to make this fabulous universe accessible. Thus the choice of author was dictated by the subject matter. C. Sivaramamurti is the former director of the National Museum in New Delhi. His cultural background, immense erudition, originality of thought and expression, poetic gifts, and numerous scholarly publications have made him renowned.

The photographic illustration also presented problems that were difficult to resolve. The photographs for this series are especially commissioned, in order that each volume have an overall pictorial harmony and present previously unpublished illustrations. Certain imperatives governed the choice of the photographer who would be commissioned

to go to India. It was necessary that he know India very well, especially its seasons, since monsoons prevent exterior photography. It was also important that he have current knowledge of transportation, which is often difficult, and know the customs of each region. Jean-Louis Nou had just returned from a long stay in India during which he had taken many beautiful photographs. When he learned that this volume on India, written by C. Sivaramamurti, was in preparation, he offered to make the trip, which would take more than six months.

The logistics of his journey were mapped out in detail. Itineraries, taking into account the seasons, were developed, and estimates were made of travel expenses and the cost of photographic equipment, including special floodlights and film. It was also necessary to plan for the return of exposed film to Paris, where it would be developed under strict quality controls.

Once everything was in order, Jean-Louis Nou took off for Delhi where he met C. Sivaramamurti and received his instructions about the photographs. Over a number of months Jean-Louis Nou crisscrossed India, from north to south and from east to west, using all forms of transportation and traversing regions with sharply contrasting climates—from the smothering heat of Calcutta to the great cold of Kashmir where some temples are situated on the snow line.

On his return Jean-Louis Nou catalogued the thousands of photographs that he had taken. It proved necessary to undertake a second, shorter trip to rephotograph certain very important works and also to photograph in its entirety the celebrated frieze of the temple of Lakshmana at Khajuraho. A complete picture of this frieze is published for the first time in this volume.

The organization of color illustrations in this book is unusual because the rhythm of Sivaramamurti's presentation is very different from that of most art books. This book does not have the simple chronological structure that often permits the culminating point of the text to coincide with illustrations of the most accomplished and beautiful artworks. In following the thought of the author, it was necessary to present together works of different periods, styles, and regions. Thus, from the opening pages, the reader will be immediately plunged into the prodigious diversity that is one of the great charms of Indian art, and he should not be surprised to find a work reproduced several times in different contexts.

The art of India in a strict sense ends with a singular éclat with the amazing temples, which are literally covered by a gesticulating throng of gods and goddesses, celestial nymphs, and human beings, and with the gigantic and rapturous gopuras of southern India that defy all comparison. Thus India, with its thousands of temples and hundreds of thousands of statues, bas-reliefs, etc., presents an almost hallucinatory vision.

The Muslim art that flourished in India and developed parallel to the indigenous art is represented in the first section by illustrations of the Kutab-Minar and the Taj Mahal of Agra, masterpieces of Mogul architecture, and of several remarkable paintings and manuscripts. The principal Mogul monuments are treated in the section on archaeological sites. Mogul art in India is studied at length in another volume in this series—Islamic Art. In fact, it is more properly viewed in the context of the great Muslim civilization that extends from Spain to the Far East.

Like the colorplates, the documentary illustrations are arranged in a manner that facilitates comparative study. A major section, one of the most important of the work, discusses nearly 140 archaeological sites. The detailed descriptions of monuments, buildings, and artworks are complemented by more than two hundred photographs, ground plans, and elevations.

Another section is devoted to the gestures and symbols of Indian iconography. The 180 drawings illustrating this subject are indispensable aids to understanding the concepts that form the basis of Indian statuary and painting. There is also a glossary of nearly one thousand words. The catalogues of Hindu divinities and of philosophers, writers, poets, architects, and painters were written by Nicole Balbir. And finally there is an extensive bibliography and an index.

We thank all those who rendered expert assistance during the preparation of The Art of India: Mr. M. N. Deshpande, director general of the Archaeological Survey of India, New Delhi; Mrs. Debala Mitra, director of the Monuments Division of the Archaeological Survey of India, New Delhi; Mr. Unithan, director of the Kerala Archaeological Department; Miss Vanaja, keeper of the Numismatic Section of the National Museum, New Delhi; Mr. Sharma, director of the Mathura Museum; Dr. Satyamurti, director of the Madras Museum; Mr. Dass, assistant director of the Indian Museum, Calcutta; Mr. H. Sarkar superintendent, Temples Division, Archaeological Survey of India, Madras; Mr. K. V. Soundara Rajan, superintendent, Archaeological Survey of Southern India, Madras; the Maharani of Jaipur; Mr. Gupta and Mr. Chatteyee, Photographic Division, Archaeological Survey of India, New Delhi; Mr. Kapur, Press Office of the Indian Government, Ministry of Information, New Delhi.

We thank those who opened their museums and collections: Mlle. Jeannine Auboyer, chief curator, Musée Guimet; Mlle. Deneck, curator, Musée Guimet; Mr. K. V. Soundara Rajan, superintendent, Archaeological Survey of India, Madras; Mr. A. de Franciscio, superintendent of antiquities, Naples; Mr. J. C. Harle, director, Ashmolean Museum, Oxford; Dr. V. Moeller, Museum für Indische Kunst, Staatliche Museen, Berlin; Mr. Douglas Barrett, Department of Oriental Antiquities, British Museum; Mr. Sherman E. Lee, the Cleveland Museum of Art; and the director and curators of the Birmingham Museum, the Boston Museum of Fine Arts, the Brooklyn Museum, the Cincinnati Art Museum, the Field Museum of Natural History (Chicago), the Detroit Institute of Arts, the India Office Library (London), the Nelson Gallery–Atkins Museum of Fine Arts (Kansas City), the Los Angeles County Museum of Art, and the Metropolitan Museum of Art (New York).

We thank the Office du Livre of Fribourg for permission to reproduce plans 762, 771, 808, 822, 861, 909, 940, and 944.

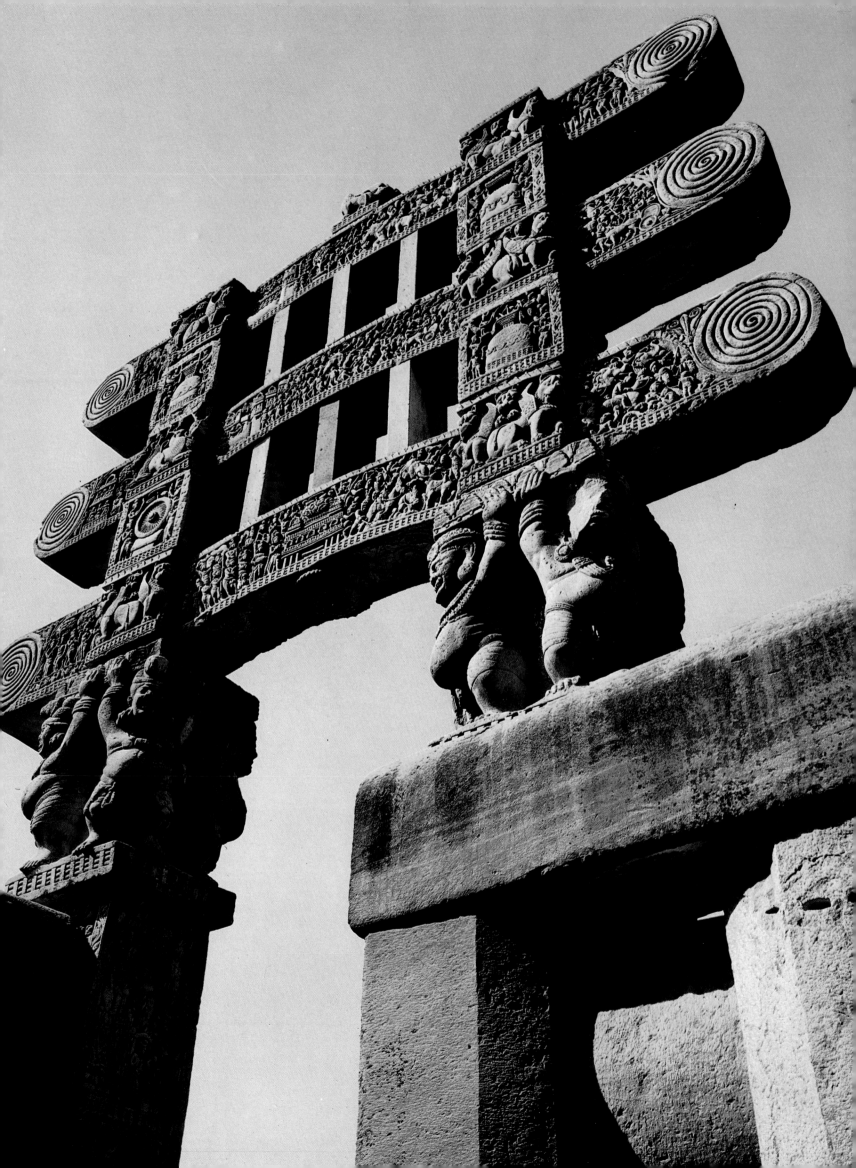

3

4

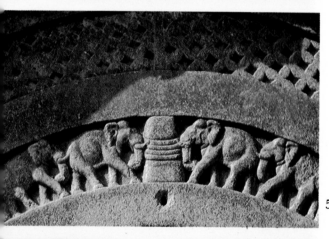

5

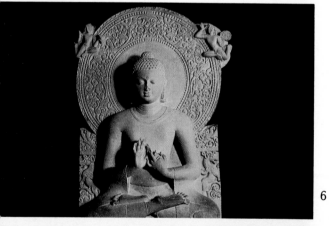

6

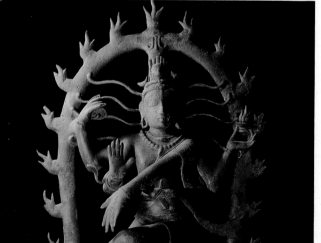

7

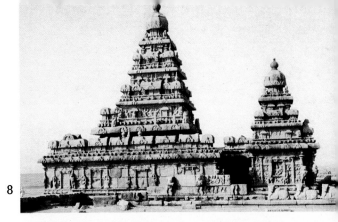

8

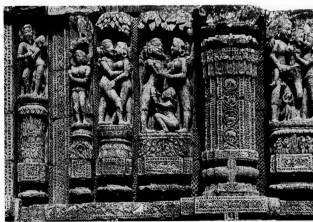

9

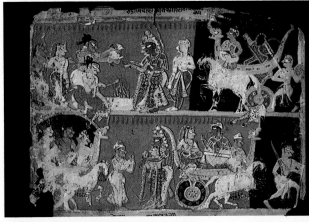

10

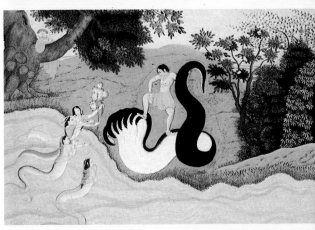

11

12

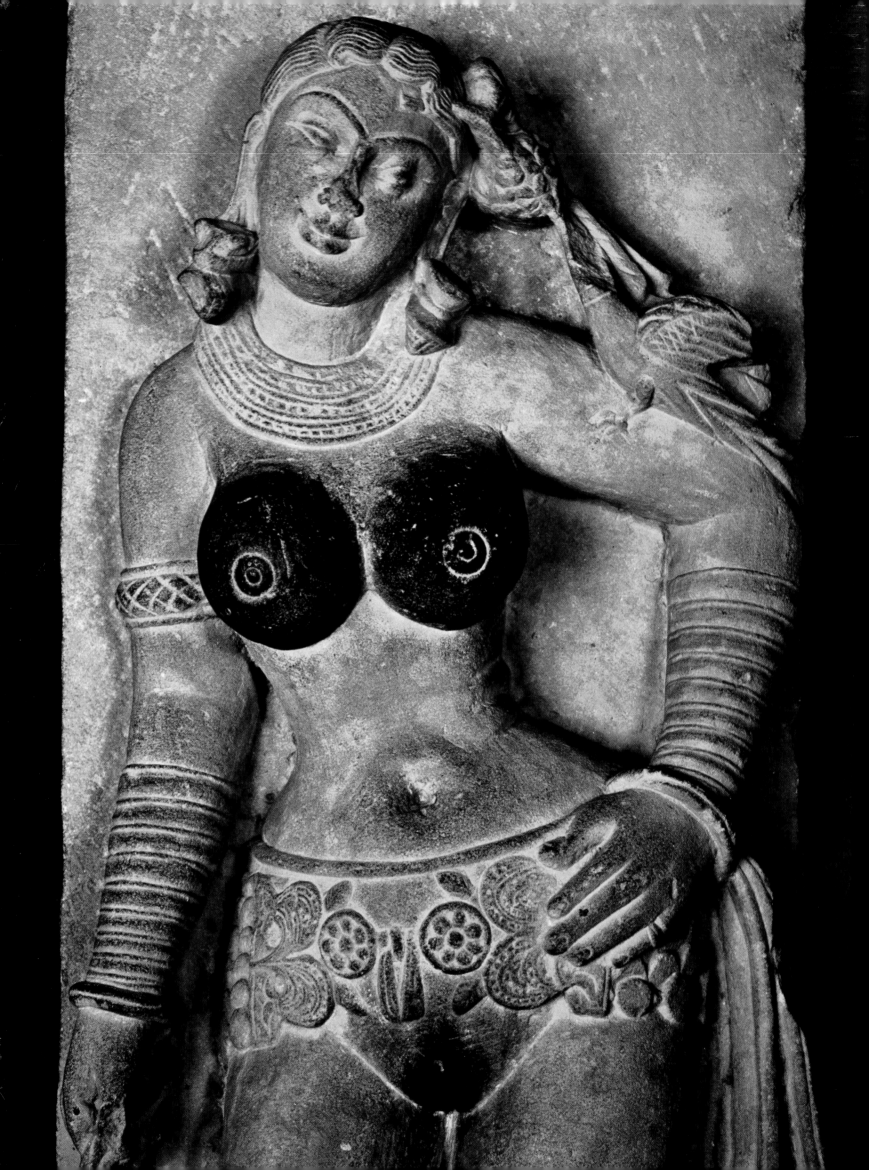

THE ART OF INDIA

PREFACE

INDIAN *art and aesthetic principles lead one into a flowery paradisiacal garden. The land is so vast, and its history so complex, that Indian art presents a rich kaleidoscopic vision of styles and forms. But this colorful diversity has an underlying unity—a noble spiritual force that is the same from the Himalayas to Cape Comerin, from Gandhara to Assam.*

India has always loved to share its riches with others. From the earliest times Indian navigators carried men of taste and learning throughout Southeast Asia. And the fragrance of Indian art wafted through central Asia and beyond. It is hoped that this volume will lead the reader into this enchanted world created by the Indian spirit.

I wish to express my thanks to the Archaeological Survey of India; the National Museum of India, New Delhi; the Government Museum, Madras; the Prince of Wales Museum, Bombay; the Baroda Museum; the Archaeological Museum, Mathura; the State Museum, Lucknow; the Indian Museum, Calcutta; the Patna Museum; the Chandigarh Museum; the Srinagar Museum; the Government Museum, Trivandrum; the Archaeological Museum, Trichur; the Mysore Government Museum, Bangalore; the Asutosh Museum, Calcutta; the Bharat Kala Museum, Benares; the British Museum, London; the Musée Guimet, Paris; the Metropolitan Museum, New York; the Nelson Gallery–Atkins Museum, Kansas City; the Museum of Fine Arts, Boston; the Cleveland Museum of Art; the Rijksmuseum voor Volkenkunde, Leiden; the Rijksmuseum, Amsterdam; the Musée National Vithei Ang Eng, Phnom Penh; the Djakarta Museum; the Dacca Museum; and the Colombo Museum.

C. Sivaramamurti

INDIAN PROTOHISTORY

WHEN the railroad was being laid in the Punjab in the mid-nineteenth century, the clearing of the roadbed revealed a strange type of seals. These artifacts, which may have been used for sealing compacts or as amulets, bear representations of men and animals (among them bulls, elephants, buffalo, and unicorns), individually or in groups, and have pictographic legends. Scholars have not yet deciphered the peculiar script of the legends, and no bilingual seal has been discovered. Thus the meaning of these seals still remains a puzzle.

Sir Alexander Cunningham, the first archaeological surveyor of India, discovered a number of seals at Harappa in the Montgomery District. Because of these finds, the Indus Valley civilization of the third and second millenniums B.C. is often termed Harappan. In 1922 at Mohenjo-Daro R. D. Banerji, an Indian officer of the Archaeological Survey who was in quest of a Kushan stupa, fortuitously uncovered objects almost identical with the Harappan creations. Excavations at Mohenjo-Daro and at Harappa have revealed the protohistoric phase of ancient civilization in India, which existed long before the dawn of recorded Indian history. This civilization is characterized by well-planned cities which were commercial centers, skilled and sophisticated craftsmanship, and a freedom of religion and thought that suggests a highly developed intellectual society.

fig. 24 · The technical excellence of the metal dancer from Mohenjo-Daro is only surpassed by the aesthetic sense of the artist who appreciated that the dancer's graceful repose is as striking as the dance itself. The negroid features of this figure show that the sculptor was influenced by civilizations far beyond the shores of India. Two noteworthy stone sculptures have been found at Harappa. A fine red sandstone torso, which is strikingly Greek in idiom, has baffled art historians since it is a unique specimen. The second sculpture, a male dancer in limestone, is remarkable for its vivid portrayal of movement.

fig. 26

fig. 27 · The patterns and tints on the painted jars from Mohenjo-Daro amply illustrate the color sense of the earliest painters in India. It is unfortunate that no painting except that on pots and jars has survived from the protohistoric period. But the metalwork of this era—the bronze buffalo from Mohenjo-Daro, for example—is marked by delicacy of treatment and faithfulness to nature. Among the many outstanding terra-cotta pieces are a jumping monkey with carefully delineated fur, a toy bird on wheels transformed by its horns into a creature of fantasy, and a mother goddess in folk style. Other notable objects from the Indus Valley civilization are a crocodile head carved from bone and a faience squirrel sitting on its haunches and eating. Perhaps the most famous work is the limestone bust of a royal priest who wears a trefoil-patterned garment across his shoulder.

figs. 183–87

fig. 182

fig. 29 · With the partition of India and Pakistan, Mohenjo-Daro and Harappa and other sites such as Chanu-Daro fell within Pakistan. Indian archaeologists then turned their attention to fresh sites, among them Rupar in the Punjab, Lothal in Gujarat, and Kalibangan in Rajasthan. Their explorations led to the discovery of a civilization identical to that of Harappa within the present geographical limits of India. The art of this early civilization is a noble but still incomplete picture of

notable achievement in almost every medium—clay, metal, stone, ivory, bone, beadwork, and faience. (The jeweler's art was especially well developed.)

All these artifacts are testaments of the earliest phase of civilization in a country where art has flowered beyond all expectations. But there is still little knowledge of the art of the transitional period between this protohistoric era and the Mauryan Age. And despite earnest digging in recent years, historians are not yet able to present a clear picture of the continuous stream of Indian civilization.

SEALS
Steatite from Mohenjo-Daro
2500 B.C.

14. RHINOCEROS

15. BUFFALO

16. TIGER

17. ELEPHANT

18. SACRIFICIAL RITE

19. FABULOUS HORNED ANIMAL

20. PASUPATI

21. THREE-HEADED ANIMAL
 REPRESENTING THE PAST,
 THE PRESENT,
 AND THE FUTURE

22. FABULOUS HORNED ANIMAL

23. BUFFALO

24. YOUNG DANSEUSE
 Bronze from Mohenjo-Daro
 c. 2500 B.C.
 National Museum
 of India, New Delhi

25. BULL
 Terra-cotta from Mohenjo-Daro
 c. 2500 B.C.
 National Museum of India, New Delhi

26. MALE TORSO
 Red sandstone from Harappa
 c. 2500 B.C.
 National Museum of India, New Delhi

27. PAINTED JAR
 Terra-cotta from Mohenjo-Daro
 c. 2500 B.C.
 National Museum of India, New Delhi

28. MOTHER GODDESS
 Terra-cotta from Mohenjo-Daro
 c. 2500 B.C.
 National Museum of India, New Delhi

29. ROYAL PRIEST
 Limestone from Mohenjo-Daro
 c. 2500 B.C.
 National Museum of Pakistan, Karachi

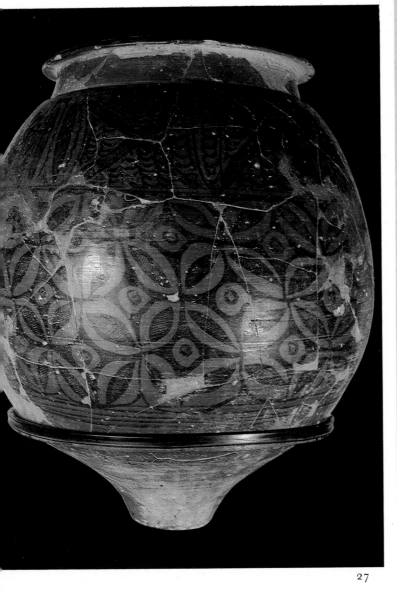

27

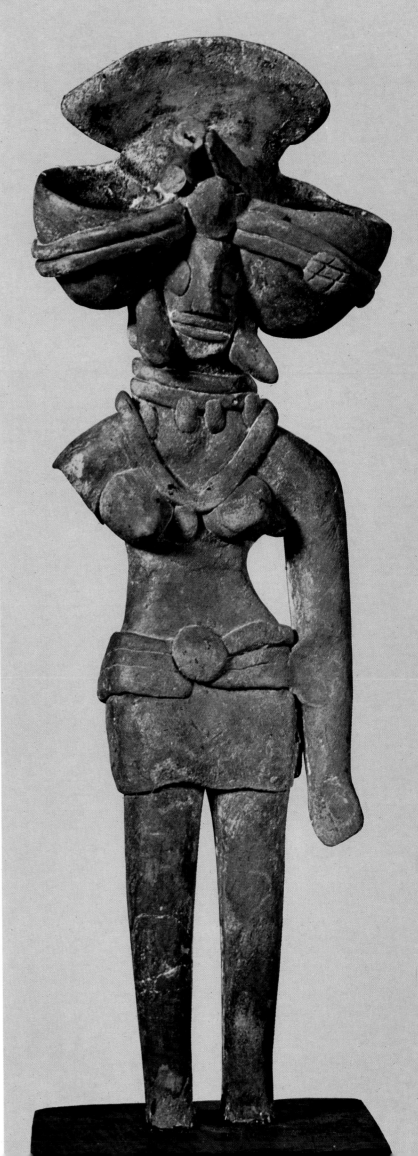

28

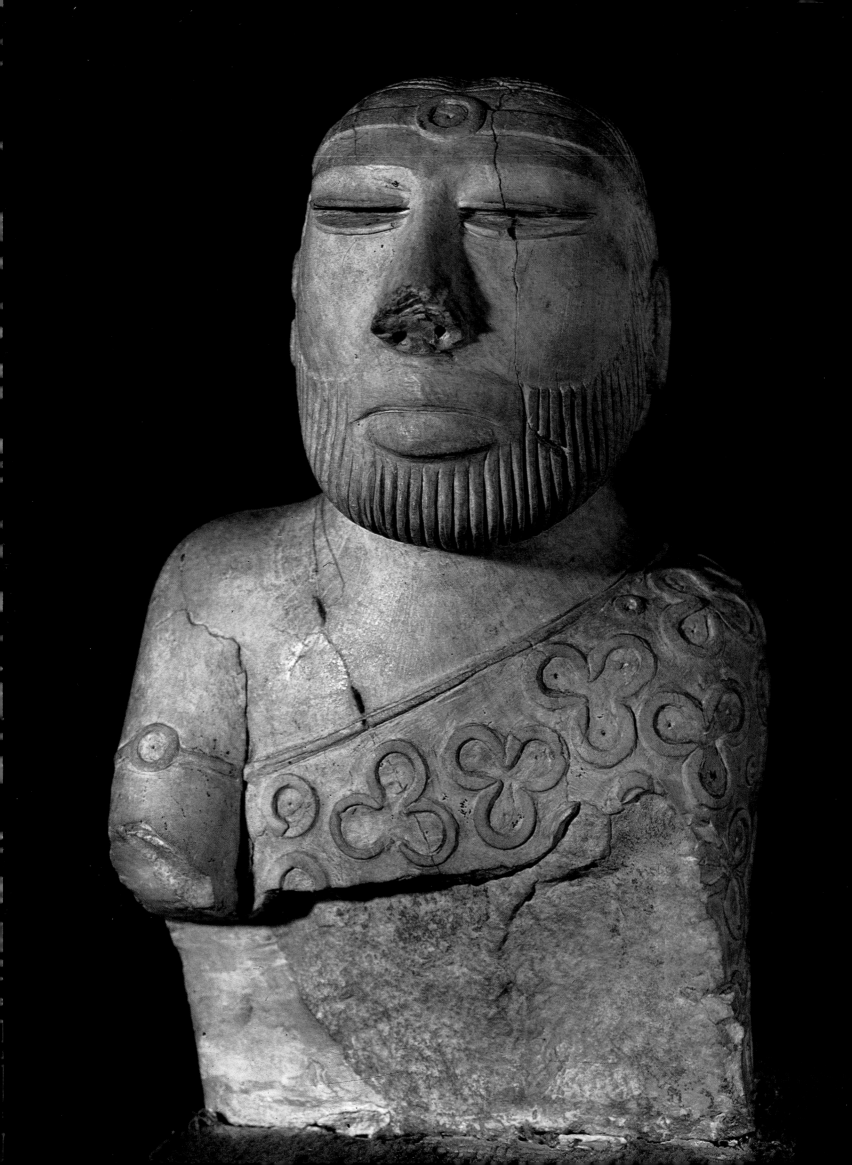

THE EARTH AND THE PEOPLE

INDIA, *the vast subcontinent of Asia, is bounded on the east by the Bay of Bengal and on the west by the Arabian Sea. It extends from the Himalayas in the north to the Indian Ocean in the south and has three great natural divisions—the Himalayas, the riverine plain, and the Deccan. The highest summits in the world are found in the Himalayas, the crescent-shaped range that stretches for fifteen hundred miles along India's northern border. To the south lies the Indo-Gangetic plain, the rich land that is watered by rivers flowing from the Himalayas and that reaches from the Bay of Bengal to the Pakistan frontier and the Arabian Sea. The third great natural region is the Deccan, the triangular tableland of southern India. A broken series of mountain ranges, known collectively as the Vindhyas, separates the high plateaus of the Deccan from the riverine plain. The Eastern and Western Ghats, mountains extending south from the Vindhyas, form the other sides of the southern triangle.*

India's distinct landscapes are marked by sharply contrasting climates. The weather in some areas varies little from season to season—the heights experience continuous intense cold, and the southern climes are almost always warm and sunny. But other regions undergo abrupt changes during the year. In the riverine plain, for example, there are precipitous shifts in temperature during certain months. Rainfall varies greatly from place to place, some areas receiving torrential downpours and others experiencing near-drought conditions. Thus India has both lush rain forests and burning deserts.

The mountain fastness nurtured a hardy people, simple and somewhat rugged in their habits; the people from the water-fed plains were less robust but more sophisticated and intelligent. The littoral areas, with their long coastlines, fostered a seafaring people. With initiative and courage they spread the culture of India throughout the civilized world and had an especially strong impact on Southeast Asia.

Despite the extraordinary length of the Indian coastline, there are few natural harbors. But even so, the port cities of ancient India, like Sopara (Surparaka), Nagapattinam, Kaveripumpattinam, Puduchcheri, Karaikal, Kadalmallai, Masulipatnam, Kalingapatnam, and Rangmati, played a major role in the economic and cultural life of the country. Indian culture influenced, and in turn was influenced by, the great civilizations of Iran, Egypt, Greece, and Rome. The silk routes in Central Asia carried Indian culture as far north as Khotan and Kyzyl, especially during the era of the mighty Kushan empire.

The groves and orchards with their canals and streams, the fields and terraces, the fruit and flowers differ from area to area and create a charming mosaic of Indian natural life, with each region of this vast subcontinent distinguished by enchanting and unique characteristics.

As the coniferous trees flourished on the heights, so the coco palms and palmyras thrived on the seashore. The banana, the cow, and the granary were the only true affluence for the contented rustic. Jackfruit abounded everywhere, and in the south it was used in some of the most delicious dishes of the Indian cuisine. The betel plantations, sugarcane fields, and grains mentioned in the Yajur-Veda give a hint of the variety of food that was cultivated.

The wonderful variety of beasts and birds and of fruit-bearing trees, flowering plants, and vines and the lushness of the green grass carpet inspired the picturesque motifs developed by poet, painter, and sculptor. Artists were enchanted by the weather and climate and the seasons when the land undergoes a colorful change. Paintings catch and glorify all the phases of the yearly cycle—the dark clouds of the rainy season (July–September); the clear sky lit up by the beautiful

moon of autumn (October–November); the cold blasts of winter (December–February); the blossoms and tender shoots that give a gay appearance of quickening verdure in spring (March–April); and the glare of the blazing summer sun (May–June).

Every season has its beauty, and it is a delight to travel through India to watch the plowing of the fields, the sowing, the watering from river-fed channels, the reaping and gathering of grain, and the stacking of hay. As one moves along, one cannot miss seeing groups of women replanting rice plants in fields, an essential part of raising paddy crops. The abundance of coconuts, and their importance in the economy of Kerala, is evident in the heavy traffic of boats carrying this valuable cargo. The agricultural prosperity in the Punjab and the wealth of cattle in Hariana have existed from a very early date. And today one can see an eleventh-century sculpture come to life as one watches water carried by a chain of pails to irrigate fields.

In earlier days there were festivals celebrating each stage of the agricultural process. All the villagers came together to offer a communal thanksgiving, usually to the sun-god, for the bounty of the land and to express the most cordial feelings toward each other. In these ceremonies whole villages acted as one family. The weal or woe of each villager was shared by the entire community. In fact, even now when a newly wedded groom is welcomed to his bride's village, he is the honored son-in-law not only of his bride's parents, but also of the whole village which welcomes him with joy and affection. This concept of the village community (gokula) is well illustrated in a story told of Krishna. He protected all the Indian people who came together as a vast hamlet under the Govardhana Hill. Krishna held this mount aloft on a single finger for seven long days, as the heavens rained down a furious torrent.

The vast expanse of India led to an inevitable variety of customs and crafts. These traits have survived through the ages and give a colorful richness to Indian life. For centuries Kashmir has been noted for the shawls and carpets produced by its weavers. These woven goods, so necessary as protection from the cold, have aesthetic value since the workers developed striking motifs based on the beauty of their surroundings. Central Asia, a meeting place of cultures, is not very far from Kashmir, and therefore Iranian and other influences are apparent in the woven designs. In areas where natural rock is scarce, such as Bengal, Bihar, and Uttar Pradesh, terra-cotta became the favored medium of artistic expression. The Gupta tradition of terra-cotta temples, seen in Bhita, Ahichhattra, and other places in Uttar Pradesh, has continued till recent times in Bengal. And the contemporary terra-cotta figures of Durga and Sarasvati attest to the continuing genius of the Bengal potter.

The ancient glory of Konarak and Bhuvaneshwar is reborn in the craftsman of Orissa who still plies the time-honored trade of carving soft stone into elegant figures. The craftsman entirely devoted to folk art reveals himself in the Daśāvatāra and other toys from Kondapalli in Andhra Pradesh. The intricate inlay work of bidri ware is a craft that is still practiced near Bidar in Andhra Pradesh. One wonders if these craftsmen are descendants of the great temple-builders of Chidambaram and Madura and whether bronzes like the Nataraja of the Brihadisvara temple could still be fashioned. An affirmative answer is found in the temples still built and consecrated by stone carvers in Tamilnad who are equally adept at casting metal images.

Rural crafts are still common in India. There are intricate sandalwood carvings from Mysore, ivory carvings from Kerala, and wood carvings from Karaikudi. In the hills of Chamba and elsewhere artists are engaged in the traditional work of mural painting. On the plains in Rajasthan there are performances of quaint instrumental folk music and of the folk dances of the Nagas, Gonds, and others. These dances are performed in mandalas, or circles, and recall the rasas (dance dramas) of ancient India. The puppet plays of Rajasthan and the shadow plays

with their lovely and carefully prepared figures show their ancient influence in distant islands like Java where the wayang, a similar entertainment, is still performed.

Classical art has not been neglected, and much importance is given to it. Art itself is learned and practiced as an offering to the divinity. The hall of dance (nātyasabhā) at Chidambaram, where the Lord of the Dance eternally performs, is not only for witnessing the dance of the Supreme Being, but also for presenting the best that the mortal dancer can give the Preeminent One. In fact, at one time there were a number of danseuses attached to each temple who offered the best of their art to the divinity. And even today a dance offering is made by the danseuses of the temple at Puri. Halls of dance that now exist in Kerala, like the famous one in the temple of Vadakkunatha, are used for kathakali, chakkiyarkuttu, and other dance dramas. Bharata natya, the supreme art of dance said to have been developed by the sage Bharata, is the universal dance of India. With its orchestra of stringed, percussion, wind, and metallic instruments, it has retained its enchantment through the centuries, telling its tale in a marvelous language that is all its own. Kathakali is an equally striking dance drama but is more violent and tempestuous than the soft and delicate bharata natya. There are other varieties of the dance drama, among them the kathak and manipuri of northern India and the yakshagana and kuchipudi of southern India. The musical groups in temples for the recital of Nāgaśvara, particularly in southern India, make a noble musical offering. The delicate play of the stringed vina is complemented by the flute, and the drum accompanies the pipe.

The consonance of vocal strains in devotional music composed of Tevāram *and* Tiruvāy-moli *in the temple and the chants in sonorous voice of groups of* kramapāṭhīs *and* ghanapāṭhīs *cannot but evoke the highest admiration for the music of the Veda. This art was fostered in each village. The school of Vedic learning met in a pavilion of the temple. Grammar (the works of Panini and Patanjali's learned commentaries on them), philosophy (particularly the thought of Kumarila and Shankara), and rhetoric were studied intensely in the temple school. The children usually started their studies with their parents and brothers, a tradition that survived until a few decades ago.*

The persistence of older styles is seen everywhere. On the banks of the Godavari near a temple one can see the elaborate kaccha *dress of a Maharashtra woman. The distinctive red turban with a carved bump on top distinguishes an old-world scholar from Maharashtra.*

The attitude of a devotee toward the object of worship is evident in the earnest waving of the chowrie by the pious Sikh before the holy book, the Granth Sahib, which is wrapped in silk and kept in almost regal splendor. The pilgrim center is an equally interesting spectacle. The potent force of a sacred place induces the rich man to part with his wealth to help the needy, and at Nathdwara one often sees a Gujarat merchant giving coins to beggars. A whole pageant of past chivalry is conjured up by the imposing sight of a Rajput in Rajasthan—his flowing beard parted in the middle, he walks with the majesty of his warrior forebears. In contrast is the simple and peaceful pandit lost in meditation on the ghats of the Ganges at Benares.

Festivals are celebrated with éclat throughout the land. In January the solar movement northward is welcomed by the adoration of the sun-god in his golden chariot. The revelry of Holi in the spring (March), which is noted for colorful sprays of tinted water, is a favorite theme in miniature paintings. Dewali, the Festival of Lights in October, expresses joy at the end of darkness which is symbolized by the slaughter of the demon Naraka. The festival of Dasehra marks the triumph of good over evil, represented by Ravana's fall. Among other festivals are the vigil of Śivarātri, *the celebration of* Rāmanavamī *and* Kṛṣṇāṣṭamī *(the birthdays of the most beloved*

deified heroes), and the worship of knowledge and wisdom personified in Sarasvati and Ganesha on the days sacred to them. And the temple festivals, including the car and the barge festivals, which last for several days each year, are glorious sights to see and enjoy.

On festival days wooden replicas of stone temples (vimānas) on wheels are taken around as ornate chariots (rathas). The figure of the deity, which has been elaborately dressed and decorated, is placed in this vehicle which is slowly drawn by thousands of devotees. These chariots are still constructed by carpenters whose profession and tools are passed from father to son.

In watching festivals today, one often feels that antique representations have come to life. A girl draws colored patterns of rice powder in the street while awaiting the temple procession. The deity is received with great fervor in every home—the procession pauses and each household is blessed. Every facade has been colorfully decorated, and the air has been cooled by sprinkling water in the streets.

In the past each home had its own festivals and ceremonies for rejoicing, mourning, and marking important events (some of these rites still survive). To ensure the birth of a male child, the ceremony of puṁsavana, *in which the pregnant woman is given a ritual bath, was performed. (The bath before Buddha's birth is an ancient example of this rite.) The first ceremonies after the birth were the* jātakarma *(the whispering of mantras into the baby's ear) and the* nāmakaraṇa *(the naming of the child). During the child's third year, the barber dressed his hair for the first time. In this ceremony the hair was styled in sidelocks or in other modes, among them the tonsure. The commencing of studies was marked by the* upanayana *ceremony which was held when the boy was between eight and ten. The child was led to the teacher who would impart the knowledge that led to the highest bliss.*

At the end of his studies (which ideally lasted for twelve years), the student was allowed by his teacher to assume the householder's life. The passage to this stage in life was marked by the ceremony of samāvartana. *Shortly afterward he married, taking a companion for life in the ceremony of* vivāha. *Of the various modes of marriage (brahma, arsha, rakshasa, paisacha, and so on), the noblest is the giving of the girl to the groom by the parent. With his newly wedded bride the husband pledged to begin a life of sacrifice and service to the community; he welcomed the wedding guests and played host to neighbor and stranger, friend and foe. Moving about a fire while holding the hand of his bride, the husband walked seven steps with her, thus making her his closest friend and companion. He took her as his wife not so much to fulfill his carnal desires as to produce offspring and thus continue his line of ancestry.*

In India's present division into eighteen states, the country's variety of language is almost formalized. But in its earlier history, India had but one great official language—Sanskrit—with simpler dialects known as the Prakrits. While most learned treatises and political documents were written in Sanskrit, some of the first reformers like Buddha and Mahavira chose the language of the people, Prakrit, for their sermons. And early monarchs also used Prakrit as well as Sanskrit. The origin of regional languages is mostly of a comparatively late date, though Tamil had its heyday before the Christian Era, Kanarese a few centuries later, and Telugu by the ninth and tenth centuries A.D. *The medieval period saw the spread of Persian as the official language. This very diversity of the huge polyglot population gives a touch of gaiety to the kaleidoscopic culture of the subcontinent.*

A LAND TEEMING
WITH GODS AND LEGENDS

INDIA's majestic mountains and innumerable perennial streams have always been considered as pure symbols of the most noble qualities. And from them the Indian people have drawn their ideals of grandeur and generosity.

Called the "sublime summits" (*kulaparvatas*), the mountains are seen as towers of dignity and majesty, their great might capable of supporting the universe. The mighty snow-clad mountains of the north, often styled the "roof of the world," make it difficult for invaders to enter the rich plains, and this fortresslike barrier has made the people of India into a single great family.

The lofty mountains inspired man to simulate their height by achieving the most elevated virtues. In like manner, the depth of the ocean called forth deep and noble qualities in man. Kalidasa, the sweetest poet of India, likens the Himalayas to a measuring rod for the earth—stretching from sea to sea, this great overlord of mountains appears truly divine—*astuyttarasyām diśi devatātmā himalayo nāma nagādhirājaḥ pūrvāparau toyanidhī vagāhyā, sthitaḥ prithivyā iva mānadaṇḍaḥ (Kumārasambhava, I, 1).*

The mountain Vindhya is the personification of the great Vindhyan range in central India, the most ancient rocky region of the country. This noblest and oldest of mountains is reputed to have eclipsed in glory the celestial golden mountain, the Meru (or Sumeru), in the center of the world beyond the Himalayas. It is also said that Vindhya once grew and grew, threatening to block the light of the sun, much to the consternation of the gods. They appealed for help from the sage Agastya, who was renowned for having swallowed the entire ocean in one gulp—*vindhyasya samstambha-yitā mahādreḥ (Raghuvaṃśa, VI, 61).* Agastya journeyed south, and Vindhya bent low to honor the revered sage. And at Agastya's request the mountain has remained bowed over ever since.

Mahendragiri, the great blue mountain of Orissa, picturesquely changes color during each day and from season to season, like Rip Van Winkle's Catskill Mountains. It shelters elephants in its forests and has been eulogized as a symbol of strength. The lord of the region was once poetically described as meeting his foe in battle with an array of elephants as imposing as their abode, the Mahendragiri itself.

The slopes of the Malaya Hills—with their aromatic cardamom groves and fragrant sandalwood trees, the trunks entwined by large pythons that are fascinated by the sweet odor of sandal—are the glory of the extreme southwest. They are the abode of the cool and welcome breeze called *Malayamāruta*. The Pandya lord of the south is compared by Kalidasa to the great mountain Malaya; the lord's dark body, adorned with a long necklace of lustrous pearls, is likened to the mountain with its shadowy sandalwood forests, embellished by an argent stream flowing down its slopes.

The poet Bhasa describes the earth as a young damsel gaily wearing the two great mountains Himavan and Vindhya as ear ornaments. And Kalidasa fancies that the mountains Malaya and Dardura are the earth's sandal-perfumed breasts.

The glorious height and enchanting contours of the mountains, whose peaks resemble shikaras, are echoed in the poetic descriptions of the loftiest royal palaces and temples—they are said to reach almost to the sky, like Meru and Mandara—*merumandarasamkāśair ālikhadbhir ivāmbaram (Rāmāyaṇa, V, 9, 14).*

The splendid mountain valleys are enhanced by rapid streams, flowing with

plashing sound and then suddenly slackening and bubbling into wide rocky beds. The mountain slope, red with laterite, is a striking scene of natural beauty that has not missed the attention of the sensitive nature poet. Sometimes a mountain is described as nestling a picturesque city on its slopes with a silver rivulet flowing around it. The city is a young damsel, her silken garment (the stream) loosened, reclining on the lap of her lover, the mountain.

Although the mountain, its peaks covered with snow, may be difficult to approach, it is filled with precious treasures—*anantaratnaprabhavasya yasya himam na saubhāgyavilopi jātam eko hi dosho guṇasannipāte nimajjatindoh kiraṇeshvivānkah* (*Kumārasaṃbhava*, I, 3). Its richness is like that of the earth, which is viewed as a neverfailing cow yielding great wealth. Legend has it that Meru is the milkman and Himavan the calf, the young one of the earth herself and the producer of the most precious earthly goods—herbs and gems.

Legend and faith have both hailed Himavan as the most sacred of mountains. Holy in himself, he is further sanctified by the flowing of the celestial stream Ganga on his crest. Himavan is also styled Gauriguru; that is, he is the father of Gauri (Devi), who is the consort of Shiva, one of the supreme trinity of gods in Indian legend and thought. Kalidasa admires Himavan's nobility—the mountain is a refuge for all who are terror-stricken. Even darkness, terrified by light, rushes into his caverns to seek refuge and is given protection by the lofty mountain—*divākarād rakṣati yo guhāsu linam divābhitam ivāndhakāram kṣudrepi nūnam śaraṇam prapanne mamatvam uchchaiśśirasām sativa* (*Kumārasaṃbhava*, I, 12). This mountain is so special because he embodies the essence of Vishnu, symbolizing the immovable aspect of the Great One.

The *Ramayana* describes Mainaka, the mountain prince and son of Himavan, appearing in human form on his peak to address Hanuman, the monkey god. Following this text, the *Vishnudharmottara* clearly tells how mountains should be depicted anthropomorphically on their own peaks. One of the most striking examples of such representation is the Kalyanasundara panel at Elephanta. The stately and noble Himavan, accompanied by his queen, Mena, gives his daughter Uma in marriage to Shiva. At Ellora the rishis, headed by Brahma himself, are shown conversing with Himavan and Mena and asking that the Mountain Lord give his daughter in marriage to Shiva. The tradition of personifying mountains survived, and in a seventeenth-century painting Shiva is shown bowing to Himavan, whose embarrassment is wonderfully delineated by a spirited artist of the Kangra school.

fig. 194

fig. 196

In India rivers have also been viewed with great reverence. The river has always been thought of as a loving mother, sustaining the people with an abundance of water and assuring fertility and prosperity just as an earthly mother sustains her little ones with milk. On the lap of her sandy shores the children of the soil can sit and muse without a thought for the future. The riverine region is styled *nadīmātṛka* ("sustained by the river"), and the regions depending on heaven for rain are styled *devamātṛka* ("nourished by the gods").

In India the most holy of rivers, the best known and most honored, is the Ganges, which is personified as the goddess Ganga. A celestial river, she is not confined to earth but flows down from heaven, from the foot of Vishnu himself, and is therefore called Vishnupadi. She descends on the Himalayas, flows on Himavan's lap like a daughter (and is therefore called Hamavati, or "daughter of Himavan"),

and then streams down to the netherworld as Patalaganga. Since she covers three spheres—heaven, earth, and the netherworld—she is styled Tripathaga. Another legend tells that she descended from heaven onto the head of Shiva, who answered King Bhagiratha's prayer that he divert her for a time, since a sudden drop of her torrential stream meant sure destruction of the earth. By receiving Ganga on his locks, Shiva assumed the epithet Gangadhara. After she was released, she followed Bhagiratha, as he led her to purify the ashes of his ancestors, and she is therefore called Bhagirathi. The proud stream engulfed Jahnu's hermitage, and he humbled her by swallowing her up in one gulp. But at the meek request of Bhagiratha, he released her through his ear. Because Ganga was reborn from the ear of Jahnu, she came to be styled Jahnavi or Jahnutanaya, the "daughter of Jahnu."

Ganga has been represented in many different forms. She is seen as the celestial stream and as the triple stream; as the daughter of Jahnu; as a bride approaching Shiva; as a damsel, pride incarnate, who rushes down on Shiva's head, intending to drown him but instead becoming entrapped in his locks; as a co-wife, causing annoyance to Gauri, the spouse of Shiva; and as the river mother feeding the children of the soil with the water of plenty from her pitcher. At Elephanta Ganga is seen on the locks of Shiva Gangadhara. And at Pattadakal she is depicted as a mermaid dancing on the locks of Shiva which swirl as he performs the tandava, an energetic and virile dance.

fig. 195

figs. 201–4

The story of the goddess Ganga is one of the most important themes in Indian legend and art. The doorway of every temple in India is guarded by an anthropomorphic representation of the river Ganges. In the south Ganga usually appears on both jambs, but in the north Ganga is represented on one jamb and Yamuna, the personification of the Jumna River, on the other. On these portals Ganga is represented as a damsel holding a water vessel and standing on her mount, the crocodile. Yamuna is shown on her own mount, the tortoise. Gupta artists are noted for their representation of Ganga and Yamuna on temple portals. These celestial guardians are seen most frequently on sanctuaries dedicated to Shiva, although they are often present in shrines to other deities and even appear in the Vakataka caves of the Buddhist faith at Ajanta. One of the most beautiful representations of Ganga and Yamuna flanking a doorway is from a Gupta temple in Dah Parvatiya in Assam. There are several similar representations of Ganga and Yamuna personified on door jambs, such as those from Buxar that are now in the Indian Museum. Each river goddess is shown on her mount and is accompanied by attendants, one of whom raises a parasol over her head. The swans that flutter above, with garlands of lotuses or lilies in their beaks, suggest the cool fragrance of an aquatic environment.

figs. 256, 258

The dark and silvery beauty of the rivers was greatly appreciated, and the confluence of the sacred streams Ganges and Jumna at Prayag is described by Kalidasa in a striking series of metaphors. The rivers come together like a necklace of sapphires and a string of pearls, like a garland of white lotuses and one of blue lilies. Their confluence brings to mind a row of white swans on the wing against a bank of dark clouds; or sandal-smeared earth, darkened here and there by streaks of sweet-smelling aloe smoke; or a silvery moonlit landscape broken by dark shadows; or white autumnal clouds with streaks of blue sky seen through them; or the ash-smeared body of Shiva, adorned with dark reptile ornaments.

fig. 86

Ganga has always remained a standard of purity and holiness. Even from a

distance the remembrance of her name purifies devotees. A look at the Ganges, and far more a bath in her waters, assure sanctity. According to legend, the waters of Ganga flow into every river in India at a certain time each year; these streams then assume the great holiness of Ganga herself and the power to purify pilgrims. The sanctity of rivers was heightened at a sacred confluence like Prayag. In fact, a believer who died there was sure to attain heaven.

The sanctity of the third stream, the Saraswati (personified as Sarasvati, the goddess of learning), which joins the Ganges and Jumna at Prayag, is equally great. In the vicinity of holy Kurukshetra, the Saraswati has a special sanctity. Here the mind is made pure through the blessings of the goddess Sarasvati, just as the sacred soil of Kurukshetra is nourished by the holy presence of the pure waters of the Saraswati. One of the most interesting sculptural representations of the personified streams is that of the three rivers at Ellora—Ganga stands in the center with Yamuna and *fig. 35* Sarasvati flanking her.

One of the major sacred rivers of central India is the Narbada (personified as Narmada) which flows west. At Ellora, Sarasvati is portrayed on her vehicle, the *fig. 199* swan, and Narmada is represented in a similar manner in Chedi sculpture from the Bundelkhand area.

The worship of the rivers has a special importance, and Sita is often depicted offering prayers to the Sarayu, Godavari, and other rivers. They are all called *punyasalila*, "with water rendered holy." The Godavari is also called Gautami, because it is associated with the great sage Gautama Buddha. The Kistna (Krishnaveni) River, which flows to the south of Godavari, is another stream famed in literature and legend. The Cauvery River farther south is described in a Pallava inscription as "water lovely to behold"—*kāverīm nayanābhirāmasalilām*.

The Mahanadi in Orissa and the Brahmaputra in Assam are large and imposing rivers, particularly the latter, which has an almost oceanic vastness. Crossing this mighty river was such a difficult task that the king of Assam took the possibility of invasion seriously only when he learned that the powerful Raghu had succeeded in fording it.

The rivers of the Punjab are first mentioned in the Rig-Veda; a famous line mentions each stream—*imam mē gange yamune sarasvati śutidri*.

A legend about the origin of a great tributary of the Jumna, the Chambal (Charmanvati), describes it as a stream of blood that flowed from the innumerable cows sacrificed by the great mythical king Rantideva, to whom the animals themselves prayed to be sacrificed so that they would thereby attain heaven.

The strong faith in the holy atmosphere around a river fostered the concept of *gaṅgāyām ghoṣah* ("the village on the river")—the presentation of a microcosm of the universe in a cool and pure environment. The sculptor has often delighted in depicting this theme, and a splendid illustration is found at Mahabalipuram. Here a magnificent group of celestials fly toward a stream, suggested in the cleft between two rocks, to witness the penance of Arjuna for the invincible weapon that Shiva *fig. 138* vouchsafed to him. There is a temple on the bank of the river, and sages, young and old, are shown in attitudes of penance. Young hermits bathe, wring out their wet garments, fill their waterpots, and offer ablutions. The time is midday—the sages clasp their fingers in *yamapāśamudrā*, peep at the sun, and utter Vedic mantras. This representation of ritual ablutions, salutation of the sun, prayers, and penance recalls the description of rishis in literature. The nagas in the cleft signify water, and thereby

the stream of the river, and the river glorified is Ganga. The elephants are the *digga-jas*, or the elephants of the quarters in Patala (the netherworld), and the sun and moon at the top of the work signify heaven. The terrestrial region is suggested by the temple and the mortal sages seated in meditative pose.

fig. 36 A beautiful Sena sculpture of Ganga shows her standing by the wish-fulfilling tree, which is a symbol of heaven. In her hand is a pitcher, indicating prosperity through abundance of water. (The presence of water in an artwork almost always signifies life and immortality.)

In the sculpture at Ellora of the confluence of the rivers, there is also a very important anthropomorphic representation of the ocean as Ratnakara, the repository of precious gems. A bath in the sea is considered the most efficacious of ritual ablutions—all the holy rivers flow to the sea and mingle there. The ocean is masculine, the lord of all the streams, and the rivers are feminine, the consorts of the ocean who rush eagerly to meet their beloved. Kalidasa pictures the ocean as a prince lovingly fondling his consorts, the streams, drinking from their mouths, and feeding them with mouthfuls of water—*pibatyasau pāyayate cha sindhūh* (*Raghuvamśa*, XIII, 9).

The tree's cool canopy of leaves was a most welcome shelter from the blazing Indian sun. A long caravan could rest for a while in the shade; a weary traveler, a monarch with a mighty army, a simple teacher and his pupils—all thought of the tree as a benevolent protector.

The trees and creepers were treated with great affection and were personified. It is not surprising that these were thought to return human love; they scatter flowers like teardrops at the great grief of Sita, abandoned in the forest with much reluctance by her loving consort Rama. Some trees were held in such respect and esteem that they were believed to be the very personification of the Supreme Being. In the *Vishnudharmottara* the trees Nyagrodha, Udumbara, and Asvattha are taken as his manifestations. Shiva himself is Sthanu, or a tree trunk devoid of leaves (*aparnā*); but since Aparna is also the name of Devi herself, with Devi he is *saparnā* ("luscious with leaves"). And Sri is personified as a tree—this botanical representation recalls her zoomorphic form as a cow; her symbolic mark, the *śrivatsa*; and her anthropomorphic presence as a damsel amid lotuses. Bilva, khadira, and other trees were so sacred that their wood was used for the sacrificial post (*yūpa*).

The wish-fulfilling tree (*kalpavṛkṣa*) was a major motif in literature and art. It was believed that pots of gold and bags of precious gems lay at its roots. It was surrounded by the Seven Treasures (the conch and the lotus among them), and the tree had the power to bestow all precious things. Kalidasa describes the kindly spirits of the forest trees that treated Sakuntala, the simple hermit girl, with much affection. Sakuntala greatly loved the delicate plants and flowers and the tender shoots, and though wanting to adorn herself, she would not gather them. The woodland spirits returned her love and offered her silken garments and jewels from the wish-fulfilling tree to adorn herself before setting out for her husband's palace.

From Nachna comes a striking representation of the wish-fulfilling tree, spilling forth silken garments, jewelry, and all other earthly treasures. The earliest representation, however, is from the coping of the Bharhut rail, where the meandering vine is the wish-fulfilling creeper (*kalpavalli*), in whose tendrils are jewels, flowers, pots of fragrant wine, lovely garments of exquisite pattern. This wondrous vine closely an-

swers Kalidasa's description of the celestial plants in Alaka, the kingdom of the Lord of Wealth, where the damsels look to them for almost everything they want—*vāsas chitram madhu nayanayor vibhramadeśadaksham pushpodbhedam saha kisalayair bhūshaṇānām viseshān lākshārāgam charaṇakamalanyāsayogyam cha yasyām ekas sūte sakalam abalā-maṇḍanam kalpavṛshah* (*Meghadūta*, II, 120). A hand appearing from among the boughs at Bharhut offers food and water; this recalls an incident in Kalidasa's *Sakuntala* in which the gift of silken clothes by the tree sprite is made by a hand slipping through the branches. The most magnificent representation of the wish-fulfilling tree is from Beshnagar. It was probably the crowning piece of the banner column opposite the temple of Sri Lakshmi, the goddess of prosperity, or of Kubera, the god of wealth. The treasures are shown at the roots—the most prominent are the lotus and the conch from which gold coins tumble.

The *Mahabharata* and the *Ramayana* contain long passages describing the won-derful objects vouchsafed by wish-fulfilling trees. The Buddhist Jatakas also graphical-ly portray similar trees as the abodes of kindly sprites who cheerfully attend to the needs of passersby by feeding and clothing them. These are the vanadevatas, the god-desses of the trees. There was great desire that the celestial tree grow on earth. Krish-na's consort Satyabhama demanded it, and Krishna fought the Lord of the Celestials and brought the fabulous tree to the garden of his earthly palace. The most effective sculptural representation of this episode is at Angkor Wat.

Trees have been so loved, particularly by the women of India, that they are thought of almost as companions. Sex was attributed to them, and there was a mating of trees and creepers, a wedding of beloved ones. Lamenting for his lover, who lies in his lap with her eyes closed in death, Aja exhorts her to awaken and witness the fruition of her desire—the marriage of the mango and the liana. And the poet com-pares red palasa flowers, curved like the crescent moon, to nail marks imprinted by a lover—*nakhakṣatāniva vanasthalinām* (*Kumārasambhava*, III, 29).

In a land with such concepts, it is not surprising that the return of man's love by plants and trees was accepted as an almost absolute certainty. This explains the development of the concept of *dohada*—the power of a young damsel to make a plant bloom out of season. There are various modes of *dohada*, a theme as pleasantly handled in sculpture as in literature. As Kalidasa has it, there are two who are entitled to the privilege of receiving a gentle kick from a beautiful damsel: the asoka tree that tarries in blossoming and the unfaithful lover erring but repentant—*akusumitam aśokam dohadā-pekshayā vā praṇihitaśirasam vā kāntam ārdrāparādham* (*Mālavikāgnimitra*, III, 12).

The *kuravaka* tree is brought to blossom by the embrace of a damsel, and the bakula by the sprinkling of mouthfuls of wine. The *kesara*, less exacting than the others, is moved by a damsel's loving glances. All these actions are the *uddīpanas*, or stimulants for flowering out of season. A Sunga sculpture from Bodh Gaya shows a damsel climbing a tree to gather flowers, helped by her lover who holds both her foot and the branch with great tenderness. *fig. 360*

The trees on the banks of the river Nairanjara extended their boughs toward Buddha as he crossed the stream, thus allowing him to step easily onto the shore. The birds warbled and flew about him, saluting his noble qualities. The presence of Buddha and similar saintly beings makes even natural enemies, like the tiger and the deer, come together. Saintliness triumphs and creates peace—the timid and the ferocious, the innocent and the wicked, all mingle in friendly fashion. This scene is strikingly

fig. 190
shown in a sculpture from Amaravati. And an architrave from Sanchi shows the wisdom of animals, who worship the bodhi tree, the tree of wisdom. Buddha's presence invites even animals and birds to come and offer worship. Buddha is only one of the saints and seers of India who have commanded the respect of both animate and inanimate worlds.

fig. 79
Gautama Buddha and his predecessors each had a special tree associated with them. These trees are represented in interesting panels at Bharhut, which show a very ancient tradition of tree worship. The Bodhighara itself, a temple built around the tree, is a survival of an earlier cult of tree worship and of ancient deities associated with the tree. And each Jain Tirthankara had a particular tree as an emblem.

Shiva, as the great teacher Dakshinamurti, is shown under a banyan, the most magnificent of trees, surrounded by the ancient seers who are his disciples. Vishnu as teacher is Narayana of the Naranarayana pair, with the *badari* tree spreading its shade over both their heads. The most impressive representation of this theme is a Gupta sculpture from Deogarh.

A sculpture from Bharhut represents the rishi Dirghatamas teaching his pupils in a forest. The Aranyaka, one of the sacred Hindu writings, was to be studied in the forest glade (in Sanskrit *āraṇyaka* means "forest treatise"). The cool shade of the trees, the hermitage, and the sylvan surroundings were thought to be the best environment for cultivating concentration, memory, and philosophic speculation. It is not surprising that animals like the elephant and the monkey were chosen as companions in these surroundings, as in the Bharhut panel illustrating Bhaisa Jataka.

The personification of nature extended to the earth itself, which is described as a beautiful damsel, the wife of a king. The monarch looks lovingly through the balcony windows of his palace at his beloved, the earth. The shining river is the long plaited hair of his consort, and the flamingos on the stream ornament her braid.

The lotus ponds and lakes have been thought of as the abode of Lakshmi, the goddess of prosperity. The seasons themselves are personified and wonderfully presented in literature and art. The most charming is Vasanta Lakshmi, the beautiful lady of springtime, whose image is mirrored in the blooming flowers and clear water of a pond. Picturesquely colorful, the pond is frequented by flamingos, cranes, and swans; the breeze wafts the perfume of the lilies and lotuses from this cool and pleasant place. Accompanied by the hum of the bees, which are maddened by the nectar from the flowers, the plants and trees about the pond perform the lasya, the lyric and feminine dance.

Even the cities were thought of as beautiful damsels who attend their king. A coin of Zionises wooing the victor king as her overlord is an interesting Greek rendering of Indian thought. The celestial city of Alaka in the Himalayas is the capital of Kubera, the Lord of Wealth. With her high mansions wreathed by clouds during the rainy season, Alaka is the very picture of a beautiful damsel, her hair adorned by rich pearls—*muktājālagrathitam alakam kāminīvābhravṛindam* (*Meghadūta*, I, 66).

It is said that the city of Ayodhya came before Kusa in his impregnable palace at Kusasthali and, taking him by surprise, asked him to return and restore her, a deserted city, to the opulence and gaiety that once were hers. She appeared in soiled garments, her braid unkempt, like a woman mourning her separation from her lord. Acceding to her wishes, Kusa returned to the capital of his ancestors.

As early as the Rig-Vedic hymns, Ushas, the goddess of dawn, is described as a fair and beautiful damsel revealing herself in all her charm and glory. The Lala Bhagat pillar depicts sunrise—the god of light approaches in his chariot which is drawn by four horses and preceded by the dwarf sages Valakhilyas. The joy at the coming of the day is indicated by the dance of the peacock with spread tail and by the lotus pond in bloom. The goddess of the pond is represented as Gajalakshmi, bathed by elephants amid lotuses. She is indeed the glory of morning welcoming the light of the sun, the beginning of the day's activities.

fig. 326

This is even more beautifully represented in the Gupta sculpture from the architrave of the temple at Garhwal. This work illustrates the break of day, the activity till noon when the sun is at his height, and then the afternoon. It ends with the rise of the moon at the approach of twilight. At the terminals are the sun in a circular orb, riding his chariot drawn by four horses, and the moon on his crescent with his beloved, the star Chitra. The central figure is Surya, glorified as Narayana in his Visvarupa aspect, combining in himself all the divine powers personified as different devas. An umbrella is held over him as a devotee kneels in adoration. There is music and dance and festivity. The peasant is up and moving at daybreak to carry paddy rice from the field; the plowman walks with his simple tools on his shoulder; the pupils salute their master before commencing their studies in the forenoon; and the disciple goes to gather alms, indicating the simple and austere life of a student. The feeding of workmen during the day is beautifully represented—relief of hunger and thirst being considered the greatest act of merit.

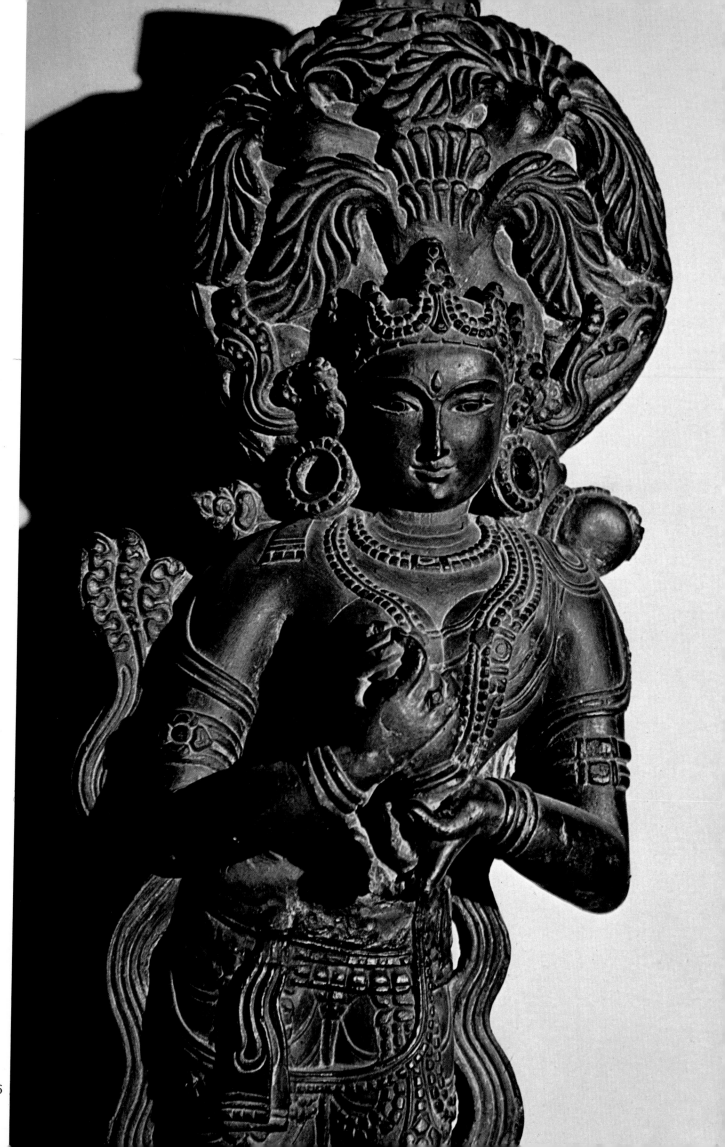

36

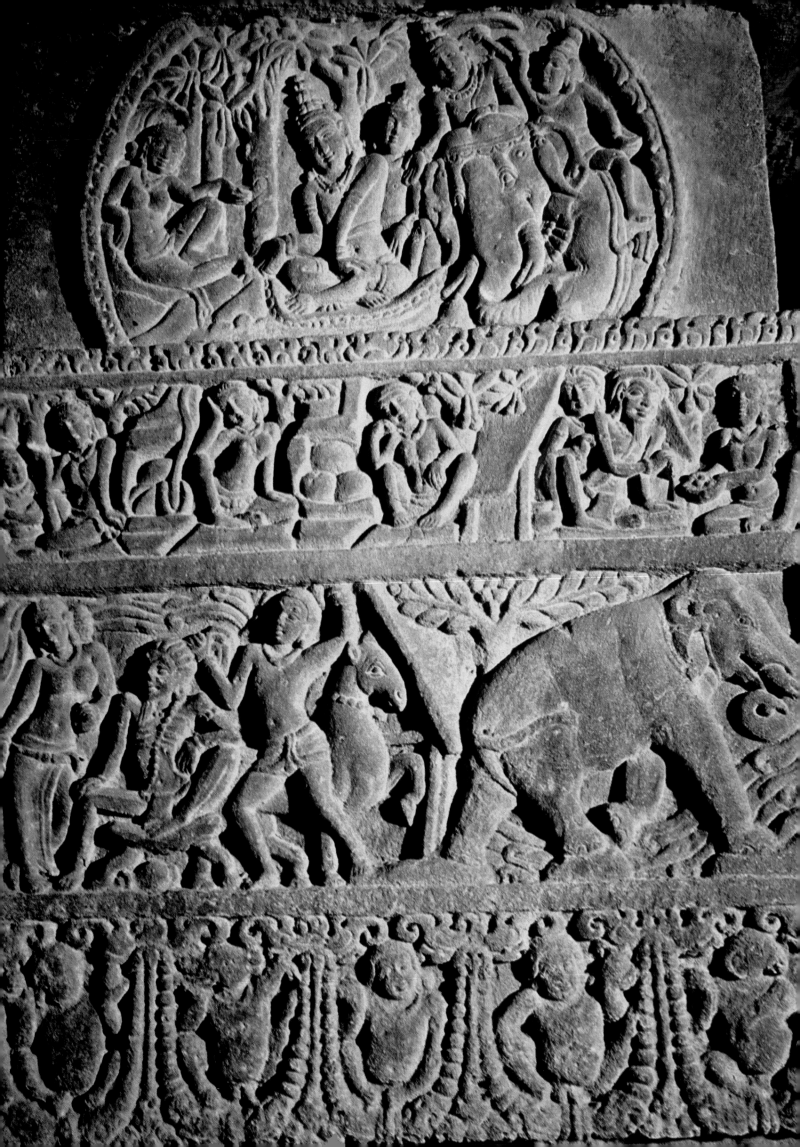

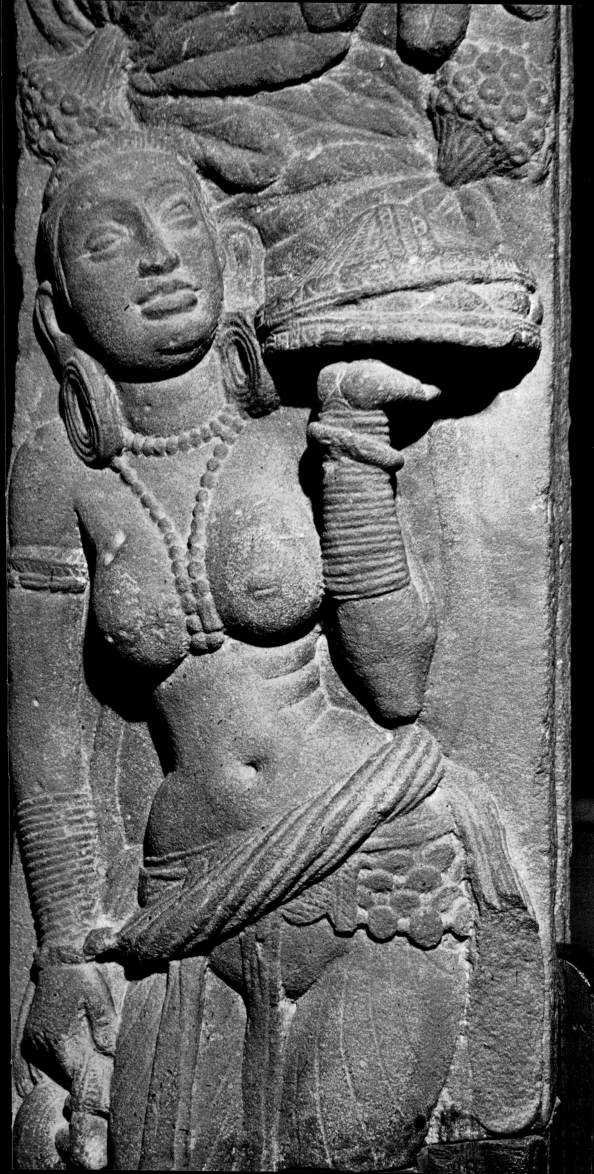

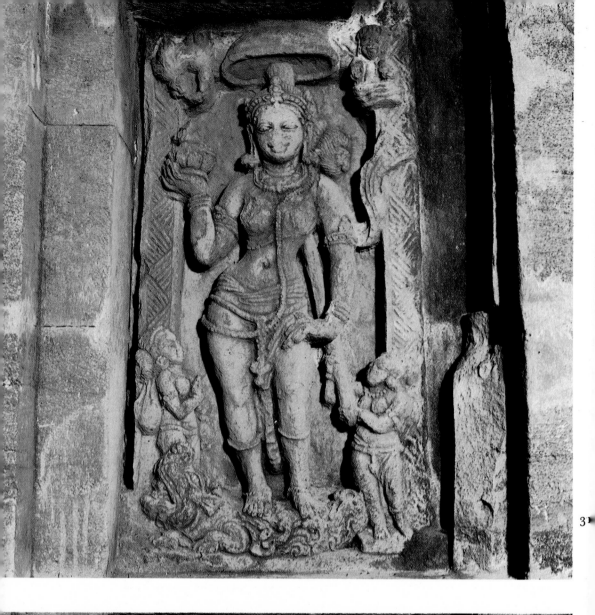

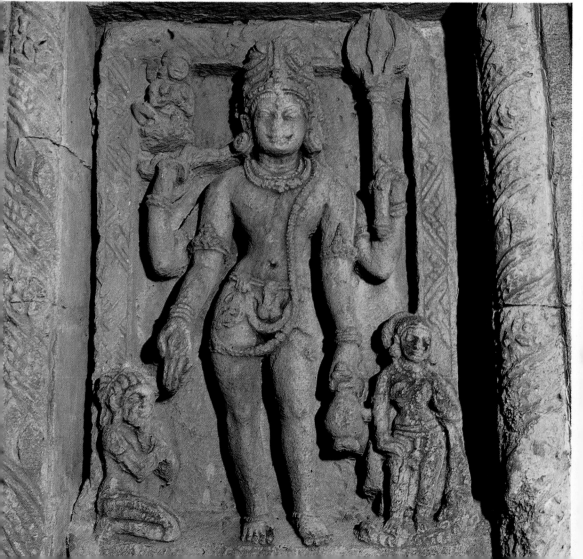

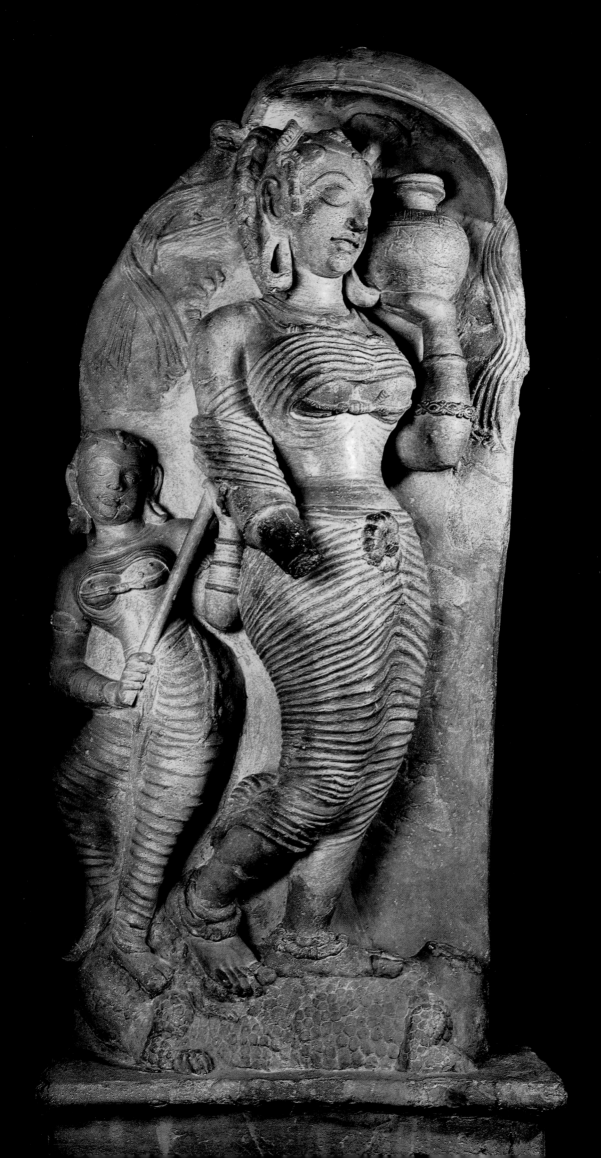

34

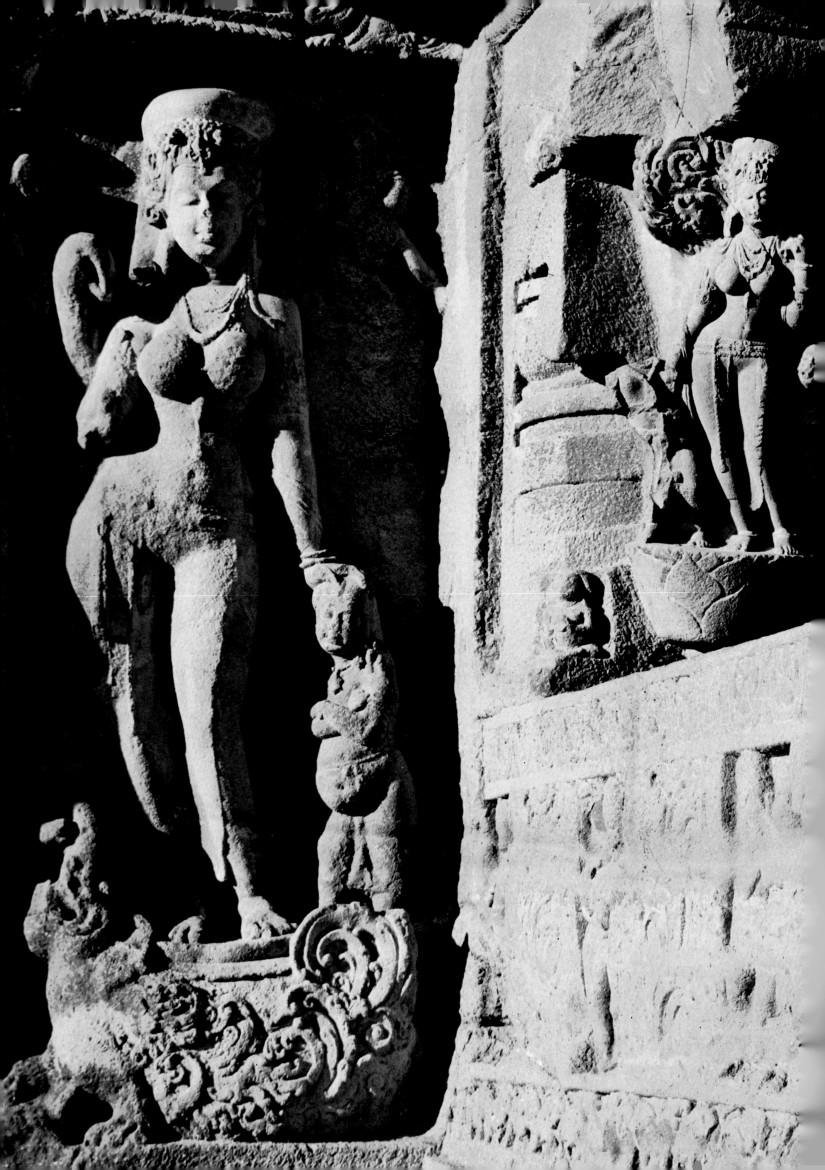

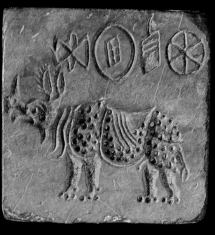
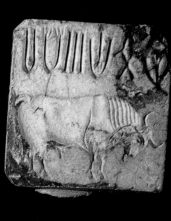
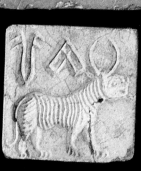
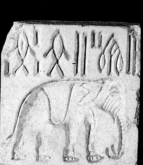
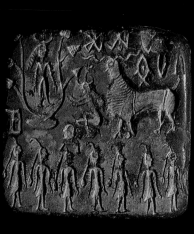
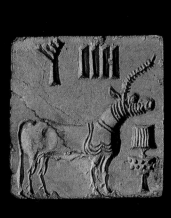
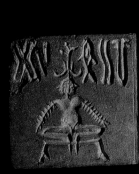
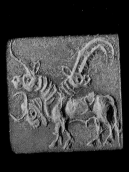
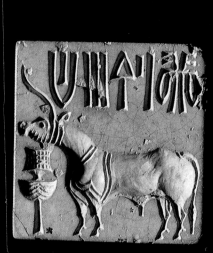
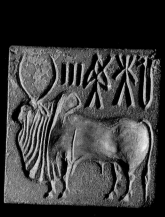

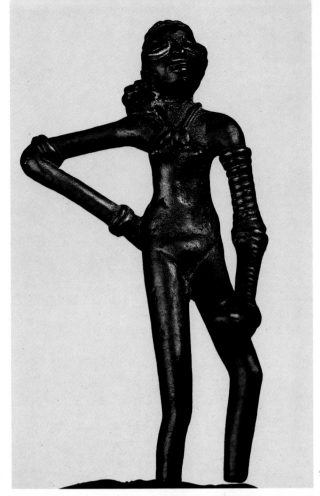

24

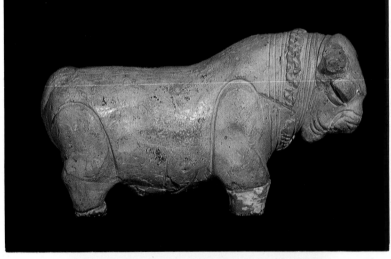

25

26

THE WRITTEN LANGUAGE

INDOLOGISTS shall always be indebted to Sir William Jones who in 1784 founded the Bengal Asiatic Society for the study of Indian antiquities, ancient Indian literature, and Indian culture. With his translations of *Sakuntala* and the Institutes of Manu, he was among the first to lift the veil of obscurity from the treasures of Sanskrit literature. On Jones's premature death in 1794, Henry Colebrooke, an expert in the classical and Sanskrit languages, became the head of the society. He ably carried on Jones's work until 1815, when he was succeeded by Horace Hayman Wilson, an equally well-read Sanskrit scholar. Wilson compiled a Sanskrit dictionary of great merit; translated Kalidasa's *Meghaduta*; gave the European world an account of the Hindu theater and dramatic art; presented the Hindu history of Kashmir in a translation of the *Rajatarangini*; and translated several episodes of the *Mahabharata*. Dr. Mill, whose knowledge of Sanskrit was in no way inferior to that of his predecessors, succeeded in the noble task of Wilson. His departure from India was keenly felt by James Prinsep, who assumed the leadership of the society. Through his work a new era dawned in the study of India's past. Like Shiva unraveling the veil of illusion, Prinsep dispersed the ignorance that obscured the earliest Indian inscriptions.

In May 1837 Prinsep published his readings of legends of Kshatrapa coins from Saurashtra. His letters to Alexander Cunningham, a young man of twenty-three, who was a worthy confidant and later carried on his great work, enchant us like a fairy tale in which the magic wand works marvels. On May 11, 1837, Prinsep sent Cunningham two plates of numismatic engravings and asked him to try his hand at deciphering them. But at seven the next morning Prinsep sent a note, "You may save yourself any further trouble. I have made them all out this very moment on first in-spection. . . . Every one of them gives the name of his father of blessed memory, and we have a train of some eight or ten names to rival the Guptas! Hurrah! I hope the chaps at home won't seize the prize first." The next day Prinsep again wrote to Cunningham—"I have made progress in reading the Peacock Saurashtrans."

It should be remembered that the correspondence quoted was written within a three-day period. Prinsep's enthusiasm enabled him to combine these rigorous studies with his strenuous work as master of the mint. And in three years of study he deciphered several inscriptions from the Sanchi stupa and the Delhi pillar and the rock inscriptions of Asoka, commencing with that of Girnar. There were moments of de-spair as Prinsep tried his hand at the Allahabad pillar inscription of Samudragupta; his "want of competent knowledge of the Sanskrit language" made him wonder if he would succeed in deciphering the inscriptions. But his increasing grasp of San-skrit, and the help he received from the Pali scholar Ratnapala, assured his success. By the end of July 1837 Prinsep had deciphered the ancient Brahmi alphabet with the exception of a few rare letters like *gha, jh, ṅ, ñ,* and *ṇ.* On May 23, 1837, while sitting at his breakfast, he translated *Devanampiya piyadasi raja hevam aha* as "the most partic-ularly beloved of the gods, Raja, declareth thus." With great excitement he im-mediately wrote to Cunningham, "We shall be able to read the whole of these mani-festos of the right faith—Buddha's bulls. Will send plates after breakfast."

But even as he was engaged in these tremendously important pursuits, Prinsep

was suffering from an illness that had stricken him in September 1836. And after lingering a year, he died at the age of thirty-nine in the midst of a brilliant career. This great scholar was the father of Indian epigraphy and numismatics, and he gave the world the key to the earliest history of India. All the work of later scholars ultimately rested on his decipherment of the Brahmi and Kharoshthi alphabets.

Another major breakthrough—the decipherment of the baffling Tamil Brahmi script of the extreme south—was made by K. V. Subramania Iyer. Before his work epigraphists had failed to translate the inscriptions, which were written in what appeared to be Brahmi interspersed with special letters unknown in standard Brahmi. It was believed that the language was Sanskrit or some form of Prakrit. But in a brilliant insight Subramania Iyer realized that the language was Tamil.

The culture and antiquity of a country can often be assessed through its literature, the written texts that document a civilization. In India, however, learning itself was known as *śruta* ("learned through the ear by hearing"). And the most sacred book embodying the wisdom of the ancients, the Veda (including the Rig-Veda, the Yajur-Veda, the Sama-Veda, and the Atharva-Veda), is styled *śruti* ("learned through the ear"). These works were heard, repeated, and memorized. Although a text was not necessary for the Vedic scholar, the sacred works were transcribed in several scripts. The *Lalitavistara* mentions a number of scripts learned by Prince Siddhartha at school, including Brahmi and Kharoshthi.

An early Sunga terra-cotta of the second century B.C. from the ancient site of *fig. 4* Srughna and now in the National Museum shows a boy of five copying the vowels of the alphabet. Writing each letter five times, the pupil copies the curves and the lines demonstrated by the master; and as he forms each letter, he repeats its correct pronunciation. By learning the script in the proper fashion, the young student would ultimately reach the ocean of knowledge—*liper yathāvat grahaṇena pārthivaḥ nadīmukheneva samudram āviśat* (*Raghuvaṃśa*, III).

Although great importance was given to the oral tradition in India, the ability to write was highly prized. Calligraphy was cultivated as a great art, and the skilled scribe known as a Kayasth was famed for his beautiful and clear script (he could also write in a cursive fashion if he chose to make his meaning obscure.) The Srotriya, or Vedic scholar, was so indifferent about his script that his lines were barely intelligible. In fact, Chanakya, the great prime minister of the emperor Chandragupta Maurya and a Vedic scholar, remarked that the script of a Srotriya was unintelligible, even when written with special care—*prayatnalikhitānyapi śrotriyāksharani niyatām asphuṭāni bhavanti* (*Mudrārākṣasa*, I). But noting the graceful lines and forms of letters in a document prepared by a Kayasth, he exclaims, "How lovely to look at are these letters" (*Aho darśaniyānyaksharāṇi*). (And, although without calligraphic skills themselves, the Srotriyas greatly appreciated beautiful script.)

Despite its vastness India has enjoyed the boon of a unified culture. From the earliest times learning was so respected, coveted, and sought that great universities flourished. Students traveled great distances to acquire knowledge in universities at Taxila, Benares, Nalanda, and Kanchi. And the impact of Indian learning was felt far beyond the subcontinent's shores. The language of India in the earliest phases was Sanskrit, and it continued to be so through the centuries. Although there were frequent disputes and wars among ruling dynasties, Sanskrit was always accepted as

the premier language. Thus the state language was Sanskrit whether the inscriptions were from the north or the south and whether the dynasty was Gupta, Vakatak, Vardhana, Maukhari, Pratihara, Paramara, Chandella, Pala, Sena, Gahadavala, Haihaya, Ganga, Pallava, Chola, Pandya, Chalukya, Rashtrakuta, or Vijayanagar. Inscriptions were sometimes written in regional languages, but they invariably had a preface in Sanskrit. This may be seen in the Telugu, Tamil, and Kanarese inscriptions of the medieval period.

Although most scribes were competent, there were specialists in this field, favored by kings and especially appreciated for their excellence, who were known as *rājalekhakas* ("the king's own scribes"). In a panel from Nagarjunakonda a scribe is fig. 74 portrayed writing with a stylus on a palm leaf; he is recording the horoscope of the infant Siddhartha. Inscriptions at Sanchi and Amaravati give a synonym of *rāja-lekhaka*, *rājalipikara*. In the Apsad inscription of King Adityasena, the *lipikara* Sukshmasiva from the Gauda country describes his letters as very beautiful. The scribe Mahidhara compares elegant letters to the bright stars in the sky. And the scribe who engraved the charter of the Eastern Chalukyan king Narendramrigaraja styles himself an expert in engraving beautiful letters (*akṣaralatitācārya*). Some of these letters are called *sphuṭākṣara* ("extremely clear, well cut") and *vimalākṣara* ("without the least blemish, immaculate"). The importance given to delicacy in delineation is suggested in a line from the Vasantagadh inscription that describes the letters as soft and delicate (*mṛdu varna*). Perhaps the most distinguished scribe, Somesvara, proudly compares himself to a lover painting his beloved with a variety of colors. Sovarasi, a twelfth-century Kanarese sculptor of distinction noted for his inscription concerning the Chalukya king Vikramaditya VI, entwined animal forms (the elephant, lion, parrot, and others) among his letters. His skill was so great that no other scribe dared compete with him.

Kuṭila ("bent" or "crooked") letters were also assiduously practiced, and there was a script (*lipi*) known as *kuṭilalipi*. The scribe Takshaditya from Gauda describes himself as a well-known exponent of this style. A florid script, which was also widely used, was marked by deliberate ornamentation of simple letters. In the Banskhera plate of Harshavardhana, the letters, though decorative in shape, are of the normal variety, while the signature of the emperor is in a highly floriated type. The Nagari inscriptions in the south in the Kailasanatha temple at Kanchipuram, giving the numerous titles of Rajasimha Pallava, are neatly incised in both the simple and ornamental styles. This southern ornamental script is the equal of that of the north. There are lovely lines and vinelike curves, and the necks and wings of birds, such as the peacock, are used as decorative elements. On a pillar of the Rajivalochana temple at Rajim in central India, the name of Purnaditya is written in ornamental letters. The peculiar script called "shell characters" is used for some short legends and poses an epigraphical puzzle not only in India but in distant Java.

The script of southern India is marked by curves and circles and is written with a stylus on a palm leaf. In the north the script is angular and is written with pen and ink on a birch leaf. These distinctive styles and materials account for the marked difference between the northern Nagari and the southern Grantha scripts, although both are derived from Brahmi.

The *nāgaraka*, the sophisticated urban connoisseur, was adept in writing. The fig. 613 statue of a princess writing the titles of the Chalukya king Vikramaditya on a scroll

shows that daughters of distinguished families studied calligraphy as well as literature and fine arts. A similar figure in the Indian Museum shows a damsel writing a love letter. This striking example of Chandella art illustrates how well a cultured girl could express herself to her lover. The *Abhijnanasakuntalam* tells of Sakuntala writing a letter to Dushyanta. This shows that even the unsophisticated girl of the hermitage was trained to write, since the great ascetic Kanya knew that Sakuntala would become the consort of a great emperor.

fig. 38

By far the most beautiful element of any written document was the signature, and perhaps the finest example of a royal signature is that of Sri Harsha, in which the name of a king is prefaced by the phrase *svahasto mama* ("this is my signature"). This, the best-preserved highly florid royal signature, has no peer in the whole range of epigraphical literature. A very simple but striking example of signature is that of the Vijayanagar emperor Harihara which simply reads Sri Harihara. King Bhoja of Dhara, famous for his devotion to Sarasvati, the goddess of learning, always signed his documents with the phrase *svahastoyam śribhojadevasya*.

Like a signature, a seal attested to the authenticity of a document. The seals bear beautiful legends in couplets of short pithy lines often describing the glory of the king, which are written in letters characteristic of the period and the area. The dharmashastra decreed that a seal be affixed to a legal document, and a sealed document could not be repudiated. Many seals have been found throughout India—those of noblemen, generals, ministers, judges, princes, and rulers themselves, and those of institutions such as monasteries, universities, temples, and guilds. The seals often bear the symbol of the royal family or of an institution or a high office. The bull of the Maukharis is among the most striking of the symbols. In fact, it is difficult to say whether the Maukhari seal is most admired for the beauty of its script or for the charm of the bull and the human figures that appear on it. The bull on the Pallava seal, though simple, is equally charming. The grandeur and glory of the Chola emperor Rajendra is captured in the symbols and legends of his Tiruvalangadu copperplate grant. The deep faith and almost self-effacing piety of the Palas can be observed in the *dharmacakra* flanked by deer on the charter of Dharmapala. The picturesque zoomorphic representation of Vishnu on the Chalukyan seals, particularly those of the Eastern Chalukyas, show a goad, symbolizing the king's power over his enemies who are like elephants running amok. The Vakataka seals of the fourth and fifth centuries bear beautiful examples of the box-headed script that is used for short legends. The Allahabad inscription of Samudragupta tells that golden seals with the Garuda emblem were presented to the emperor by several vassal kings. Gupta seals were indeed magnificent—the beauty of the Garuda emblem is matched by that of the script. And the legends are the best ornate poetic compositions in numismatic history. Harsha's seal bears a detailed description of his ancestry, a magnificent example of the florid variety of early Nagari script.

The earliest known historical scripts in India are Kharoshthi and Brahmi, and varieties of the latter are found throughout the country. Variations in the earliest phase of the Brahmi script can be noted in the reliquary inscriptions from Bhattiprolu and in several other inscriptions, mostly in the Tirunelveli, Ramnad, and Tiruchirapalli districts. During the centuries and in different areas of the vast Indian land, the

script underwent many changes, and it is interesting to compare the different varieties—such as Kshatrapa in the west, Kushan in the north, and Satavahana in the Deccan, all of which date from the second century A.D.

The most beautiful script of the first and second centuries A.D. is seen in the Nasik inscriptions of Ushavadata, the Junagarh inscription of King Rudradaman, and the inscription of the queen mother Balasiri in the Nasik cave. A long ornamental type with curls and flourishes, which dates from the second and third centuries A.D., is from Nagarjunakonda. Closely allied to this is the early Pallava script of the Mayidavolu plates. Western Indian script of this period is best represented in the Traikutaka inscriptions. From the Kushan script of northern India is derived the later type

fig. 209
fig. 210

of Brahmi, seen in Samudragupta's inscription at Allahabad. The Mandasor inscription of King Yasodharman shows the development from Brahmi to Nagari. The most beautiful calligraphy of the seventh century is based upon this transitional script and is seen in the Banskhera plate of the emperor Harshavardhana and in his sign manual. These letters are so beautifully and ornamentally incised that J. G. Bühler, the German Indologist, remarks, "If Harsha really used these characters in signing all legal documents, he must have been a most accomplished penman, and the cares of government and the conquest of India must have left him a great deal of leisure." But it should be remembered that Harsha was an eminent poet and connoisseur, an able administrator, and a devotee, and his appreciation of penmanship may have led him to master the beautiful script attributed to him. The florid lines of these letters have parallels in the southern Pallava Nagari inscriptions at Mahabalipuram and in the Kailasanatha temple at Kanchipuram.

Nagari in eastern India is illustrated in the script of Sasanka, a contemporary of Harsha. Further development in the Gangetic region in the eighth and ninth centuries is seen in the inscriptions of the Pratihara king Mahendrapala of Mahodaya. And the twelfth-century script of this area is seen in the inscriptions of the Gahadavala king Chandradityadeva of Kanyakubja. Western Indian Nagari of the eleventh century is illustrated in the Banswara plates of Bhoja Paramara of Dhara. The script of northeastern India is seen in the inscription of Vijayasena from Deopara, which dates from the eleventh or twelfth century. To the south in Kalinga, another variety of Nagari appears in the Nagda plates of Vajrahasta.

Further south the Pallavas used not only the Grantha and Tamil scripts, but also Nagari (in florid and plain varieties) for their bilingual inscriptions. A whole series of titles are incised in the florid Nagari script, which closely resembles that of Harshavardhana. It is interesting that Nagari was used throughout southern India—on the eighth-century Paliyam copperplates of Varaguna Pandya; on coins in the early Chola issues of Uttamachola, Rajaraja I, and Rajendra I (tenth and eleventh centuries); in Ceylonese issues such as the coins of Parakramabahu, Vijayabahu, Lilavati, Sahasamalla, Dharmasoka, and Bhuvanaikabahu, all of which resemble those of the great Chola emperor Rajaraja; on Keralan coins; and on the issues of the Yadava, Kakatiya, and Vijayanagar dynasties (on these a debased variety, known as Nandinagari, is used).

The earliest use of Nagari in western India and the Deccan is seen in the Samangad plates of Dantidurga and the Pattadakal pillar inscription of Kirtivarman II, both of the eighth century. Rashtrakuta Krishnaraja's Talegaon plates and the Bagumra plates of Indraraja III (dated 915) illustrate the next stage of development.

The Western Chalukyas of Kalyan also used Nagari, as in the twelfth-century Sital-badi inscriptions of Vikramaditya VI. In the Deccan Nagari was used by the Yadavas of Devagiri and later by the Vijayanagar rulers. During the Vijayanagar period the text of copperplate grants was in Nagari, while the signature was usually in Kanarese.

In central India, the box-headed script of the Vakatakas was similar to that of the Guptas. The Nachneki-talai inscription of Maharaja Prithvishena is a very early Vakataka inscription. The Kadambas also perfected a distinctive box-headed script, seen in the Talagunda inscription of Kakusthavarman, where the letters are long and narrow. The use of the box-headed script in Kalinga is seen in early Eastern Ganga inscriptions, such as the Jirjingi plates of Indravarman. The early Pallavas used a similar script in which the box-head was less prominent.

The forerunner of the Telugu-Kanarese script is the early Chalukyan type that spread through the west and the east. The script in the sixth-century Badami cave inscription of Mangalesa and in the Aihole and Pattadakal inscriptions marks the initial stage of Kanarese-Telugu. The earliest Kadamba script, that of the Western Gangas, also influenced this variety. The Huli inscription of Vikramaditya VI is a fine example of later development. And the final phase of this variety is seen in the Hoysala copperplate, dated 1117, from the Belur temple, which is a fine example of this most decorative script with its beautiful designs and floral patterns.

The development of Telugu script in southern India and the Deccan should be studied with that of Kanarese in western India. Kubjavisnuvardhana's Timma-puram grant offers an example of seventh-century Telugu in the south. The impressive tenth-century script of Vijayaditya III illustrates the changes that occurred with the passage of time. The best example of Telugu script is from the reign of the Kakatiyas (thirteenth century); this most graceful script can be seen in the Chebrolu inscription of Jaya. The lithic inscription in the Rangaswami temple at Hampi gives an excellent example of Kanarese-Telugu script of the Vijayanagar period.

The earliest Grantha-Tamil script shows close affinities to the early Kanarese-Telugu varieties. The script of Mahendravarman I and even Narasimhavarman is closely akin to an early common variety of southern India and the Deccan. From the end of the seventh century onward, the individuality that is characteristic of the Grantha-Tamil script becomes more marked. This script is nearly identical in Chola, Pandya, and Chera areas, except that a modified cursive form, known as Vatteluttu, occurs in the southern Pandya and Chera regions.

The Pallava script had great influence and served as a prototype for scripts in distant corners of Southeast Asia. This Pallava-Grantha script has a florid and a simple variety, both of which were used in the cave temple of Mahendravarman and in the titles incised on the Dharmarajaratha at Mahabalipuram and on other monu-ments. The most beautiful Pallava-Grantha script is seen in the Kailasanatha temple at Kanchipuram, which dates from the end of the seventh century.

The Tiruvellarai inscription of Dantivarman (late ninth century) offers a fine example of early Tamil script. The Cholas, Pallavas, and Pandyas used Tamil letters to express pure Tamil passages and Grantha script for Sanskrit words or lines. Rajendrachola's Tiruvalangadu plates show the typical eleventh-century Chola script, which uses both Grantha and Tamil elements. The final stage of this script can be seen in the Vijayanagar inscriptions.

The Vatteluttu characters, which are closely akin to Tamil though distinctively slanting and curved, serve as the script for several inscriptions of the Pandyas, the Cheras, and even the Cholas. Pandya Parantaka's inscription of the eighth century provides an excellent example.

Indian coins bear legends that enable the scholar to determine not only their distribution, but also their date. A distinct flavor is added by symbols and figures, often in compositions of great artistic merit. Some coins, like those of the Guptas, display exquisite artistic workmanship. The human and animal figures they bear are wonderful examples of the sculptor's art. The legends are usually composed with great care, and they are striking both for their poetic expression and for their calligraphic beauty. These legends express, often in symbolic terms, the majesty and goodness of the sovereign—his accomplishments, conquests, material prosperity, and spiritual elevation. These lines reveal the spirit of a people whose outlook was governed by a yearning in the ethical direction, dharma. This religious emphasis continued after the Hindu period and is evident in later coinage.

Even the early Indo-Greek coins express philosophical or religious ideals. The

fig. 226 concept of *dharmavijaya* ("righteous conquest") is depicted on a coin of Zeonises—the goddess of a conquered city accepts the victor as her lord and offers him laurels in tribute. The coin of Apollodotos bears a bull on the obverse and an elephant on the reverse. Thus the magnificence of the crown prince is iconographically depicted—he is the noblest of his stock, like the imposing humped bull or the stately tusker, both symbolizing "the best."

fig. 227 In the coins of the powerful Yaudheya tribe, the magnificent image of Skanda, the Warrior Lord, expresses the heroic ambitions of the Yaudheyas, who dedicated themselves to Skanda Brahmanyadeva, the youthful commander in chief of the celestial army.

The Kuninda coin, with its zoomorphic, anthropomorphic, and symbolic representations of Lakshmi, the goddess of prosperity, emphatically suggests the prosperity and good fortune of the Kushans, the great dynasty that issued it. The appearance of such diverse deities as the Greek Herakles and Selene, the Hindu Shiva and Lakshmi, and the Buddha reveals the Kushan emperor's catholicity—he welcomed all deities with adoration, and he offered them all homage, hoping thus to ensure the well-being of his people.

The Asvamedha coins of the Guptas are similar to those of the earlier dynasties such as the Satavahanas. On the obverse the horse represents the sacrificial animal that is offered to the gods; on the reverse the goddess of prosperity holds the chowrie for the emperor in all his glory, who confirms his greatness by performing the sacri-

figs. 43–50, 229 ficial rite. The emperor is shown as a harmonizing force, his umbrella representing his unification of a vast area that had been torn asunder by rival monarchs.

The *cakravikrama* type, the unique example of which comes from the Bayana Hoard, represents the emperor deriving his strength and prosperity from adoration of the wheel of Vishnu—the symbol of power, justice, rhythm, and military splendor. The ruler is controlled by the highest ethical codes and performs voluntary sacrifice for the weal of the people, who are in a sense his children.

The king-and-queen type represents an ideal pair with a great sense of sacrifice, who live a life of abstinence in order to serve humanity. The king is usually shown

with two consorts—his earthly queen on the obverse and the goddess of prosperity on the reverse.

In the Sri Pratapa type of coin the prince is claimed by the goddesses of both prosperity and learning; one is confined to the face and the other to the chest, with a pearl necklace on the neck the boundary between the two. This is a rare combination—a wonderful coming together of learning and prosperity in a prince who was a treasury of both knowledge and riches.

The king as undaunted hunter is seen on the *khaḍga* coin where he cuts the horn of the rhinoceros. The lion-slayer type is similar; here the legend describes the valor of the king as *siṁhaparākrama* ("like the might of the lion that he has overcome"). The king is also portrayed as the lion-trampler or the tiger-destroyer.

The ruler's magnificent personality, imposing as a sal tree, is emphasized in the *chatra* type where he towers over the dwarfish umbrella-bearer. The umbrella raised over the king emphasizes his power; he brings the entire earth under his sway, represented by the shade of a single parasol.

The lyrist type, in which the ruler is seen thrumming a vina, shows the prince's *fig. 230* great musical talent. He is therefore not only the abode of valor, but also the repository of the fine arts. The Allahabad inscription states that Samudragupta's musical skill outshone that of such divine musicians as Tumburu and Narada.

The king as aesthete is shown as a reclining figure with the legend *Rūpākṛti* ("prince charming"). The lotus he holds suggests the ample leisure that he uses to appreciate artistic achievement. The prince's superior knowledge of the arts and literature was dedicated to appreciating and rewarding the deserving. Such a prince could not but be the darling of his subjects, who would ever delight to see him riding on the state elephant, with the umbrella held over his charming face to ward off the sun that could mar his lovely complexion.

In the magnificent Chola series of coins, that bearing the legend *Gaṅgaikoṇḍa-* *cola* has great import. It commemorates the achievements of Rajaraja I, the greatest *fig. 233* Indian warrior-prince. The legend is the epithet he gained by bringing home the water of the Ganges, the only tribute he demanded from the kings he vanquished, from the extreme south—Ceylon and the Pandyan kingdom—to the territory of the Palas and the Pratiharas in Bengal and Uttar Pradesh. When this coin was issued, Rajendra was engaged in constructing a huge temple as a thanksgiving offering to Shiva for his victories. He also commissioned a triumphal waterway, several miles in length and filled with water from the Ganges.

The *Gaṅgaikoṇḍacola* coin was the model for other commemorative coins like the *Kaḍāramkoṇḍa* issued by Kulottunga who conquered Burma and Malaya and the *Talakāḍugoṇḍa* issued by the Hoysalas who overran Western Ganga territory. The principle of *dharmavijaya*—the return of a vanquished kingdom to its former ruler in return for his recognition of the sovereignty of the conquering prince—is seen in the coin that bears the legend *Kaccvilaṅgam perumāl* and that shows Kanchi and its surrounding territory being returned to its vanquished ruler.

Some emblems were associated with particular dynasties—the bow with the Cheras, the boar with the Chalukyas, the fish with the Pandyas, and the tiger with the Cholas. Other symbols were more widely used. For example, Sri Lakshmi appears on many series of medieval coins, among them those of Sallakshana and Jajalladeva.

The last series of coins struck by Hindu princes in the Punjab, with the bull

on the reverse and the cavalier on the obverse, is a reminder of a period when chivalry and the cavalier were most honored. This motif was continued in the earliest Muslim series in India, some of which have bilingual legends in Nagari and Arabic.

fig. 236 Akbar the Great, the Mogul emperor of Hindustan (1556–1605), was known for his deep appreciation of aesthetic perfection. His "hawk coin," which glorifies his prowess as a hunter, brings to mind the magnificent paintings of animals and birds by his court painters. Jahangir, Akbar's son and successor, issued the zodiacal series, *figs. 237–41* one of the most famous of Indian coin series. These coins show both his high aesthetic standards and his passionate interest in astrology. Jahangir's enthusiastic abandon in drinking bouts is suggested in the detailed portrait on his coin, which shows him holding a wine cup.

Sanskrit (which means "refined") was the ornate language of official and learned statements; the natural unaffected language of the folk was Prakrit. Sanskrit was considered the language of the gods, vouchsafed to mankind by the rishis, and it held an honored place as the national language. The oldest book in the most archaic form of Sanskrit is the Rig-Veda. This work contains 1,017 hymns, plus eleven more known as Valakhilyas, in ten mandalas, or books. The other Vedas are the Yajur-Veda, Sama-Veda, and Atharva-Veda.

In general, Vedic literature is composed of Samhitas and Brahmanas. The Samhitas are mantras or hymns and the Brahmanas are elaborations. The Aranyakas and Upanishads, which can be considered appendixes to the Brahmanas, are the most esoteric and speculative of the sacred writings. The Upanishads embody the highest thought and philosophy. While the Rig-Veda has invocations to the gods of the Vedic pantheon, who are presented most picturesquely, the Yajur-Veda is the sacrificial book stating the rituals necessary for the proper conduct of sacrifices. The Sama-Veda contains the laudatory hymns to the devas. Vedic gods such as Indra, Varuna, and Mitra are mentioned in the Boghaz Keui inscription in Asia Minor. This inscription records a treaty between the Hittites and the kings of the Mitanni in about 1400 B.C. and thus helps to establish the great antiquity of Vedic literature.

Many iconographic elements of later literature are present in the Vedic canon, but often in an embryonic form. Except for Viratpurusha, who is described in the *Parushasukta* as having innumerable hands, eyes, heads, and limbs, the Vedic deities are almost human. Rudra, for example, has only a single pair of arms, although they are golden. The description of Ushas, the goddess of dawn, is a most lovely passage from the Rig-Veda. The glorious portrait of the sun-god moving in his celestial chariot, observing the good and evil deeds of man, is another marvelous Rig-Vedic composition. Varuna is the lord of rita, upholding righteousness. The daily life and culture of the time are incorporated in the Vedas. The hymns addressed to the plants before even a twig is plucked show the regard for tree sprites and sylvan godlings. This belief in the most cordial relationship between man and the natural world continues throughout the long history of Indian thought. A number of the kings whose histories are later related in epic literature appear in the Vedas. And the Vedic doctrine of karma is the basis of the numerous stories of the lives of Buddha embodied in the Jatakas and Avadanas. Upanishadic thought gave rise to the later schools of philosophy like Sankhya, Yoga, Vaisheshika, Nyaya, Mimamsa, and Vedanta.

In the seventh century B.C. the great grammarian Panini used the study and

definition of language and its patterns to make an invaluable contribution to the understanding of Vedic texts. The age of the sutras (500–200 B.C.) was characterized by a number of books that discuss Vedic religion and rituals as well as the life of the individual as a social animal and as householder. Thus, there were the *Srauta Sutra* (text on sacrificial ritual) and the *Grihya Sutra* (text on domestic ceremonies). There were also dharmasutras that laid down codes of conduct. Among the dharmashastras (books of law), which are attributed to several great seers, those of Manu and Yajnavalkya are preeminent.

The *Ramayana,* composed of twenty-four thousand slokas, or forty-eight thousand sixteen-syllable lines, is attributed to Valmiki who burst into poetry at the sight of a hapless bird lamenting the death of its mate. This epic, which contains charming descriptive passages, has inspired thousands of sculptural panels, murals, and miniatures in India and in Southeast Asia. The *Mahabharata,* composed of one hundred thousand couplets in eighteen books, contains the distillation of Indian wisdom, particularly of the concept of dharma. The ancient kings of the country decreed regular recital and exposition of these valuable parts of the epic in the pillared halls of the temple that existed in almost every village. This certainly molded the character and outlook of successive generations. The epics were a national legacy, studied and understood by all, even the illiterate, who learned from oral exposition.

Another popular literary form was the fable or fairy tale that pointed out a moral. These are found in the *Harivamsa,* an early book describing the pranks of Krishna, and in the Puranas. Both classical Sanskrit and Prakrit literature have innumerable works of *kavya* poetry and prose and a mixture of both (*champu*). There are also many dramatic compositions (*nāṭakas*)—from one-act farces to long serious dramas like the fifth-century *Mricchakatika* ("The Little Clay Cart") of Sudraka, Kalidasa's approximate contemporary. More than any other work, Kalidasa's drama *Abhijnanasakuntalam* ("The Recognition of Sakuntala") drew Western scholars to the study of Sanskrit.

A study of Kalidasa's fanciful poem *Meghaduta* ("The Cloud Messenger") is necessary to the understanding of Indian sculpture and painting. Other works of Kalidasa, Bhavabhuti, and Bana are also indispensable aids to comprehending artistic iconography. Sanskrit works on music, dance, architecture, and culpture—such as Bharata's *Natyasastra*; *Sangitaratnakara*; *Mayamata*; *Manasata*; *Kasyapasilpa*; and the *Vishnudharmottara*—help illuminate Indian art. In fact, knowledge of Sanskrit and Prakrit literature allows one to recognize and interpret themes that are strikingly presented by the chisel or the brush.

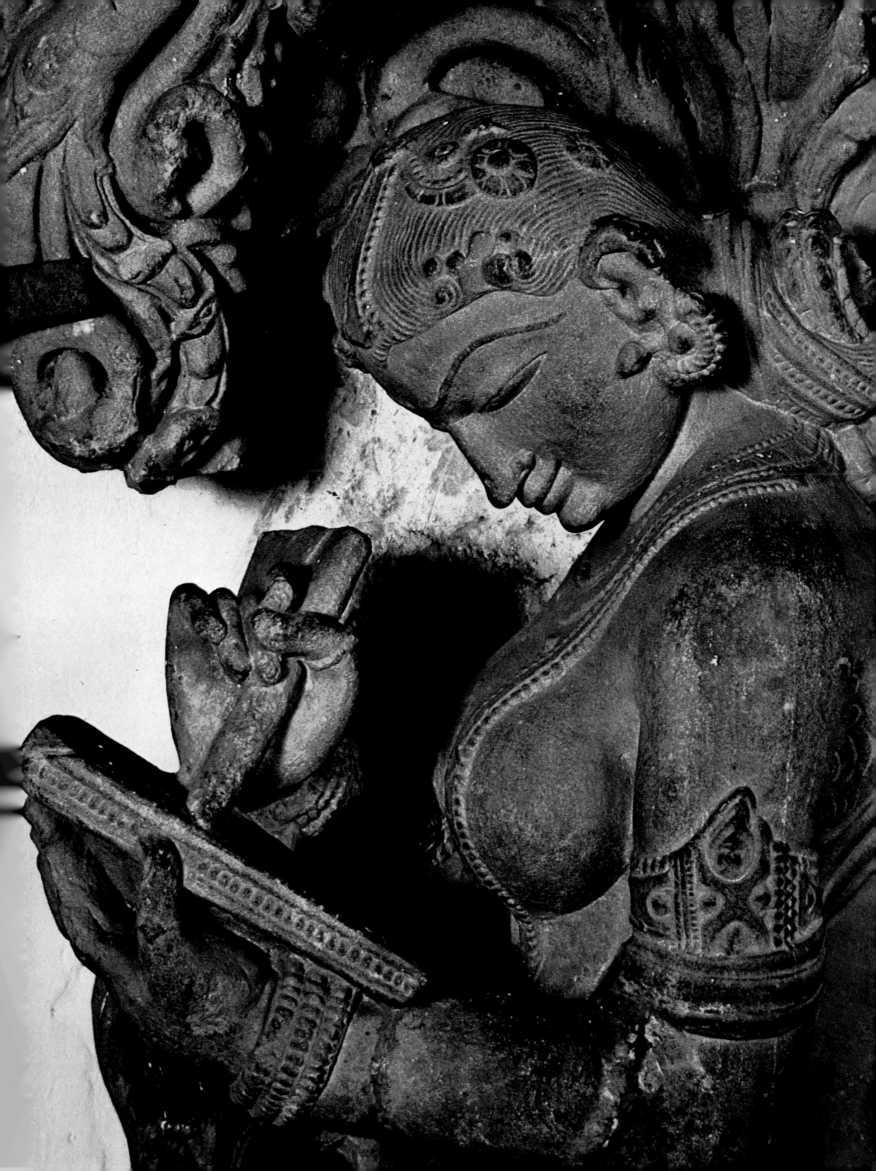

39 40

41

42

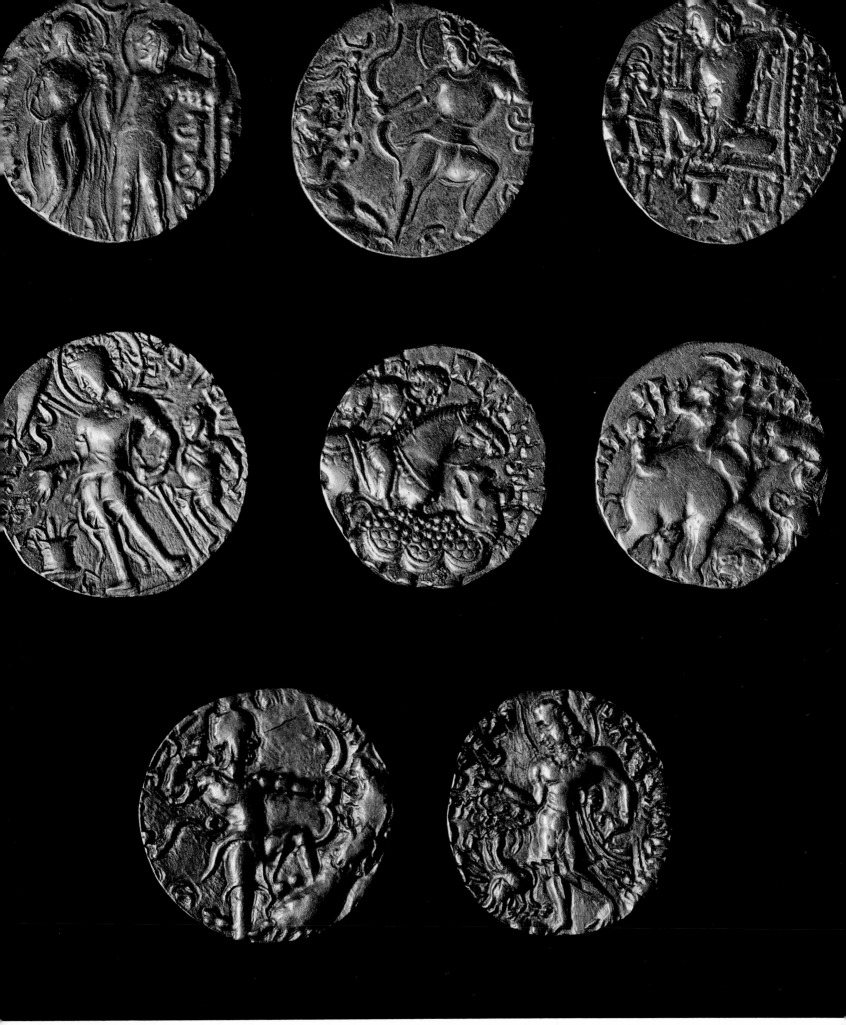

51

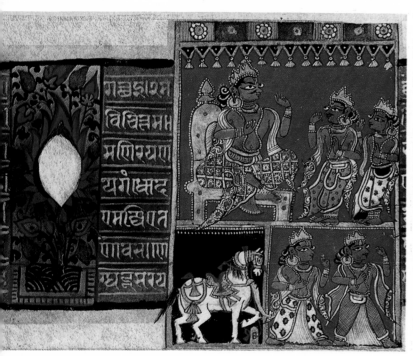

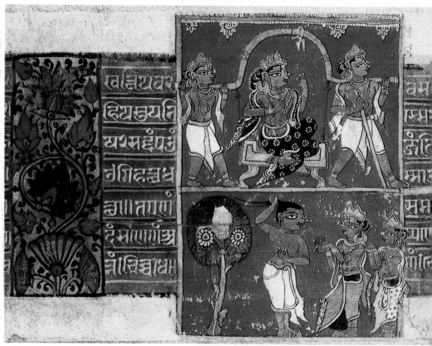

THE INDIAN PANTHEON

THE Vedic deities display marked anthropomorphic characteristics. Rudra, the mighty, has only two arms (although they are golden); Indra wields his thunderbolt; Surya rides his golden chariot; Ushas unveils herself; and Agni approaches like a household priest, leading believers on the right path. There is a human touch and form in all the early deities; only later do ferocious multiarmed iconographic concepts develop and almost engulf their creators in superstitious turmoil.

The folk have always had their own simple sylvan, aquatic, terrestrial, and celestial nymphs, elves, fairies, and goblins in the form of yakshas, nagas, gandharvas, and the like. Yaksha is from the root *yaj* ("to worship"), and the earliest deities are sometimes addressed (in the Upanishads, for example) as "worthy of worship." A tree associated with Chandramukha Yaksha was sculptured in Amaravati in the second century B.C., and a shrine under the tree is dedicated to this deity. The word *caitya* was applied not only to a temple but also to the tree worshiped, *caityavṛksa*. The *Mahabharata* mentions sacred trees that were worshiped like deities, and the epics, the Itihasas and Puranas, state that certain trees were associated with Shiva or Vishnu. In the *Bhagavadgita* the topsy-turvy fig tree is described as Bhagavan himself. Trees were worshiped even in the burial ground.

A yakshi named Jara was worshiped in Rajagriha (mod. Rajgir), and according to the *Mahabharata* this worship was accomplished by preparing a tinted sketch or a painting on the wall. Gandharvas, kinnaras, and apsarasas are all known in literature. Sri herself is one of the apsarasas raised to the highest rank as the consort of Vishnu himself. Urvasi, the consort of Vikrama in Puranic literature, is mentioned in the nucleus of the story in the *Satapatha Brahmana*. Rambha, Menaka, Tilottama, and a host of others appear in later legends. Four of them are mentioned by name as achchharas in a sculpture of music and dance from Bharhut. In legends on early sculpture a distinction is made among the devata, achchhara, yaksha, yakshi, naga, nagini, and other celestial beings. Thus, we recognize Sirima Devata (the goddess of prosperity), Suchiloma Yakshi, Kupira or Kubera Yaksha, the yakshi Sudarsana, the naga Dadhikarna, the yaksha Ajakalika, and Chandramukha Yaksha—the names of all of whom are known from legends on sculptures of them, which date from before the Christian Era. These simple deities were adopted by Buddhism and Jainism, where yakshas and yakshis became devotees of the Buddha or Tirthankara.

The *Mahabhashya* of Patanjali tells of the palaces built for Brahmanic deities like Rama and Kesava. Rama is also known as Balarama or Sankarshana and Kesava as Vasudeva. There are many early inscriptions expressing salutations to Sankarshana and Vasudeva. The earliest known sculpture of Sankarshana, now in the Lucknow Museum, shows him as almost human, with a single pair of arms and a turban on his head. The snake hoods over the hand distinguish Balarama, and in his hands are the plow and the pestle, the objects associated with him.

The earliest form of Vishnu that was worshiped was Vasudeva, depicted with a turban and a single pair of arms. The survival of this two-armed Vishnu can be seen in the Panduranga (Krishna) from Pandharpur, the Krishna with conch and arms

akimbo from Chakratirtha near Tirupati, and the unusual early Vijayanagar metal image from Komal, now in the Madras Museum. The last shows Vishnu seated with his consorts with conch and wheel on his palms. The Mathura Museum has fine examples of Kushan and early Gupta images where the crown is still very like a turban and the club is unusually long and pestlelike. The deity does not hold the club but only pats it with his palm to which it sticks. The Seshasayi from Bhitargaon *fig. 263* is a two-armed turbaned Vishnu with little drapery. In the early forms of Vishnu, as in the terra-cotta from Rajgir, his weapons—Sudarsana and Kaumodaki, the wheel and the club—are personified as a man and woman and flank the deity whose hands rest on them. The *śrivatsa* mark on the chest, which changes over the centuries in both the north and the south, is especially distinctive in some Gupta sculptures.

The Vishnu of the Pala school is interesting because Sri and Sarasvati appear as consorts, flanking the deity. (In the south, however, the consorts are Sri and Bhudevi.) Even when Vishnu is mounted on Garuda, as in the early Pala sculpture from Lakshmankati in the Dacca Museum, the consorts are Sri and Sarasvati. He carries them in two of his arms, and Sarasvati holds the early type of harp-shaped lute, which suggests an early date for the image. The four-headed Vishnu in the museum at Srinagar represents an unusual type, Vaikuntha, a favorite in the *fig. 284* extreme north of India. In this type Bhudevi stands between the feet of Vishnu.

Bhudevi is further emphasized in the Visvarupa form in the adjacent territory of Nepal where, though diminutive in size, she supports Vishnu by holding his feet, aided on either side by personified snake gods, Takshaka and Vasuki, who uphold the earth. The Visvarupa form, which is seen in an early Gupta work from Mathura, finds its best expression in the Gurjara-Prathihara version from Kanauj. Here the vision of the *Bhagavadgita* is translated into chiseled form—the avatars of Vishnu are suggested by the heads of the tortoise, boar, lion, and fish, by the forms of Vamana, Parasurama, Balarama, Buddha, and Kalki, by the twelve Adityas, the eight Vasus, the eleven Rudras, the heads of the Ashtabhairavas, and so forth. The whole world of celestials is shown as an emanation of Vishnu, whose description in the litany of the Thousand Names of Vishnu begins with *Viśvam*, "embracing the universe." The importance of the *vanamālā* ("garland of fragrant flowers") and *śrivatsa* is seen by the special place given to them in the damaged Gupta figure of Vishnu from Udayagiri in central India; the Gupta type of *śrivatsa* on the chest is very prominent in this work. *fig. 315*

The early Varaha (the boar avatar, the third incarnation of Vishnu), consecrated by Dhanyavishnu at Eran, is a complete zoomorphic representation. As in *figs. 318, 289* the Visvarupa, the celestials, which compose the bristles, are emanations of Vishnu. This concept is continued in northern medieval sculpture, notably in a Chandella figure from Khajraho.

While the Naranarayana panel from Deogarh emphasizes the human aspect *fig. 104* of asceticism, the Western Chalukya Yoganarayana from Hirahadagalli is a god in contemplation, in no way different from the nearly contemporary northern Indian representation of Yoganarayana from Garhwal in the Mathura Museum. In all these, the *dhyāna* pose (hands held in the meditative position) is a common factor.

Of the avatar forms of Vishnu, one of the finest and most rare is the Matsya (the first incarnation), almost a merman, in the Dacca Museum. An equally impor- *fig. 281* tant and rare piece is the marriage of Lakshmi and Vishnu of Pratihara workmanship in the Allahabad Museum. Lakshmi rose out of the milky ocean while Vishnu as

Kurma (the tortoise avatar, the second incarnation of Vishnu) held up Mount Mandara. But the anthropomorphic Vishnu helped the gods and demons to churn the sea and also wedded Lakshmi.

fig. 56

fig. 318

fig. 90

One of the earliest of the magnificent exploits of Varaha is represented in a most striking way in the Udayagiri cave near Bhilsa, where all the gods are depicted admiring Varaha rescuing the earth from the ocean. These deities are, however, shown as so many bristles in the zoomorphic representation of the same avatar of Varaha at Eran, where the Gupta inscription lists the donors of this masterpiece. The Varaha is also seen at Badami, Mogalrajapuram, and Mahabalipuram. Vishnu's protective role is evident in other of his avatars. Narasimha (the man-lion, Vishnu's fourth avatar) is shown destroying the demon Hiranyakasipu at Mugalrajapuram. As Trivikrama (Vishnu encompassing the universe—earth, sky, space—in three steps), he overcomes Bali at Mahabalipuram. This Trivikrama encompasses the terrestrial and celestial spheres with his legs, and one raised foot is near Trisanku who falls headfirst from heaven. In the Badami panel one foot approaches the head of Rahu, the demon who is all head and no body and who runs after the sun and moon on the high road of heaven. The graceful execution is noteworthy in the Gurjara-Pratihara Trivikrama from Abaneri, and this work surpasses even the charming one from the Rajivalochana temple at Rajim. The naga near the foot suggests Patala (the netherworld) where the foot is planted.

figs. 1, 296

As Trivikrama, Vishnu reaches vertically toward heaven; as Seshasayi Vishnu (the deity reclining on Ananta, the serpent of the endless coils), he extends horizontally over the whole surface of the universe. This popular theme is represented throughout India with much variety—at Udayagiri, Ellora, Mahabalipuram, Khajraho, Srirangam, and Kerala. It is also treated in almost every school of medieval art. The most magnificent representation of Seshasayi Vishnu is the Gupta bas-relief from Deogarh. And among the western Indian representations of the theme, the panel now in the Prince of Wales Museum in Bombay is a beautiful one. A striking early medieval work in a pond at Katmandu shows the deity lying on his back with his legs crossed. And a plaque from Nepal represents Visvarupa Vishnu standing above and Seshasayi Vishnu slumbering on Ananta below, almost in Patala. This expresses the full import of Vishnu—he encompasses and completely fills the universe. The *caturvyūha* concept (representation of four forms of Vishnu—Vasudeva, Sankarshana, Pradyumna, and Aniruddha) is also presented here. The plowshare of Balarama is decorated with a makara, thus suggesting the slumbering Sankarshana; the alert Vasudeva stands above in Visvarupa; and Pradyumna and Aniruddha are evoked by the makara, since Pradyumna's banner bears a crocodile.

figs. 104, 1

The two significant panels of Naranarayana and Seshasayi at Deogarh illustrate respectively the *dhyāna* ("meditation") and *yoganidrā* ("meditative slumber") aspects of Vishnu. Although deep in ecstatic slumber in the second panel, he is able to conquer Madhu and Kaitabha through the power of his own maya, Vishnumaya. Unstained and unaffected by any thought, Naranarayana, who represents the highest asceticism, is completely wrapped in his own introspective urge. In a characteristic act he created Urvasi from his thigh to reproach Indra for sending so many beautiful celestial damsels to distract him.

In the earliest representation of the *bālalīlās* ("pranks") of Krishna, his extraordinary power of protection is stressed. Thus the raising of Mount Govardhana

by the infant Krishna is shown in a Gupta work from Mandor and in a Vishnukundin sculpture from the Mugalrajapuram cave.

The finest metal statue from the Pallava-Chola transition period shows Krishna conquering the demon Kaliya. The Venugopala from the Belur temple represents perfection in the Hoysala style; and the Krishna with consorts from Chimakurti is the best example of Eastern Chalukya workmanship in metal.

figs. 63, 295

We know from literary references that in early India there were temples dedicated to Kama, the god of love. One of the earliest known sculptures is from the Kushan period and shows Kama wearing a turban with a sugarcane in his hand. Though most sculptures from the temple of Vishnu at Awantipur in Kashmir have been damaged or lost, there are a few intact, including a beautiful panel that shows Kama and his consorts Rati and Priti playing with parrots. The representation of the same scene from the Uttaresvara temple in Bhuvaneshwar is a fine example of Eastern Ganga work. There is no more interesting Rati-Manmatha group than the almost unconventional rendering of Manmatha, Rati, and Priti from Abaneri. This beautiful Pratihara piece shows the flowery arrows and thus suggests the season most suitable for Kama—spring, when the mango blossoms.

figs. 271, 288

The Shivalinga from Bhita has five heads corresponding to the Tatpurusha, Aghora, Sadyojata, Isana, and Vamadeva and composing Sadashiva. The complex iconography of this piece, which dates from about the second century B.C., is testimony to a deep-rooted and ancient craving for iconographic forms. The representation of Shiva at Gudiamallam goes back to the early phase of the Satavahanas. Here is Shiva as Kalagnirudra, a pillar of fire, symbolic of Agni and Rudra in unison. Shiva, erect and two-armed, carries the club, the ax, and the vessel of ghee and the ram for the sacrificial rite. His locks are combed into a turbanlike form. There is a peculiar representation of *ūrdhvaliṅga* ("phallus"); though draped, it is much more prominent than in contemporary and even somewhat later sculpture of the Gupta period.

The gold plaque thought to depict Shiva and Parvati, which is from the Jalan Collection in the Bharat Kala Bhavan, is a very important early representation of the Umasahita form. Vinadhara Shiva (Shiva as the Musician) is first represented in Sunga terra-cotta sculpture.

Buddha himself is represented in a peculiar symbolic fashion at Amaravati and Nagarjunakonda, and there is a distinct echo of these works two centuries later in distant Central Asia. In this form a pillar of fire rests on a pair of feet and is surmounted by a lotus and a wheel supporting the triratna. The lotus is an emblem of Brahma, the lotus-born; the feet recall Vishnu whose Trivikrama strides are famous; the flaming pillar represents Agni and Rudra; the wheel symbolizes the sun; and the triratna evokes Buddha, dharma, and sangha. The Buddha from Katra, with a single curl on his head, represents the typical muni, or hermit sage.

fig. 417

Parsvanatha and other Tirthankaras of the Kushan period have the *śrivatsa* mark on their chests, demonstrating that the mark of Sri on the chest of Vishnu is echoed in Jain iconography. In fact, the Tirthankara is close to a *pusushottama* ("best of beings") like Vishnu.

The three-headed Shiva from Central Asia is clearly an echo of an earlier three-headed Shiva from Elephanta and Ellora, a form that also inspired carvings now preserved in the Gwalior Museum. One head is the auspicious Shiva, one Aghora

the terrible, and the last the *lalita* or charming form of the goddess Devi who is eternally the left half of Shiva.

There are early representations of Lingodbhava (Shiva as the phallic deity) from several parts of the country. The form occurs in the Mugalrajapuram cave, in Ellora, Rajasthan, and Orissa, and in Pallava and Chola sculpture.

The early representation of Lingodbhava Shiva on a pillar in Mogalrajapuram is similar in concept to Vishnu Visvarupa. Shiva baffles the world by filling himself from within the lingam, unable to be comprehended even by Brahma and Vishnu. It is interesting to compare this with the Lingodbhava of the Pratihara school in the Ajmer Museum. Lingodbhava is strikingly presented at Ellora, and this form is represented at the back of almost every Chola vimana, where some of the most magnificent early creations have an unforgettable sculptural grace.

fig. 286

Shiva as the Lord of Wisdom has two forms—Lakulisa and Dakshinamurti. Lakulisa is found in northern temples, while Dakshinamurti appears in the southern shrines. In the south Lakulisa is represented in a lone carving at Tiruvottiyur, which was commissioned in a spirit of connoisseurship by the appreciative Rajendra after his conquest of Kalinga. While Lakulisa is represented in the west at Modhera in Gujarat, in the north at Payar in Kashmir, and in the east at Bhuvaneshwar in Orissa, Dakshinamurti in several forms occurs throughout the south. A lovely Dakshinamurti playing the drum—an unusual musical figure close to the Vinadhara—is seen at Kalugumalai. The Dakshinamurti from Kaveripak, which is more sophisticated than the similar figure from the Olakkanatha temple at Mahabalipuram, is an exquisite example of this form.

fig. 268

Bhikshatana (Shiva as the Beggar), which is a concept almost confined to the south, is well presented in the Golingesvara temple at Bikkavolu, and the finest examples of this form are Pallava and Chola. Shiva, the source of all good fortune, is himself a wandering beggar, fed by the sages' wives who succumb to his charm. An occasional representation of this theme in the north, as in Orissa and in southern Uttar Pradesh, adds an interesting flavor to the iconography of northern India.

fig. 267

Kalyanasundara (Shiva as the Bridegroom) appears in multiform iconography throughout India. At Elephanta Himavan gives away the shy bride, his daughter Parvati, to the handsome Kalyanasundara. But in the early Chola metal group in the Tanjore Museum, Vishnu, the brother of Devi, gives her in marriage to Shiva who holds her hand. This clasping of hands (*pāṇigrahaṇa*) symbolizes their comradeship throughout life. In the Gurjara-Pratihara example at the Bharat Kala Bhavan Museum, Shiva and Parvati, his bride, join hands to walk around the fire, the husband solemnly promising to be faithful to his wife. In the late Vijayanagar and Nayak examples of Kalyanasundara, such as that in the temple of Minakshi at Madura, Parvati is given away by Vishnu. In Pala sculpture, however, the Kalyanasundara theme expresses the *saptapadi*, or Shiva and Parvati walking seven steps together—a marriage ritual that symbolizes their companionship throughout life.

fig. 194

fig. 64

fig. 311

Somaskanda (Shiva with Uma and Skanda) and Umasahita (Shiva with Uma) are often seen in the south; Umamahesvara (Uma and Shiva) is a great favorite in the north and in the Deccan and is frequently flanked by their sons Ganesha and Skanda. In eastern India Haragauri (Shiva and Gauri or Uma) appears seated in a

style peculiar to this region. Ravana lifting Mount Kailasa, while Shiva presses him down, is a theme repeated often in early monuments.

The spirit of self-sacrifice demonstrated by the Almighty is nowhere better represented than in the Vishapaharana, of which there is a fine Pallava example in metal in the Madras Museum. Shiva is depicted drinking without hesitation the deadly poison that meant sure death and destruction for the world. For charm of form and pose, there is no sculpture of Shiva that can rival the Maitraka Shiva from Samalaji or the monolithic Shiva with attendants from Mandasor.

As Gangadhara, Shiva receives Ganga on his locks, and this magnificent theme is expressed in a variety of ways. In an early Gupta panel from Rajauna, Ganga is seated on a makara and respectfully approaches Shiva, who offers her a curl of hair as an abode. Ganga is here the goddess Devi—the bride received by Shiva. At Elephanta, Gangadhara receives the goddess on his locks, much to the annoyance of *fig. 195* Parvati, who is vexed at the prospect of a rival. The noteworthy feature here is that Ganga is a triple-headed mermaid—the three-streamed river (Tripathaga) purifying heaven, earth, and the netherworld. The famous Gangadhara from Trichinopoly *fig. 34* shows Shiva's utter disdain as he holds out a single lock to receive Ganga, who falls as a mermaid. This form prevailed in subsequent centuries until, in the mid-Chola period at Gangaikondacholapuram, Shiva is depicted as more engaged in appeasing the enraged Parvati than in heeding the stream that falls on his head. And in a painting of the Vijayanagar period from Lepakshi, Ganga is shown as a large stream flowing on Shiva's locks, while he earnestly beseeches Parvati not to be vexed. In medieval sculpture from Nepal, Gangadhara was an especially popular theme, with Ganga falling on Shiva's head in *Gaṅgāvatarana* (the descent of Ganga in dance).

The Ardhanarisvara (Shiva as Hermaphrodite) undergoes change through the centuries. Among the earliest is the masterpiece, striking in its simplicity, of late Kushan or early Gupta date and now in the Mathura Museum. The magnificent *fig. 440* Ardhanarisvara at Elephanta is not easily matched by another. An outstanding early medieval example of this form is the Gurjara-Pratihara work from Abaneri now in the collection of the Maharaja of Jaipur. Though charming, the early Chalu- *fig. 61* kya Ardhanarisvara from Mahakutesvara is excelled by carvings of the earliest Chola phase, such as those from Kodumbalur. The Ardhanarisvara on the Dharmarajaratha at Mahabalipuram demonstrates the skill of the Pallava sculptor at blending masculine and feminine contours in a single figure. The Ardhanarisvara in the Dacca Museum has the *ūrdhvaliṅga*, characteristic of the Pala style, on the right side of the figure. One of the most effective Ardhanarisvaras is the early Chola metal image from Tiruvenkadu now in the Madras Museum. Here the beauty is enhanced by asymmet- *fig. 68* ric elements; for example, there is one hand on the left side but two on the right. In fact, an overly symmetrical approach mars the stylized Ardhanarisvaras of the Vijayanagar and Nayak periods. In Orissa and Nepal Ardhanarisvara is often shown with one leg on the bull and the other on the lion. Shiva dancing as Ardhanaris-vara is particularly interesting; the most striking examples are perhaps those from the Chandella territory—the bearded right cheek is effectively contrasted with the smooth left.

The early representations of Nataraja (Shiva as the Lord of the Dance) include those of the Gupta period from Nachna and elsewhere; the magnificent Vakataka

figs. 262, 131 figure from Elephanta; the early Western Chalukya representation from Badami; the Nolamba figure in the Madras Museum; the mutilated Vishnukundin carving from the facade of the cave at Mogalrajapuram near Bezwada; the multiarmed Nataraja from Mukhalingesvara at Mukhalingam in Orissa; the Pallava example from the Siyamangalam cave; and the forceful carving from Payar beyond Srinagar. All these represent the first expressions of a concept that later assumed immense importance in both religion and art.

The most glorious of these early works is perhaps the Gupta Nataraja from Nachna now in the collection of Mrs. Pupul Jayakar. The Vakataka representation of Nataraja in a panel from Elephanta shows Shiva removing the veil of ignorance and illusion. This is one of the five acts of *pañcakṛtya*—creation, protection, destruction, removal of the veil of ignorance, and liberation. This theme is repeated in slightly later sculptures, such as that from Pattadakal.

The Nataraja theme is prominent in several Chalukya temples, among them those at Badami, Pattadakal, and Alampur. It is usually represented on the vimana facade in a large individual panel. This feature is also seen in Paramara and Eastern Ganga temples.

The dance of Shiva is nowhere more beautifully portrayed than in a unique early Chola image in metal. In this work from Tiruvarangulam which is now in the fig. 274 National Museum, Shiva is shown in the *catura tāṇḍava* pose.

The bull Nandi is often associated with the dancing Shiva. In the Deccan and in central India the Lord of the Dance is frequently shown with Nandi behind him or at his side. In the version characteristic of Bengal, seen in a sculpture from Shankar- fig. 70 bandha near Dacca, Shiva dances atop the bull. A parallel form from southern India depicts Shiva dancing on the dwarf Apasmara. The bull and the dwarf symbolize ego and ignorance, which Shiva conquers through his dance. The only known metal representation of this form from Bengal was carried to the south as a war trophy by fig. 275 Rajendra and is now in the Melakkadambur temple.

The multiarmed Nataraja, dancing in the *lalita* or *catura* pose, occurs in many monuments throughout India. The Gurjara-Pratihara Nataraja from Abaneri is a magnificent rendering of this form. In Gurjara-Pratihara as well as Gahadavala sculpture from northern India, Shiva occasionally dances with the vina in his hand.

His body moving forward in *tāṇḍava*, Shiva is depicted effectively in a Rashtra-kuta masterpiece from Ellora. The twist near the waist characteristic of this dance is also well presented in the Nolamba Nataraja in the Madras Museum. The dancing Shiva from Ujjain now in the Gwalior Museum has a great serenity, but there is greater force and movement in the Nataraja from the circular niche of the facade of the temple of Udayasvara at Udaipur in Malwa which is a gem of Paramara art.

The Vinadhara (Shiva as the Musician) with Devi from Lakhamandal, a very early and exquisite figure, far outshines several others, though the expression of the same theme in the Vijayalayacholisva temple at Nartamalai is very charming. And the early Chola metal images of Vinadhara in the Tanjore Art Gallery, as well as that in the Musée Guimet, are exceedingly well done.

When Shiva as an ascetic contemplates himself, he does so for the peace of the world. Similarly when he marries Parvati at the request of the gods, he does so to

produce the offspring that will overcome the deadly demon Taraka and relieve the world of infinite misery. The marriage of Shiva is probably nowhere better represented than in the Elephanta cave. While Seshasayi Vishnu is a static representation and Nataraja is dynamic, the underlying concept of both is the same. Both perform the *pañcakṛtya*—one in active movements and the other in deep yogic slumber. As creator and protector respectively, Brahma and Vishnu are linked; and Padmanabha Vishnu, from whose navel Brahma issues on a lotus, demonstrates that Brahma is a part of himself, a projection of himself that creates what he would protect. Shiva as Ardhanarisvara is the protector and the destroyer or the transformer, since Devi is no other than Vishnu and Vishnumaya, the protector and mother of the universe. Nataraja is the transformer, and by his own dance he recreates and transforms the world. The parallel forms of dancing Krishna and Nataraja are interesting. Nataraja crushes Apasmara, a dwarfish creature who represents ignorance. Krishna as Kaliyamardana dances on the hoods of the snake Kaliya and thus overcomes pride and ego which are forms of ignorance.

fig. 194

The entire mother cult gradually became centered on Shiva. The mothers (seven or eight in number) and even the sixty-four yoginis became attendants of Shiva. Vinadhara, Virabhadra, Ganesha, and Skanda are also associated with this mother group. While the Madugula plaque, which is of very early date, shows the happy family of Shiva, including Parvati, Ganesha, Skanda, Nandi, and Chandikesvara, the Peddamudiyam plaque of the same period is an even more important example of the earliest phase of southern iconography. All the deities except Mahishamardini have only a single pair of arms, and Lakshmi appears in semisymbolic form as *śrivatsa*. Brahma has four heads but only a single pair of arms—the other pair is still absent at this early stage of evolution. A similar but more interesting figure is the two-armed Shiva of early Pallava date in the Bezwada Museum. He carries the battle ax, and the bull Nandi is at his feet.

fig. 266

When the concept of trinity developed in the earlier centuries, all the gods were brought together. A number of figures appear above the Seshasayi Vishnu from Deogarh—Shiva and Parvati on Nandi, Brahma on the lotus, Karttikeya on his peacock Parvani, and others. In the early Pallava period Somaskanda is invariably represented with Brahma and Vishnu in the background. The early representation of the trinity is a group of three cells styled *brahmeśvaraviṣṇulakṣitāyatanam* by the Pallavas in the Mandagappattu inscription.

fig. 1

Brahma, shown with four heads but a single pair of arms at Deogarh, has more individuated features in slightly later Gupta representations, as in the metal image from Mirpur Khas in Sind. During the Gupta period in northern India Brahma is depicted as youthful and beardless; this style continues in early medieval Western Chalukyan works, of which a fine example is the panel from Aihole. Here Brahma is adored by rishis. The *jatāmakuṭa* ("crown of hair") and other attributes, including the book and the sacrificial ladle, are interesting. A charming early medieval image is the seated Brahma in the Kandiyur temple; this is an early Chola work, and similar ones are now in the Metropolitan Museum in New York and in the Boston Museum.

fig. 564

The Matrikas (the seven mother goddesses), which appear often in early medieval sculpture, have in their earliest appearances, in the Kushan and Gupta periods, a very sweet and natural treatment. Even Varahi has a charming human countenance, and Chamunda is not hideous. But the characteristic frightful features are seen

figs. 466,
136, 206
in later sculpture from Ellora and Jaipur and in the very early Chola figures of the Loo
Collection now in the Musée Guimet.

Mahishamardini is a deity often depicted in sculpture, and there are excellent
examples from the Kushan period onward. In the Peddamudiyam plaque, where all
the other deities have only a single pair of arms, Mahishamardini has four arms. With
her knee planted on the back of the buffalo demon, she powerfully smites the monster
fig. 513
in the work from the Durga temple at Aihole. A similar work from Eastern Ganga
territory is seen in the Vaitaldeul temple. The most powerful delineation of Mahisha-
mardini, astride a lion and attacking a buffalo-headed demon of heroic size, is in the
figs. 299, 464
Pallava panel from Mahabalipuram. She is almost tamely depicted in a Rashtrakuta
panel from Ellora which shows the same episode.

Mahishamardini Durga, standing with her feet planted on the severed head of
the buffalo demon, is a popular figure in southern India from the Pallava period
onward; she is especially prominent in Chola temples and often appears in one of the
niches around the main shrine (an exquisite example of this type is that from the
Nagesvara temple at Kumbakonam). The metal image of Mahishamardini Durga
from Baramaur near Chamba is a work of the Karkota school of Kashmir and is one
of the most remarkable metal figures representing this deity.

At Mahabalipuram, Lakshmi is depicted as an aquatic deity. Seated on a
lotus, she is attended by nymphs and bathed by elephants holding pitchers of water.
fig. 197
In the Kailasa temple at Ellora, the lotus-born goddess is depicted with great live-
liness in the center of a lotus pond. Lakshmi bathed by elephants appears from the
figs. 245,
248, 249
Sunga period onward, and through the centuries this theme has been expressed in
beautiful works throughout India.

The river goddesses, seen in their early personified forms at Amaravati, slowly
develop distinctive characteristics and mounts. The Ganga and Yamuna from
figs. 256, 258,
198, 200
Buxar (now in the Indian Museum) or from Dah Parvatiya in Assam are typical
Gupta examples. Vakataka works from the same period are seen at Ajanta and Ellora.
The most magnificent terra-cotta figures of these goddesses are from the brick temple
fig. 36
at Ahichchhatra. A rather unconventional rendering of Ganga is the Sena carving
now in the National Museum.

The Varuna holding a noose from the Rajarani temple is a fine example of
fig. 272
Eastern Ganga work. Since the Guardians of the Quarters are often represented in
Orissan temples, one can compare iconographic variations and styles through the
centuries.

The earliest Ganesha dates from the beginning of the Satavahana period in the
second century B.C. This representation from Amaravati shows him as a Shivagana
(attendant of Shiva) among the Ganas (attendants of the gods) who carry garlands.
During the Kushan period in Mathura, Ganesha was depicted nude and devoid of
ornament, with a realistic elephant head and the body of a human baby. This
concept took root, and the natural elephant head without a crown, or just the lotus
indicating the beginnings of a crown, marks the Gupta type. The earliest of the
Gupta figures of Ganesha is that from Udayagiri which is very similar to the simple
Kushan type. Ganesha appears as a slightly more stylized figure at Nachna, Bhumara,
Bhitargaon, and Deogarh. The sacred thread of bells is particularly interesting at
fig. 257
Bhumara. In all these early sculptures Ganesha has only a single pair of arms, as he

does in the earliest Pallava sculpture (the panel from Madugula and the Peddamudi-yam plaque). A Matrika sculpture from Samalaji, which shows a two-armed, haloed Ganesha with Ganas, is an exquisite piece with great human appeal.

When Ganesha is shown with a *makuta* ("crown"), it is a *jaṭāmakuṭa* ("crown of hair") in the north, a *ratnamakuṭa* ("jeweled crown") in the Deccan, and a *karaṇḍamakuṭa* ("crown simulating tapering pile of pots") in the south. The large Ganesha at Bikkavolu, a fine Eastern Chalukya monolith, represents the deity almost nude, without elaborate dress and ornamentation and with only a single pair of arms. This is not unlike the Western Chalukya carving from Cave 1 at Badami. fig. 694

An example of the most elaborate Chalukya type of Ganesha is the famous Hoysala monolith at Halebid. Here the trunk is held horizontal for most of its length, and its tip rests on a bowl of sweets. The dancing Ganesha at Belur is one of the most beautiful examples of this form. The earliest Chola Ganesha in metal is from Okkur; in this typical southern representation the entire length of the proboscis is vertical and Ganesha holds a single sweetmeat in his palm. The monolithic Ganesha at Bikkavolu is shown with the *jaṭāmakuṭa* which most medieval Ganeshas of northern India wear. Pala Ganeshas not only wear the *jaṭāmakuṭa* but also sometimes dance on a mouse, as Nataraja dances on his mount, the bull.

Karttikeya or Skanda, the younger son of Shiva and Parvati, is often exquisitely depicted. Skanda is usually shown as a little boy; his mother fondles him and is therefore called Skandamata. This theme is expressed in one of the finest sculptures of the Matrikas from Samalaji. In a fine Gupta figure of the juvenile deity, now in the Bharat Kala Bhavan, tiger claws adorn the pendant of his necklace, and he fondly embraces his mount, the peacock Paravani. The *kākapakṣas* ("sidelocks for children") and *vyāghranakhas* ("tiger claws"), like those of the Bodhisattva Kumarabhuta from Nalanda, Sarnath, and elsewhere, enliven the figure. figs. 60, 251

The anointing of this juvenile warlord as commander in chief of the army of the gods by Brahma and Indra is wonderfully represented in a damaged sculpture now in the National Museum.

An early representation of Skanda is styled Brahmanyadeva; in this form he is the patron deity of the Yaudheyas and is shown on their coins exactly as he is seen in Kushan sculpture. As Gurumurti (Master of Wisdom), Skanda teaches Brahma the significance of the sacred syllable, and he is depicted in some Pallava sculpture with almost all the attributes of Brahma except the four faces. Skanda, dancing or holding lotuses, is similar to Surya, but is distinguished by his juvenile appearance.

The earliest representation of Surya and Indra at Bhaja shows a simple and human conception of these lofty celestials. The great hero-kings in India were comrades of Indra and went to heaven to aid him when he was in distress. These terrestrial rulers had therefore earned the right to wear the *ushṇiṣa* ("turban with frontal protuberance") which is Indra's characteristic headdress. Indra himself is depicted much as an earthly king would be. Thus, mounted on his elephant Airavata, he moves gaily through his celestial paradise, just as a terrestrial king on his state elephant rides through his gardens. And in an early Satavahana work, the turbaned Surya, riding in a chariot drawn by four horses, is not superhuman, although below him a supernatural element is introduced—darkness personified as a huge dwarfish demon. fig. 57 fig. 396

A representation of Surya at Gaya repeats this early form though not so fig. 247

effectively. Not until a much later date, during the Gupta period, does Surya appear wearing armor and top boots and holding lotuses in both hands. The flanking attendant figures of Danda and Pingala are a common feature from the Gupta period onward. The motif of the seven-horse chariot develops slowly, as seen in the Surya Konarak or in the Ajmer Museum in Rajasthan or in the many figures from Bihar and Bengal. Surya is occasionally shown seated, as in the lovely Pala image from Kashipur now in the Asutosh Museum. The Surya on horseback in the temple at Konarak is a rare and unusual figure dating from the thirteenth century; it is an exquisite example of Eastern Ganga work.

fig. 282

fig. 270

The Navagrahas, eight in number until the end of the Gupta period when Ketu was added, are usually shown in a row—the sun and moon carry lotuses and lilies; Rahu is all head and no body; Ketu is snakelike; the others carry a string of beads and a waterpot. This group appears on the lintel of almost all northern shrines.

Siddhartha was born a prince, but through asceticism he became the Supremely Enlightened One—Buddha Sakyamuni. He had all the attributes of a chakravartin, a universal monarch, and though he had become a monk, he was still fondly pictured as a prince in all his glory. Thus Pala sculpture depicts Buddha jeweled and wearing a crown. This concept can be traced to earlier sculpture from Fondukistan.

A sage rapt in meditation and attended by serpents like Muchalinda, Buddha overcame Mara, the demon of death. Here Buddha is very similar to Shiva who, deep in contemplation and accompanied by nagas, prevailed over Kama and Rati.

Parallels with Hindu and Buddhist deities are also seen in the Jain Tirthankaras. Like Pasupati, Santinatha has the deer for his emblem (the deer signifies all the beings of the universe that he controls). And like Shiva, Chandraprabha has the crescent moon as his emblem. All the Tirthankaras are shown seated in contemplation or standing erect like a tree trunk (a symbol of Shiva). They are nude because nudity signifies detachment and liberation from all desires. Like Buddha and Shiva, Jina triumphs over evil and passion, here symbolized by Kumatha, the Jain equivalent of the Buddhist Mara. One of the most effective illustrations of this scene is the fine Gupta panel in the Indian Museum. Like Muchalinda, whose serpent canopy shielded Buddha from a great storm, the Jain serpent king, Dharanendra, protected Parsvanatha with his hoods.

Like Vishnu who has the *srivatsa* mark on his chest and is endowed with other auspicious signs and symbols, the Buddha and Tirthankara also bear the sacred mark on their chests and possess the attributes of a great personage—the thunderbolt, the wheel, and so forth. As Vishnu is worshiped by the elephant Gajendra, so Buddha is shown being adored by elephants at Amaravati, Sanchi, and elsewhere. The gestures used by Shiva and Vishnu in their protective or boon-conferring attitudes express the same sentiments in Buddha. And Buddha depicted as a teacher is similar to Dakshinamurti Shiva. As Hanuman humbly approaches Rama, an incarnation of Vishnu, with the crest jewel of Sita, so at Vaisali a monkey approaches Buddha with a honeypot.

Some of these parallels can be traced to a common source. Tara of the Buddhist pantheon, like Ambika of the Jain, is an adaptation of a Brahmanic deity. And Brahma, Vakdevi, Indra, Garuda, Naga, Yaksha, the four Lokapalas, and a host of other Hindu deities are veiled versions of the earlier Brahmanic pantheon.

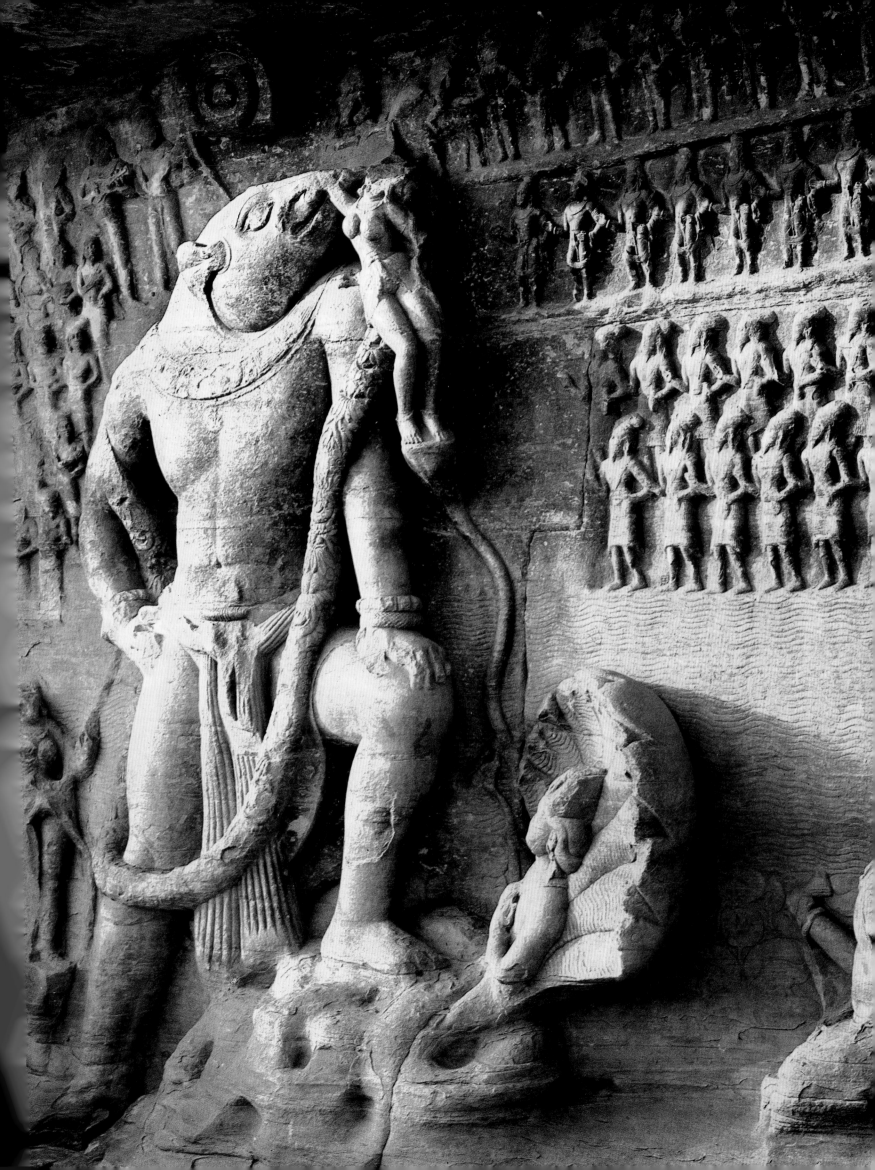

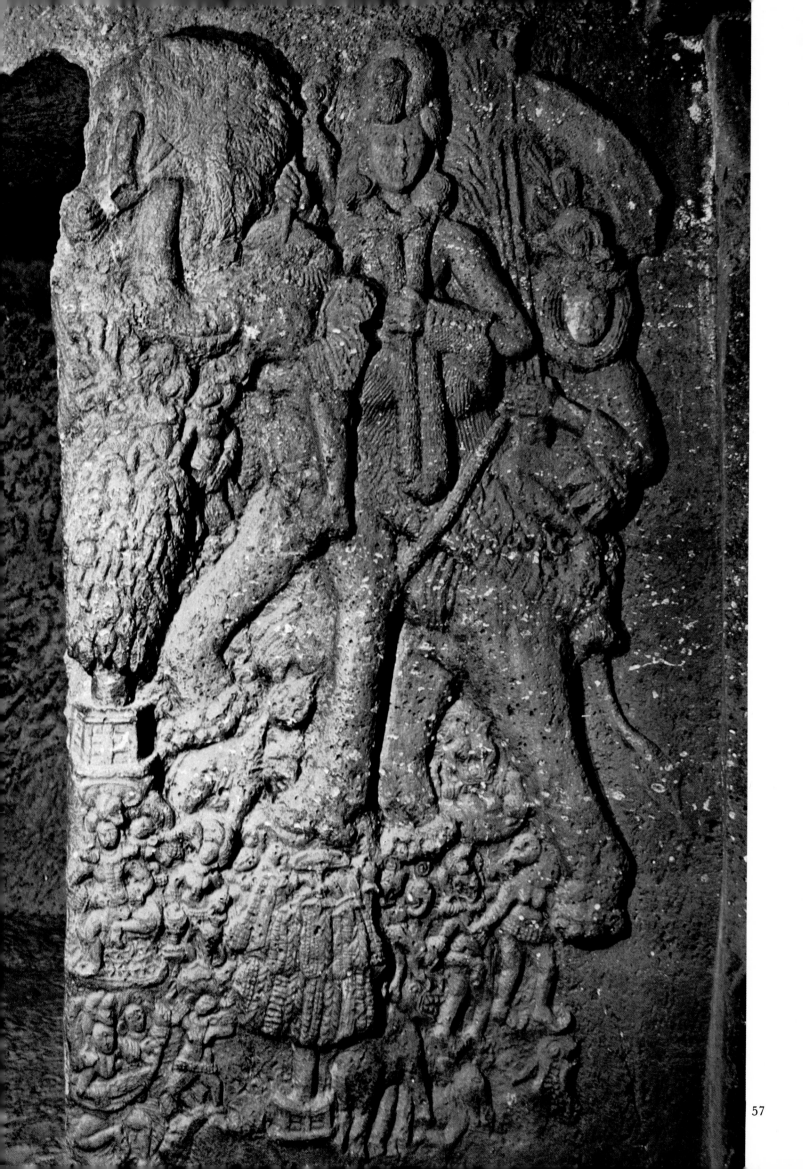

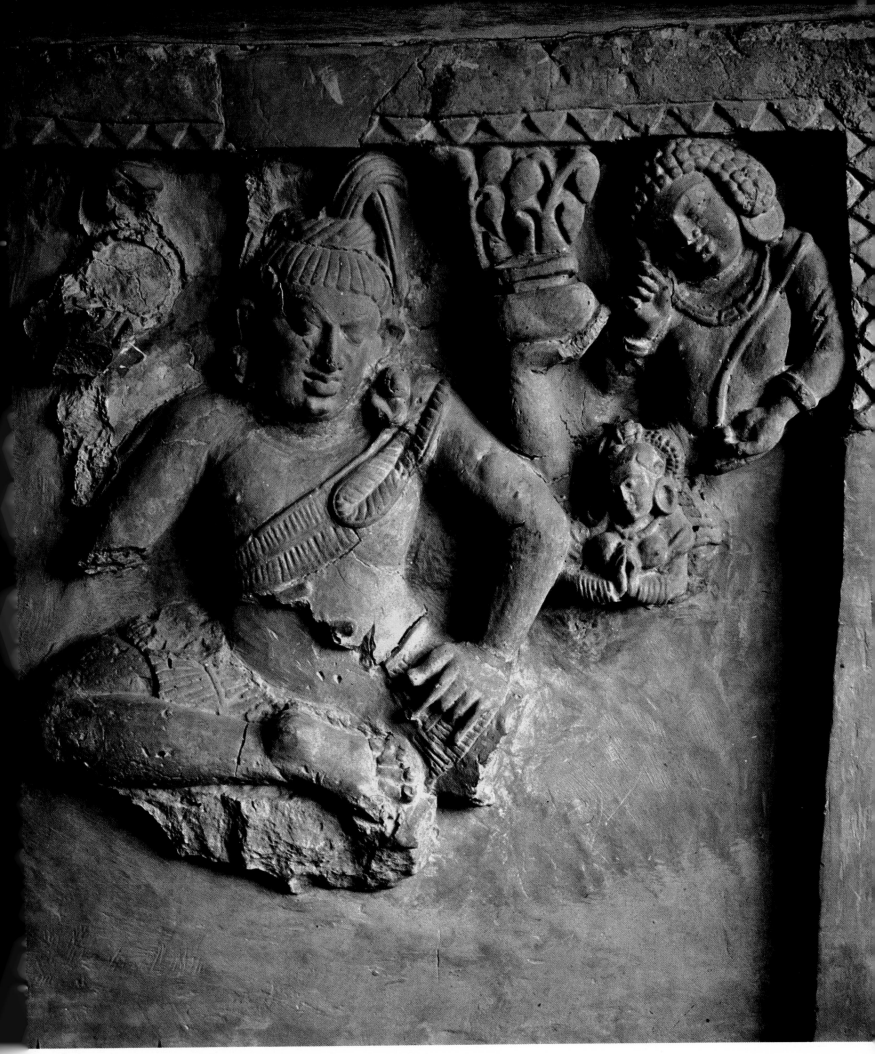

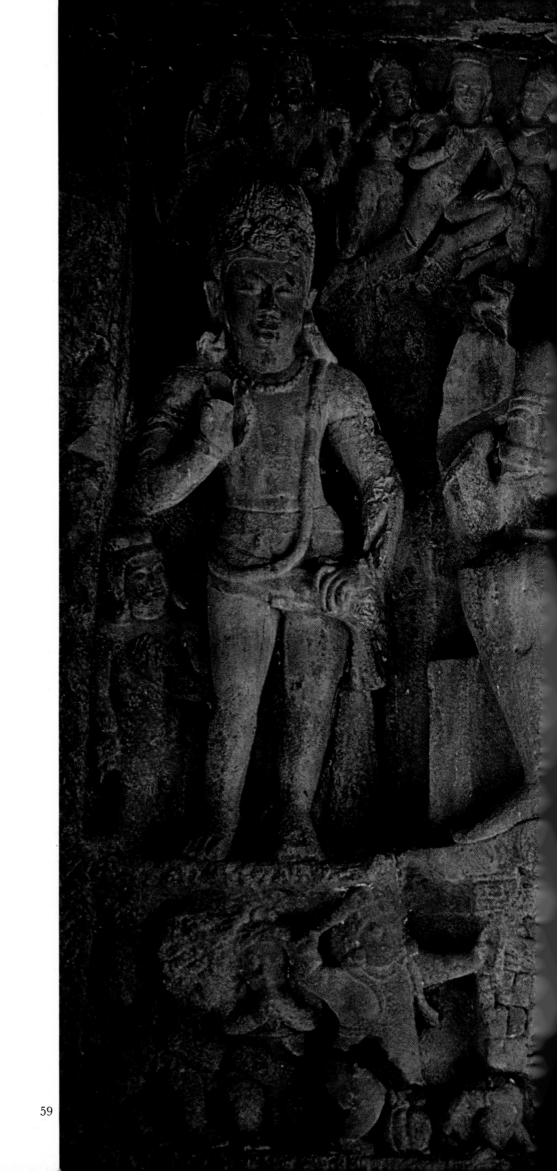

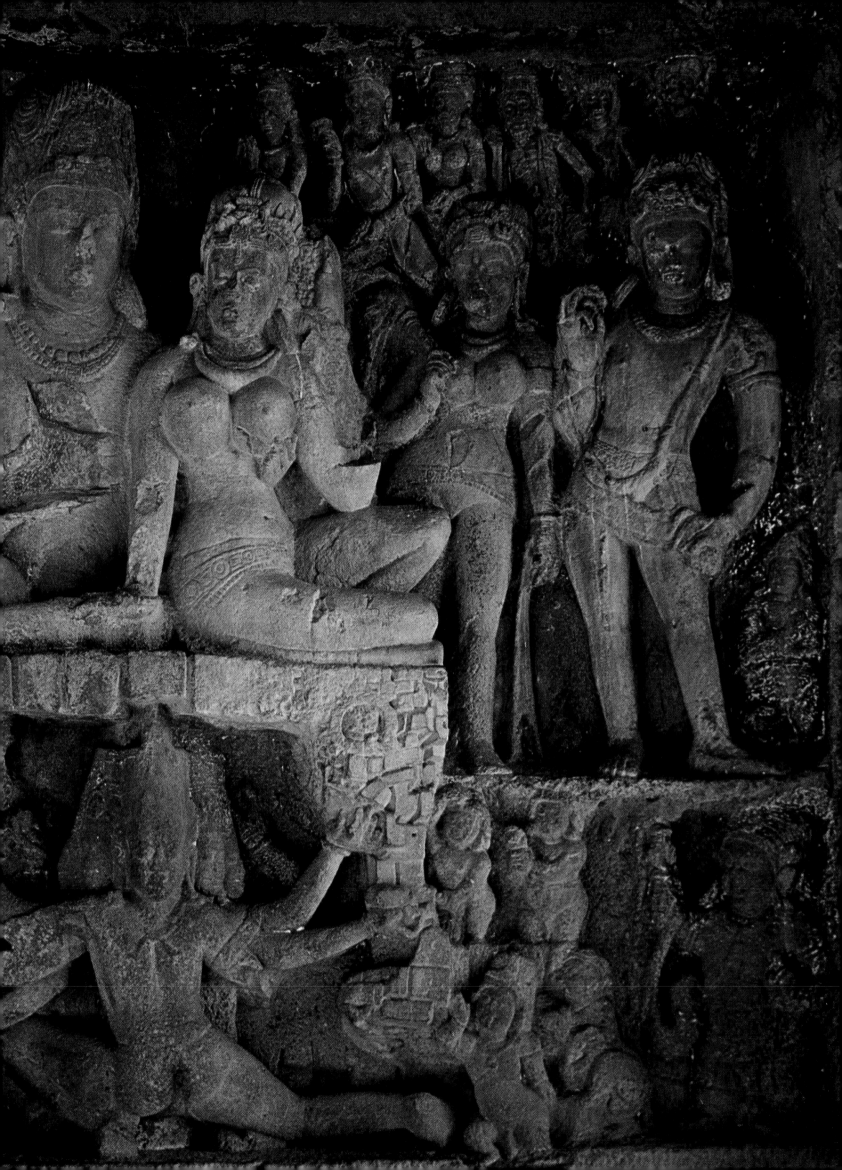

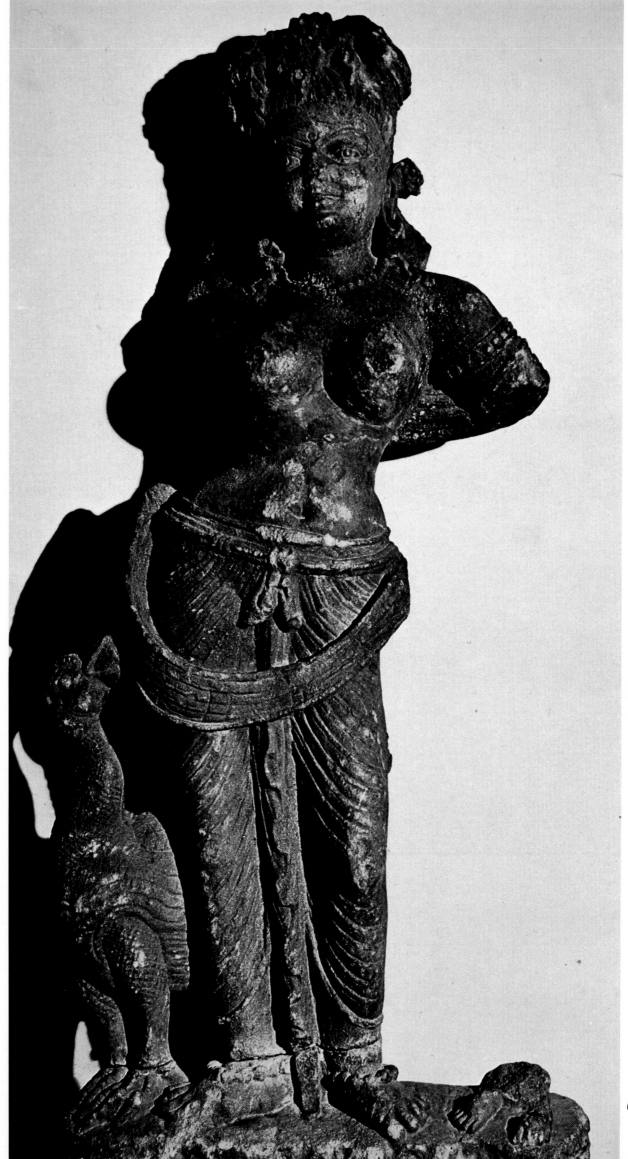

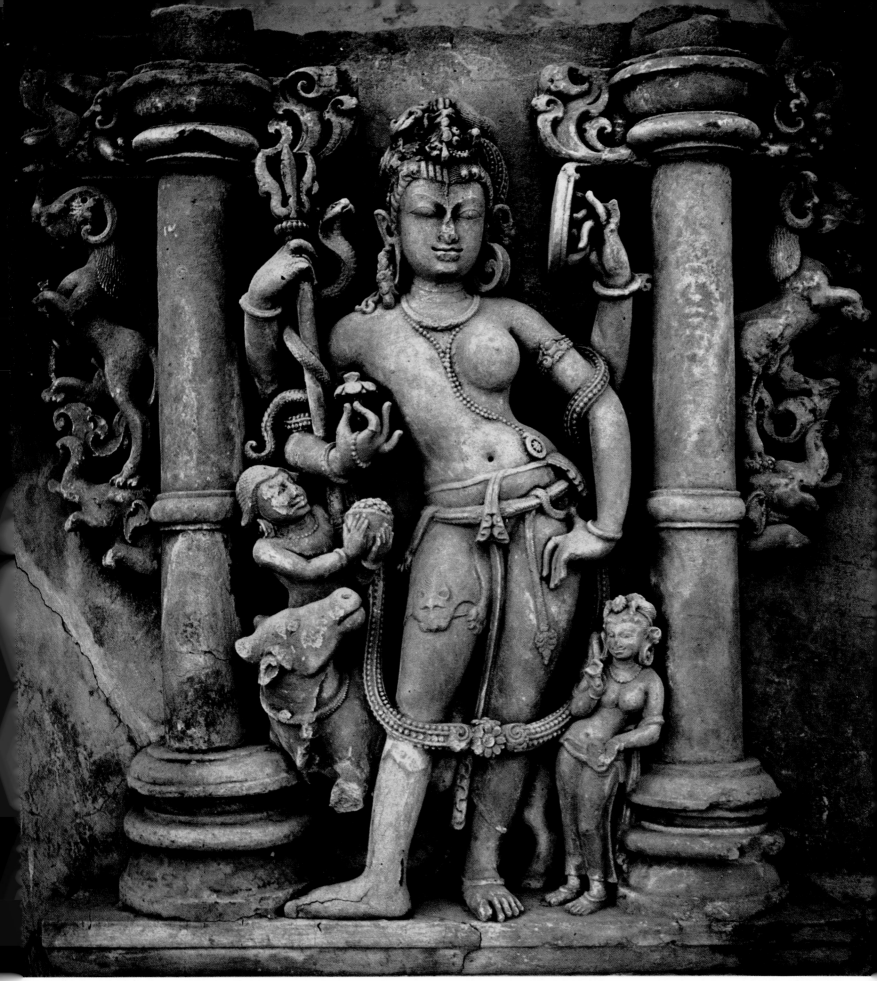

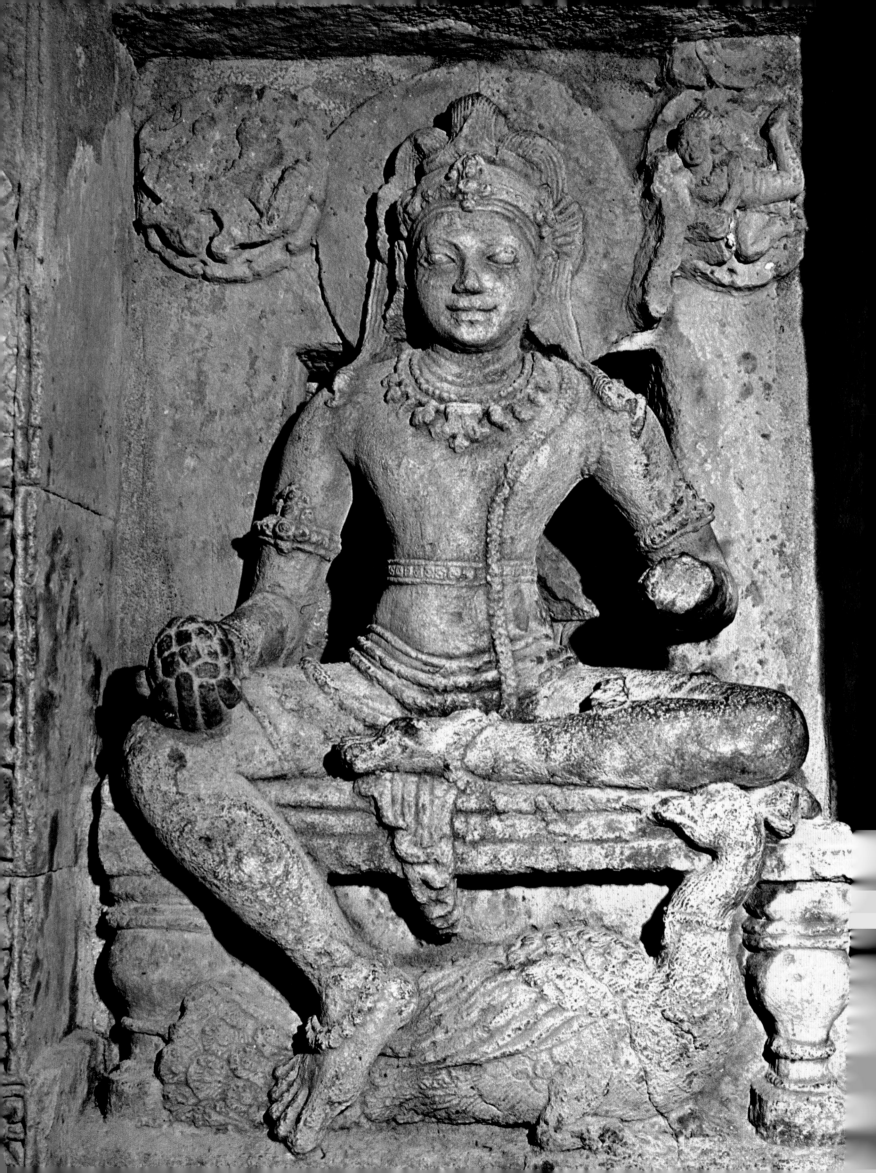

63.	KALYA KRISHNA
	Bronze. Pallava-Chola, 9th century
	National Museum of India, New Delhi

64.	KALYANASUNDARA SHIVA
	Bronze. Chola, early 11th century
	Art Gallery, Tanjore

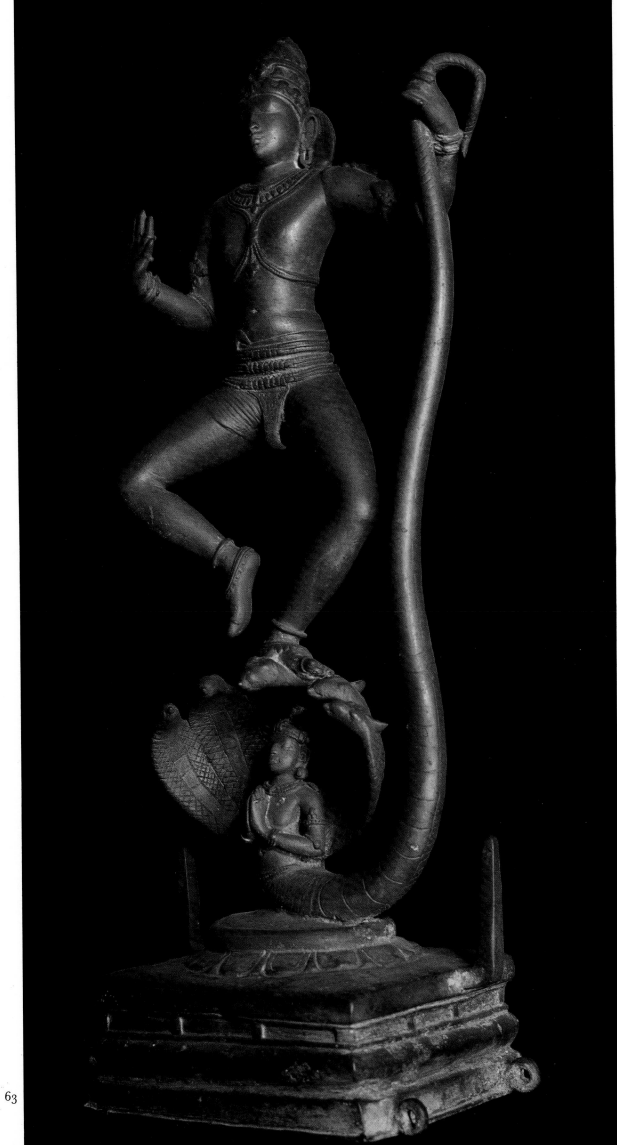

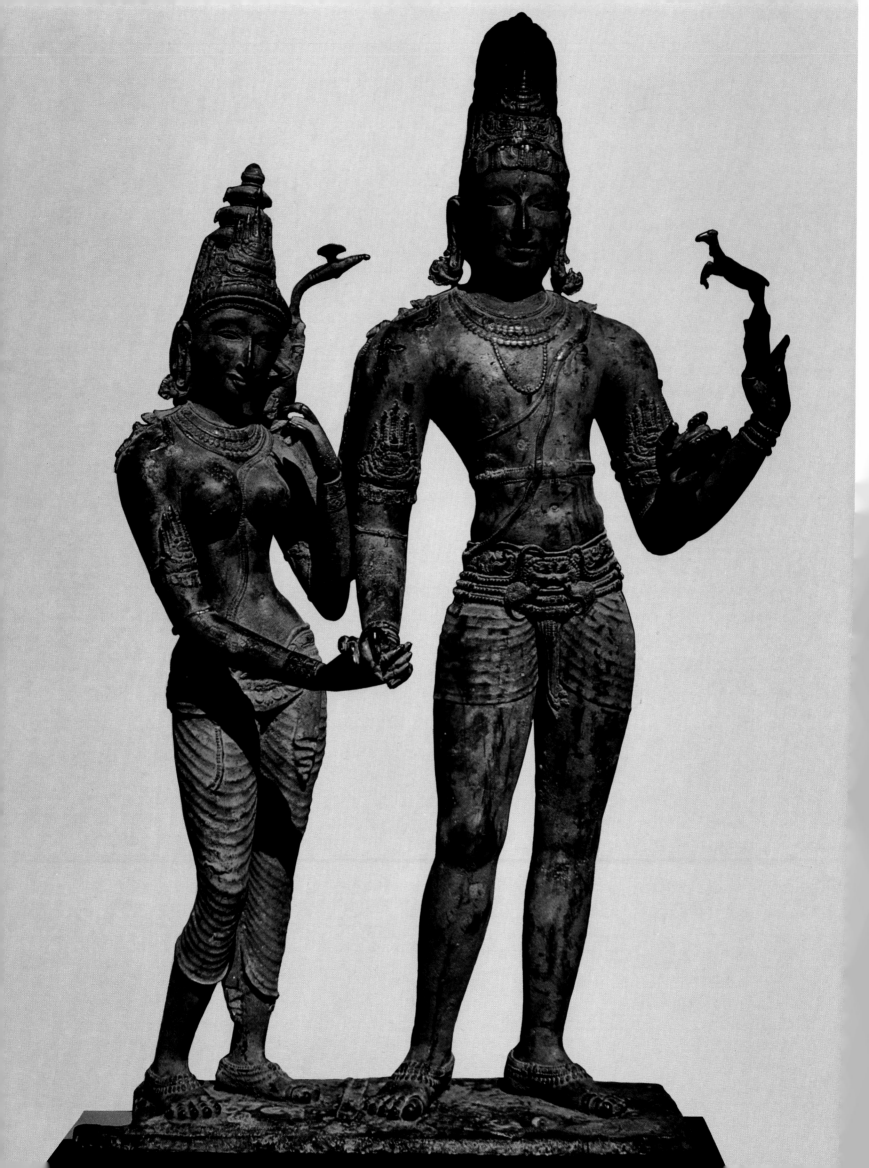

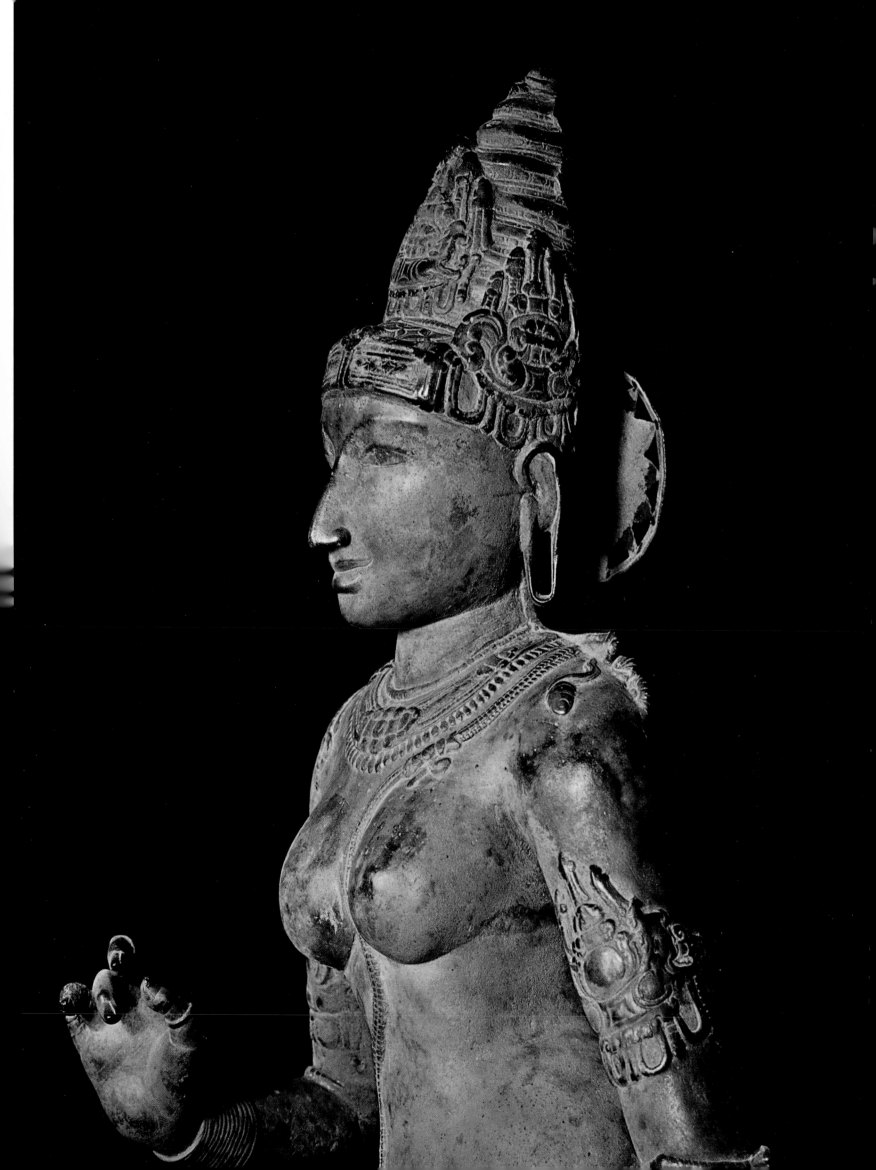

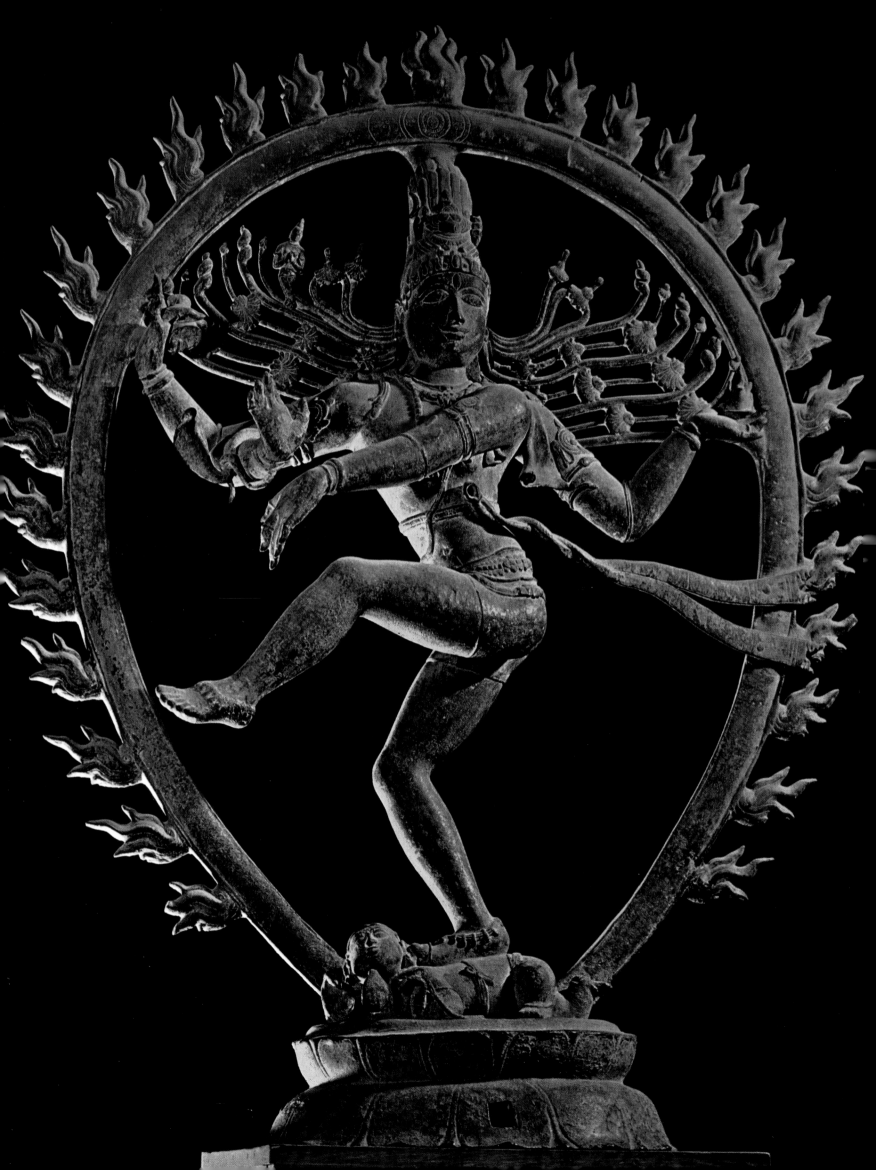

65. DEVI, SPOUSE OF VRISHABHANTIKA (DETAIL)
Bronze. Chola, 11th century
Art Gallery, Tanjore

66. NATARAJA
Bronze from southern India
Chola, early 11th century
Musée Guimet, Paris

67. SVACCHANDA BHAIRAVI
Chamba, Utpala, 9th century
National Museum of India, New Delhi

68. ARDHANARISVARA
Bronze from Tiruvankadu
Early Chola, 11th century
Government Museum, Madras

69. PARVATI
Bronze from southern India
Chola, 10th century
Metropolitan Museum of Art, New York

70. NARTESVARA DANCING ON BULL
From Sankarbandha, Bangladesh
10th century
Dacca Museum

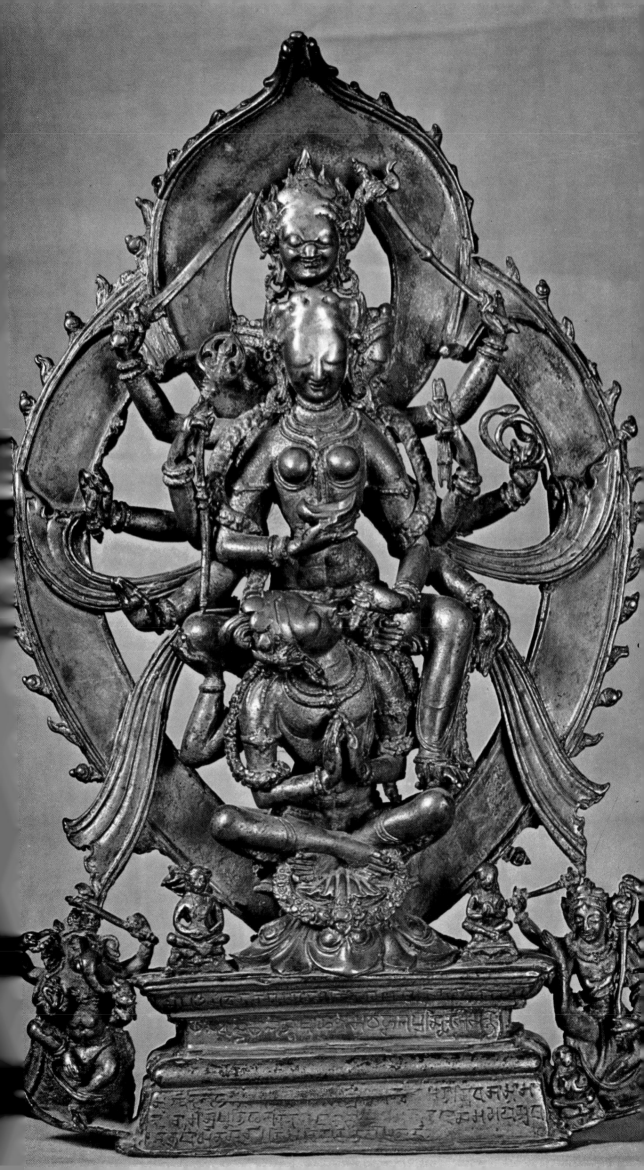

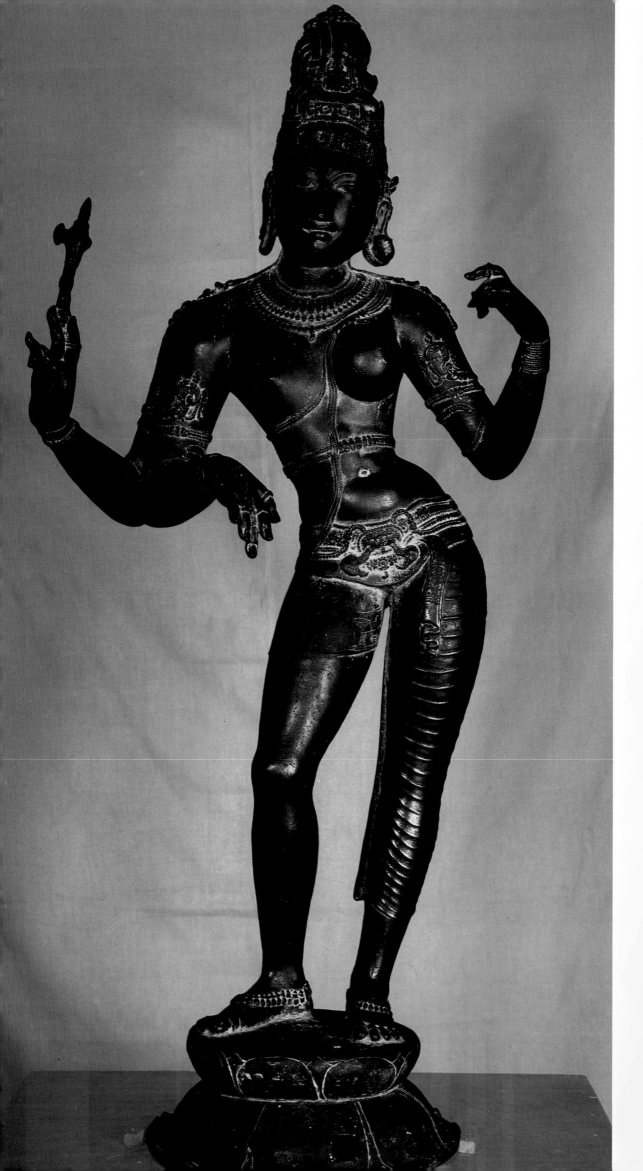

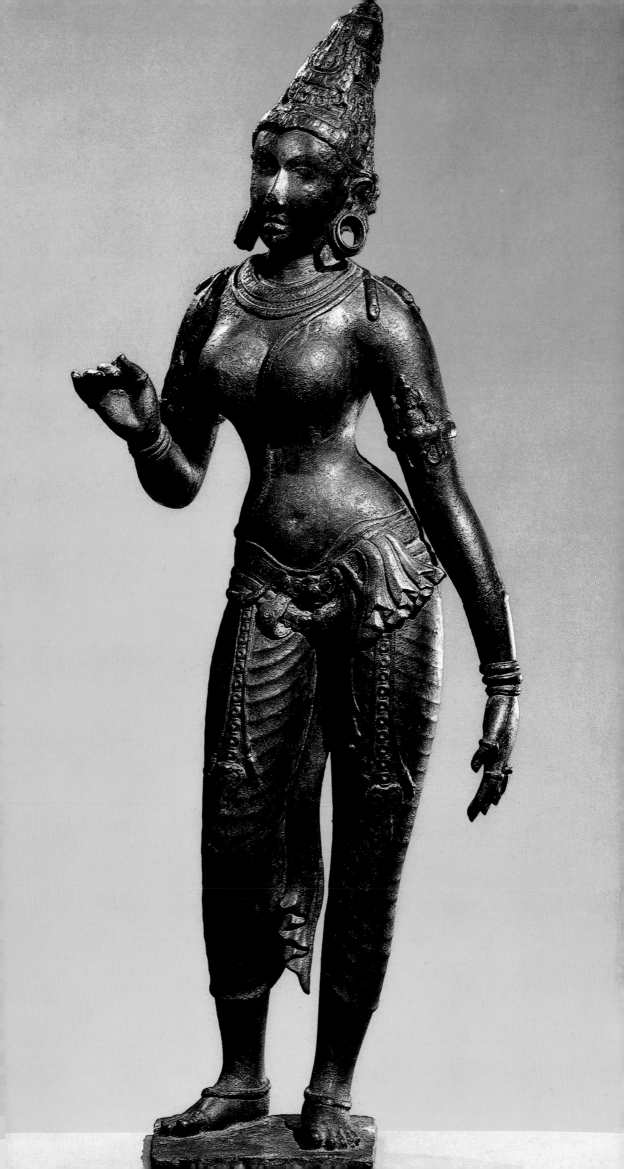

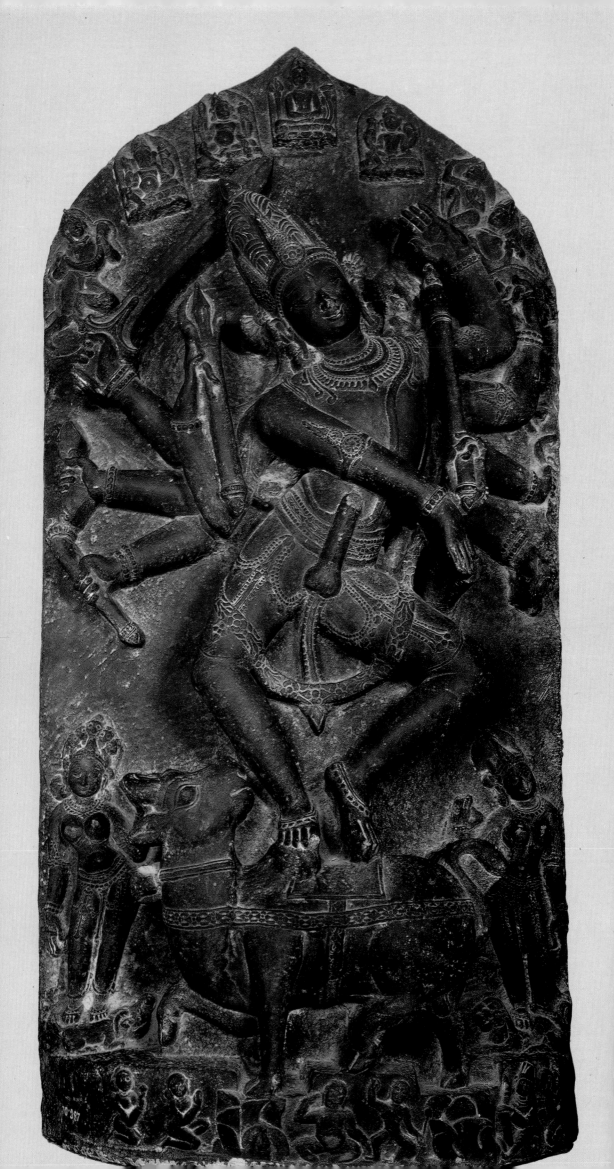

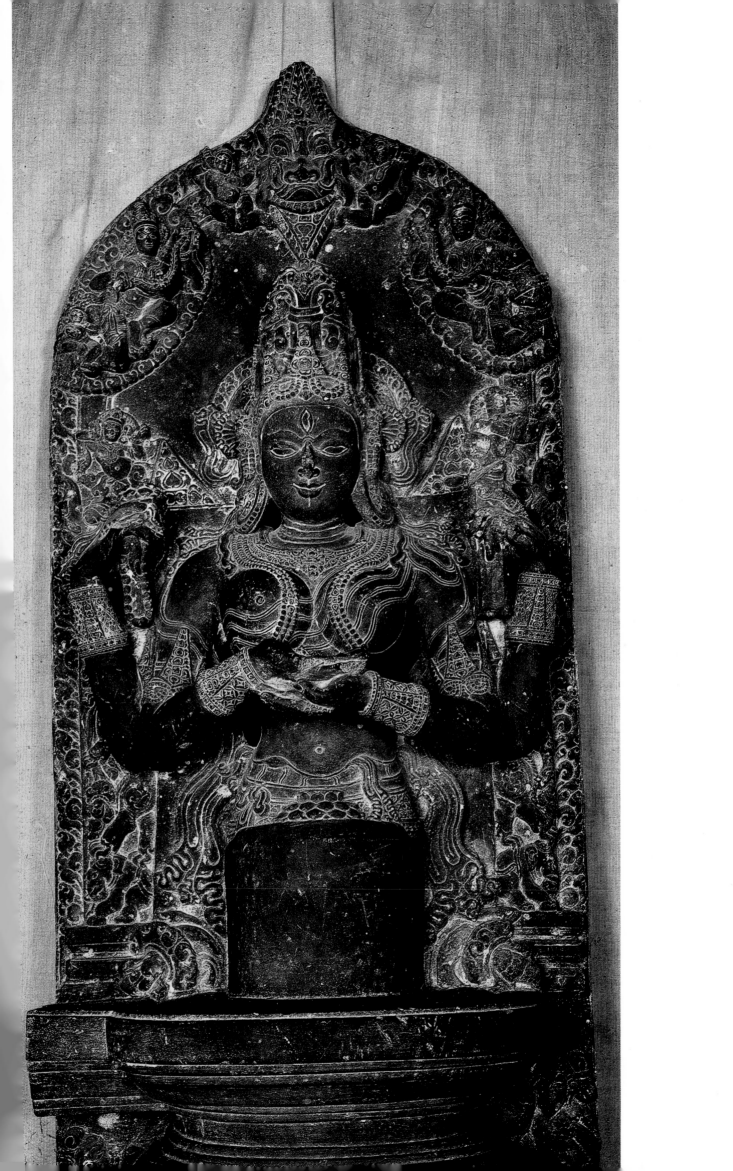

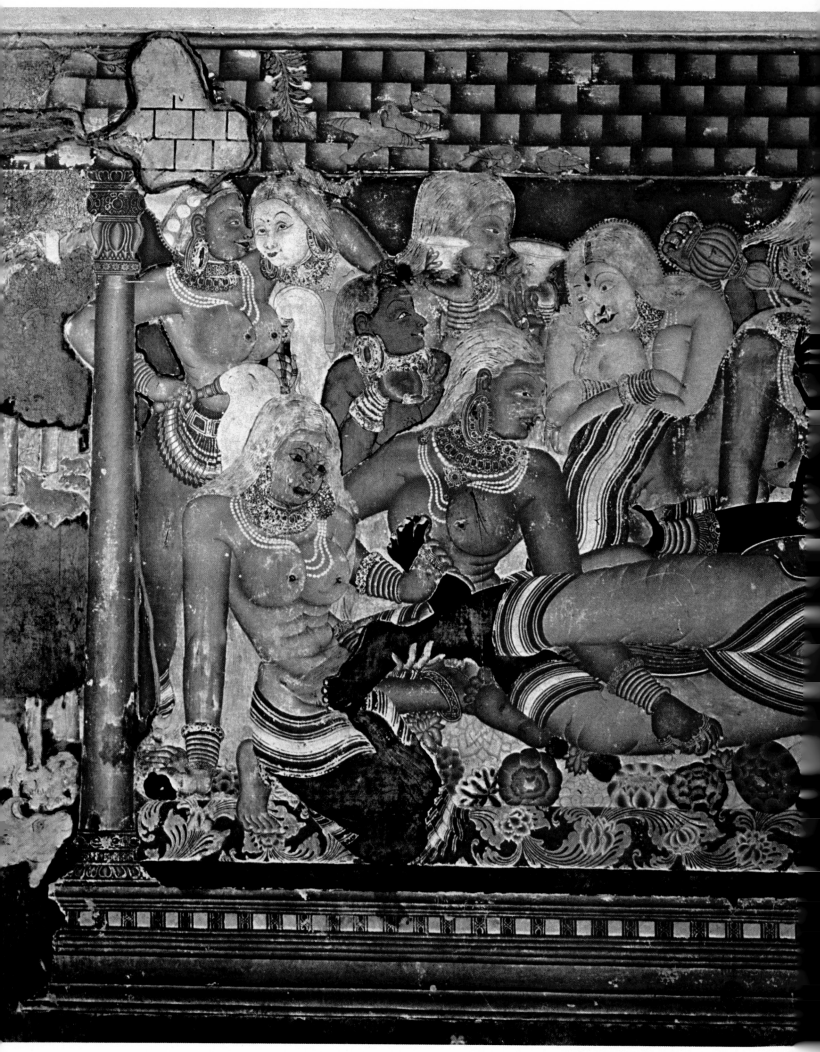

73

HEAVEN AND EARTH MEET

If their merit diminishes, the celestials themselves must be reborn on earth and again prove themselves worthy to ascend heavenward. By repeating a cycle of births and deaths in sad and monotonous succession, they hope to achieve spiritual perfection and thus elevate themselves to the state of bliss (Nirvana) where there is no sorrow or joy, only unending peace. This blissful condition is possible only when the individual soul merges with the universal soul—the Immanent Almighty.

The great Indian philosophers have taught that the earth is the sphere in which one must struggle to achieve bliss. In the heavens there is nothing but happiness; only on earth, where there is the sharp and deep contrast between joy and sorrow, can man realize a third state beyond these, that of bliss. The great masters have striven to find the true path to Nirvana. After experiencing an acute realization of the world's misery, Buddha became determined to achieve supreme knowledge. The Jain Tirthankaras withdrew from the world to practice asceticism; among them was King Neminatha, who meditated on the immense misery caused by just one of the many feasts celebrating his coronation. Thus evil often goaded men to seek the good and became a harbinger of the dawn of wisdom.

Heaven was never far off. Kalidasa sings that a glorious part of heaven had been brought down to earth in the most magnificent city of Ujjain, where everything was divinely beautiful. Buddha goes to heaven to preach to his mother about the great law (dharma) he has formulated on earth. This knowledge is valued as much by the celestials as by the mortals, and attended by the noblest of celestials, Buddha descends on a triple ladder to preach to the mortals. The celestials themselves keenly watch the terrestrial region and carry Siddhartha's royal turban and his begging bowl to heaven for adoration. Even Indra, the Lord of the Heavens, comes to earth to attend Buddha and await an interview. Indra knows that celestial music is calming and will persuade Buddha to receive him kindly. Therefore he orders Panchasikha, the celestial musician, to play his harp and with soft music delight the Sakya sage. The nagas of the netherworld, the celestial devas, and a whole congregation of demigods—the nymphs, elves, gnomes, and tree sprites—join in urging the Master to expound his dharma.

In the Jain tradition the Tirthankaras are revered as pathfinders in the quest for Nirvana. The celestials are so concerned about the birth of the Tirthankaras that Naigamesha descends to earth and transfers an unborn Tirthankara to a more propitious womb. (In the Buddhist tradition a similar concern is shown by the Dikpalas who wrap the newborn Siddhartha in a silken garment.) The Jain legend tells that Sakra himself brought the infant Tirthankara to the top of Mount Meru, the mountain of the gods, for the divine bath. Joining a host of nymphs, the Lord of Celestials himself danced; and Indra and Ajatasatru, a great ruler on earth and contemporary of Mahavira, waved the chowrie before the Tirthankara.

Early sculptures show winged celestials fluttering above a stupa to show their deep reverence for the conquering Buddha (Jina). These popular deities had been admitted into the Buddhist fold by the wise mentors who knew that simple folk deities commanded great devotion. When these deities became attendant on Buddha, the Master himself was enhanced and gained many devotees. Thus at Bharut we see rep-

resentations of a host of popular deities and tree sprites. The adoration of the stupa by nagas and naginis is in the same tradition of assimilation.

The desire of man to live with celestial beings—to bring them close to him and to invoke them with affection and devotion like well-loved companions—has indeed enriched Brahmanic spiritual life. The Hindu gods and goddesses have been adored with affection, anger, jealousy, patience, self-control, abandon, frolicsome high spirits, austerity, intelligence, innocence, deep tenderness and compassion, and valor—the very qualities inherent in the divinities as they descend to earth to serve mankind by rewarding and protecting the good and punishing the wicked.

Although he is the greatest of ascetics, Shiva must marry—not for his own pleasure but for the good of the celestials, since his son Kumara (Skanda) will end the misery of the gods. Shiva is the austere deity of learning, the very embodiment of knowledge. He is both the sound and the meaning of language, and he creates the grammar that perfects speech. Bent with age, seers with grizzled beards learn from him, the eternally young master. Shiva speaks in silence, and his exposition resolves all doubts. He does not frequent the celestial heights but inhabits the terrestrial sphere, sitting on a hillock under the banyan tree. And this tree, the most earthy of the earth, is symbolic of his presence. (Following this archetype, prophets like Buddha and the Tirthankaras are also associated with particular trees.)

The austere Shiva is also most frolicsome. He plays at dice with his consort Parvati, loses in the game, and is laughingly teased by her and her companions. Shiva and his consort are joined in the hermaphroditic figure of Ardhanarisvara.

Immanent, Shiva has eight forms that embrace heaven and earth. His feet dance on the earth, but in his *lalāṭatilaka* pose they touch the sky. The sky itself composes his locks of hair, on which the crescent moon is tranquilly berthed. Shiva both performs and witnesses his own dance. He dances not only on Mount Kailasa, but also at Chidambaram and on the slopes of the Himalayas. In his great mercy Shiva accords mortals the divine privilege of approaching him and witnessing his dance, which would otherwise be invisible to them. Musicians and dancers are brought before him so that he may judge their skill, and he listens intently to the earthly music that rises to the portals of heaven.

The ancient seers and poets believed that knowledge helps in overcoming temptation and leads to the highest bliss. They had learned well the lesson of Buddha's temptation, an episode in which he overcame the demon Mara and thus gained celestial wisdom. They invoked and brought down to the earth the celestial goddess of learning, Vagdevi. One of the greatest devotees at her altar, Paramara Bhoja, erected an inscribed image of her at the university he established at Dhara. Scholarship was greatly revered, and Vidyarnya, the embodiment of learning, is often shown in a palanquin in a procession. Patanjali, the great grammarian, promises the highest bliss in heaven and the fulfillment of all desires for those who write and pronounce correctly. Learning is compared to a milch cow—when cared for and cherished, she is bountiful.

The concept of immortality is expressed in the elixir of life, amrit, a boon more valuable than all material wealth; in the wish-fulfilling tree (*kalpavṛkṣa*); and in the most precious jewel (*Kaustubha*) that glistens on Vishnu's chest. Lakshmi, the goddess of prosperity whom Vishnu claimed as his spouse, is the very essence of auspiciousness and, as such, appears on all monuments whether Brahmanic, Jain, or Buddhist. But

even her power is overshadowed by that of the amrit, the elixir of immortality for which the gods and demons churned the ocean, a scene shown on the doorway of the Beshnagar cave.

The marks of distinction (such as the *ushṇiṣa*, or "protuberance on the skull," and the *ūrṇā*, or "tuft of hair between the eyebrows") are often mentioned or depicted. They represent a superhuman element in man that allows him to be elevated almost to godhood. And the concept of avatars shows that men can rise heavenward in excellence and reach celestial grandeur. The winged human figures of early sculpture show this heavenward flight. Even animals and reptiles have been given wings by the hopeful artists who conceived these fantastic creatures. Created thus are the divine horse Uchchaisravas, the celestial elephant Airavata, and the sacred bird Garuda.

fig. 350 Humans could sometimes elevate themselves to a very high sphere through supreme faith, as when Ravana offers nine severed heads to Shiva as a garland, an episode represented at Ellora. Even the humblest and the lowliest could hope for the highest celestial contact. The courtesan Lonasobhika and the outcaste Nanda sought union with the Lord of the Dance at Chidambaram. Buddha demonstrated that he, the sage on earth, was higher than even the celestials. Sageness is beyond the celestials and is nearly at the level of the Almighty himself.

The legend of Rama and the Lord of the Ocean shows that the dignity and power of man is sometimes raised above that of the celestials. Drawing his bow, Rama challenges the ocean and declares that he will dry it up by shooting a fiery arrow into its watery depths. But he desists when the Lord of the Ocean implores his mercy. A similar tale is that of Tripurantaka's conquest of the invincible lords of the three brazen castles. In the *Mahabharata* the mortal hero Arjuna, a noble and brave knight, wrestles with Shiva who has descended to earth in the guise of a hunter. The celestials and the terrestials also meet on less ominous occasions. The mother goddess Parvati visits earth with her child Skanda and the celestial Krittikas to show her affection to her devotees. She is welcomed by the Seven Mothers carrying their infants who represent all the good-natured children on earth. The baby Skanda is indistinguishable from the other infants, and all are fondled with equal affection. Skanda, the very personification of beauty, rests on the shoulder of a maid as his mother caresses him, a scene shown in a lovely carving from Samalaji.

The baby Krishna, an incarnation of Vishnu, loves to be fondled by the humans who rock his cradle, sing him songs, give him milk to drink, and chide him for stealing butter and offering it to the cat and the monkey. Krishna charms all with his pranks. When caught stealing butter and gobbling it up, he opens his mouth wide to proclaim his innocence; he then disconcerts his foster-mother by declaring that the universe is an illusion. This vision of heaven and earth, evident in Krishna's lovely divine pranks, forms the theme of the *Bhagavata Puranas* and *Vishnu Puranas*.

fig. 753 The sacred bird Garuda is often seen atop a column in front of temples dedicated to Vishnu. This emblem, whether at Beshnagar or a millenium later at Jagannatha, serves to direct man's attention toward heaven. The fivefold acts of Shiva—creation; sustenance; destruction; drawing the veil of illusion of permanence over transient things; and removing that veil to vouchsafe final beatitude—are revealed in the dance of Shiva as Nataraja and are suggested in the fivefold form of Sadashiva himself.

Mortal frailties are not unknown among the celestials. Devi turns her head from Shiva in anger at the thought of Ganga resting as a co-wife on his locks. Devi takes great pleasure in adorning herself and in performing the lasya, a dance for which she is renowned. Terrified by the movement of Mount Kailasa, which is shaken by Ravana, she clings to Shiva. These are clear flashes of humanity in the celestial sphere. The divine qualities, in all their aspects beneficial to the denizens of the earth, are represented in fourfold composite icons, such as Chaturmurti Surya, Chaturmukha Shiva, Chaturvyuha Vishnu, and the like. Similarly, the degradation of high qualities of valor and power, blinded by ego, is seen in Mahishasura and is symbolized by his buffalo head; his arrogance is condemned even by the mother, who descends as Mahishamardini to chastise him.

The equality and companionship of man and woman is shown in the dance of Nataraja and Devi, both of whom are adept in this great art. Devi can be coy and bashful as a bride; tall, majestic, and almost masculine in her Durga aspect; and fearful as Chamunda. Rama, who as a prince was the most ardent disciple of the sage Visvamitra, is also represented seated under the heavenly tree, expounding the highest thought to the sages Vasishtha and Vamadeva, as Hanuman, the most learned, reads from the book of philosophy.

The Lord often completely subsumes his celestial nature in his mortal form. As a child, he obstinately cries for the moon, till he is given a reflection of it in a small *fig. 177* vessel filled with water. Incarnate as a human, the Lord sometimes reveals his celestial nature. A simple herdsman, he returns from the fields with his calves and kids, but he then expounds to the sages on the greatest wisdom.

These not infrequent encounters of the celestials and terrestrials, though often improbable or incongruous, are beneficial for both since the highest qualities of each are brought into play.

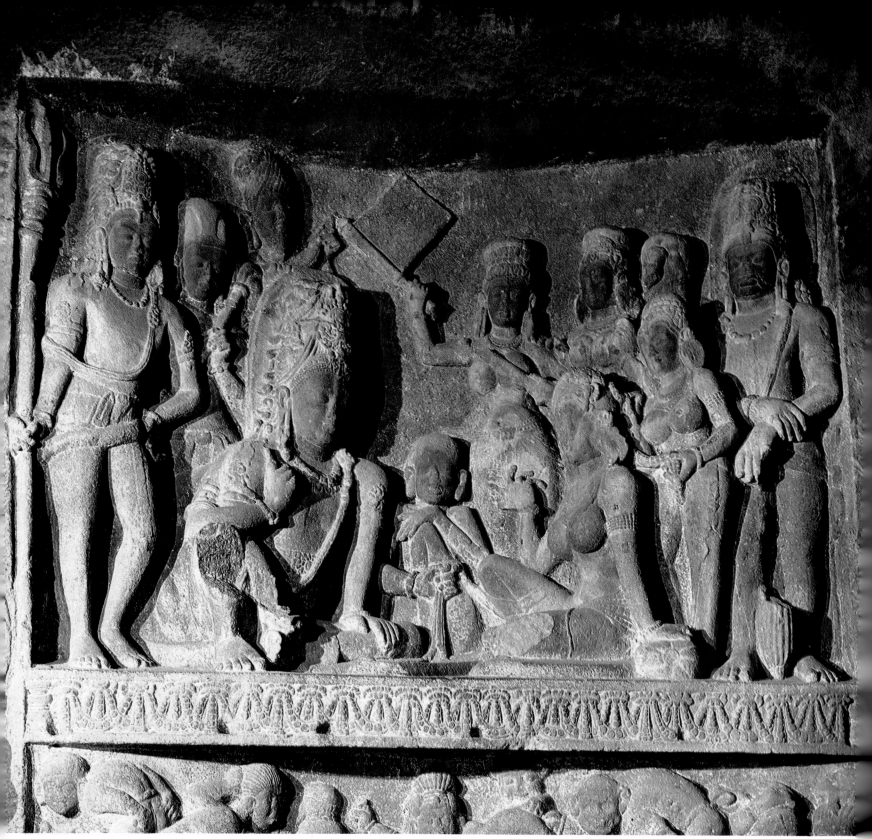

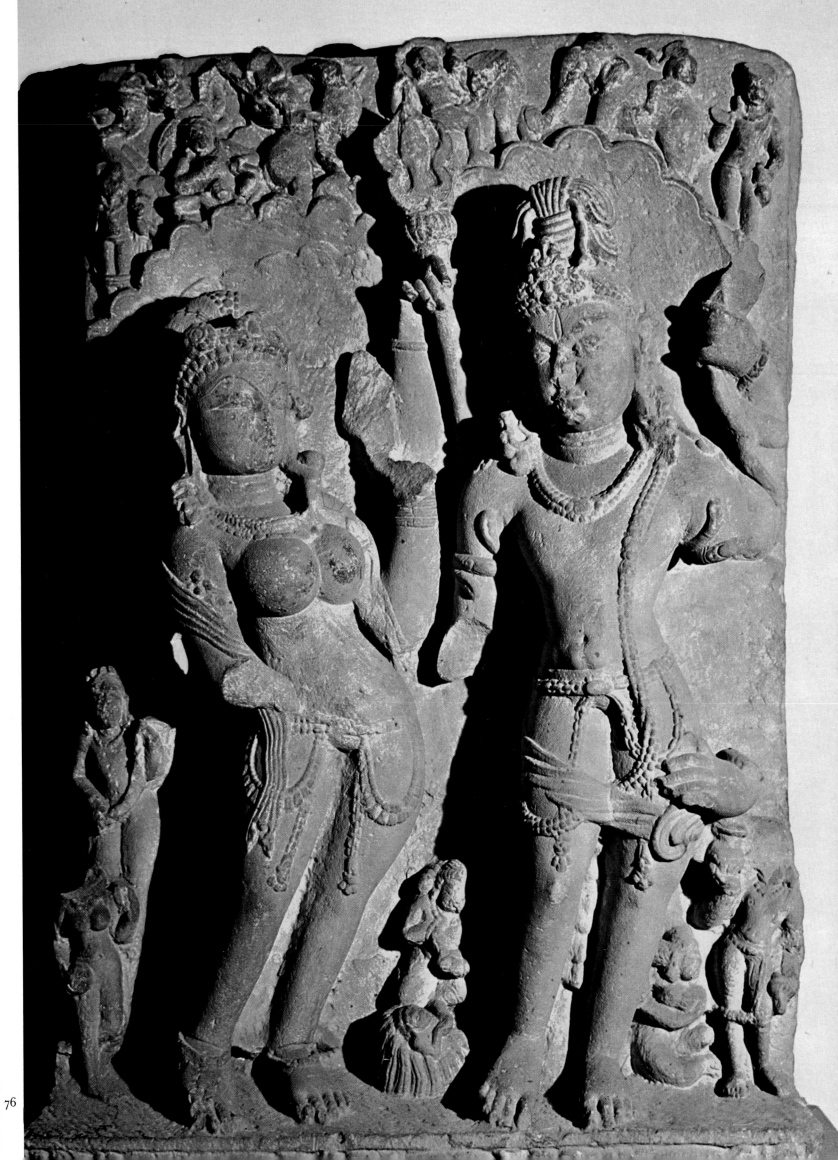

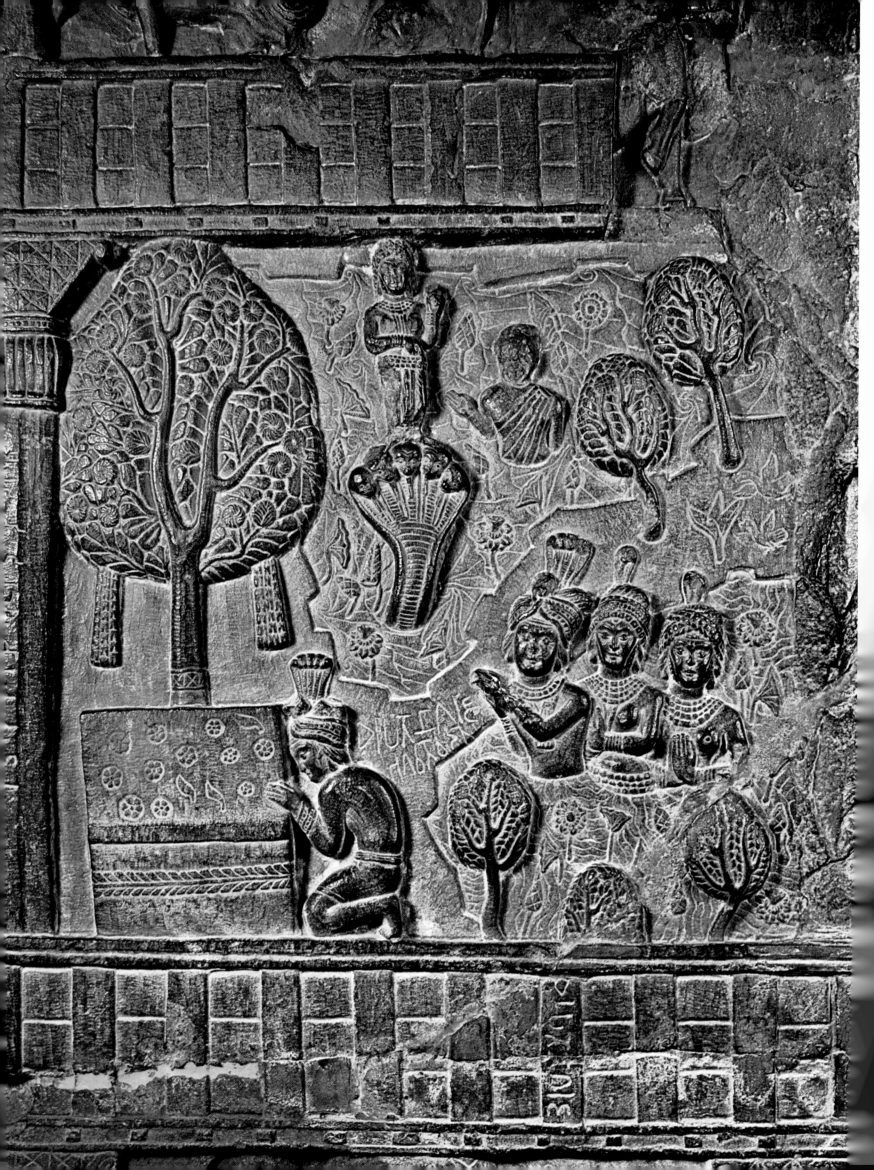

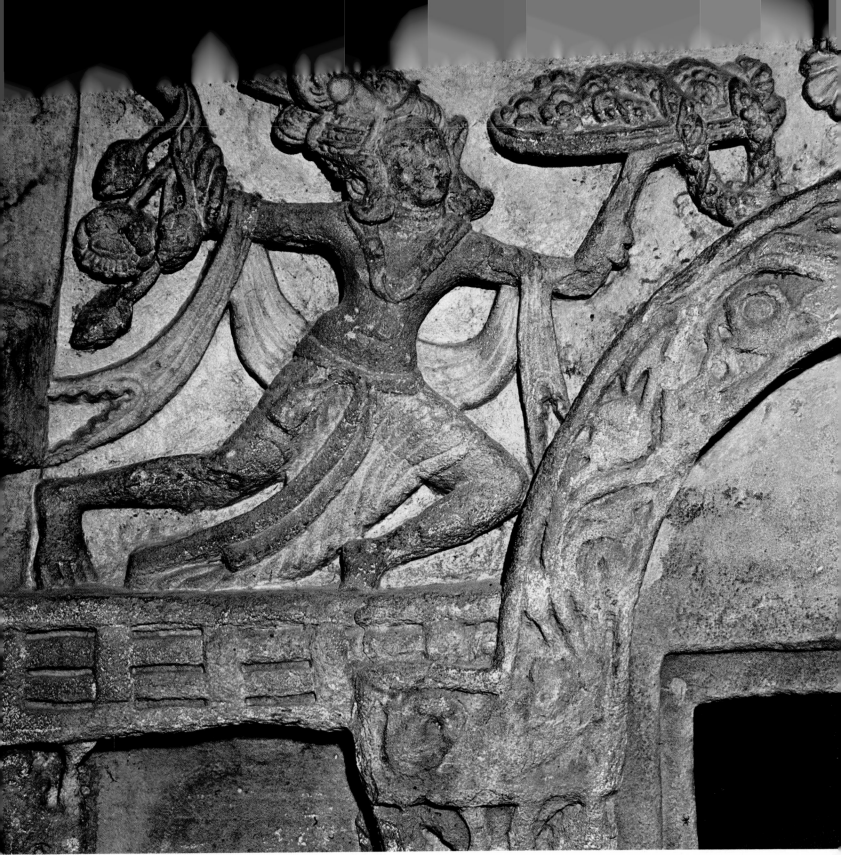

RHETORIC AND ART

ART and literature are essentially joined together. The techniques and rhetoric of literature are also those of the plastic arts. Poetry is enhanced by skillful verbal suggestion, which evokes the fragrant ideas associated with words, and this quality is equally powerful in the plastic arts. Veiled sense, conveyed indirectly in a charming way, is compared by Mammata to the beauty of the feminine form, lighty covered by a diaphanous garment that both reveals and conceals.

Suggestion may be direct or simple, indirect or subtle; both have their own charm. Kalidasa describes the fall of the first summer raindrops on the limbs of the penitent Parvati—*sthitāḥ kṣaṇam pakṣmasu tāditādharāḥ payodharotsedhanipātchūrṇitāḥ valīṣu tasyās skhalitāḥ prapedire cireṇa nābhim prathamodabindavaḥ* (*Kumārasambhava*, V, 24). The drops fall on her eyelashes and linger there for a moment, then moisten her lips, fall to her full bosom, scatter and flow atremble over the luxuriant folds of her stomach, and at last reach her cuplike navel. Her lips, alluring as a luscious vermilion fruit, are so soft that the fall of the drops almost bruises them. The tumbling of the drops on the folds of her stomach suggests its almost steplike formation. The word *cireṇa* ("at long last") signifies the depth of her navel. This symbolic and allegorical style is the highest mode of expression in art as well as in literature.

A yakshi listens to a parrot, which has been taken out of its cage and perches on her shoulder, almost whispering into her ear. Her charming smile suggests that the damsel, separated from her lover but with her thoughts always on him, is talking to the bird and is pleased by the words of affection that it has been taught by its master. The bird's chatter amuses her in no small measure and gives her relief from her lovelorn distress.

figs. 379, 85 The first act of *Mricchakatika* ("The Little Clay Cart") is portrayed in a sculpture from Mathura. Vasantasena, the heroine, is a courtesan, and a scene in her house garden is represented. The advice of the *Viṭa* ("the man of the world," a stock dramatic character)—to throw away the fragrant flowers and the jingling anklets that betray her even in the dusk—is suggested in a masterly way by the sculptor. The artist shows that the anklets have been pulled up to silence them, and Vasantasena is seen covering the flowers on her braid with her veil to smother their perfume. Thus the wicked clown, the *Śakāra*, will not be able to pursue her in the darkness. The *Śakāra* is afraid because he hears voices, as Vasantasena calls for her maid, and he hides behind his friend, the *Viṭa*. Vasantasena is an opulent courtesan, the fairest gem of Ujjain, and this is indicated by the attendant figure holding a parasol over her.

While illustrating the sense of the text faithfully, the sculptor deviates from it in fact. Instead of being thrown away, the anklets are pulled up to prevent their jingling, and the flowers on the braid are not discarded but covered by a veil. This is a good example of a scene (and emotion) conveyed through suggestion rather than direct expression.

The impatience of the ardent damsel (*vāsakasajjikā*), who beautifies her home, prepares the bed, and awaits her lover, is indicated by the placement of her finger against her lip. This gesture has greater eloquence than a more extended and realistic expression of her mood.

The bashful bride trying to escape from her lover as he pulls at her garment is a representation of the *mugdhā*—the shy maiden still too coy to yield readily to her heart's desire.

A shy damsel peeping from behind a half-closed door, a motif in Eastern Ganga fig. 386 sculpture from Bhuvaneshwar and elsewhere, represents the longing wife. She awaits her husband, long wandering in distant lands, but whose imminent arrival is indicated by the caw of the crow perched on the door.

A carved ivory panel from Begam now in the Musée Guimet depicts a damsel walking gaily followed by a swan. The jingling of her anklets attracts the swan, whose leisurely and stately stride closely imitates the lovely gait of the damsel.

A sculpture, illustrating Prince Siddhartha enjoying earthly pleasures, oblivious of the misery that exists in the world, shows a stream in which a damsel swims while grasping a swan. This recalls a line from the *Mricchakatika*, in which the courtesans are likened to pleasure boats, their breasts and hips resembling the bow and stern.

The lovers enjoying the mirth of springtime is clearly seen in a panel from fig. 387 Abaneri where the soft music of the vina and the budding green mangoes suggest the awakening earth. A Hoysala bracket figure, portraying a nude damsel teasing a monkey with a sprig of flowers, is an eloquent allegorical narrative—the human mind is a monkey captivated by the ravishing beauty of the fair sex whose coquettish anger and flowery strokes serve only to increase passion. The pair of deer at Mahabalipuram and pairs of birds from Prambanan in Java and Pattadakal in India also illustrate this passionate attachment to beauty.

A lady, emerging from her bath and preparing to dress, is depicted on a pillar fig. 370 bracket at Belur. A scorpion is prominently shown at the base, recalling the pitfalls of addiction to pleasure and indicating that physical beauty is transitory and that excessive passion is fraught with the danger of dreadful wasting disease. The maddening effect of beauty itself is suggested in another nude figure, that of Bhikshatana (Shiva as the Beggar), whose physical perfection inflamed the wives of the sages. The passion of the wives is suggested by the garments slipping from their hips.

Shiva as Kalyanasundara, the charming bridegroom, holds the hand of his bride as she is given to him in marriage by her father, Himavan. This clasping of hands in friendship, assuring companionship in life, ennobles matrimony as the highest ideal of friendship and partnership between husband and wife. The theme of matrimonial harmony is also seen in Rama and Sita seated together in pleasant conversation. The contentment of this ideal loving couple is echoed by the pair of cooing birds perched on the roof of the terrace.

The yakshi carrying a platter in one hand and a pitcher of water in the other represents the river as mother goddess. She assures plenty and prosperity, as water brings agricultural wealth to a riverine area. Similarly Sri Lakshmi, standing on lotuses issuing from a brimming pitcher, promises maternal nourishment to the earth. The river, mother of the children of the soil, feeds them with a never-failing supply of *payas*, meaning both water and milk. The goddess's smile and the motif of the dancing peacock with spread tail which appears on her armlets suggest a joy born of prosperity. She is both the goddess of prosperity and the river goddess; her maternal role is suggested by her hand touching her breast.

The deer pierced by an arrow, the personification of misery, recalls a line of

Kalidasa poignantly comparing the planting of a sharp arrow in a tender body to the throwing of a torch on a bundle of soft wool. Bhishma on a bed of arrows, the very picture of heroism, suggests the highest endurance in a determined warrior.

The Visvarupa form of Vishnu (for example, that in the Mathura Museum or that from Kanauj) represents his immanence through indirection. A famous painting of Buddha from Central Asia, showing the holy marks on his body, has significant suggestive meaning. The *śrivatsa* mark, for example, is normally not seen on Buddha's chest, which is usually covered by a cloak. But here it is prominently shown, thus equating him with *Puruṣottama*, the most magnificent among the cosmic beings, Vishnu himself. The *amṛta kalaśa* ("jar of ambrosia"), which is encircled by a snake, suggests the Churning of the Ocean. This subtly states that the moon—the ambrosia itself—is born out of the mind. The flaming pillar topped by the solar wheel—already used at Nagarjunakonda and Amaravati to indicate Buddha's superiority over Agni, Rudra, Vishnu, Brahma, and Surya—is here painted on the arms of Buddha, emphasizing the importance of the Master.

The appearance of five of the nine planets in a scene of nativity indicates the birth of a prince whose good fortune will have no bounds. It was believed that an infant born under such an exalted planetary configuration would enjoy the highest prosperity and position.

A crown held aloft by celestials symbolizes an impressive success or victory. Prince Siddhartha's great renunciation is magnificently indicated by such a crown. And this emblem appears in the Gajendramoksha panel from Deogarh; the crown held by celestials, who flutter above Vishnu, celebrates the rescue of the elephant who sought succor.

In a sculpture from Amaravati, the glory of Mandhata who overcame all obstacles is cleverly indicated. The emperor is shown striding with heroic grandeur. At his foot a naga with hands clasped in adoration represents an obstacle that he had overcome and humbled. This mode of depicting triumph—through the heroic posture of the victor and the symbolic representation of the vanquished—gained wide acceptance. The attitude of defiance and bravado with the arms akimbo is repeated in the Maradharshana scene. Here Mara is undaunted by obstacles and darts forward, even as his followers plead with him and grasp his legs.

Discomfiture is also portrayed through suggestion. Mara is shown twice on his elephant Girimekhala, first gallantly proceeding and later retreating with his hands clasped in adoration but his head bowed in shame.

Mandhata's fall from heaven embodies his message to the world—a warning that there should be a limit to ambition. This sentiment is indicated in a panel from Nagarjunakonda, where Mandhata points to the luminous sphere of heaven and to his own present helpless state, almost as if saying, "I was there and I am now here and all because there was no limit to my ambition."

The gaping head of a demon toward which is lifted a leg of Trivikrama is a clever indication that the foot is raised heavenward. The celestial sphere, described by the poet Valmiki as the high pathway of the gods including the sun and the moon, is here suggested by the severed head of Rahu which always runs after the sun and the moon to gobble them up. Since the foot touches Rahu's head, it has reached the sky. Similarly, the motif of Trisanku's downward trail is shown in relation to Trivik-

fig. 82

fig. 89

fig. 368

rama's raised foot. This configuration serves to indicate the sky or heaven whence Trisanku fell, though the penance of Visvamitra stayed him and a new heaven, albeit topsy-turvy, grew around him.

A sculpture from Thailand illustrates the descent of Buddha, flanked by Indra and Brahma, at Sankisa by a triple ladder; the sacred bird Garuda is shown at the feet of the Master. Garuda is the mount of Vishnu, *Viṣṇupāda*. The term *Viṣṇupāda* also means the sky. Thus, when the mount of Vishnu is depicted, the sky itself is represented, and Buddha's descent from heaven is thereby cleverly suggested.

A sculpture from Java shows the bodhisattvas at school—the boys are in a row, their hands clasped in an attitude of *sankalpa* to show their determination to master a task. This depicts the annual ceremony held at the commencement of Vedic studies, a ritual observed even now. The teacher is on an elevated seat with his pupils before him; this shows *guru-śishya bhāva*, the correct attitudes of master and disciples.

An Amaravati medallion in the British Museum that shows Buddha's crossing of the river Nairanjara is a marvelous narration in expressive sculpture that does not use an anthropomorphic figure of the Master to convey the sense. The approach of the nagas on one side, their feet toward the bank, indicates that the Master is moving. The glory of the Master is recognized even by the birds and is expressed by their circular movement. The solicitude of the trees and plants that bend to help the Master cross safely is also a happy idea adopted by the sculptor.

How pleasant is a dip in a pool and how cool in summer—these sensations are indicated by the long stalks of a lotus in a pond, whence emerges a damsel after her bath. The long stalk itself indicates the low water level caused by the blaze of the summer sun. This representation from a painting from distant Dandan Uiliq in Central Asia demonstrates how ideas travel and how the thought of an early Indian poet is glorified in a far-off land. The time of the day, noon, is expressed by a group of sages performing ritual ablutions; one holds his hands in *yamapāśamudrā* to look at the sun and repeat the prayers, thus clearly showing that it is midday.

How long was Mount Govardhana held up by Krishna? A sculpture from Badami indicates that this extraordinary act was sustained for one week. The milk-maids are shown under the shelter of the mountain; some of them are churning butter in order to prepare ghee. The curdling of the milk itself takes a day or two and the gathering of the butter another two days. This is a clever way of indicating the passage of time, and the sculptor is to be congratulated on such a happy device.

In the Govardhanadhari cave at Mahabalipuram, the activities—the gathering of fodder and fuel, the coming of the herdsman with the ax on his shoulder, the return of the old man with his grandchild perched on his head, preceded by his daughter with a pile of pots on her head for butter—indicate the lapse of more than three days. This is the time required for the preparation of ghee from the butter that was gathered a day earlier from milk curdled still earlier; and the lapse of each day is indicated by the fatigue caused by work during the day, which is eased by playing the flute or fondling the cows.

All these examples show suggestive expression in art. But there is also decoration or embellishment in art. These embellishments, known in literature as

alaṃkāras, have their parallels in artworks. These decorative *alaṃkāras* are like embellishments for the body which, when chosen and used with taste, are very effective and striking.

Bhrānti, or "delusion," is a well-known figure of speech where one thing is taken for another because of their close similarity. For example, the honey-drunk bee may mistake the face of a maiden for a lotus. In the Varadaraja temple at Kanchipuram the roof of the pillared hall is decorated by a carving showing cats running after doves. The representation is so realistic that it recalls a literary description of the people in the city of Dvaraka who gazed at a live cat standing still and about to pounce on statues of doves. The doves were so lifelike that the observers took them for live ones. After realizing their mistake, they compounded their error by thinking both the cat and the doves to be realistic lithic representations.

Rūpaka, or "metaphor," is a figure of speech in which there is complete obliteration of the differences between the objects or persons compared. A coin from the Gupta series, showing the goddesses of learning and wealth flanking the ruler, not only compares but actually identifies the monarch with Vishnu and his consorts. The sculptor translates pictorially a line from Kalidasa and shows that Sri and Sarasvati who normally live apart find a common abode with this prince as with Vishnu.

fig. 91

Ullekha, an *alaṃkāra* representing the multiple impressions of the same object viewed by different spectators, is illustrated in a glorious sculpture of the Gurjara-Pratihara period. Here amplitude and attenuation, opposites themselves, compose one figure of eloquent grace, marked by an attenuated waist, ample breast, crimson lips, and curly black braid.

Samāsokti is a figure of speech in which the description of one object or person brings to mind another not mentioned. For example, the line "*ayam aindrīmukham paśya raktas chumbati chandramāḥ*" ("Look! The passionately red moon is kissing the face of the eastern quarter") evokes the image of a passionate lover kissing his beloved. An

fig. 86

excellent sculptural representation of this device is from Udayagiri near Bhilsa where Ganga and Yamuna are personified streams; these streams join and flow toward the ocean, which also appears in human form holding a receptacle of gems (thus concretely illustrating the ocean's epithet Ratnakara). The *nāyikā-nāyaka-bhāva*, the attitude of lovers, is significant in the Varaha panel from Udayagiri, where the streams are shown as wives of the ocean, who fondly welcomes them.

Ślesha, or "paronomasia," was a great favorite, and sculptors and painters expressed themselves very cleverly in this mode. This device, which uses puns to express multiple meanings, is seen in the line "*sarvado mādhavaḥ pāyāt sa yo gaṃgām adīdharat.*" This is a salutation to both the Lord of Ma (i.e., Vishnu) and to Uma (i.e., Shiva, Madhava, and Umadheva). Thus in one sense it refers to Vishnu who lifted *aga*, the "mountain," and *ga*, the "earth"; and in another, it refers to Shiva holding Ganga on his locks.

A beautiful and oft-repeated motif is the combined elephant and bull—the trunk and tusks of the elephant shape the hump and the horns of the bull, and the snout of the bull forms the temples of the elephant. This motif finds a pleasant repetition in a fifth-century Gupta sculpture at Deogarh, in a sixth-century Chalukya carving from Badami, in a twelfth-century Chola design at Darasuram, in a Ceylonese monument of the same period, and in a sixteenth-century Vijayanagar panel in southern India.

figs. 353–54

Paryāyokta, or "paraphrase," is the use of indirect rather than direct statement. Thus, instead of the straightforward "Salutation to Vishnu," one may find the long-winded "Salutation to him who made the breasts of the queens of Rahu futile." A verse quoted by Appayya Dikshita in his *Kuvalayananda* describes Shiva as the emperor of the celestials whose quiver is the ocean, whose horses are borne by the great sages like Vyasa, whose jewel casket is the netherworld, whose flower garden is the sky, whose raiment is guarded by Indra and others, and whose body is perfumed with sandalwood ashes of Kama. The ocean is Shiva's quiver since his arrow, Vishnu, lies on its waters. The horses yoked to Shiva's chariot in his Tripurantaka aspect are the Vedas, and the rishis carry them in their utterances. The netherworld is his jewel casket, since his jewels, the snakes, have their abode there. His locks form the sky, and the moon is the flower resting on his hair. Shiva is Digambara since the quarters cover his nakedness; thus the lords of the quarters are the guardians of his dress. An excellent example of this mode of description is in the Tripurantaka panel from the *fig. 335* Kailasanatha temple at Ellora which clearly shows Brahma as the charioteer, the Vedas as the horses, and so on.

Asambhava expresses the wonder of the unexpected occurrence. An excellent example of *asambhava* in sculpture is seen on the pillar of the Virupaksha temple at Pattadakal. The stream of Ganga is presented both naturally and anthropomorphically. As she approaches the sage Jahnu, he holds a small water vessel into which he draws the proud stream, sips her up, and releases her only on the entreaties of Bhagiratha. Escaping through the ear of Jahnu, she is given the appellation Jahnavi, "daughter of Jahnu." Both the sipping and the releasing of the stream through the ear are unexpected happenings—*asambhava*.

Viṣama stresses inconsistency. A literary example is the description of the moon shaping itself into the face of a lovely damsel in order to rid itself of a dark blemish. But the damsel then paints a mark on her forehead, and the moon is thwarted. In the famous painting from Ajanta known as *The Princess's Toilet*, the beautiful face *fig. 114* of the princess, which is likened to the moon, is decorated with this mark and the mirror is held to reflect it.

Adhika is a figure of speech that expresses hyperbole. A fine early Satavahana coin of Gautimiputra Satakarni illustrates the extent of the prince's fame—his renown had crossed the mythical mountains forming the boundary of the world, spanned the four oceans, gone down to the netherworld, and shot up to heaven. Four symbols, each incorporating the crescent, illustrate this hyperbolic concept, since fame, brilliant like the moon, is represented by the crescent. A zigzag symbol illustrates the netherworld, abode of snakes, and a cluster of stars, later replaced by a solar symbol, suggests the celestial sphere. The verse of Kalidasa describing the fame of Raghu, which other rulers emulated, is thus adroitly represented.

Praharṣaṇa describes the joy at easy success. A literary example is the verse that describes a fawn-eyed damsel who tries to climb a tree by placing her foot on it and thus causes the branch to blossom in scarlet asoka flowers. A sculpture from Bodh *fig. 360* Gaya, which shows the climbing damsel aided by her lover, illustrates this episode.

Perhaps the most vivid example of *viṣadana*, the figure of speech indicating disappointment, is seen in the Lala Bhagat pillar. This early series of panels illustrates *fig. 326* an anonymous verse—"The night will pass. There would be bright day again. The sun would rise and gladden the horizon and the lotus pool. So thinks the bee as it

retires into the lotus bud. Alas! Alas! The elephant pulls out the lotus." The harbingers of day—the solar chariot with the sun flanked by Usha, Pratyusha, and Chchhaya; the dwarfish Valakhilya sages preceding the chariot of the sun; the dance of the peacock with its spread tail suggesting the gladdening of the horizon—heighten the poignancy of the uprooted lotuses.

fig. 111 The hand lovingly placed on the neck in embrace, as in a painting at Ajanta or in the sculpture of Vikramaditya and his queen at Pattadakal, clearly illustrates *ullāsa alamkāra*, where the merit or defect of one person or object is compared with that of another. Compared to the neck, which is caressed by the beloved's hand, the other limbs of the body are indeed most unfortunate.

Yukti is used to express the covert meaning of events and is well illustrated by an episode from the *Amarusataka.—dampatyor niśi jalpator grihaśukenākarnitam yad vacas tat prātar gurusannidhau nigadatas tasyātimātram vadhūh karnālambitapadamarāgaśakalam vinyasya cañcūpute vridārta vidadhāti dādimaphalavyājena vāgbandhanam.* A young bride is terribly tormented by shame at the indiscreet utterance by a pet parrot of all that it has heard spoken by the couple during the night. She stops its prattle by thrusting her ruby earring in its beak on the pretext of offering it a pomegranate. A beautiful sculpture from Nagarjunakonda is a striking rendering of this incident. The damsel with a parrot on her left wrist is actually choking the beak of the bird with her ear jewel, while her amused consort looks on.

fig. 397 Natural description, or *svabhāvokti*, is an important embellishment in literature and art. A fine example is the milking scene from the Govardhana cave at Mahabalipuram. Here Mayura's verse telling of the enthusiastic thrust of the calf at the udder of the cow while the latter fondly licks the young one is more than equaled in the sculptural glory of its representation.

An abiding flavor, or *rasa*, is the soul of an artistic or literary theme. There are nine recognized *rasas*: *śṛṅgāra* (erotic), *hāsya* (comic or humorous), *karuṇa* (compassionate), *vīra* (heroic), *raudra* (fearful), *bhayānaka* (horrific), *bibhatsa* (repellent), *adbhuta* (wonderful), and *śānta* (tranquil).

Emotions (*bhāvas*) that rise and subside quickly, like waves ruffling the ocean, are also used in artistic composition. *Anubhāvas* and *sātvikabhāvas* suggest fleeting feelings of grief and sorrow. *Vyabhicāri bhāvas* are most fleeting and include momentary reactions like despair, fatigue, doubt, and jealousy. These elements complement the *rasa* that the artist has chosen to portray. And the abiding and dominant flavor, the *sthāyibhāva*, allows the observer to recognize the *rasa* at once. The *uddīpana vibhavas*, which inflame the emotions, are aids like moonlight, spring, flowers, or the cool breeze. Or they may be things that bring to mind the beauty of the beloved, like the frightened looks of the deer, the charming gait of the swan, the lovely pink of the lotus, and the flamboyant tail of the peacock.

In *śṛṅgāra* the hero and the heroine form the *alambana vibhava*, since the flavor is entirely dependent on one or the other. There are two varieties of *śṛṅgāra—sambhoga* (that of united lovers) and *vipralambha* (that of separated lovers). The former is best seen in the innumerable *mithunas* ("loving couples") in sculpture and painting. The lover is often shown conversing in a lively manner or expressing joy in a game won, while caressing the beloved's shoulder. There is no better representation of this than Parvati winning at a game of dice and almost taunting Shiva on his defeat. A

Madanantaka sculpture from Darasuram depicts the brief heroic stand of Kama before *fig. 395* he is destroyed by the scorching gaze of Shiva. Shiva's wrath is most effectively represented by a single finger raised in a menacing manner (*tarjani*). The wail of the celestials rushing to plead with Shiva that he spare Kama is also suggestively delineated. And Rati, disconsolate beside the lifeless Kama, is a telling portrait of *vipralambha*, the anguish of the desolate lover.

Hāsya, which provokes laughter, has a fine example in the representation of *Secha Jataka* from Bharhut. The old and wise monkey gravely pulls up flowering plants and inspects their roots to determine how much water each needs. The monkey thinks that he is helping his old friend the gardener. Other monkeys enthusiastically carry water, but although eager to nourish the plants, the wise old monkey is careful not to waste water. A sculpted medallion shows a monkey as a doctor pulling out the teeth of an ogre. A rope, tied to the tooth of the titan, is pulled by a huge elephant. There are a variety of similar representations that provoke laughter.

In a frieze from Khajuraho, the arrow planted in the delicate body of the spotted deer arouses agonized *karuṇa* in the viewer. *Vira rasa* is nowhere better realized than in the frieze from the Amaravati coping that shows the hero on the battlefield. The warrior Bhishma, reclining on his bed of arrows, is another magnificent representation of the ideal hero.

Raudra rasa is clear in the Tripurantaka panel from the Brihadisvara temple where the demons who are in combat with Shiva look the very personification of anger. Sculptures like that of Chamunda or Putana, the ogress that tempted Krishna to drink milk from her breast, are fearful representations that evoke a feeling of terror. The snakes on the flaming hair, the breastband composed of reptiles, the corpse or owl in the earlobe, the sacred thread composed of severed human heads—all are indeed ghastly sights, creating a feeling of disgust characteristic of *bibhatsa rasa*. The expression of wonder, *adbhuta*, is seen in the Deogarh panel that shows Krishna kicking the cart to kill the demon who has assumed that form, while a milkmaid looks on in wonderment with a finger on her lip.

Śānta rasa is nowhere more wonderfully represented than in the atmosphere of the hermitage in the Naranarayana panel. The chanting of the hymn of bliss is recalled in the panels from Bharhut and Pattadakal depicting students at the feet of the elderly sage who teaches the sacred scriptures.

Bhāvaśabhalatā, or the commingling of several *rasas*, is also often cleverly represented, as in the painting of Shiva from the Brihadisvara temple at Tanjore. The knitted brows and flashing eyes of the warriors, as they brandish their weapons, show their determination to win or die. They are oblivious of their wives who cling to them in despair, tearfully beseeching them to desist from battle where doom and destruction are certain. Here the *raudra*, *vira*, *śṛṅgāra*, and *karuna rasas* commingle with great effectiveness.

Another example is an Amaravati medallion with a synoptic representation of the elephant Nalagiri, first furious on a highway of Rajagriha and then subdued. The fury of the elephant is reflected in the attitude of the spectators on the balcony in one half of the panel; the peace and calm of the animal bowing to the Master are reflected in the worshipful spectators on the balcony in the other half of the panel. This is a commingling of agitation and calm, *bhayānaka* and *śānta*.

82. BUDDHA
Mural from Belahan (central Asia)
Kushan, 3rd–4th century
National Museum of India, New Delhi

83. YAKSHI TALKING TO A PARROT
From Bhutesar. Kushan, 2nd century
Indian Museum, Calcutta

84. LAKSHMI AMID LOTUSES
From Mathura. Kushan, 1st century A.D.
National Museum of India, New Delhi

85. THE COURTESAN IN VESAVASA
INTOXICATED IN HER GARDEN
From Mathura.
Kushan, 2nd century
National Museum of India, New Delhi

86. SAMUDRARAJA AT THE CONFLUENCE
OF THE GANGES AND JUMNA RIVERS
4th century
Cave at Udayagiri, Madhya Pradesh

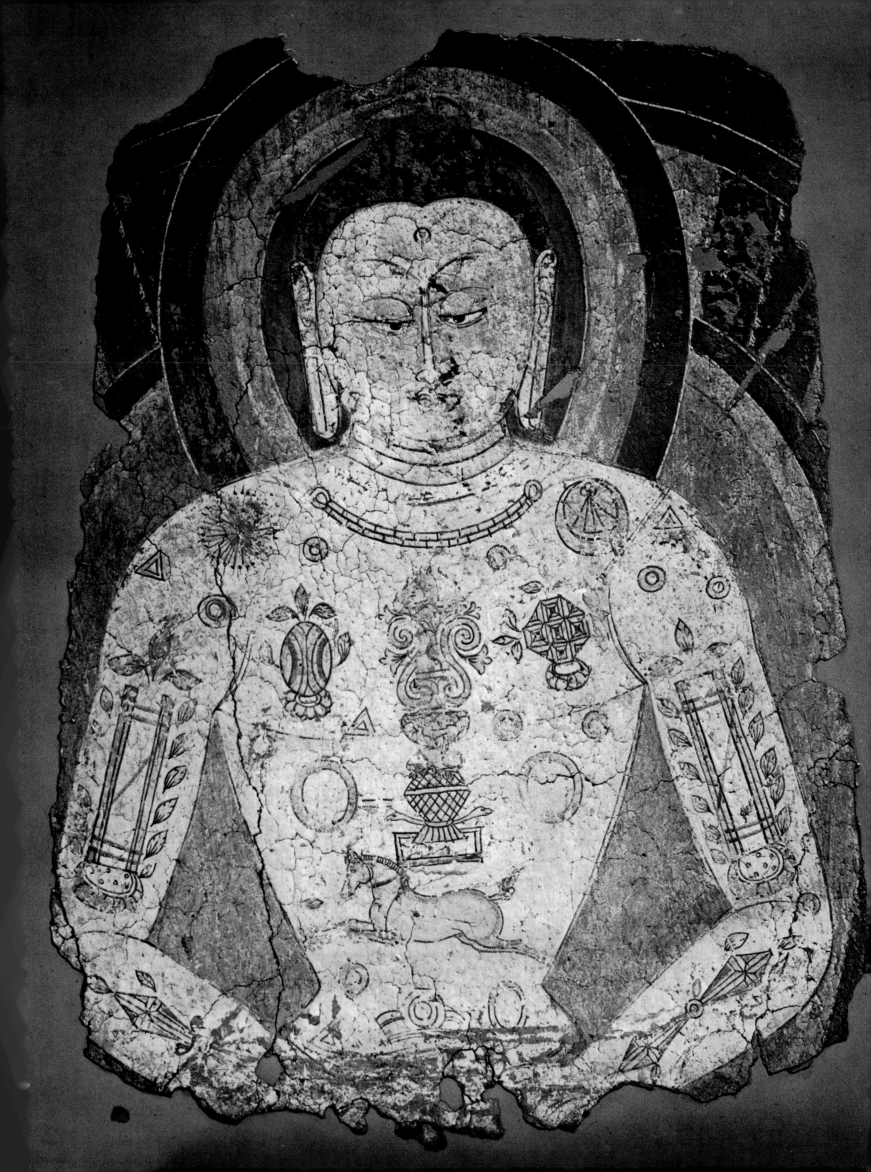

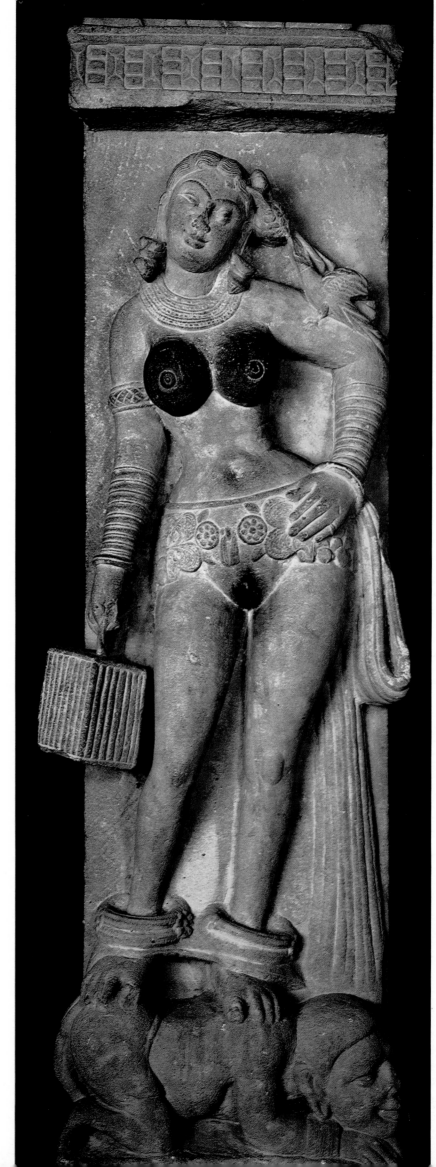

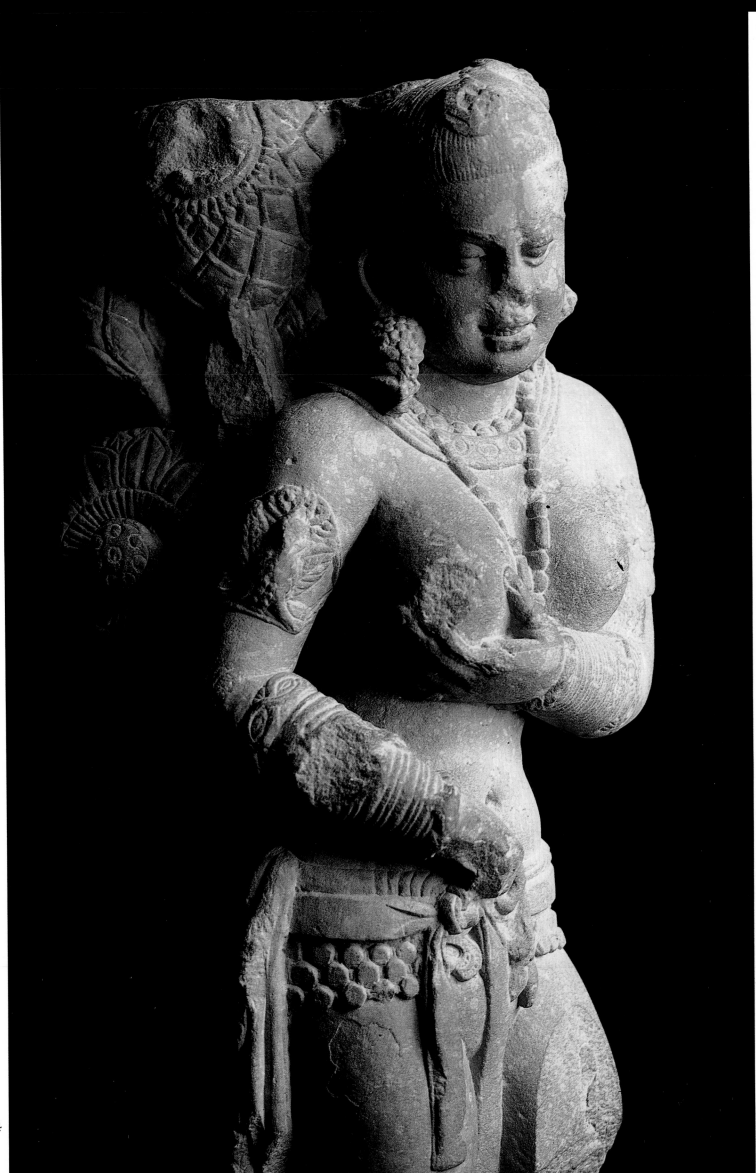

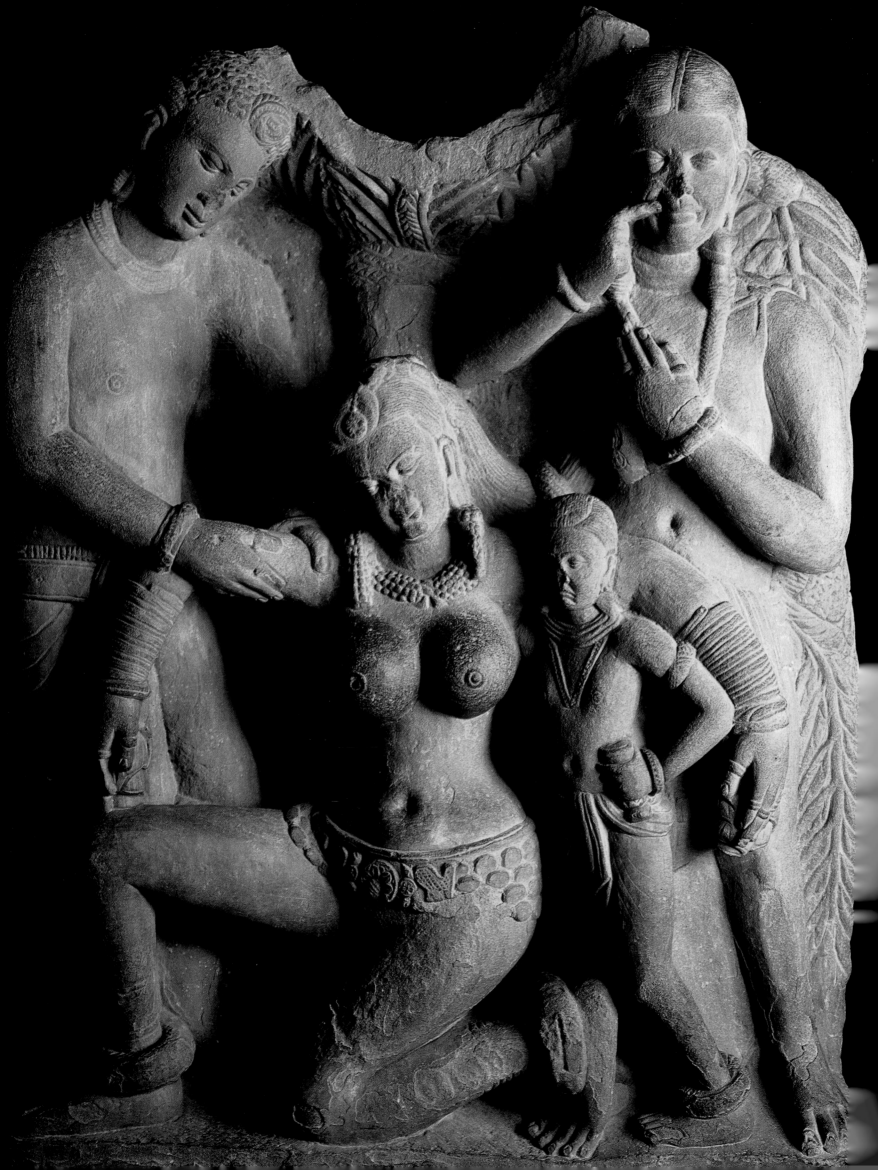

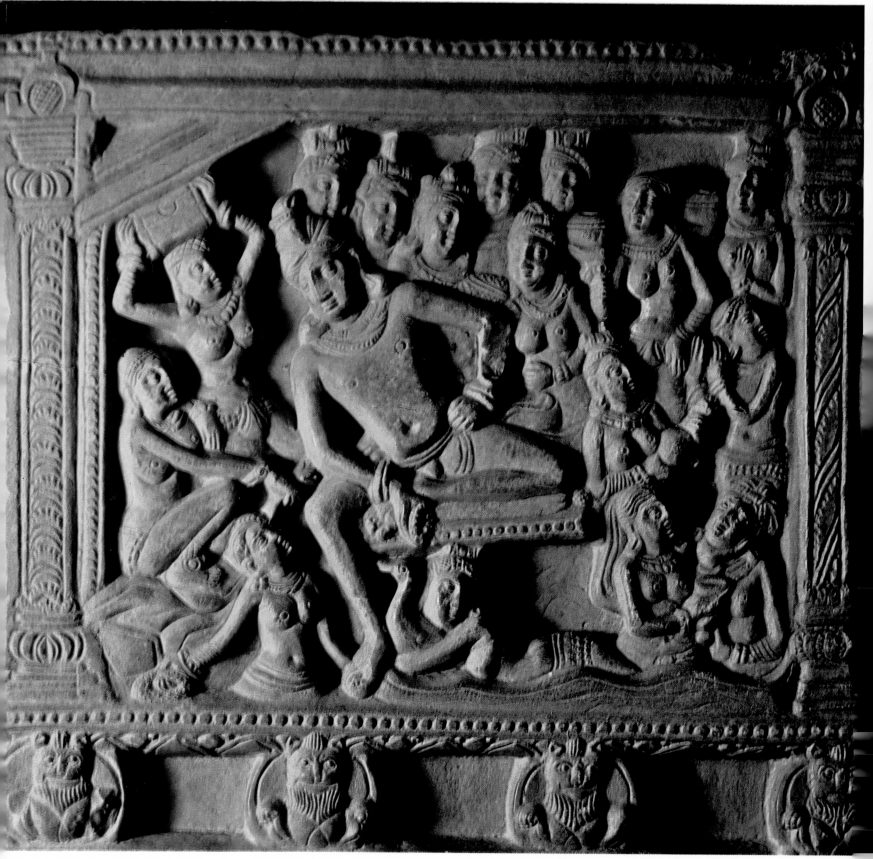

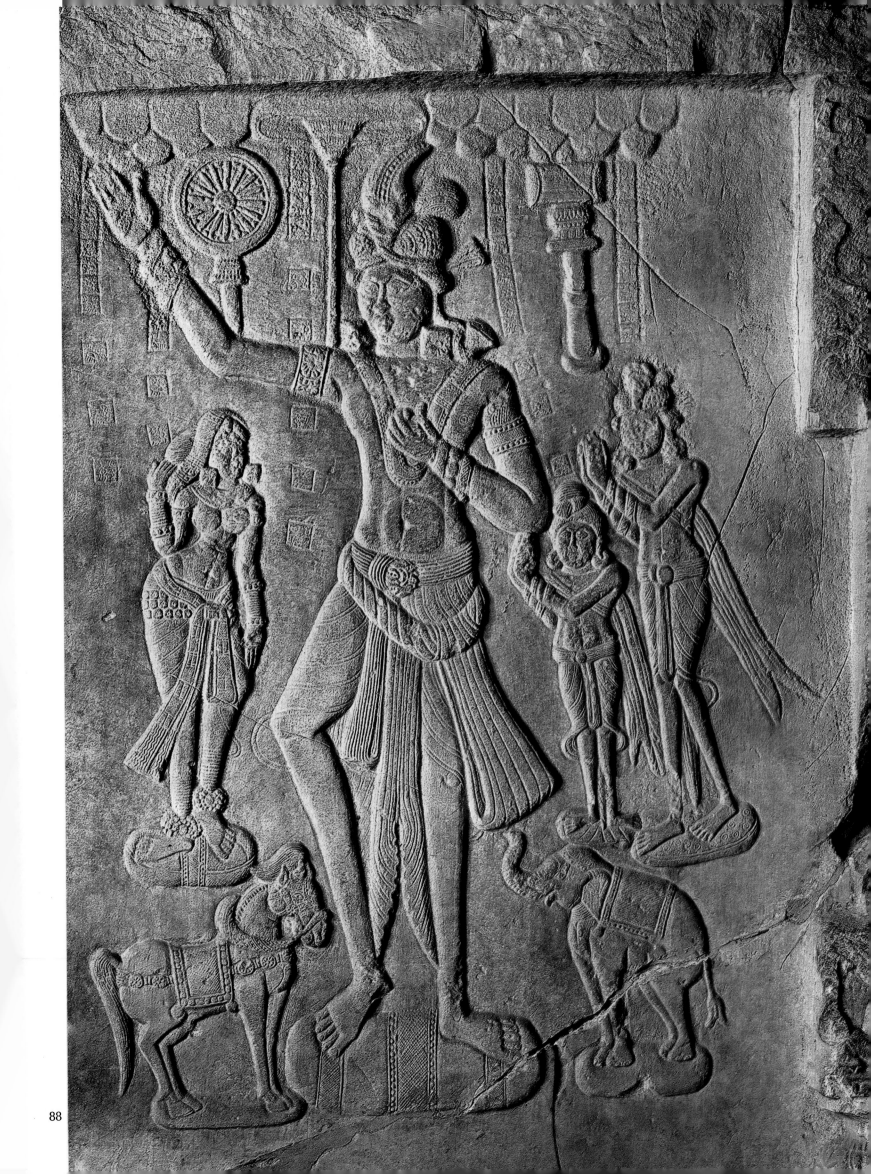

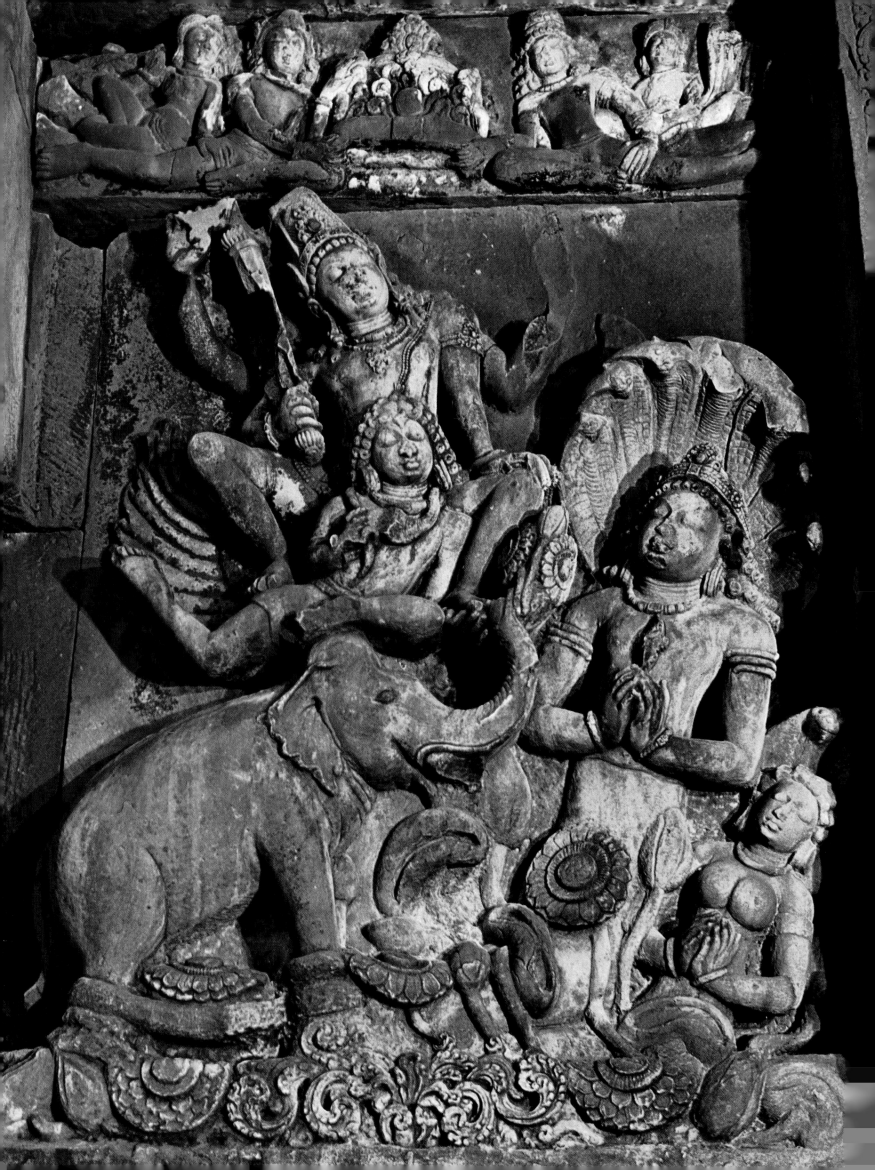

90. TRIVIKRAMA
 8th century
 Rajavalochana temple, Rajim

91. WOOD NYMPH
 From Gyaraspur
 Gurjara-Pratihara, 9th century
 Central Archaeological Museum, Gwalior

92. DANSEUSE
 Western Chalukya, 12th century
 National Museum of India, New Delhi

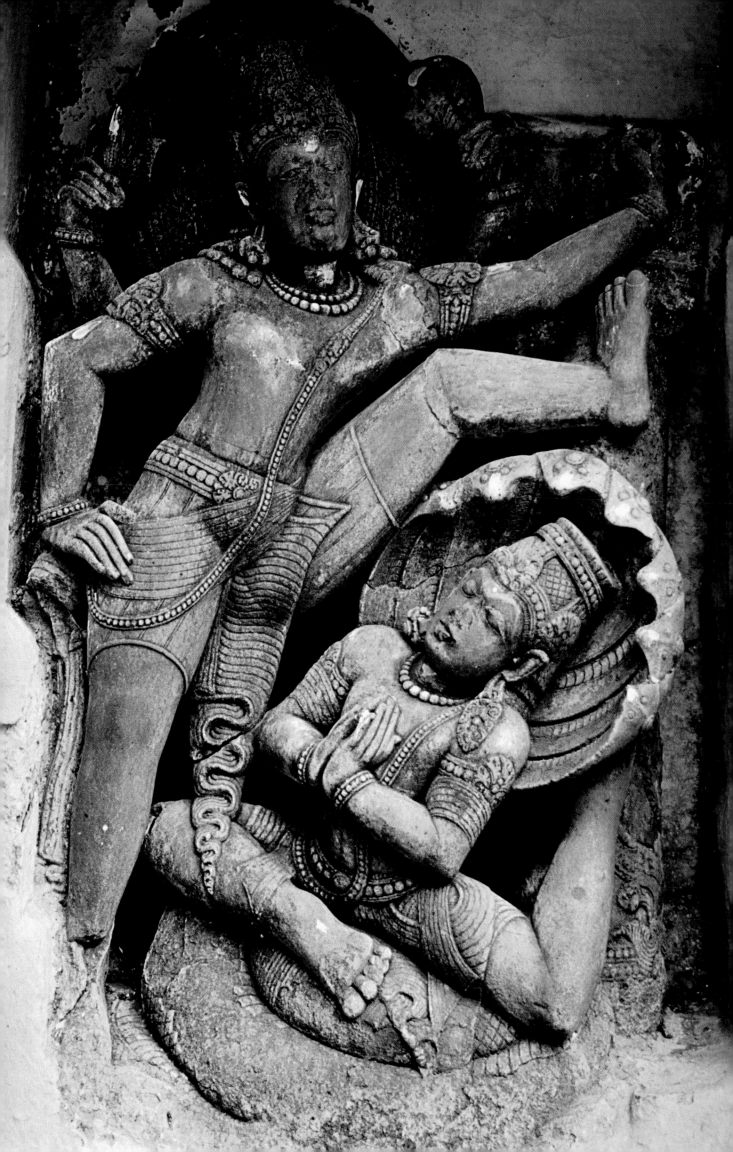

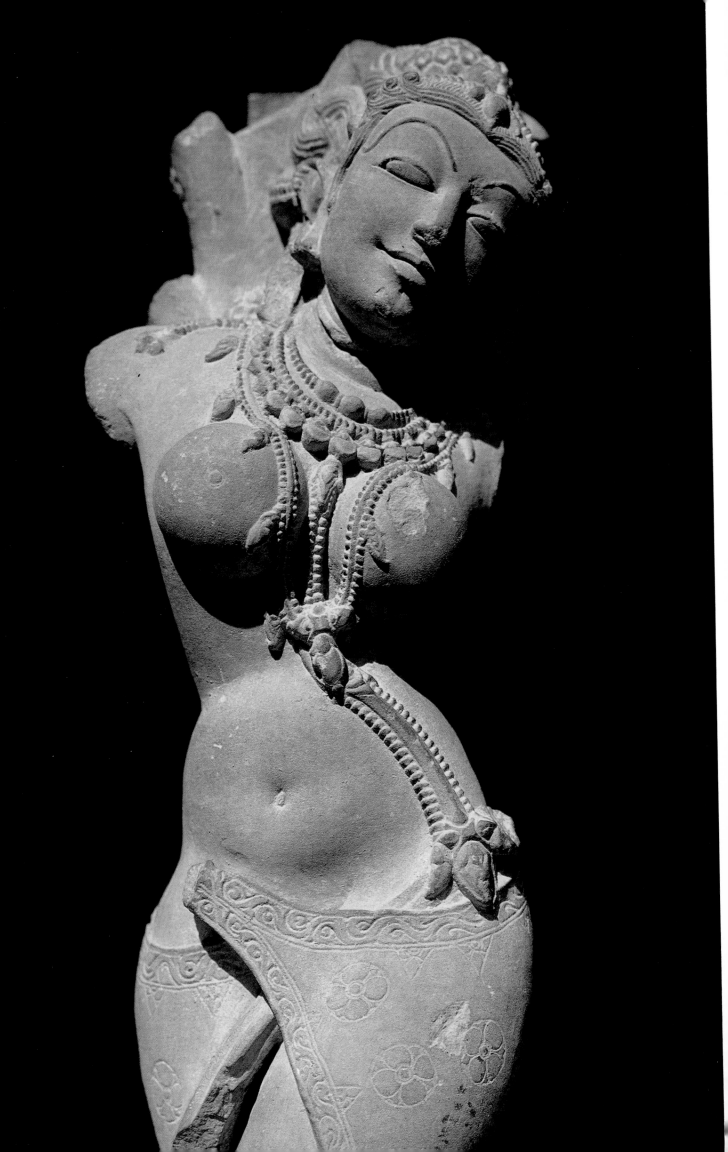

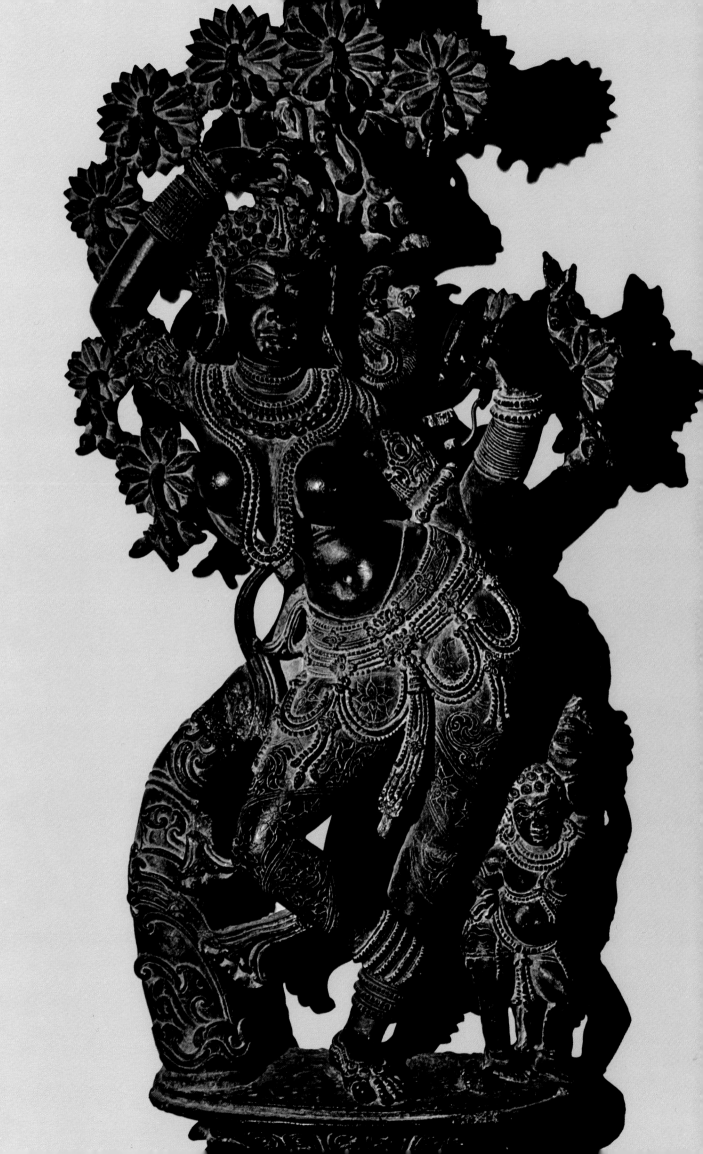

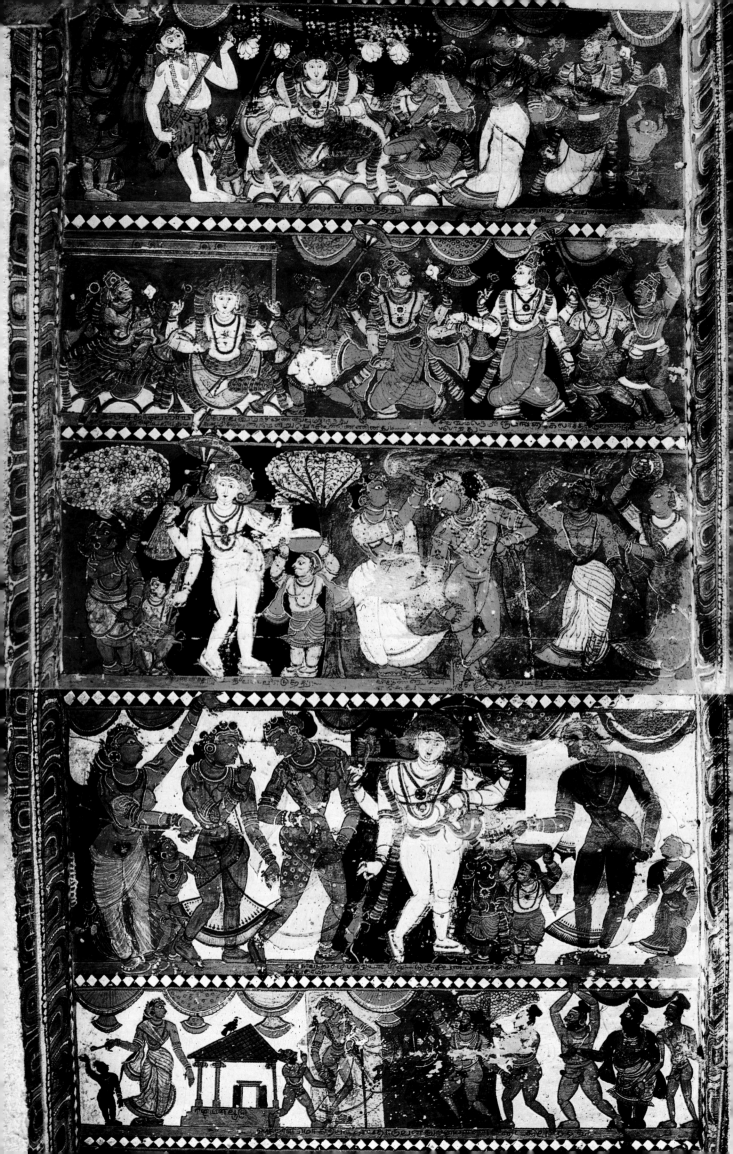

93. **BHIKSATANAMURTI AND MOHINI**
Ceiling painting. Nayak, 17th century
Nataraja temple, Chidambaram

THE EARLY DYNASTIES

MAURYA (320–185 B.C.)

fig. 94

figs. 398, 400, 320

fig. 401

Although the recorded history of ancient India begins well before the Christian Era, the earliest sculptural remains date from about the third century B.C. Thus our knowledge of the ancient workmanship of stonemasons, clay-modelers, and other craftsmen is limited. The chowrie-bearer from Didarganj, now in the Patna Museum, is a unique example of feminine grace conceived by a master sculptor who may have been a contemporary of the great Mauryan emperor Asoka. Fragments of two heads—one an aristocrat and the other a peasant—have been discovered at Sarnath. The male torso from Lohanipur is a marvel of carving; its excellent proportions and high polish are characteristic of Mauryan sculpture. The bull and the lion from Rampurva are crowning pieces of Asokan capitals, and like the quadruple lion from Sarnath, they have a mirrorlike polish which was achieved by techniques that are still incompletely understood. And although highly stylized, the carving from Sarnath has a certain rugged strength. The row of elephants on the facade of the Lomas Rishi cave at Barabar shows the sculptor's skill in composition. And at Dhauli the elephant emerging from the rock is so lifelike that the sculptor's mastery of naturalistic representation cannot be doubted.

fig. 399

The artist worked not only in stone, but also in more malleable materials. The terra-cotta head of the laughing boy from Patna, as well as the dancer with swirling skirts, illustrates the potter's dexterity.

SUNGA (185–72 B.C.)

fig. 321

fig. 78

The Mauryas were succeeded in the north by the Sungas and in the south by the Satavahanas. The masterwork of Sunga art is the embellished rail around the stupa at Bharhut. Though there is a certain primitiveness, excessive frontality, and conventionality in the treatment of figures by the Sunga craftsman, there is also a freshness, vivacity, and telling narrative skill in the representation of the Jatakas and scenes from the life of Buddha. There are also depictions of historical events like Ajatasatru visiting the Master and Anathapindada presenting the Jetavana garden with a monastery built in it. Buddha's descent at Sankisa by a triple ladder has its earliest representation here. (This work is also probably the earliest attempt at depicting a miracle.) The great and steep descent from heaven to earth is indicated in a naive manner—a foot is carved at the top of the ladder and another at the bottom.

Texts from the Jatakas and the Master's life are incised as legends which indicate the theme of the panels. For example, the panel showing the mansion of Indra, where the turban of Siddhartha was worshiped by the gods, has an explanatory legend. And there is mention by name of the famous celestial dancers Urvasi, Padmavati, and others and of the yakshas, yakshis, and nagas like Supavasa Yakshi, Chakravaka Naga, Sirama Devata, and Kubera Yaksha. The beliefs and rituals of the day—the worship of the tree sprites, nagas, and river gods and goddesses and of the celestials like Indra—are all tellingly expressed at Bharhut.

The representation of earlier Buddhas, such as Kakuchada and Visvabhu,

shows a highly developed iconography. Each, for example, is depicted with his own tree of knowledge. Some of the Jatakas represented offer a moral or a word of caution. Others stress the highest moral qualities. Thus, the *Miga Jataka* shows that even a deer can make a great sacrifice. The *Bhisa Jataka* emphasizes the supreme value of truth and sacrifice. The *Kukkutabidala Jataka* is the old folktale that tells of one animal trying to outwit another. Here the cock proves to be too clever for the cat.

Among the recently discovered Bharhut sculptures, which are now in the National Museum in New Delhi, there are many interesting pieces, including a medallion depicting the "division of the relics." This anticipates similar work at Amaravati three centuries later and is a most interesting representation of an important episode in Buddha's life. The musical scene is similar to the orchestra and dancers shown adoring Siddhartha's turban in a work in the Indian Museum.

fig. 404

Among the terra-cottas of the Sunga period, the most outstanding is a plaque from Kosam now in the Allahabad Museum. This piece illustrates an episode from Udayana's life—his elopement with the charming princess Vasavadatta, after he had outwitted the soldiers sent after them by her royal father. Another striking plaque illustrates the musical talent of Prince Naravahanadatta, the son of Udayana. According to the *Kathasaritsagara*, he played the vina as his consort danced in the palace gardens. In another work the lover strums the vina and tarries awhile, amusing himself with the soft strains of music while awaiting the belated arrival of his beloved. This episode echoes the praise of the vina in the *Mricchakatika*. Intensely imbued with vigor and strength is the terra-cotta from the Allahabad Museum that shows the mighty demon Ravana carrying away Sita.

One of the most striking compositions in terra-cotta is the large plaque in the Asutosh Museum in Calcutta that depicts a group of damsels. A well-known terra-cotta from Kosam shows a sophisticated company setting out for a picnic. These are examples of early Sunga art, and to this period must also be assigned the famous *kalpavṛkṣa* capital from Beshnagar which once ornamented a pillar in front of a temple of Sri Lakshmi or of Kubera. A figure from Beshnagar that represents Sri Lakshmi or more probably a yakshi is also an interesting early Sunga work. The highly polished yaksha from Patna probably antedates this work and may be from the Maurya-Sunga transition period. The large yaksha from Parkham, which is marred by its unsophisticated frontality, and the small stone relief from Bhita, which shows a prince washing the feet of his beloved, are other examples of the early phase of Sunga art. The later phase is illustrated by interesting works from Bodh Gaya which depict the presentation of Jetavana, Surya in a chariot drawn by four horses, and a lover helping his beloved climb a tree.

figs. 406, 408

fig. 360

SATAVAHANA (Second Century B.C.–Second Century A.D.)

The Satavahanas who are also known as the Andhras had a vast empire in the Deccan that reached from sea to sea, and they had the resources to create monuments that still amaze connoisseurs of art. Among their works are the Sanchi stupa with its marvelous torans, rock-cut temples in western India, and monuments, including a stupa, near Amaravati, the eastern capital in the Kistna Valley.

The earliest phase of Satavahana art is seen in the panels at Bhaja. Here the sun-god drives his chariot and crushes darkness, which is depicted as a huge ogre,

fig. 396

fig. 57 beneath his vehicle. Seated on his celestial elephant, Indra rides about his delightful garden of paradise, which abounds in *kalpavṛkṣas*. Indeed, in spite of their primitive features, these panels are perhaps the most lively masterpieces of Satavahana art.

The Jaggayyapeta panels from the eastern region of the Satavahana empire also have a beguiling liveliness. Here the emperor Mandhata is seen with his hand slightly raised, invoking a shower of gold to benefit his subjects.

fig. 99 From Pitalkhora cave comes a dwarf yaksha of great interest. An inscription on the figure's hand gives the name of its sculptor, the goldsmith Kanhadasa. This noble sculpture is enhanced by his jeweler's skill, especially in the detail and finish he has lavished on it. Another work from Pitalkhora shows a prince with his consorts and attendants seated on a couch with soft woolen coverlets. This evokes the wealth and splendor of the royal harem so graphically described in the *Sundarakanda* of Valmiki.

figs. 2, 96, 190, 409–15 The one early freestanding monument of the Satavahanas that remains in almost original condition is the Sanchi stupa with its beautiful torans. The lotus-laden pools and streams of the heavenly garden are beautifully depicted. Here the celestial couples carouse all day long, and on moonlit nights their loving faces are reflected in the cups of perfumed mead they raise to their lips. There is no more picturesque representation of the War of the Relics than that on the south gate at Sanchi. The story of Prince Vessantara is shown in detail, and the poignant tale of the White Elephant, Chhaddanta, is well represented on this south gate. The wisdom of the elephant is evident from the adoration of the bodhi tree by a group of animals.

The colossal wickedness of Mara is indicated by his impressive stature on the northern gateway at Sanchi. The adoration of Buddha by all animals is seen in the monkey's offering of honey to him at Vaisali. The earliest representation of this episode is that carved on the northern gate. An orchestra and a dance group, which adore the turban of Siddhartha in heaven and worship the stupa on earth, are also graphically portrayed on this northern toran. And the pillar-bracket carving at Karli is equaled only by the wonderful *sālabhañjikās* on the eastern and northern gateways at Sanchi. The ivory-carvers of Vidisa who executed the eastern gateway were adept in different mediums. Their touch was as facile in stone as in the softer medium of ivory.

The glory of later Satavahana architecture is clearly seen in the cave facades of western India at Karli, Kanheri, Bedsa, and Nasik. At Nasik huge figures of dwarfs support the structure on their powerful shoulders. This brings to mind the titanic, bejeweled night-prowlers who support Ravana's palace—*vahanti yam kuṇḍala-śobhitānanā mahāśanā vyomacharā niśācharāḥ* (*Rāmāyaṇa*, VI). The donor couples at Kanheri are among the best examples of Satavahana portrait sculptures.

Satavahana work in the malleable medium of clay is best seen in the magnificent series of human and animal figures unearthed during excavations at Kondapur in Andhra Pradesh. The only surviving paintings of the second century B.C. are those from Caves 9 and 10 at Ajanta. Here the *Chhaddanta Jataka* is elaborately and touchingly depicted. The grandeur of the elephant surrounded by a vast following, with his abode under the large banyan tree near the lotus-laden pool, is contrasted with the wickedness of the hunter and the remorse of the dying queen who demanded the tusks of the elephant.

The Kshatrapas who ruled in western India constructed several early cave temples like those of their contemporaries, the Satavahanas. The facade of the cave at Khambalidha has a wealth of detail; these carvings, which date from the second

century A.D., represent the earliest phase of art in Gujarat and are the only known examples of Kshatrapa art.

KHANDGIRI

The early phase in eastern Indian art is seen in the Ananta and Ganesha sanctuaries in the Udayagiri cave at Khandgiri (Orissa). The Cheta dynasty attained its greatest glory under Kharavela, whose inscription at Khandgiri is a historical landmark. The frieze on the veranda illustrates various stories, including that of Prince Udayana, who was a favorite personage in Brahmanic, Buddhist, and Jain lore. The pillar bracket in the Ganesha sanctuary shows a nymph whose curved body echoes the contour of the bracket. This recalls similar carving of the earliest date at Mathura and elsewhere.

The cow elephant offering her mate soft lotus stalks expresses the loving care described by Kalidasa in his *Raghuvamsa*. A frieze in the Rani sanctuary depicts a scene of music and dance. Even such details as the makara decoration on the flute are lovingly represented by the sculptor. The row of elephants on a lintel at Khandgiri certainly recalls the facade of the Lomas Rishi cave.

fig. 416

SCHOOL OF AMARAVATI

The first and second centuries A.D. saw the finest flowering of Kushan art in the north and Satavahana art in the Deccan. The railing around the Amaravati stupa, which dates from about 150 A.D., was built under the direction of Nagarjuna, the great Buddhist teacher and a close friend of the Satavahana sovereigns. This imposing railing is lavishly embellished and is known for the magnificent medallions and panels on its crossbars, copings, and uprights.

The great collections in the Madras Museum and in the British Museum are rich storehouses of the most glorious artifacts of the Satavahana civilization. There are important narrative representations of Jatakas and scenes from the life of Buddha that are nowhere else depicted. It has proved valuable to compare these works with contemporary Sanskrit and Prakrit texts. And these sculptures are sometimes the only evidence of early texts that, although now lost, were preserved in medieval literary works such as the *Avadanakalpalata* of Kshemendra and the *Jatakamala* of Aryasura. Though Bharhut, Ajanta, and Sanchi are rich in narrative works, only at Amaravati is there a marked originality in the choice of theme. One example is the representation of the story of Sumana, Udayana, Samavati, and Padumakumara. Another episode is based on an early text of the *Sibi Jataka*, which is now lost but was preserved in the medieval text of Kshemendra.

figs. 97, 98, 322–24, 364–67, 417–23, 425

figs. 367, 420

The carvings from Amaravati offer excellent examples of aesthetic principles. The synoptic method is observed in many panels (for example, in that portraying the subjugation of Nalagiri) and in the medallion illustrating the *Chhaddanta Jataka*. The glory of Nagaloka is suggested by the richness of the throne on which the reliquary is placed for worship. The composition of the elephants adoring a stupa is clearly indicative of the decorative skill of the sculptor. Symbolic representation is best seen in the work depicting the departure of Siddhartha. Here the prince himself is not shown; the umbrella held over his steed indicates his presence. The snake charmer and the monkey in the *Champeya Jataka* are enhanced by skillful naturalistic detail.

A medallion, now in the British Museum, depicts Buddha's visit to his wife, Yasodhara. Full of pathos, this piece shows the child Rahula at one side, "with milk still on his neck" and his toys around him, and Yasodhara, the delicate youthful princess, unaccustomed to asceticism—in contrast to the haloed figure of the great monk, whose only wealth is the supreme knowledge that he freely gives as a patrimony to his beloved only child.

The miniature bronze of an elephant with royal riders in the Kolhapur Museum is perhaps the most outstanding example of metalwork from this period. Other well-known pieces include the fragments of hands and legs from Buddham and other places, now in the British Museum, and the almost complete Buddhas in the Madras Museum. The latter, however, were probably created later than the third century A.D., although they are in the early Amaravati style. This style was continued by the Ikshvakus in the Kistna Valley. Ikshvaku sculpture has been recovered from *fig. 426* other sites in the vicinity. At Goli, for example, the story of Prince Vessantara is narrated in pleasing detail.

NAGARJUNAKONDA

Nagarjunakonda has yielded excellent examples of later Amaravati art. Kapphina's visit, which is represented at Nagarjunakonda, is as interesting as Ajatasatru's *fig. 424* visit, depicted at Amaravati and Bharhut. (Ajatasatru's visit is also represented here.) *Sasa Jataka* is a particular favorite here and is used to emphasize self-sacrifice as the highest moral quality. The numerous *mithuna* figures at Nagarjunakonda are outstanding examples of this form, particularly the one in which the lover gazes at his beloved's reflection in a mirror.

The poignancy of Buddha's visit to Yasodhara is well expressed in the long frieze from Nagarjunakonda. And the earlier painting in Cave 10 at Ajanta certainly inspired the representation here of the queen fainting at the sight of the tusks of Chhaddanta.

KUSHAN (First–Third Centuries A.D.)

Contemporaries of the Satavahanas, the Kushans had a vast empire bordering on Central Asia in the north and extending eastward far beyond Mathura. An indigenous Kushan art existed in the Mathura area; it was, however, totally different from the Kushan art of Gandhara, which was strongly influenced by foreign traditions, including those of Greece and Bactria.

The Kushan art of the Mathura school, which was a continuation of the indigenous Sunga tradition, developed great aesthetic maturity and charm. The Bhutesar yakshis, which are now in the Mathura Museum and the Indian Museum, have a perfection that arrests attention; the sculptor's careful study from life is seen *figs. 83, 430* in his dextrous modeling of body contours and arrangement of drapery. The earliest figures—the seated Surya, the Matrikas, and the two-armed Ganesha with a natural elephant head—show the beginnings of the complex iconography of the Kushan *figs. 30, 372* period. The yakshi in the Mathura Museum, who is shown carrying a platter and pitcher, has a counterpart in the Bharat Kala Bhavan Museum. Such motifs as *dohada*, *figs. 191, 431* the mother-and-child, and *toranasalabhañjika* are among secular themes that were judiciously chosen and strikingly presented. The architrave that depicts the adoration

of Buddha in a symbolic manner shows a common spirit at Mathura and at Amaravati; both schools represent the Master in symbolic and human forms. Some foreign motifs are depicted—for example, Herakles with the Nemean lion and the drinking bout of Bacchus.

fig. 434

The sculptor's iconographic repertoire is evident in the monolithic bodhisattvas (whose inscription states that they were gifts of Friar Bala), the Parsvanatha in the Lucknow Museum, the Katra Buddha with its unusual single dextral curl, the frieze depicting Harinaigamesa of Jain legend, and the votive plaques showing Arya Bhagavati, and Tirthankara with the Eight Auspicious Signs. Iconographic details can be noted in such images as Varaha with the wheel in both hands. Vishnu with a mace taller than himself, Ekamukhalinga with the third eye horizontally on the forehead, and Mahishamardini throwing her weight on the buffalo to destroy it. The head of the Ardhanarisvara is important in the study of early Kushan iconography; the crown and earrings are details that are especially noteworthy. The frequent representation of the Jatakas demonstrates the immense popularity of these legends.

figs. 435, 252

The high regard for the preceptor in ancient India is clear in the medallion that shows the teacher shaded by an umbrella. This reverence is also seen in the relic box of Kanishka, the greatest Kushan ruler, from Shah-ji-ki-Dheri.

GANDHARA

The Gandhara sculptor was unexcelled in his skill at representing the human form. Almost unique to Gandhara art is the ascetic Buddha, emaciated and skeleton-like. Perfection of beauty is seen in the Maitreya from Sahri Bahlol and in Sakra's visit to Buddha from Mamani Dheri. The narrative flair of the sculptor is seen in such panels as Buddha and the barking dog at Sravasti, Devadatta's assassins attacking Buddha, Siddhartha riding to school in a ram cart, and Sumedha bowing at the feet of Dipankara Buddha. The two small friezes showing Nanda meeting Buddha, with Sundari at her toilet in the background, are studies in poignancy. The state of agony is impressively presented in the stucco head from Gandhara now in the National Museum.

fig. 441

fig. 445

The Gandhara sculptor also excelled in miniature work; his skill is evident in several beautiful circular toilet trays that have survived. The exquisitely wrought stuccos, both colossal and small, illustrate the continuity of tradition in the region; some of the finest have been found at Hadda and at Taxila. In the Gupta period these inspired terra-cotta and stucco works from as far away as Kashmir.

There have been occasional finds of images in pure Gandhara style in the Mathura region. And ivories closely resembling Kushan sculpture have been discovered at Bagram in the Gandhara region. The Kushan kings were liberal in their thought, appreciated all forms of art throughout their vast empire, and probably commissioned not only their own artists, but also the carvers of Vidisa to fashion the series of magnificent ivories that were unearthed at Begram and now enrich the Kabul Museum and the Musée Guimet. Not a trace of Greek influence can be noticed in either the themes or style of these pieces, and the gateways represented on them are very much like those known from Bharhut, Sanchi, and Amaravati. It is in this context of indigenous Indian art that the ivory from Pompeii, which is undoubtedly Kushan, has to be understood and interpreted.

fig. 103

fig. 102

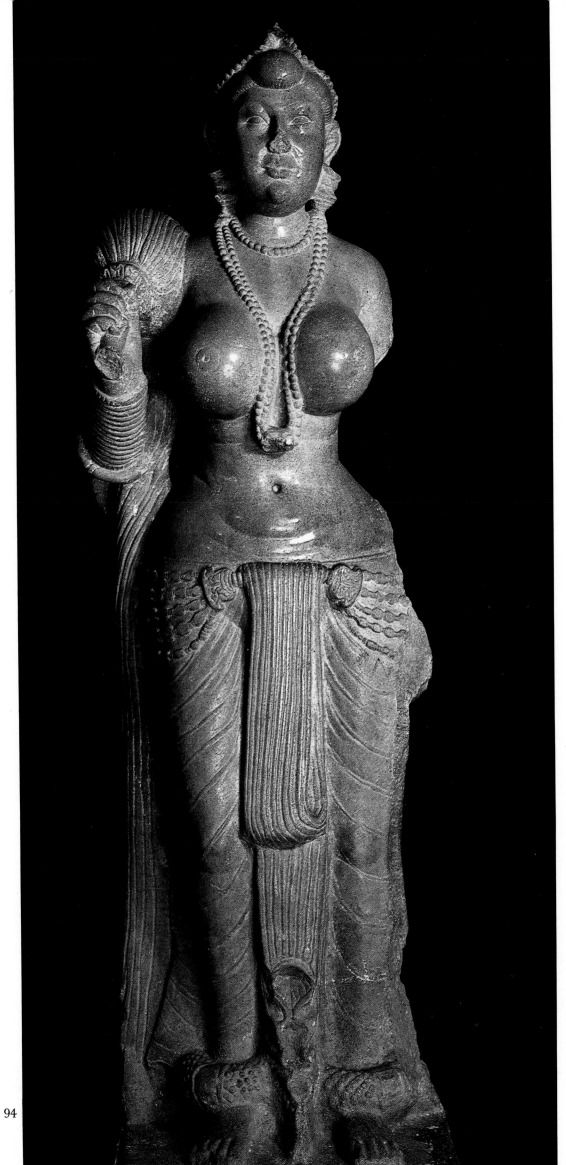

94

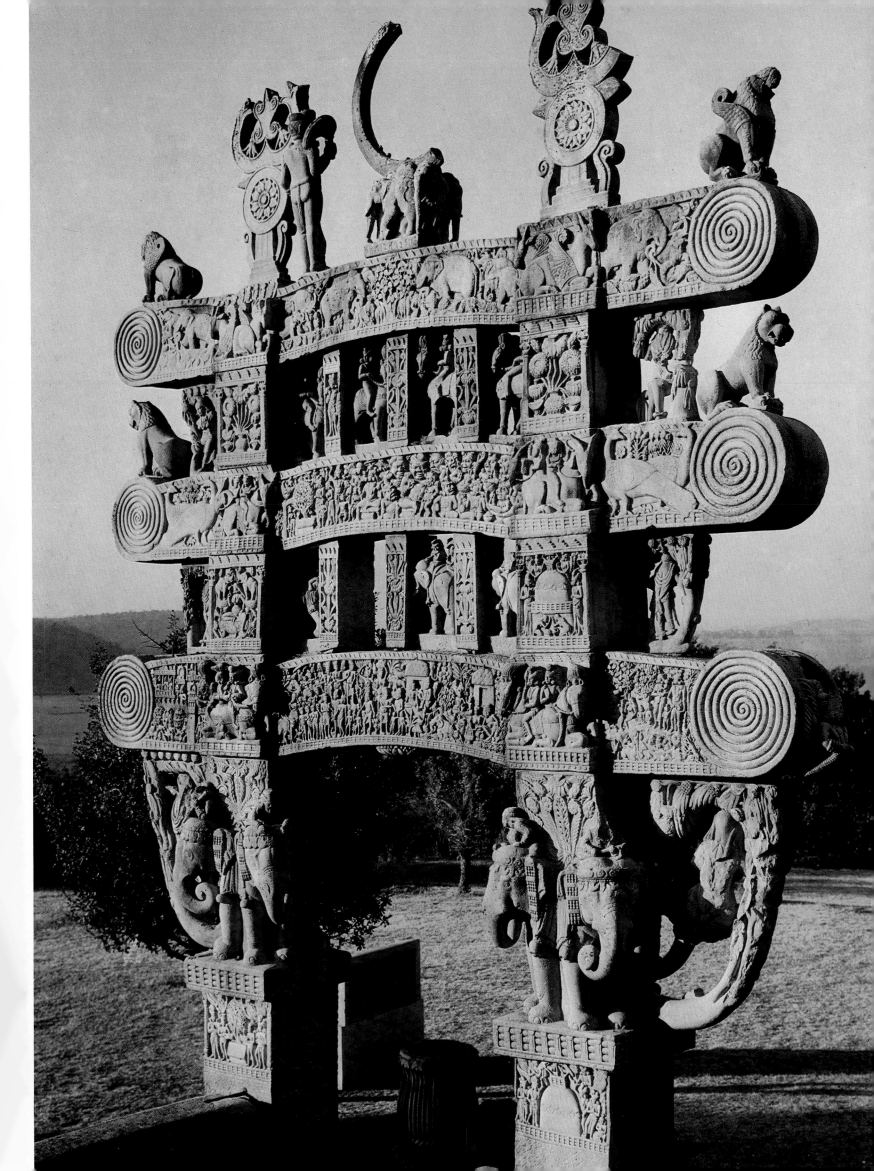

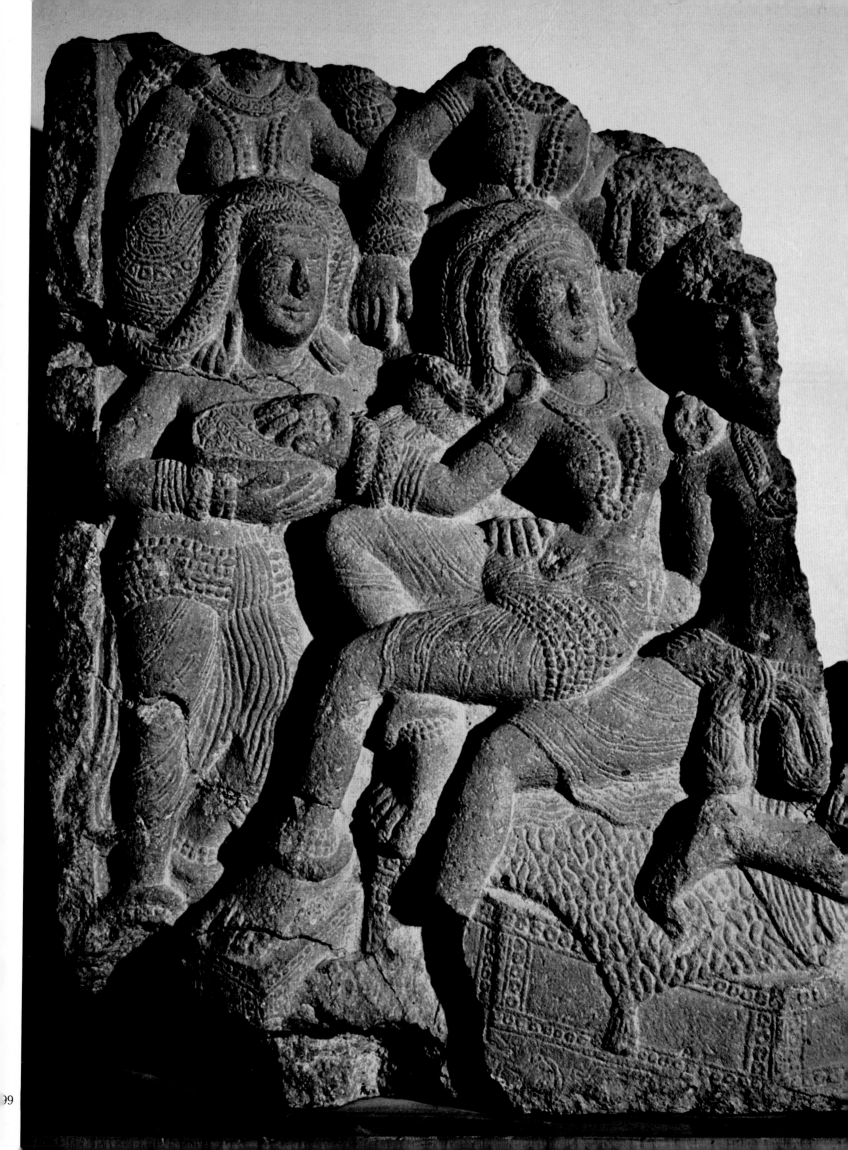

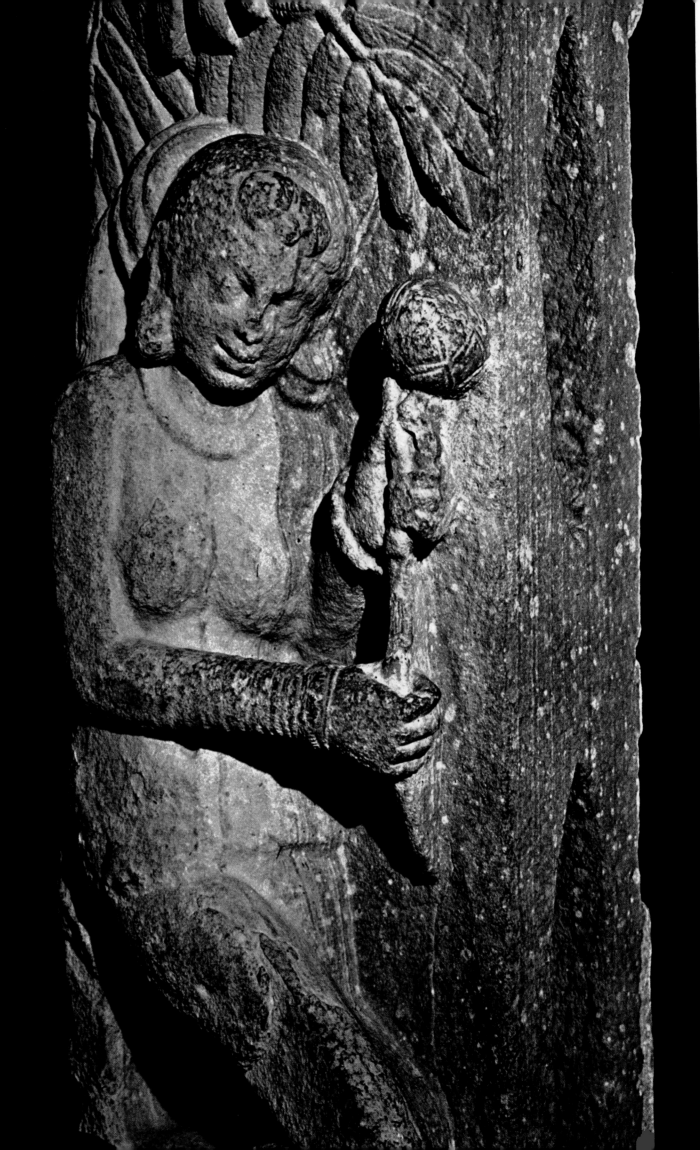

102

103

THE RICH MATURITY

GUPTA ART (Fourth–Sixth Centuries)

Guided by old traditions, the Guptas in the north and the Vakatakas in the south continued to excavate cave temples out of solid rock as well as to raise structural ones. The remains from this period provide us with a record of the stylistic development of the temple form and its decoration. One of the earliest Gupta caves is that at Udayagiri near Beshnagar. It has the typical doorway of the period, a lintel decorated not merely with the figure of Lakshmi, but with the whole story of her origin—the Churning of the Ocean to extract the elixir of immortality. A row of demons and celestials tug at the serpent god who entwines Mount Mandara, which is the stirrer of the milky ocean.

The simple Gupta temples at Tigawa and at Sanchi are early structures; they consist of a sanctum and a mandapa. Then came the excellent temples of medium size such as the ones at Nachna and Bhumara. And finally large elaborate temples were built—as seen at Deogarh in stone and at Bhitargaon and Ahichhatra in terra-cotta.

The temple at Deogarh is rightly one of the most famous in India. Much of the sculpture here has been lost, but from the remaining relief panels on the plinth, one can get an idea of what it once must have been. The three large reliefs on the sides of the main vimana and the elaborately carved doorway, flanked by Ganga and Yamuna, indicate the selectivity and restraint of the sculptor. Rather than attempting a confusingly large number of incidents, he was content with just three. The Seshasayi Vishnu here is the most perfect version of the theme, and the Gajendramokshada and the Naranarayana are also excellent. Other outstanding panels at Deogarh include Ahalya freed from a curse, Devaki giving baby Krishna to Vasudeva to be transported to Gokula, and the punishment of Surpanakha. The flying Vidyadharas from Gwalior, now in the National Museum, are a Gupta sculptural group of great charm. Other panels of this type, such as the monkeys laying the bridge over the sea (now in the Bharat Kala Bhavan) and the council of war between Rama and the monkeys (in the Ramban Museum in central India), are excellent examples of Gupta workmanship.

figs. 1, 89, 104, 332, 446, 448

fig. 453

The wealth and range of Gupta sculpture is amazing. At Beshnagar one finds some of the earliest forms, such as the standing Vishnu flanked by personified weapons, the two-armed seated Ganesha bereft of a crown, and the spirited multiarmed Mahishamardini Durga slaying the buffalo demon. These are all important for an understanding of early Gupta iconography, but the most inspiring and imposing sculptural group here is the monumental one in which Varaha raises Prithvi from the ocean. Varaha's foot rests on the snake god, as myriads of gods and sages adore him; Samudraraja and the personified Nadidevatas are shown against ripples of the sea and coursing streams.

The bust of Vishnu from Mathura, now in the National Museum, is an almost exact replica of the large recumbent figure in the Seshasayi panel from Deogarh. The Avalokitesvara from Sarnath, with its half-closed eyes and its delicate coiffure with a few trailing locks on the shoulders, is charming. Krishna as Govardhanadhari in monumen-

fig. 447

tal glory is the pride of the Bharat Kala Bhavan. Although a smaller piece, the Ganga from Beshnagar, now in the Boston Museum, is a delightful work. An extremely interesting depiction of royal childbirth—the nativity of Krishna—is seen in the Gwalior Museum. The preaching Buddha from Sarnath is shown with fingers delicately entwined, suggesting the first turning of the Wheel of Law; the eyelids droop gracefully, the eyes are directed at the tip of the nose, and the legs are tucked up in the lotus position. This is a rare and charming Gupta masterpiece and is iconographically important because of the webbed fingers, the cranial bump, decorated halo, and several other peculiar characteristics. The pillar from Rajouna has a splendid narration of two important themes from the epics: Arjuna fighting Shiva before he obtained the Pasupata weapon; and Shiva receiving Ganga, who approaches bashfully and bridelike on her crocodile, on the locks of his hair.

figs. 374, 6

figs. 333, 334, 375

Preserved in the Bharat Kala Bhavan is a sculpture of Chandragupta Kumaradevi that is closely connected with the king-and-queen theme on Gupta coins. Of the utmost importance is the lion capital of a Gupta pillar, where the personified zodiacal signs are seen all in a row but facing the different quarters. The best representation of the wish-fulfilling creeper in Gupta sculpture is seen at Garhwal, and the Seven Mothers (already represented in Kushan sculpture and usually worshiped in households) are seen in wonderful large-scale examples, each one with a child on the lap, in the Gwalior Museum. The four-faced Shiva at Nachna is excelled by the exquisite Ekamukhalinga from Khoh in the Allahabad Museum.

figs. 43–50, 460

The Trivikrama panel from Pawaya that is now in the Gwalior Museum is a fragment, but one can tell from this small piece that the intact original was an exceedingly lovely carving. Even the fragment has carving on both sides depicting scenes of ritual sacrifices. The post for tethering the sacrificial horse, the assemblage of priests, and the rest of the visitors (including women viewing the scene from the balcony) are all graphically represented. Both religious and secular music and dance had a place in the sacrificial hall. Here the music-and-dance scene, showing the four instruments played by women and a gracefully gyrating danseuse, is typical of a sacrifice in ancient India. On the opposite side is the imposing figure of Trivikrama.

The dance scene on a lintel in the Sarnath Museum in another important carving. The dancer is dressed in a long tunic and tight trousers, as is a similar figure at Deogarh and another in the painting from the *Mahajanaka Jataka* at Ajanta. This costume for dancers is usual during this period. In the Indian Museum the miniature carving from Sarnath of the Vidyadhara couple is the most graceful of its kind; although simple, it has tremendous movement, and great emotion is evident in the faces.

fig. 480

The now-abandoned temple at Bhumara once housed a variety of typical early Gupta work—dwarf demigods that disport themselves in a variety of frolicsome attitudes; figures of Indra, Surya, and other deities placed in chaitya arches; door guardians with wiglike hair; and a Ganesha with a long garland of bells.

The panels from Ahichhatra are testimony to the craftsman's ability to work in terra-cotta in a large format. Their wide range of subject matter, exquisite composition, and enormous size make them worthy of the huge temple. The subjects include Dakshinamurti at Ahichhatra; Yuddhishthira and Jayadratha fighting; Vikrama carried off by Urvasi in the form of a centaur; and the whole row of scenes of the destruction of Daksha's sacrifice by the dwarfs of Shiva. There are also some fragments

figs. 33, 58

from a group of the Seven Mothers—a horrifyingly realistic torso of Chamunda (the emaciated form) is a remarkable example, and the others reveal an interesting mode of feminine apparel, a tight or a loose bodice covering the breasts with an upper garment over it. A famous feminine braid found at Ahichhatra has a circular crest on it that resembles the makara decoration from an earlier phase found at Nagarjunakonda and Amaravati.

fig. 263

The terra-cotta Ganga and Yamuna, which served as doorkeepers at Ahichhatra, are the largest terra-cotta figures yet found from this early period. Large terra-cotta relief panels were also found at Bhitargaon; these include the simple but effective Vishnu reclining on Seshanaga, the Ganesha crawling along in search of sweets, and the destruction of Madhu and Kaitabha. Any discussion of Gupta terra-cotta work must mention the nagini and Vishnu from Rajgir, the chubby faces from Akhnoor in Jammu (from the late phase of this period), the elegant vina player from Rupar, and the carved bricks from Karavan (now in the Pratap Singh Museum in Srinagar) that show the peculiar delicate attenuated style of the late Gupta period.

Gupta metalwork is probably best seen in the famous Buddha of the Boman Behran Collection and in the Brahma from Mirpur Khas in Sind and now in the Karachi Museum. The latter has four heads and a single pair of arms—early characteristics observed in stone at Deogarh and elsewhere. The Akota hoard, which is a valuable collection in the Baroda Museum, contains some early examples in metal, among which the Parsvanatha, Jina with attendants, and the chowrie-bearer are striking. The Jivantaswami, another bronze in the Akota Hoard, is almost as important as the crowned Buddha in Buddhist art.

fig. 106

The huge late-Gupta Buddha in the Birmingham Museum is a striking example. One might wonder that a metal figure of such size could be made at that early date, but it must be remembered that the famous iron pillar at Mehrauli was forged a couple of centuries earlier.

fig. 107

A Gupta figure with strong Gandhara elements is the famous Vishnu with personified weapons from the Gandhara area now in the West Berlin Museum of Indian Art.

A remarkable ivory in the Prince of Wales Museum depicts meditating Buddha attended by several yakshas and the Chaturmaharajikas (the four guardians of the quarters—Dhataratta, Virulhaka, Virupakkha, and Vessavana). The serene Master, with his meticulously arranged robe and his prominent *ushniṣa* and curl of hair between his eyebrows, is in contrast to the figures of the attendants who have dreamy eyes and grins. The entire group carved is modeled in a most elegant manner and appears to be made of malleable material. Equal to this is the Maradharshana carving in the collection of Gopi Krishna Kanoria. It is a scene of malignant fury as the hosts accompanying Mara try to distract the attention of the Master who is determined not to be disturbed.

Another lovely ivory Buddha of the same period, now in the Prince of Wales Museum, is the very personification of humility to whom all the attention of Lokesvara is turned. The arrangements of the locks of hair descending on Lokesvara's shoulder, the downward look, the smile on the face, the delicacy of the fingers, the long garland, and the arrangement of the lower garment and the decorative ornaments—all are characterized by utmost delicacy.

Remnants of Gupta paintings are very scarce, but the paintings of dancers from the Bagh cave are among the most valuable in assessing the Gupta painter. There are also other paintings in these caves of princesses riding on an elephant and of a prince in a long procession.

The Maitrakas, who were feudatories of the Guptas in Gujarat, made some of the most delightful sculptures of this period. There is a mother and child from Sama- *fig. 459* laji in the National Museum and similar and more complete examples in the museum at Baroda. The Skandamata from Mahodi—a delightful rendering of Parvati fondling the child on the shoulder of her maid—is most felicitous. Other notable works are the youthful mother Kaumari and the Haragauri standing against the bull (both in the Baroda Museum) and the Shiva with the bull in the Prince of Wales Museum.

VAKATAKA ART (Third–Sixth Centuries)

The Vakatakas, who ruled the Deccan as the contemporaries of the Guptas and were matrimonially related to them, were great patrons of art and literature. Most of the caves at Ajanta, the earlier ones at Ellora, the Elephanta caves, and several others are Vakataka works. These cave temples were usually built either as apsidal chaityas, with long rows of pillars forming the aisles and hall with a stupa at the end of the apse, or as viharas containing cells for monks. And there is a definite sequence in the evolution of each stylistic motif and every structural part—the pillars, capitals, *kūḍu* arches, and so forth—of these temples. At every stage and in every part of these structures, the Vakataka sculptor excelled. The porch and its pillars, the walls and the large arch of window above, forming the facade of Cave 19, is one of the most attractive in Ajanta. Here, the large panel of Nagaraja and queen with chowrie-bearer is a masterpiece of Vakataka sculpture.

In the caves at Ajanta the glorious Vakataka wall painting far outshines the sculpture—to such an extent, in fact, that the latter is almost ignored. But many lovely sculptures have come from caves, including the erotic-couple bracket figures from Cave 16, the large Maradharshana panel in Cave 26, the Avalokitesvara relief at the *fig. 482* entrance of Cave 4, and the decorative detail on many pillars and pilasters.

At Ellora the river goddess Ganga with dwarf attendant against a pillar in *figs. 35, 461* Cave 16 is unsurpassed for its grace. One of this period's finest dancing Shivas is in Cave 6, and in the Ramesvara cave there is a magnificent Mahishamardini. In the Dumarlena cave there is a spirited Gajantaka; and in Cave 21 the Vinadhara *fig. 462* Virabhadra, accompanied by the Seven Mothers, and the row of the naturalistic and appealing mother goddess are indeed fascinating. In Cave 21 there is also an excellent sculptural rendering of the giant Ravana shaking Mount Kailasa. *fig. 59*

Cave temples elsewhere also hold wonderful Vakataka treasures. There is no *figs. 75, 467,* more beautiful musical scene of the period than the relief of dancers and musicians *468* from Cave 7 at Aurangabad, and Cave 3 at this site contains a fascinating representation of the Seven Worshipers.

The large cave on the island of Elephanta is also of this period, and the imposing relief panels in it are renowned. They are so full of fascinating details that they are veritable galaxies of Vakataka masterpieces. One such is Brahma on a flock of swans, recalling the impressive picture given by Bana in his *Harshacharita*. Among the prominent sculptures here are the three-faced Shiva that shows his benign, terrifying, and

fig. 194

fig. 195

figs. 262, 378

feminine aspects; the panel showing Kalyanasundara holding out his hand to shy Parvati as Himavan and Mena give her in marriage; the Gangadhara with a three-headed mermaid representing the triple stream; the charming half-male, half-female Ardhanarisvara symbolizing the dual nature of the universe; the Nataraja who banishes illusion by removing the veil; and the perfect composition of the yogi in a trance, seated in the lotus position and surrounded by figures that conjure up a wondrous celestial world. These panels at Elephanta are indeed a glorious achievement.

Parel in Bombay offers a rare and significant sculpture. It is the earliest representation of Shiva in his aspect as the Lord of Music, Dakshinamurti. His body is composed of the seven musical notes of the *sama* chant, and at his feet dwarf ganas play the flute, the vina, and other musical instruments.

figs. 109–14,
469–81

Despite all this glorious sculpture, it is in painting that the Vakatakas really excelled. The Ajanta cave temples are actually magnificent art galleries, and the murals found there constitute an illustrative commentary on the Jatakas and Avadanas of Buddhist literature. These artists meticulously followed the conventions known as the "six elements" of painting. (These elements concern the proportion of a figure, color, emotion, and so forth.) Among the great murals at Ajanta the most notable are the lovers and the Padmapani in Cave 1; Buddha before Yasodhara and Rahula in Cave 7; the Avalokitesvara in Cave 4; the Maradharshana in Cave 6; the royal couple in a harem in Cave 1; and the row of erotic couples above the doorway in Cave 17. The painters of Ajanta were masters of complex forms—whether human, animal, or plant. The diversity that they created is itself a marvel, as is the way in which they worked within the precepts of the ancient guidelines. For instance, *bhavayojana* ("infusion of emotion") is well used in the painting of the dying princess in Cave 16; in the scene of *Purnavadana*, showing a shipwreck; in the *Matriposhaka Jataka*; and in the *Vessantara Jataka* in Cave 17. The *Vessantara Jataka* is also a happy example of repetition of identical figures; it is done so well that the element of "likeness in portraiture" is very obvious. Also worthy of mention are the dance scene from the *Mahajanaka Jataka*, the scene of the bath of the prince (an elaborate royal daily ritual), and the rendering of the flying Vidyadhara.

The beautifully painted Cave 16 has an important inscription stating that it was dedicated by Varahadeva, the minister of the Vakataka king Harishena. This inscription also describes the cave as adorned with windows, doorways, picture galleries (*vithis*), carvings of celestial nymphs, ornamental pillars and a shrine (*caityamandira*), and a large reservoir.

fig. 266

figs. 264, 265

Farther south the Pallava dynasty was following in the footsteps of the Ikshvakus and creating exquisite sculpture. The early Pallava two-armed Shiva with a bull at his feet, now in the Victoria Jubilee Museum in Bezwada, is of pale white marble not unlike the Amaravati and Nagarjunakonda sculptures. Madugula, a village in Guntur District, was the site of some excellent finds of this period, including a Vishnu, a Brahma with two arms, and a sculptural group depicting Shiva and his family—Parvati, Ganesha, Skanda, and several dwarfs.

The Vishnukundins were contemporary with and connected by marriage to both the Vakatakas and the Pallavas. This dynasty ruled in the Kistna region and among its best-known monuments are the sixth-century cave temples at Mogalraja-

puram near Bezwada. On the facade of one of the caves is a mutilated and worn figure of Nataraja, the most important of its kind. Multiarmed and dancing on Apasmara, this dancing Shiva combines both northern and southern elements. The horned door guardian here is a precursor of several later ones such as that found in Mahendravarman's caves. On the pillars in Mogalrajapuram cave one can see some interesting sculptures, including those of Lingodbhava Shiva and of Hanuman meeting Sita from the *Ramayana*. Slightly later in date but before Mahendravarman is Simhavishnu's creation at Bhairavakonda. The Shiva and Harihara on the facade of this cave are the earliest representations of these two deities in southern India.

fig. 486

104. NARANARAYANA
Gupta, 5th century
Deogarh

105. BUDDHA
From Mathura. Gupta, 5th century
National Museum of India, New Delhi

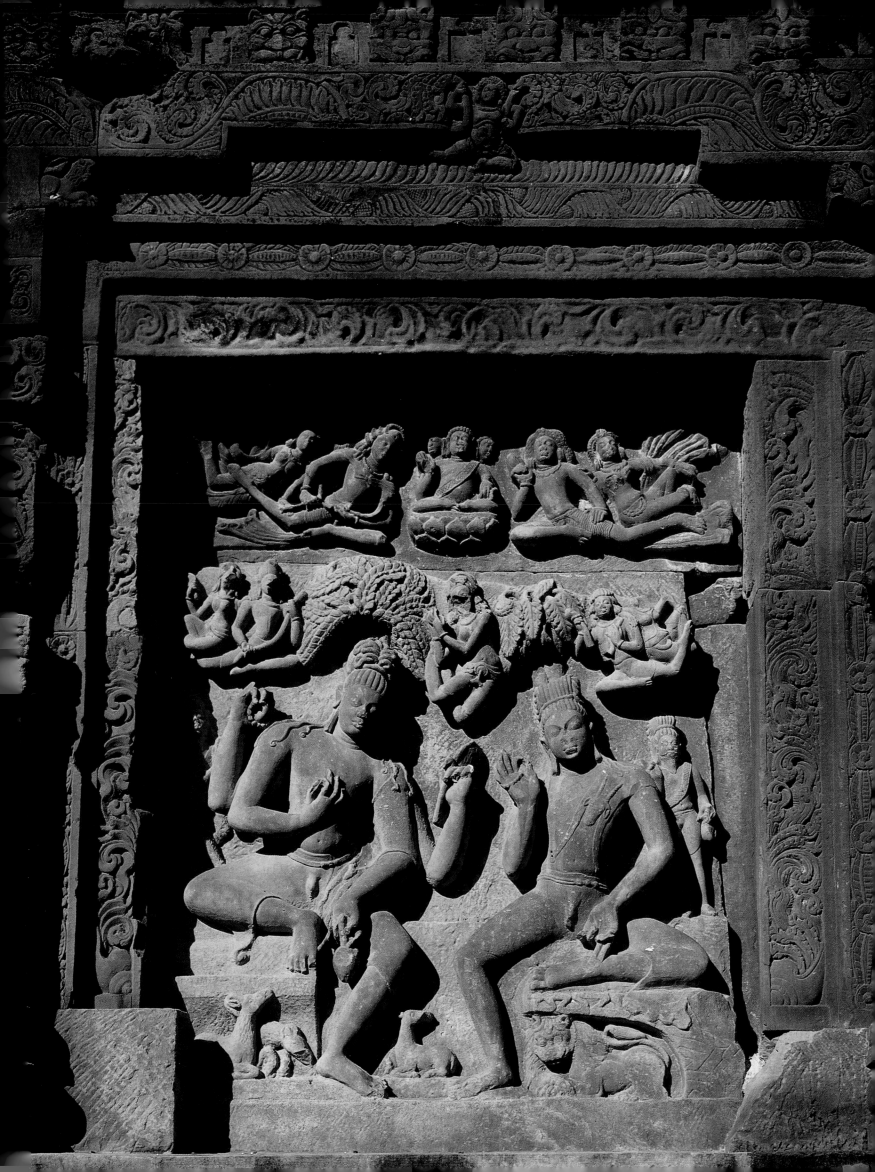

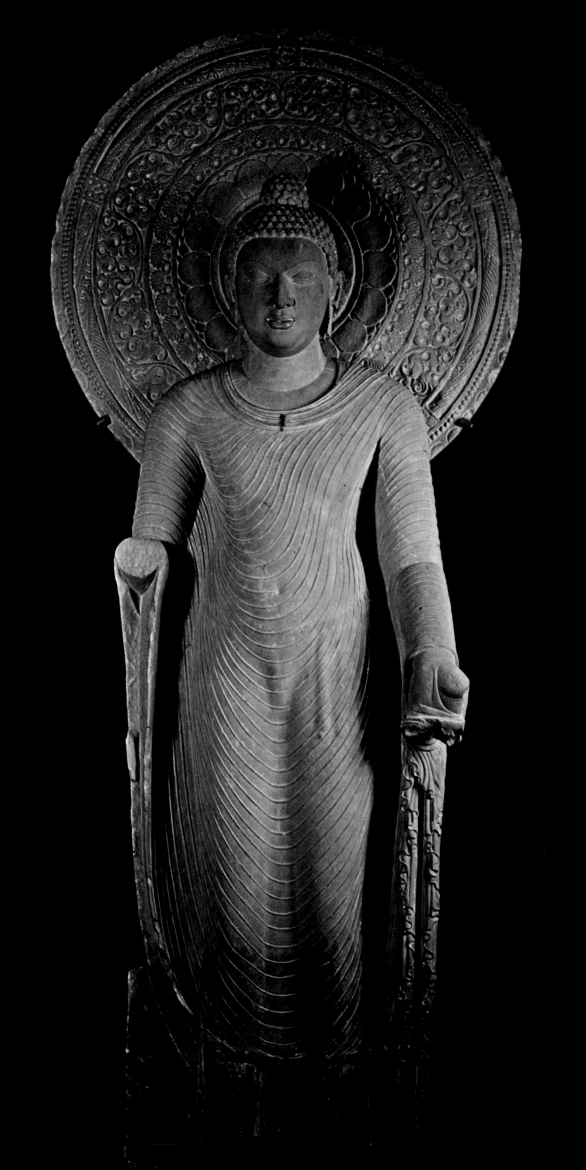

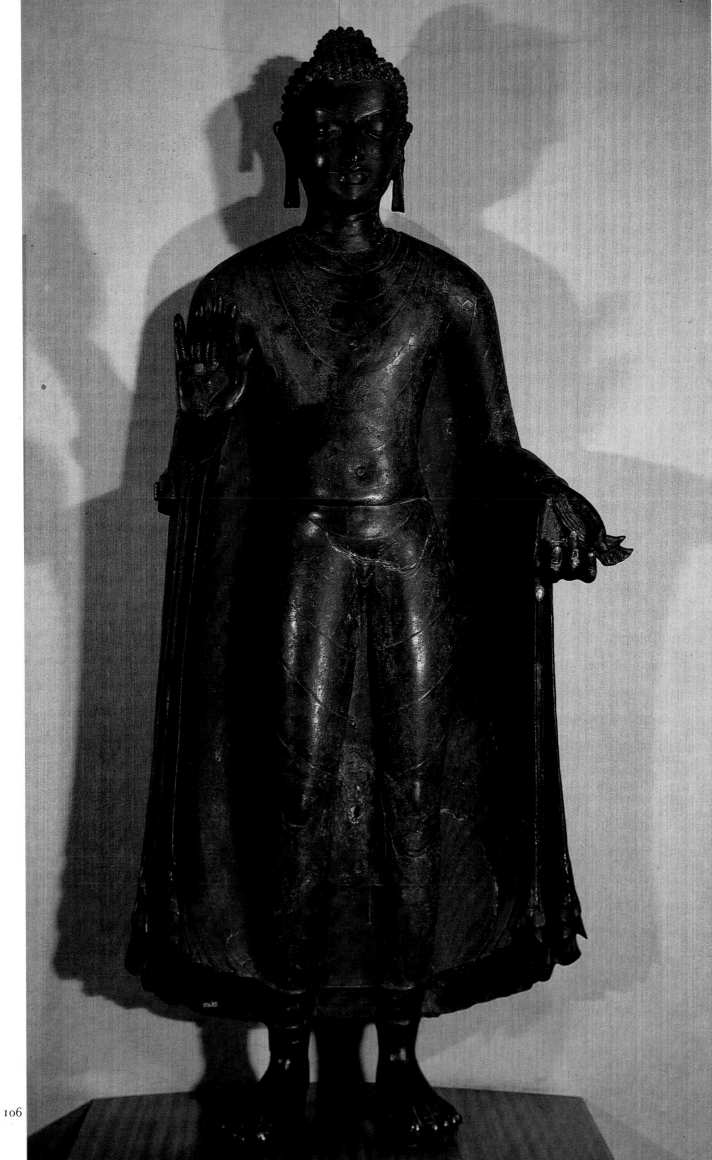

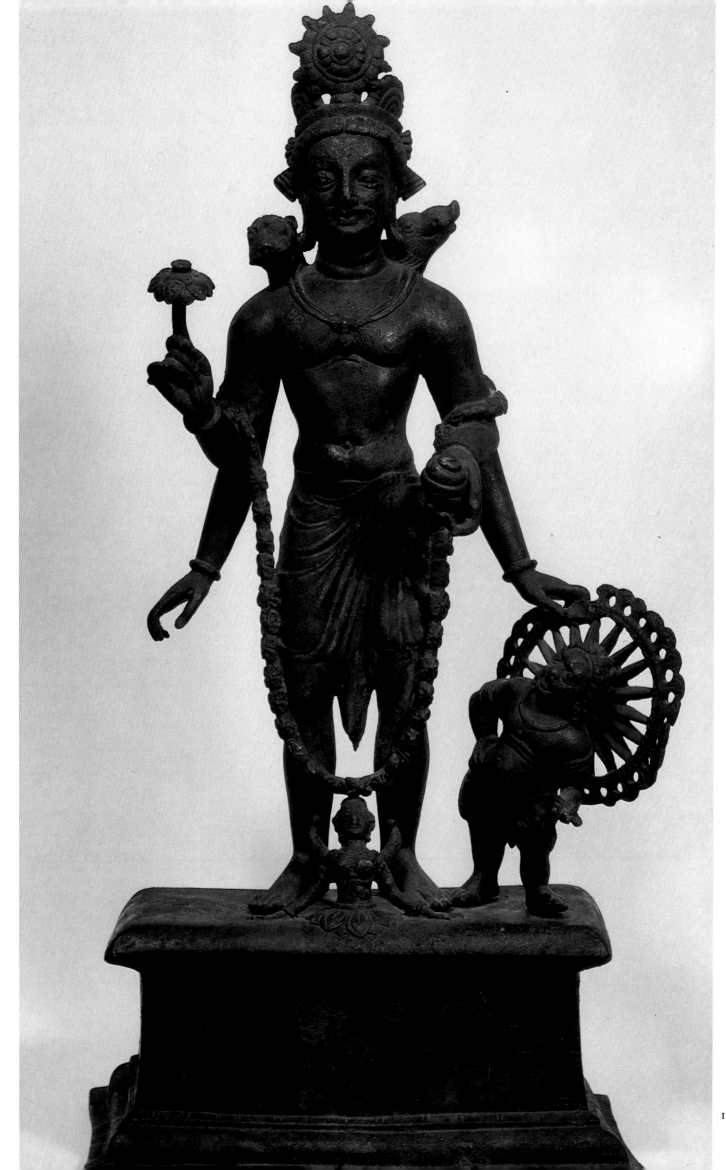

106. BUDDHA
Gupta, 6th century
Birmingham Museum, England

107. VISHNU AND AYUDHAPURUSA WITH SUDARSANACAKRA
From Kashmir. Late Gupta, 5th–6th century
Indische Kunstabeilung, Staatliche Museen, Berlin

108. ENTRANCE OF CAVE 2 AT AJANTA
 Vakataka, 5th–6th century

109. HAMSA JATAKA
 Vakataka, 5th–6th century
 Cave 2, Ajanta

110. PRINCE
 Vakataka, 5th–6th century
 Cave 17, Ajanta

111. PRINCESS IN GARDEN
 AND ROYAL COUPLE IN HAREM
 Mural. Vakataka, 5th–6th century
 Cave 17, Ajanta

112. ROWS OF BUDDHA FIGURES
 Vakataka, 5th–6th century
 Cave 17, Ajanta

113. CEILING PAINTING
 Vakataka, 5th–6th century
 Cave 2, Ajanta

114. PRINCESS AT HER TOILET
 Vakataka, 5th century
 Cave 17, Ajanta

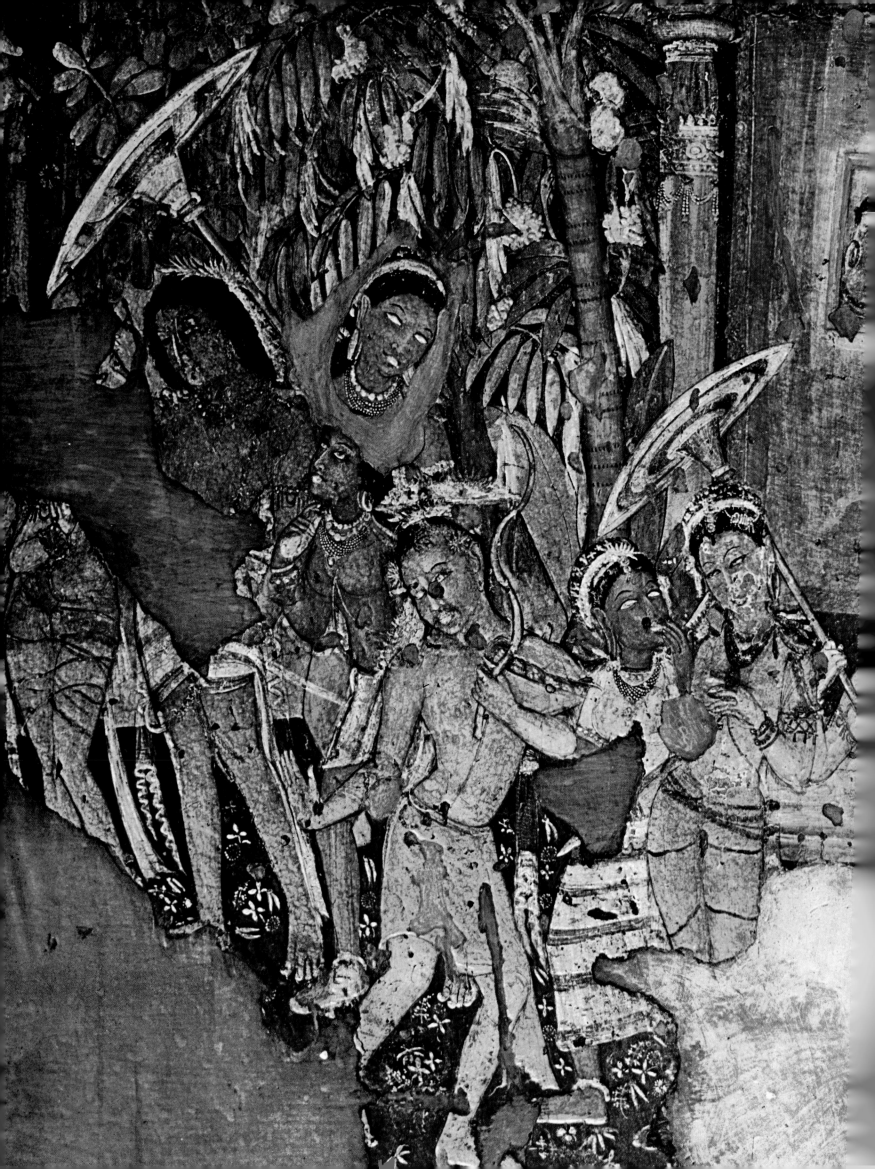

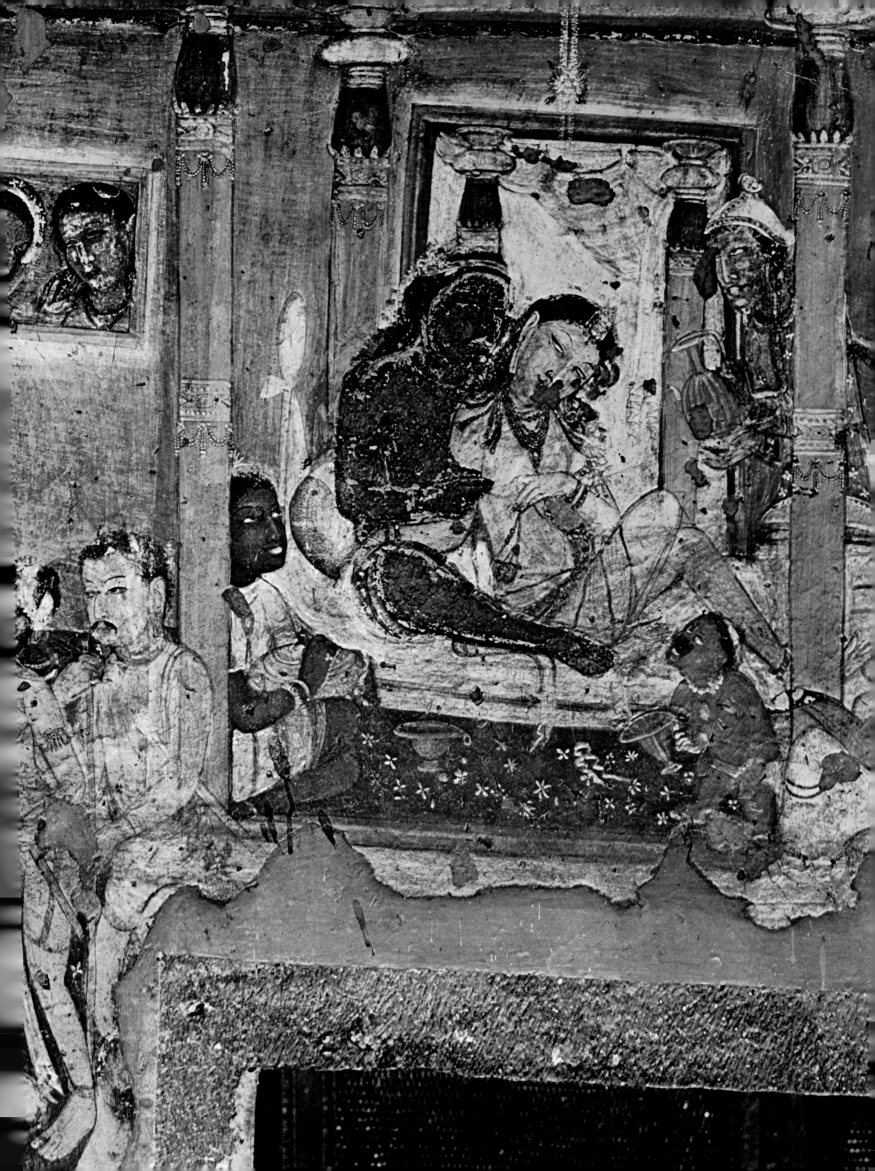

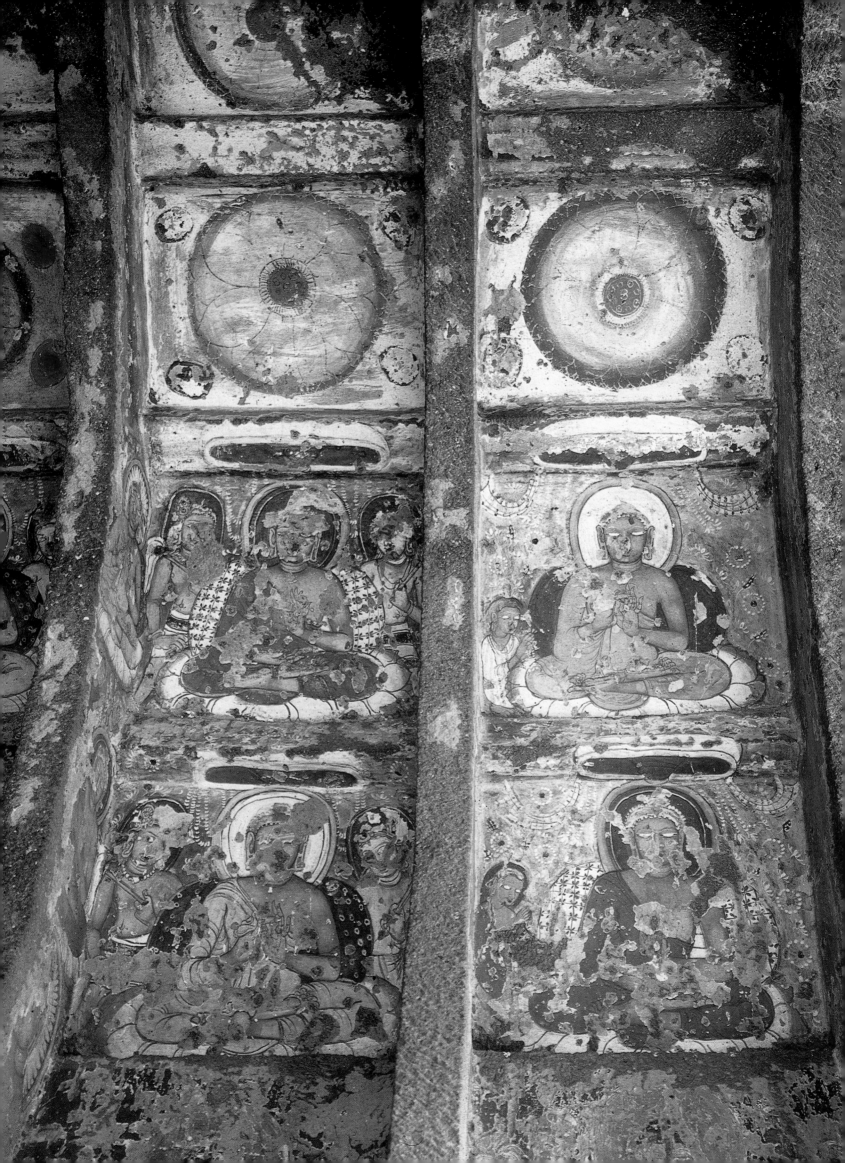

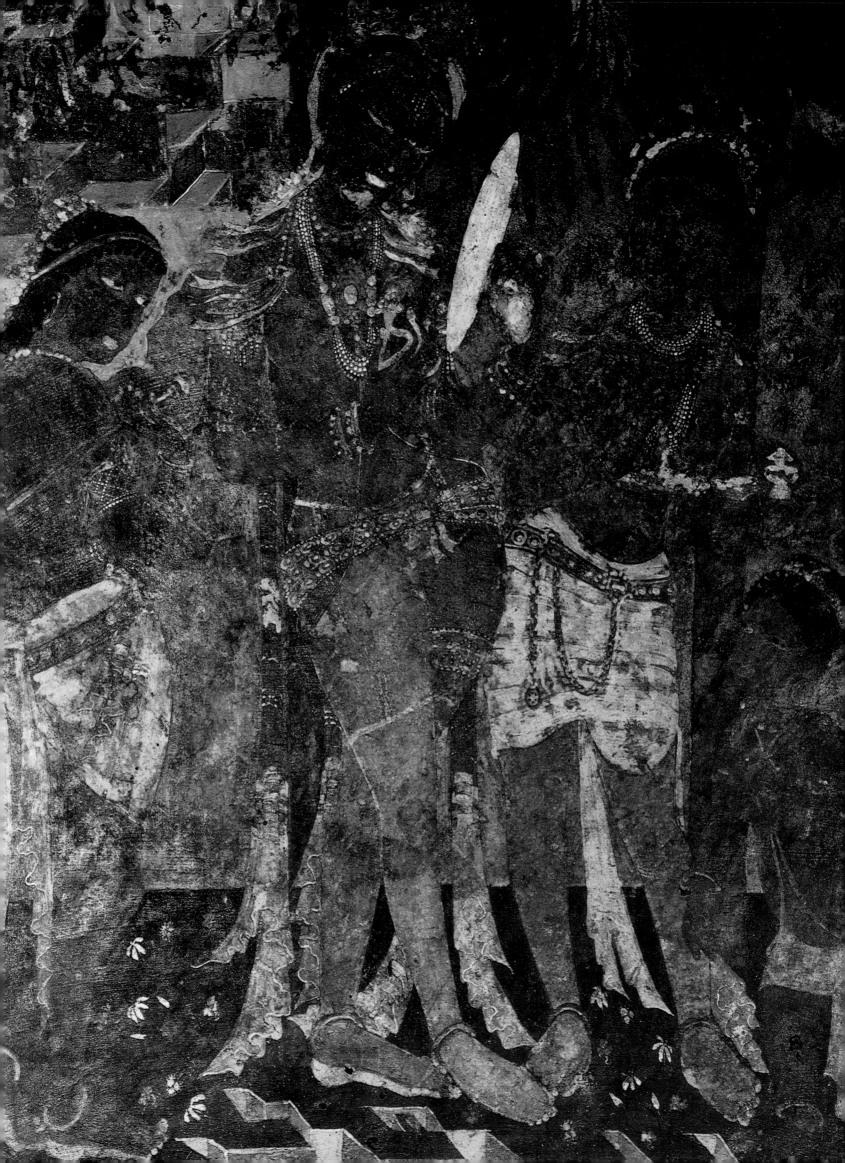

INDIA'S INFLUENCE

THE unquenchable traits of curiosity and inquisitiveness spurred bands of explorers from different parts of India to explore and see strange lands across the sea. Ships sailed to far-off lands carrying with them the culture of the subcontinent.

One of the famous panels from the stupa at Barabudur depicts this foreign travel in the Pallava period. The scene shows traveling merchants being welcomed on their arrival, with their magnificent ship in the background. And there are Satavahana coins whose inscriptions indicate the importance of the Indian navy. The Satavahanas had trade relations with Rome; the *Baveru Jataka* gives a glimpse of early trade with Babylon; and Kalidasa mentions sea and land routes to Iran and beyond. The discovery in Bogaskoy, Turkey, of figures resembling Hindu iconographic forms, as well as inscriptions mentioning Indra, Varuna, Mitra, and so forth, attests to the contacts India maintained with the outer world. And a Vedic hymn tells of travel from east to west across all five rivers of the Punjab and beyond—*iman me gange yamune sarasvati śutudri stoman sachatā peruṣṇiyā asikniyā marudyṛte vitastayārijikīye.*

Inscriptions found in Kutei in Borneo closely resemble passages from the epics like the *Ramayana*. And at times the names of kings closely resemble those of the mainland. The Mahendratataka, the tank built by King Mahendra of Champa, is described in a Sanskrit inscription in letters closely resembling contemporary Pallava-Grantha characters from southern India. The temple inscription in Kalasan in mid-Java, mentioning Tara, recalls this region's connections with Bengal. Raktamrittika or Rangmati is commemorated in a wonderful plaque from Malaya, now in the Indian Museum, with an inscription, incised in early Grantha characters of the fourth-fifth century A.D., mentioning Budhagupta, a sea captain. The close connections that the Sailendra dynasty of Southeast Asia had with India is clear from the Chola king Rajaraja's patronage of a Buddhist monastery at Negapatam, which is mentioned in the Leiden Museum copperplates. The earlier Nalanda copperplate grant of Dharmapala shows the most cordial relationship between the Pala kings of Bengal and the Sailendras. Among manuscripts discovered in Bali and edited by Sylvain Levi, the version of the *Mahabharata* is interesting for the *dhyānaśloka* of Vyasa—*abhraśyāmaḥ pingajaṭābaddhakalāpaḥ prāmsur daṇḍi kṛṣṇamṛgatvakparidhanaḥ sākṣāllokān pāvayamānaḥ kavimukhyaḥ pārāsaryaḥ parvasu rūpam vidadhātu.* This passage is found only in the southern versions of the epic and thus its source is verified. In early Cambodian inscriptions, there is mention of the city of Kanchi and its rulers, and in a ninth-century inscription, Shivasoma, the rajaguru of Kambuja, declares himself a disciple of Bhagavatpada Sankaracharya.

CEYLON (SRI LANKA)

As early as Mauryan times—the third century B.C.—Asoka sent missionaries to Ceylon and close connections were established with the mainland. During the Satavahana and Ikshvaku periods, Ceylonese Buddhists freely communicated with those in the Kistna Valley. One can see further connections with the mainland in

sculpture now displayed in the National Museum at Colombo. It was found in Ceylon and is in the Amaravati style. Similarly, at Anuradhapura in Ceylon a dagoba of the first century B.C. has elephants as caryatids, a feature that is also found at Mahabalipuram, in the temple at Arjunaratha, and a century later in the great Kailasa shrine at Ellora. At Anuradhapura the Nagaraja holding the "overflowing vase" and standing in almost the attitude of a door guardian is very similar to carvings at Amaravati and is a favorite theme in early Ceylonese sculpture. The bodhisattva from Anuradhapura—sometimes called King Dutthagamini—is a fine sculpture of the second century A.D. that also recalls contemporary Amaravati models, as does the monolithic seated Buddha. The bronze Buddha from Badulla (also in Ceylon) is not very different from some of the metal images of Buddha of the Amaravati school. Similar ones have also been found in Malaya, Vietnam, and the Celebes Islands. The image of the sage Kapila found at the Isurumuniya vihara near Anuradhapura, as well as the exquisite carving of elephants almost submerged in a nearby pool of lotus-filled water, look like early Pallava carvings. And it is a historical fact that Narasimhavarman, a close friend of Manavarman of Ceylon, used the Pallavan military to restore the island monarch to his throne after it had been usurped by a wicked cousin. The painting of celestial nymphs at Sigiriya in Ceylon is not unlike the charming Pallava paintings from Kanchipuram and elsewhere. There was close and almost constant contact between the Chola and Pandya dynasties and northern Ceylon. There is not a single inscription that fails to mention the Indian monarchs as conquerors of the island, and there are a number of Chola temples at Polonnaruva and elsewhere in that area. The famous motif of the combined elephant and bull, observed in monuments on the mainland, is found in the late Chola and Vijayanagar periods in Ceylon, and the tenth-century Ceylonese bronze of Pattinidevi is actually a rendering of the heroine of the great Tamil classic *Manimekalai*. The sculptural portrait found at Polonnaruva and believed to be of Parakramabahu is another Ceylonese version of a mainland theme—this one a favorite of the Cholas. The death of Buddha is nowhere so effectively presented as at Polonnaruva, where the huge monolith shows Ananda standing beside the Master. It is fascinating to see the way in which the iconography of the mainland was altered and transformed in the soil of new countries.

figs. 487, 489, 491

fig. 490

figs. 116–18

fig. 115

INDOCHINA

Seshasayi Vishnu—Vishnu lying on the serpent-couch with Brahma on the lotus issuing from his navel—is a popular theme throughout India, and it has been found in several temples in Vietnam and Cambodia. An interesting rendition of this theme is seen in the Shiva temple at Prambanan in Java. Here Vishnu is seated on the snake rather than lying on it, and the milky ocean full of aquatic animals, as well as the adoration of the gods, is graphically represented. The Nataraja is another popular form, and perhaps the most magnificent dancing Shiva of all is from Banteay Srei in Cambodia. While having a multiplicity of arms in the northern style, Shiva is attended by Karaikkalammaiyar. This female devotee who keeps time as Shiva dances, is known only in southern Indian lore. Shiva dancing on a bull from Mi-son in Vietnam is very much like the eastern Indian Pala concept of Martesvara. Krishna

lifting Mount Govardhana, found at Vat-Ko and now in the National Museum at Phnom Penh, Cambodia, recalls the graceful Gupta sculpture of the same figure in the Bharat Kala Bhavan. The Harihara in the National Museum at Phnom Penh is the usual Cambodian type. It is clearly an adaptation of an original Indian theme done in a pleasant local style. The Umamahesvara from Banteay Srei, now in the National Museum at Phnom Penh, is close in spirit to its Indian prototype, but in a different style. An Avalokitesvara from Chaiya in Thailand, now in the National Museum at Bangkok, has the same delicacy and grace as early medieval Indian sculpture. And in the National Museum at Phnom Penh there is a bronze fragment of Seshasayi Vishnu from Western Mebon, Angkor. The temple of Angkor Thom has given the world a magnificent rendering of the Churning of the Ocean. Long rows of gods and demons hold the serpent Vasuki—a motif that is found in an earlier Gupta sculpture on the doorway to the cave at Udayagiri near Bhilsa and again in various phases of Western Chalukyan and other schools. The version at Angkor Thom is the most exuberant of all, and the theme was so appealing to the sculptor that it is repeated on all four sides of the monuments. The elaborate nautical scene at Angkor Thom, with its warriors, war canoes, and ship with aquatic animals all around the bow, is analogous to the four faces of Shiva, while he swallows up the poison as it rises from the vast expanse of the milky ocean. Thus this representation at Angkor Thom is an expansion of the original Indian concept by an imaginative Cambodian sculptor. At Angkor Vat, although it is rendered in low relief, there is a greater detail and a special spirit in the representation of this same theme. As represented in various Puranas and in the *Bhagavadgita*, Vishnu joins hands with and assists the devas and at the same time, as the primal tortoise, supports the mountain from below. The often repeated scene of Ravana shaking Mount Kailasa is nowhere better represented outside India than at Bantay-Srei in Cambodia. And the combat between Vali and Sugriva is seen in a very lively representation here. At Phnom-Bok there is a fine example of the head of Shiva in the Chandrasekhara form with the moon prominent on his locks. The Cambodian sculpture's regard for the literary context is seen in a carving of a scene from the Kumārasambhava, now in the Musée Guimet. Parvati is shown stopping her ears to avoid hearing ill of Shiva. The episode of the serpent Muchalinda sheltering Buddha, which is seen in stylized form at Amaravati and Nagarjunakonda, has a more realistic representation in Cambodia. Buddha is shown seated on a pedestal composed of the coils of the reptile; the hoods are raised over him, providing shelter. A Cambodian lintel depicting Trivikrama and a Ganesha in the Tourane Museum in Vietnam recall similar figures found in India.

fig. 500

fig. 502

INDONESIA

In Indonesia the most striking similarities, both in theme and in execution, to Indian originals are observed. The style is a charming fusion of Pallava and Chalukya. At the Barabudur stupa, for instance, one sees a treatment of the theme of purgatory that is similar to ones in Indian sculpture and painting (particularly that in the *Yamapata* where the rewards and punishments are meted out by Yama, the Lord of Death, whose judgments are unquestioned). The temptation of Buddha by the demonic Mara and his daughters, a favorite theme in Buddhist art in India,

fig. 124

has most glorious representation at Barabudur. The torans and gargoyles with the makara motif on this monument are very similar to those in India. Not far from Barabudur in Chandi Mendut, there are scenes from the *Panchatantra* carved in stone that closely resemble the richly embellished pierced windows in the Muktesvara temple at Bhuvaneshwar. The story of Rama and Krishna—so well told at Deogarh on the plinth of the Gupta temple and in the Kailasa temple at Ellora, the Nagesvaraswami at Kumbakonam, the Lad Khan at Aihole, the Mallikarjuna at Pattadakal, and the Ramaswami at Kumbakonam—has probably its most effective rendering in the Shiva temple at Prambanan. Every detail is here— Rama slaying Vali; the abduction of Sita; Rama humbling the ocean; the tender affection of the young Rama and Sita (indicated by cooing birds on the eaves); Hanuman setting fire to the city of Lanka (graphically portrayed by such details as the tiny animals fleeing for their lives through small holes); Hanuman respectfully speaking to Sita whom he discovers in the Asokavana; and Krishna subduing the snake monster Kaliya. All are rendered in Indonesian style, preserving the essence of the Indian story and its charm. Time and again throughout Java, there is a special native flavor to basically Indian themes—for example, the Durga in full panoply on the buffalo from Singasari; the charming Prajnaparamita as Queen Dedes (now in the Leiden Museum); and the Vishnu as King Erlanga on the water fountain at Belahan. The Agastya from the Chandi Bamon temple recalls the many figures of this popular sage from the Chola period in southern India—specifically, the ones at Vedaranyam, Tiruvengadu, and Darasuram. And the dancing Bhairava from Sumatra cannot help but recall the one at Batukabhairava in southern India that it so closely resembles, even to the image of the dog.

BURMA

Burma has also yielded a number of examples that bear the stamp of India. In fact, at Pagan there is complete depiction of the Jatakas that is more elaborate than any in India itself. Here, of course, legends are inscribed in Burmese script. And the Mahabodhi at Pagan is a magnificent imitation of the Mahabodhi at Bodh Gaya. The Ananda temple at Pagan has some of the most beautiful interpretations of the story of Buddha and the Jatakas. One also finds Brahmanic deities here—for instance, the Brahma from Nanpaya.

CENTRAL ASIA

Caravans traversed the silk routes through important sites in central Asia, and Chinese monks, Indian Buddhist masters, merchants, and many other travelers carried the banner of Indian culture into many of these places, as the interesting remains that have been discovered eloquently proclaim. A seventh-century work from far-off Dandan Uiliq shows a damsel arising from a pool, the water level at her knee as she covers her breasts with her hand. She looks very much like Sri Lakshmi in early Kushan figures; she could almost be illustrating a verse of Kalidasa—*uddaṇḍapadman gṛihadīrghikāṇām nārinitambadvayasam babhūva.*

λ The three-faced Shiva seated on two bulls, also from Dandan Uiliq, has the peaceful countenance in the center, flanked by the terrifying visage to the right and the benign feminine aspect to the left. This same composition is seen in the central figure of the shrine at Elephanta. The dancing Shiva flanked by attendants, also from Dandan Uiliq, illustrates how a striking theme travels great distances.

Among Buddhist themes, the fourth-century rendition of the *Vessantara Jataka* at Miran is unparalleled. Almost unique in its choice of theme is the panel showing the unfurling of a pictorial scroll before Ajatasatru to tell him gently of Buddha's death. The great monolithic images of Buddha in Afghanistan near Banian with their elaborately folded draperies are variations of a style that was popular in the Kushan and Gupta periods. The jeweled Buddha, which occurs only in Kashmiri, Nepalese, and Pala art, has its roots in Fundukistan. And Buddhist themes in Tibet, China, and Japan evolved into fantastic creations with novel iconographies, so changed that even basic themes are transformed beyond recognition. The guardians of the four quarters, for example, become monstrous figures. In China early paintings of the bodhisattva come close to the Ajanta style, and one wonders how the transformation at a later date could be so completely different.

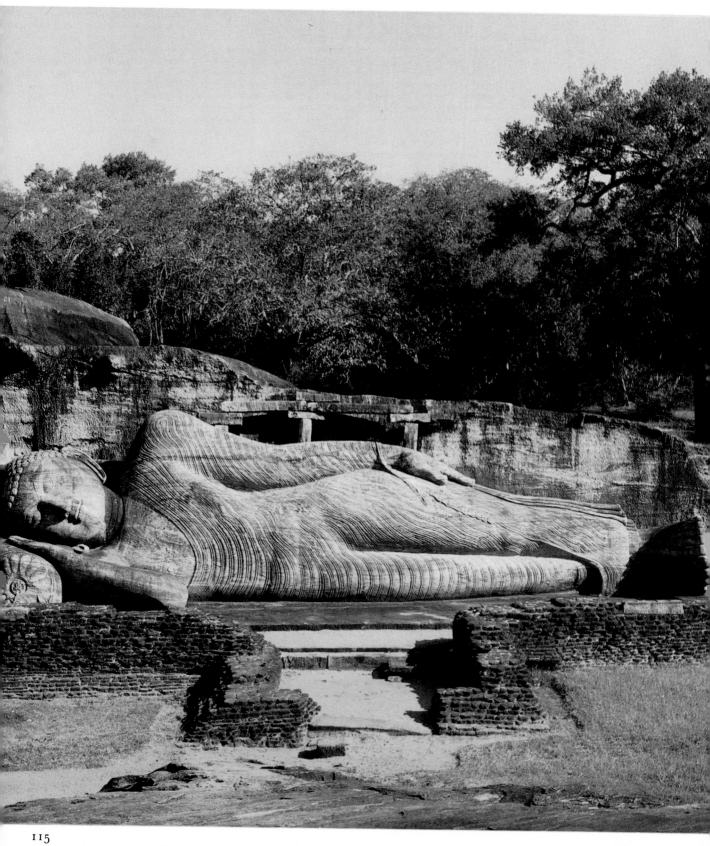

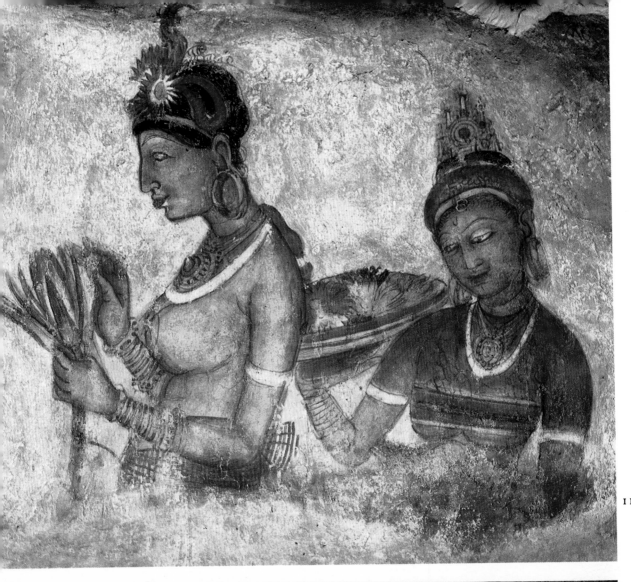

116

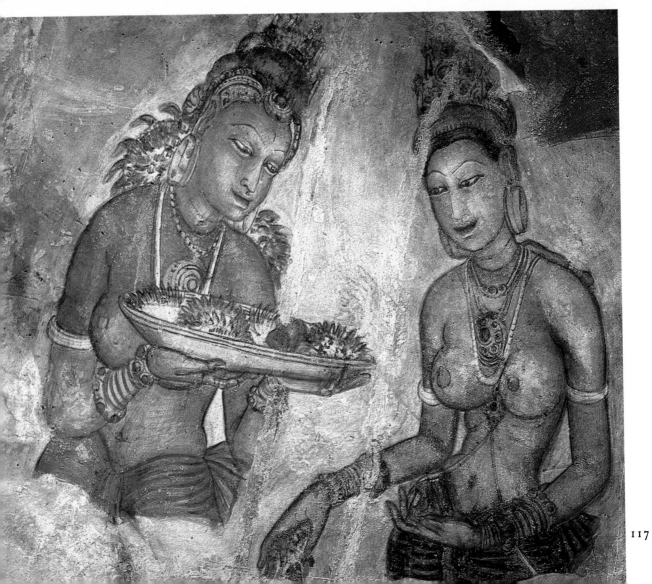

117

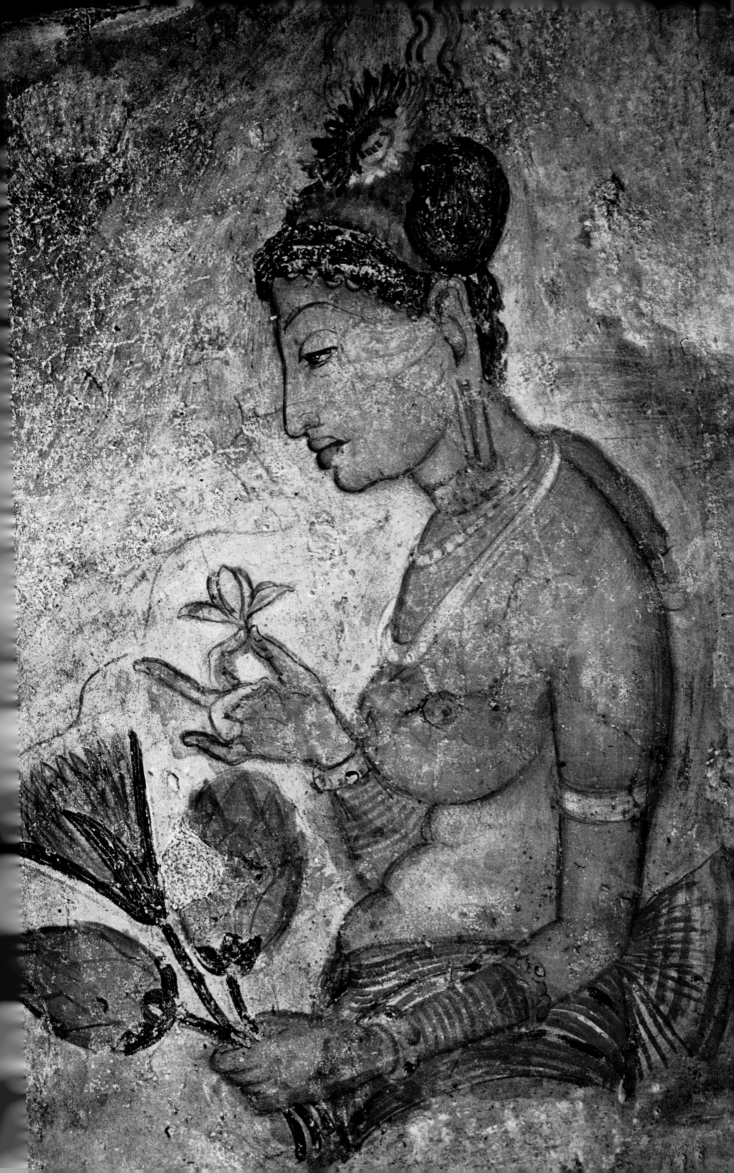

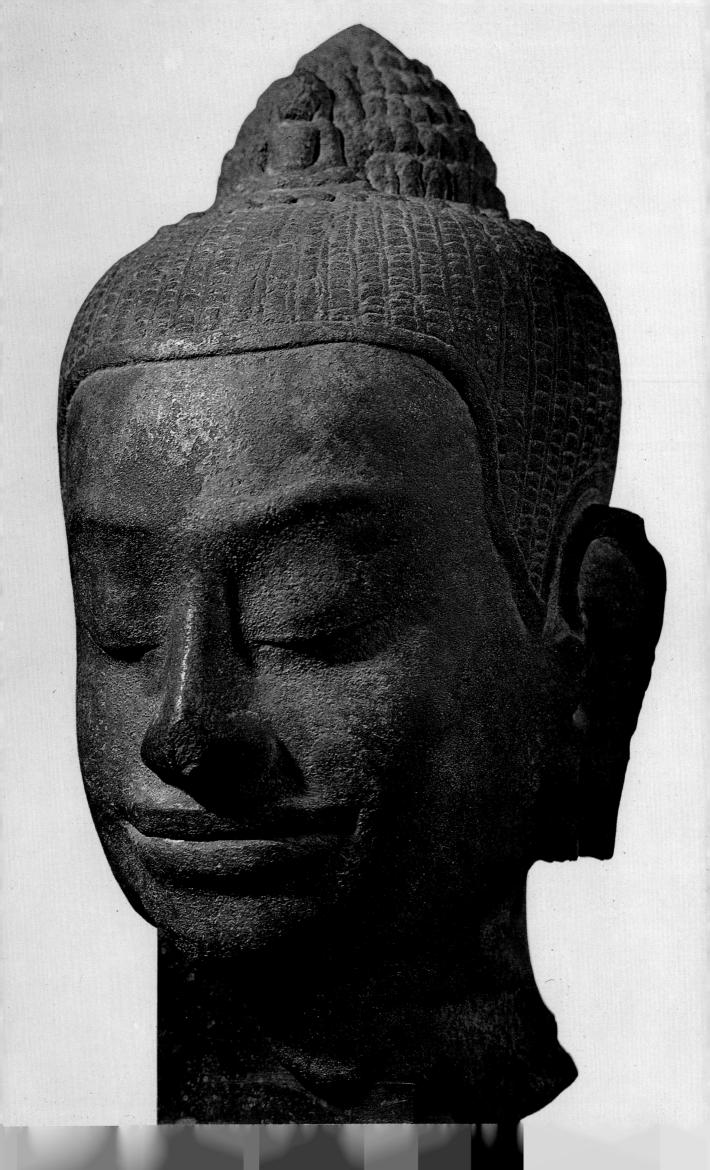

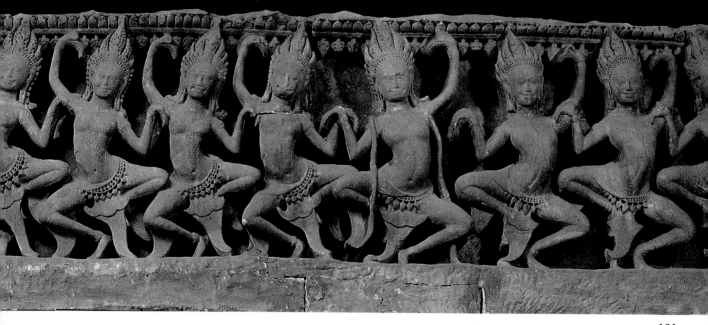

121

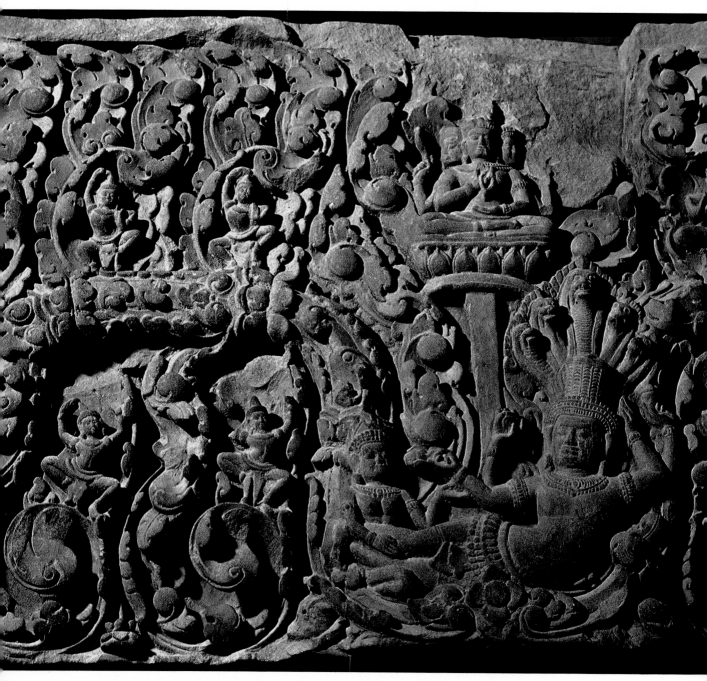

122

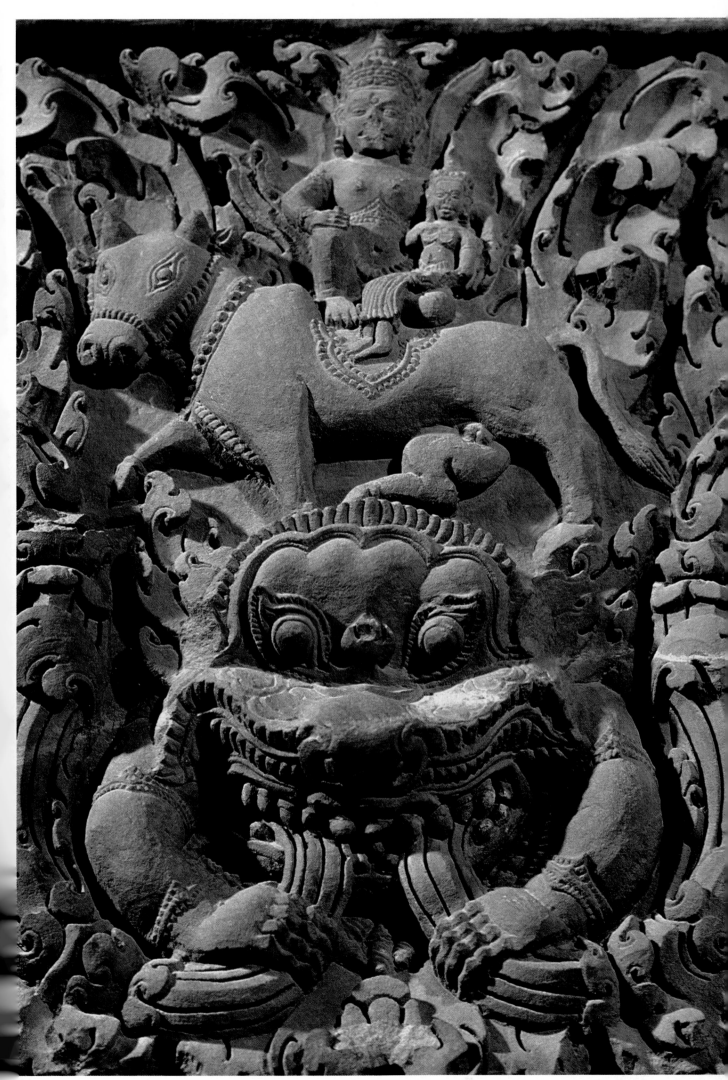

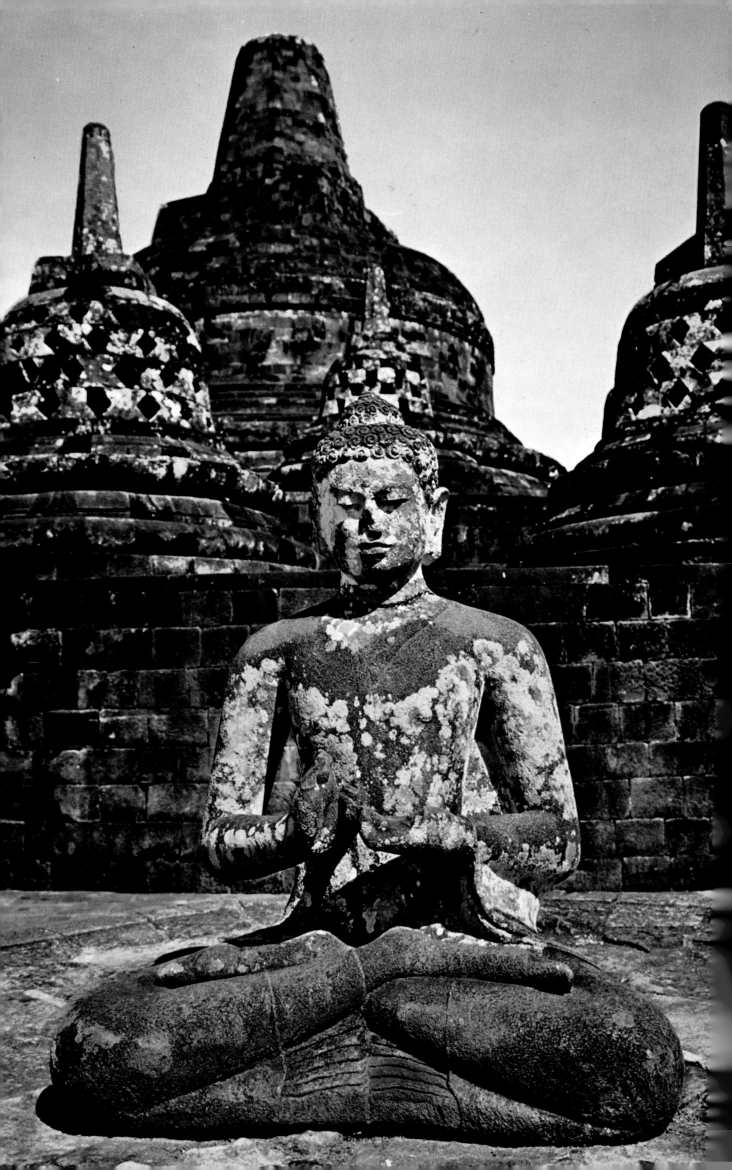

ARTISTIC ELEGANCE
OF THE MIDDLE AGES

In the late sixth and early seventh centuries, there were three remarkable rulers in the Indian subcontinent—in the north Harsha ruled from Thanesvar and Kanauj; in the Deccan Pulakesin I had his capital at Badami; and in the south Narasimhavarman ruled at Kanchipuram. These three courts became cultural centers for the diverse schools of art whose light shined so brilliantly for four centuries.

THE PALLAVAS

During this period the northern Indian kingdoms became more powerful, and some could be termed empires. The Pallava kingdom on the southeast coast enjoyed a particularly striking spiritual and artistic flowering.

Though the Pallavas ruled from Kanchipuram beginning in the early centuries of the Christian Era, this dynasty's architectural and sculptural activity began during the reign of Simhavishnu. Mahendravarman I, the son of Simhavishnu, was an artist, poet, engineer, sculptor, architect, painter, and musician. His epithets, like "tiger among artists," and "the curious-minded one," indicate his passion for the arts. As the Mandagappattu inscription states, he created a temple dedicated to all three deities—Brahma, Vishnu, and Shiva—and built without brick, timber, metal, lime, or mortar—*etad aniṣṭakam adruman alauhan asudham vicitracittena nirmāpitam nṛpeṇa brahmeśvaraviṣṇulakṣitāyatanam.*

The earliest cave temples of his time are found mainly in the Chingleput, North Arcot, and South Arcot districts in places such as Mandagappattu, Mamandur, Dalavanur, Kilmavilangai, and Tirukalukunram. Temples from the early phase of this so-called Mahendravarman style have massive pillars that are divided into three sections. The upper and lower parts are square in section and the middle one is octagonal. They have brackets that slope outward at forty-five degrees and are sometimes rounded and decorated with a wavy ornament on either side of a simple central band. The chaitya window, *kūḍu* as it is known, is always simple with a human head in it that looks out. The finial of the *kūḍu* is shaped like a spade. The door guardians in these caves have a single pair of arms, are rather hefty, carry heavy clubs and are sometimes horned. The sacred thread is usually draped over the right arm. The figures are tall and hefty with well-rounded limbs and elongated faces with a double chin and rather thick lips. In the time of Mamalla Narasimha I, the son of Mahendravarman, the style advanced. The pillars became more slender and are often supported by squatting lions. The *kūḍu* remains in almost its original state, and miniature ornamental pavilions simulate thatched huts. The niche for carved figures is ornamented by a toran arch and makaras with riders and floriated tails. The doorkeepers now have a slimmer contour and remain pleasant in countenance. Toward the end of the seventh century, Narasimha II (who built the Kailasanatha at Kanchipuram and the Shiva temple at Panamalai) exhibited a definite predilection for constructing temples in stone rather than excavating them in the living rock. These masonry temples are more slender and lighter in appearance then the earlier ones. Sculpture in general became more pleasing and delicate. The *kūḍu*, which still retains the spade-shaped finial, becomes more decorative, as do the figures which now

have greater ornamentation than at an earlier stage. The number of small panels increases, and the central vimana, such as that in the Kailasanatha temple, is quite large. The gopura, however, is just beginning to appear and is very small. A number of cloister cells are usually arranged around the courtyard of these temples. Aspects of Shiva such as Gangadhara, Ravananugraha, Gajantaka, Dakshinamurti, and Nataraja, become very popular. Somaskanda becomes a great favorite in this period and is invariably placed against the wall behind the Shivalinga in the central hall.

fig. 34 Simple figures like the Vishnu at Kilmavilangai and the Shiva as Gangadhara in the Tiruchirapalli cave are exceedingly well done and are probably the earliest depictions of these forms in southern India. Here the foot of Gangadhara planted on Apasmara is a precursor of such a configuration for several forms of Shiva including Tripurantaka, Dakshinamurti, and Nataraja on the back of small dwarf figures. The single lock of hair held out for Ganga is a characteristic that becomes more and more important as a clear means of identifying Gangadhara. The door guardian at Tirukalukunram is another exceedingly fine example of Mahendra style. The Mahi-

figs. 299, 300 shamardini and the Seshasayi Vishnu panels at Mahabalipuram are two great displays of skill in sculpture from Narasimhavarman's time. Individual panels on the

fig. 298 Dharmarajaratha have been dexterously managed, but Varaha in both the Varaha caves and Sri Lakshmi bathed by elephants and attended by apsarasas—with exquisite realistic treatment of the lotuses and the elephants' flapping ears, tusks, and trunks—are the creations of a master artist. The Govardhanadhara cave has a wealth

fig. 397 of figures composed in the most meaningful fashion to depict the milking of the cow and the Lord of the Cowherds holding up the mountain.

The most arresting composition at Mahabalipuram is Arjuna's Penance, which

fig. 138 is so unlike any other Pallava monument. It shows the prince as an ascetic, emaciated and lost in contemplation, unaware of the mountain valley or the holy river that flows through three regions purifying heaven, earth, and the netherworld. The devas in the celestial sphere, the sages on earth in the daily ritual, the elephants of the quarters indicating the approaching netherworld, and the nagas representing the waters of the stream—all proclaim the skill of the sculptor in suggesting infinity. Here are the

fig. 562 beginnings of later iconography, and there is no more beautiful figure than Shiva Vrishabhantika against the Arjunaratha delicately fashioned by Narasimhavarman's sculptor. The panels representing seated Simhavishnu and his queens, Mahendravarman leading his queens, and Narasimhavarman unattended indicate not only skill in portraiture but also the proper behavior of a son toward parents and grandparents.

Rajasimha's period is also represented at Mahabalipuram. Mahishamardini

fig. 8 Durga on a lion, near the shore temple, is almost a sculpture within a sculpture—the shrine was created by excavating the chest of the lion itself to enshrine the goddess, who is also seated on its back.

The historical sense of the Pallava sculptor is seen at its best in the Vaikun-

fig. 561 thanatha temple of a slightly later date where the whole pageantry of Pallava royal life and achievements is narrated in labeled panels on the courtyard walls.

THE CHOLAS

The Cholas, whose dynasty included such great figures as Karikala who built a dam on the Cauvery River, rose into prominence in the middle of the ninth century

when Vijayalaya carved out a kingdom around Tanjore which became one of the greatest Indian empires. His son Aditya I and grandson Parantaka expanded the kingdom and beautified it with temples. According to the Anbil plates, Aditya built a row of large temples to Shiva that stood like victory banners on the banks of the Cauvery. Temple building was characteristic of the Cholas, and they were also great patrons of art and literature with appropriate titles such as Panditavatsala and Nityavinoda. Their noble stature is indicated in the title *Rājagambhīra*, and their conquests in titles like *Gaṅgaikoṇḍacoḷa* ("the Chola who brought home the Ganges") and *Maduraiyum iḷamum koṇḍa* ("he who captured Madura and Ceylon"). The Cholas were devotees of Shiva, and their zeal can be seen in the Chidambaram temple where the dance hall was covered with gold by Parantaka. Gandaraditya, a younger son of Parantaka, was a great devotee. Widowed early, Sembianmahadevi, Gandaraditya's queen, gave herself to the pious work of temple construction and renovation. Loved, honored, and revered by successive rulers up to the time of her grandnephew, Rajaraja, she has left an indelible mark in Chola history and art. The temples of the earlier Chola phase—Vijayalayacholisvaram at Nartamalai, the Muvar and Aivar temples, the Kilayur temple, the temple of Kuranganatha at Srinivasanallur, the temple of Nagesvaraswami at Kumbakonam, and the Saptarshisvara at Lalgudi—are marked by simplicity in the arrangement of every architectural part. Chola structures gradually became more complex, and the culmination of their development is seen in the glorious twin temples at Tanjore and Gangaikondacolapuram which date from the first half of the eleventh century. The simple Pallava makara-toran arch on the niche is now circular and charming in decorative detail; the *yāli* frieze on the plinth is very imposing; and the *bhūtagaṇas* below the cornice, which is decorated with *kūḍu* patterns, form a vivacious frieze with a striking originality in form and pose. The simple but effective *yāli* frieze distinguishes the early Chola structures from those of the Pallavas and from the later vimanas of the Cholas themselves. In this phase of Chola art the door guardians are very simple and human. The majesty of the slim figure of Shiva as the Beggar from the Sundaresvara temple at Melapaluvur is arresting, as is the smile of the beautiful Vinadhara Dakshinamurti in the Saptarishisvara temple. The Bhikshatana from the Nagesvaraswami temple at Kumbakonam has a most appealing beauty, and the portrait figures, such as that of the chieftain with a turban of *rudrākṣa* beads and of *fig. 565* the princess with a braid, are marked by great elegance. In the Kuranganatha temple at Srinivasanallur, a prince and a nymph emerge from their niches in a lifelike manner, but a celestial glory makes them unearthly. Though mutilated, the Dakshinamurti at Srinivasanallur retains its air of perfection. Shiva as the Lord of Dance and as the gleeful elephant-slayer is well presented in the early Chola sculpture of the Muvar temple. An earlier work that clearly shows the transition from the Pallava to Chola style is the magnificent group of Manmatha and Rati and a rare Sarasvati bathed by elephants from the Sundaravarada temple at Uttaramerur. The Nisumbhasundari from Tanjore and the Ardhanarisvara from Tiruchampundi are noteworthy among the earliest Chola carvings. The Brahma from Kandiyur is similar to figures in *figs. 564,* the Boston Museum and the Metropolitan Museum. A number of charming Matrikas, *136, 306* one of which is now in the Musée Guimet, show the Rashtrakuta elements that were incorporated in some early Chola art. The Gangavisarjanamurti from Aduturai is one of the most elegant sculptures of this era. But it is perhaps surpassed by the majestic Ganesha from Pullamangai attended by *bhūtagaṇas*.

During this period miniature sculptures of great elegance were used as decorative panels in temples, and they are among the great Chola masterpieces. At Pullamangai one sees Varaha with Bhudevi on his lap, Nataraja dancing in *ūrdhvajānu*, and Narasimha wrestling with Hiranyakasipu. Among other remarkable works are the Chandesanugrahamurti from Kamarasavalli; the small *Ramayana* panels from the Nagesvara temple at Kumbakonam; the intricately carved makara-toran decoration of the niche top from Srinivasanallur; the Kalyanasundara in the makara-toran at Tiruvelvikudi; and the multiarmed Nataraja that is a toran decoration at Tirumayachur.

fig. 274

The early bronzes of the Chola phase include the Tiruvarangulam Nataraja in the National Museum. This is a unique representation of the tandava in metal, and the striking grace of the slim moving figure is characteristic of the period. Another important Nataraja of this period is from Tandantottam; here the leg is half-raised, the hand is held in a protective gesture, the face expresses the reverie of the performer absorbed in dance, and the locks trailing on the shoulders are decorated with flowers. Shivakamasundari, the figure cast as the consort of this magnificent image, is a worthy companion. Another very important Nataraja of this early phase shows the lord dancing in lalita. This image, which presents a rarely seen pose with remarkable skill, is a treasure of the temple of Agnisvara at Kumaravayalur. The Tripurantaka and Tripurasundari from Konerirajapuram form an exquisite group; unfortunately the

figs. 63–65, 273

Kalyanasundara group from the same temple is now scattered. The finest image of the latter group is the bride Devi. The Kaliya Krishna now in the National Museum is perhaps the best of this type and has stylistic elements characteristic of the transition from Pallava to early Chola.

The earliest phase of Chola painting is seen in the fragments of color and line surviving in the Vijayalayacholisvara temple and in the exquisite fragments recovered from Chola temples in north Ceylon. The flowering of the painter's art is seen at its best in the grand series that adorns the walls of the Rajarajesvara temple at Tanjore.

THE PANDYAS

Although the earliest Pandyas built great sacrificial halls and closely observed Vedic rites, Ninrasir Negumaran, the king who ruled at the beginning of the seventh century, was a Jain. However, he was converted to the religion of his forefathers by the child saint Tirujnanasambandar who was aided by the efforts of Ninrasir's devoted queen, a Chola princess. This great king—also known as Arikesari Parankusa—was a contemporary of Narasimhavarman, the famous Pallava king. Parankusa's son Ranadhira, a warrior like his father, triumphed over the Cheras and Cholas. The son and successor of Ranadhira, Maravarman Rajasimha, defeated Pallavamalla, according to the Velvikkudi grant. (The Udayendiram plates of Pallavamalla confirm this Pandyan conquest and tell that Udayachandra, the minister of Pallavamalla, rescued his master who was besieged in Nandigrama.)

Marangari—a trusted minister of both Rajasimha and his son Varaguna—is famous for an inscription that tells of a stone temple he built for Vishnu. Also known as Madhurakavi, he was a Vishnuite seer. His brother Maran Eyinan was also a minister, and he brought the whole of the Kongu country under Pandyan rule. Varaguna (also known as Nedunjadayan) was a very powerful monarch and his kingdom

extended to the Tanjore, Salem, and Coimbatore districts. His son Mara Srivallabha was equally strong and succeeded in overcoming a confederation of Gangas, Pallavas, Cholas, Kalingas, Magadhas, and others. But his son Varagunavarman was less successful in battle, and at Sripurambiyam the Pallava king Aparajita put him down with the aid of the rising Chola power.

There are exquisite temples representing all these periods of early Pandyan history. One of their cave temples is at Tirumalaipuram in a rock known as Vannachchipparai. Facing the Podiyal Mountains, which are associated with the sage Agastya, this cave has two massive pillars and two pilasters on which are simple lotus medallions, much like those in early Pallava shrines. The elephant fish decorates a circular medallion on the pillars. The pillars are tripartite; the lower and top portions are square in section, the central part octagonal. The temple's plan is simple—a mandapa leading on to a cell situated to the west. The door guardians lean heavily on huge clubs. Like other early door guardians, they have a single pair of arms and a mass of wiglike hair under a crown adorned with gems. They each also wear an armlet, a heavy girdle with a ribbon-shaped loop, a stomach band, heavy earrings, and the sacred thread. The heavy bodies of these figures are like those of the Pallava door guardians. There are four large carvings of deities in niches—Brahma, Ganesha, Vishnu, and a dancing Shiva. As in earlier Ganesha figures, most of the length of the proboscis extends along the paunch and curls at the tip to hold a sweet. In two of his four arms, Ganesha holds the noose and the sweet. His ears are spread out and the single tusk is prominent. A crown in the shape of a pile of pots adorns his head. The sacred cord over his right arm, Vishnu stands erect and holds the conch and the discus. He wears a heavy cylindrical crown, and a somewhat enlarged halo surrounds his head. He also wears heavy earrings, and in his lower right hand he carries what looks like a fruit or a bud as in very early Nolamba sculpture. Nataraja, who dances in the *catura* pose, has his left hand thrown up while the right hand is almost in the attitude of beckoning to bestow boons. A dwarf plays a folk instrument resembling the vina. Brahma has the sacred cord over his right arm and a water vessel in his left hand.

An early cave temple at Tirupparamkunram is unfortunately almost hidden by a comparatively late Nayak structure in front of it. The cave has the usual heavy pillars and pilasters with three cells in the main hall facing the mandapa and two side cells. Skanda, Durga, and Ganesha are in the main cells and Vishnu and Shivalinga in the two side ones. But all of them are covered with a heavy coating of plaster and oil that makes it almost impossible to determine their original features. There are two panels on the outside wall of the cella containing the Shivalinga that remain untouched and provide a glimpse of the skill of the early Pandyan carver. Between the three pilasters and just above the gargoyle there are two panels. Shiva dances in one, and Parvati as Shivakamasundari, Ganesha, and other divinities watch from the other. Here Shiva has four arms, dances on an apasmara, and carries the banner of the bull just as he does at Pattadakal. Nandi the bull also watches and listens with rapt attention that recalls the line "the animal, the child and even the snake can appreciate music"—*pasur vetti sisur vetti vetti ganarasam phani*. Parvati rests one hand on a dwarf maiden and holds a lily in the other; an orchestra of dwarfs plays the flute and drum; and Vishnu, Brahma, and others watch the dance from behind the clouds. The entire composition is delightful.

At Anamalai, not far from Madura, a temple for Narasimha was carved in the rock by Madurakavi, the chief minister of King Nedunjadayan Jatila Parantaka. Near this is the temple of Ladamuni, where Skanda as Devasenapati, the god of war, is seated with the personified army of the celestials as his consort. The attendant figures flanking the cell are seated and face toward the deity inside the shrine.

In the cave temple at Kunnakudi, which is like most of the others of this early medieval date, Vishnu as Garudantika leans on the bird Garuda, an iconographic rarity, reminiscent of the Vrishabhantika figure in the Arjunaratha temple at Mahabalipuram. Garuda has his hands crossed in an attitude of devotion and thus recalls one of the personified weapons portrayed similarly at Deogarh. This characteristic is also observed in early Chera and Chola art.

The eight-armed Nataraja in another cave temple at Kunnakudi has the "forest of arms" feature, just as does the late Pallava metal image of the same subject from Nallur. Two dwarfs on either side keep time to the music, but unfortunately a stucco coating masks the original form of these carvings. The doorkeeper here is massive and has all the usual characteristics of this period including the horns.

Very close to Kunnakudi, the cave temple of Pillaiyarpatti has a lovely relief carving of Shiva or Subrahmanya. Here he has a single pair of arms, and the sacred thread runs over the right hand which is graciously posed in the attitude of offering. It is a very pleasing figure with the usual heavy ornamentation.

At Tirukkolakudi a similar rock-cut temple has a magnificent lifelike sculpture of a rishi which recalls the Munikumaras at Mahabalipuram. With his right hand raised in salutation, he holds lotuses in the left; the upper garment is arranged as a sacred thread over the shoulder, and the folds of the lower garment are neatly arranged.

At Sendamaram in the temple at the foot of the Virasigamani Hill, there are usual doorkeepers guarding the central cell of Shiva. One of them, wearing a heavy mass of hair and a thick sacred cord over the right arm, looks very impressive indeed. The unfinished figures of a nagaraja and nagini, the king and queen of the serpents that face each other in the cave temple at Chokkampatti, appear to be portrait statues of a Pandyan royal family.

By far the most important rock-cut monument of the Pandyan period is the Shiva temple at Kalugumalai, known locally as Vattuvankoil, or "the sculptor's temple," and it is indeed a sculptor's dream fulfilled. It is a simple building, composed only of the vimana and a narrow pillared hall, and it looks like a miniature version of the Kailasa temple at Ellora. The temple is unfinished—the roof of the vimana is wonderfully carved, but the lower portion was abandoned before it was completed. Nevertheless this is an excellent example of early Pandyan art. Shovel shapes and lion heads embellish the horseshoe windows of the vimana. There is a fascinating lotus motif that is composed of both large and small petals, and the decorative border with its tassel pattern is lovely. Two long rows of dwarfs in various attitudes enliven the porch, and the figure carvings in each of the three tiers are extremely beautiful. Some of the celestial damsels are legless half-figures, following a tradition already observed at Mahabalipuram. (These recall the musicians in the anteroom at Konarak whose bodies are elongated above the waist so as to appear in correct proportion when viewed from below.) The figures on each of these tiers are full of life, extremely delicately proportioned, and restrained in their ornamentation. To the south, the figure

wielding a drum is Dakshinamurti, which is unusual for here one would expect to find Vinadhara. To the west is a seated Vishnu; to the north a seated Shiva holds the snake in his Vishapaharana aspect, swallowing its deadly poison to save the three worlds. Higher up in the next tier Narasimha is to the west, Brahma to the north. The *fig. 558* Nandi bulls facing the four cardinal points are so lifelike that they seem to breathe and move, and the dwarfs lined up in a long frieze, curly haired, playing music or dancing, smiling, gesticulating, whispering, or just frolicking, are never-to-be-forgotten examples of their kind. One of them bangs the cymbals close to his ear; another thumps the drum, startling his neighbor; a third takes the flute from his lips, seeming to demand applause for his tune; and another plays with a snake in great display of glee, not fright. It is all a virtuoso display of the fertile imagination of a master sculptor. The Narasimha with its unusual face recalls the famous Narasimha of Badami, just as several other figures of the friezes of monsters and lions and many other of the decorative features recall similar forms in Pallava monuments.

A boulder close to the temple is richly carved with Jain figures. There are yakshas, yakshis, and Tirthankaras with their attendants, but the most beautiful carving is that of the demigod Dharanendra Yaksha guarding Parsvanatha and using *fig. 555* his hoods to protect him from a great storm. Yakshi Padmavati looks on in adoration. This rhythmic composition is a jewel of early Pandyan art.

Some Pandyan painting can be seen in Tirumalaipuram, where birds, flowers, and human figures are painted on the ceiling. But Sittannavasal is the richest storehouse of ninth-century Pandyan wall paintings. And they are delightful—fish, ducks, larger animals, and people gathering lotuses from a pool filled with the flowers are all handled with great delicacy and elegance. The texture of the lotus stalk, the curve of the lotus petal, and the contour of the fish darting in the water are managed with dexterity. The two dancing figures with their simple ornamentation, their coquettishly arched brows, and their arms and legs moving in the rhythmic patterns of dance are most charming.

A remarkable bronze from Poruppumettupatti, now in the Madras Museum, *fig. 292* dates from the end of the early Pandyan period. This work illustrates a dance of Shiva peculiar to the Hall of Silver at Madura—the right leg is lifted instead of the left. Other Pandyan bronzes are from Kodumudi: a Tripurantaka with the early feature of the sacred cord over the right arm and his consort Tripurasundari resting her hand on the braid of her dwarfish handmaid. There is also an extremely important Vishnu from this temple as well as a Nataraja in the lalita pose, a form rarely met with in metal sculpture.

THE CHERAS

Early cave temples built by the Chera dynasty are seen in Kaviyur. That in Vilinjam consists of only a simple cell, flanked not by door guardians but by Tripurantaka on one side and Nataraja with Devi as Shivakamasundari to his left, watching his dance. The latter is unfinished though the Tripurantaka is fully carved. The Kaviyur temple, which is sacred to Shiva, is no more elaborate and bears a close resemblance to the Pallava type. The usual pairs of pillars and pilasters are massive and simple, and there is a rectangular hall in the front of the sanctum. The doorkeeper with hands crossed in an attitude of devotion recalls several other such early forms. Its

simplicity and lack of ornamentation make it a close companion to early Pandya and Pallava forms. In the cave at Irinjalakkuda, the four-armed Shiva Dakshinamurti in the heroic pose, expounding to the sages at his feet, is again in the Pallava tradition.

At Chitaral there are several excellent early Jain panels. In one, Dharanendra Yaksha holds his protective hoods over Parsvanatha, and in another the Yakshi Padmavati—in the attitude of respect also seen at Kalugumalai—is effectively represented. A century later, in the temple at Trivikramangalam, the earliest Chola influences can be seen in the lively dance scenes that decorate the wall of the balustrade on either side of the flight of steps leading to the main temple shrine. Here the figures of musicians vie with those of the dancers. In the temple at Kadangur the *kudakūttu*, or the "dance of pitchers," is a lovely work from the later phase of early Chera art. In the Peruvanam temple at Cochin the caryatid dwarfs support a gargoyle and recall a similar arrangement in the Rajarajesvara temple at Tanjore.

figs. 559, 560

The Kongu area has some interesting cave temples that are contemporary with the early Chera ones and that strongly recall, in both their theme and their execution, the Pallava work at Mahabalipuram. These caves are of the time of the Ay rulers who were friendly with the Pallavas. The figures of Ranganatha, Lakshminarayana, Bhuvaraha, and Vaikunthanatha are especially noteworthy here.

Chera bronzes combine Pallava, Rashtrakuta, and Chalukya features. For instance, in the two early images of Vishnu in the Trivandrum Museum, the more elegant, though unfortunately mutilated, figure wears a peculiar tasseled necklace, the *ananta* type of armlet, a decorative crown, and an arrangement of loops over the lower garment. Thus this figure combines the decorativeness of the Chalukya style and the simplicity of Pallava art.

A fragment of a Chera painting from Tirunandikkarai that shows the face of a *mahāpuruṣa* ("great personage") is from the earliest phase of this period. It closely resembles the figures from cloister cell 34 in the Kailasanatha temple. The entire wall of the mandapa of this cave was once covered with murals, but only this fragment remains to give an idea of the glory of early Chera painting.

THE WESTERN GANGAS

The Western Gangas who ruled Gangavadi from their capital at Talakad on the Cauvery River were, though eclipsed by the Rashtrakutas and Chalukyas, a power to be reckoned with. Durvinita and other monarchs of this family were Jains. A sculpture of the ninth century now in the Bangalore Museum shows the style of Ganga workmanship. It presents an unforgettable scene—Nitimarga, the Ganga king, receiving the crown from King Rachamalla who lies on his deathbed. But it was Chamundaraya, Rachamalla's minister and general, who was responsible for the greatest Western Ganga monument, the colossal image of Gomatesvara (c. 983) at Sravanabelgola. This fine image is a tribute to the workmanship of the Ganga sculptor.

fig. 556

THE CHALUKYAS

In the Deccan the Western Chalukya throne (550–753) was successively occupied by Kirtivarman, by his young brother Mangalesa, and then by his son Pulakesin II who succeeded his uncle in 609.

Mangalesa created the magnificent cave temples at Badami. The Vaishnava

cave bears an inscription of Mangalesa dated 579, the twelfth year of his reign, that is both interesting and important. It describes the temple as "exceeding the height of two men and of wonderful workmanship, extensive in its major and minor parts, the ceiling and sides all extremely beautiful to behold" (*paramabhāgavato layana-mahāviṣṇugṛiham atidvaimānuṣakam atyadbhutakarmaviracitam bhūmibhāgopabhāgopari par-yantātiśayadarśanīyataman kṛtvā*) and states that the image of Vishnu was installed in the cave. So devoted was Mangalesa to his brother Kirtivarman that he bequeathed the cave offerings to his royal brother in heaven. A look at the inscription compels the visitor to look at the ceiling and walls to appreciate the wonderful decoration of the cave by Mangalesa's craftsmen. Among the things that the visitor sees are sculptures such as the monumental Vishnu seated on the coils of the serpent and representations of Trivikrama, Narasimha, Trailokyamohana, and Varaha. The ceiling is magnificently carved—the guardians of the four quarters are encircled by lovely patterns of snake gods. The bracket figures on the pillars include Shiva and Parvati, Manmatha and Rati, and other works of great literary and aesthetic value. The cave, which is composed of a veranda, a large mandapa, and a main shrine at the far end, contains many other exquisite carvings. Its plinth has a long row of dwarfs on either side of its steps, and the great variety of facial and bodily expressions in the dwarfs testifies to the mastery of the sculptor.

fig. 130

The cave was originally completely covered by wall paintings, but today there are only a few fragments left. Some painting is visible on the vaulted ceiling of the mandapa. There is a seated figure who appears to be Indra, in his magnificent Vaija-yanta palace. He rests a foot on a stool and wears a crown and a beautiful necklace with a pendant decorated with tassels in the Chalukyan style, as he witnesses the dance of Tandu or Bharata. The female dancer may be Urvasi. Female musicians play the flute and the drum.

The accompanying panel depicts a royal figure seated at ease, his right leg on the footstool, the left one raised and placed on the seat. There are several attendant princes seated on the ground to the right. The usher, a woman holding a staff, is toward the far end. The queen is attended by female chowrie-bearers and other attendants who paint her feet with red dye; while the prince is swarthy, the queen is fair. This is clearly a royal group and very probably portrays Kirtivarman himself, suggesting that the ruler in all his glory liked to be thought of as not inferior to Indra in his court—an idea that was often expressed by Indian poets. According to Kalidasa, the thunderbolt of Indra in heaven and the bow and arrow of the king on earth sustain the two worlds. The earthly ruler, when he reaches heaven, becomes partners with Indra. As Mangalesa expresses it—"When he [Kirtivarman] aspired to the glory of Indra in heaven, his brother Mangalesa became the king" (*tasmin sureśvaravibhūtigatābhilāṣe rājābhavat tadanujaḥ kila maṅgaleśaḥ*).

fig. 132

In another fragment there are a pair of flying celestials, one of them wearing a crown and the other a beautiful braid. The hand of one is on the neck of the other, and one is fair, the other swarthy. They recall the lines of Kalidasa, "This king is dark like a lily, you fair like musk; let you both unite like the cloud and lightning." These limited remains are invaluable for an appraisal of sixth-century painting in the Deccan.

There is, however, a great deal of Western Chalukyan sculpture of the sixth, seventh, and eighth centuries. There are glorious ruins at Aihole, Badami, Pattadakal,

Alampur, Bastar, and elsewhere. The Mahakutesvar inscription of the sixth century, which is contemporary with the last phase of Gupta-Vakataka art, explains the close resemblance of the Chalukyan style to that of Vakatakas. In Aihole there is one of the earliest Western Chalukyan monuments, the Durga temple. Exquisite relief panels of Shiva, Narasimha, Mahishamardini, Vishnu, and Varaha beautify the apsidal shrine. The pillared mandapa also has lovely carvings. On its ceiling there were several flying Vidyadharas, two panels of which are now in the National Museum. The Narasimha from this temple, like the simple form of Shiva, is very impressive and resembles the gigantic and imposing Narasimha at Badami. It is interesting to note that the modeling on the face of this Narasimha recalls an early Pandyan representation in the monolithic temple at Kalugumalai.

fig. 390

A simple early temple is the Lad Khan at Aihole, whose facade is decorated with both the brimming-vessel and the loving-couple motifs. One of the celestial musicians here has the equine face, making the figure an *aśvamukhi*.

In the Papanatha temple there is a most striking example of Tripurantaka on a pillar. And the entire story of the *Ramayana* is sculpted here in panels with identifying labels. There are also many innumerable well-carved loving couples in a variety of poses.

figs. 296, 128

In another early temple here, the Kunti, there are reliefs of Shiva, Vishnu, and Brahma on the ceiling. The famous Seshasayi, Haragauri, and Brahma panels from this temple are now in the Prince of Wales Museum and are exquisite carvings of this period. The most magnificent stone renderings of Ambika is unquestionably the one in the Jain temple on the hillock at Aihole which bears the famous inscription of Pulakesin II. It is very naturalistic and unconventional—not a frontal view but rather a three-quarter one—done with all the skill and grace the sculptor had at his command.

fig. 539

At Aihole a simple type of figure carving, which follows an earlier tradition, is seen in such examples as the Vishnu seated on the snake from the Huchiyappa temple (now in the National Museum). Shiva dancing with the Seven Mothers, a grouping that is peculiar to medieval sculpture in Madhya Pradesh, Rajasthan, and Uttar Pradesh, is particularly well depicted in the Ratapadi cave at Aihole. The figures are somewhat unusual, with elongated headgear, and are quite unlike any other contemporary sculpture.

fig. 131

Among the caves at Badami, Cave 4, which is Vishnuite, is without doubt the most important. Cave 1 is also outstanding and contains magnificent sculptures of Ardhanarisvara, Harihara, and Nataraja.

A slightly later phase of early Western Chalukyan art is seen in the Virupaksha temple at Pattadakal, a gem of temple architecture constructed by Trailokyamahadevi, the queen of Vikramaditya II. The inscription here notes that the temple was built by the southern architect Sarvasiddhi who had "great proficiency in the art of architecture and sculpture and could fashion a great variety of monuments in different styles." This inscription also confirms Vikramaditya's victory over the Pallavas, as well as his appreciation of the temple of Rajasimhesvara at Kanchi (he brought southern sculptors from Kanchi to beautify his kingdom). It is also interesting that Trailokyamahadevi, with her flair for art, supported temple building in much the same way as the Pallava queen Rangapataka helped her husband, Rajasimha, in his artistic activities at Kanchi.

As at Pattadakal, Shiva Tripurantaka is shown seated in the warrior pose. This form is seen in many Pallava sculptures and appears in Chola times in an unusual gigantic painting in the Brihadisvara temple. Among the elegant sculptures in the Virupaksha temple are many that depict episodes from the *Mahabharata*, the *Ramayana*, and the Puranas. The loves of Ahalya and Indra are shown in great detail, as is the Churning of the Ocean and the descent of Ganga from heaven to earth and thence to the netherworld. Here is an example of the depiction of erotic scenes allowed by the *Vishnudharmottara* in temples and palaces but forbidden in private homes.

figs. 201–4, 37

Pulakesin II (c. 608–c. 642), the military genius who checked the advance of Harsha and was the acknowledged sovereign of the Deccan, took his brother Kubajavishnuvardhana along on his tour of conquest. After his victory in the Vengi area, he went on to Kanchi and established his brother as viceroy at Vengi.

In the long Chalukyan tradition of artistic patronage, Kubjavishnuvardhana erected colossal temples near Bezwada. And with a catholicity that was characteristic of great rulers, the consort of this king built Jain temples there. A pair of monumental door guardians, one of them inscribed and now in the Madras Museum, and a pair of gigantic elephants illustrate the grand style of the period. In the early stages the Eastern Chalukya, as this dynasty was called, drew its inspiration from the Western Chalukyas. Thus the colossal figures here are not unlike those in the cave of Mangalesa at Badami or the earlier Vakataka ones at Aurangabad, Ellora, Ajanta, and Elephanta. Of exceptional beauty, the guardians wear armlets and other ornaments that bear the lion-face motif. The sacred thread that one of them wears is entwined with lotuses and lilies; the other's has bells suspended from it at intervals. With a finger raised in the attitude of warning and a hand in a pose of wonder, these four-armed figures arrest the attention of the spectator. The inscription on the back of one of them gives the name of the sculptor—Gundaya—and states that he was the favorite sculptor of the Eastern Chalukyan king.

fig. 125

It is learned from inscriptions that the warlike Vijayaditya II, or Narendramrigaraja, built a temple for each of the battles he fought in the twelve years it took him to establish himself as the sovereign of his realm. Most of these monuments of gratitude have perished, but some still exist. Probably from one of these are such fragments as the lovely carved capitals, friezes from plinths and cornices, and various other carvings that compose the impressive mandapa at Jamidoddi, not far from the Akkannamadanna cave. Equally interesting is the ninth-century pillar (the date is corroborated by its inscription) on the Indrakila Hill that depicts episodes from the story of Arjuna and Kirata.

In the Eastern Chalukyan temple at Bikkavolu the Ganga-Yamuna motif on the doorway reveals an important historical fact. This motif always appeared on northern doorways during the Gupta period. When Vikramaditya triumphed over the Pratiharas, the motif was carried to Badami. The Rashtrakutas, the successors of the Chalukyas, also used this motif. The Eastern Chalukyas, however, did have moments of triumph over the powerful Rashtrakuta dynasty. Vijayaditya III defeated Rashtrakuta Krishna II and then used the Ganga-Yamuna motif at Bikkavolu almost as a trophy of victory. Vijayaditya III was a great builder, and the temples at Bikkavolu, particularly the Golingesvara and Rajarajesvara, contain great sculptural wealth. The floriated-tail makara decorations on the niches recall Pallava work, while at the same time frequently simulating Chalukyan decorative skill. In Eastern Chalukyan

temples one also sees the elegance of Pala and Eastern Ganga forms. These are simple, elegant vimanas, square in plan with a pyramidal roof and a shikara not unlike a Pallavan one and with the same type of arrangement of niches, pillars, and pilasters. And many sculptures are similar to those found in neighboring regions; for example, Nataraja has four arms as in the southern mode. The peacock of Skanda and the swan of Brahma are extremely naturalistic and pleasing as in early Western Chalukyan work. The Ganga here is very like that at Pattadakal, and Ganesha, whose figure is seen even on the vimana top, has a single pair of arms and a natural elephant head without a crown, not unlike the image on the bronze seal of Gunagavijayaditya. Lakulisa appears in place of the more common Dakshinamurti, and Ardhanarisvara is shown with one foot on a bull and the other on a lion. These forms originated in Kalinga, which had long and abiding political and cultural contacts with the Chalukyas.

figs. 267, 505-7 King Bhima, another bellicose Eastern Chalukyan ruler, built a temple for Shiva (named Bhimesvara after him) at Samalkot and an even more famous shrine at Draksharaman. Another temple of his time is the Parthasvami on the Indrakila Hill at Vijayawada. The kingdom of Vengi was a meeting place of Western Chalukya, Eastern Ganga, Pallava, Rashtrakuta, Haihaya, and Chola traditions, and all these influences are clearly seen in the sculptures at Bikkavolu, particularly in the Golingesvara temple. The "crown of hair" of the lovely large Ganesha here is reminiscent of Eastern Ganga and Pala traditions. And the Surya here, unlike those in southern India who are barefoot, wears top boots and closely resembles the Surya from the Kalinga territory. Vishnu, however, carries his club and his conch in the Pallava-Chola manner rather than in the Pala or Kalinga fashion. Here Brahma has no beard and is nearer the Pallava idiom.

THE RASHTRAKUTAS

With the weakening of the power of the Western Chalukyas, Dantidurga, a warrior-prince, asserted himself and became the ruler of the Rashtrakutas. However he was short-lived and was soon succeeded by his uncle, Krishna I, the creator of one of the most wonderful monuments in all Indian art—the Kailasa at Ellora. For over two centuries, from 750 to 973, the Rashtrakutas wielded extraordinary power and were constantly at battle with the Cholas, Cheras, Chalukyas, Chandellas, Pratiharas, Haihayas, and Paramaras. But despite their great battles and military triumphs, the Rashtrakuta kings found the time for the arts of peace. The great Kailasa temple is described in a Rashtrakuta copperplate grant as "compelling the admiration of even the celestials, who pause on their heavenly course to gaze at the beauty of so magnificent a monument and wonder how anyone could create so extraordinary a structure."

This stupendous monolithic temple was hewn from the top downward out of a hill of solid rock. The entire plan of the huge edifice was always present in the mind of the sculptor as he carefully worked his way down. The work was done with a precision rarely equaled in Indian architecture. The entire edifice—the several pillared halls, the cloistered cells, the large court, the monolithic elephant, the banner pillar, and the front tower—was chiseled from that one large hill.

It should be remembered that the Kailasa temple was patterned after the Vru-

paksha at Pattadakal, which in turn has its ultimate source in the Rajasimhesvara temple at Kanchi. Therefore the southern traditions were brought to the Deccan. The carvings here are of the great and oft-repeated themes: Lakshmi amid lotuses; Ravana shaking Mount Kailasa; Shiva as Tripurantaka; the Seven Mothers; Rati and Manmatha; celestial guardians such as Indra, Agni, Vayu, and so forth; and the auspicious treasures Sankha and Padma. In addition there are other such important groups as Ganga, Yamuna, and Sarasvati (the three famous rivers that have their confluence *figs. 198–200* at Prayag; their presence here indicates that the Kailasa temple is almost as holy as Prayag itself) and a rare sculpture of Ravana offering his severed heads to Shiva. *fig. 350* There are also miniature carved illustrations of tales from the *Ramayana*, *Mahabharata*, and *Vishnupurana*, such as the fight between Vali and Sugriva and Ravana attacked *fig. 351* by Jatayu. Other episodes are seen in lovely large carvings on the main wall of the shrine, thus creating a magnificent sculpture gallery in the temple itself. Among the loving couples some depict Kalidasa's yaksha who longs for close unison with his beloved—*aṅgenāṅgam pratanu tanunā gāḍhataptena taptam sāsreṇāśrudrutam aviratotkaṇṭham utkaṇṭhitena* (*Meghadūta*).

The elephant caryatids at Kailasa are forms with a long tradition; they are *fig. 549* also found in the Ruvenvali stupa in Ceylon and the Arjunaratha temple at Mahabalipuram. There are a number of other Rashtrakuta monuments in the early Chalukyan style, of which the Kuntesa temple, showing an advance in style, is interesting. Many of the elements here—the decorative foliage, the cloud patterns, the jeweled crowns and ornaments, and the elongated halo—are distinctive characteristics of the Rashtrakuta school. A few decades later Rashtrakutas excavated the Indrasabha, a famous Jain monument at Ellora. Its facade is very impressive, and the loving couple on the upper gallery is done with great taste. The carvings of Ambika and Indra, *fig. 548* which face each other, are masterpieces. The Gomatesvara flanked by his sisters is a figure of great elegance, and though not as large as the later monolithic Ganga figure at Sravanabelgola, it certainly is more delicate. A Gomatesvara very similar to this is the famous Rashtrakuta bronze in the Prince of Wales Museum. The bronze lamp chain, found in the Jogimara cave and now in the Prince of Wales Museum, and the bronze Devi (or Yakshi) in the British Museum are other fine examples of Rashtrakuta metalwork.

The murals in the Kailasa and Indrasabha temples show that the Rashtrakutas continued the painting tradition of the early Western Chalukyas. The paintings in the Kailasa temple of Natesha, of Lingodbhava flanked by Brahma and Vishnu, and of the very lifelike elephants in a pool of lotuses, as well as those of the guardians of *fig. 139* the four cardinal points and the flying celestials in the Indrasabha, are excellent examples of Rashtrakuta painting of the eighth and ninth centuries.

THE NOLAMBAS

During this great period of artistic expression even the weaker dynasties were intensely active. The Nolambas ruled an important portion of the Chalukyan realm from their capital, Hemavati. They were feudatories at one time or another of the Western Gangas, the Western Chalukyas, the Rashtrakutas, and the Cholas, yet they were powerful enough to maintain their individuality. Though following the Chalukyan style, their sculptors maintained a special distinctiveness that makes the

Nolamba school fascinating. The Chola monarchs Rajaraja and Rajendra never tired of mentioning their conquest of Nolambavadi in their inscriptions, and Rajendra eloquently proclaimed the superior skill of Nolamba sculpture when he took a long row of exquisitely carved pillars from Nolambavadi as a war trophy. He set these around the central shrine of Apparsvami at Tiruvaiyar near Tanjore. And a finely carved pierced window with musical celestial pairs from Hemavati was taken to the Brihadisvara temple by the Cholas.

fig. 554

The Nolambas graced their capital with a number of imposing temples, all in a shining greenish-blue stone that looks like an amalgam of emerald and sapphire. These temples at Hemavati have exquisite carvings on their elaborately wrought pillars. Some of the pillars are burnished and mirrorlike, as if worked on the lathe, but most of them have carvings of the overflowing vase, the lion's head, or the "four dwarfs" motif on them. There also are ornamental lattice windows and screens and elaborate decoration on the ceilings that usually shows the guardians of the cardinal points in addition to intricate designs. But their mandapas and shrines are simple in layout, unlike later Chalukya and Hoysala structures where there is great elaboration even in the ground plan.

One of the finest Nolamba sculptures is the Umamahesvara now in the Madras Museum. (There is an inscription on the pedestal naming the princess Pasanabbe as the donor.) Also in that museum is an exquisite Surya with the intricate ornamental jewelry characteristic of Chalukyan work, an example of ceiling carving showing the celestial guardians, and a loving couple—probably Rama and Sita. In Hemavati itself are a Gajantaka, a dancing figure of Shiva, a Natesha with his legs crossed and his body twisted, several of the Seven Mothers (some of them, like Chamunda, are particularly striking), and the Alingana-Chandrasekharamurti.

This was a period of great heroism and chivalry and warriors were appreciated and commemorated. There are many memorial pillars throughout the land with inscriptions illustrated by striking battle scenes. (The Western Gangas went one step further and once, at least, made a memorial for a favorite hound that had engaged a wild boar in battle and died from his wounds, but not before killing his opponent. The memorial for him carries a striking portrait of the fight and an inscription explaining the scene.)

THE EASTERN GANGAS

The Eastern Gangas, who originally ruled Orissa from Dantapura, were great builders, and some of their very early temples bear witness to the sculptor's appreciation of the earlier Gupta-Vakataka tradition that was continued by them. Among the most early temples is the Parasuramesvara at Bhuvaneshwar, a simple shrine of the *deul* type in the northern style crowned by an amalaka with a large mandapa porch. The Vaital temple, also at Bhuvaneshwar, though slightly later than the Parasuramesvara, is earlier than the Muktesvara, and is particularly important for the wagon-shaped roof of the *deul*, recalling the southern gopuras based on the *śala*

fig. 144

pattern. Because of its stupendous size and typical *deul* construction and decoration, the Lingaraja stands out as a model of Eastern Ganga temple architecture.

The most beautiful miniature temple of the Gangas is the Muktesvara which looks like a delicate carving in ivory. A temple approaching it in excellence is the later

Bhimesvara at Mukhalingam. Here the dancing figure of Shiva is prominently represented in a niche on the top of the vimana facade, a feature repeated in almost all the Shiva temples in the Ganga territory. While the Rajarani temple at Bhuvaneshwar is a special type nearer the Khajuraho style of temple construction, it is more complex in its shikhara decoration which is multiplied over and over again on the tiers in diminishing size.

For sheer decorative detail and historical narration the gateway of the Mukhalingesvara temple is unrivaled. The *naga nagini* motif, with the serpent's coils entwining the pillars and the human part of the anthropomorphic figure holding a jewel, tray, or garland in the most delicate manner, is probably best represented in the porch of the Rajarani temple. The delicate decorative detail reaches its climax at *figs. 149, 571* the Konarak temple, which is a mass of flowery decoration.

The characteristic Gupta grace is seen in early Ganga sculpture. The large panels of sculptures arranged on the three sides of the Bhimesvara temple at Mukhalingam offer the best examples of early workmanship. The Ganesha with twirling trunk and the juvenile Skanda seated with his peacock show typical ornamental detail with a predominant element of pearl decoration. In the Muktesvara temple, which depicts revelry in miniature, the pierced windows show scenes from the *Panchatantra* which are presented with gusto. The celestial beauties (*surasundaris*) represented here vie with the literary heroines (*nāyikās*) in beauty. One of them, a *prositubhartṛka* whose lover is far away, welcomes the bird coming to announce his early return. Naginis offer perfume, garlands, incense, and jewels. In the Rajarani temple, one of the most striking figures is the danseuse slipping the anklet on her foot with her face turned aside in coquettish anger. The young girl who plays the cymbals to coax her peacock to dance was certainly inspired by a line from Kalidasa —*tālais śiñjāvalayasubhagaiḥ kāntayā nartito me yām adhyāste divasvigame nīlakaṇṭhas suhṛd vaḥ*. Among the guardians of the quarters represented here, Varuna with the *pāśa* in *fig. 272* his hand is striking. The *pāśa* itself is peculiar in shape and appears again in the Varunani now in the National Museum. The Nagaraja holding a pot, which serves as an outlet for water from the central cell of the Mukhalingesvara temple at Mukhalingam, is not only a perfect example of artistic charm, but is also important as the inspiration of several such figures in Java.

Remarkable sculptures of early Ganga workmanship are seen at Bhuvaneshwar. In the Parasuramesvara temple two musical groups decorate the *jagamohan* window and there are also a dancing Ardhanarisvara and a seated Haragauri; in the Vaital- *figs. 341, 511, 516* deul there are figures of Mahishamardini Durga, Manmatha and Rati, and Ardhanarisvara; and in the Lingaraja temple a young damsel, elegantly dressed and impatient for her lover, questions her maid. The monolithic figures like Ganesha and Devi, which almost cover a whole side of the central cell of the Lingaraja temple, are a clear demonstration of how the eastern Ganga sculptor, who worked like a jeweler on minute details in miniature sculpture, could also create massive statuary.

Some very fine sculptures have been found at Jaipur in a peculiar pleasing style; of these the Durga among other Matrikas is especially noteworthy. In the ninth-tenth-century temple at Mayurbhanj a special style, marked by rare grace and charm in the contour of figures and extremely delicate ornamental work, is evident. This style from the Bhanja area is noteworthy in Orissa. Monolithic sculptures from Nalatagiri and Lalitagiri are also known, some of which are now in the Indian Museum.

The bronzes of the Ganga school, though not found in profusion, have great historical and aesthetic importance. A Vishnu in the National Museum shows the commingling of northern and southern traditions. Southern elements—the club resting on the ground with a palm leaf on it, the conch held with its pointed end upward, the wheel with no central tassel, and the presence of Sri and Bhudevi as flanking deities—appear in a work whose tone is distinctly northern. In fact, the sculpture closely resembles Pala works from farther north.

Paintings closely resembling the elephant procession at Bagh were recently discovered at Sitabhinji in the Keonjhar District. One painting, damaged by weather, is on the smooth-cut underside of a boulder, known as Ravanacchaya. This dates from the Bhanja dynasty in the eighth century. The royal procession of a king on an elephant, surrounded by cavaliers and foot soldiers, is one of the earliest examples of painter's art in India after the Gupta-Vakataka paintings.

THE VARDHANAS

The reign of Harsha was a glorious era in the medieval history of northern India. Poet and great patron of the arts, Harshavardhana (606–647) succeeded his older brother, Rajyardhana. Although very few monuments remain, they are well enough preserved to allow us to describe the art and architecture of this period.

The Lakshmana temple at Sirpur, built of brick, is a magnificent example of the continuation of the Gupta tradition of Bhitargaon and Ahichhatra. The Mundesvari temple is another important monument of this period. The chaitya windows, the amalaka decoration at the angles, and the large central niche on each of the three sides, following the arrangement of large single panels at Deogarh, are noteworthy characteristics at Sirpur. The apsidal chaitya at Sanchi is a simple but elegant lithic construction. Panels like Surya in a chariot drawn by four horses continue the earliest mode of representation of the god of light. Among the other sculptures that decorated the monuments of Harsha are the Matrikas in the Gwalior Museum. And there is a striking feminine bust with magnificently dressed braid decked with pearls and perfumed by sweet-smelling tender shoots tucked here and there. Her fine muslin shirt with lace-decorated fringe adds dignity to the delicately carved, pleasant features of the damsel, undoubtedly a princess. It is not unlikely that this work is a portrait of Rajyasri, the sister of Harshavardhana who was of pious disposition and helped her royal brother in the affairs of government. The seal of Grahavarman Maukhari, the prince who married Harsha's sister, bears an exquisite bull and two dwarfs. Apart from the seal's importance for its inscription, it is also an object of great aesthetic value—rarely has the modeling of the bull been equaled. A coin of another contemporary of Harsha, Sasanka of Gauda, has been found. It shows Shiva seated on the bull, fashioned in a most elegant manner by a master sculptor.

THE PALAS

In the eighth century eastern India was plagued by great lawlessness and confusion. Fortunately Gopala took control and restored stability through orderly government. His successors, Devapala, Dharmapala, and others, gathered strength and assured the glory of the Pala Empire (765–1175). Dharmapala, the most renowned Pala

prince, was devoted to Buddhism and enriched the monastery at Nalanda. He was kind and helpful to the Sailendra emperors who established close contacts with him and the university at Nalanda. Javanese elements in some of the Pala bronzes of this period demonstrate this close cultural contact.

Bengal has little rock and has therefore developed a tradition of terra-cotta monuments, decorated with interspersed stone carvings. The magnificent stupa at Paharpur, the most imposing in this area, is thought to have been inspired by the famous monument of Barabudur in Java. The long dadoes of terra-cotta plaques *fig. 124* that ornament the Paharpur monument are famous examples of early Pala work. The tenth-century Siddhesvara temple at Bankura, one of the best examples of the nagara type, is a fine terra-cotta work in the Gupta tradition of Bhitargaon and Mahasthan. Important stone sculptures include Radha and Krishna, the boys Balarama and Krishna fighting Chanura and Mushtika, and Balarama with his attributes and snake hoods over his head.

Nalanda was a great center of Pala art and is famed for its beautiful stucco figures, large and imposing yet delicately molded and with a lingering Gupta grace about them. Buddha, standing with his bowl in his hand at the gate of his wife Yasodhara and compassionately gazing at their son Rahula, cannot but recall the well-known Buddha from Ajanta.

The finest stone sculpture of early Pala date is perhaps the Avalokitesvara Padmapani from Nalanda now in the National Museum. The charm of the face and the hair, the delicate way the flower is held, the arrangement of drapery, and the poise of the figure are all remarkable.

The Dacca Museum is a treasure-house of exquisite stone sculptures. A very early Lakshminarayana from Lakshmanakati in this museum is noteworthy not only for its early features, but also for the peculiar representation of Sri and Sarasvati. Here they are not flanking figures but are held in the hands of Vishnu himself. Sarasvati is of special interest because of the vina she holds, which indicates a very early date of the ninth or the tenth century for the figure, as this type of musical instrument went out of vogue after the tenth century. It is noteworthy that a similar harp-shaped vina is seen in the metal image of Vagdevi from Nalanda.

The fish incarnation of Vishnu, Matsyavatara, is best represented in Pala sculpture in the Dacca Museum. The Mahamaya, Ardhanarisvara, Sadyojata, and Nartesvara are also noteworthy. The Nartesvara from Sankarbandha, showing Shiva's dance on the bull while Ganga and Uma wave the chowrie and the celestials watch, introduces a special mode of representing dancing Shiva in eastern India. Parnasabari, Bhrikuti, Khasarpana, and Mahapratisara are exquisite examples of Buddhist sculpture in the Dacca Museum.

The Jain Tirthankaras of the J. C. French Collection in the Indian Museum are important early Pala sculptures. Among the imposing monumental sculptures of Vishnu in the Indian Museum, two are remarkable for elegant workmanship, poise, movement in the devis and personified weapons flanking the central deity, and the way in which the personified *cakra* and *sankha* carry their emblems on their heads.

In Bengal the forms of Nataraja and Vina Dakshinamurti are combined, and there are fine examples like the Nataraja with vina from Ballalabadi and that at Natghar in Brahmanbari. The special stress on the walking of seven steps together by the bride and the bridegroom in the Kalyanasundara form of Shiva is an interesting

feature in a sculpture in the Bangiya Sahitya Parishad Museum. An early figure of Surya in a chariot from Kasipur, Sudarban, in the Asutosh Museum is almost rivaled by a Surya image in the Rajshahi Museum. An unusual Seshasayi Vishnu in stone is on the wall of the temple near Jaipur in Bankura District.

Among the metal images, one of the earliest and most important is the gold-plated Chandi from Chandargaon, south of Comilla, with an inscription of Queen *fig. 276* Prabhavati of Devakhadga dating from the eighth century. An exquisite Balarama from Nalanda, with an inscription stating that it was made in the time of Devapala, is matched by a contemporary inscribed Hariti from the same location. The reign of Devapala was very rich in metal sculpture, and several of the images fashioned during his time record this date in inscriptions.

An interesting early image of Shiva is the Lokesvara Shiva from Barisol now *fig. 279* in the Asutosh Museum. A metal image of Surya from Nalanda, like a similar image from Chandimuda in the Dacca Museum, is noteworthy. Two images in metal stand out in the collection of the Bangiya Sahitya Parishad—a multiarmed standing *fig. 523* deity and a seated Hrishikesa with *gadā* and *cakra* on a lotus. Another noteworthy early image is the birth of Buddha in the National Museum. The Haragauri theme so popular in Pala art has an excellent representation in an image in the Boston Museum. *fig. 522* An unusual image is the representation of a prince and princess on an elephant, recalling a painting at Bagh.

The Kurkihar bronzes represent a distinct style in the Pala school; noteworthy *figs. 521,* examples are the seated Tara, preaching Buddha, descent of Buddha at Sankisa, and *520, 278* the seated Haraguari. The early feature of personified weapons flanking Vishnu in a metal image is seen in a work in the Nalanda Museum. A unique image is the Nartesvara in metal with a group of attendant figures against a Prabhavali. This work was taken from Bengal as war trophy by Rajendrachola Gangaikonda and was placed in a temple close to Chidambaram, where it still rests.

The earliest manuscripts, which are beautifully written on palm leaf and are gaily decorated with paintings, make the Pala school very interesting in the study of Indian miniatures. The flow of the stylus of the Pala craftsman is easily seen in some excellent incised drawings on metal like the famous one from Sundarban in the *fig. 51* Asutosh Museum. The early Pala paintings were book illustrations that follow the classical tradition. The outlines are sinuous, full of vitality and grace. Usually the paintings are centrally placed with texts on either side. The most renowned illuminated manuscript is the *Prajnaparamita*, dated in the sixth regnal year of Mahipala, though there are other outstanding ones such as the *Gandavyuha* and the *Sadhanamala*. The usual theme is iconographic, but there are also pictures illustrating scenes from Buddha's life and the Jatakas.

NEPAL

Early traditions traveled to Nepal where there blossomed a new style with pronounced Pala features. The Nepalese, with their great tradition of wood carving, erected structures in wood like those of Kerala. The wooden facade of the temple, the curvilinear roof, the bracket figures for the pillars, the highly decorated pillars and perforated windows, and the long carved frieze on the cornice show the special

predilection for wood carving in this area. The sculptures in terra-cotta and stone are equally interesting.

The most famous Nepalese temple is that of Pasupatinatha at Katmandu, though it has been remodeled and seventeenth-century elements dominate. Some of the Nepalese stupas date from the beginning of the Christian Era, but renovations have given them a curious modern air.

At the Vaishnava temple of Changu Narayana the beautiful early figure of Narayana, slumbering on the snake Sesha, stands in a pool. Here there are also remarkable early sculptures of Trivikrama and Visvarupa Vishnu. The carving of the Trivikrama scene is delicate, the clouds are wonderfully treated, and the stances of all the figures are exceedingly well done. The Visvarupa is an astounding masterpiece, and even the earlier Gurjara-Pratihara Visvarupa from Kanauj pales before this work. The slumbering Sankarshana with the *caturvyūha* indicated by the makara-decorated plowshare, Vishnu as Viratpurusha supported by the frail yet powerful goddess of earth who holds up his feet with the help of the nagas Vasuki and Karkota, and the elephants of the quarters raising up the entire universe—all are magnificently realized in this work. This form of Viratpurusha is an amazing sculpture typical of the exuberance of Nepal. Shiva as Gangadhara in Nepal sculpture is especially note- *fig. 384* worthy, as the descent of Ganga here is in the *Gaṅgāvataraṇa* attitude known from the *karaṇas* of Bharata, but nowhere else represented in sculpture. The Devi in the Bick- *fig. 530* ford Collection in Cleveland, the Vishnu in the Brooklyn Museum, and the Tara in the Ashmolean Museum are excellent examples of Nepalese metalwork. An image of Buddha seated in European fashion, recalling similar ones of the Gupta period, is a valuable work in the Cleveland Museum, and the Heeramaneck Collection has a *fig. 528* fascinating nimbled image with attendant that is typical of the delicate Nepalese style.

Paintings on wood or on fabric from Nepal are renowned and are found in museums throughout the world. The Shivadharma on the painted bookcover from Nepal Bir Library at Katmandu, the painting of Brahma and Sarasvati on cloth from *figs. 527, 529* the Boston Museum, and the elaborate Vishnupata in the Bharat Kala Bhavan are fine examples of Nepalese painting.

KASHMIR

In the long and tangled tale of medieval history in Kashmir, two dynasties stand out—the Karkota and the Utpala. In the eighth century the Karkota ruler Mukta-pida, a great conqueror, overran Kanauj, surprised and subdued Yasovarman, and established his military prowess. He also immortalized himself as a great patron of art and literature. He founded and beautified the towns of Lalitapura and Pari-hasapura, and the renowed temple of Martand dedicated to the sun-god was his creation. In the ninth century Avantivarman, a powerful, wise, and beloved Utpala king, created a happy and prosperous kingdom. He built the famous Avantisvami temple for Vishnu at Awantipur and the Avantisvara not very far from the Vishnu temple. Kashmir was a great meeting place of cultures, and Gupta, Pala, and Pratihara elements were combined with a strong strain of the Gandhara tradition. This Gandhara influence is easily seen in motifs like the garland-bearers, soldiers armed with spears, damsels in Greek apparel, and so forth. The Martand temple is an imposing one, although now almost completely in ruins, with a huge cloistered and colonnaded

court surrounding the main shrine. The fluted columns with Doric or Ionic capitals, the trefoil niches enclosed by triangular pediments, and the gabled roof are all characteristics of early architecture in Kashmir. The rock-cut temples at Masrur represent a monolithic tradition observed in other parts of the country, and among these simple but effective monuments is a Varuna on makara typical of the sculptures of the time.

figs. 137, 346 The Avantisvara temple at Awantipur, profusely carved with fine figures and designs, has a magnificent panel picturing King Avantivarman with his queen and other attendants journeying to the shrine as a pious devotee. Among other important carvings on this monument are Manmatha with Rati and Priti on either side and a pair of fig. 284 parrots they are fondling. Four-faced Vaikuntha is the favorite form of Vishnu in Kashmir. He is often shown standing with two of his hands resting on the personified club and disk; the lion and boar heads flanking the central face and the face at the back distinguish this iconographic form. A three-headed standing Shiva in the Pratap Singh Museum, as well as Shiva as Kiratamurti and a series of Matrikas including Kaumari, represents the grand style of the sculptor of early medieval Kashmir. figs. 531, 533 The Lakshminarayana on Garuda and the seated Narasimha are other striking examples of this school.

One of the finest examples of metalwork is the large *prabhāvali* for an imposing Vishnu image in the Pratap Singh Museum, which bears exquisite miniature figures of the different avatars of Vishnu, including some rare ones not usually represented. Some of the finest images of the early phase of Kashmiri art are found in Chamba at Brahmaur and Chatrarhi. An image of Devi with an inscription mentions the sculptor Gogga who worked under the orders of King Meruvarman; equally interesting images fig. 67 are Narasimha and Mahishamardini Durga. The inscribed Svacchanda Bhairavi, now in the National Museum, is a striking example of miniature work in metal. An image of colossal size is the striking Vishnu from the Hari temple at Chamba, which illustrates the four-faced Vaikuntha form with Prithvi rising from between the feet to support the legs.

THE PRATIHARAS

In the ninth and tenth centuries, the Gurjara-Pratihara Empire, which encompassed Gujarat, Rajasthan, Malwa, and Uttar Pradesh and bordered on Bihar, had a great cultural influence in practically the whole of northern India. Nagabhata who started the Gurjara-Pratihara line in the eighth century had worthy successors like Vatsaraja who overcame even the Pala king Dharmapala. A clash with the Rashtrakutas, the most powerful dynasty of the time, was often to the disadvantage of the Pratiharas, but they were able to regain their power. The most glorious of the rulers of this dynasty was Mihira Bhoja who in the ninth century triumphed almost everywhere.

The style of Gurjara-Pratihara art became almost the norm in several adjoining areas such as Bundelkhand, Malwa, Kanauj, and Rajasthan; the last had important centers at Osian, Abaneri, Kota, and Bikaner that represent this tradition at its best.

The early Gurjara-Pratihara temples as illustrated in their remains at Osian show a simple pattern of vimana or central cell with a porch on four pillars all of fig. 146 which have the *pūrṇakalaśa* with lotuses as the principal motif. The foliage overflowing at the four corners completes this beautiful pattern.

Some of the most magnificent sculptures found at Kanauj reveal the rare ex-

pressiveness of the Pratihara sculptor. The Visvarupa form of Vishnu is a supreme example of early medieval handling of an age-old theme glorified in the *Bhagavadgita* and the *Purushasukta* of the Rig-Veda. The nagas at the bottom supporting the feet of Viratpurusha indicate the netherworld, their abode, whence there is a gradual ascent to the terrestrial and celestial spheres culminating in the highest ranges of the universe. The principal incarnations of Vishnu, such as the fish, tortoise, boar, and lion, are suggested by their faces on either side; the rest of the incarnations (such as Parasurama, Rama, and Kalki) and the twelve Adityas, the eleven Rudras, Indra, Sarasvati, Kartikeya, and the eight Bhairavas form a body of celestials, all springing forth from the central multiarmed giant figure flanked by the personified weapons. It is an eloquent call "to behold the Adityas, the Vasus, the Rudras, the two Asvins and Maruts, wonders never seen before"—*pāsyādityān vasūn rudrān asvinau marutas tathā bahunyadrṣtarūpāṇi paśyaścaryāṇi bhārata.*

The marriage of Shiva, also from Kanauj, shows all the gods assembled to witness the ceremony. In a sculpture of the same episode from Ajmer of the early Chahamana subschool, the figure is more natural and the composition more genial and pleasing. A frieze of Shiva on the bull watching the musicians and dancers in the Atkins Museum, Kansas City, has all the delicate features of Pratihara work from Rajasthan.

The dancing Matrikas from Abaneri and now in the Jaipur Museum is one of the most beautiful sculptures from a spot which is especially important for a study of this school. Abaneri has also yielded a most magnificent dancing Shiva and a panel depicting musicians playing the vina. Manmatha with Rati and Priti and the lover listening to the music of a lute in spring are masterpieces from Abaneri. Devi is a great dancer, and literary passages have interesting descriptions of Shiva instructing his consort to excel in the art. A sculpture from Abaneri shows her decorating her feet with tinkling anklets. A lovely example of decoration for a waterspout from a temple turret is the two nymphs holding a pot, the flared mouth of which is the outlet for water. The magnificent frieze of musical nymphs and danseuses from the Shiva temple on the Harsha Hill near Sikar was constructed by the early Chahamanas but is in Gurjara-Pratihara style. Other lovely Pratihara works are the Alasakanya from Gyraspur and the marble carving of Varuna on makara in the Prince of Wales Museum. But the most magnificent of all is the Vrikshaka, a damsel against a tree, so sensitively chiseled by the sculptor that it is unexcelled in medieval art. This sculpture in the Gwalior Museum is indeed one of the greatest masterpieces of all Indian art.

An excellent example of Pratihara metal work is an inscribed tenth-century Vishnu with consorts from Mahipala's time. Also of this period is a Vishnu showing his ten incarnations on the *prabhā.*

fig. 76

fig. 348

figs. 287 344, 387

fig. 537

fig. 91

125. DVARAPALA
From Bezwada
East Chalukya, early 7th century
Government Museum, Madras

126. MITHUNA
Early medieval, 8th century
Rajavalochana temple, Rajim

127. FEMALE BUST
From Gwalior. Vardhana, 7th century
National Museum of India, New Delhi

128. HARAGAURI
From Aihole
Western Chalukya, 6th century
Prince of Wales Museum, Bombay

129. HARIHARA
From Madhya Pradesh
Chandella, 10th century

130. VISHNU ON THE SERPENT SESHA
Western Chalukya, 6th century
Cave at Badami, Mysore

131. SHIVA NATARAJA
Western Chalukya, 6th century
Cave at Badami, Mysore

132. QUEEN AND CHOWRIE-BEARERS
Mural. Western Chalukya,
6th century
Cave at Badami, Mysore

133. PARVATI WATCHING SHIVA DANCE
Mural. Pallava, 7th century
Temple of Shiva, Panamalai

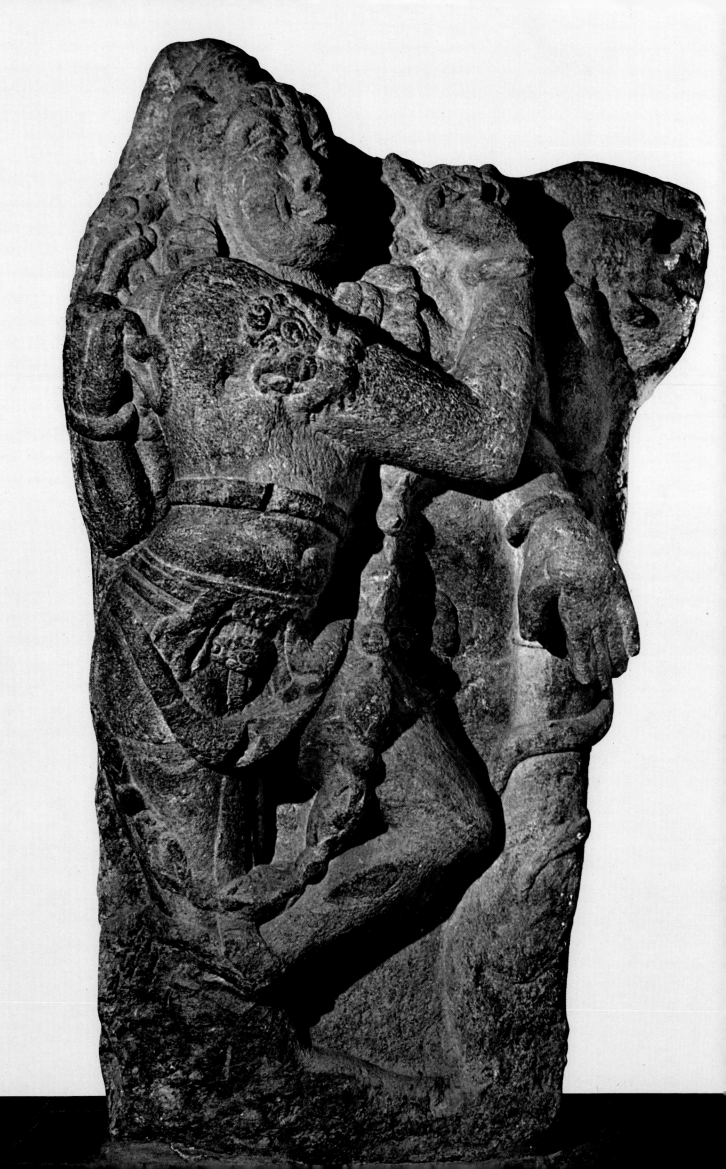

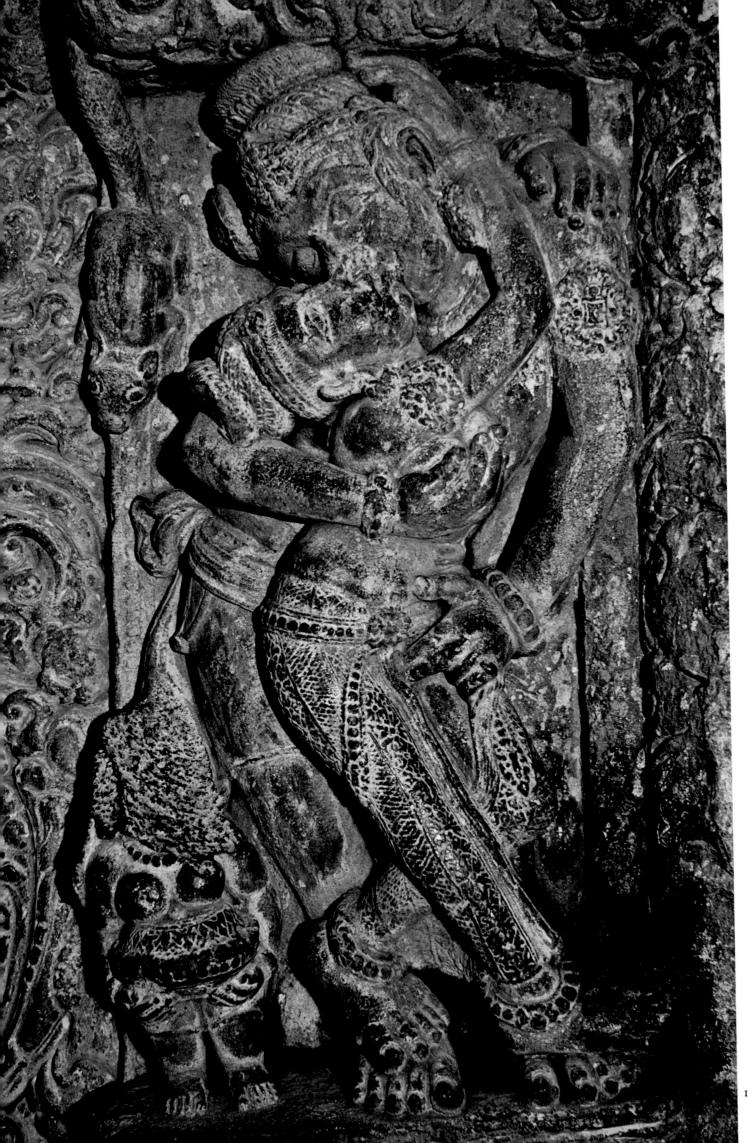

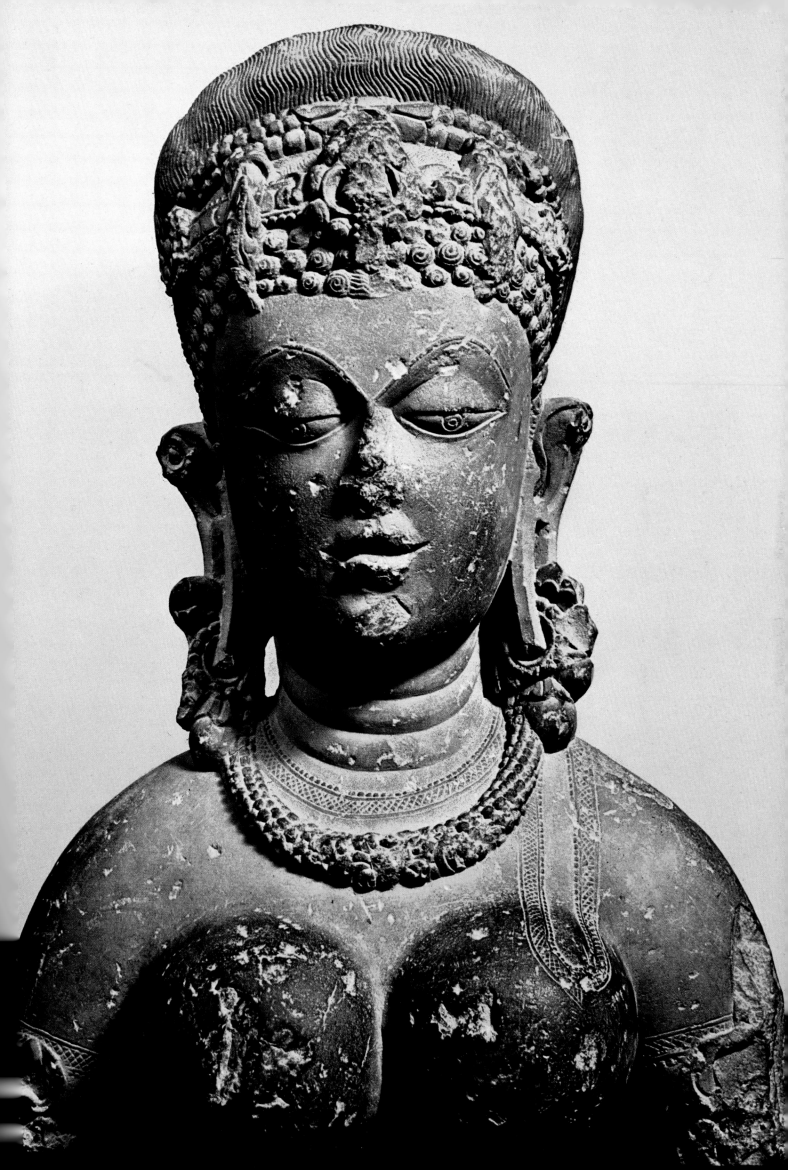

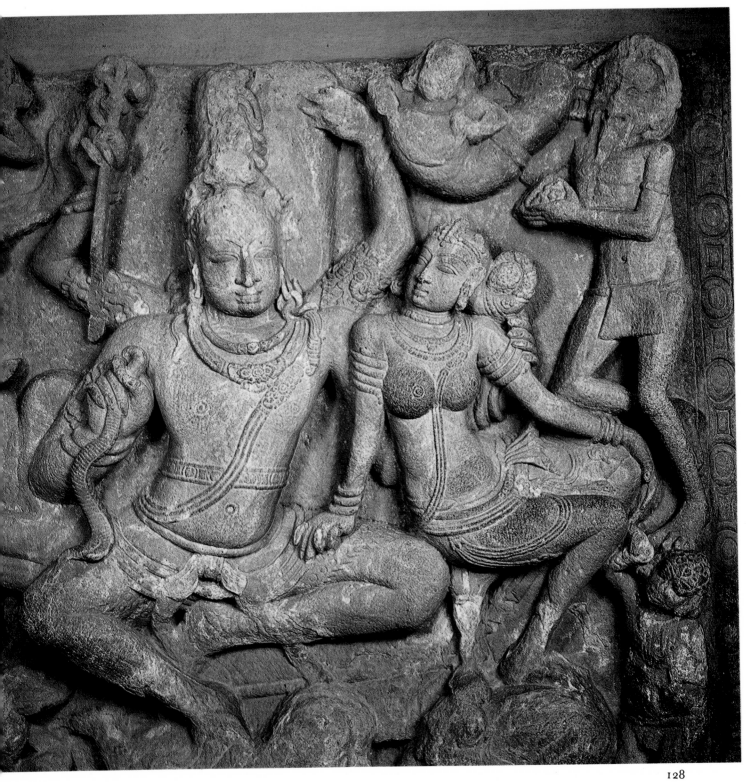

128

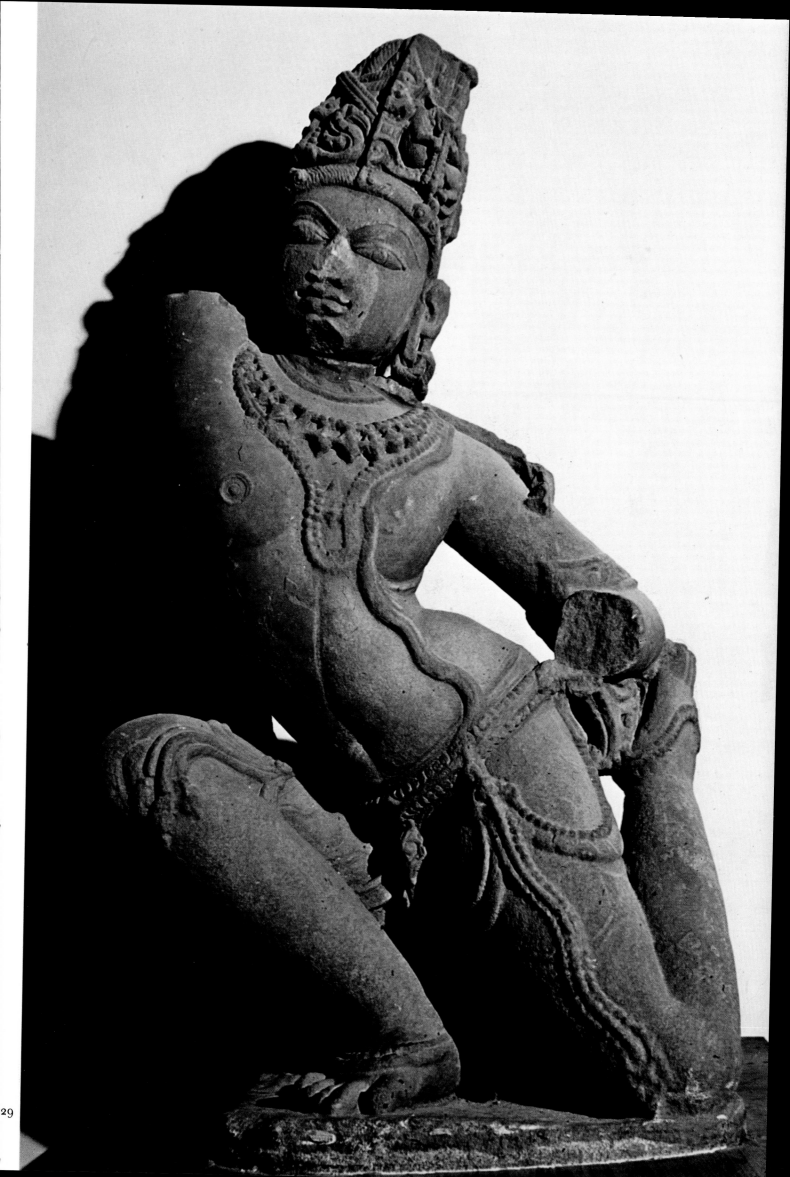

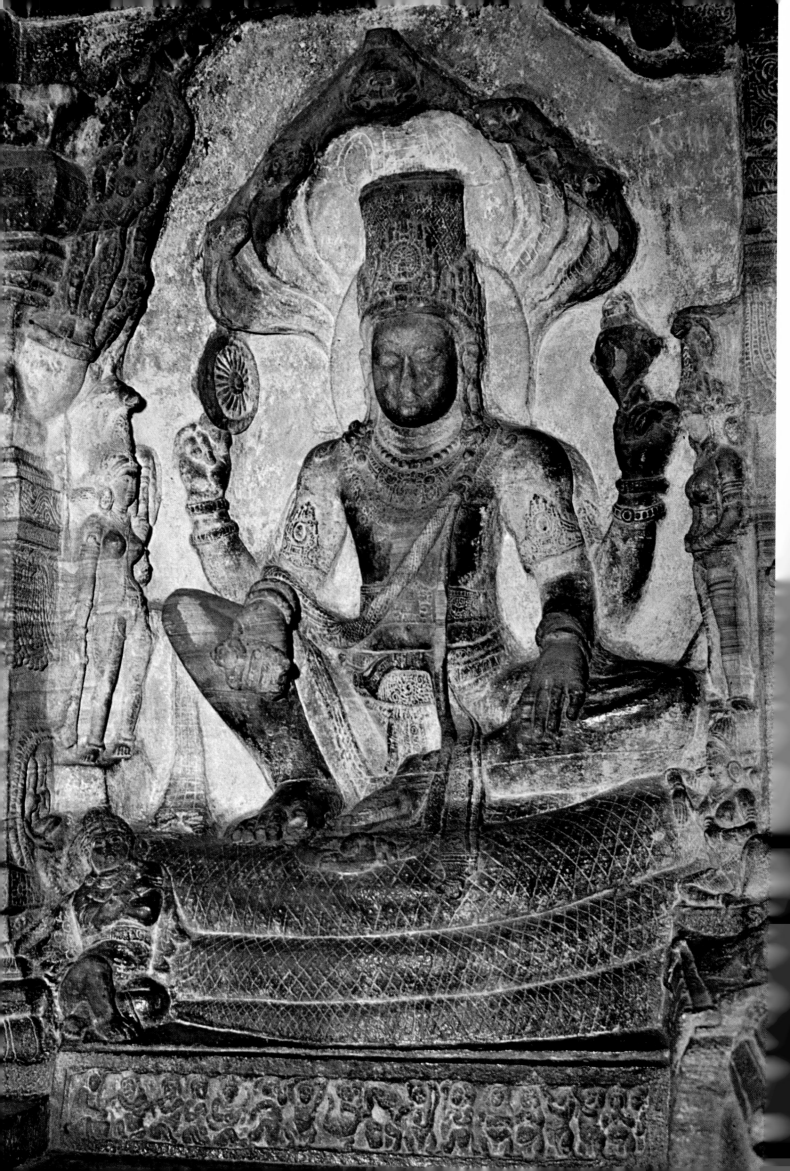

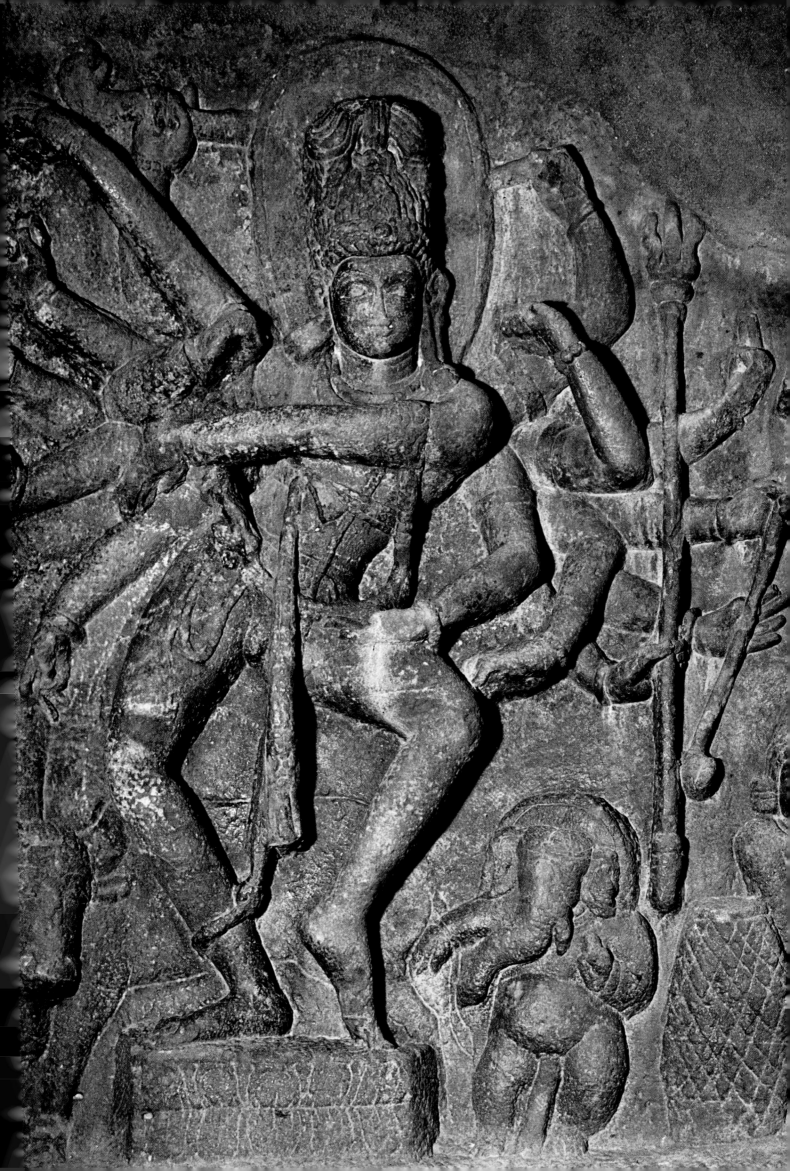

134. SEATED GODDESS
Early Pandya, 8th century
Rock-cut temple, Kalugumalai

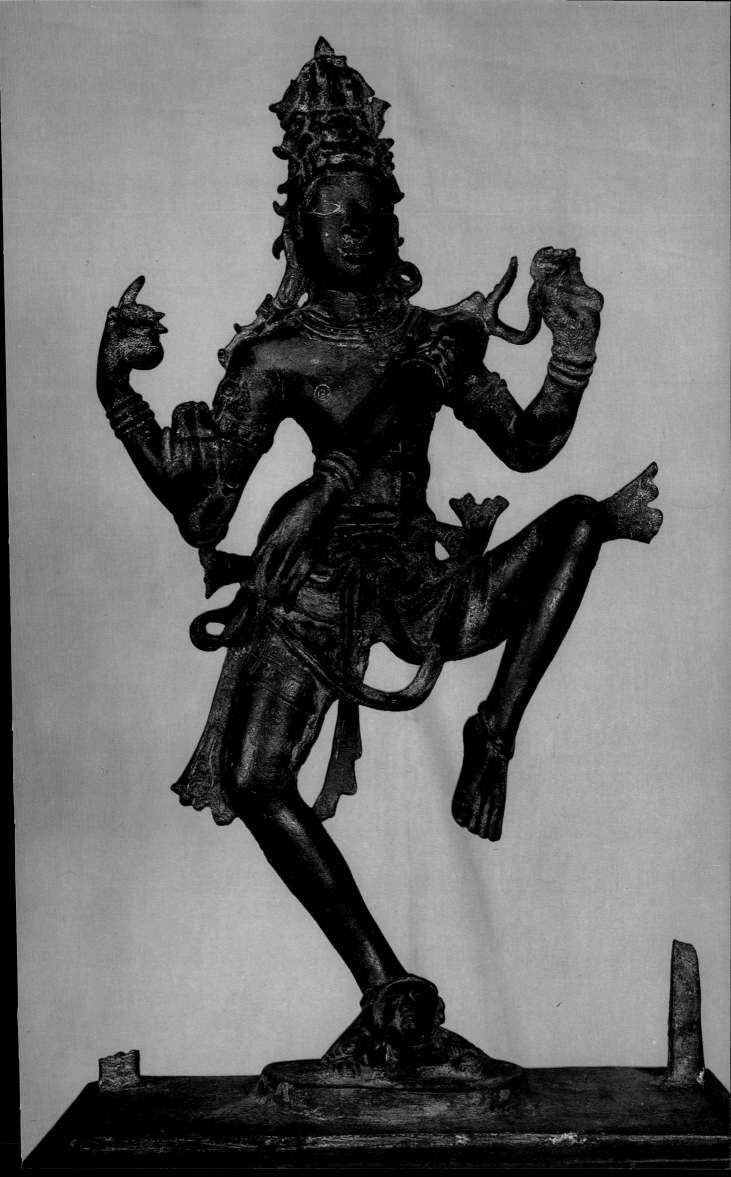

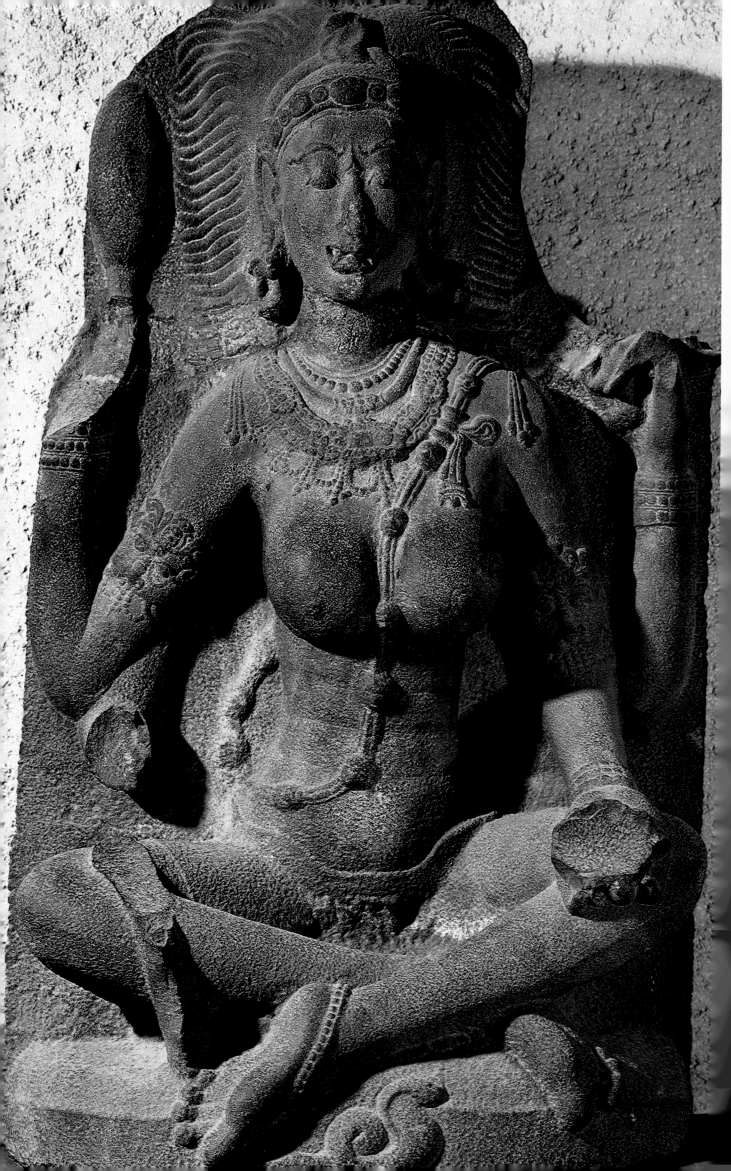

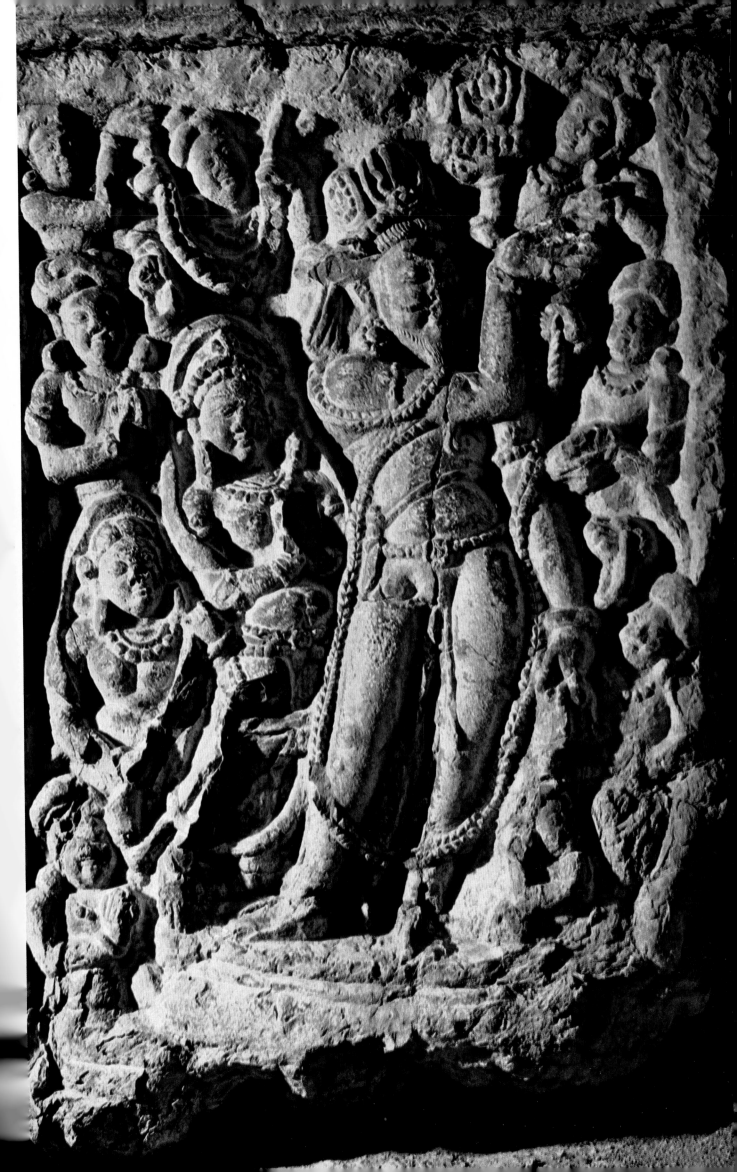

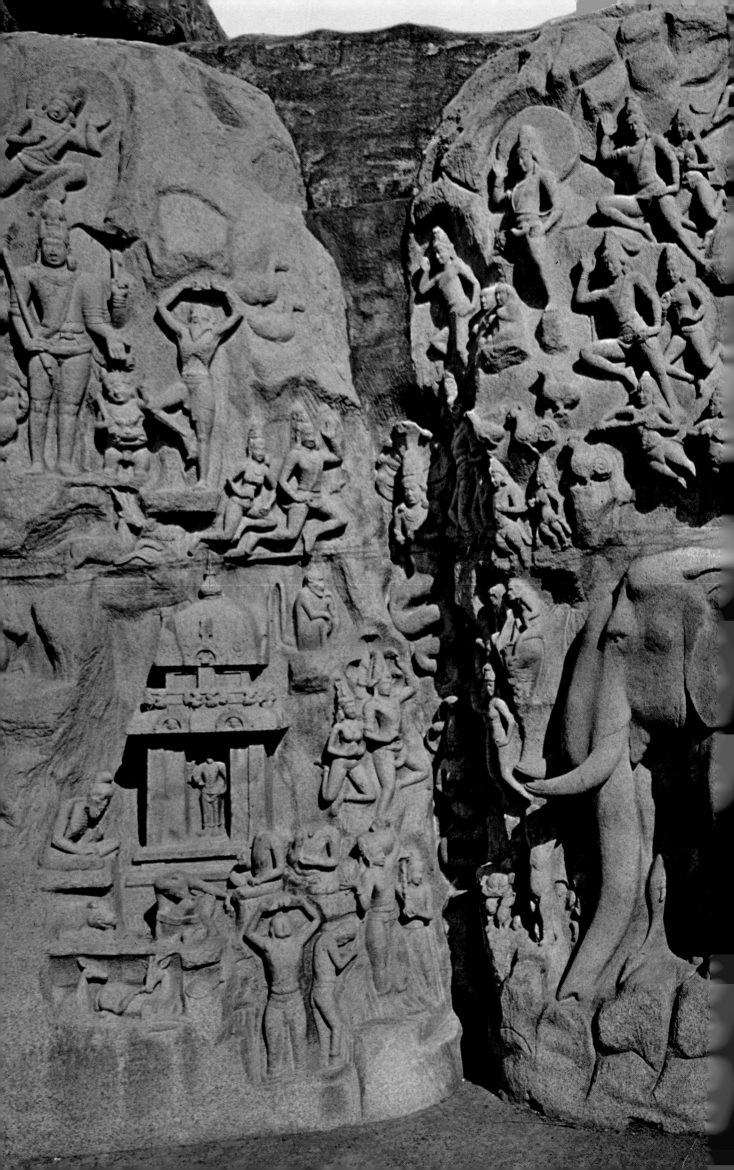

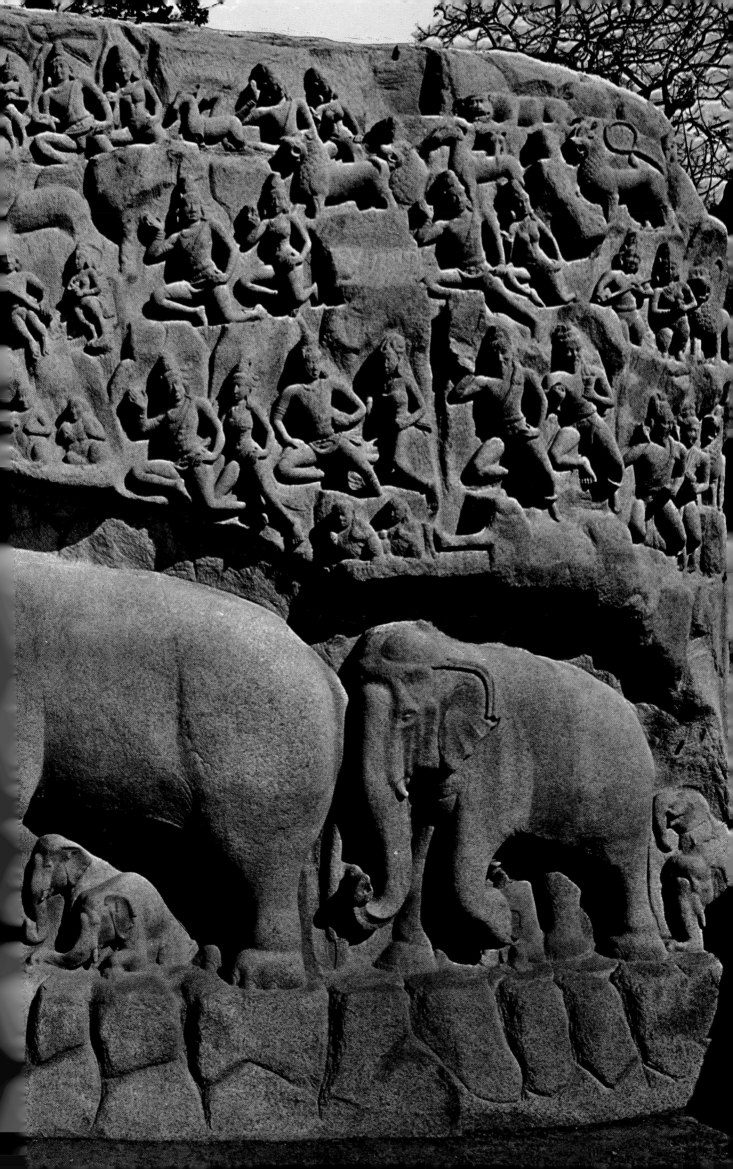

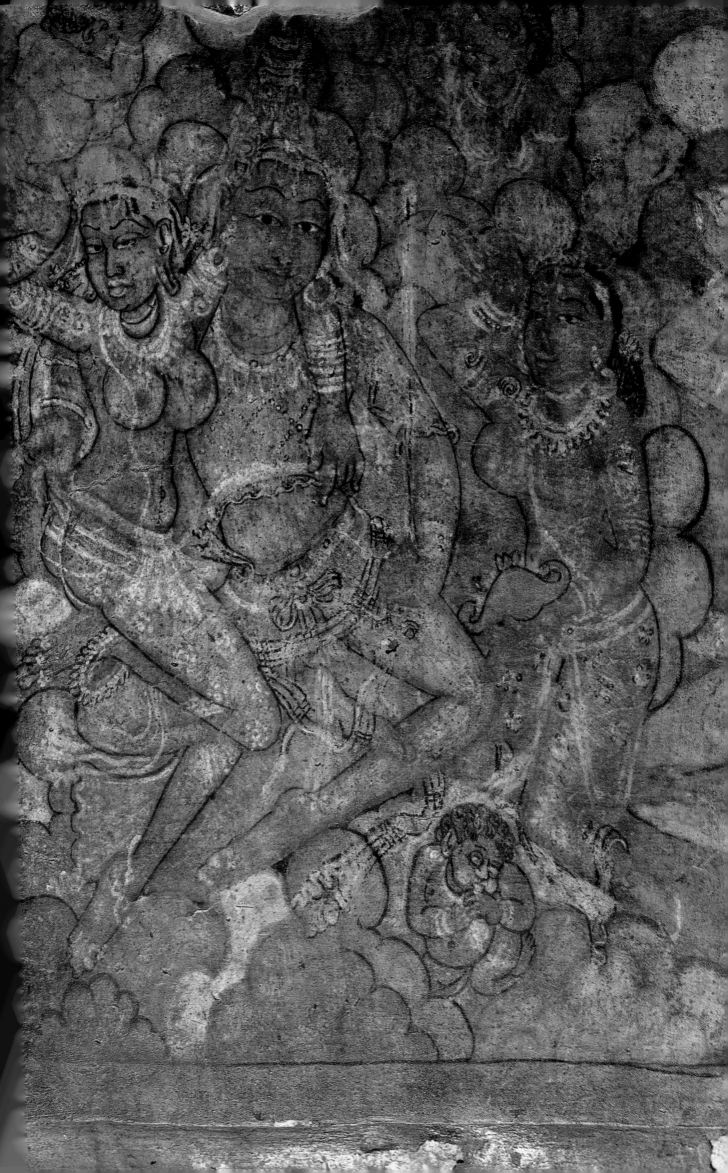

253

TRIUMPHAL ART
OF THE LAST DYNASTIES

THE GANGAS

T‌HE Eastern Gangas (750–1250) who originally ruled from Dantapura were for some centuries less powerful than their southern neighbors, the Eastern Chalukyas. The Eastern Chalukya monarch Vijayaditya II was a match even for the powerful Rashtrakutas; he won over a hundred battles and built as many temples of Shiva as thanksgiving offerings. And Vijayaditya III, known as Gunagavijayaditya, defeated the Eastern Ganga king and received both elephants and gold in tribute. However, the Eastern Gangas were great patrons of art, and their monuments inspired their conquerors to introduce Kalinga motifs in their own art.

In the beginning of the eleventh century, Vajrahasta I, Ganga king known for his great military prowess, established his power in the single consolidated kingdom of Kalinga. Vajrahasta III, a successor of his, waged war against the Chola emperor Vira Rajendra. His son Rajaraja also battled Vira Rajendra; hostilities ceased when Vira Rajendra gave his daughter Rajasundari in marriage to the Eastern Ganga prince. Anantavarmachodagangadeva, the most renowned Eastern Ganga king, was born of this political marriage, and thus his name combines the titles of both the Chola and Ganga families. During his rather lengthy reign he built the famous temple at Puri. One of his predecessors, probably Vajrahasta, Yayati, or Udayota, had built an outstanding temple in Orissa, the Lingaraja, in about 1000.

fig. 145

Visitors to the temple at Darasuram or Chidambaram see a mandapa richly decorated with wheels on either side. The ornamented spokes and the galloping horses in front make the vimana look like a chariot drawn by steeds. Against the balustrade leading to the mandapa, huge elephants are artistically carved. This concept is known nowhere in northern India, and the Eastern Ganga sculptor drew inspiration from these southern mandapas. The world-famed monument at Konarak, the temple for the sun-god, is in this form. But here the number of wheels and horses and the dimensions of the *jagamohan* of the temple are multiplied. The twelve wheels on each side make a total of twenty-four, and there are seven horses yoked to the celestial car. The whole temple is designed as the chariot of the sun-god. The Ganga ruler Narasimha, a descendant of Anantavarmachodaganga, was responsible for the temple at Konarak. It was for the Lord of Glory, the powerful sun-god who vouchsafed victory for Rama over Ravana, that Narasimha built this temple. It was a thanksgiving offering for his military conquest of Bengal and part of the Haihaya territory. Konarak is known for the intricate carving on the wheels and the delicate patterns incised on the trappings of the horses. The decorative skill of the Kalinga sculptor excels even that of the Chola and Chalukya artists. The running monolithic elephants, the detail of carving on the wheel, and the chariot itself are all glorious sights.

figs. 149, 571

The greeting of the rising sun with music and dance is depicted by rows of female musicians on the top of the *jagamohan*. The sculptural wealth at Konarak in-

cludes figures of titanic proportions, appropriate for the huge edifice, and the most intricate decoration of every square inch of rock. The overall pink tone of the rough sandstone is broken by green stone panels that bear delicate carvings of Surya in his different aspects and of scenes from Narasimha's life. One panel depicts Narasimha as a gay prince in a swing. In another, this ruler, also a poet and a great patron of the arts, is shown amid the poets of his court. Other panels show him wielding a mighty bow and adoring at the shrines built by his ancestors, such as that of Shiva at Bhuvaneshwar, that of Durga at Jaipur, and that of Jagannatha at Puri. The *deul* at Konarak has perished, but its glory can be imagined from the dimensions of the *jagamohan*.

figs. 270, 572

The delicacy of thirteenth-century sculpture is seen in the Shiva on the bull and the Varunani on makara, both in the National Museum. The Vishnu with consorts shows the blend of southern and northern elements in style.

THE SENAS

During the eleventh, twelfth, and thirteenth centuries a number of great kings ruled over different areas of the Indian subcontinent. Their patronage of art and literature was as remarkable as their vigor in carving out empires. The weakened power of the Palas was seized by the Senas (1095–1206), a dynasty of southern extraction established in Bengal by Samantasena. Vijayasena, the famous grandson of Samantasena, was a great warrior who expanded his kingdom and became the premier lord of Bengal. He defeated the Palas, while remaining on the most friendly terms with the powerful Anantavarmachodagangadeva of the Eastern Ganga dynasty. A charming inscription describes at length his construction of the temple of Pradyumnesvara with a lotus tank at Deopara. Being great Shivaites, the Senas introduced several lovely sculptural forms including the Sadashiva, a famous inscribed example of which is in the Indian Museum, and the Nataraja, who is frequently depicted in East Bengal. Lakshmanasena, a later Sena ruler, was unparalleled in his generosity to poets. Among those who gathered at his court were Dhoyi, the author of the *Pavanaduta*, and Jayadeva, whose *Gitagovinda* is a classic.

fig. 345

One of the outstanding masterpieces of Sena sculpture is the delicately carved bracket figure of Ganga who stands with a pitcher in hand under the wish-fulfilling tree. Paintings of Buddha's birth and of a Lokanatha, both from the Asiatic Society's Collection, are examples of this art from the transition from the Palas to the Senas.

fig. 36

THE GAHADAVALAS

With the weakening of Gurjara-Pratiharas in the middle of the eleventh century, there arose Chandradeva, founder of the Gahadavala dynasty that ruled from Kanyakubja. A contemporary of Vijayasena, he stemmed the growing power of Bengal. Govindachandra, the son of Madanapala, extended his empire in Magadha and made his power felt in the north. A wise prince, he was on friendly terms with Jayasimha of Kashmir and Siddharaja Jayasimha of Gujarat. Govindachandra's

grandson Jayachandra who, like his father Vijayachandra, was a great warrior kept both the Muslim and Hindu rulers at bay. He waged war against the Yadavas of Devagiri, Siddharaja of Gujarat, and the Muslim ruler Sihabuddin. But his proud isolation—he denied help to his son-in-law Prithviraj—ultimately caused the fall of the Hindu empire in the north. Jayachandra is also remembered for his patronage of Sri Harsha, the author of the *Naishadhiyacharita*.

The Vishnu from near Kutab and now in the National Museum is an inscribed fig. 576 carving typical of late Gahadavala work. An exquisite head from Bikaner is of the same school but earlier in date. The braid of this head has a dainty decoration of pearls, floweis, and tender shoots. The birth of Krishna from the remains of a pil- fig. 575 lared hall of the Vishnu temple at Kutab is an example of Chauhan or Chahamana patronage of art.

This was a time of great military prowess and patronage of art and learning. Among the forebears of Prithviraj was Vigraharaja Visaladeva, the great Chahamana ruler who, himself a poet, patronized poets. Vigraharaja's *Harakelinataka*, which is inscribed on stone slabs at a college at Ajmer (now the mosque Adhai-din-ka-Jhopra), shows the prince's poetic skill.

THE PARAMARAS

The family of the Paramaras (949–1088), who ruled over Malwa from Dhara, was a warlike one, and Vakpati Munja, the son of Siyaka Harsha, was a great hero on the battlefield who put down the Kalachuris of Tripuri and the Latas. The Karnatas under Chalukya Tailapa II also suffered defeat several times at his hands. A great patron of learning, he encouraged Dhananjaya, the author of the *Dasarupa*, and Padmagupta, the poet of the *Navasahasankacharita*. But it was Bhoja (1018–60), the nephew of Munja, who exhibited a rare combination of military skill, statesmanship, personal charm, engineering porwess, and a vast erudition and knowledge. He was adept in medicine, grammar, philosophy, art and architecture, astronomy, and lexicography. He was a warrior-emperor and greatly extended his empire through conquest; but he was also a *kaviraja* ("king among poets") and is known for such works as *Sarasvatikanthabharana*, *Sringaraprakasa*, *Rajamriganka*, and *Samaranganasutradhara*. He ardently worshiped at the altar of learning and installed the famous inscribed Saras-vati (now in the British Museum) at his university at Dhara. Devoted to Shiva, he built many beautiful temples to this god. He was also the architect of the great Bhoja-sagara, one of the largest irrigation lakes in medieval India.

Udayaditya, the successor of Bhoja, secured the fortune of his family after the death of its greatest ruler and was responsible for the temple that is the glory of eleventh-century Paramara art. The wealth of sculptural decoration on the Udayes-vara temple at Udayapur includes charming individual panels. Particularly note-worthy is the huge Shiva group in the semicircular niche on the facade of the vi-mana—multiarmed Shiva dances while Devi watches; a dancing Sarasvati and a dancing Parvati appear in two flanking panels. A similar panel of Shiva dancing is in the Gwalior Museum. The Mahakala temple at Ujjain has some lovely Paramara sculptures.

The weakening of the Pratiharas allowed other dynasties to assume power—not only the Gahadavalas but also the Chandellas (950–1203) grew in importance. The first Chandella princes were feudatories of the Pratiharas. The Chandella ruler Yasovarman became strong enough to challenge the Chedis, the Malavas, and the Kosalas, and he conquered the fort of Kalinjara. His son Dhanga defeated the lord of Kanyakubja and made himself supreme. Kirtivarman, a patron of the arts and literature, added luster to the Chandella name. He patronized Krishna Misra, the author of the *Prabodhachandrodaya*. Madanavarman who ruled in the first half of the twelfth century was among the most important Chandella sovereigns. Like Bhoja, he created a great lake which was called Madanasagara after him.

The Chandellas ruled from Khajuraho, Kalanjara, and Mahoba and embellished their towns with beautiful temples, palaces, and forts. The great temple of Khajuraho proclaims the wonderful aesthetic taste of the Chandellas who with the Gangas have probably contributed the most to Indian temple building. The pride that these kings took in achieving this artistic wealth is evident in the sculpture of the donor king and queen, a fine example of Chandella portraiture.

fig. 143 The most magnificent temple of the Chandellas was the Kandariya Mahadeva, which is a fine example of medieval temple architecture in central India. A high plinth creates a lofty terrace for the temple; projections on the four sides give this terrace a cruciform shape, with the long axis from east to west. The principal sanctuary is surmounted by a huge tower, decorated by tiers of turrets, gracefully reduced in size on their upward march. These turrets are miniature shikharas, *uruśṛṅgas* as they are called; they cluster around the body of the main shikhara, the *mūlamañjari*. The imposing ribbed amalaka with its *kalaśa* reaches a giddy height. The entrance hall with its vestibule and the mandapa, which is separated from the main sanctuary by an antechamber, create a series of rooms that must be crossed to reach the central cell. The *pradakṣiṇapatha* is a perambulatory passage around the central cell. Thus, the temple complex becomes a composition of several independent parts combined to create a unified monument. The doorway to the east has a richly carved toran lintel, and the doorsteps in the shape of the crescent moon are the *candraśilās* so characteristic of medieval temples. The decoration on the temple walls is in tiers of alternating projections and recesses. Here one sees the guardians of the quarters, flying celestials, nymphs, joyous damsels, loving couples, mythological animals, historical scenes, iconographic forms of the deity, patterns of wish-fulfilling creepers and the like, quaint Shivaganas, drummers, musicians, and dancers—a wealth of human imagination rendered in the most dazzling form. Virtually each figure has some import, some emotion or *bhāva* to convey, some significance to reveal. The sculptor's taste and learning

fig. 577 is evident in every inch of the highly sophisticated carving. The prince fighting a lion illustrates the legend of the progenitor of the race, the son of Hemavati and the Moon, who killed a tiger when only a lad of sixteen.

figs. 279, 318 The zoomorphic representation of Varaha in the temple dedicated to the deity at Khajuraho recalls an earlier masterpiece from Eran in central India. In the temples of Lakshmana, Devi Jagadambi, and Chitragupta there is a rich variety of sculpture representing musical figures and nymphs. Bracket figures on the pillars, often

fig. 594 close to the ceiling, depict damsels in many attitudes—softly sounding the flute; lost

in reverie; playing with a ball; adjusting her beautiful braid while her face is reflected in the mirror; or applying kohl to darken her eyelids; or looking back wistfully on the pretext of pulling out a thorn, a rendering of a line of Kalidasa—*darbhānkurena caranah ksata ityakānde tanvī sthitā katicid eva padāni gatvā.*

Buddhist temples, as well as Brahmanic and Jain ones, have been discovered at Mahoba. A Buddha from Mahoba, now in the Khajuraho Museum, is extremely beautiful. Here the Bodhisattva Simhanada is seated on a lion. The halo is decorated with the lotus-petal design, and the locks flowing on the shoulders recall much earlier Gupta works. The inscription on it not only mentions the sculptor but also reveals his personality. The inscribed Tara, which was carved by the wife of this sculptor, is another extremely beautiful figure.

The historical sense of the Chandella sculptor is revealed in the narrative on the wall of the Mahadeva temple at Khajuraho, which is similar to the work in the Vaikunthaperumal temple at Kanchi that presents a visual Pallava chronology. In the Mahadeva temple the Chandella sculptor also shows how young pupils were trained to sketch, paint, and chisel and how sculptures, after being carefully created, were carried and placed one above the other to construct a temple. Among the magnificent Chandella works of the tenth through twelfth centuries are: Vishnu and Lakshmi in the Parsvanatha temple; the marriage of Shiva with strikingly detailed celestials in attendance all around, now in the Bharat Kala Bhavan; the meticulously carved Ganesha in the Khajuraho Museum; the three famous images—the damsel writing a love letter, the mother and child, and the damsel playing the ball—in the Allahabad Museum; the back view, loveliest of its kind, of a female flutist from Khajuraho; and the frieze of warriors from the Lakshmana temple.

fig. 581

figs. 593-95

THE CHEDIS

Tracing their origin from the famous Kartavirya Arjuna, the Haihayas or Chedis (895–1150), also known as the Kalachuris, gained prominence under Kokalla I who ruled from Tripuri in the Jabalpur region at the end of the tenth century. Kokalla's statesmanship and political astuteness, shown in his matrimonial alliances, increased his power and prestige. He married Nattadevi, a princess of the Chandella family, and later arranged a marriage between their daughter and Rashtrakuta Krishna. Kokalla helped his son-in-law in his wars against the Eastern Chalukya ruler Vijayaditya III. In the first years of the eleventh century, Gangeyadeva extended his control far up the Kangra Valley beyond Allahabad and Benares. At this time the Pratiharas were becoming weaker, and but for Paramara Bhoja who defeated him, Gangeyadeva would have been mightier still. His son Lakshmi Karna enjoyed greater success. He destroyed the power of the Gurjara-Pratiharas and successfully led a confederacy against Bhoja of Malwa. He was also successful against the Chandellas but enjoyed only limited victories over the Pala kings Nayapala and Vigrahapala. Karna established cordial relations with the Palas through the marriage of his daughter to Vigrahapala. The rise to power of the Gahadavalas in the north, the growing strength of Udayaditya, a successor of Bhoja in Malwa, and the Chandella force under Kirtivarman finally weakened the power of the Chedis toward the end of the eleventh century.

This was an age of building lakes, cities, and temples named after the victorious kings. Karna built a new capital, Karnapuri, near Tripuri and a temple for Shiva. The Viratesvara temple at Sohagpur is noteworthy for fine carvings of nymphs and rearing griffins and bracket figures. One of the most beautiful figures of dancing Shiva, unfortunately damaged, comes from a niche in the Viratesvara temple. The temple at Chandrehi has lovely carvings of Ganga and Yamuna on the doorjambs and Ganesha, Lakshmi, and Sarasvati on the lintel. The temple at Amrakantak is a noteworthy monument from the time of King Karna. The cult of the sixty-four yoginis was most popular in Bundelkhand, and famous temples for them were built at Satna and Bheraghat. The circular cloistered temple around the courtyard at Bheraghat has a series of sculptures that are identified in pedestal inscriptions. Belonging to the tenth and eleventh centuries, these statues are typical of mature Chedi art, and the inscriptions are a valuable source of information about the iconography of the yoginis.

fig. 347 The Indian Museum has yogini carvings from Satna including Sarvamangala, Narasimhi (a female complement to Narasimha), Nagini with hoods, and Vrishabha with bovine head. From Bheraghat comes a beautiful dancing Ganesha. A Shanmukha from Tewar is an excellent example of a form that is a favorite on early Yaudheya coins and in late medieval sculpture in the south. The zoomorphic representation of Varaha from Bilhari echoes its prototype from Khajuraho and an earlier one from Eran. The Seshasayi from Sohagpur is a very lovely piece, and the Yoganarasimha is iconographically important. The juvenile sports of Krishna, seen in fragments of the long frieze that are preserved in the palace at Sohagpur, contribute to a sculptural study of the Krishna legend so popular in Indian art. At Gurgi there is an exquisite toran for the Shiva temple; richly carved, it recalls similar magnificent torans from Dabhoi in Gujarat and Warangal in Andhra Pradesh.

THE GUJARATS

Mularaja of the Chalukya line was the first to establish the power of his dynasty in Gujarat. Bhima I, nephew of Durlabha, the grandson of Mularaja, had a long reign which was violently disturbed, however, by Mahmud of Ghazni. This invader drove terror into Somanatha and left this glorious and wealthy city sacked and ruined. Bhima had been forced to flee, and he returned with great trepidation to take the reins of government. He was a member of the victorious confederacy that Lakshmi Karna Chedi led against Paramara Bhoja. Bhima's grandson Jayasimha Siddharaja, the greatest monarch of this line, added Malwa and parts of Rajasthan to his kingdom and wisely established cordial diplomatic relations with the Chedis and the Gahadavalas. Like his father, Jayasimha was an enthusiastic builder and erected a number of temples. Though a Shivaite, he was devoted to Jain institutions. In fact, Hemachandra, the famous Jain master, was held in great esteem by Jayasimha and his successor, Kumarapala, who rebuilt the temple of Somanatha. After the death of Kumarapala, the main family dwindled and their feudatory Lavanaprasada became prominent. In the thirteenth century his son Viradhavala, aided by his ministers, erected the magnificent marble temples at Mount Abu and the famous Dilvara temples.

The Dilvara temples are typical late medieval structures and have exquisite ornamentation on every element including the columns, arches, brackets, and ceil-

ings. The Rudramahalaya temple at Sidhpur, the sun temple at Modhera, and the
Vimala temple at Abu are other important structures of this period.

fig. 147

The theme of Kaliyamardana on the ceiling of the Somanatha temple, as well
as the Narasimha killing Hiranyakasipu from the ceiling of the temple at Mount Abu,
are typical examples of the Chalukya sculptor's richness of imagery. The Somanatha
temple was completely destroyed and rebuilt a number of times and has therefore
lost its original form. Several sculptures reveal the richness of the original structure.
The imposing torans with rich decorative carving from Vadnagar, Modhera, Kapad-
vanj, Piludra, and Dabhoi are justly famous. The Churning of the Ocean on the to-
ran at Dabhoi is an excellent representation of an episode that Indian sculptors never
tired of depicting. The Gujarat temples are characterized by makaras with floriated
tails, a wealth of forms of the deity, figures such as loving couples, celestial beauties,
and joyful damsels, and rows of elephants, horses, and musical figures.

figs. 605, 609

figs. 607,
608, 611

The sculptor's love of narration is seen at its best in the crowded groupings of
Neminatha's life story at Mount Abu. Here there are some exquisite dancing scenes
in the long frieze of musicians and dancers. The *rasamandalas* that are so often depicted
on ceilings in earlier Gujarat temples are undoubtedly the inspiration for these. At
Modhera there are interesting examples of the dancing Shiva, Matrikas, and dancing
Ganesha. Here one notes a confluence of Gurjara-Pratihara, Paramara, Chandella,
and Chalukya styles.

fig. 606

THE CHALUKYAS

In the confusion that followed the fall of the Rashtrakutas and the devastation of
their capital, Manyakheta, in 973, Tailapa, a member of a collateral line of the Western
Chalukyas, assumed the throne of this dynasty. At the beginning of the eleventh
century the powerful Rajaraja and Rajendra from the south and Bhoja of Dhara were
checks on the Chalukyas. But by the middle of the eleventh century, Somesvara I
consolidated the Chalukya power and added to his dominions by his victories over
Malwa and his occasional inroads into the Chola territory. His second son, Vikra-
maditya, whose glory was sung by the Kashmiri poet Bilhana in the *Vikramankadeva-
charita,* later overran Bihar and Bengal. His military prowess allowed him to con-
clude an alliance with the Chola emperor Vira Rajendra, whose daughter he married.
Vikramaditya was also a great patron of literature and art.

This phase of Chalukya art is noteworthy for intricate detail in ornamentation,
which increased to such an extent that main figures and motifs were almost drowned
in decoration. The trelliswork seen in perforated lithic screens, minutely carved
with patterns and scrolls entwining animals and birds, reminds us of the skill of the
famous Kanarese sculptor Sovarasi who boasted that he incorporated the forms of
the elephant, lion, parrot, and other animals in the letters he incised. The bracket
figures from Kuruvatti, with the *madanakai* theme so delicately presented, reveal a
rare aesthetic charm that arrests attention. The ceilings of the mandapas with their
beautifully carved panels of Guardians of the Quarters amid groups of followers follow
a tradition established earlier at Badami. The most magnificent rendering of this form
is the Nataraja with Guardians of the Quarters from Iralaguppa.

A magnificent lintel from a Hampi temple gateway, now in the National
Museum, shows the Trimurtis and has delicate miniature carvings in a long frieze

narrating the conflict between Bali and Trivikrama and the approach of the *dikpālas* and depicting exquisite musical figures, birds, and animals.

Though there are several examples of late Western Chalukya metalwork, such as the elaborate group of Tirthankaras and attendants from the Prince of Wales Museum, the finest metal figure is the magnificent image of Vishnu with consorts in the collection of Mittal.

THE YADAVAS

The Yadavas (1187–1372) were originally feudatories of the Western Chalukyas of Kalyani and assumed independent status in the twelfth century. Singhana, an important monarch of this line, successfully battled against Arjunavarman of Malwa, the Chedi Jajalladeva, and the Hoysalas. He was a great patron of arts and music, and the *Sangitaratnakara* was a musical treatise inspired by him. The *Chaturvargachintamani* (the famous encyclopedic digest of Hemadri), the *Vedantakalpataru* (a philosophic commentary by Amalananda), the *Suktimuktavali* (an anthology by Jalhana), and the famous commentary of Jananesvara on the *Bhagavadgita* all owe their existence to the patronage of the Yadavas. In the thirteenth century Singhana's grandson Mahadeva and his successor, Ramachandra, constructed many temples in a distinctive style termed Hemadpanti. Lonar, Satgaon, Mahkar, and other places in the Deccan have fine examples of Yadava temples. These heavy structures have little sculptural embellishment, but their style is not unlike that of the late Chalukya temples.

THE HOYSALAS

A motif that occurs frequently in temples built by the Hoysalas—a prince fighting a tiger—explains the derivation of their family name. Hoysala or Poysala, meaning "Strike, Sala," was said to be an utterance of the sage who commanded the founder of the Sala family to slay a tiger. Originally feudatories of the later Chalukyas, the Hoysalas slowly gathered power and ruled a large kingdom in Mysore from 1100 to 1300. Bittiga, who was styled Vishnuvardhana, made his family glorious after his conversion to Vishnuism. He moved from Belur and established a new capital at Dvarasamudra. With the zeal of a convert, he created magnificent temples all over his

figs. 148, 612

realm, and those at Belur and Halebid are gems of Hoysala architecture. Noteworthy features, as in other Chalukya temples, are the elaborate carving on the high plinth; the exquisitely designed and decorated perforated screens; the polished pillars that were worked on the lathe and surmounted with delicately carved bracket figures of *nāyikās* and *madanikais*; the elaborate scroll design and figures on the ceiling; and tiers of frieze showing rows of elephants, makaras, swans, cavaliers, musicians, and dancers.

The learned and charming princess Santala, queen of Vishnuvardhana and a Jain by faith, enthusiastically helped her husband in beautifying the temple at Belur

figs. 616–18

dedicated to Channakesava. Bracket figures from Belur—such as the damsel contemplating her beauty in a mirror, the danseuse in an attractive pose, a beauty brooking no profanation from the fickle-minded monkey that is threatened with a stick, and the parrot whose sweet chatter amuses its mistress—are fine examples of the delicate touch of the Hoysala sculptor. Vishnuvardhana and Santala appear on a perforated screen at Belur that attests to the Hoysala sculptor's skill at portraiture. The famous

dancing Ganesha, like the colossal seated figure of the same deity from Halebid, illustrates the magnificence of monumental iconographic depiction by the Hoysalas.

Given these magnificent monuments, it could be conjectured that the Hoysalas were equally adept at painting. Unfortunately no murals have survived, and even the painted manuscripts of the Hoysalas were unknown until recently. But exquisite examples of Hoysala miniatures are seen in the palm-leaf manuscripts at Mudbidri and in the commentaries by Virasena known as *Dhavala*, *Jayadhavala*, and *Mahadhavala*. The lines are sinuous, the colors bright and attractive, and the style and ornamentation similar to the Hoysala sculptural mode.

THE KAKATIYAS

The Kakatiyas (1110–1326), who ruled originally from Hanamkonda, shifted their seat to Orungallu (modern Warangal) which they beautified considerably. Originally feudatories of the Western Chalukyas, they slowly gained power. Though the first prince, Prolaraja, was a competent warrior, it was only very much later during the time of Ganapati, son of Mahadeva, that the might of the Kakatiyas was established in Andhra Pradesh. They became powerful enough to stand up against the Yadavas, the Kalingas, and even the Cholas who in the thirteenth century were fast losing their power. Ganapati's daughter Rudramba was a great ruler who assumed masculine titles. Her grandson was the famous Prataparudra, immortalized by Vidyanatha in a book on rhetoric in which the prowess of the king became a theme for every poetic illustration.

The Kakatiyas were great devotees of Shiva and built temples to him throughout their kingdom. Both their secular and religious architecture was outstanding. Their temples at Palampet, Hanamkonda, Pillalmarri, Nagulapad, Macherla, Gurzala, and Tripurantakam clearly show the impact of Chalukya forms. The high plinth, richly carved doorways, intricate work on the ceiling, makara toran, pillars with magnificent bracket figures, and polished columns are all features derived from the Western Chalukyas.

Among the examples of Kakatiya art in the Hyderabad Museum are the Sarasvati dancing on a swan and a Guardian of the Quarters dancing on his mount. The huge lintel showing the trinity dancing is one of the most magnificent sculptures of the Kakatiya period in the National Museum. Kakatiya metalwork is seen in the slim and graceful figure of the lamp-bearer in the Hyderabad Museum.

fig. 611

In the temple of Shiva at Tripurantakam the mandapa is covered with paintings which must be cleaned and studied before they can be identified and interpreted. The *amṛta-manthana* scene in a painting from the temple at Pillalmarri is a very interesting representation of this popular subject.

THE CHOLAS

In the troubled time when the power of the Chola dynasty (founded in 846) was weakened by the death of Parantaka's sons, Sundarachola, a great warrior and a just prince, was placed on the Chola throne. His son, the noble Rajaraja, was the greatest of the Chola emperors. His military triumphs, organization of the empire, patronage of art and literature, and religious tolerance are nearly equalled by his son Rajendra

who was an extraordinary military strategist. Rajaraja was a great general and statesman, and he triumphed over the Cheras, Pandyas, and Ilams (Ceylon) and conquered the western hilly tracts, Mysore, Gangavadi, and Nolambavadi. The Western Chalukya king Satyasraya was humbled by this Chola ruler. After vanquishing the kingdom of Vengi, Rajaraja, a sage monarch, gave his daughter Kundavai in marriage to Vimaladitya, whose elder brother Saktivarman, the Eastern Chalukyan king, came under his benevolent control. He sent his son Rajendra to battle in Kalinga and commemorated his victory by erecting a pillar on the Mahendra Hill. Rajaraja's mighty navy allowed him to conquer the Maldives and a number of other islands and cripple the Cheras, who were famous for their naval power. A lasting tribute to Rajaraja's devotion to the Lord is his magnificent temple, a monument of glory, the Brihadisvara or Rajarajesvara at Tanjore.

Rajendra carried the Chola power still further. He overcame Chalukya Jayasimha, overran the Eastern Chalukyan kingdom, and repeated an earlier matrimonial alliance by giving his daughter to his nephew Rajaraja, the son of Vimaladitya. The son of this marriage, Rajendra Chalukyachoda, later combined the Chola and Chalukya thrones. Rajendra's military success carried him through Kalinga, Dakshina Kosala, and the kingdom of the Palas. To celebrate these victories, he founded a new capital at Gangaikondacolapuram, and as a thanksgiving offering, he built a huge but delicately fashioned Shiva temple, almost a counterpart of the Rajarajesvara temple at Tanjore. The mighty navy of Rajendra attacked and subdued the Sailendra king Sangramavijayottungavarman of Srivijaya (Indonesia, Malaya, and Sumatra). The Chola inscriptions found in such distant places as Malaya indicate how vast and far-reaching was his power. His conquest of Burma, Ceylon, the Laccadives, and the Maldives clearly indicates his unsurpassed naval power. Like his father, Rajendra was a great patron of literature, and his scholarship earned him the title *Panditacola*. Rajadhiraja and Vira Rajendra, the sons of Rajendra, were succeeded by Rajendra Chola Kulottunga, the Chalukya sovereign and grandson of the Chola emperor Rajendra.

The gopuras of the Brihadisvara temple at Tanjore are larger than those of the Pallava temples but are still subordinated to the vimana. However, the monumental gopuras of the late Cholas, such as those at Chidambaram, Tiruvalanjali, Tiruvidaimarudur, and Tiruvannamalai, make the temple visible from miles away as a beacon of grace and piety.

The sculpture of the Brihadisvara temple stresses the warlike aspect of Shiva who is repeated in defiant attitudes as Tripurantaka, Kiratamurti, Kalantaka, and so forth. There is no sculpture more beautiful than the famous Chandesanugraha panel which shows Rajendra almost identifying himself with the devotee Chandesa and receiving a garland from Shiva as laurels of victories.

The delicate Muvarkoil temple at Kodumbalur shows the humble beginnings of a new style in the Chola realm that was to culminate in a magnificent vimana at Tanjore. The Gangadhara on the vimana of the Muvarkoil is a simplification of the earlier figure seen in the Pallava cave at Tiruchirapalli.

The most beautiful Chola monument of this period, a sculptor's dream realized in stone, is the temple at Darasuram, which is unequaled in its technical perfection and exuberant ornamentation. The wheel-and-horse motif seen here transforms the mandapa into a chariot. This Chola device was appreciated and adopted

fig. 142

fig. 308

by other craftsmen in the Eastern Chalukya and Kalinga territories, most notably the sculptor of the famous temple at Konarak. The sculptures at Darasuram illustrate music and dance groups and, on the plinth, the lives of the Shivaite saints with precise descriptive legends. Ganga, with the lower portion of the body portrayed ripplelike to suggest a stream, arrests attention.

The finest examples of late Chola sculpture are found in the niches of the gopuras at Chidambaram. Among these works are the Vrishavahana, Kalyanasundara, Vinadhara, and Tripurantaka. There are also lovely figures of personified treasures like Sankha and Padma and of Sarabha, Nandikesvara, Nagaraja, Agastya, and Gajantaka. Devi as Mahishamardini slaying Mahishasura, Shiva in *ūrdhvatāṇḍava*, and Skanda as Tarakarin fighting Taraka are other striking works from Chidambaram. Equally important are the two celestial nymphs that are the jewels of the Kampaharesvara temple at Tribhuvanam. Here, as at Darasuram and Chidambaram, the decorative charm echoes Rashtrakuta and Chalukyan work.

figs. 638, 640

The dance panels embellishing the gopuras at Chidambaram, rich and valuable from the aesthetic point of view, are also an interesting commentary on the dance modes described by Bharata in his *Natyasastra*. It may be recalled that the Chola period was the heyday of the fine arts, particularly of dance and music. An inscription states that Rajaraja III witnessed the *agamanga* performed by a danseuse at Tiruvottiyur. Another inscription also describes the renowned sculptor Ravi who built the temple at Tiruvottiyur in the *gajapṛṣṭhākāra* fashion during the reign of Rajendrachola I. The sculptor's skill is vividly described, and the zealous patronage of fine arts by Chola monarchs is again confirmed.

The famous series of paintings in the Rajarajesvara temple at Tanjore are fine examples of the Chola skill in this art. Early Chola paintings from about 1000 are seen on the western and northern walls of the central cell along the perambulatory passage. The large wall space on the western side is entirely taken up by a panel showing Shiva as Yogadakshinamurti seated on a tiger skin in yogic pose. The *yogapaṭṭa* across his waist and right knee recalls the *paryaṅkabandha* for Shiva described in the invocatory verse of the *Mrichhakatika*. He is shown watching the dance of the nymphs.

figs. 141, 625

The celestial dancers move to the melody played by the ganas and other demigods, and a row of celestials, sounding the drums and cymbals, flies toward this grand musical scene which is witnessed by a few princely celestials seated in the foreground. Sundara, the famous saint, and Cheraman, the royal devotee, are shown hurrying to the celebration on a horse and an elephant.

Beyond this is an interesting study of an early Chola temple to Nataraja, perhaps that at Chidambaram. A princely devotee, the ancestor of the Cholas who beautified the temple, is shown seated close to the shrine. In a lower panel the story of Sundara is depicted. Shiva as an old man appears with a document to prove his claim to the beautiful bridegroom Sundara, whom he brought away with him to Tiruvennainallur on the very day of his marriage. The marriage festivity is also shown in this sequence. The dance hall at Chidambaram, with a large image of Nataraja adored by a prince, obviously Rajaraja himself, and three of his queens with a large retinue, priests, and other devotees, is also represented.

The northern wall has the most magnificent of the murals. The principal figure is Tripurantaka Shiva in a chariot drawn by the four Vedas, transformed into horses, with Brahma as the charioteer. Shiva is in the warrior's pose of *āliḍha*; he is eight-

armed and brandishes weapons, including the mighty bow. Equally fierce are the hosts of demons that attack Shiva. This great masterpiece of Chola art continues the earlier tradition of Shiva in the *āliḍha* pose seen in Pallava sculpture. Shiva as the victorious warrior reflects the Chola military vision and ideals of Rajaraja.

The soft color, firm and sinewy line, ease in the execution, and energy make the Chola paintings as distinguished as their sculpture. Here is a commingling of several sentiments like *vira* (heroic), *raudra* (terrific), and *karuṇa* (compassionate)—the first two are seen in the determined face of Tripurantaka, the last in the tear-stained faces of the demons' wives who cling in despair to their fanatically fighting consorts. Shiva as Yogadakshinamurti embodies *śānta* (peace). The hands of the dancers in *vismayamudrā* suggest *adbhuta* (wonder). The dwarf ganas provoke *hāsya* (laughter). The painter's art of this period is revealed in the remarkable twelfth-century murals in the Nartamalai temple. Here Bhairava wears a pleasing patterned bodice, a *muṇḍamālā* ("garland of skulls"), and a *vastrayajñopavita* ("garment worn as a sacred thread"). Attended by a hound, she stands gracefully against an aureole of flames. Durga, a damaged figure, is shown wearing a *karaṇḍamakuṭa* ("crown resembling a pile of pots") and an elaborate breastband. She carries weapons whose flames are visible and is flanked by chowries. There are also remnants of painting on the walls of the *ardhamaṇḍapa* and a dancing figure of Kali and Gandharva on the ceiling of the inner chamber.

The Cholas, great builders of lithic monuments, produced metal images worthy of these shrines. The unusually large image of Vishnu at Paruttiyur is a most charming early metal figure with a grace rarely encountered in others of its type. A flawless and most pleasing early Nataraja, dated about 1000, was acquired by the Dick Fund of the Metropolitan Museum. Among the first Natarajas of the early Chola *figs. 64, 66, 273, 274, 633* period, those in the Victoria and Albert Museum and the Musée Guimet are especially noteworthy. The sculptor Rodin stated that the Tiruvalangadu Nataraja is the most perfect representation of rhythmic movement in the world. The Vrishabhantika Shiva and Parvati, the former with a lovely *ushṇiṣa* coiffure, are an exceedingly fine pair from Tiruvangadu in the Tanjore Art Gallery.

There is no Parvati that can equal in grace the standing figure of the goddess *fig. 69* in the Metropolitan Museum. Monumental in size, but with a remarkable liquid grace and delicacy in execution, the Devi as the bride of Shiva, now in the Gautam Sarabhai collection, is among the rarest of the early Chola bronzes. Complete dedication, loyalty, and devotion to the master are writ large on the face of the Hanu- *figs. 628-31* man from Vadakkupanayur which belongs to the Rama group. The most beautiful of its kind is the Sita from Vadakkupanayur undoubtedly worthy of this Rama group. Her flower-decked braid is exceptionally well done. The metal image of Ayyanar *fig. 635* in the Madras Museum, like the Chandikesvara and Ganesha from Velankanni, are typical of the dignity and grace of early Chola work in metal. Miniatures in metal were also fashioned, and among these there are several first-rate specimens, including *fig. 636* the Jambhala and Vasudhara from Nagappattinam.

This was also a period of outstanding bronze casting. The inscribed Chandrasekhara from the Musée Guimet, whose interest is enhanced by the inscription mentioning the shrine whence it comes and its purpose as a processional image, is noteworthy. A smaller but equally striking work is the Chandrasekhara of the Haridas Svali collection. Most interesting iconographic figures are the Sudarsana and Kaumodaki, the personified club and wheel of Vishnu, which continue the ancient tradi-

tion seen in Gupta sculpture at Deogarh. The Annapurna from the Gautam Sarabhai collection is perhaps the best representation of this deity and is noteworthy not only for the grace and poise of the figure itself, but also for the characteristic patterns decorating her garment and the elaborate braided coiffure. The Venugopala from Nagappattinam, the Yoganarasimha from Manjakkudi, and some Bhikshatanas, Pradoshamurtis, and Nateshas are strikingly beautiful works of this period. Probably the largest and most meticulously fashioned Nataraja of this phase of Chola art is the huge and imposing figure in the Rijksmuseum in Amsterdam. The Vrishavahanamurti from Vedaranyam and the Ardhanarisvara from Melakkadambur exhibit the lingering grace of early Chola style during the twelfth and thirteenth centuries.

The last of the Chola emperors, Kulottunga III, was a great builder whose reign was marked by several additions to temples at Kanchi, Madura, Chidambaram, and Tiruvidaimarudur. The great monument of his reign was the Kampaharesvara temple at Tribhuvanam. Within a few decades Chola power showed signs of weakening. The Pandyas claimed power but continued early Chola traditions in art. The eastern gopuras at Chidambaram, erected by Sundara Pandya, and the ones at Jambukesvaram and Srirangam are magnificent structures closely resembling the Chola gopuras.

142. BRIHADISVARA TEMPLE
 Chola, c. 1000
 Tanjore

143. KANDARIYA MAHADEVA TEMPLE
 Chandella, 11th century
 Khajuraho

144. LINGARAJA TEMPLE
 Eastern Ganga, 11th century
 Bhuvaneshwar

145. JAGANNATHA TEMPLE
 Eastern Ganga, 11th century
 Pari

146. TRIVIKRAMA IN MATTAJI TEMPLE
 Gurjara-Pratihara, 9th century
 Osia, Rajasthan

147. VIMALA SHAH TEMPLE
 Early 11th century
 Mount Abu, Rajasthan

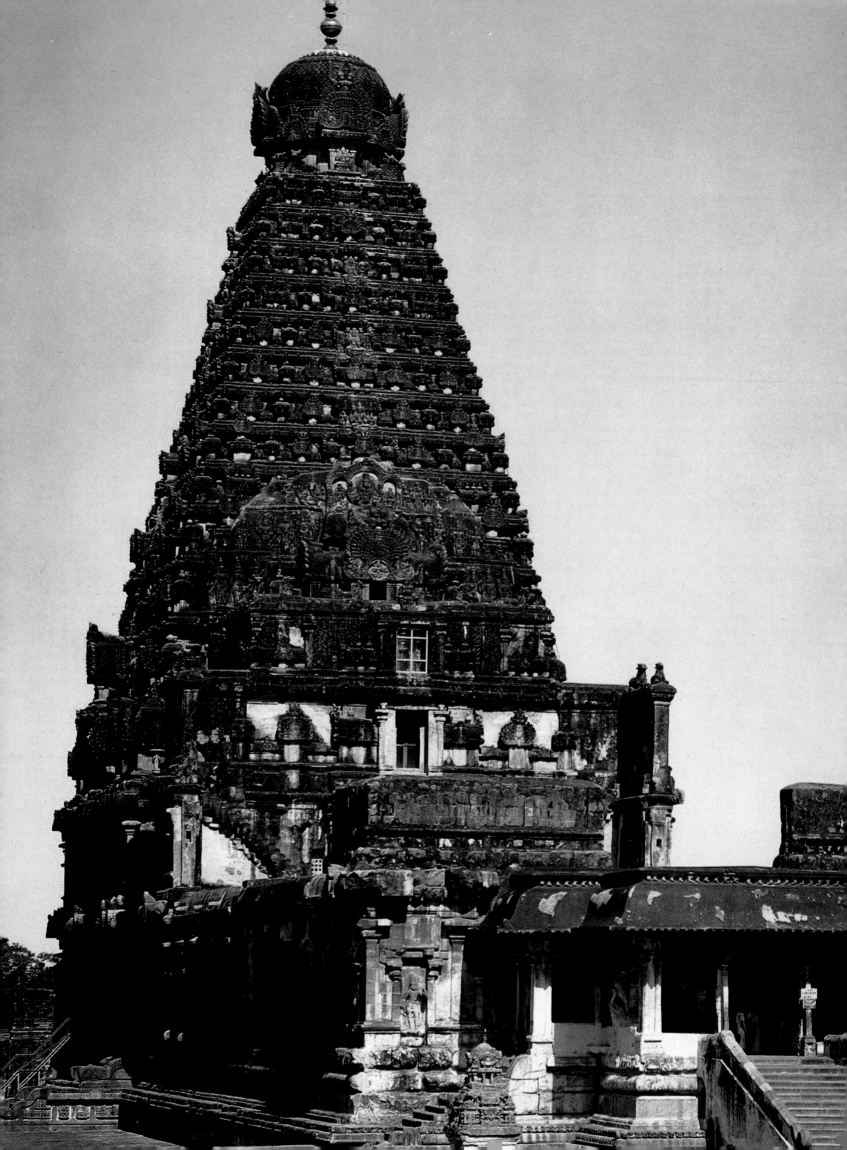

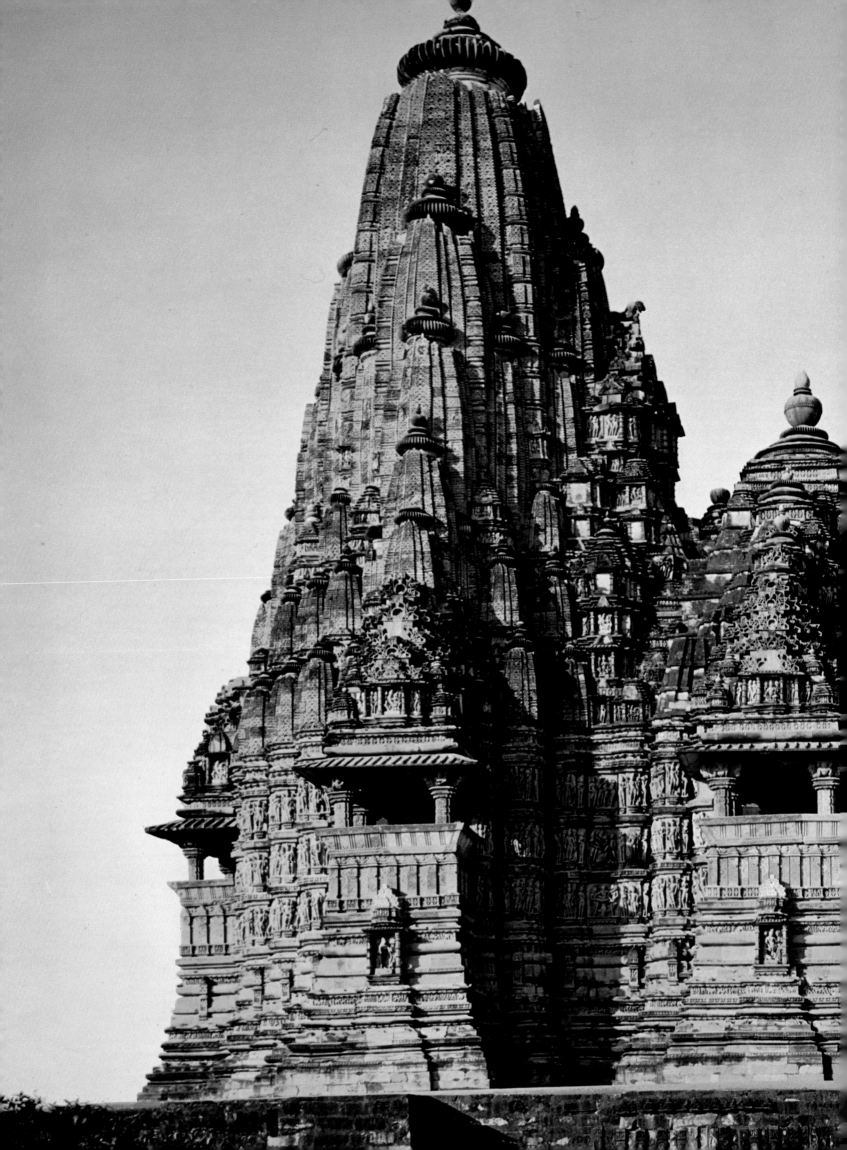

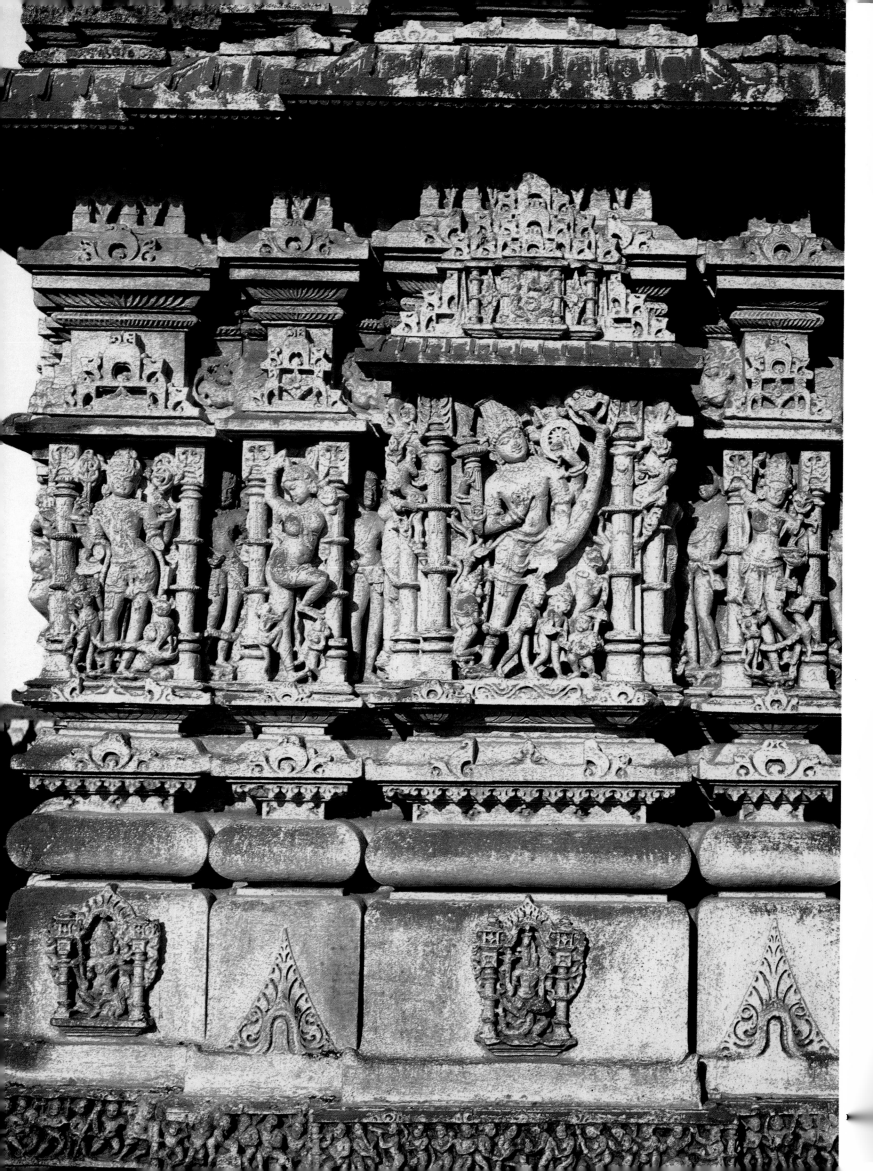

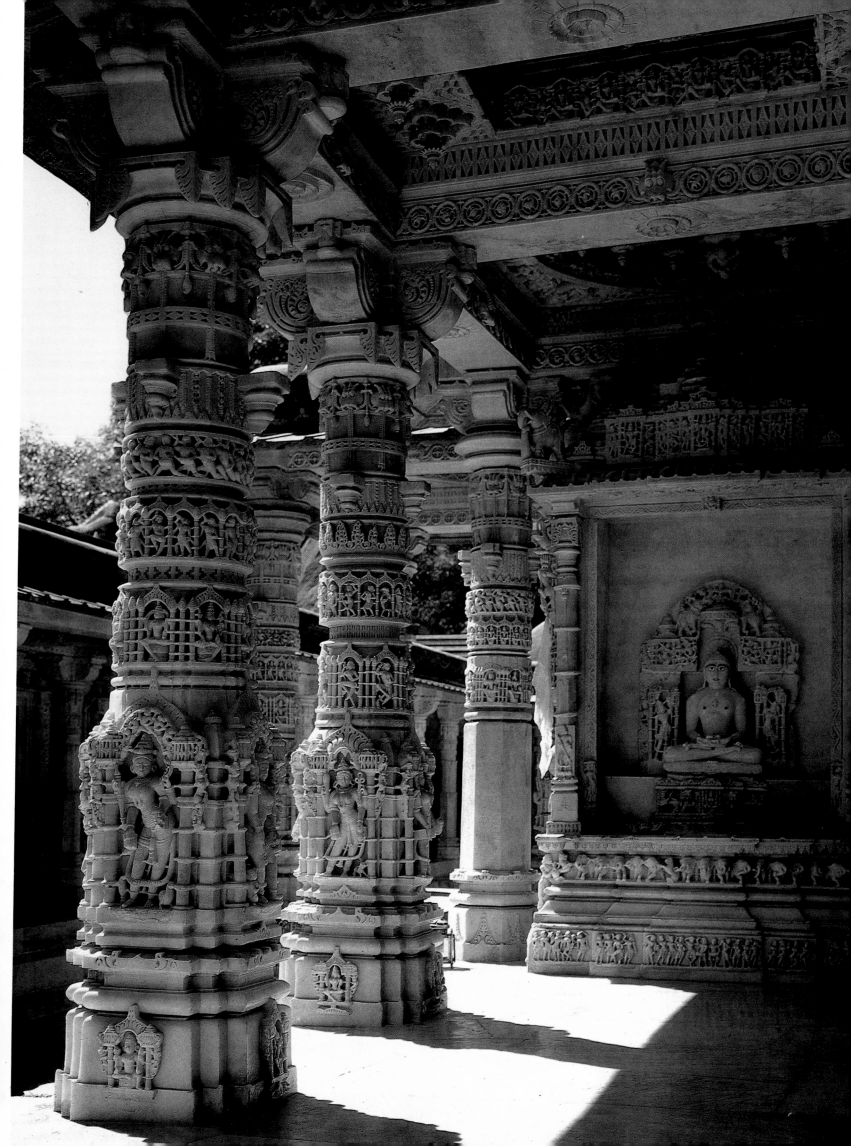

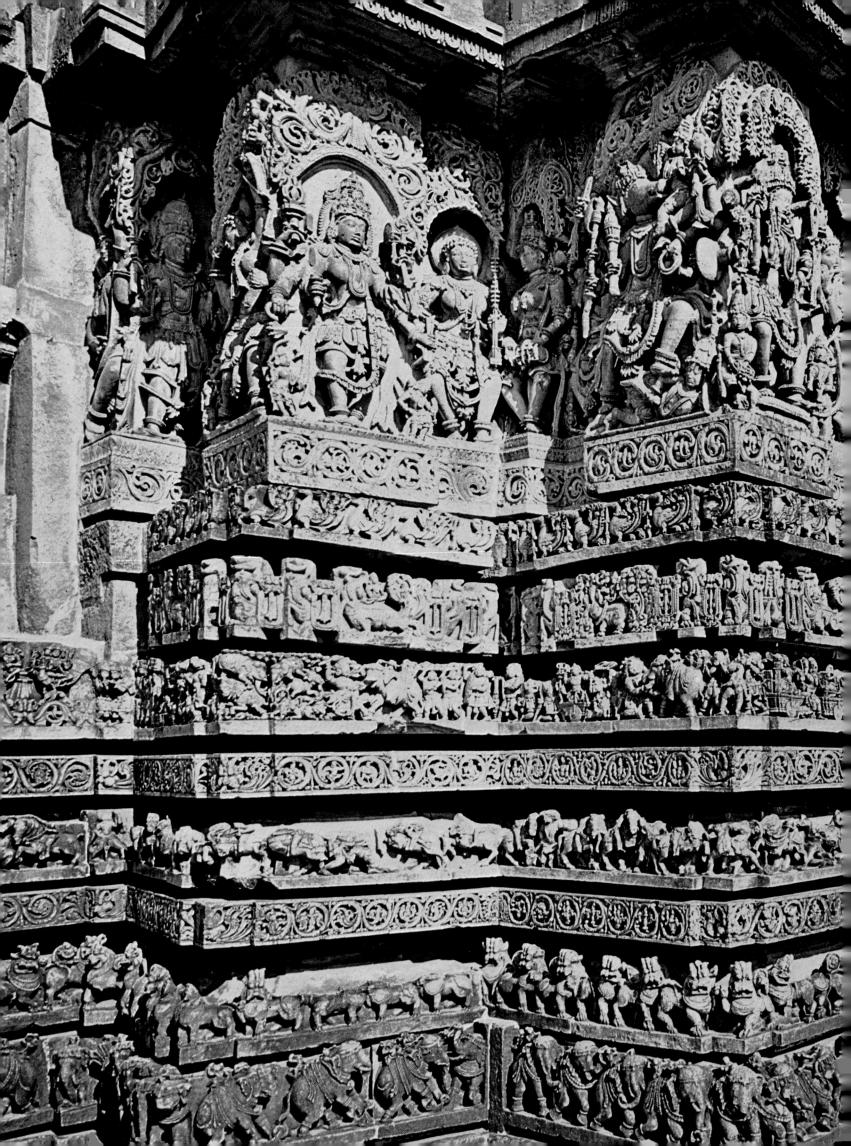

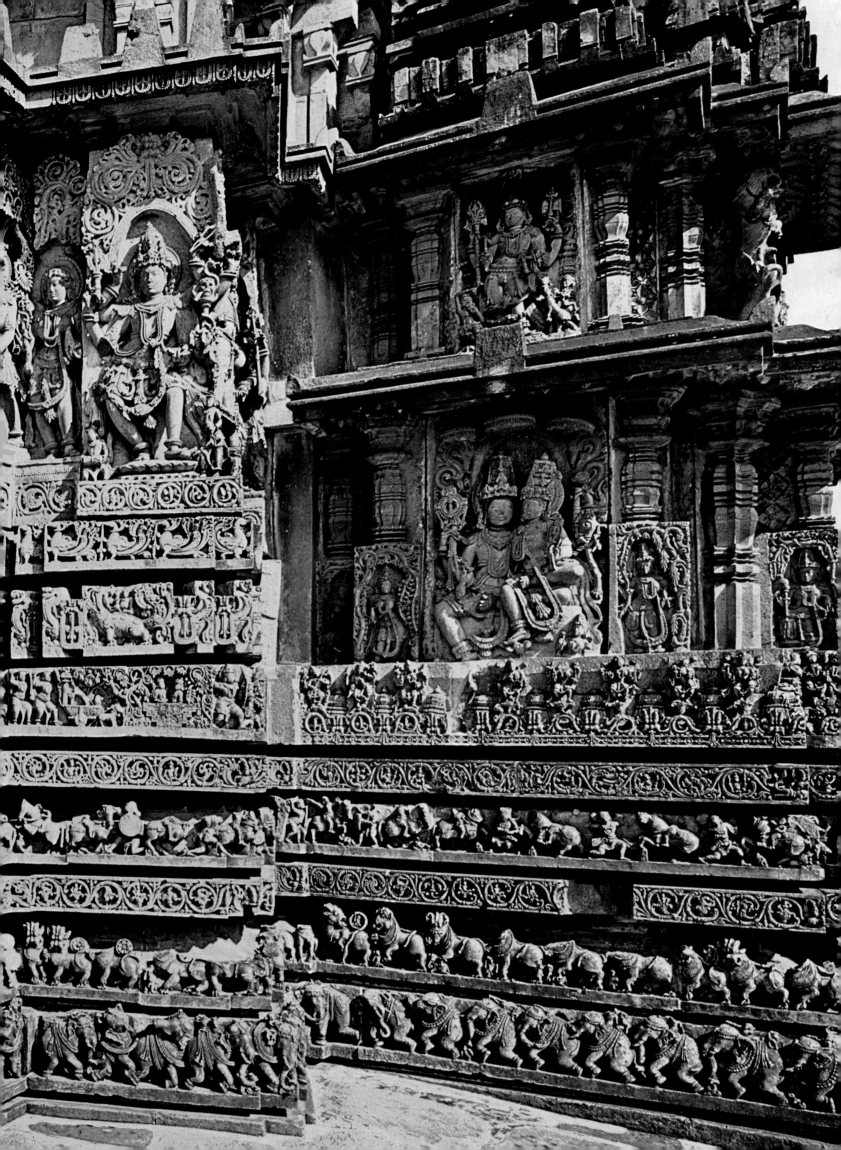

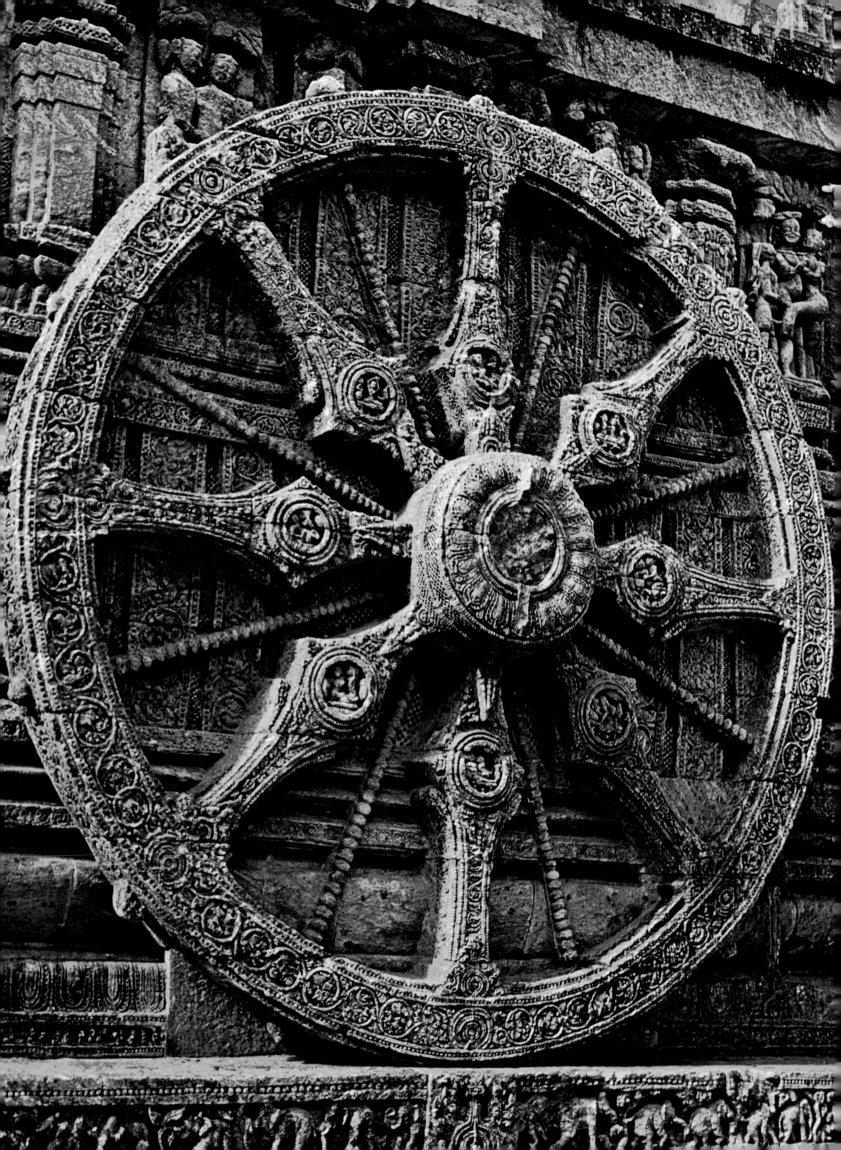

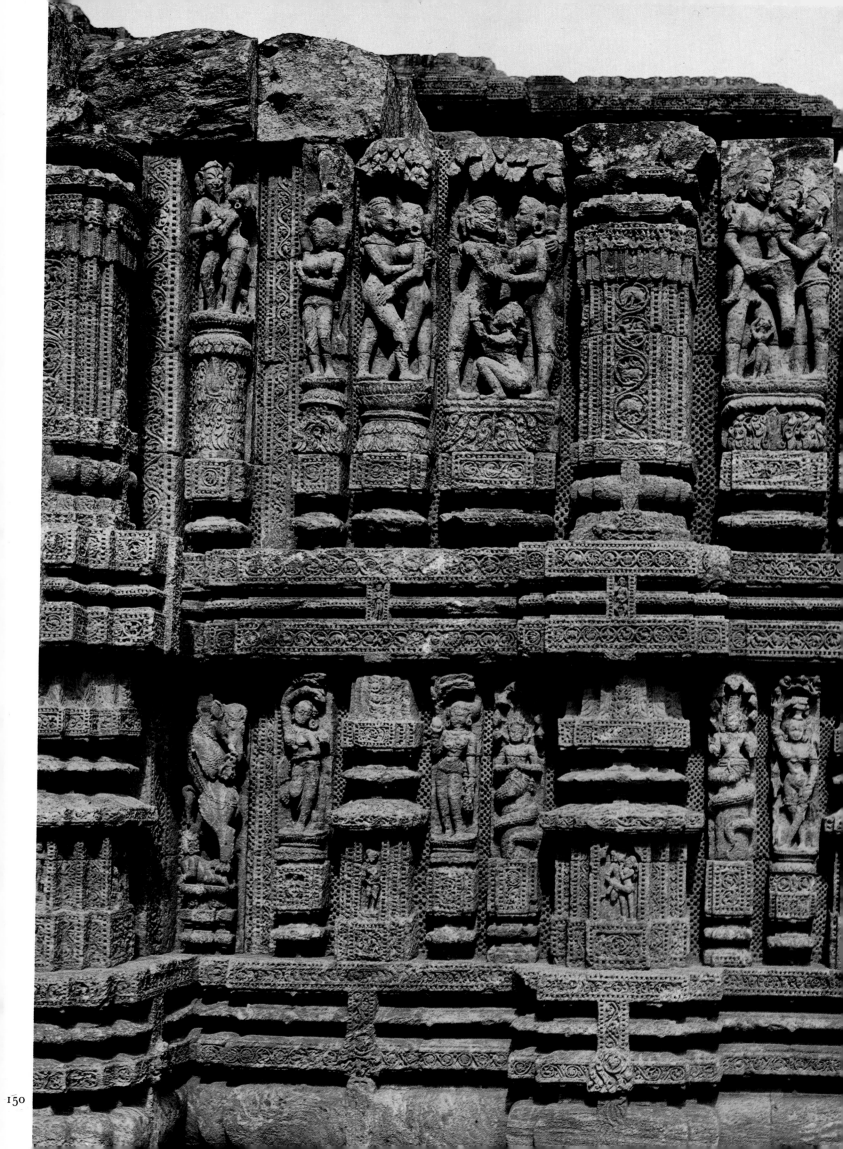

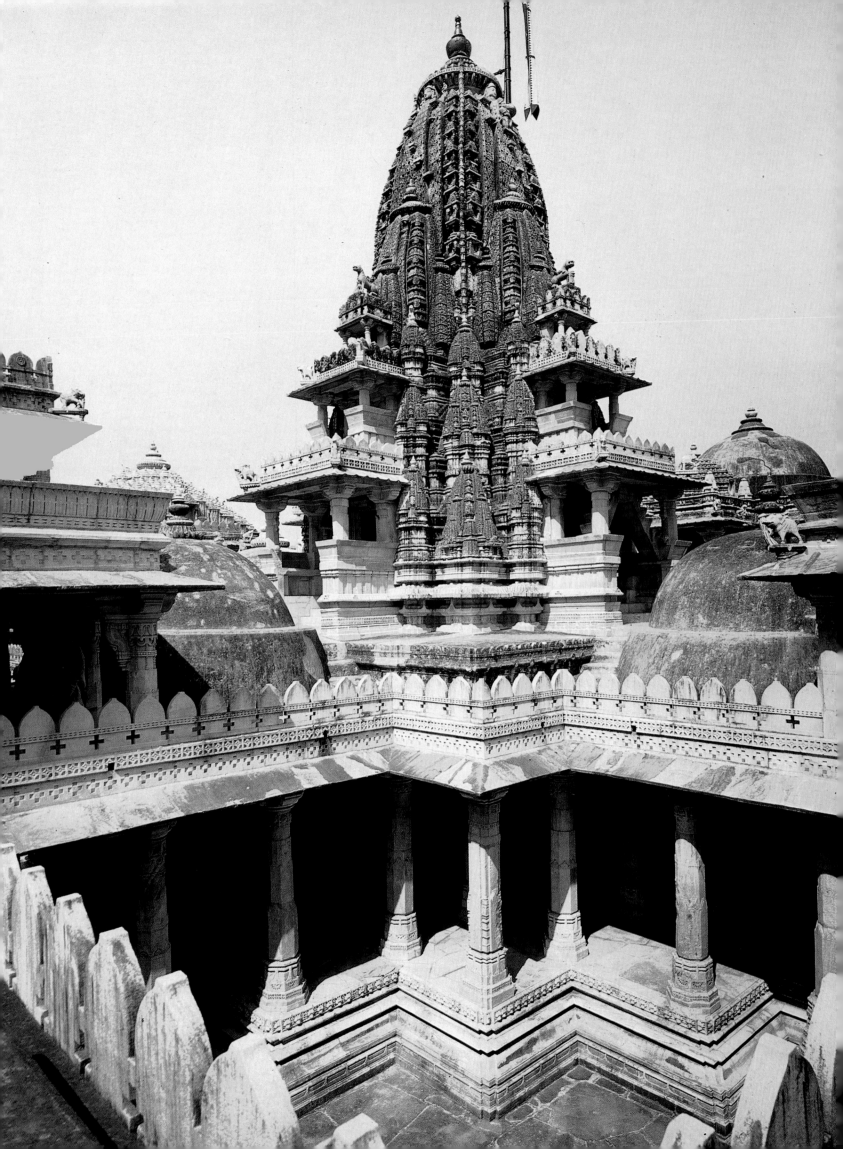

283

SWAN SONG

In 1335 Harihara, Kampa, and Bukka, the sons of Sangama, established the great Vijayanagar Empire which became dominant in southern India. With its noble aim of propagating dharma and Hindu ideals, it was reinforced by the blessings of the great master Vidyatirtha. Thus an impetus was given to temple building in the vast empire that embraced Andhra, Karnata, Dravida, Kerala, and Maharashtra, reaching as far as Orissa. In this huge arena the Vijayanagar style of architecture, sculpture, and painting evolved. It fused various elements of Chalukya and Chola art, though the Dravida element predominated. It is thus a commingling of Tamil, Kanarese, and Telugu traditions. The glory of the Vijayanagar Empire under Praudhadeva Raya during the first half of the fifteenth century greatly impressed the Persian envoy Abdul Razaak.

The greatest Vijayanagar monarch was Krishnadevaraya of the Tuluva family. He was a statesman with foresight, a valiant warrior, and a ruler of integrity; he was also a scholar and an unparalleled patron of the fine arts. A poet, he wrote works in Telugu, including the *Amuktamalyada*, a well-known version of the story of Vishnuchitta's daughter Andal. Krishnadevaraya carried home the image of Krishna as a military trophy after his campaign at Udayagiri. He built a temple at Hampi for it and installed it with great pomp, issuing speciagl old coins with the image of Balakrishna imprinted on them. This history is told in the inscriptions on the plinth of the temple itself and attests to the emperor's religious zeal and aesthetic taste. The most magnificent temple in Krishnadevaraya's capital, the Vithala, has remained without the central deity consecrated since, according to legend, the deity at Pandarpur chose to remain where he was to please his devotees. Many large gopuras in southern India have the appellation *rāyalagopura*, signifying that they were built by the emperor. Like Asoka, the reputed builder of eighty-four thousand stupas, Krishnadevaraya is credited with more gopuras than he could have ever completed. The glory of the emperor, as a patron both of literature and of art, and the magnificence of his capital and the empire itself has been recorded by Paes, the famous Portuguese traveler who visited Hampi.

The empire was weakened after the Battle of Talikota (1565), and the Nayak kings who were once loyal to the emperor slowly asserted their power and declared independence. Among these, the Nayaks of Tanjore, Vellore, and Madura were especially prominent. Tirumala Nayak of Madura, Raghunatha Nayak of Tanjore, and Chinnabomma of Vellore are famous as patrons of art and literature. The Nayak phase of art at Madura and elsewhere is as important as the earlier Vijayanagar phase. These massive sculptures with their tremendous vitality and force may be viewed as the last flickers of a great artistic flame that was about to die.

Medieval Kerala was divided into small political units. In the *Achyutarayabhyudaya* the Vijayanagar ruler Achyutaraya is described as having had a hand in defeating the ruler of Travancore, Udayamartandavarma. A successor, Virakeralavarma, also suffered defeat at the hands of a Vijayanagar army. Tirumala Nayak of Madura and later Mangamma overran Travancore. The ruler of Calicut, the Zamorin, was friendly with the Portuguese, and his kingdom was prosperous. Calicut

was a wealthy maritime city frequented by Muslim traders. Cochin was also power-ful, but it was slowly weakened by frequent territorial incursions by the Zamorin. Thus the Vijayanagar traditions can be seen in Kerala; however, the Chalukya-Hoysala traditions clearly dominated and flowered in this peculiar regional school of decorative art, strongly recalling kathakali and other modes of dance drama with picturesque costume and embellishments.

Toward the end of the seventeenth century, the Nayak power became weak in the Tamil area, and Venkoji, with the help of his half-brother Shivaji, established himself as the ruler of Tanjore. Venkoji's territory in the south, both at Bangalore in the Deccan and at Tanjore and Jinji in the Tamil area, flourished. His descendants, Sarfoji and Tukoji, continued to rule, though weakened by the Mogul inroads. The disorder in this area was fanned by the interference of the French and the English. They were eager to help oppose the nawab of the Carnatak, whose cupidity was aroused by the prosperity of Tanjore. Sarfoji, who was placed on the throne by the British East India Company, was a versatile scholar with great aesthetic taste and a lover of fine arts, science, languages, and literature. During the Maratha reign in the south, there was encouragement of music, dance, art, and literary composition, which accounts for the many murals of this period.

The Vijayanagar temples were complexes of huge gopuras, large mandapas, multiple vimanas, and large courtyards. This type appears throughout the vast em-pire. In this period there was also a special fondness for large monoliths. Two famous ones of Narasimha and Ganesha are found in the capital of the empire at Hampi. The Narasimha was inscribed in the fifteenth regnal year of the emperor Krishna-devaraya. The huge Rangantha near the Chaktratirtha tank at Tirupati and the very large and profusely decorated Chakrapurusha nearby are also important monolithic carvings.

The Ramaswami temple near the river at Tadpatri is a fine example of early Vijayanagar workmanship. The carvings of Ganga on the doorjambs are of high aesthetic quality. The Vijayanagar sculptor, like the painter, had a flair for narration of events and legends. In the Hazara Ramaswami temple at Hampi and in that of Vishnu at Penukonda, there are sculptural narrations of scenes from the *Ramayana* and of Krishna's juvenile sports. Similarly in the Shiva temple at Penukonda, there is a narration of the stories of Shivaite saints. The Vitthala temple at Hampi is one of the greatest achievements of Vijayanagar architecture; the monolithic ratha closely resembles that at Tadpatri but is markedly superior in workmanship. The Lotus Mahal at Hampi is a great testament to the catholicity of Krishnadevaraya—his edifices combine Hindu and Muslim motifs in a most happy blend.

This was an era of lavish patronage for art, music and dance, and military, civil, and religious processions. At Hampi there are long friezes on mandapa plinths portraying soldiers, cavaliers, and elephants in processions and musicians and folk dancers sounding wood rods.

During this period pillared halls (mandapas) were very popular, particularly the *kalyanamandapas* and the hundred- and thousand-pillared halls. The hall of dance at Lepakshi, with Shiva surrounded by massive musical figures depicted on its pillars, is a notable structure, but there is no better than the well-known festival hall at Vellore which has exquisite carvings of equestrians and other figures on its pillars.

fig. 162

This is a pattern repeated elsewhere, as at Virinchipuram and Srirangam. The prancing lions and horses and lively monkeys and doves carved on the mandapa roof and the movable lithic chains are all splendid examples of this art. Portraiture was a special talent of the Vijayanagar sculptor who created such exquisite figures as the group of Krishnadevaraya and his queens in metal and the portrait of the same king in stone at Chidambaram.

Portraiture was continued by the Nayaks. The most famous portrait sculpture of the period is the lifesize group of Tirumala Nayak and his queens from the *pudumandapa* at Madura. The gypsy man and woman and other figures from this pillared hall show not only the Nayak fondness for portraits, but also the monumental glory of their sculpture. The Nayak sculptor could also produce exquisite

fig. 158

and delicate carvings in ivory; several portraits in ivory of Tirumala Nayak are in the Srirangam temple museum.

fig. 647

Iconographic carvings such as the Gajantaka at Perur near Coimbatore are imposingly virile and titanic. The courts of the Minakshi temple are enlivened by such figures. This monolithic carving is not surprising in the Nayak period, because the large gopuras, growing in size from the later Chola period onward, now reached almost fantastic heights (for example, the famous tower of the Minakshi Sundaresvara

fig. 160

at Madura). Similar edifices were raised by the Nayaks at Kumbakonam, Tenkasi, and Sankaranarayanarkoil.

Paes has left a glowing account of the perfection of Vijayanagar painting during the reign of Krishnadevaraya. An earlier series of paintings can be seen in the Virupaksha temple at Hampi. On the mandapa ceiling, the procession of Vidyaranya in a palanquin seems like an ancient scene come to life. The temple at Lepakshi has some of the most perfect paintings of the Vijayanagar period, approaching those of the Krishnadevaraya period. Among the paintings at Lepakshi are those of Shiva as Gangadhara receiving Ganga on his locks and appeasing his irate wife; Shiva blessing the devotee Chandesa and making him a steward of his household by placing a battle ax, the insignia of office, in his hand; and Shiva blessing the righteous king Manunitikanda.

The famous Tripurantaka panel and the *svayamvara* of Draupadi from Hampi are masterpieces of Vijayanagar painting. The Nayaks, who continued the Vijayanagar tradition, have left such remarkable murals as a lengthy sequence at Tiruvalur illustrating the story of Muchukunda; a long narrative of the exploits of Bhikshatana and Mohini and of other episodes in the Shivakamasundari temple at Chidambaram; and a series including Shiva dancing, surrounded by musical celestials, in the Kapardisvara temple at Tiruvalanjuli. Other murals from this period are a series that completely covered the earlier Chola murals in the Brihadisvara temple at Tanjore; and those at Tirupparuttikunram illustrating the lives of the Tirthankaras, the sports of Krishna, and other scenes.

Noteworthy features of the Chera temples further south are the gabled roof, simple railing, and walls and columns based on a wooden prototype. The embellishment of Chera temple architecture clearly simulates wood carving. The long frieze above the cornice, pillar bracket figures, gable decorations, and so forth portray well-known themes from the epics and Puranas. Some of the finest examples are from Ettumanur, Chattankulangara, Triprayar, Perumanam, Tiruvangad, and Padman-

abhapuram. The dance halls in these temples—corresponding to the *nātyamaṇḍapas* in the Tamil area where the kathakali was performed—are ornamented with strikingly naturalistic carvings of dancers and musicians. The Suchindram temple has a noteworthy festival hall with elegant pillars and ceilings. An earlier phase of metalwork, with elaborate decorative detail of dress, is seen in the *dvārapālas* from Tiruvanjikulam now in the Trichur Museum.

fig. 651

The short gopura reflected in the large tank of the Anantapadmanabha temple at Trivandrum recalls the shorter though massive gopuras of the early Chola period which are continued here. The central shrines of the Valyandyadichapuram and Tiruvanjikulam temples also reveal the pattern of the vimana plan in Kerala which is different from that in the Tamil area. The peculiar gable-roof superstructure of the temples is also frequently observed, as at Kalakuttam and Turuvanjikulam.

The Trivikrama panel at Suchindram is an example of a Vijayanagar type modified by prominent Chalukyan and other decorative features. Like the wood carvings of Kerala, the Chera murals play an important role in enlivening temples. Tiruvanjikulam offers some of the most beautiful paintings illustrating a meditative hymn from the *Ramayana* and a portrait of Venugopala. There are magnificent murals in the Padmanabhapuram palace. A striking one is the battle between Rama and Ravana; Seshasayi, Gajalakshmi, and other similar panels are all very interesting.

figs. 154–56, 652–58

A somewhat earlier painting from Mattancheri palace has some striking examples of Puranic episodes, such as Krishna holding up Mount Govardhana. The lively scene of cowherds and milkmaids under the shelter of the mountain is indeed fascinating. Krishna surrounded by gopis, also from the Mattancheri palace, cannot but recall the songs of Jayadeva from the *Gitagovinda*. The process of painting and coloring these murals is easily seen in miniature drawings from Keralan manuscripts.

figs. 205, 72

The Nayak period was followed by the Mahratta phase, which is marked by predominantly southern Indian forms, slightly modified by Deccan and western Indian motifs. The western Indian paintings of the *Kalpasutra* are interesting for comparison. Vijayanagar influence was felt as far north as Orissa, where paintings of the seventeenth and eighteenth centuries remind one how complete was the surrender of the Gajapatis to Krishnadevaraya.

Secular architecture at its best has also survived from the time of the Vijayanagar emperors. The word *prāsāda*—the mansion of the celestials—could well be applied to the palaces of the Vijayanagar monarchs at Chandragiri and those of the Nayaks at Tanjore and Madura. The close relation of religious and secular architecture is seen in the similarity between these palaces and the pyramidal vimanas. For example, the palace at Tanjore and the Brihadisvara temple vimana cannot but strike one as a repeated pattern.

Some of the finest Indian forts were built during this period. They have bastions and entrance towers and are surrounded by large moats. The finest example of this type of fort is the famous one at Vellore, which is almost as fresh as when it was built.

152. ADIPALA KILLING BUFFALO DEMONS
 13th century
 Mount Abu, Rajasthan

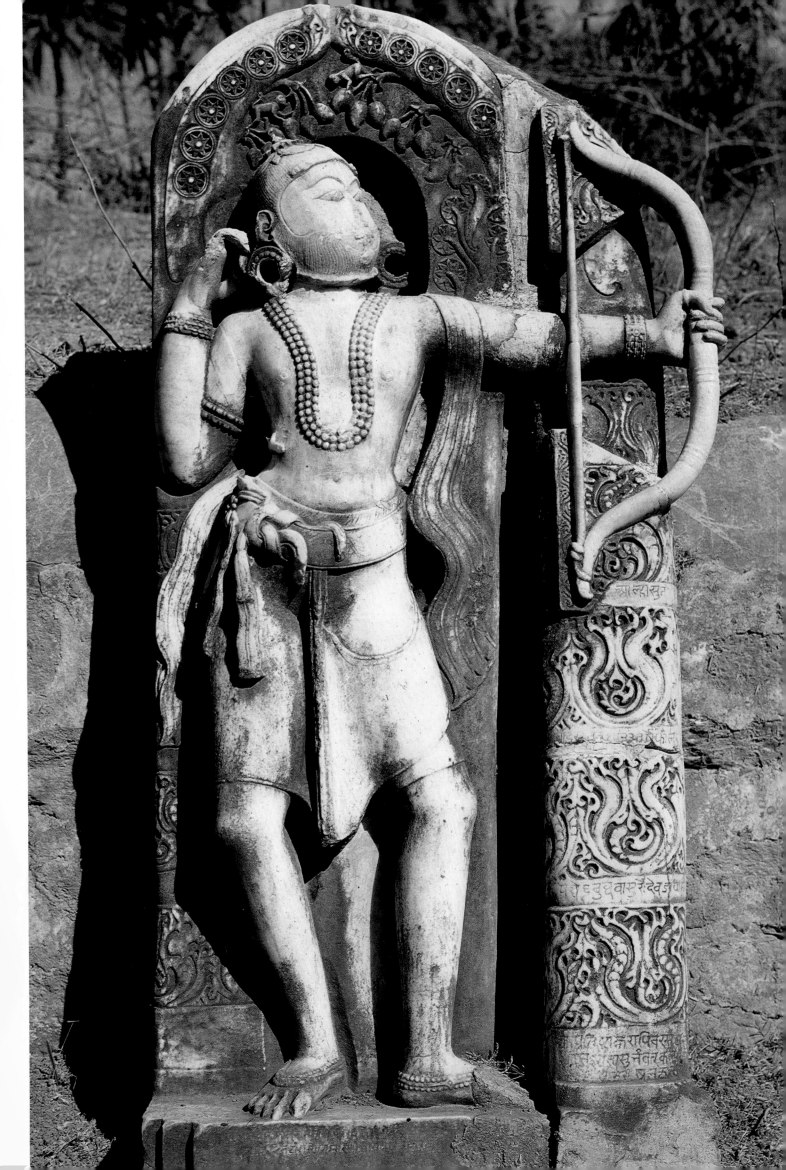

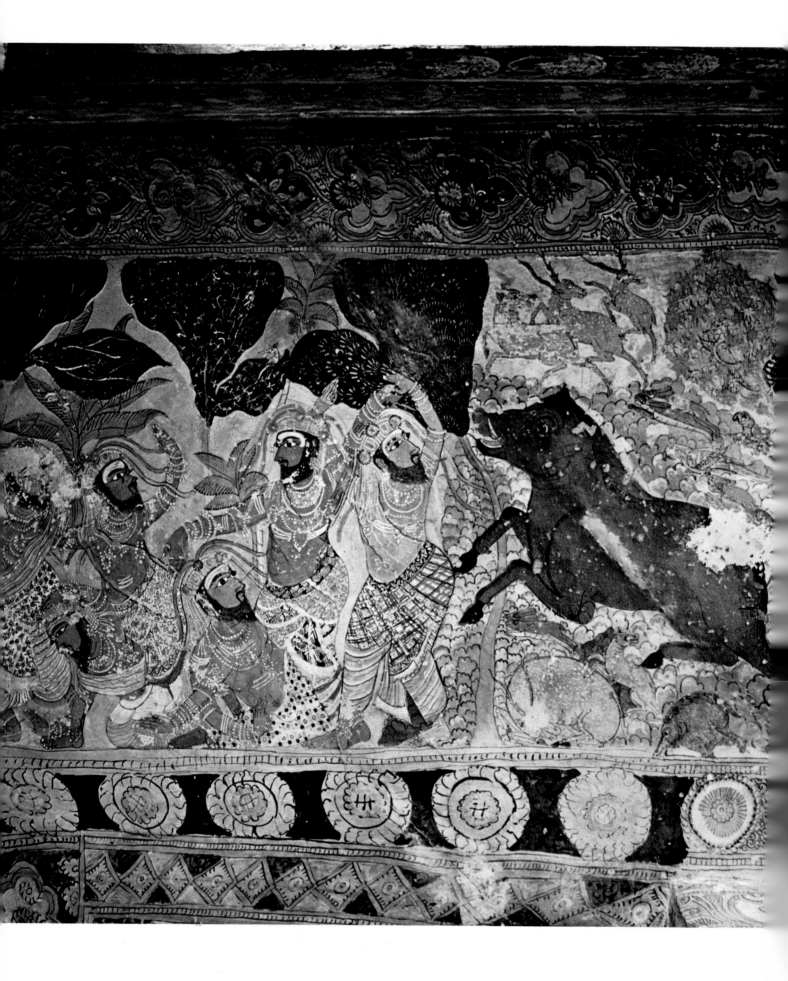

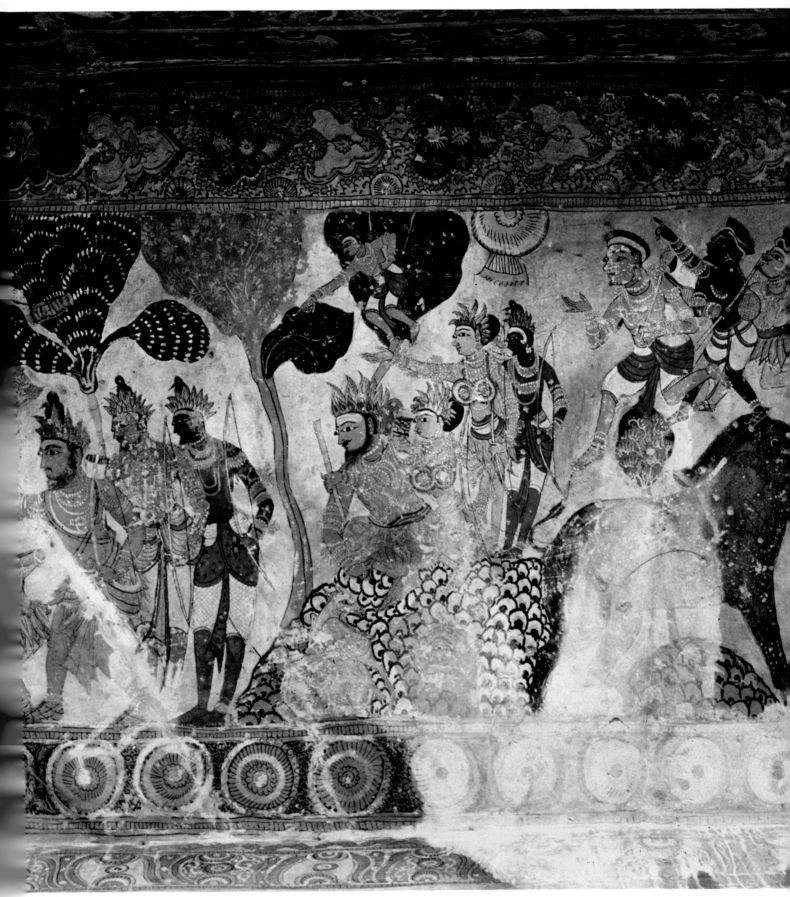

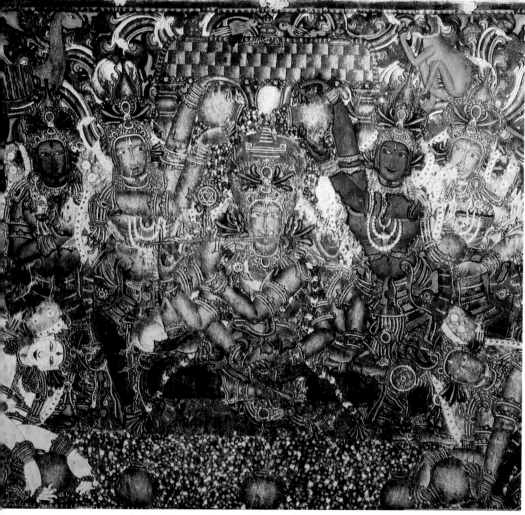

154

155

156

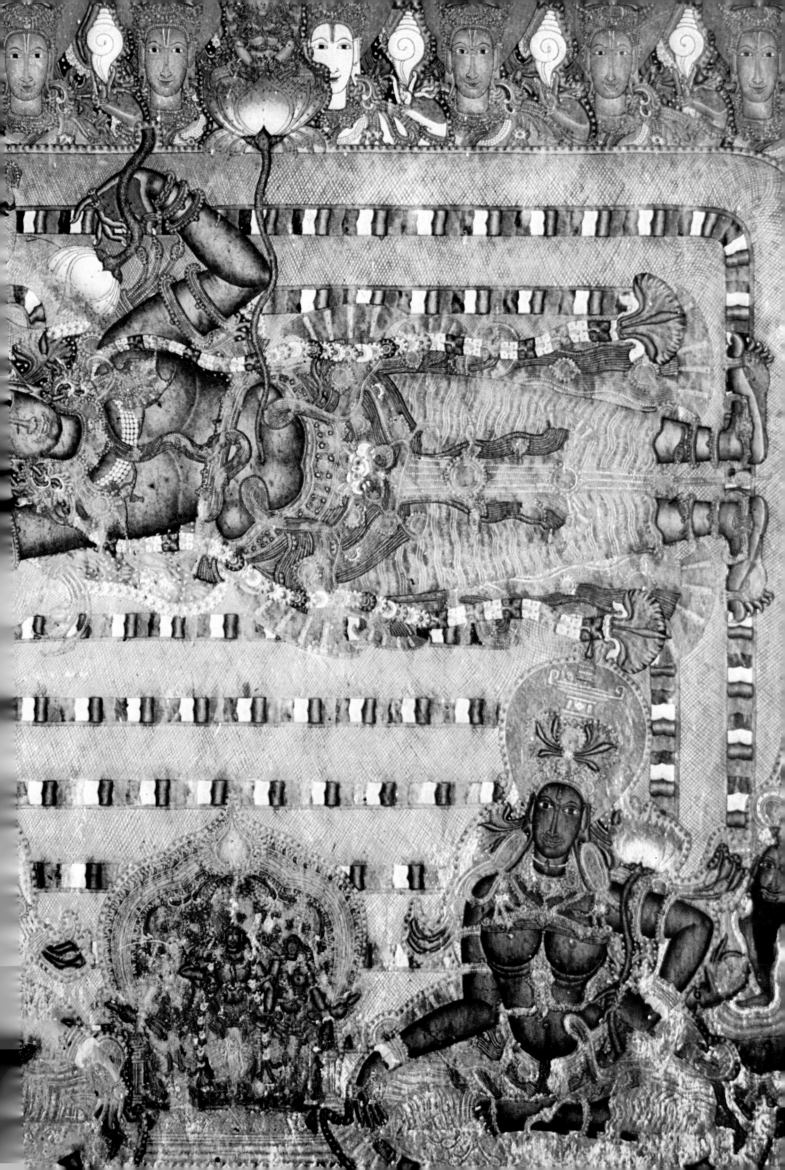

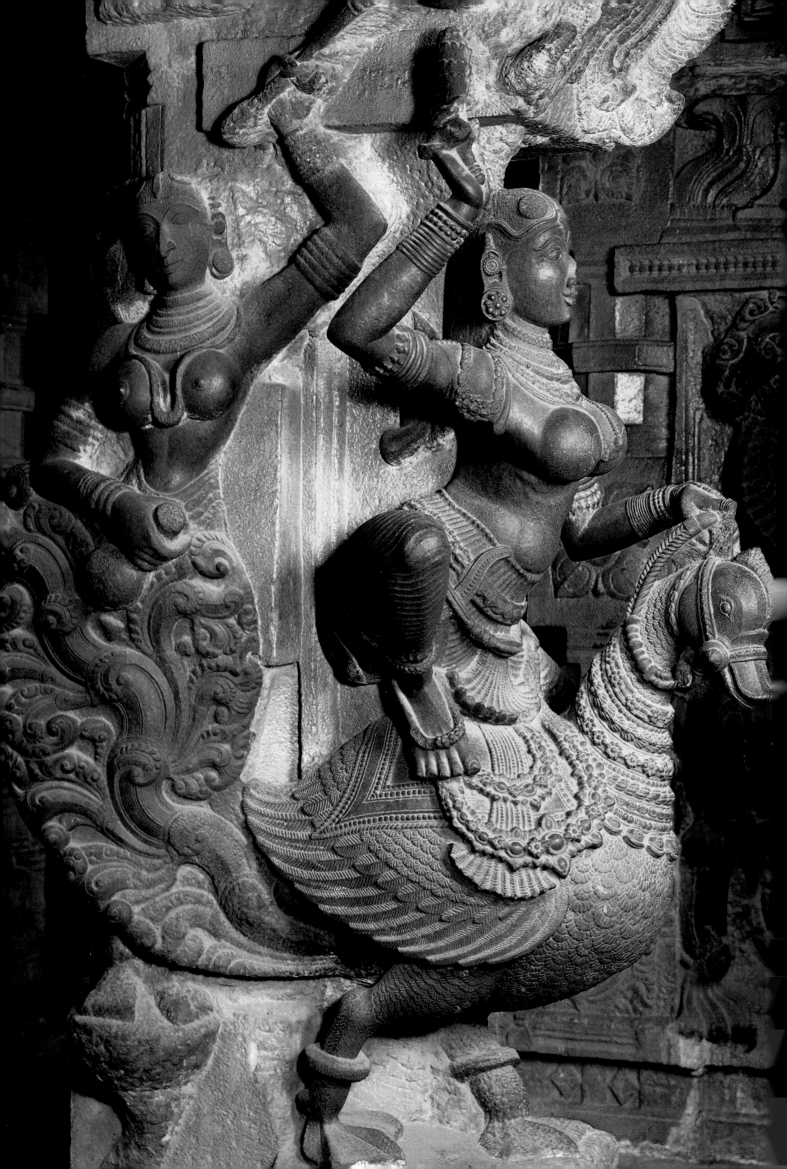

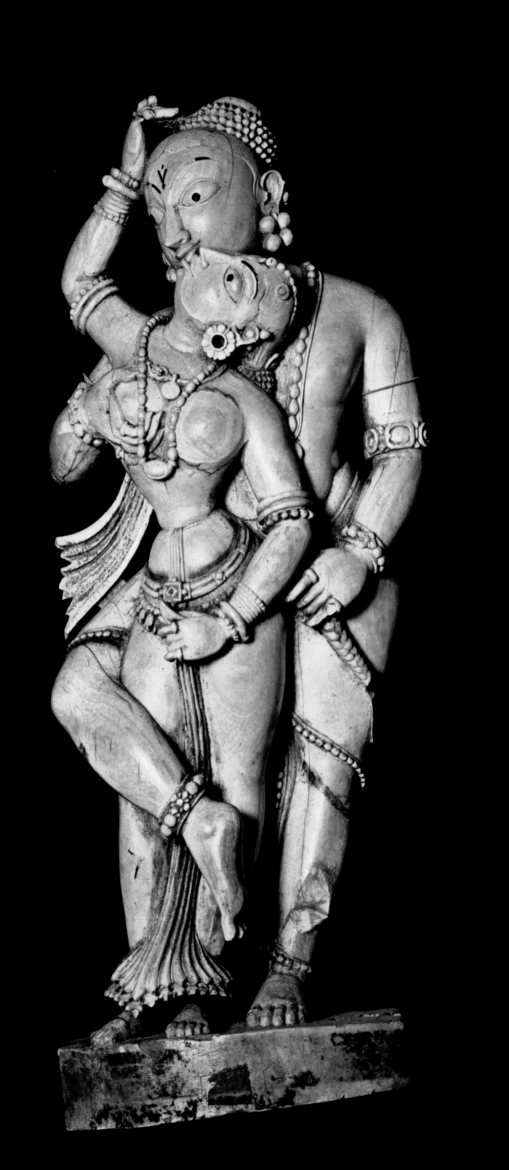

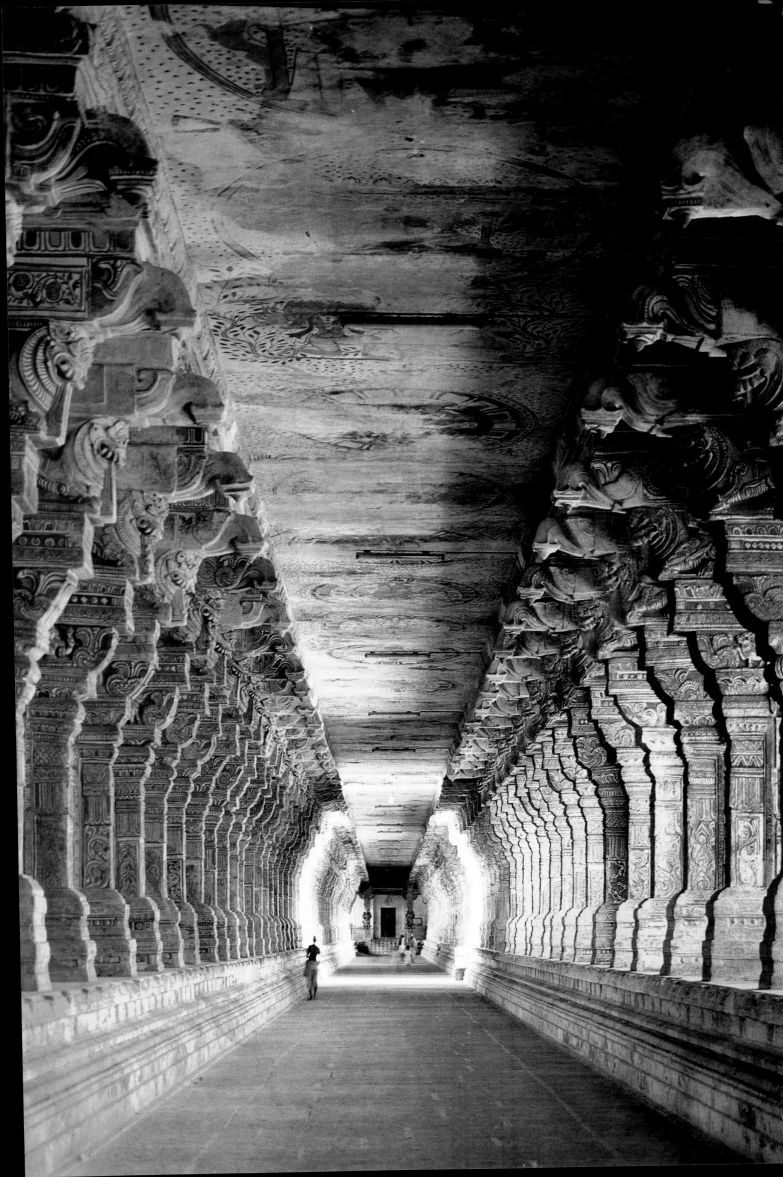

160. MINAKSHI TEMPLE
 Nayak, 17th century
 Madura

161. MINAKSHI TEMPLE
 Detail of gopura. Nayak, 17th century
 Madura

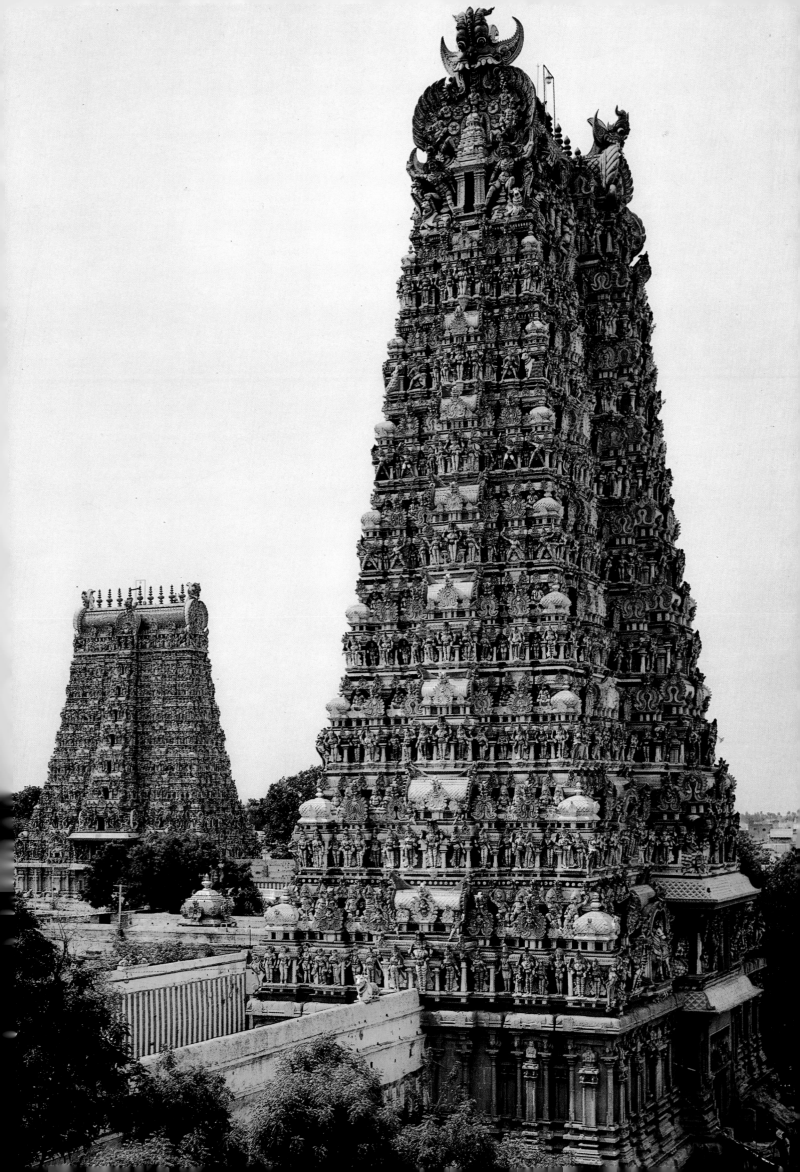

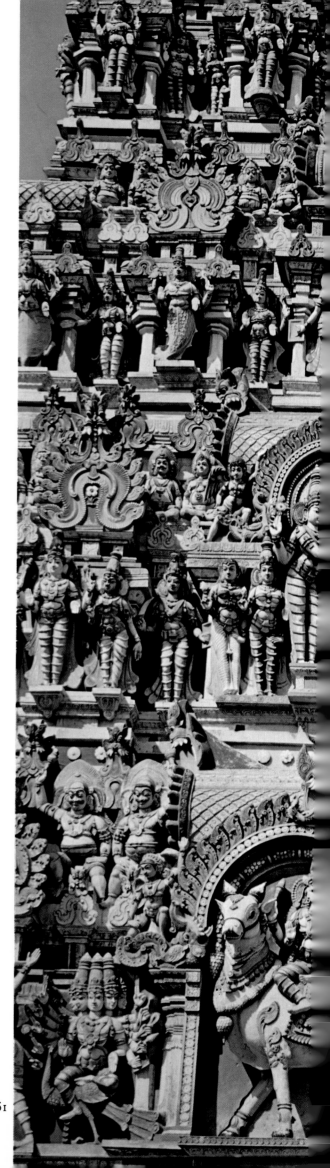

161

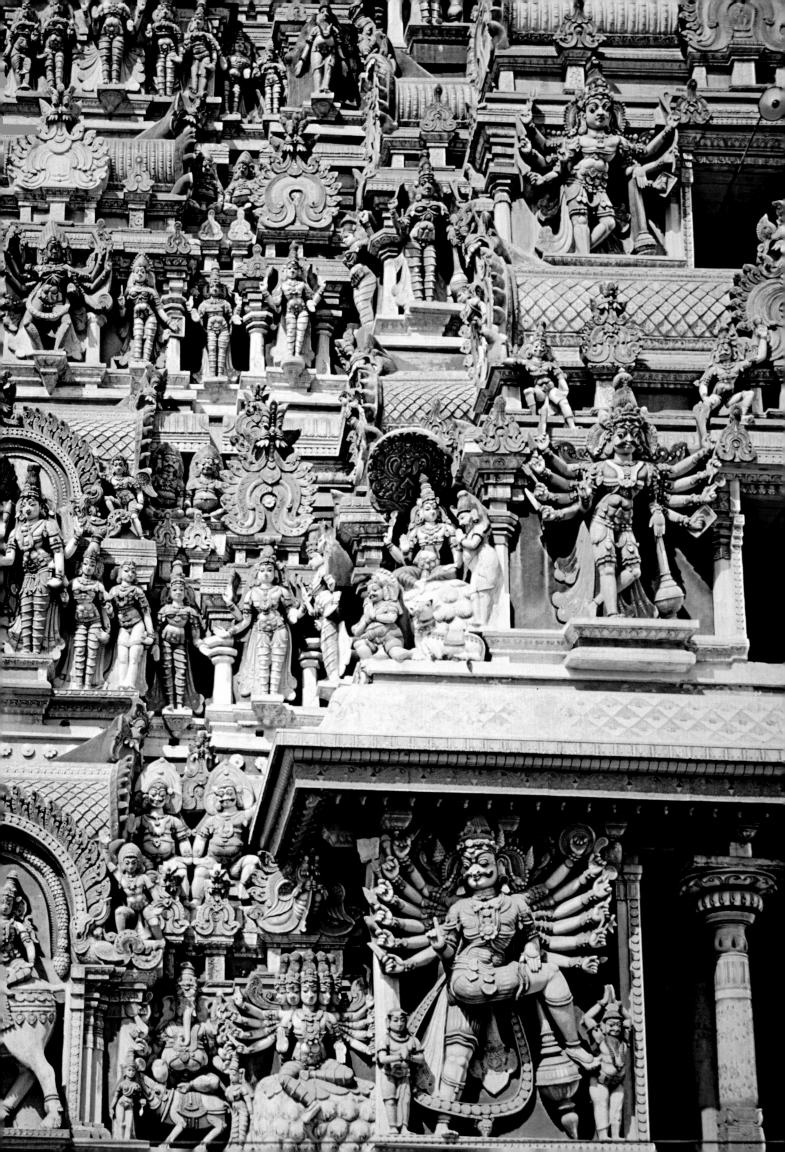

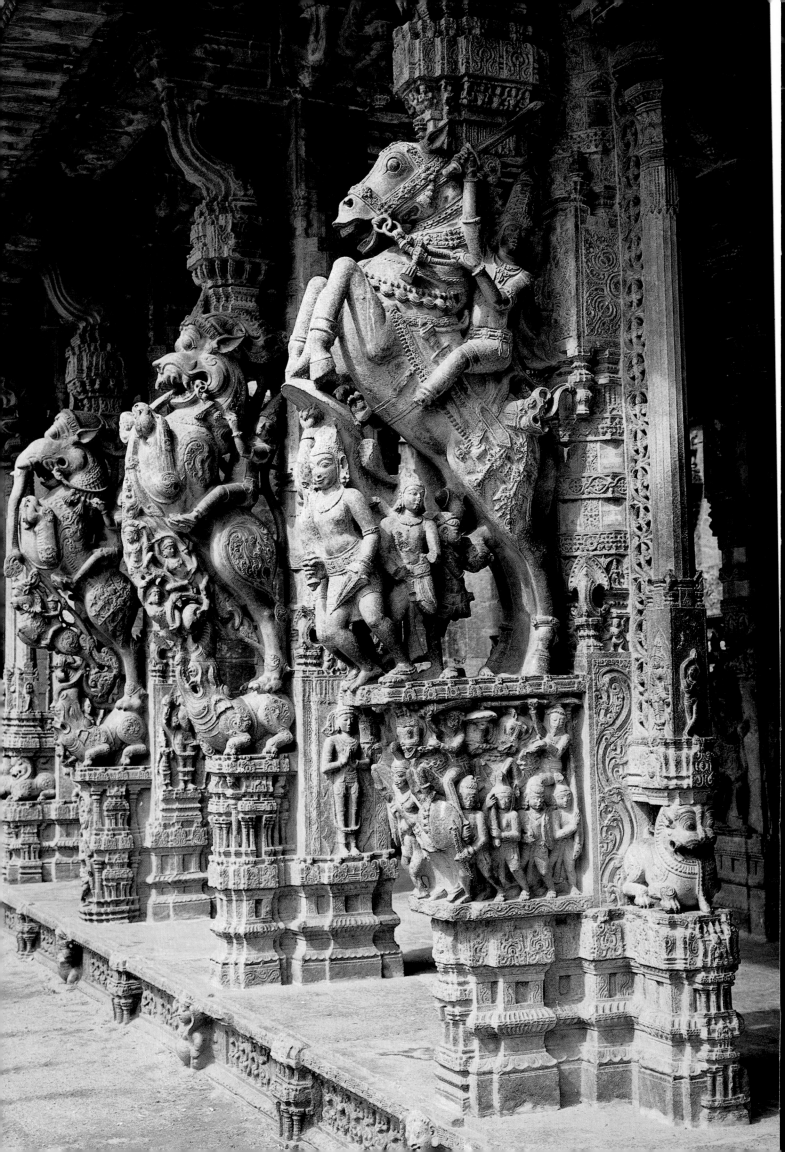

SYNTHESIS OF
TWO CIVILIZATIONS

INDIA was a great caldron in which the traditions of the hordes that poured across the northwestern frontier were mixed to form a culture of kaleidoscopic beauty. With the coming of the Greeks, a new phase of art began in the Gandhara region; Greek elements were assimilated, but the Indian themes stood out sharply. The Kushans of Central Asia introduced new idioms to Indian art and gave a special touch of richness to the indigenous traditions. With the arrival in India of the Muslim invaders, Persian elements crept into Indian art and there slowly evolved a pleasing Indo-Islamic synthesis. The earliest Muslim invaders cooperated in this mingling of cultures. The seeds of this synthesis are seen in the coins of Mohammad-bin-Sam; here Nagari and Arabic are used in bilingual inscriptions. And the warrior-and-horse motif on the medieval coins of the rulers of the Punjab was continued in the early issues of Mohammad-bin-Sam and his successors.

It is most interesting to note that the Islamic and Hindu viewpoints, which were almost diametrically opposed, blended so harmoniously. While the mosque was an open court for offering mass prayer, the temple was a dark, somber, and mysterious cell before which each individual communed with the deity. While the *pradakṣiṇavi-this* of the temple meant that the devotees had to make several clockwise circuits around the *garbhagṛha* to reach the holy of holies, the mosque was simply a large court for kneeling and prostration—no movement toward the interior was necessary. In fact, the name *masjid* means the "place of prostration," and the *jumma masjid* is simply the place where a large congregation assembles for prayers. While the mosque was the very embodiment of simplicity—with such simple requirements as a *mihrab*, or "alcove," and a *mimhar*, or "pulpit"—the temple was a large network of complexity with highly sophisticated, richly carved halls for different purposes. There was a hall for exposition of dharma; another for music and dance; one for offerings to be made to the deity; and yet another for the congregation of devotees. While the temple was rich in sculpture and is a fantasy of artistic creation, the mosque and the tomb in Islamic architecture were as simple and spare as possible. The Hindu architects adopted the principles of Islamic architecture, and the true arch, the dome, and the minaret are all Islamic forms adopted by the Indians. The Hindu architects retained the Islamic spirit of simplicity in these elements, but they added a fantastic richness of floral design and arabesques. They were so successful that their monuments are among the most important Islamic structures in the world.

There are two distinct phases of Islamic architecture in India. In the first Indian temples were razed to clear ground for Islamic construction, but the new structure utilized as much of the original material as possible. Often whole series of columns from pillared halls were left standing, thus making the structure look rather unbalanced. In the next phase, however, the mosques and tombs were planned independently, without reference to previous structures. These were constructed with exquisitely carved blocks, especially quarried for each project.

In India the temple was the most important architectural unit; palaces and other secular buildings did not receive the same careful attention, as is evident from the great number of these structures that have perished. The stone forts that have

survived, as at Vellore and Gingi, date from long after the Muslim conquests. Islamic secular architecture was regarded perhaps more highly than that of mosques and tombs. Sandstone and marble were utilized as freely and lavishly on secular buildings as on religious structures. In fact, all the great palaces, mahals, and forts of the Hindu princes from the fifteenth, sixteenth, and seventeenth centuries are based on those of the Moguls and the provincial nawabs and sultans.

fig. 163
fig. 679

In the thirteenth century the Slave dynasty constructed a great monument in its capital, Delhi. Kutb-un-Din and his son-in-law Iltutmish conceived and executed a great minar, the Kutab Minar. The abundant floral designs and the ribbed contour cannot but remind one of the work of Hindu craftsmen, but wonderful bands inscribed with lines from the *Koran* and geometrical patterns highlight the Islamic texture of the monument. Here much of the pillared hall of the Hindu temple, which originally stood on the spot, has been utilized for the large prayer court of the mosque. (This is also true of the mosque at Adhai-din-ka-Jhonpra in Ajmer of the same date.) The large and noble arch, delicately carved with Islamic inscriptions and floral motifs, and the iron pillar shows the Hindu element in the earliest Islamic architecture in India. There is also the wealth of ornamental design that is characteristic of Hindu work.

The Quwwatul-Islam, the work of Iltutmish, is more austere and therefore more Islamic in character. It has patterns of Tughra and Kufic characters as its ornamentation. After the Khaljis and Tughlaks, the Sayyids and Lodis, Babur triumphed in India. But his son Humayun suffered a reverse at the hands of Sher Khan and had to retreat to Persia, where he sought refuge with the monarch who was his friend. Sher Khan died in 1553, and Humayun then reconquered his kingdom. The tomb that Sher Khan built for himself at Sasaram is a picturesque pyramidal structure in the center of a pond.

fig. 983
fig. 985

With the advent of the Moguls a great advance in Indo-Islamic architecture was made. Akbar, who succeeded Humayun, dreamed of joining the two cultures. A great builder, he founded Fatehpur Sikri (City of Victory), where he erected several magnificent monuments. The tomb he erected with affection and reverence for Chishti, the great saint who blessed him with a son Salim, is very delicately wrought with exquisite latticework screens entirely of marble. The Buland Darwaza at Fatehpur, a great arch of victory, is probably the most imposing of its type. The Panch Mahal, with its five stories and lovely columns and pavilions, is a magnificent blend of architectural traditions. Another wonderful creation of Akbar at Agra is the throne on a single large pillar in the center of the Diwan-e-Khas; it is supported by thirty-six brackets on the capital of the column and was used by the monarch when he presided over philosophical disquisitions. This was itself a novel creation approaching the *dipastambha* pattern in Indian architecture. Birbal's palace and some of the zenanas for the queens, such as that of Jodh Bai where there is a predominant Hindu decorative pattern commingling with the Islamic arch, are similar creations of Akbar.

fig. 683

While the tomb of Humayun in Delhi with its white marble dome is Islamic in character, Akbar's tomb at Sikandra, built in three stories by his son Jahangir, lacks a dome but is a perfect example of a delicate work in marble.

fig. 978

The pattern of the fort at Agra with its great public and private audience chambers was repeated in 1650 at Delhi by Shah Jahan in the imposing Red Fort, which is the greatest ornament of the capital. The intricate plumbing, which allowed

water to flow through hidden channels in the palace halls, brought in the waters of the Jamuna which once flowed past the fort. The inlay work is marked by intricate arabesques and floral designs of light and unobtrusive elegance.

fig. 12

This great achievement of Shah Jahan is almost eclipsed by the magnificent white marble tomb at Agra, the most famous in the world, for his beloved wife, Mumtaz Mahal. The Taj Mahal was completed in twenty-two years, and twenty thousand masons are believed to have worked on it continuously during this period. The exquisite inlay work is lavishly executed with semipreciouss stones. It is believed that the Persian architect Ustad Asi was in charge of the project, and the magnificent dome is attributed to a Turkish architect. With its four minarets, large dome, stately proportions, and well laid-out garden with long water channels and fountains, the Taj Mahal is one of the great architectural wonders of the world. Shah Jahan was the last of the great Moguls devoted to art, and as a builder, he was perhaps second only to Akbar.

fig. 164

Among the provincial schools, the most beautiful culmination of the Hindu craftsman's art of decoration was reached in the magnificent marble fretted windows, delicately carved with patterns of the celestial tree, in the Sidi Sayyid mosque at Ahmadabad, one of the most famous Muslim monuments in Gujarat. In the Deccan, Ibrahim Adil Shah brought great glory to his kingdom, Bijapur. The mosque of the tomb of Ibrahim Rauza, with its beautiful domes and minarets and brackets supporting the porch roofs, is lavishly decorated with arabesques and inscriptions and is among the most charming of monuments. The Gol Gumbaz is a unique monument because of its enormous dome, among the largest in the world. The slightest whisper at one side is heard on the other. It also has four seven-storied towers which, along with its large and imposing dome, make it the most remarkable Muslim monument in the Deccan.

fig. 674

fig. 839

fig. 840

In the wake of the Mogul embellishments in architecture, the palaces of Indian princes began to show a harmonious blend of Islamic and Hindu motifs. Maharaja Man Singh, who was closely associated with Akbar, so beautified his city of Amber that the palaces here rivaled Akbar's magnificent buildings at Fatehpur Sikri. A palace at Amber has Islamic grace in its arches, trelliswork, pierced windows, and projecting balconies typical of Mogul structures. But it also has a modified śalā and kūṭāgara shape to the roof, so it can be said to be a blend of the two cultures. The brackets and balustrades and the floral designs show the skill of the Hindu craftsman, and the spacious and cool halls, chambers, and arcades are familiar elements in the Muslim monuments.

In a spirit of emulation many beautiful forts, like that in Gwalior, were constructed. The culmination is seen in the Hava Mahal at Jaipur. It is gorgeous in its multistoried magnificence, but it is only a splendid facade.

The Udaipur palace in its picturesque surroundings near a lake is another of the great Hindu palaces that combine the best of the two traditions. In the south, the tomb of Sultan Tipu, which is decorated with paintings, is interesting, although it does not rival the great monuments of the Moguls. The last important Mogul monument was built by Aurangzeb, a great ruler who despised art. He did, however, build a beautiful tomb for his wife at Aurangabad, which emulates but does not rival the Taj Mahal.

Because of their religion, the Moguls could not represent human or animal forms in art. Therefore they concentrated on architecture, calligraphy, and painting. Mogul painting on Pwas basedersian works, which in turn were greatly influenced by Mongolian art. This blend of the central Asian art of Chinese Turkistan and that of Persia was introduced into India. It flourished and flowered there as a strange and lovely tree of paradise with a rich perfume and colorful glow derived from the indigenous Indian traditions.

Though Mogul painting is a distinctive school with a splendor all its own, it is still basically Indian with a flavor of its Persian antecedents. Though Bihzad, a masterful artist, was a contemporary of Babar, the emperor did not utilize him for developing art. Like his son Humayun, Babar was taken up by his ambitious quest for an empire. Since Humayun had to seek refuge in the Persian court, he came into contact with Bihzad, Mirak, and other court painters of Shah Tahmasp.

Akbar, who succeeded his father when he was only four years old, had a rare flair for both learning and art. He used both his ears and eyes and was a great scholar, though illiterate, and a fine connoisseur. Himself unlearned, he knew the value of books and had a magnificent library of Arabic, Persian, and Sanskrit volumes. With a great passion for the fine arts, he encouraged Persian artists in his court. The *Akbar Nama*, the *Razm Nama*, and other literary works were profusely illustrated at his command. The Persian techniques were assimilated and enriched by Indian artists, and a rare blend of the charm of both traditions arose in a new school. Manchar, Farukchela, Basawan, and Madhu were among numerous painters of this period. Khwaja Abdus Samad of Shiraz, originally the protégé of Humayun, enjoyed the favor of Akbar. The emperor also appreciated the merit of Daswant, the son of a poor palanquin-bearer. Daswant was apprenticed to Abdus Samad and became one of the best painters of his day. The painters often signed their pictures, and therefore a large number of artists are listed in the *Ain-i-Akbari*, among them Mukund, Madhu, Khemkaran, Harbans, and Kesavlal. This glorious heyday of painting under Akbar has given us wonderful illustrated texts of *Babar Nama*, *Akbar Nama*, *Hamza Nama*, and *Razm*

figs. 168, 169, 662

Nama. In all these paintings the Persian mode of treating the background and landscape, the mountains, trees, animals, and birds, is evident.

Jahangir, who left the reins of government in the hands of his able queen, had ample leisure for enjoying wine and appreciating art. A great patron, he had a number of talented painters in his court. In his memoirs he takes special pride in his connoisseurship. Through his deep study of the strokes and style of individual artists, he was able to distinguish the work of different hands. He encouraged portraiture

fig. 167

and had himself and his queen, family, and noblemen depicted in gay paintings. Bishandas and Mansur were among the famous painters of his day.

Shah Jahan, who was also a great connoisseur of art, was interested mainly in the noble art of architecture. But painting flourished until it was given the death blow by the puritan Aurangzeb.

In Malwa, as in the Mogul court, Persian influences had their effect. Such sultans as Nasirud-din-Khilji encouraged Persian artists, and fine illustrated books such as the *Bustan* of Sadi were produced. In these paintings the Persian element dominated, although it was enlivened by the indigenous Hindu motifs, as in the *Nimat*

fig. 659

Nama and the *Laur Chanda*. The southern schools of Ahmednagar, Golconda, and Bijapur were strongly influenced by the Vijayanagars, as were the Gajapatis in Orissa.

The illustrated palm-leaf manuscripts of western India, the earliest of which date from the eleventh century, have colorful illustrations with gold and silver lettering and rich color decoration. Jain manuscripts, such as the *Kalpasutra, Siddahemala-ghuvritti, Kumarapalacharita,* and *Kalakacharyakatha,* are famous. There are other illustrated texts—the *Vasantavilasa, Balagopalastuti,* and *Salibhadracharita.* These illustrations are characterized by simplicity of color, formalized figures, and austerity. The face is usually presented in three-quarter profile with angular nose and large bulging eyes. The calligraphy is equally interesting and important. As a natural consequence of this tradition, the Rajasthani schools came into being, and their miniatures are found in such profusion that they have enriched numerous art collections in India and other parts of the world. Although they are simply miniature copies of the murals of the day, they are drawn with a boldness and ease that almost denies the effect of Mogul influence. *figs. 52–55*

The Mogul paintings—aristocratic and individualistic, strong in portraiture, patronized by royalty—are marked by glory, vanity, and pomp, while the Rajasthani paintings are more in tune with everyday life and are sublime in their themes and universal in appeal. Their spirit of religion and mysticism interprets the moods of nature in spring, summer, and rain; they reveal the emotions of man and animal, conveying a message of love for both the animate and inanimate, the bird and the beast, the peacock, the deer, the dove, the monkey, the cows and calves, trees and creepers, running streams with shady bowers, moisture-laden clouds showering raindrops with circling cranes, lovers in union and separation. These paintings touch the hearts of the noblest and the humblest. There is a ruggedness and a colorful strength in Rajasthani paintings, while in the works from the hilly region of Pahari there is a softer and greater decorative charm. The themes have always been great favorites—episodes from the *Mahabharata* and *Bhagavadgita;* the sports of Krishna; scenes from the life of Rama; complex episodes from the epics; the love of Nala and Damayanti; *fig. 178* the victory of Chandi; personified musical modes; and the months in succession, the rains pouring from laden clouds, spring with its flowers in bloom, summer with its hot winds, and so forth.

There are various branches of the Rajasthani school—Mewar; Bundi; Jaipur; Bikaner and Jodhpur; Kishangarh; the Pahari from the hills, with Kangra its most graceful phase; and others such as Guler, Ghamba, Nurpur, Garhwal and Jammu, Kulu and Basohli, the last two with a strong folk element. The painters of all these locales have immortalized in a visual way the great vernacular poetry of Kabir, Vidyapati, Umapati, Chandidas, Tulsidas, Kesavadasa, and Bihari.

163.　KUTB MINAR AND RUINS
OF ANCIENT HINDU TEMPLE
13th century
Near New Delhi

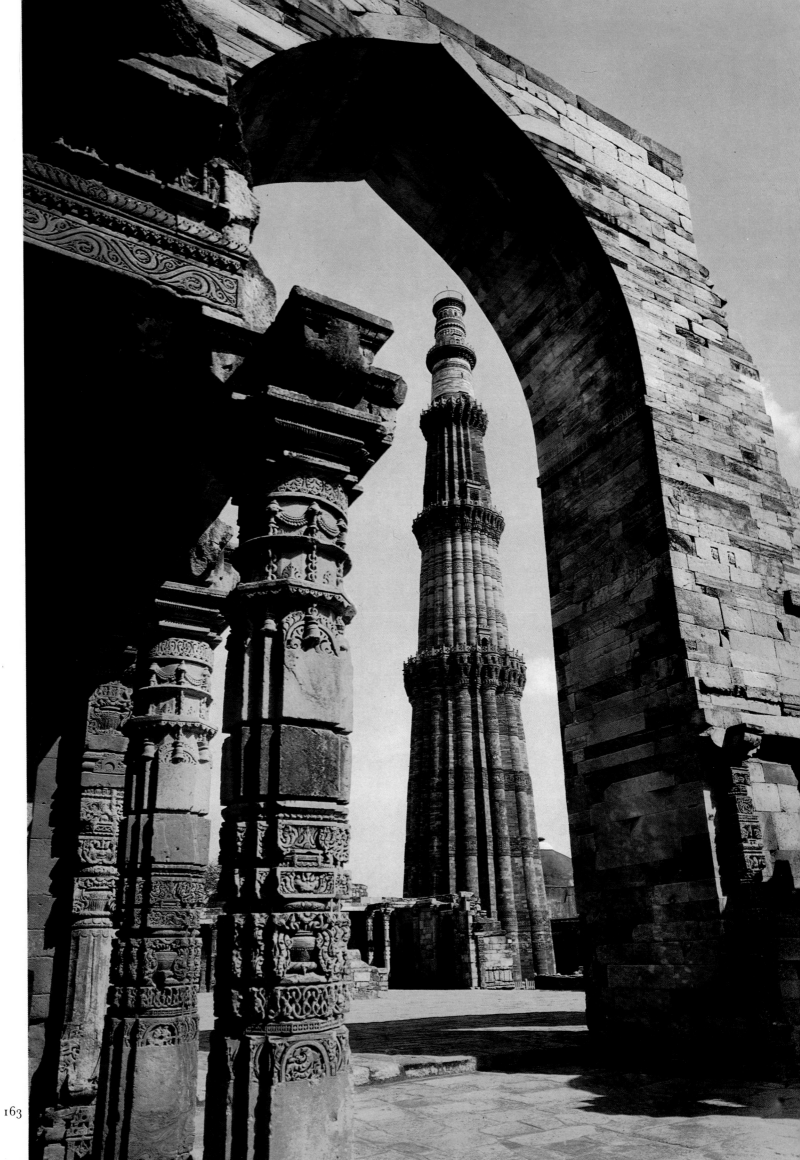

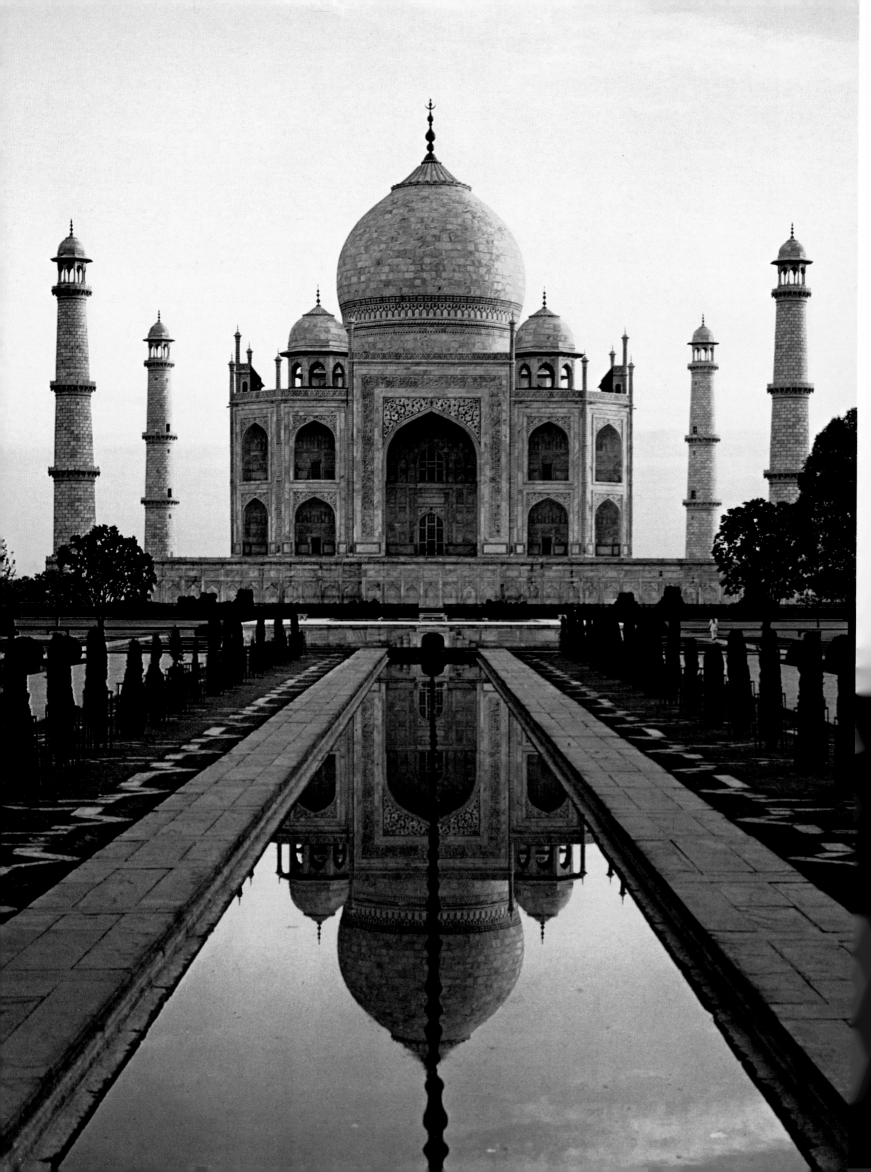

164. TAJ MAHAL
17th century
Agra

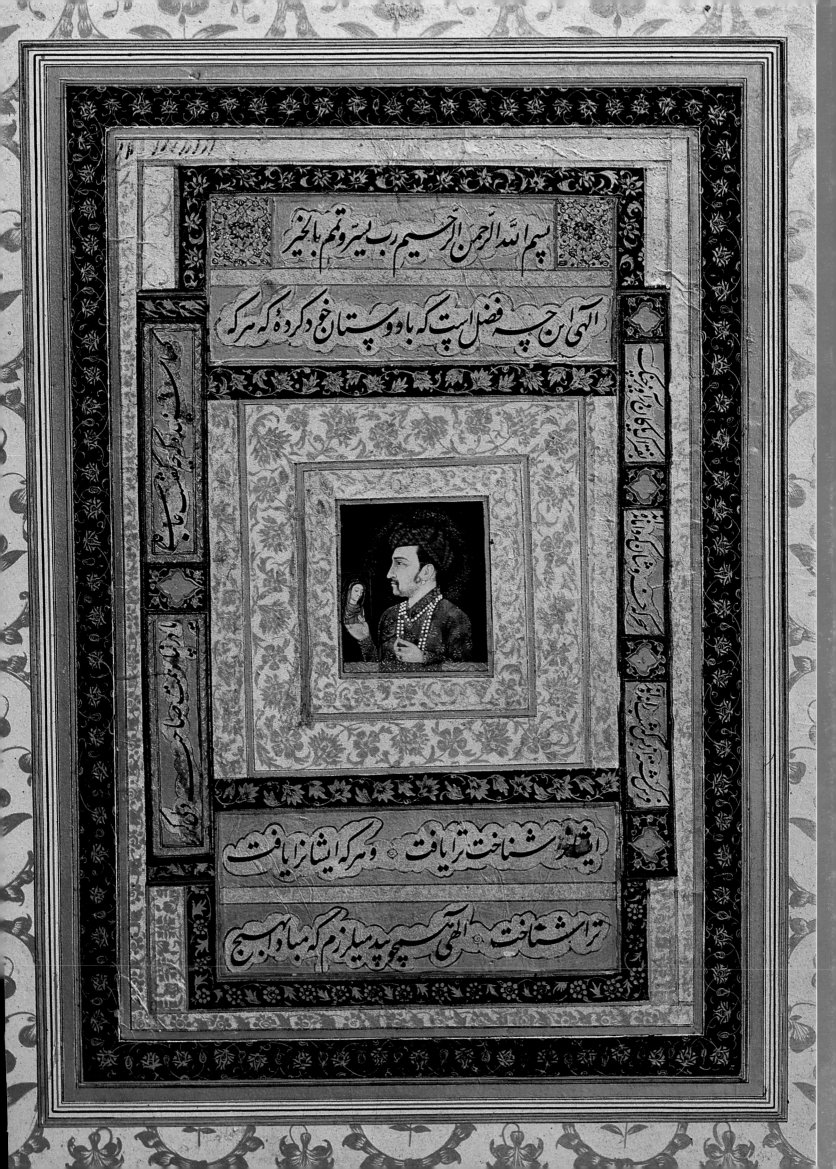

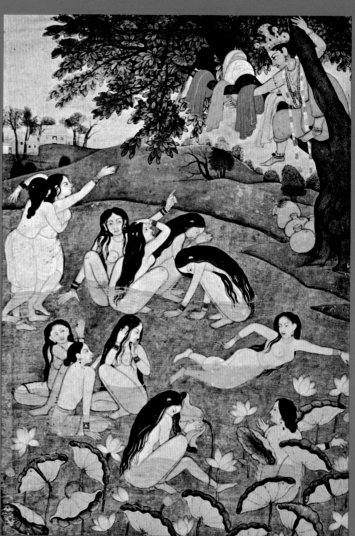

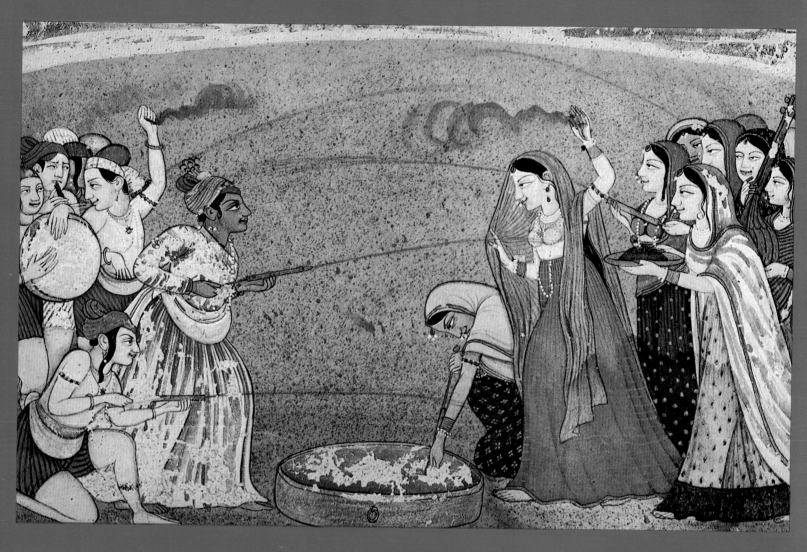

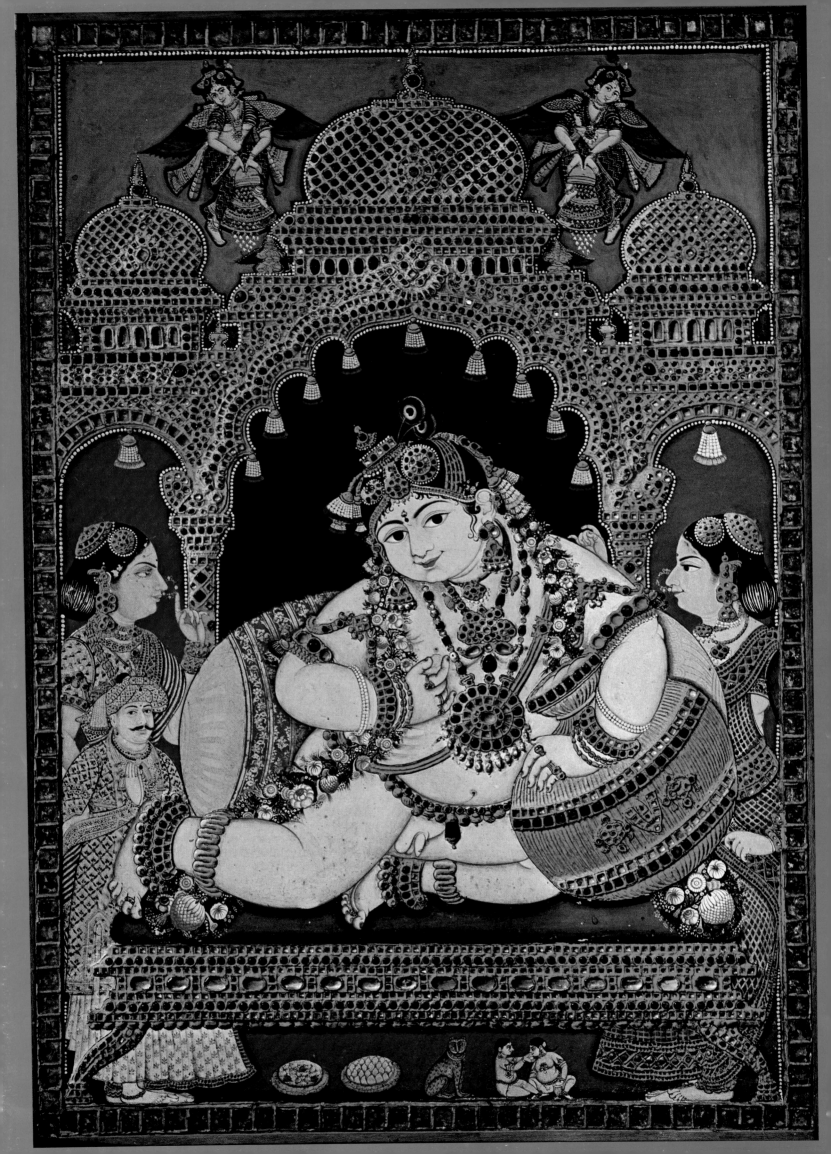

PHOTOGRAPHIC DOCUMENTATION

protohistory

(FOR CAPTIONS SEE PAGE 425)

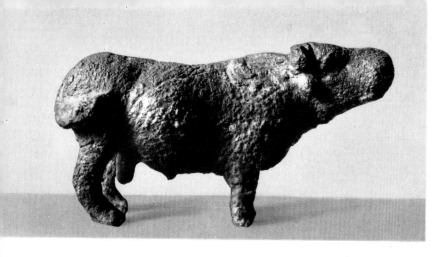
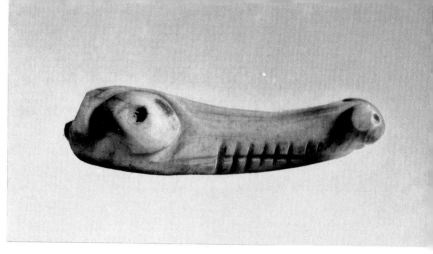
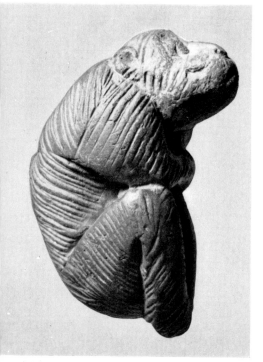
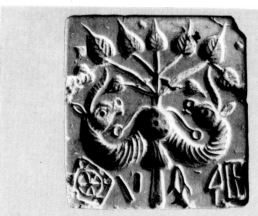
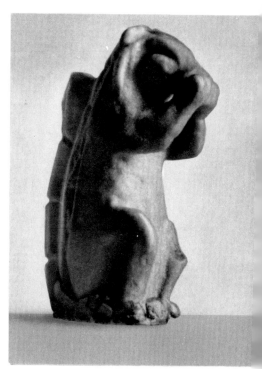
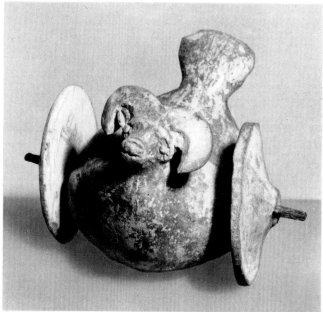
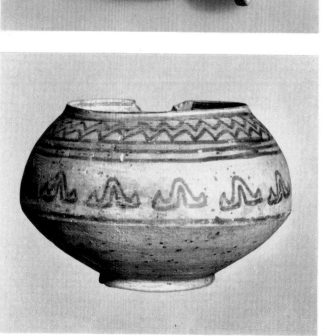
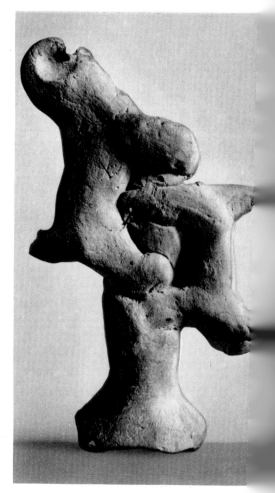

Left to right, top to bottom Nos. 181 through 189

nature and iconography

(FOR CAPTIONS SEE PAGE 425)

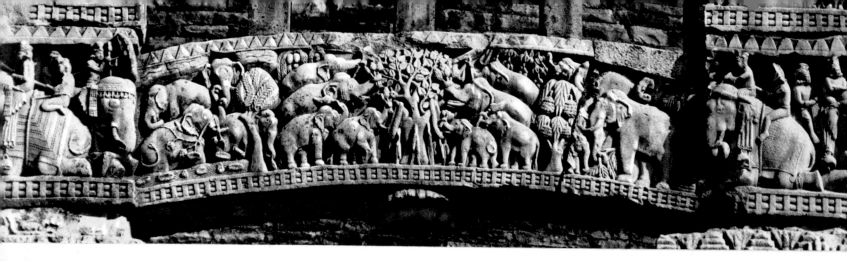

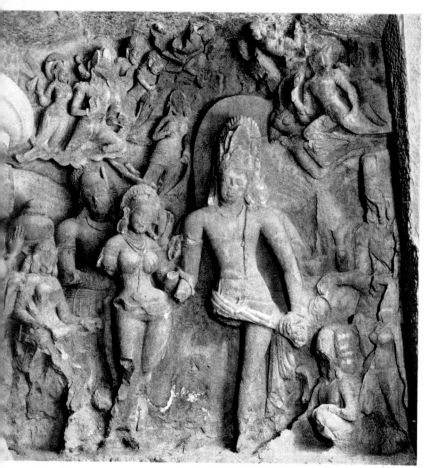

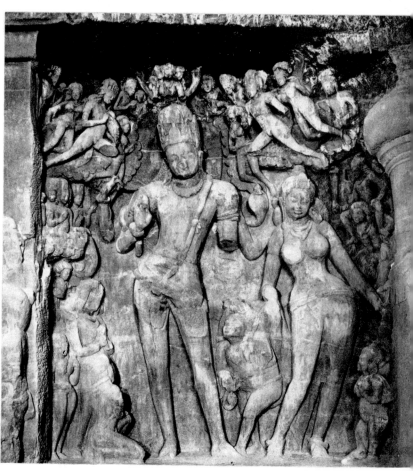

Left to right, top to bottom Nos. 190 through 195

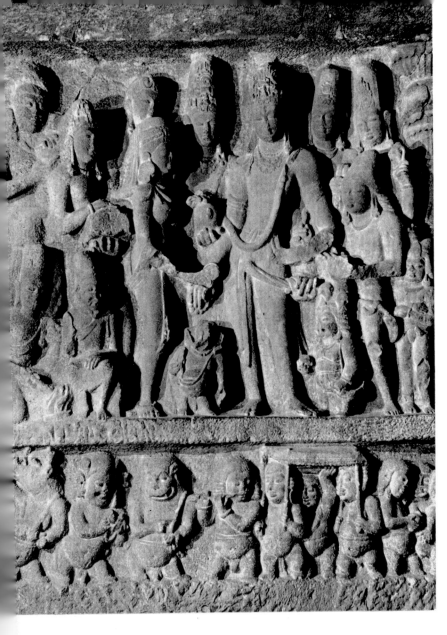

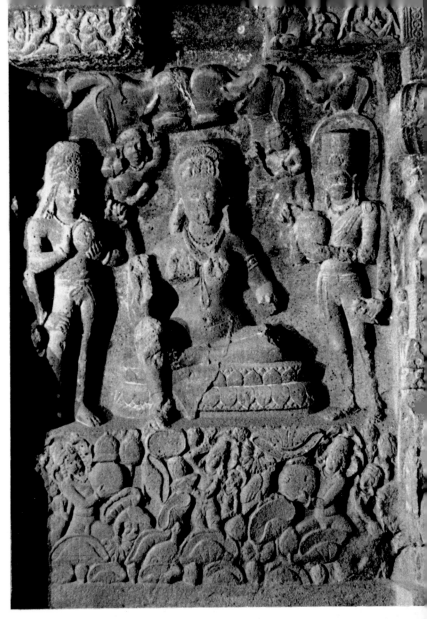

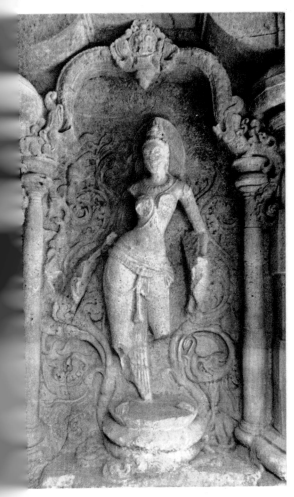

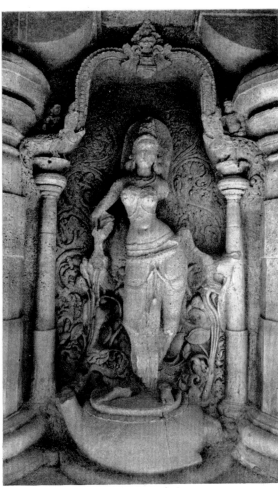

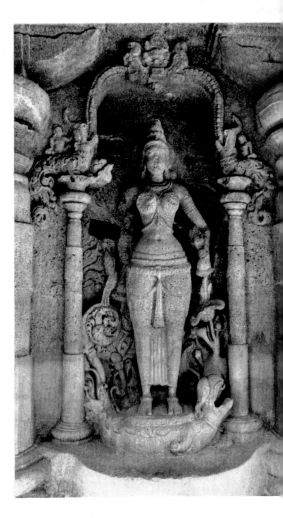

Left to right, top to bottom Nos. 196 through 200

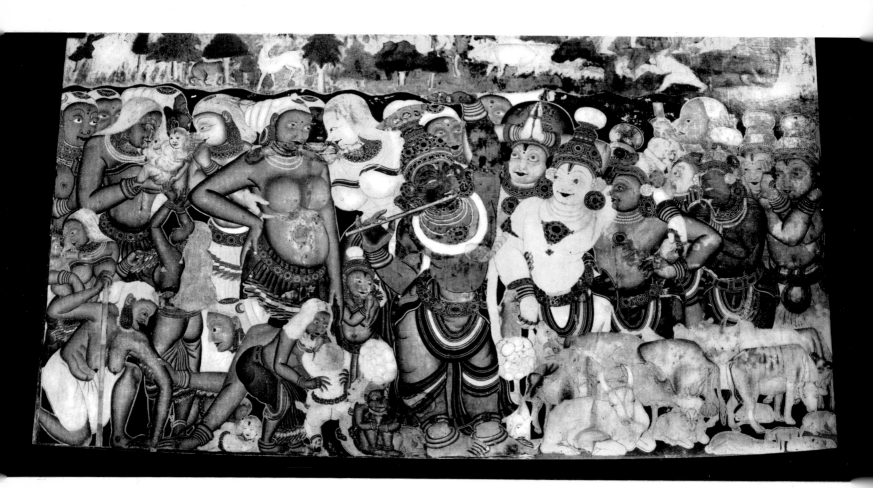

Left to right, top to bottom Nos. 201 through 205

Indian scripts

(FOR CAPTIONS SEE PAGES 425 THROUGH 426)

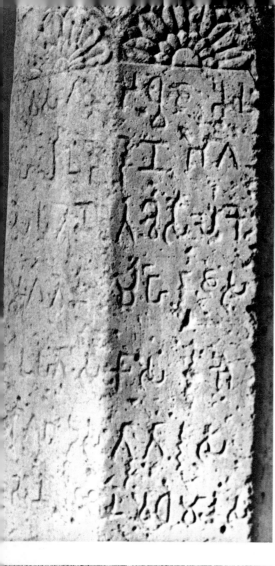

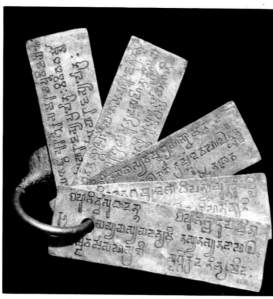

Left to right, top to bottom Nos. 206 through 214

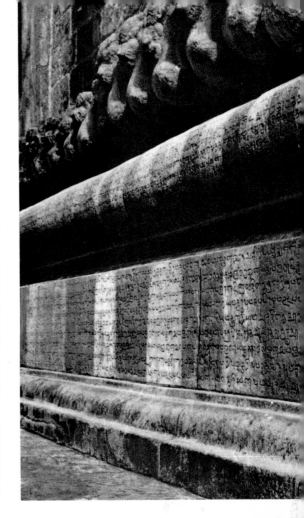

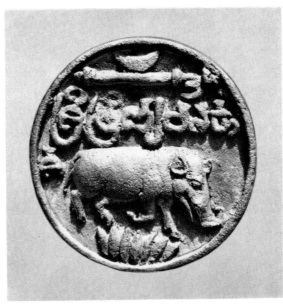

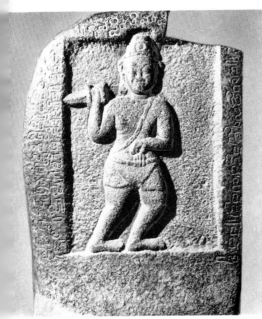

Left to right, top to bottom Nos. 215 through 225

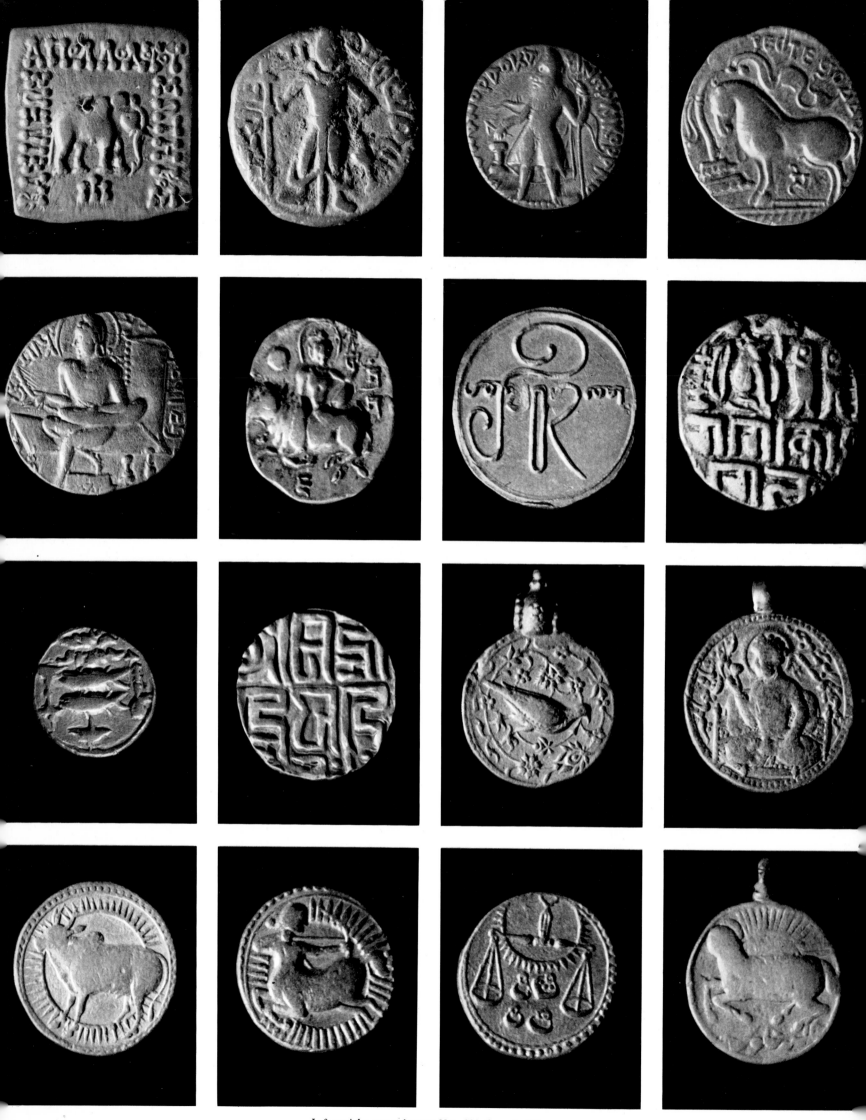

Left to right, top to bottom Nos. 226 through 241

Vedic gods

(FOR CAPTIONS SEE PAGES 426 THROUGH 427)

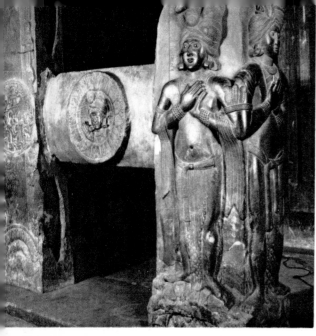
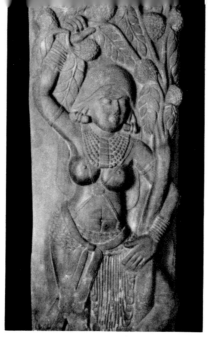
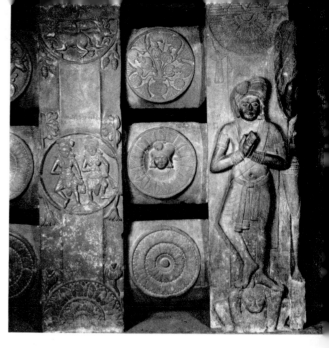
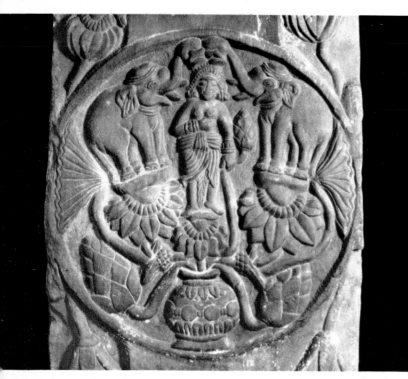
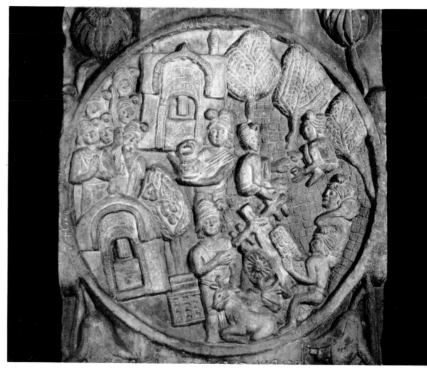
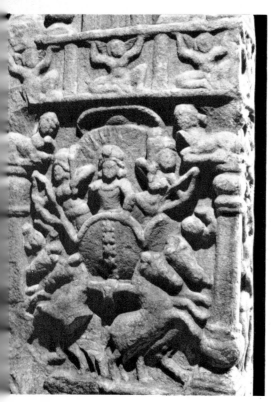
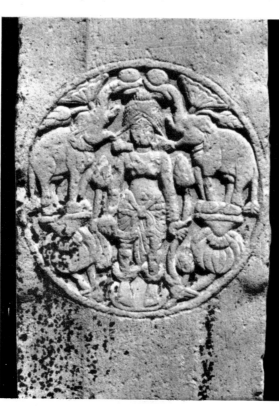
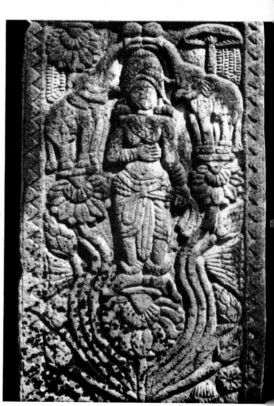

Left to right, top to bottom Nos. 242 through 249

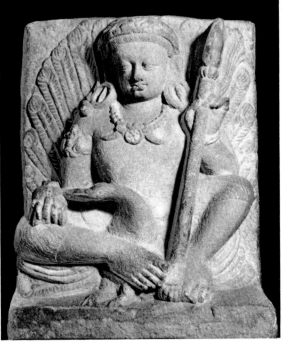
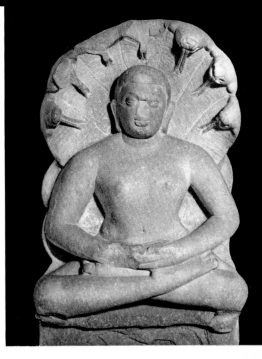
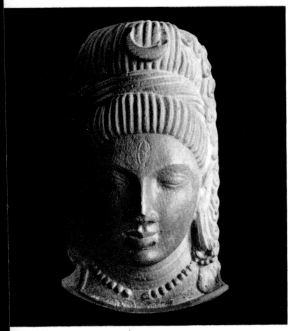
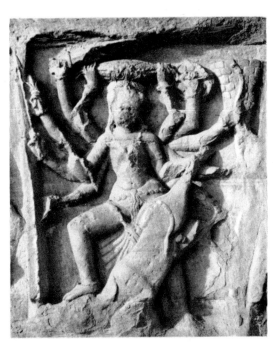
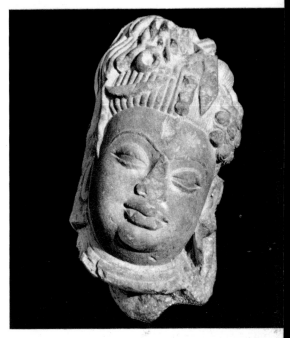
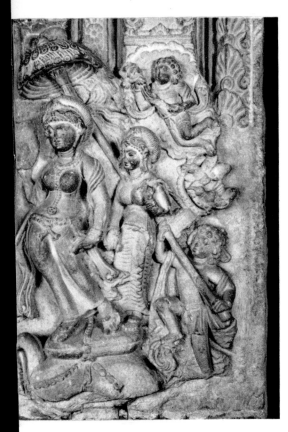
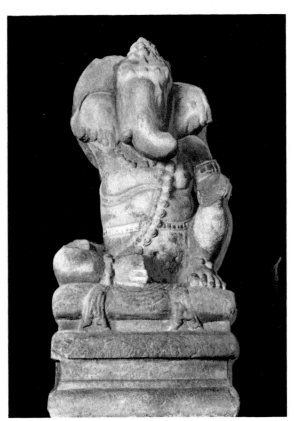
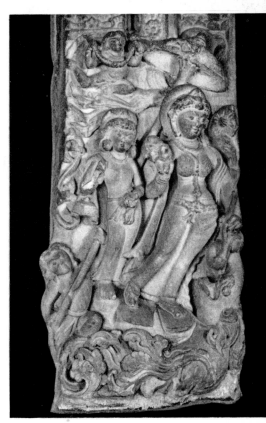

Left to right, top to bottom Nos. 250 through 258

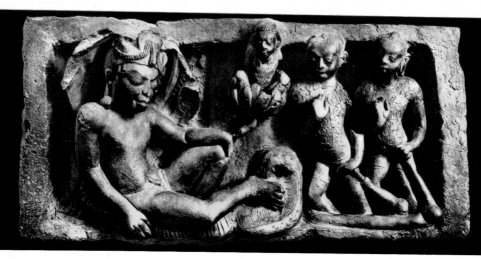

Left to right, top to bottom Nos. 259 through 263

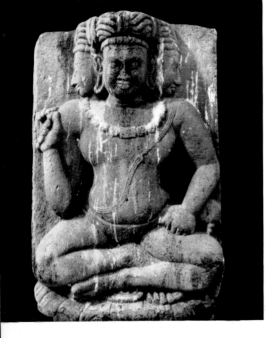
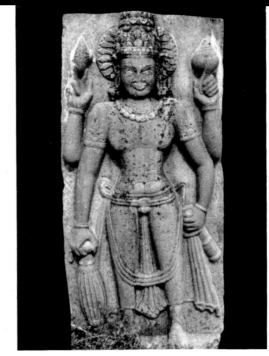
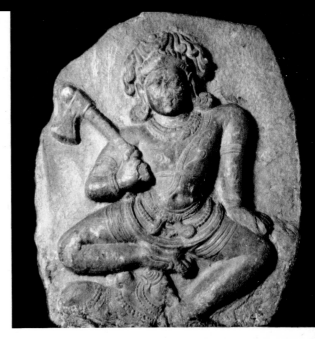

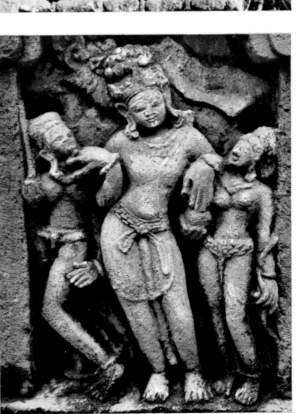
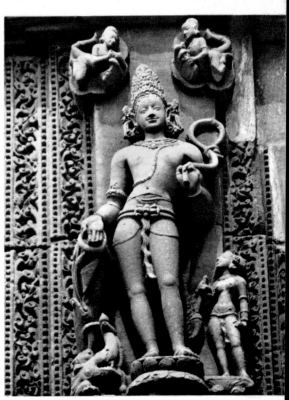

Left to right, top to bottom Nos. 264 through 272

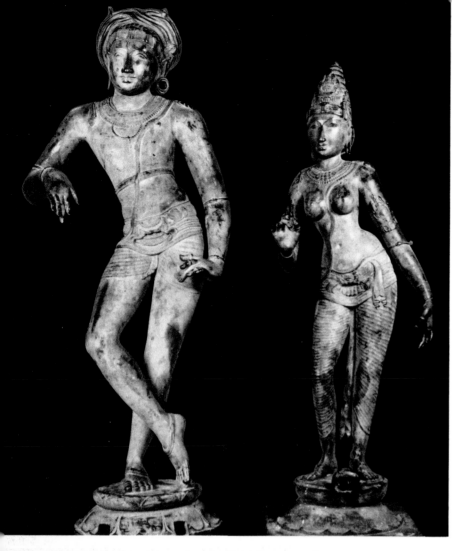
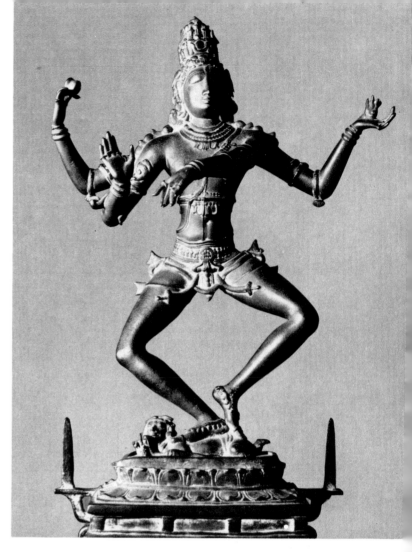
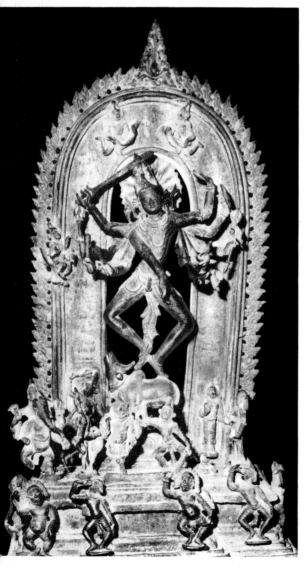
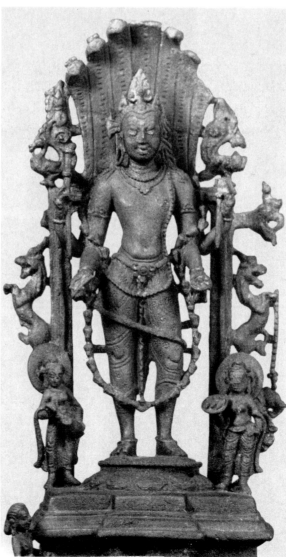
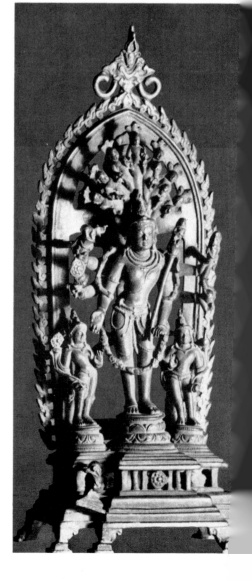

Left to right, top to bottom Nos. 273 through 277

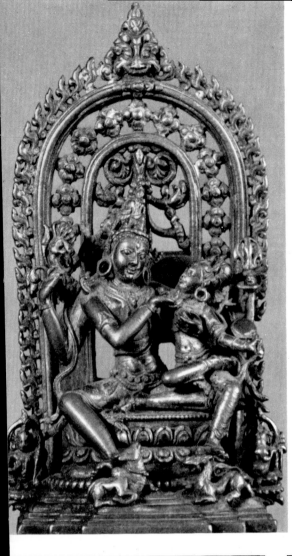

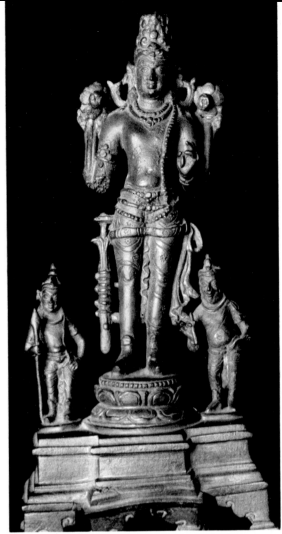

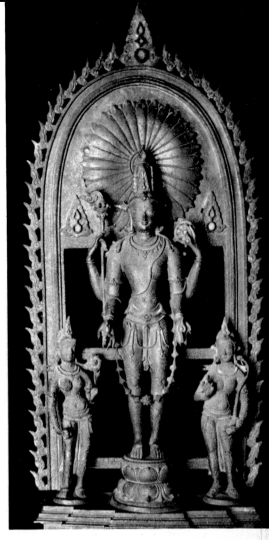

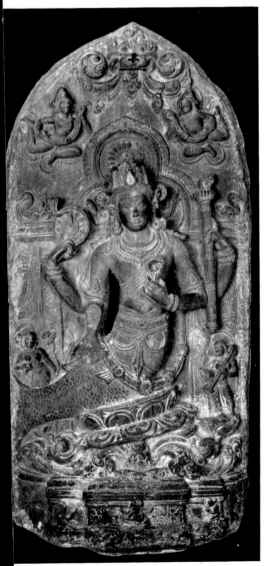

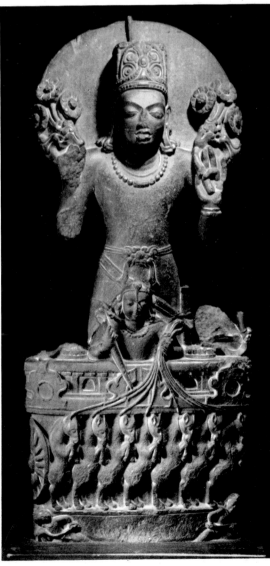

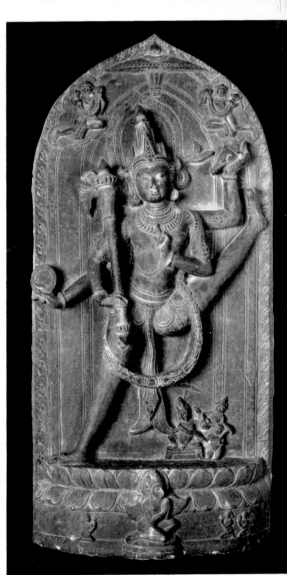

Left to right, top to bottom Nos. 278 through 283

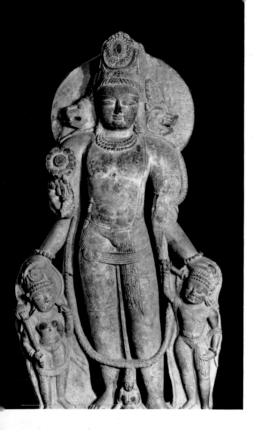
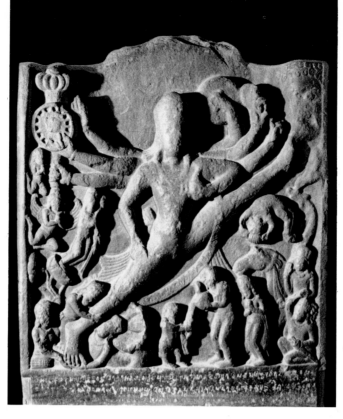
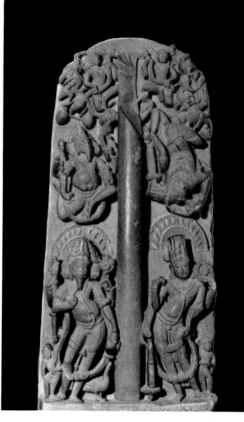
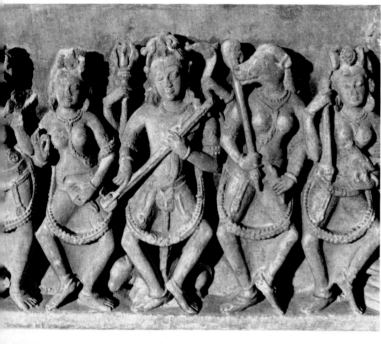

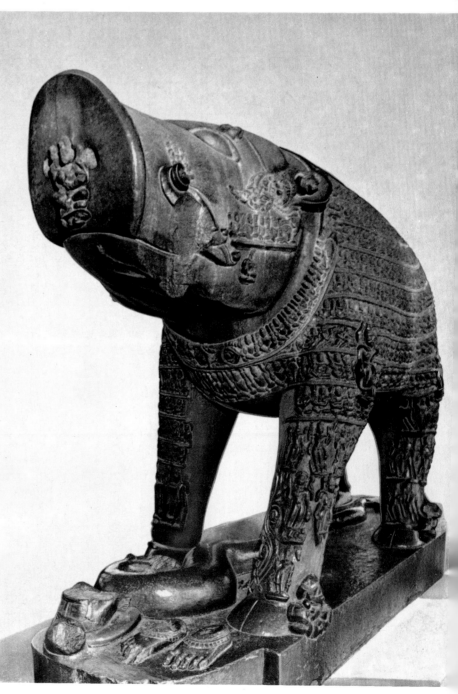

346 Left to right, top to bottom Nos. 284 through 289

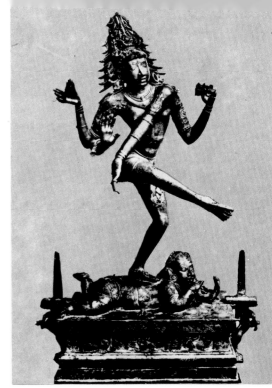
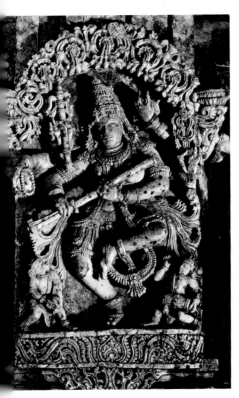
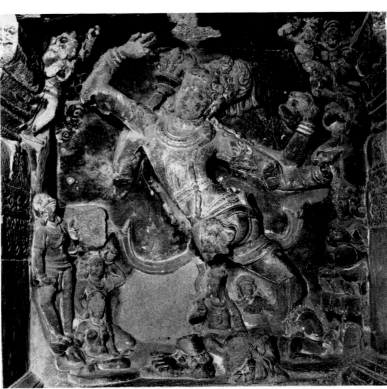
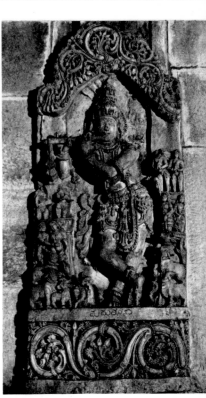
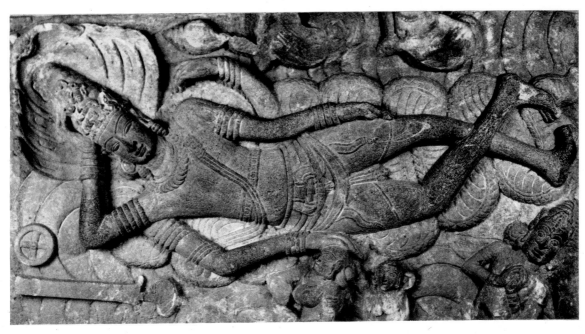

Left to right, top to bottom Nos. 290 through 296

347

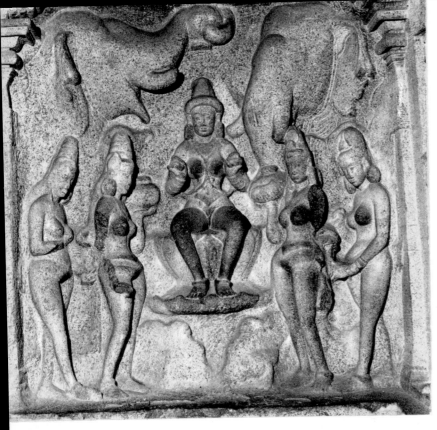
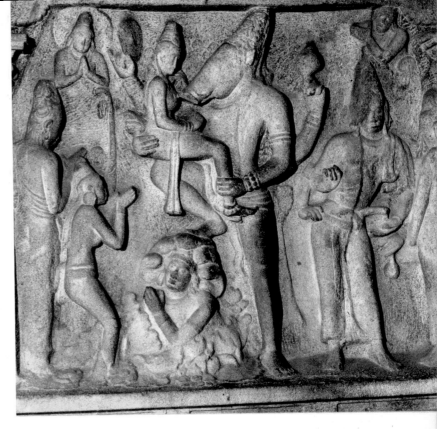
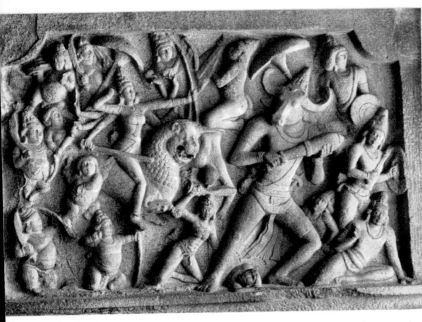
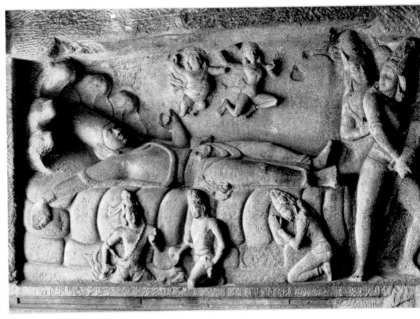
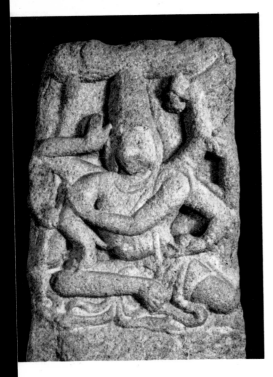

Left to right, top to bottom Nos. 297 through 303

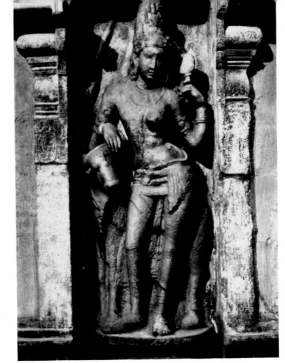
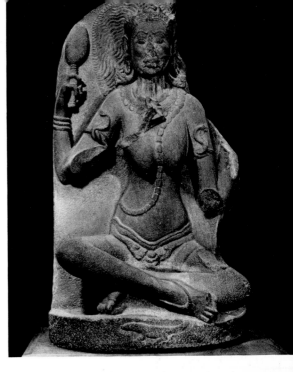

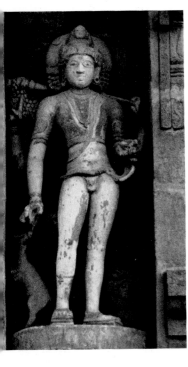
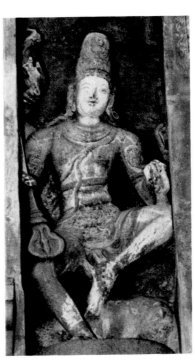
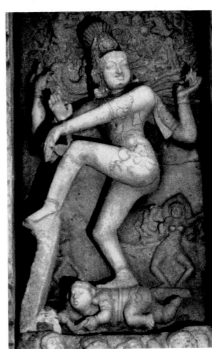
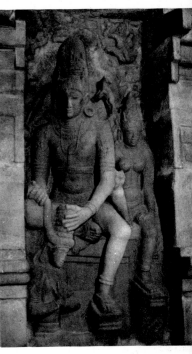

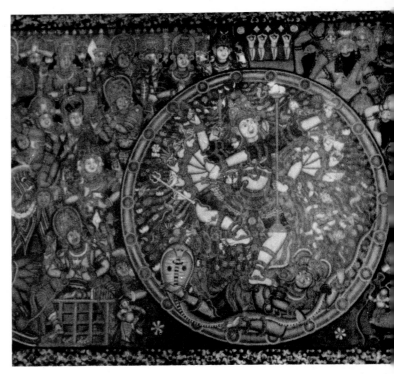

Left to right, top to bottom Nos. 304 through 312

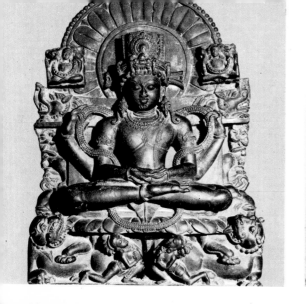
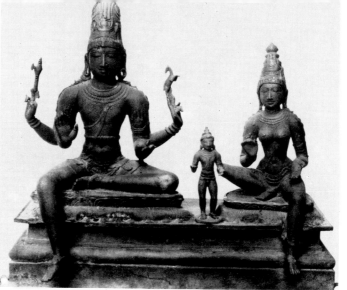

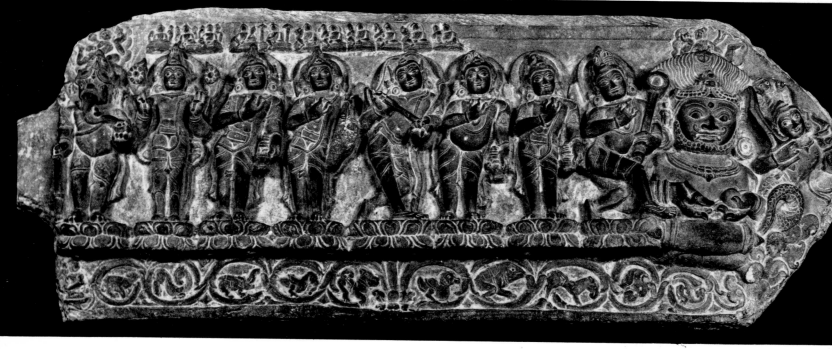

Left to right, top to bottom Nos. 313 through 319

great religions

(FOR CAPTIONS SEE PAGE 427)

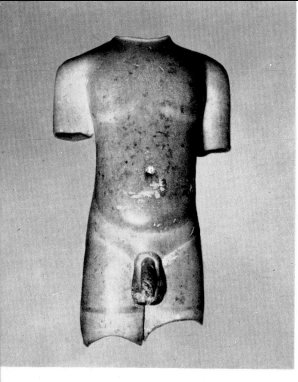

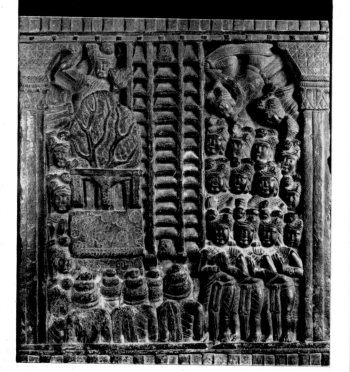

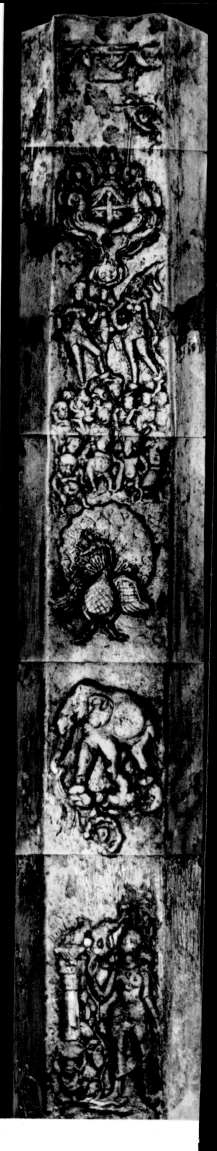

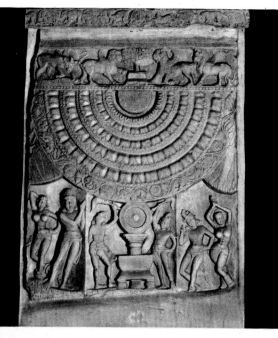

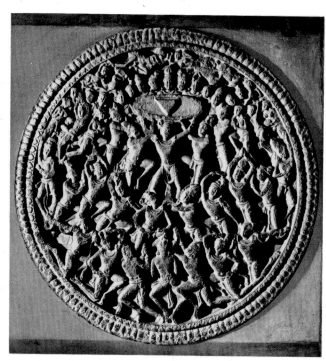

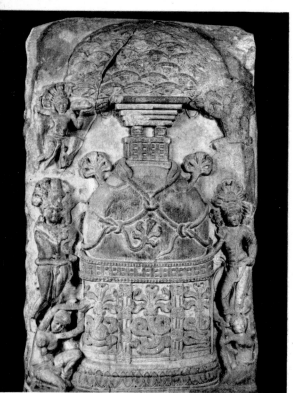

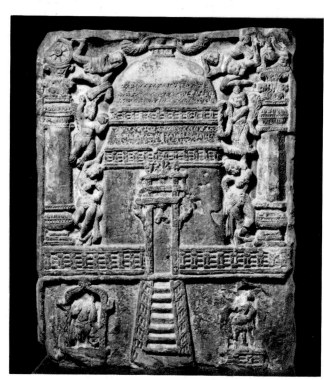

Left to right, top to bottom Nos. 320 through 326

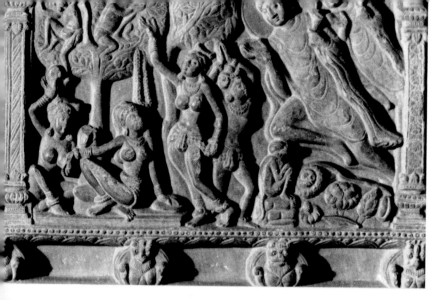

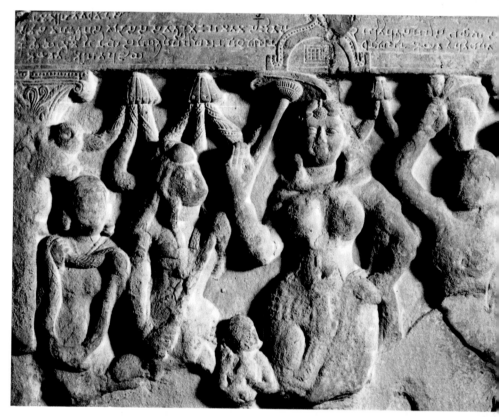

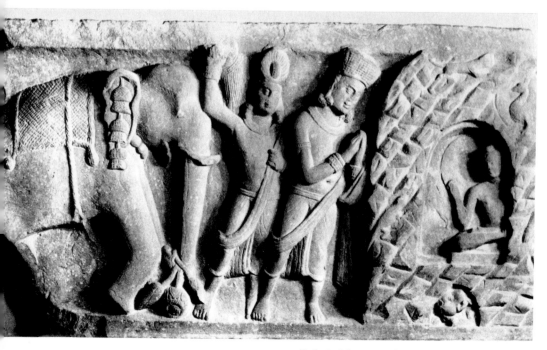

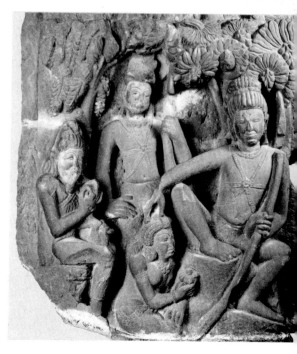

Left to right, top to bottom Nos. 327 through 332

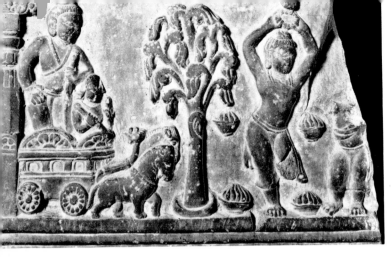
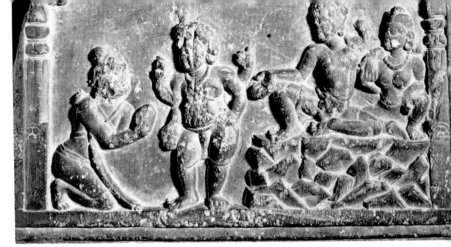
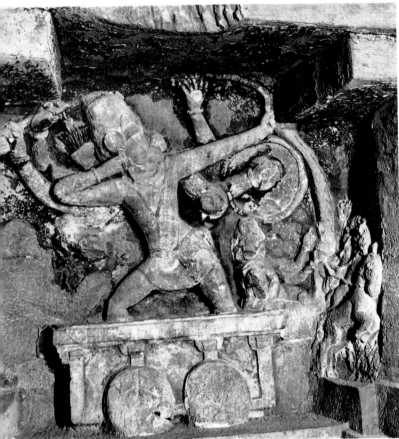
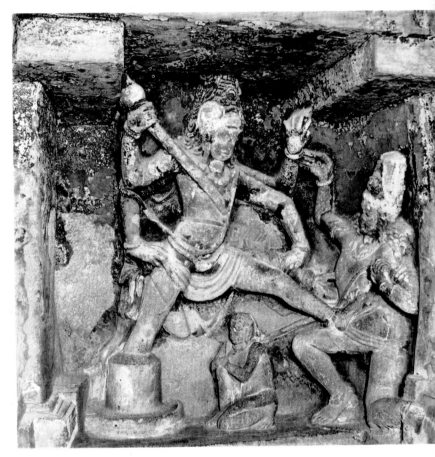
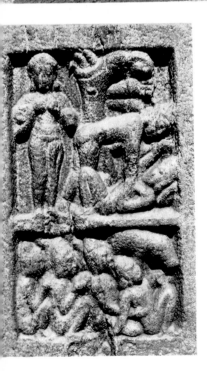
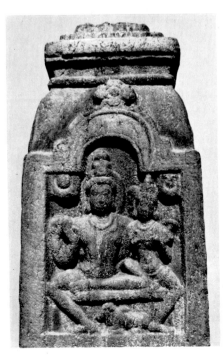

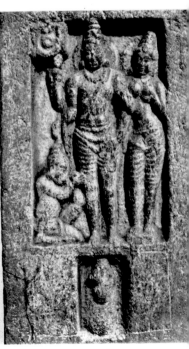

Left to right, top to bottom Nos. 333 through 340

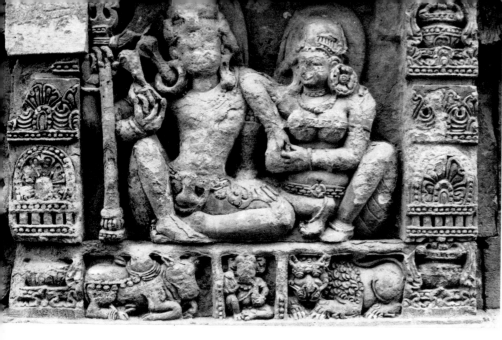
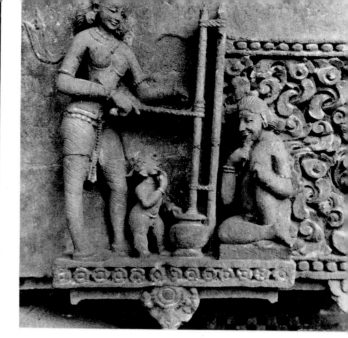

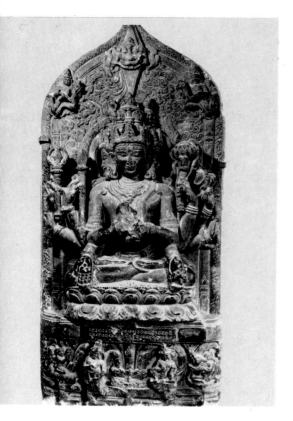
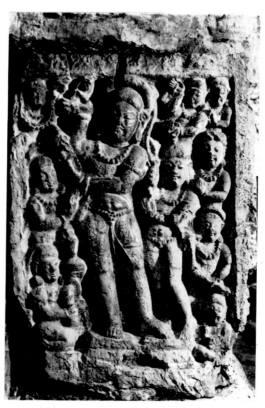
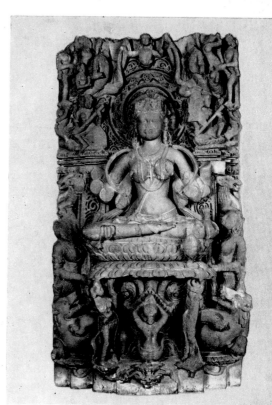

Left to right, top to bottom Nos. 341 through 347

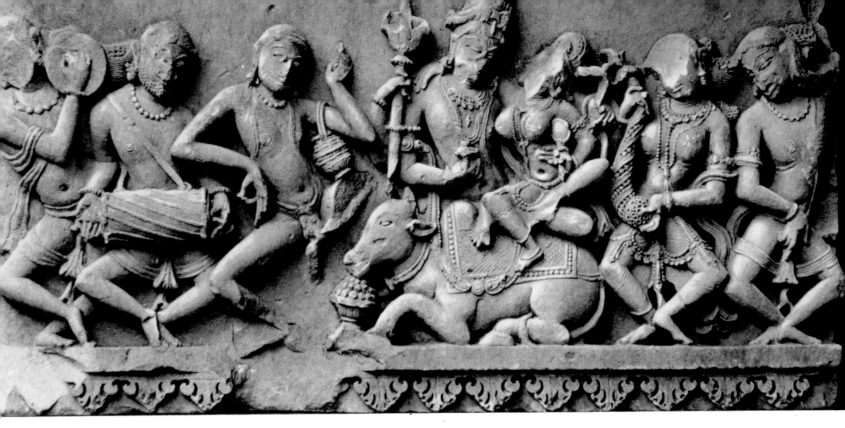

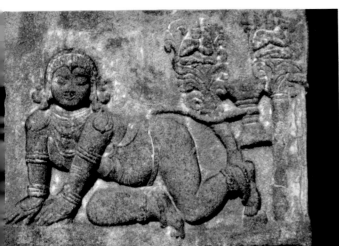

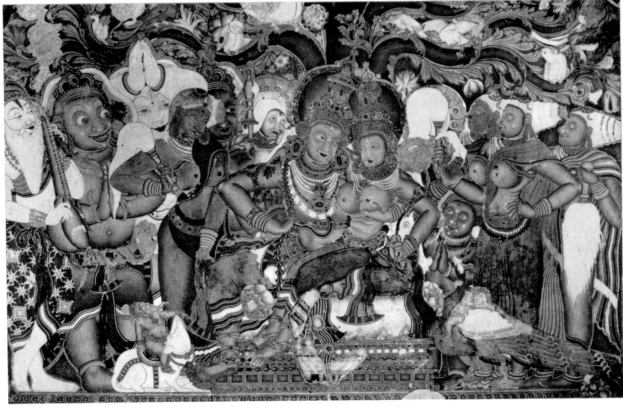

Left to right, top to bottom Nos. 348 through 352

narrative skill

(FOR CAPTIONS SEE PAGES 427 THROUGH 428)

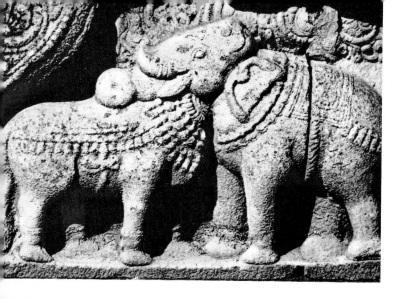
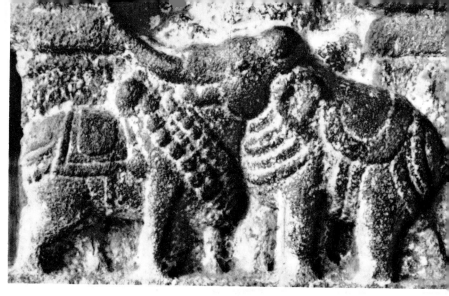
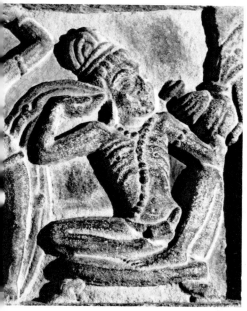
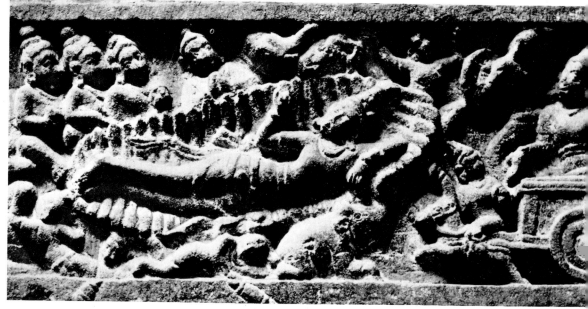
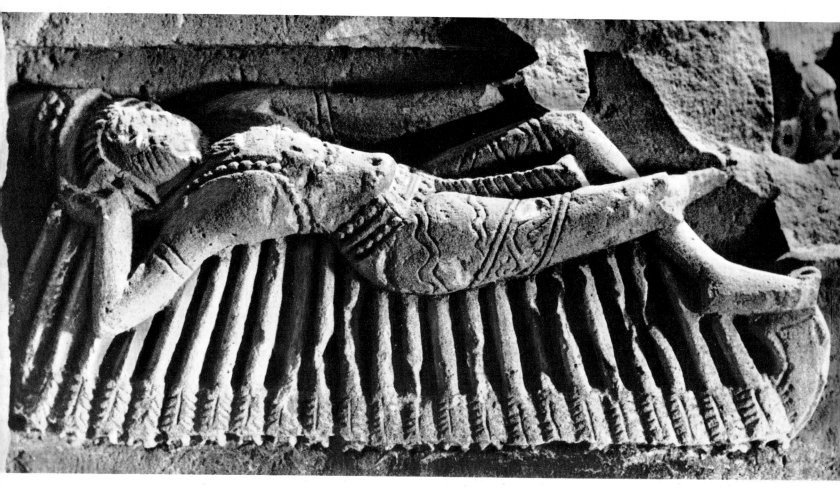

Left to right, top to bottom Nos. 353 through 357

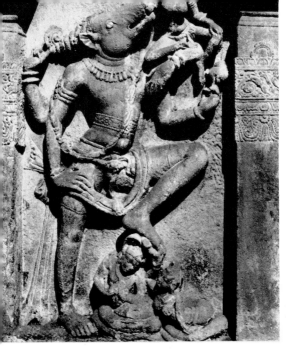

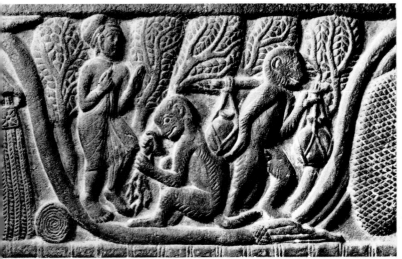
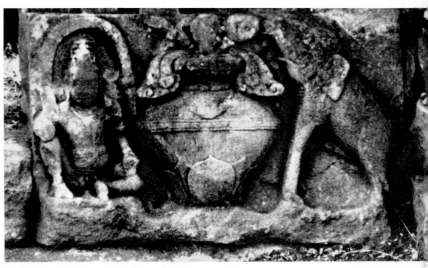

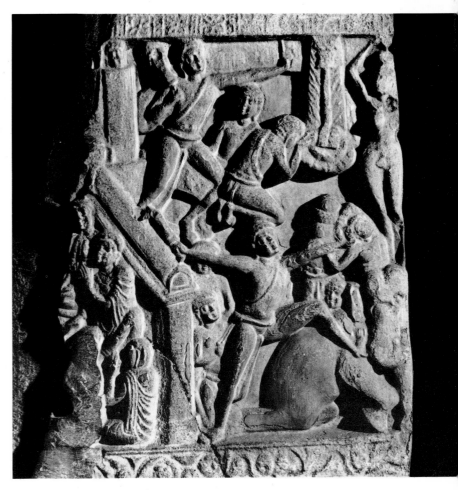

Left to right, top to bottom Nos. 358 through 364

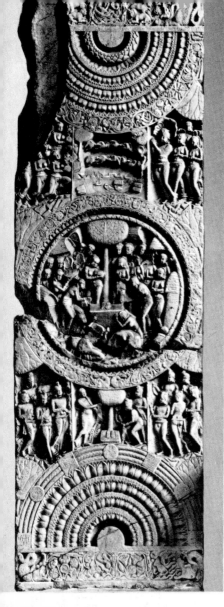

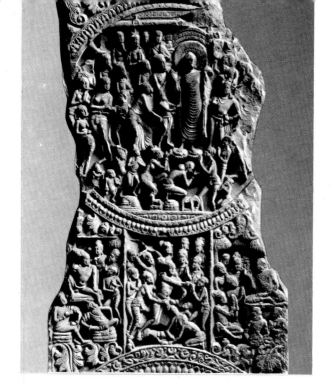

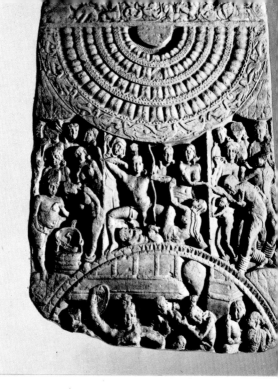

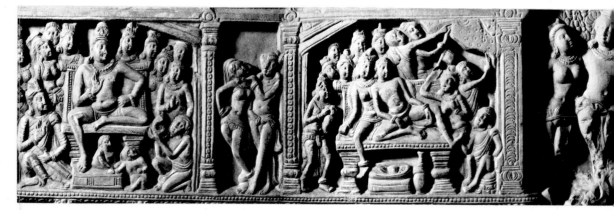

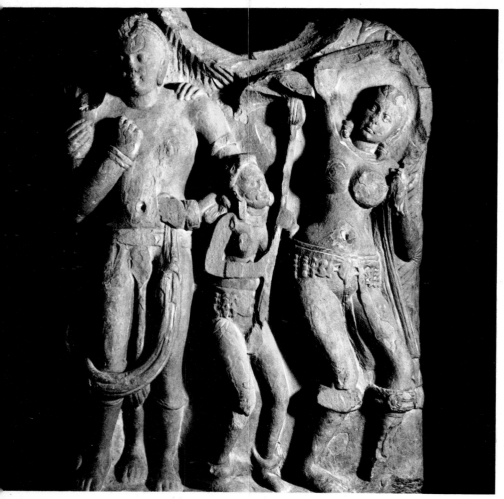

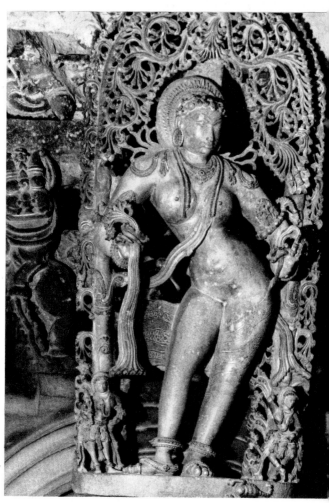

Left to right, top to bottom Nos. 365 through 370

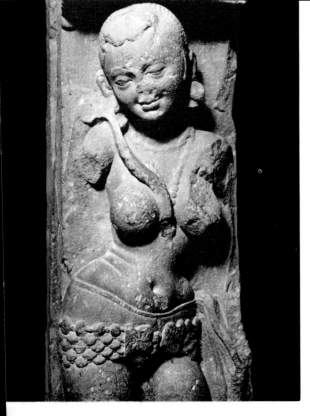
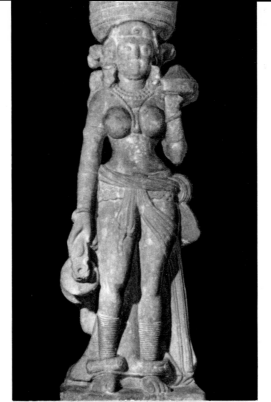
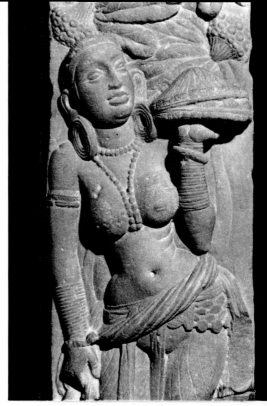
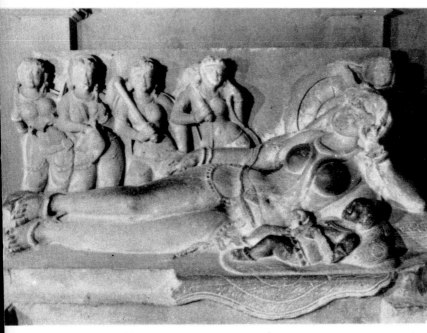
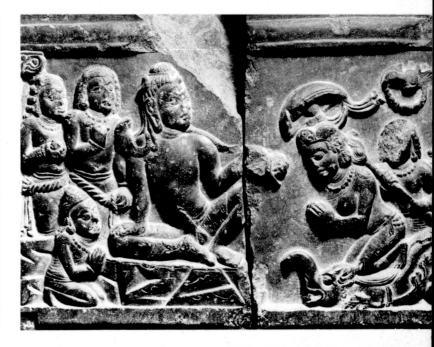
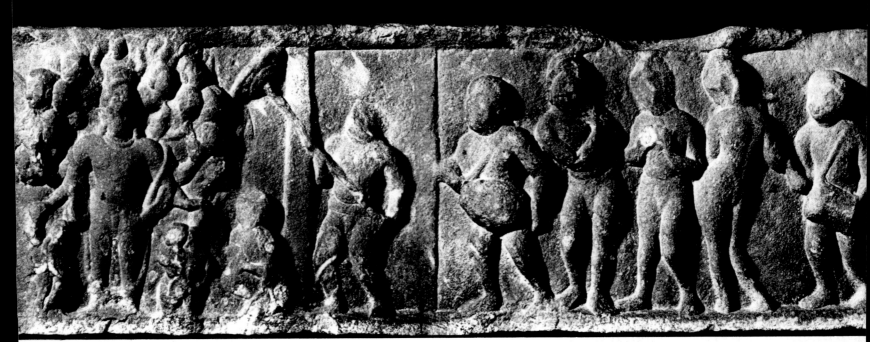

Left to right, top to bottom Nos. 371 through 376

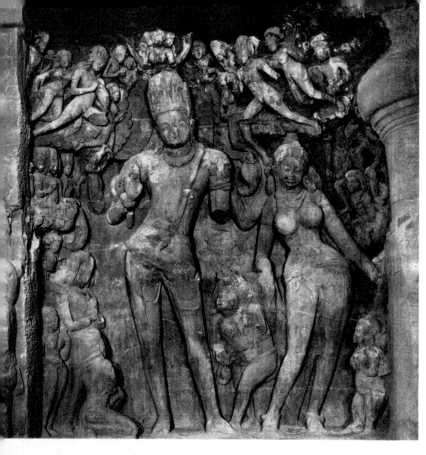

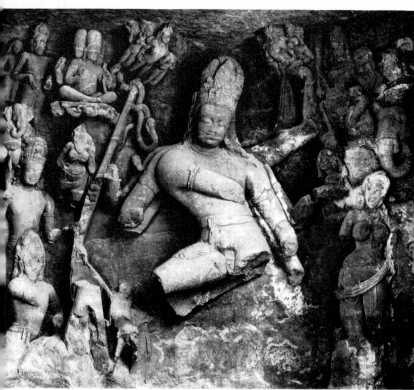
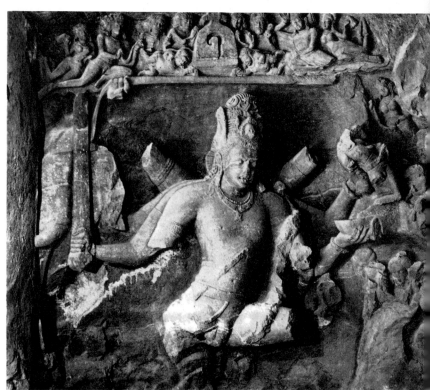
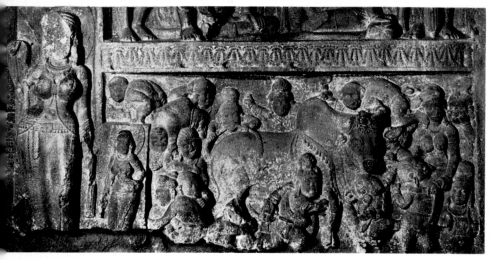

Left to right, top to bottom Nos. 377 through 382

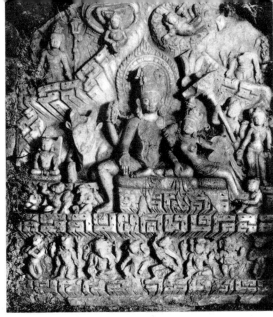
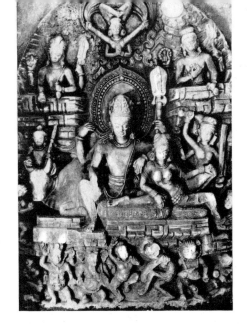
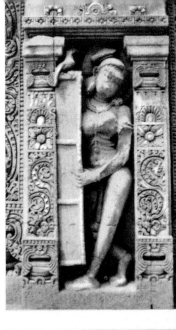

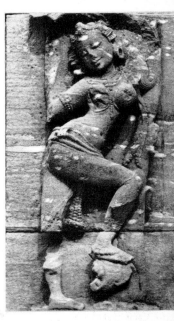

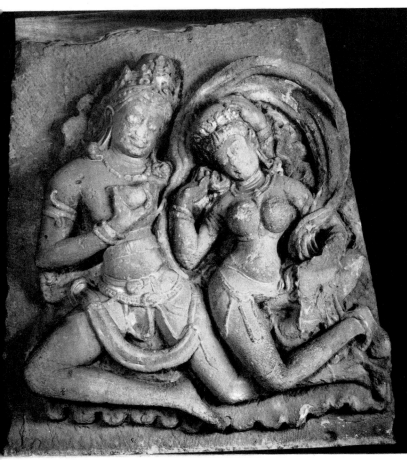
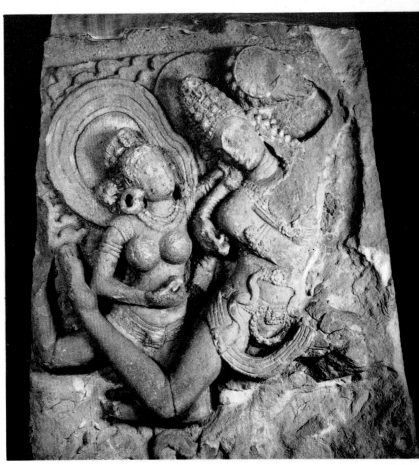

Left to right, top to bottom Nos. 383 through 390

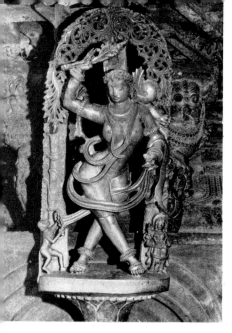
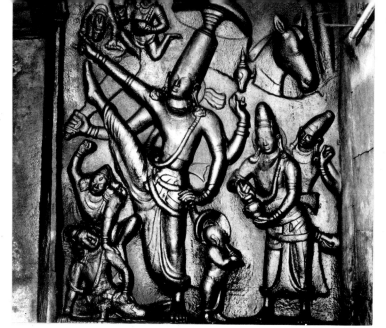
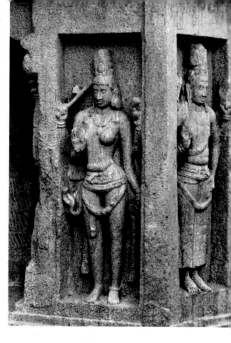
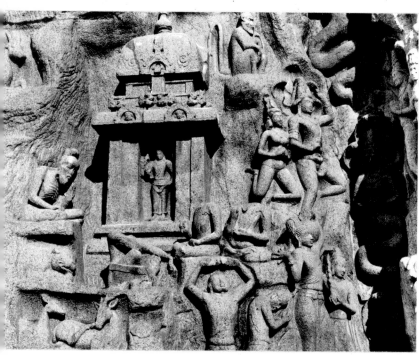
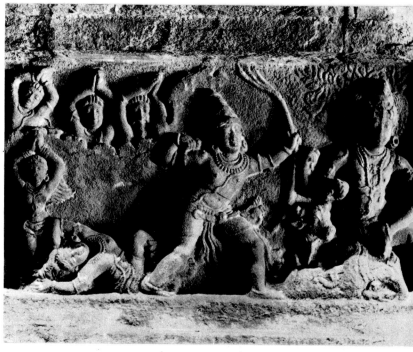
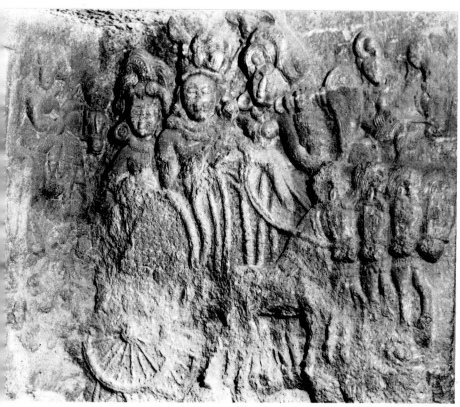
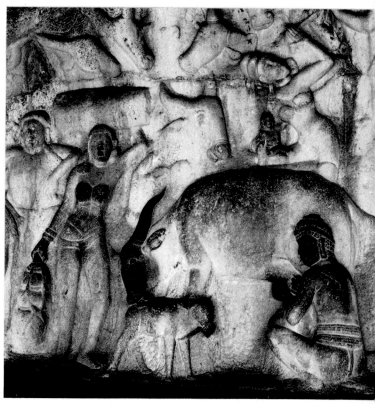

364 Left to right, top to bottom Nos. 391 through 397

from the Mauryas

to the Gandharas

(FOR CAPTIONS SEE PAGES 428 THROUGH 429)

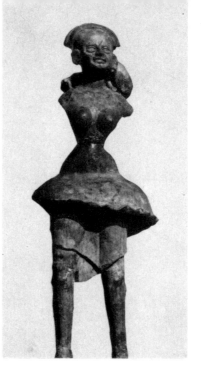
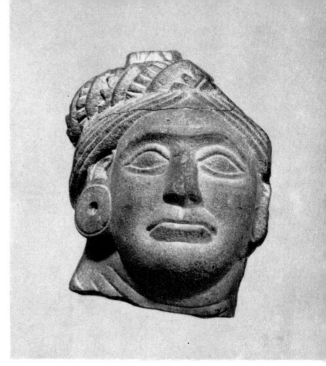

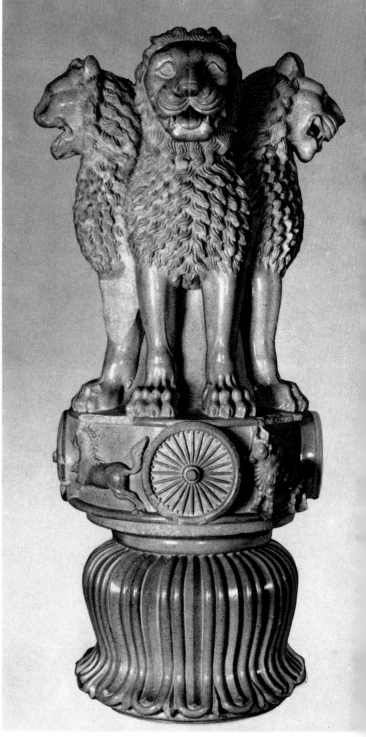

Left to right, top to bottom Nos. 398 through 402

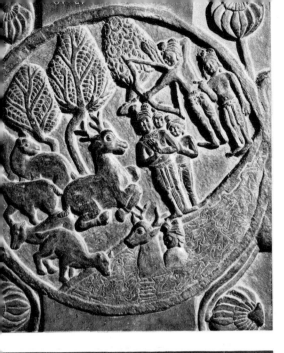

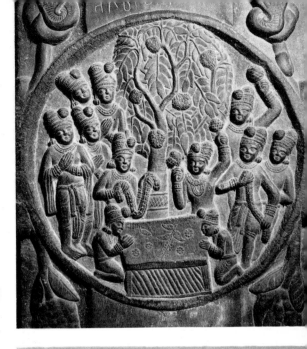

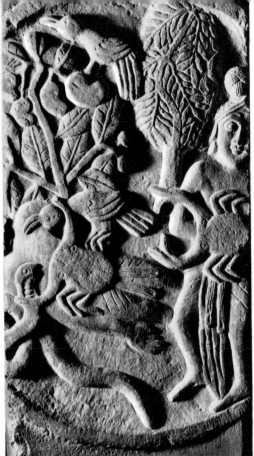

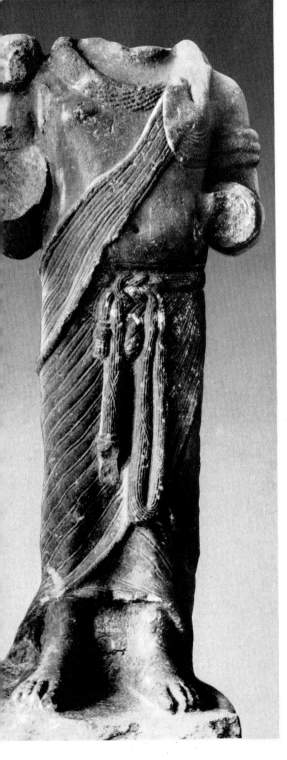

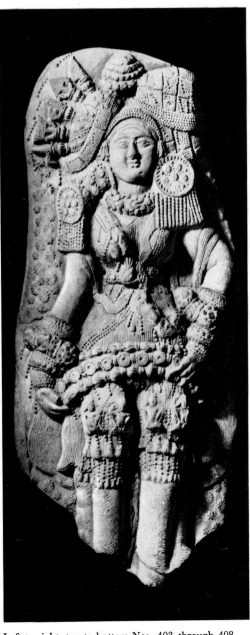

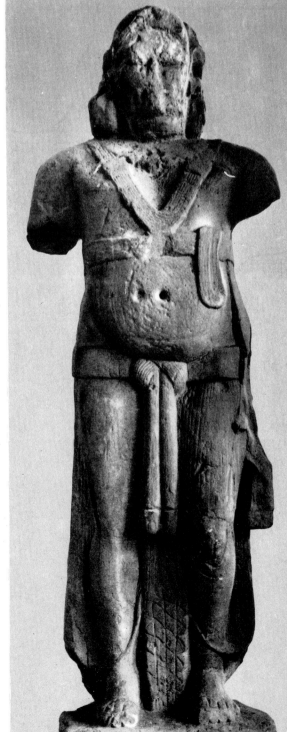

Left to right, top to bottom Nos. 403 through 408

367

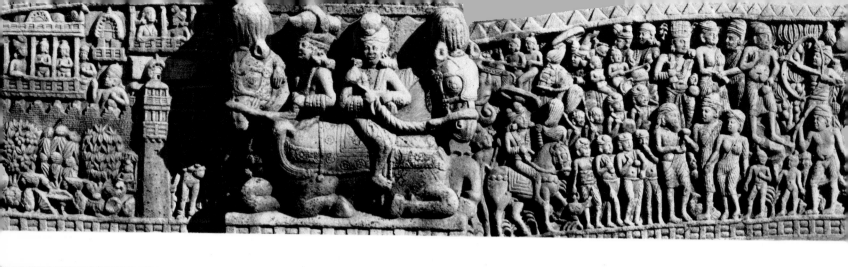

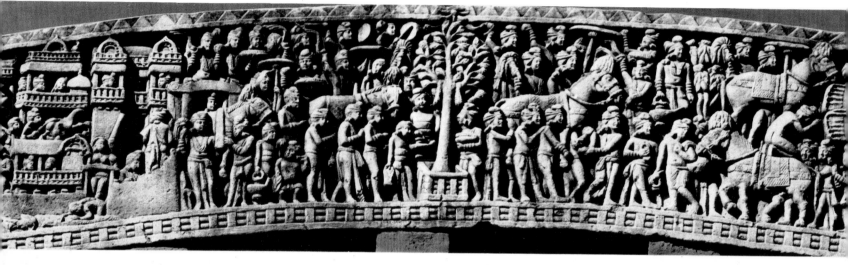

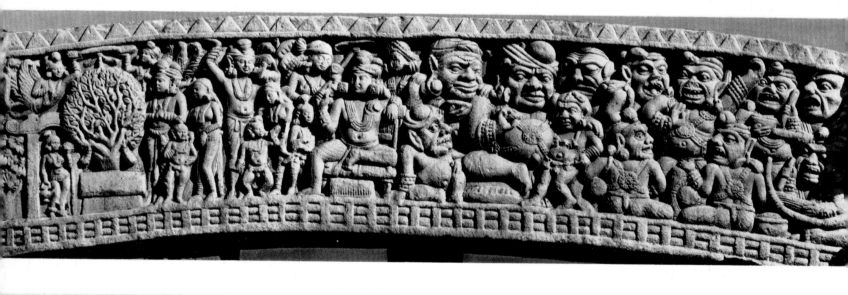

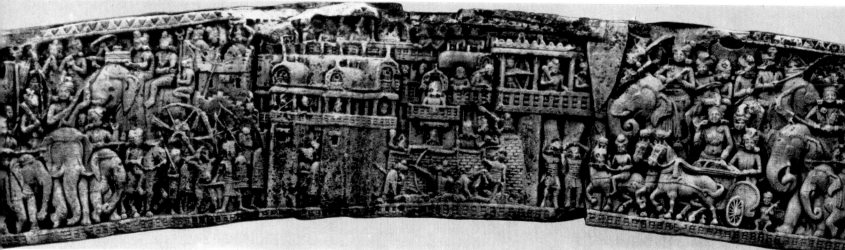

Top to bottom Nos. 409 through 412

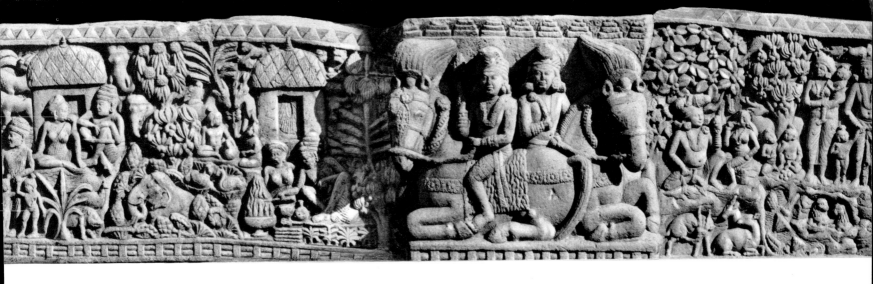

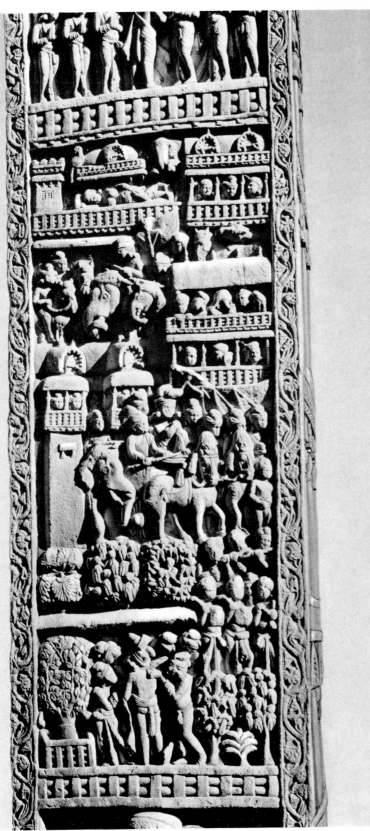

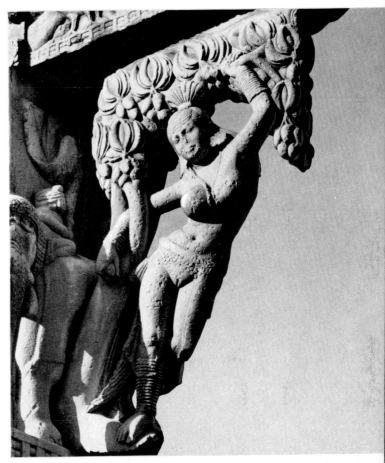

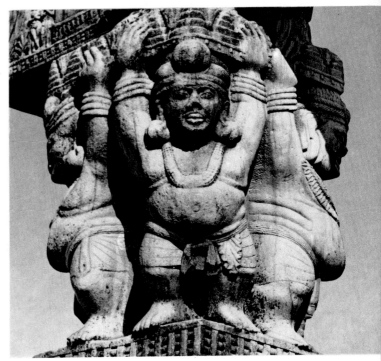

Left to right, top to bottom Nos. 413 through 415

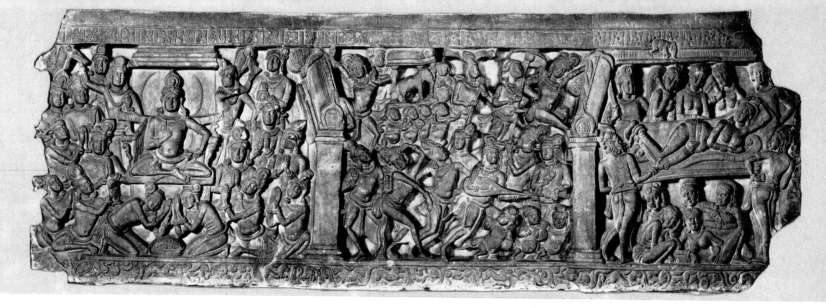

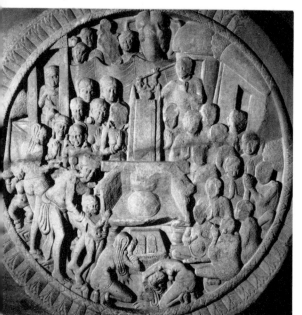

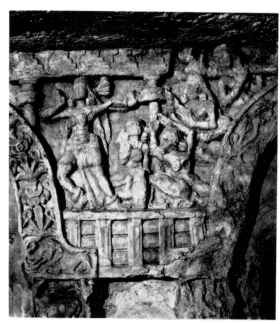

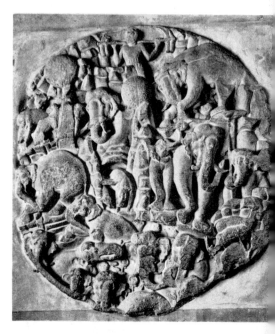

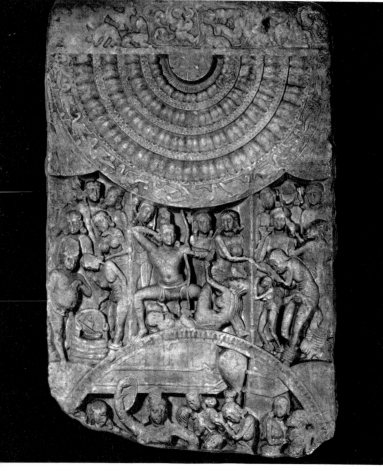

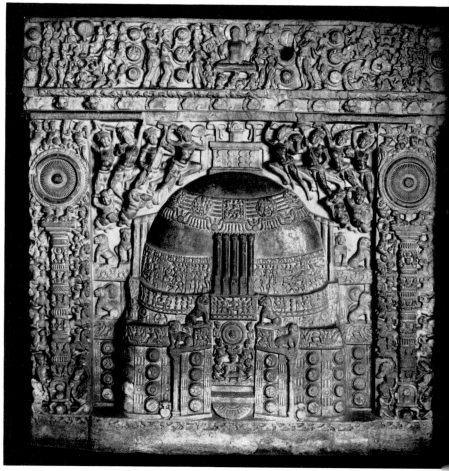

Left to right, top to bottom Nos. 416 through 421

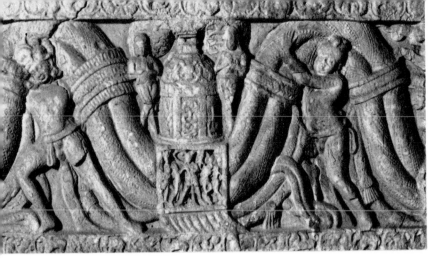

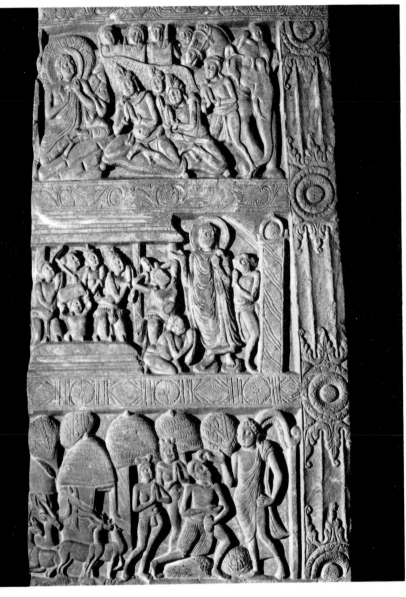

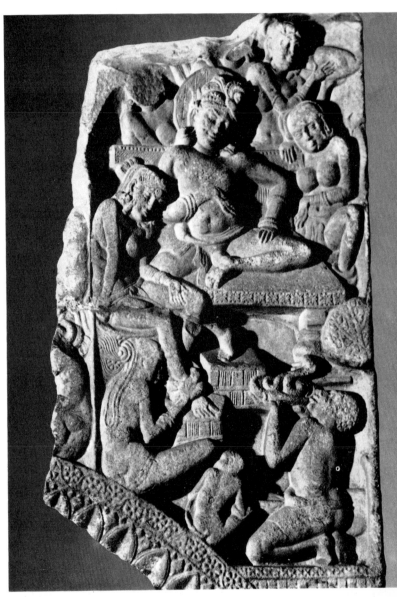

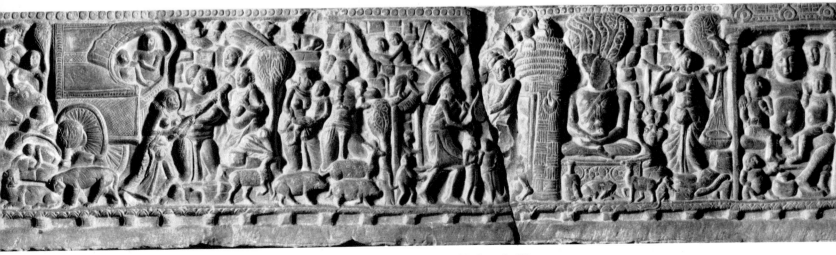

Left to right, top to bottom Nos. 422 through 426

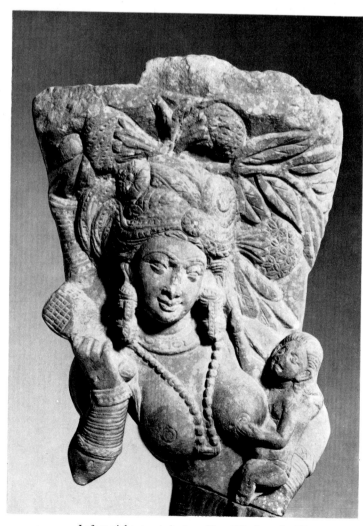

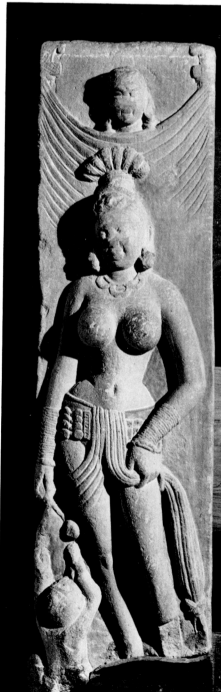

Left to right, top to bottom Nos. 427 through 432

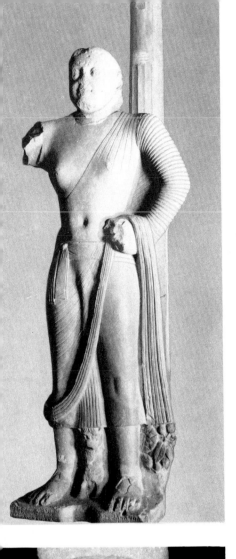

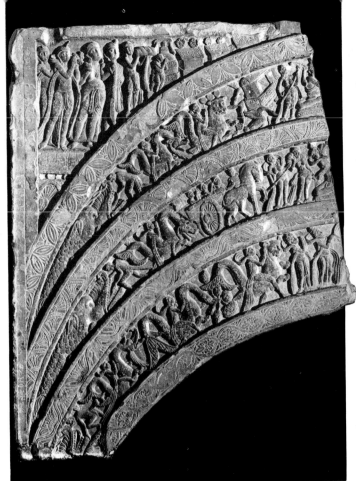

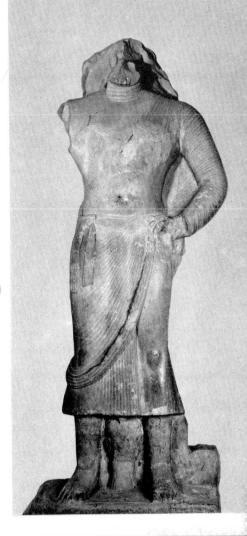

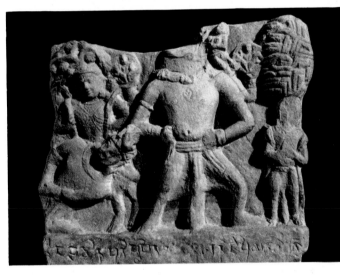

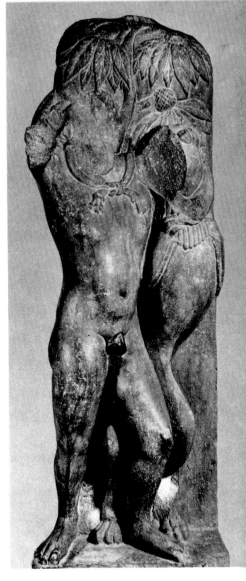

Left to right, top to bottom Nos. 433 through 439

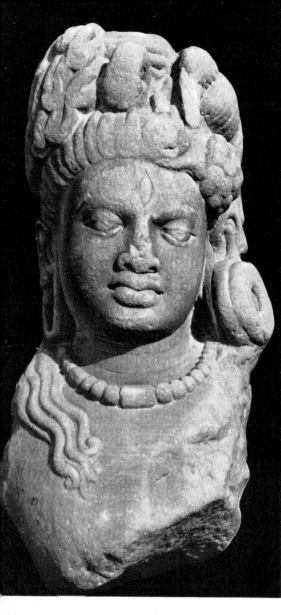
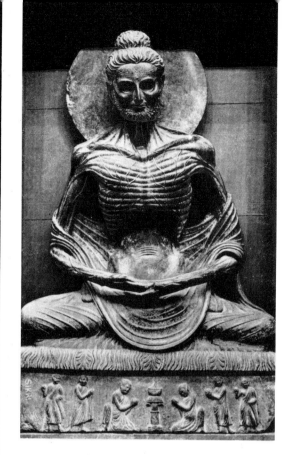
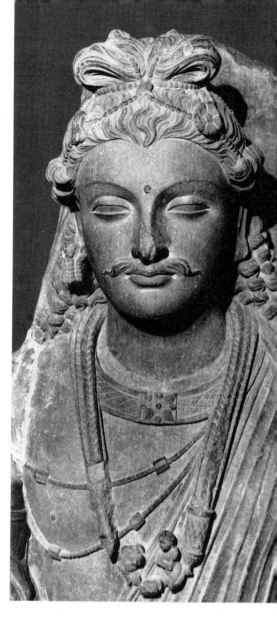
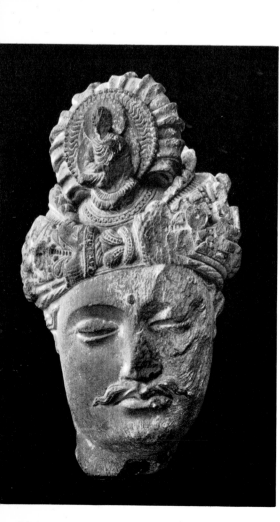
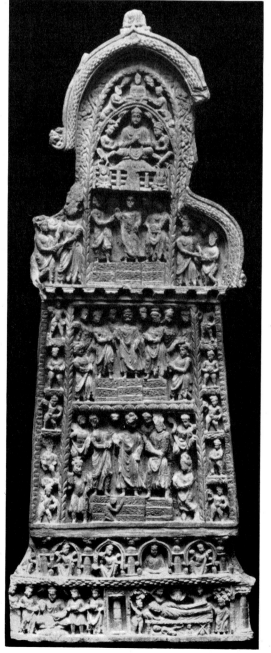
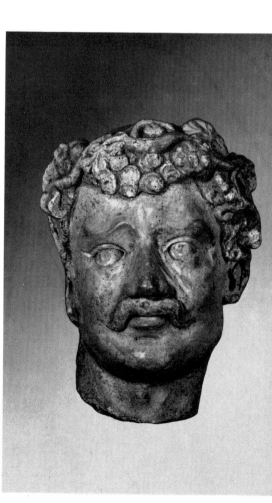

Left to right, top to bottom Nos. 440 through 445

art of the Guptas

and the Vakatakas

(FOR CAPTIONS SEE PAGES 429 THROUGH 430)

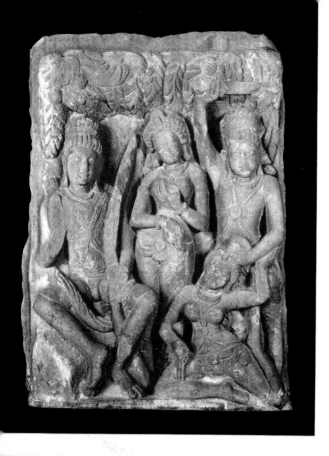

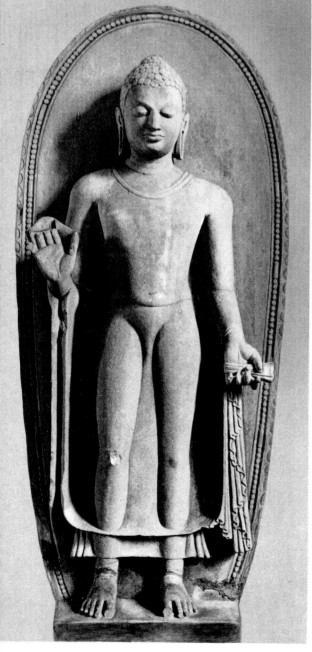
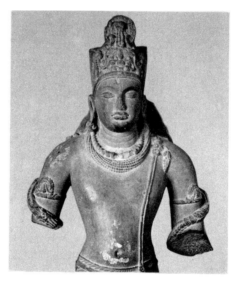
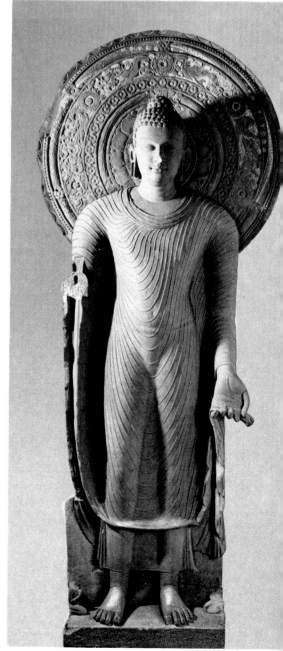
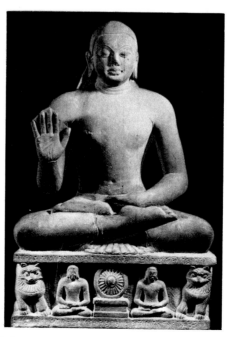

Left to right, top to bottom Nos. 446 through 452

Left to right, top to bottom Nos. 446 through 452

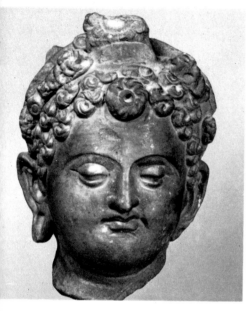

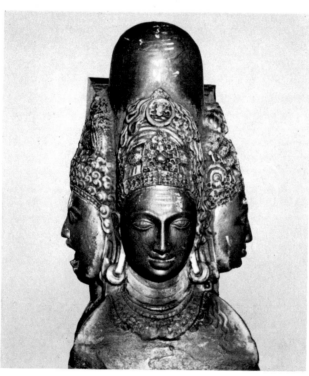

Left to right, top to bottom Nos. 453 through 460

377

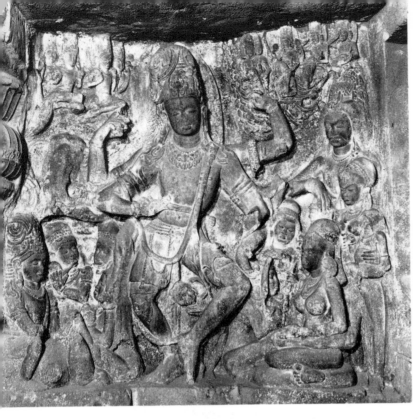

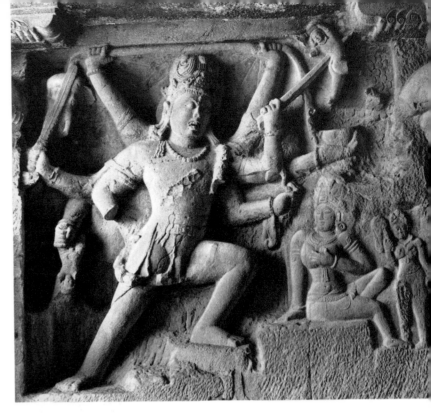

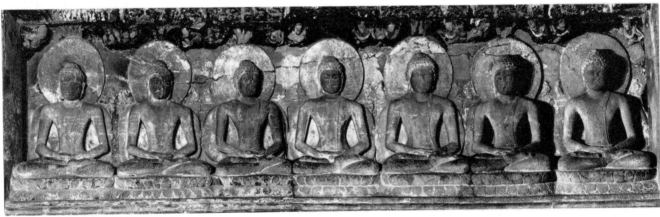

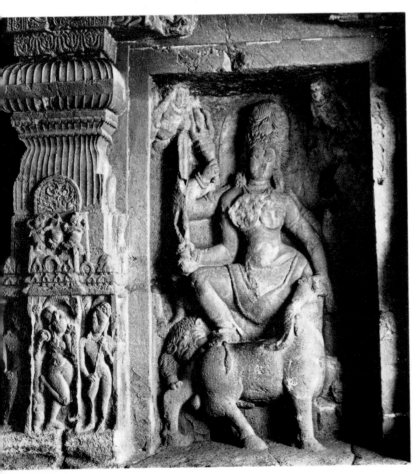

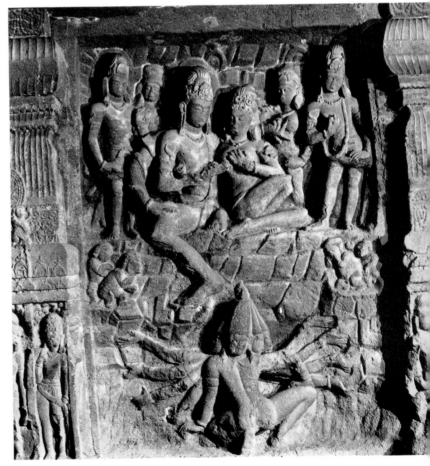

Left to right, top to bottom Nos. 461 through 465

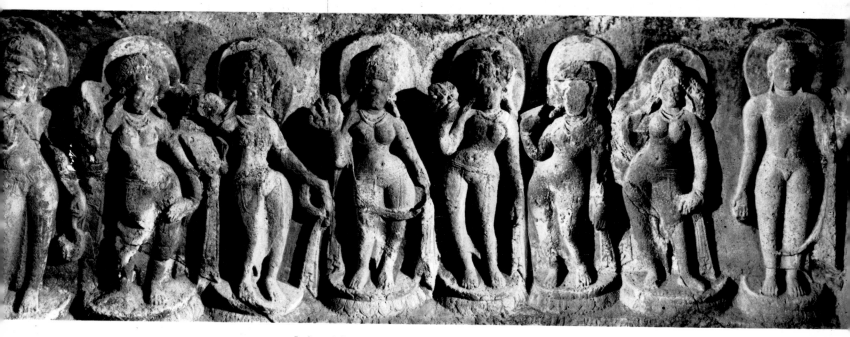

Left to right, top to bottom Nos. 466 through 468

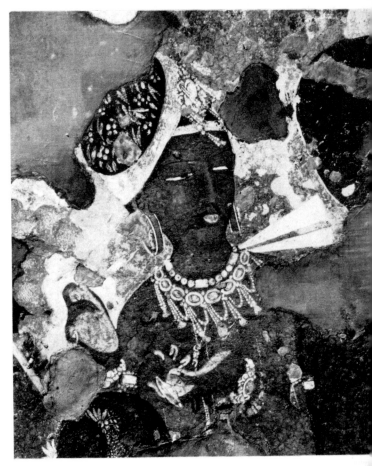

Left to right, top to bottom Nos. 469 through 475

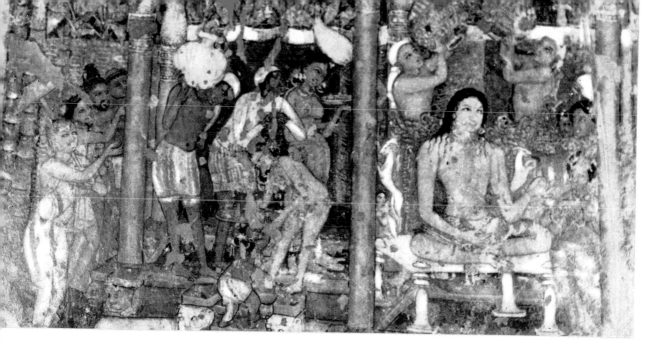

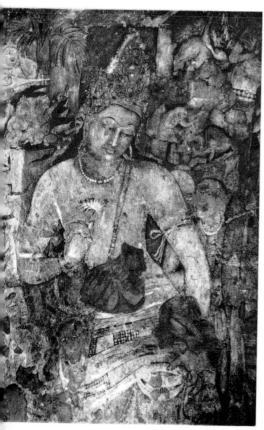

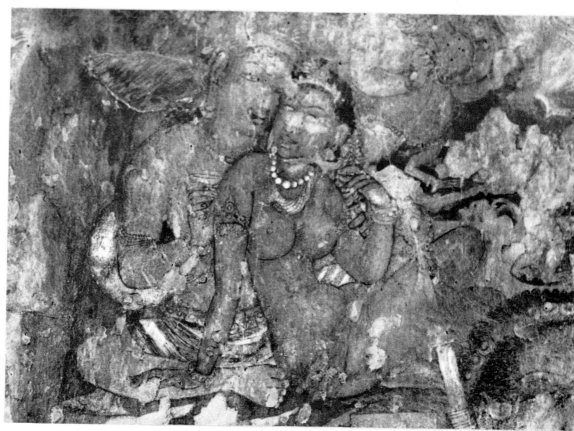

Left to right, top to bottom Nos. 476 through 481

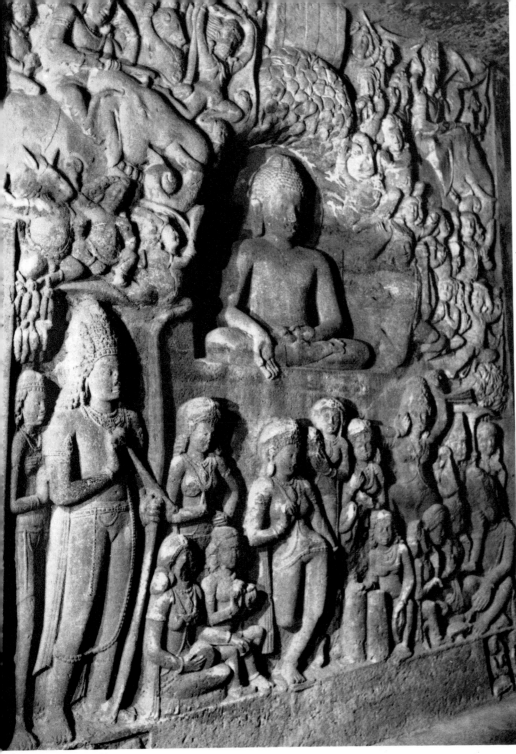

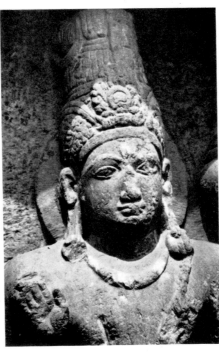

Left to right, top to bottom Nos. 482 through 486

Indian element

in Asian art

(FOR CAPTIONS SEE PAGE 430)

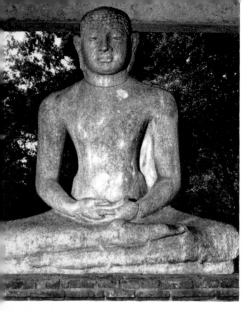

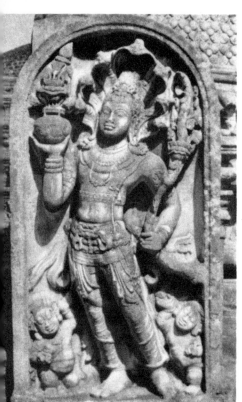
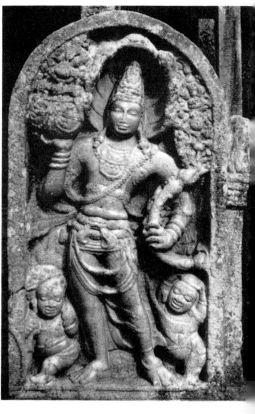
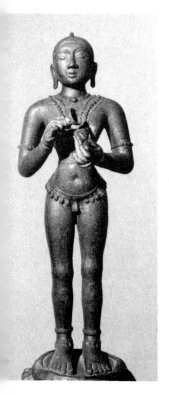
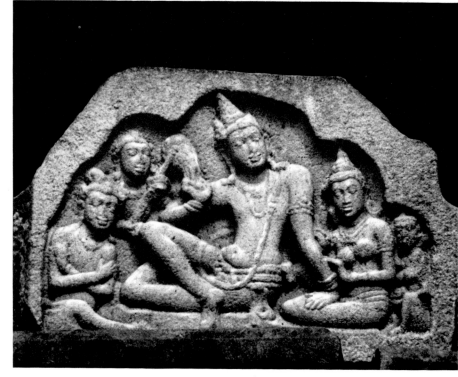
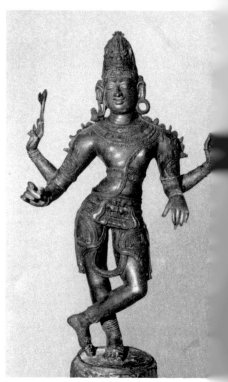

384 Lefthand side top to bottom Nos. 487, 488, 492. Center Nos. 489, 493. Righthand side Nos. 490, 491, 494

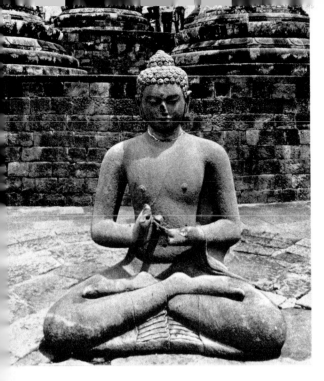

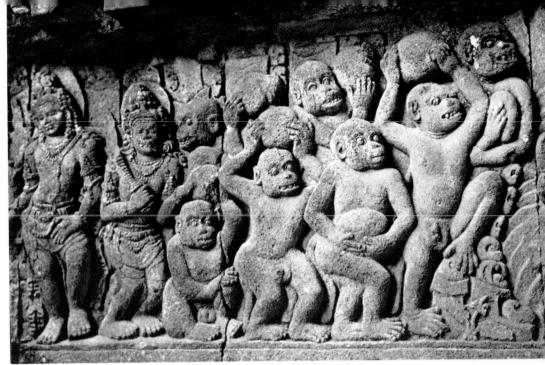

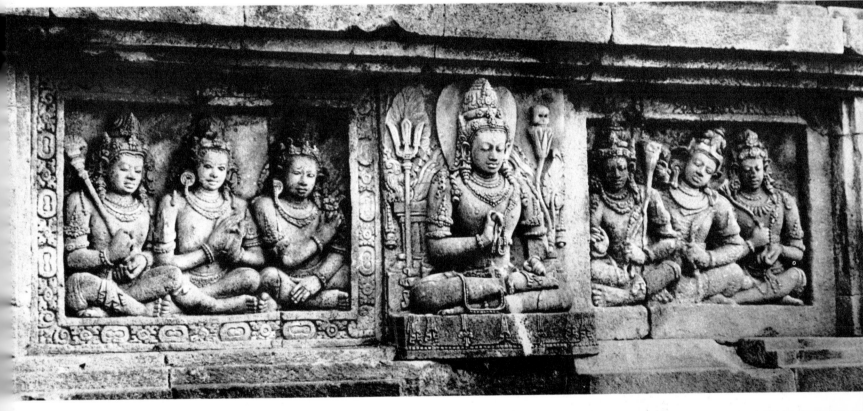

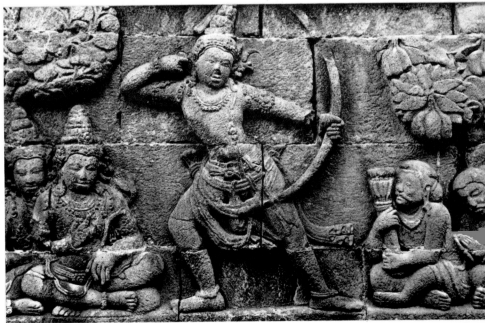

Left to right, top to bottom Nos. 495 through 499

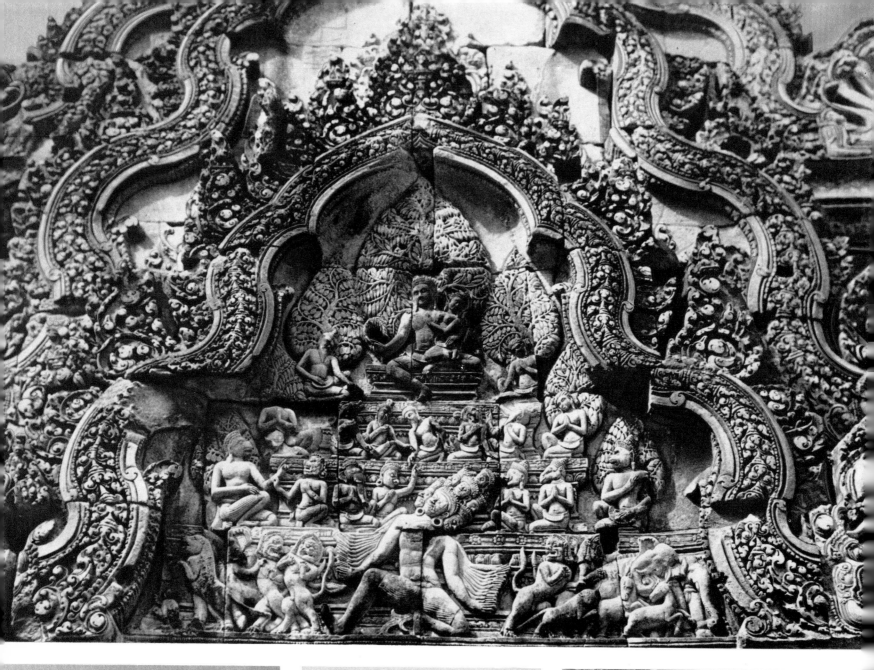

Left to right, top to bottom Nos. 500 through 503

perfection of art

in the middle ages

(FOR CAPTIONS SEE PAGES 430 THROUGH 431)

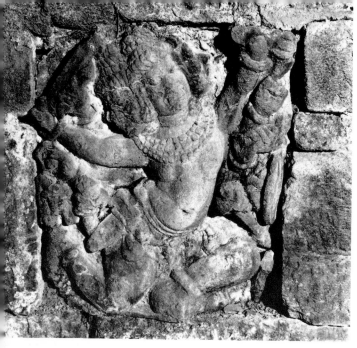

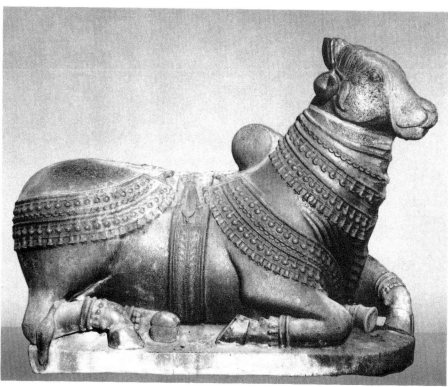

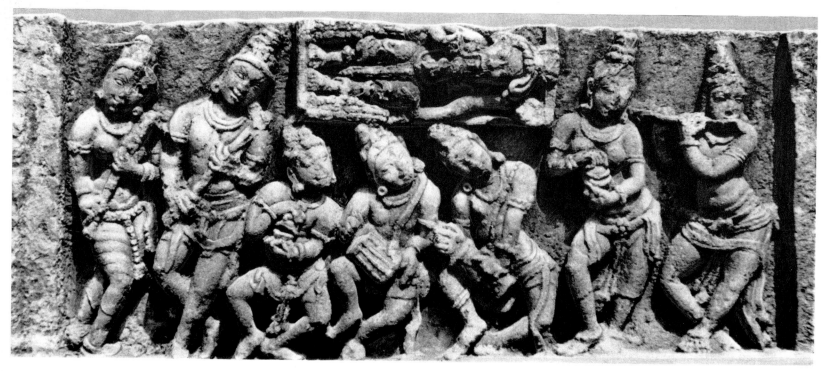

Left to right, top to bottom Nos. 504 through 510

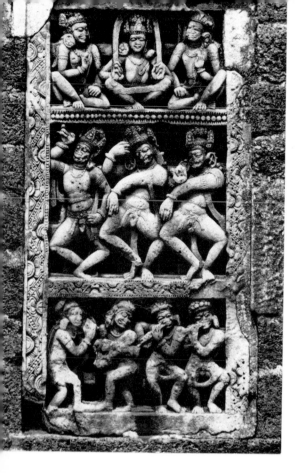

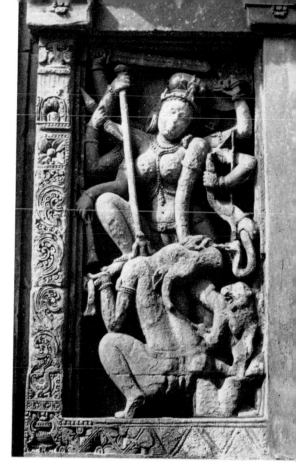
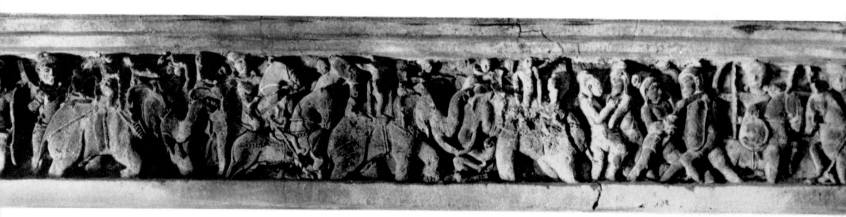
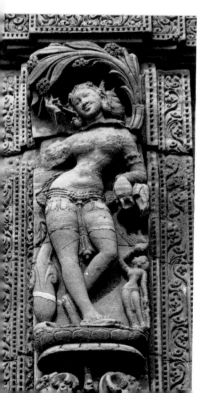
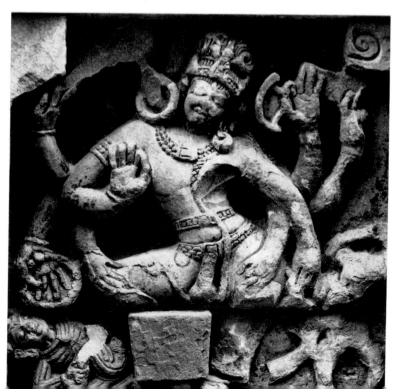
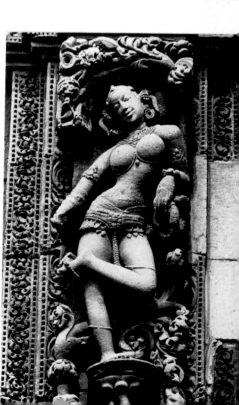

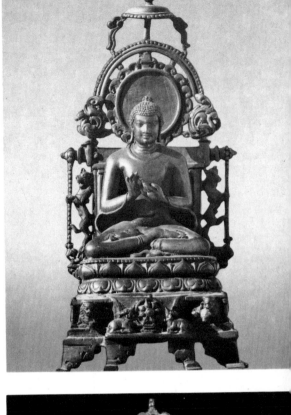

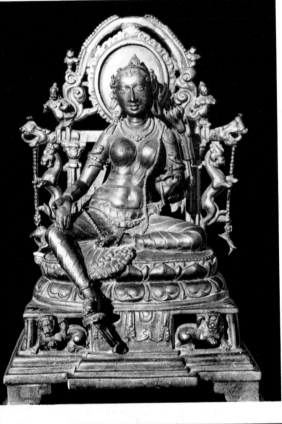

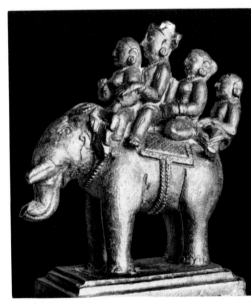

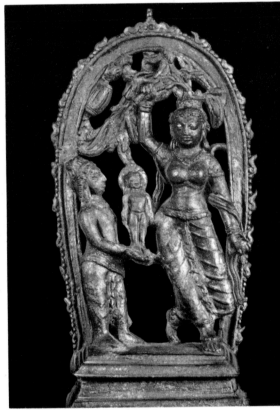

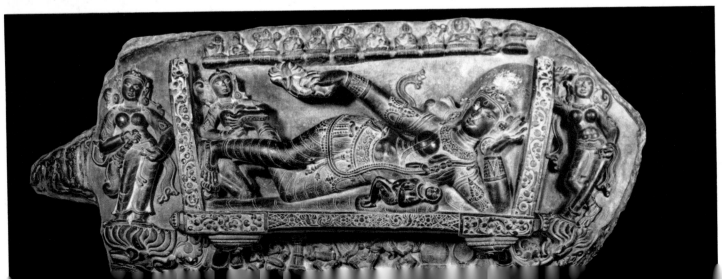

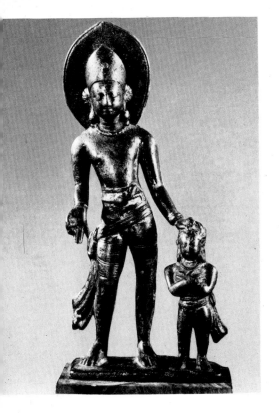
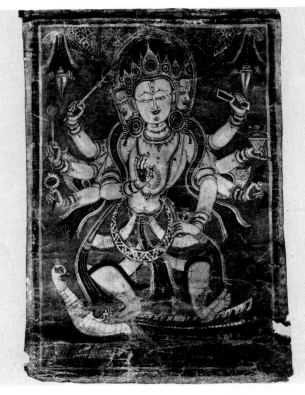

Top to bottom, left to right Nos. 525 through 530

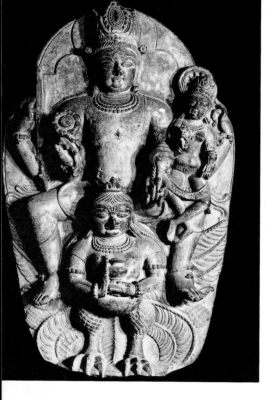

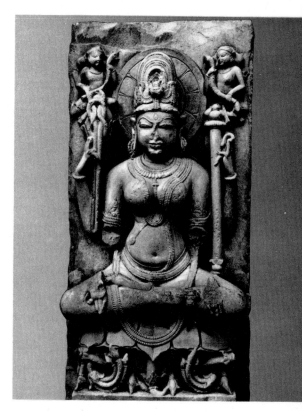
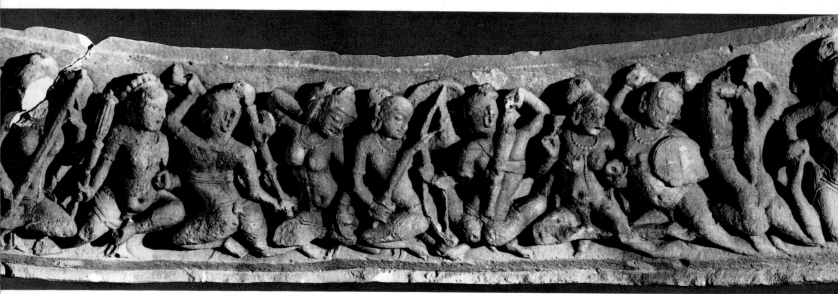

Left to right, top to bottom Nos. 531 through 537

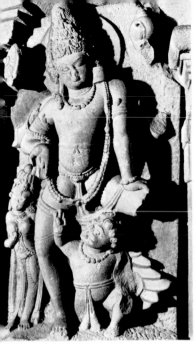 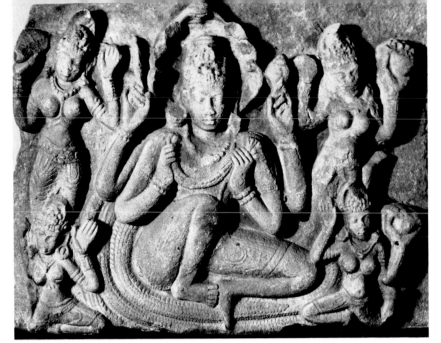 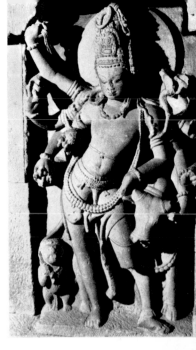

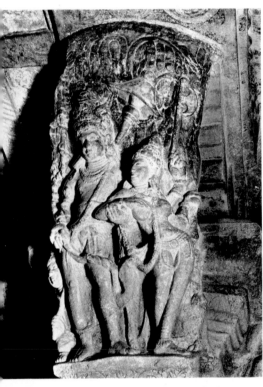 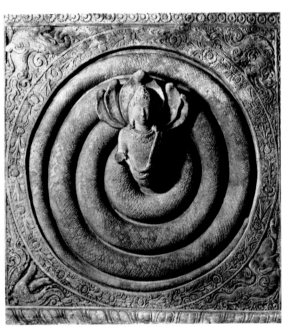 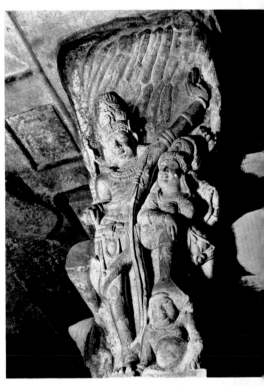

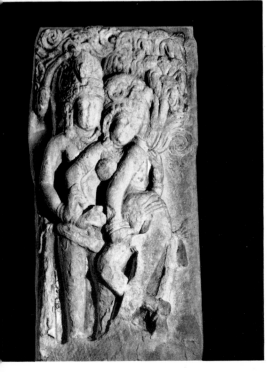 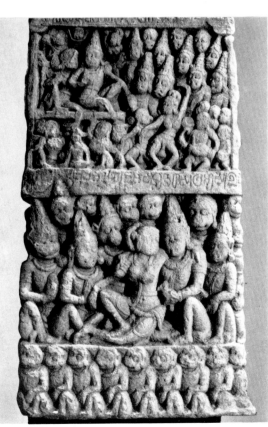 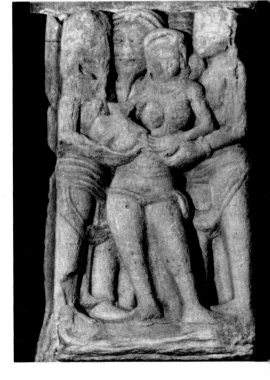

Left to right, top to bottom Nos. 538 through 546

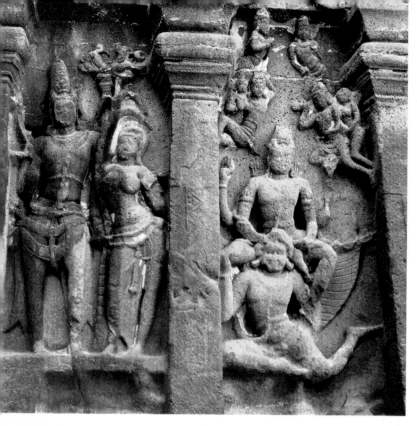
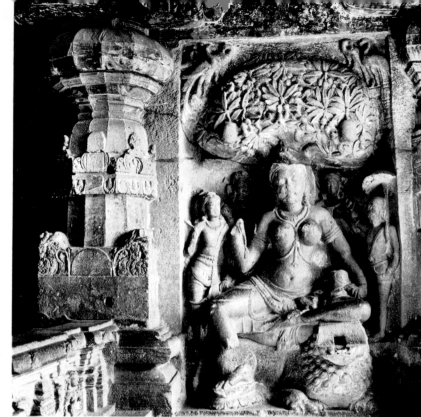
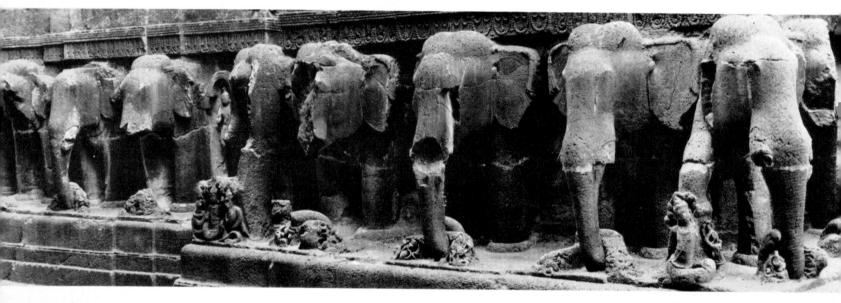

Left to right, top to bottom Nos. 547 through 551

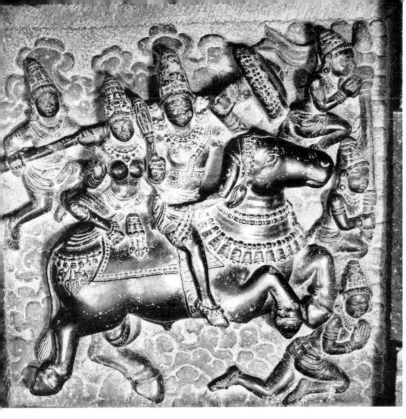

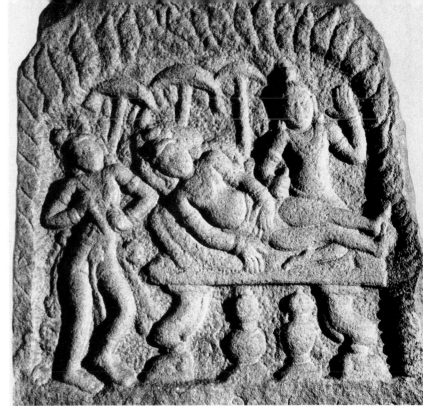

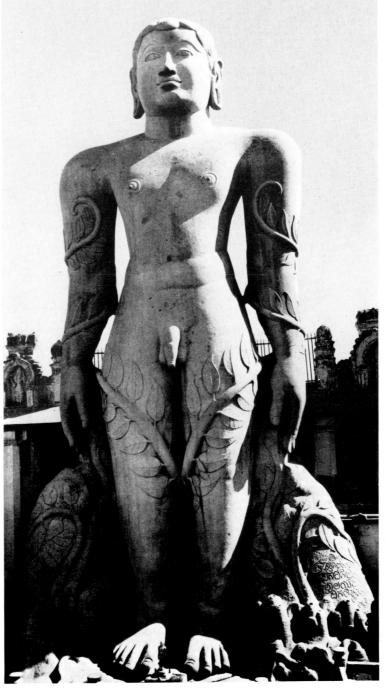

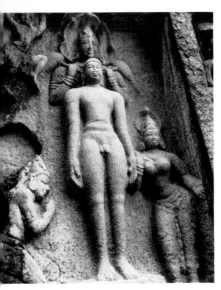

Clockwide Nos. 552, 553, 557, 558, 556, 555, 554

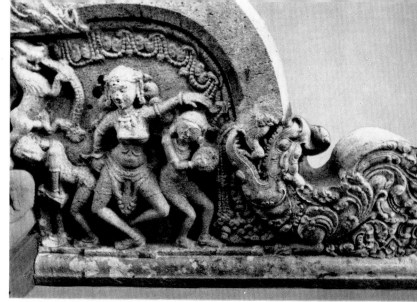
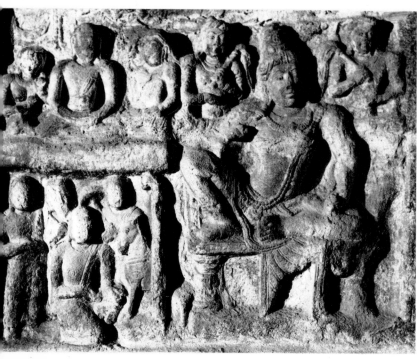

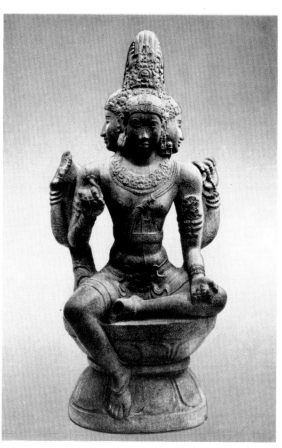
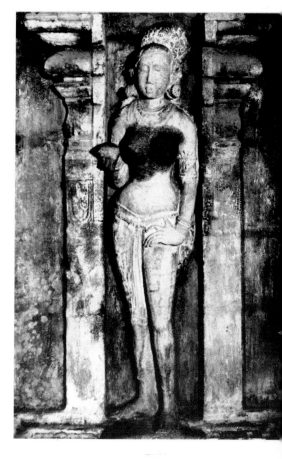

Left to right, top to bottom Nos. 559 through 565

triumphal art
of the last dynasties

(FOR CAPTIONS SEE PAGES 431 THROUGH 432)

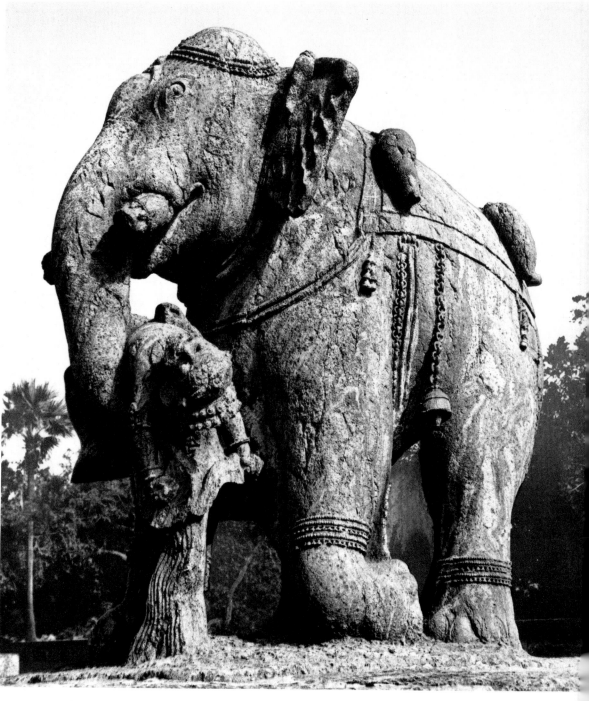

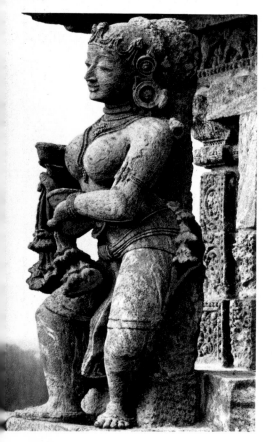

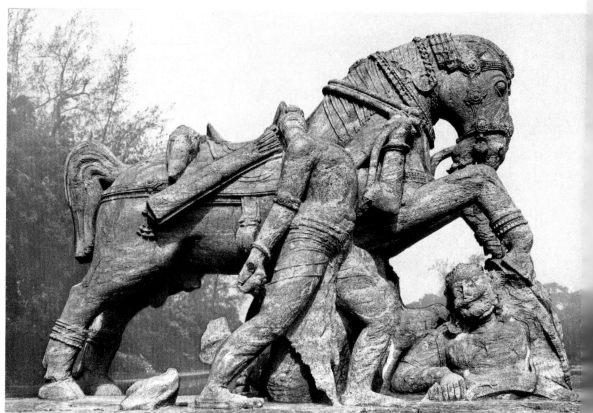

Lefthand side Nos. 566, 567, 569. Righthand side Nos. 568, 570

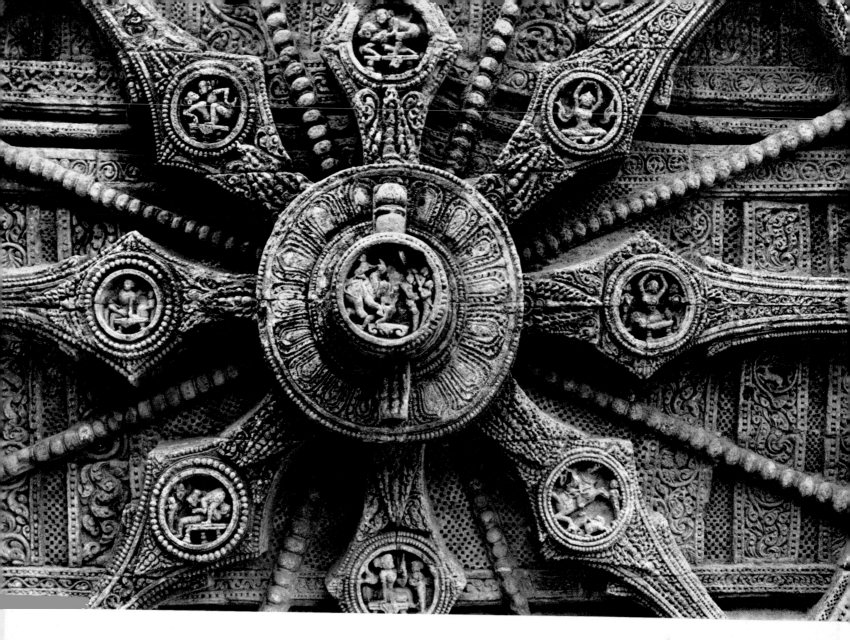

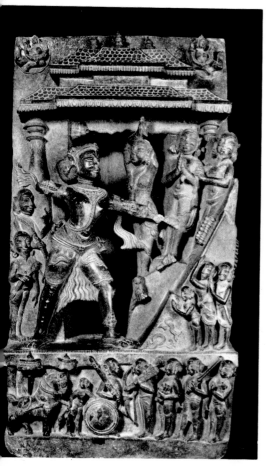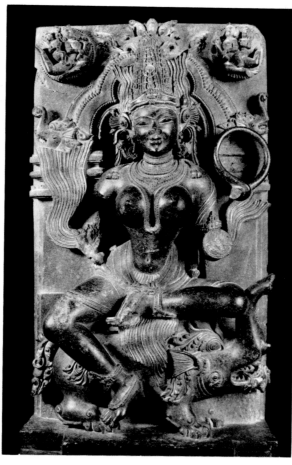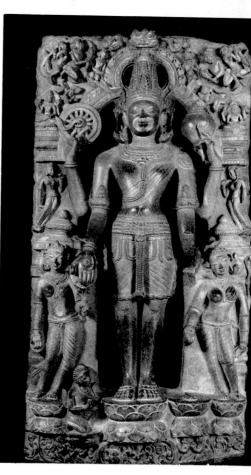

Left to right, top to bottom Nos. 571 through 574

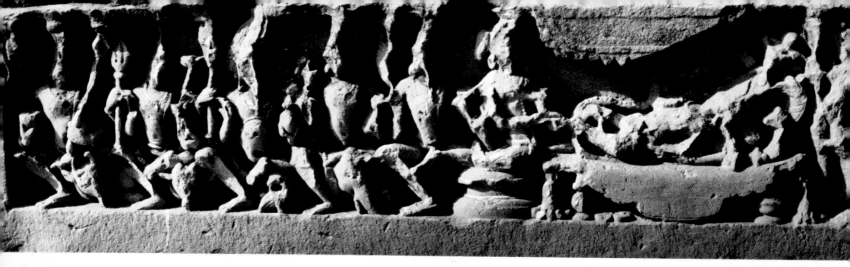

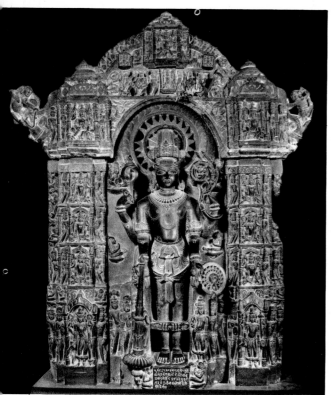

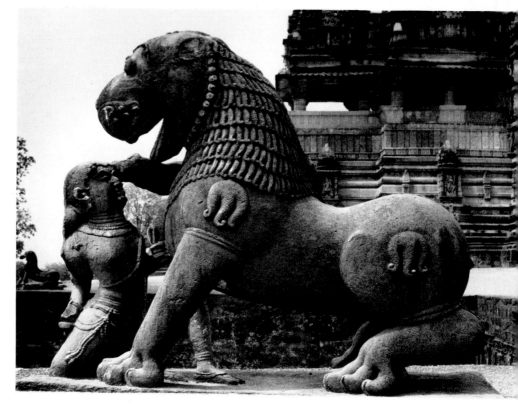

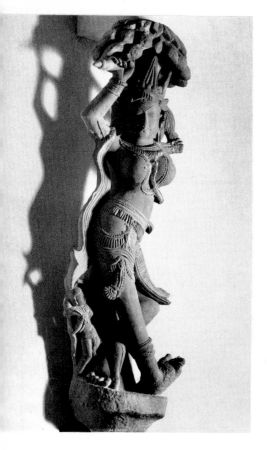

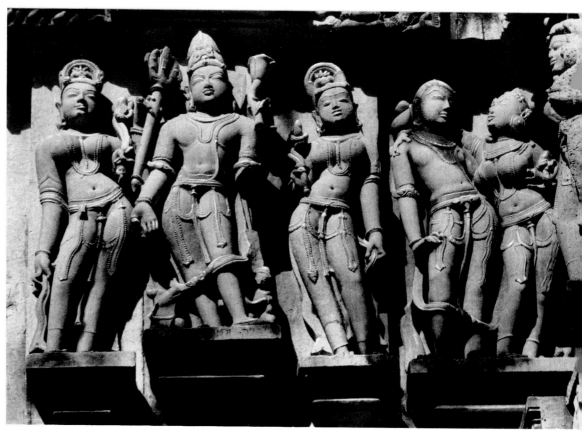

Left to right, top to bottom Nos. 575 through 579

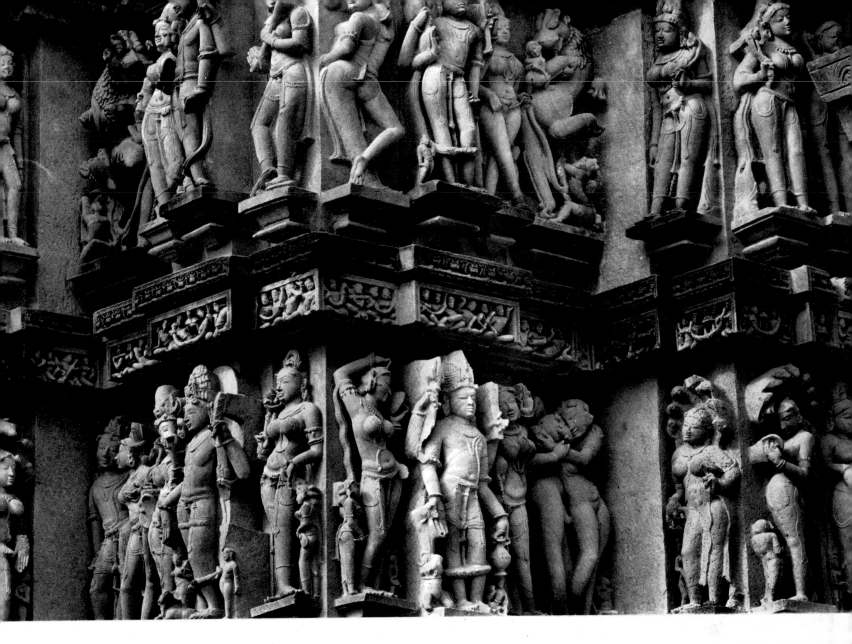

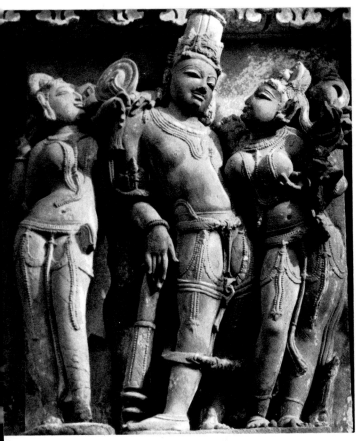

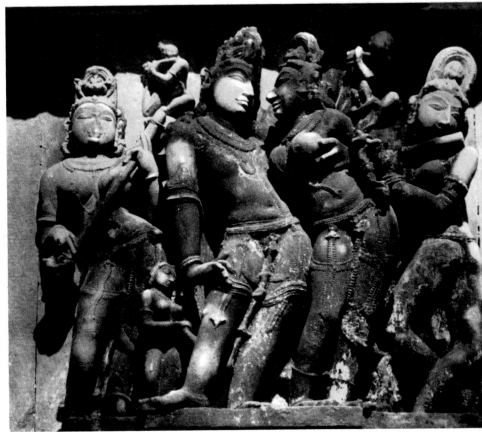

Left to right, top to bottom Nos. 580 through 582

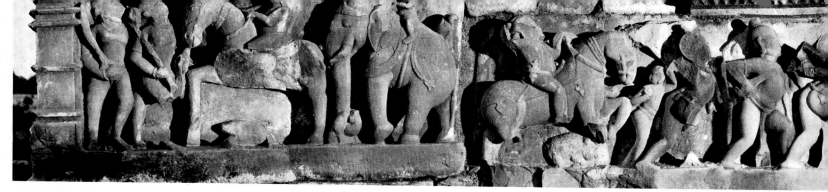

SOUTHERN FRIEZE

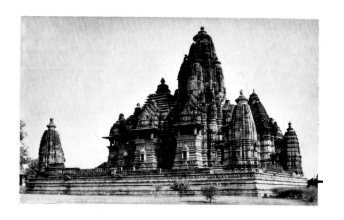

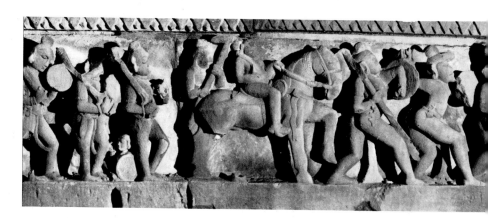

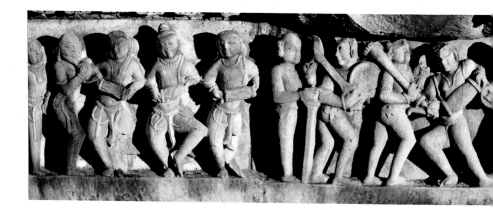

**583–92 TEMPLE OF LAKSHMANA
(KHAJURAHO)**

Four friezes of the temple
Part of the eastern frieze
has been destroyed

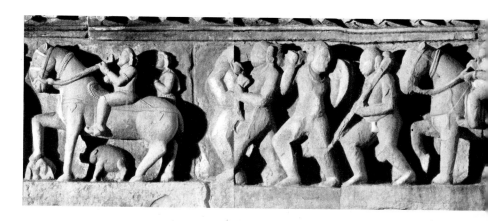

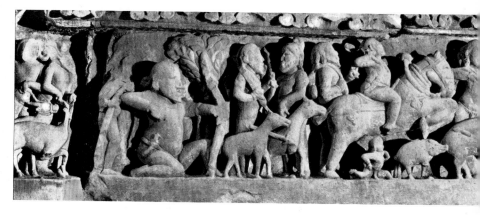

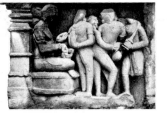

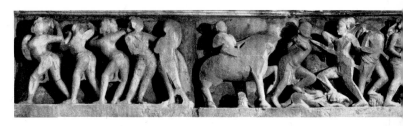

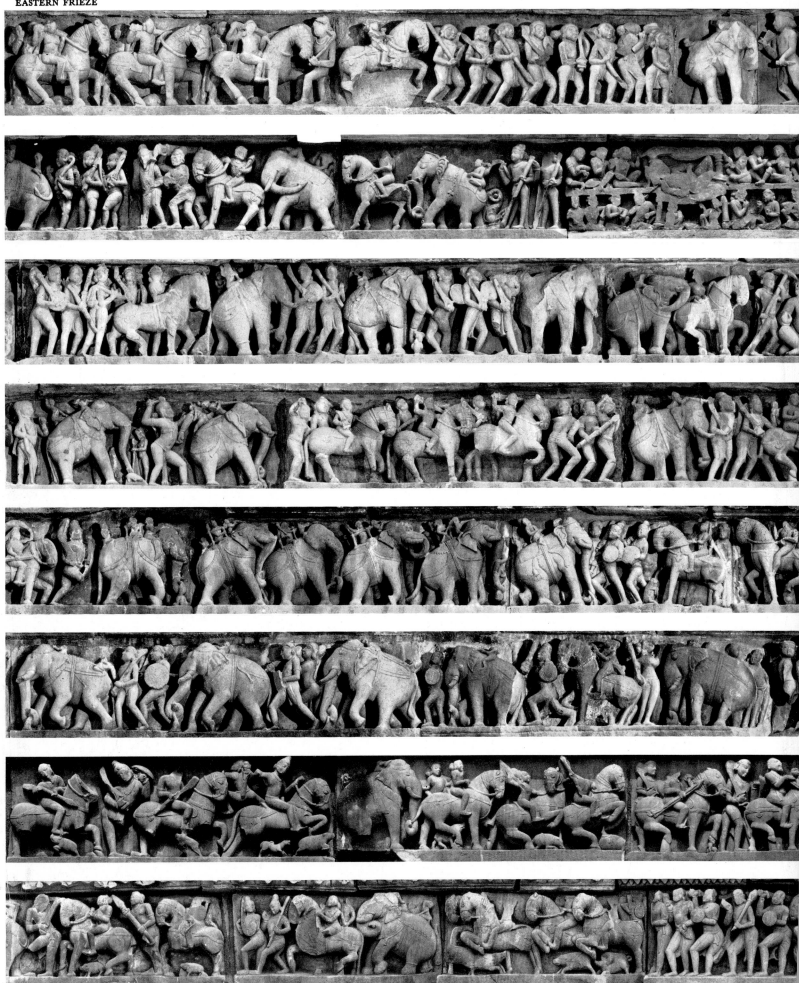

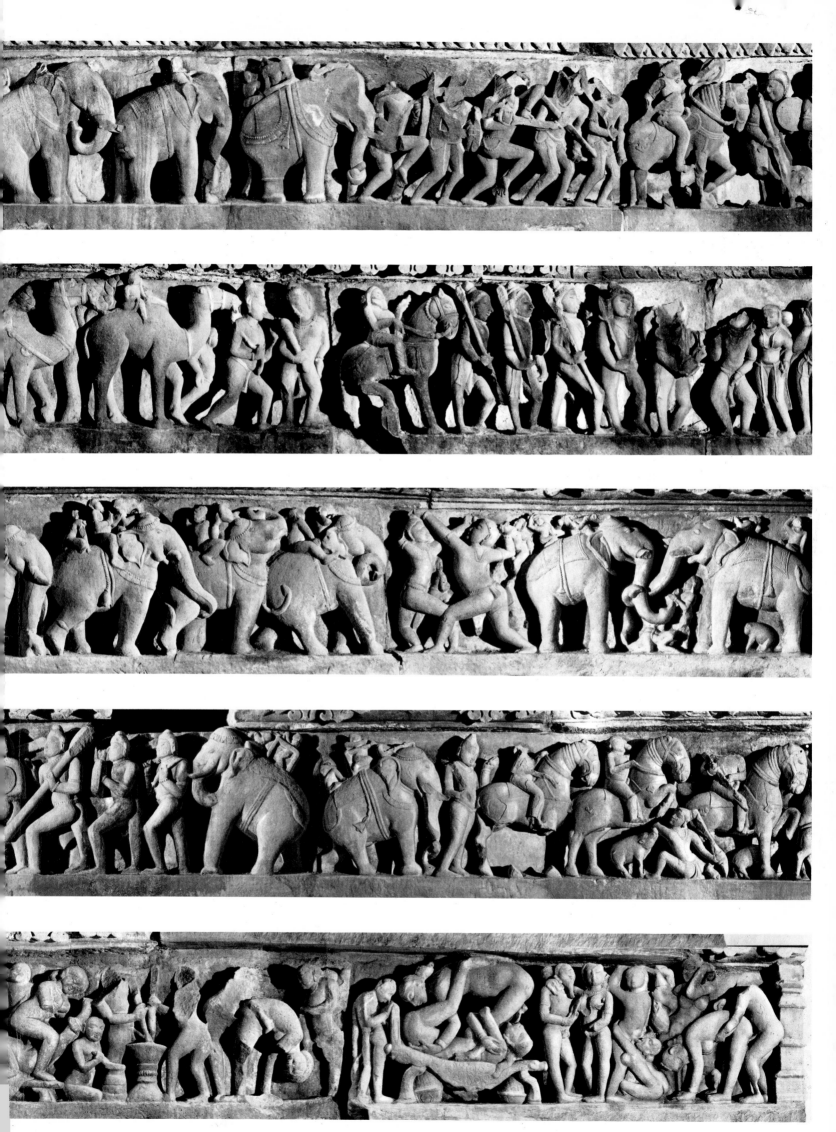

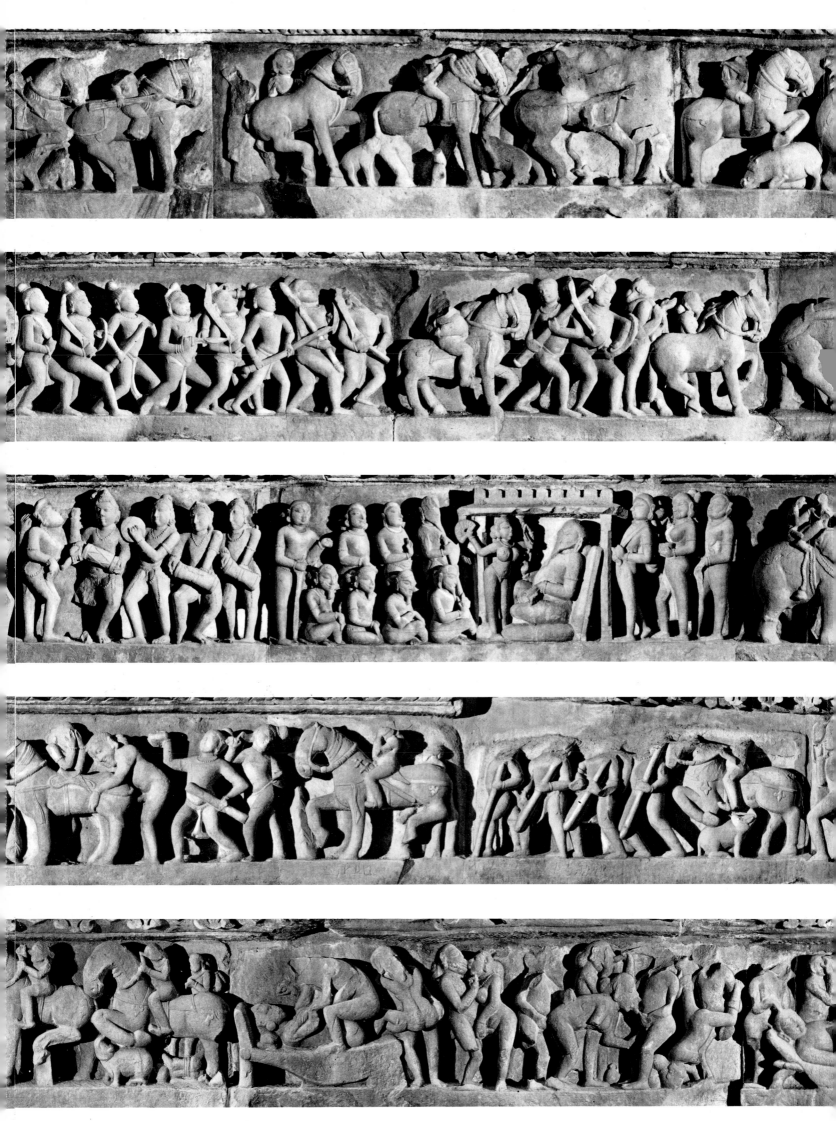

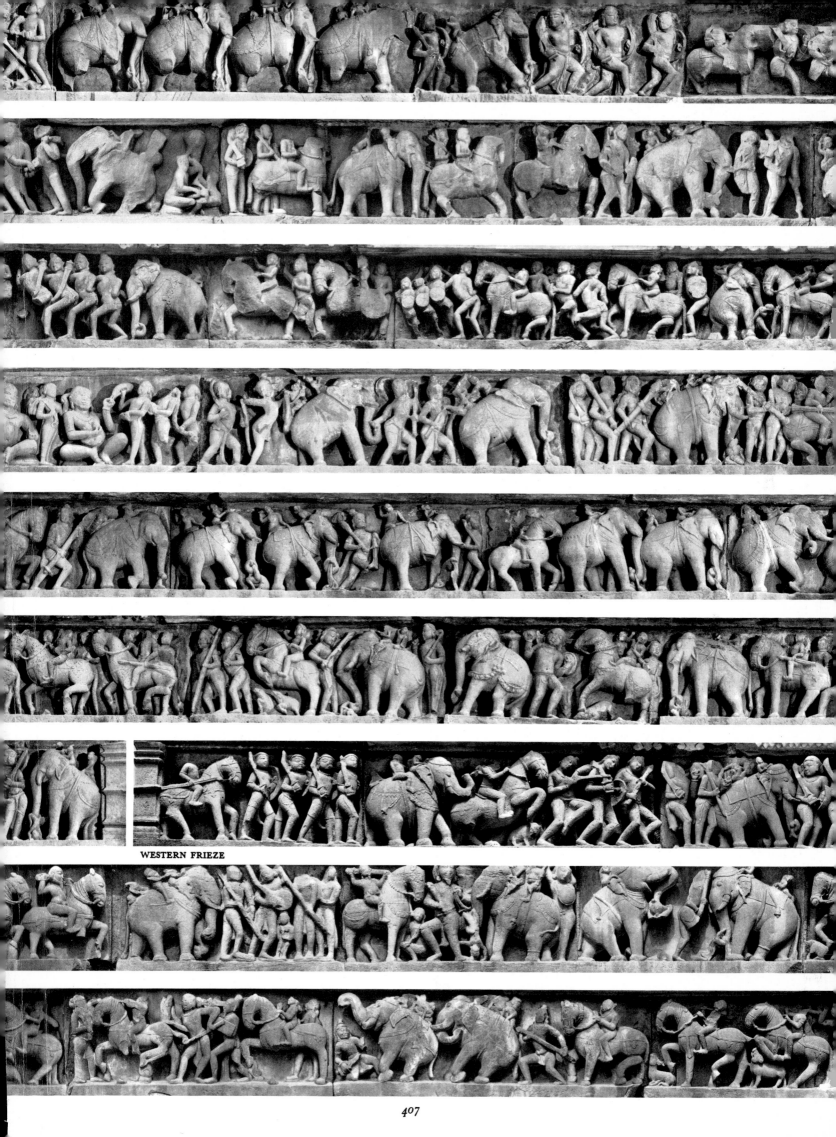

WESTERN FRIEZE

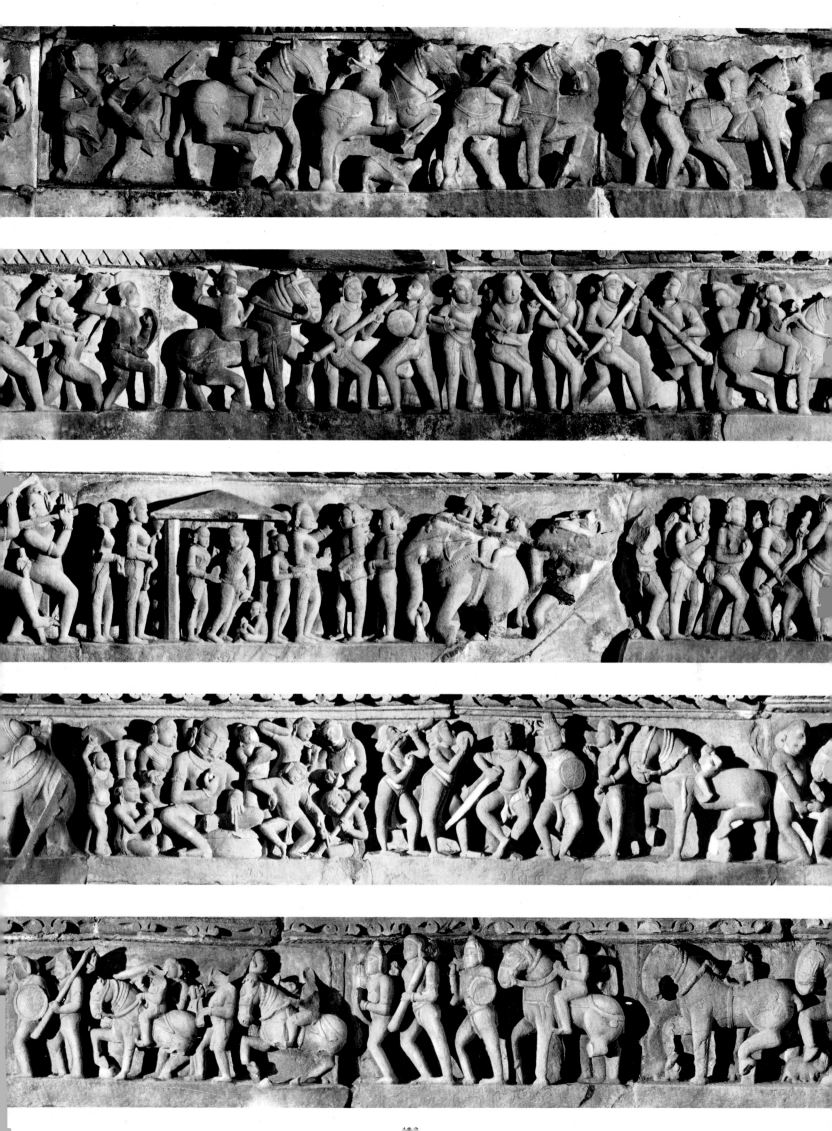

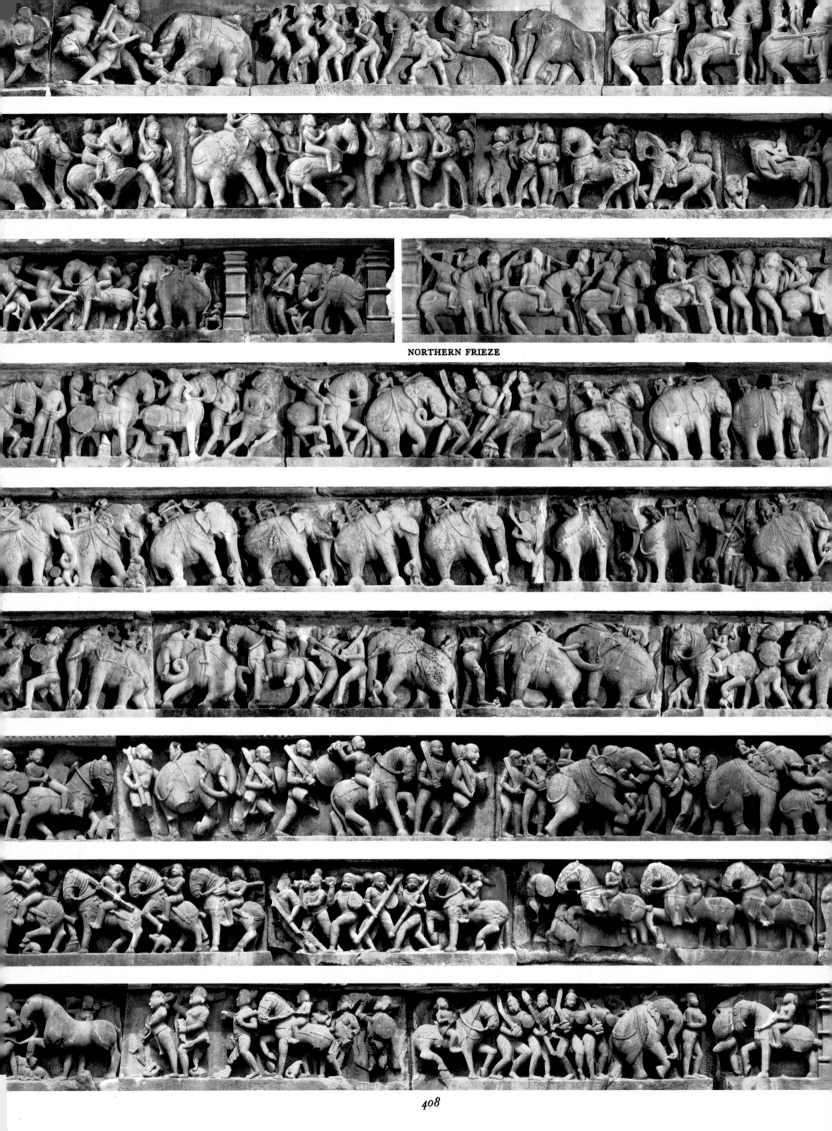

NORTHERN FRIEZE

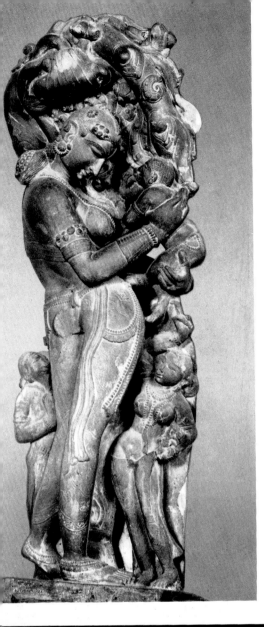
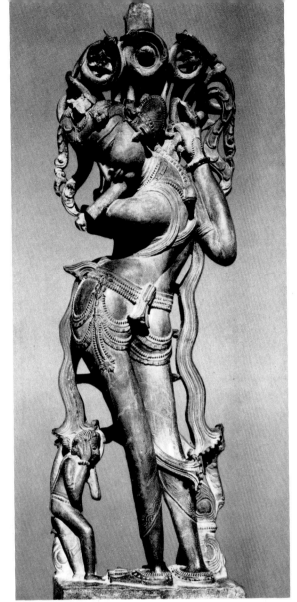
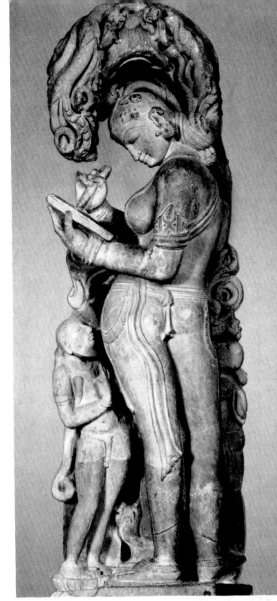
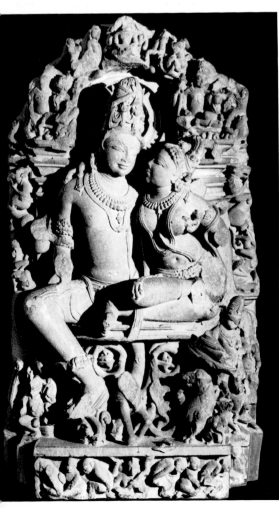
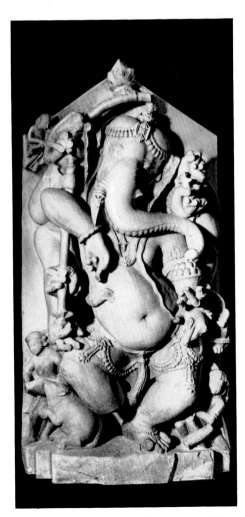
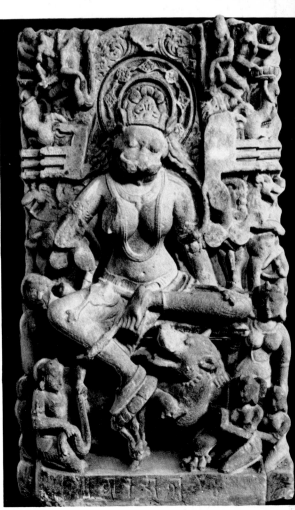

Left to right, top to bottom Nos. 593 through 598

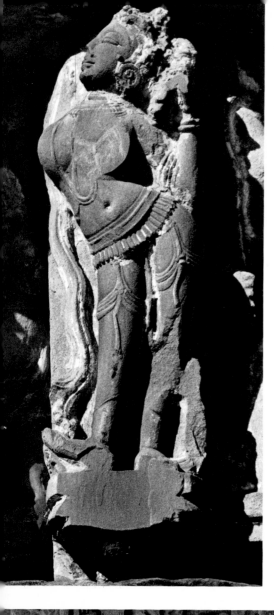
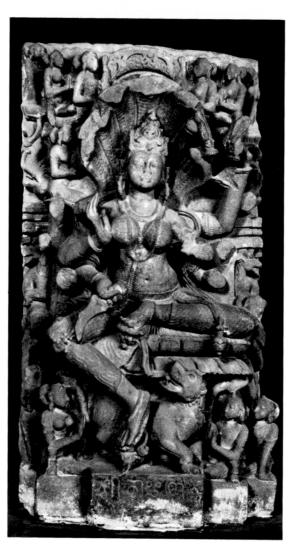

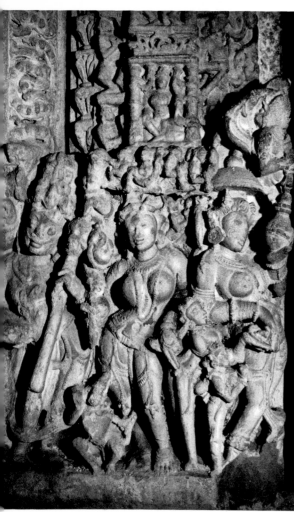
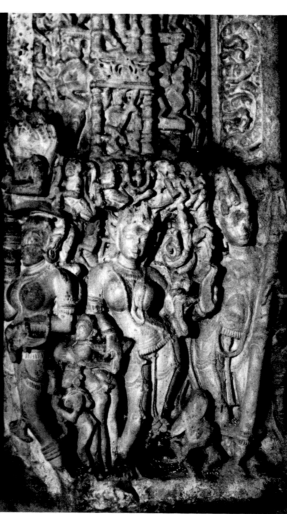
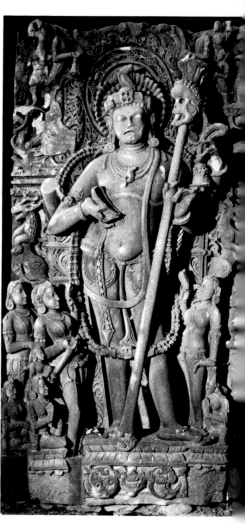

Left to right, top to bottom Nos. 599 through 604

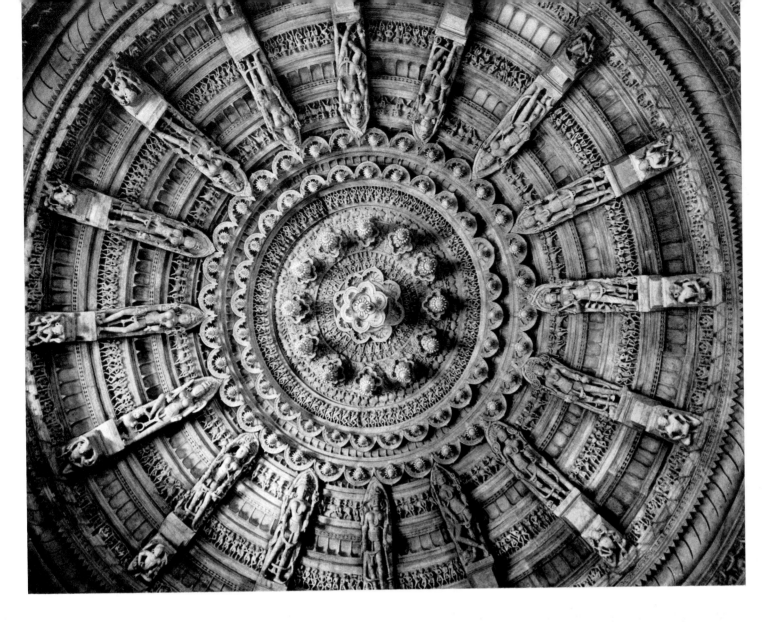

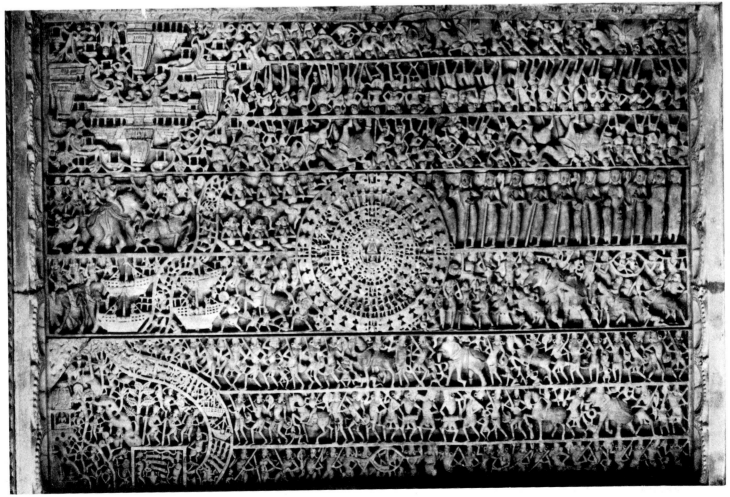

Top to bottom Nos. 605 through 606

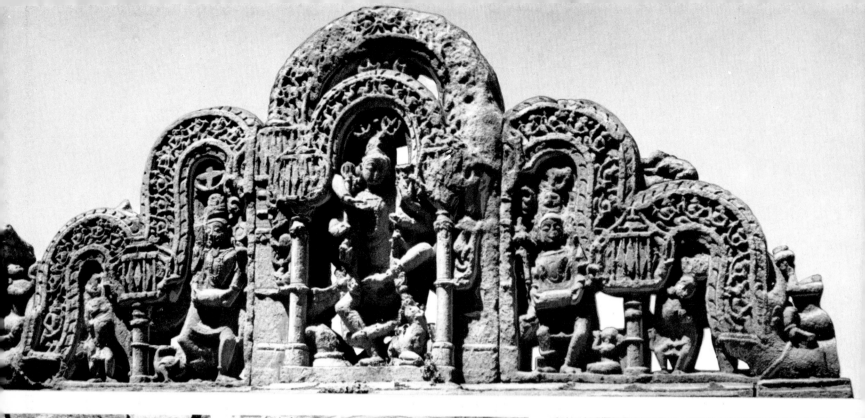

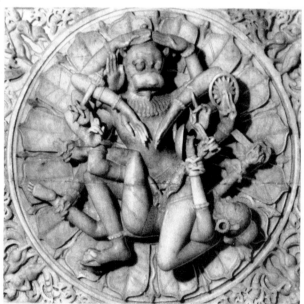

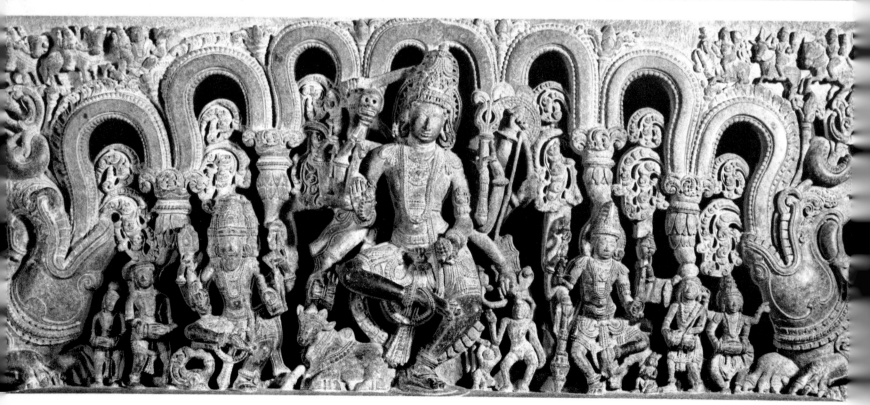

Left to right, top to bottom Nos. 607 through 611

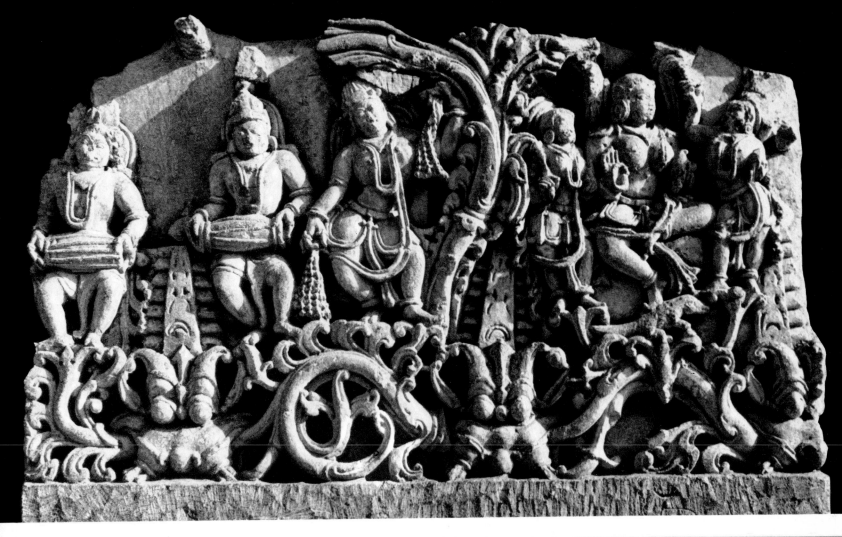

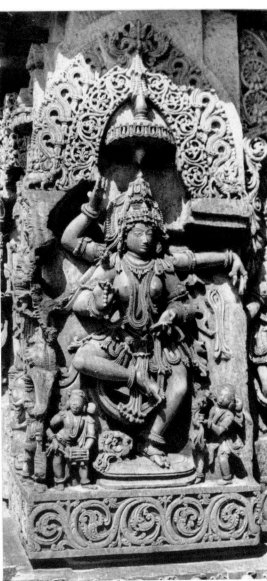

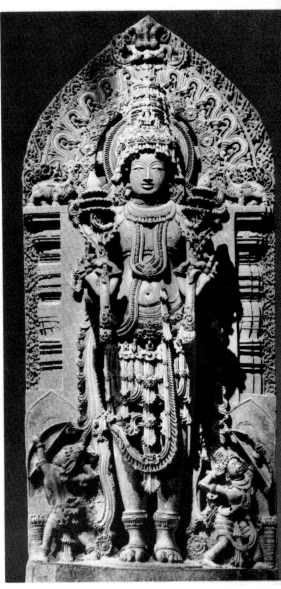

Left to right, top to bottom Nos. 612 through 615

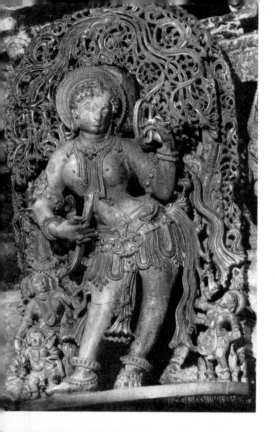
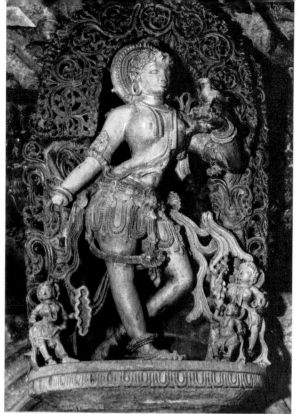
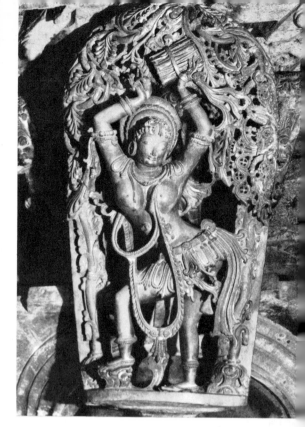

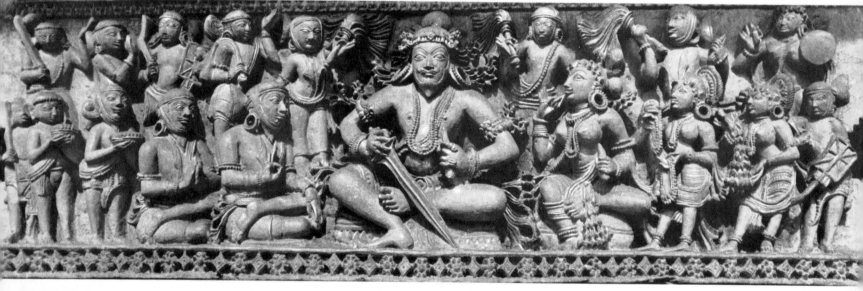

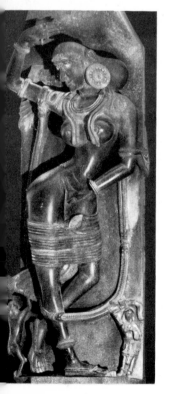
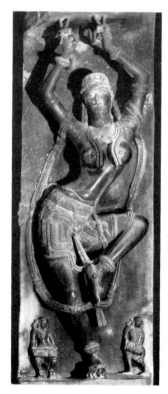
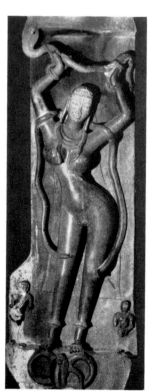
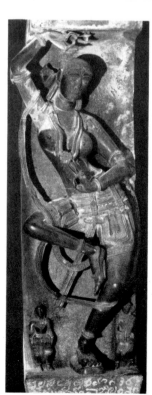
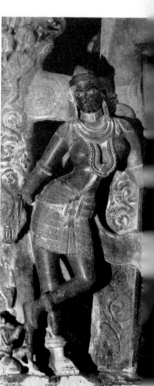

Left to right, top to bottom Nos. 616 through 624

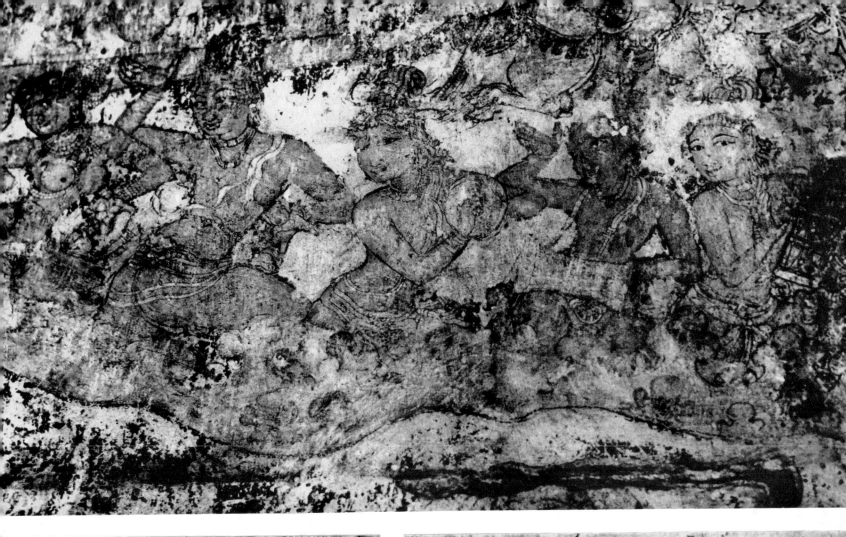

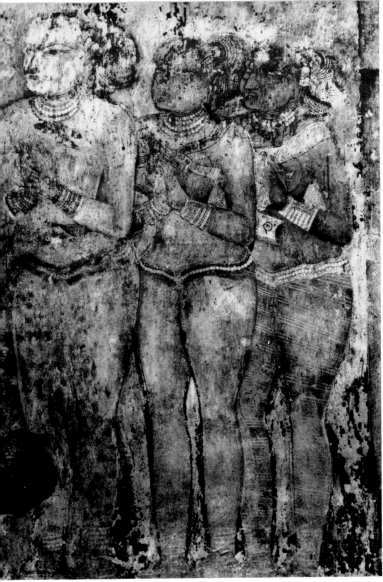

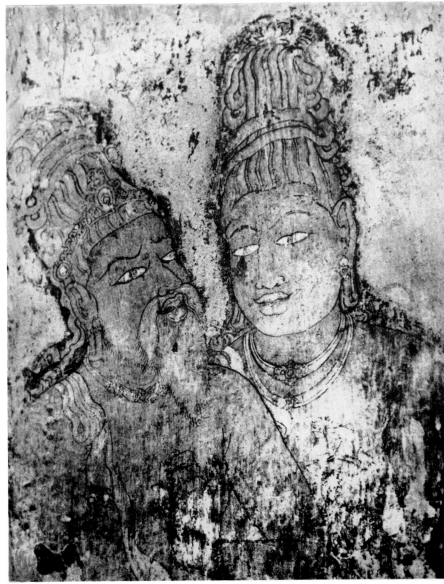

Left to right, top to bottom Nos. 625 through 627

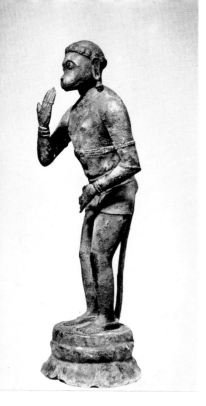
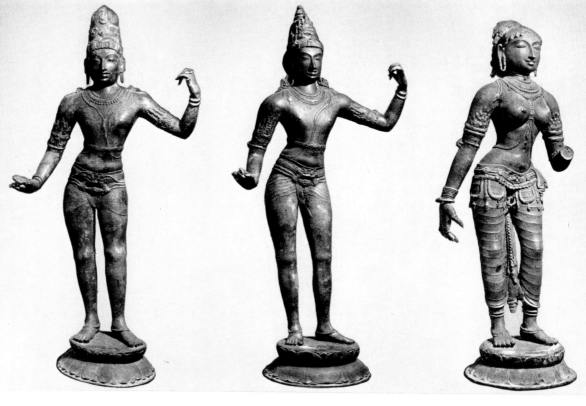
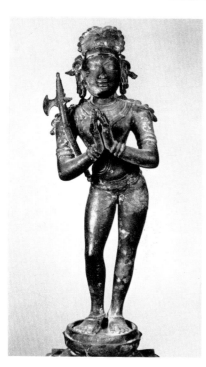
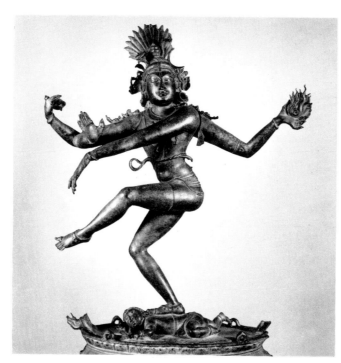
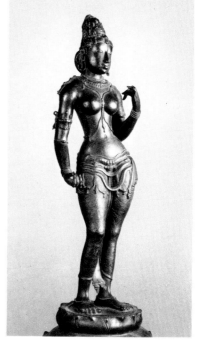
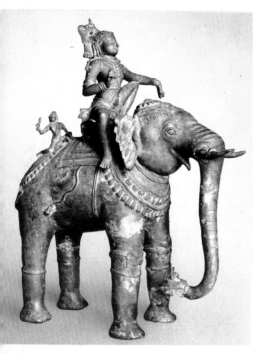
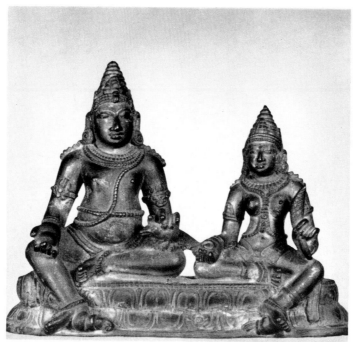

Left to right, top to bottom Nos. 628 through 637

last Indian art

(FOR CAPTIONS SEE PAGE 432)

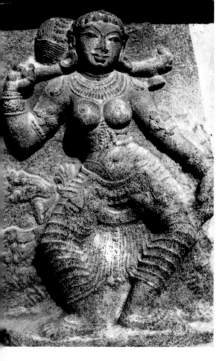
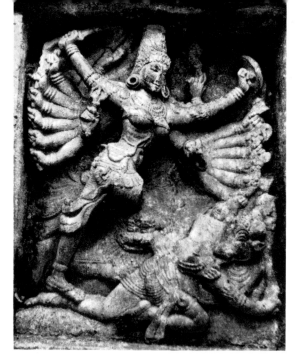
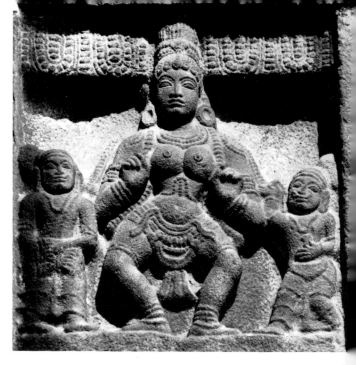

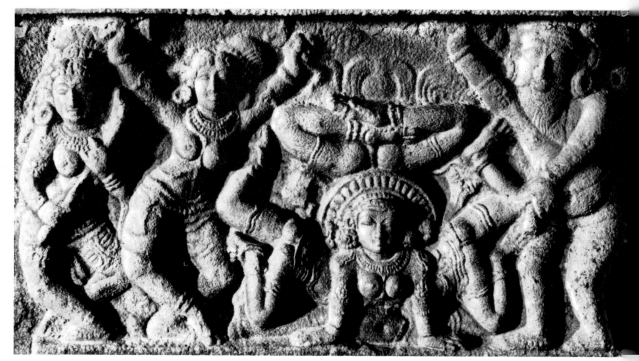

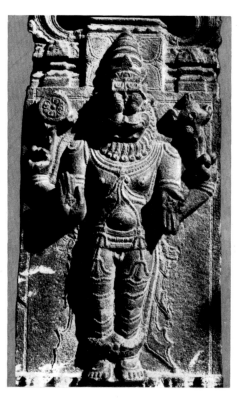

Left to right, top to bottom Nos. 638 through 645

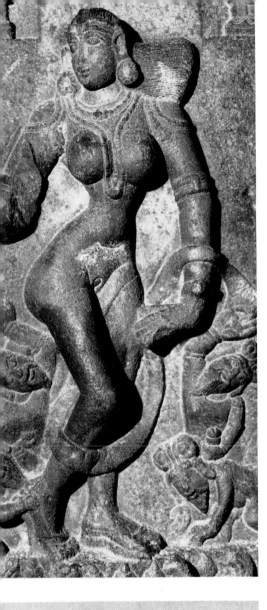
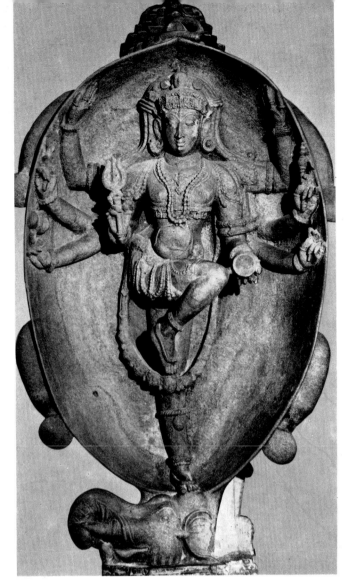
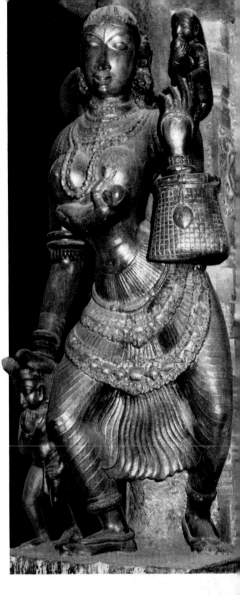
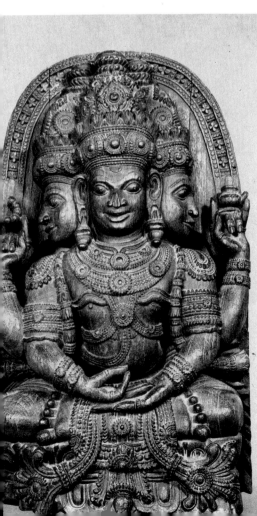
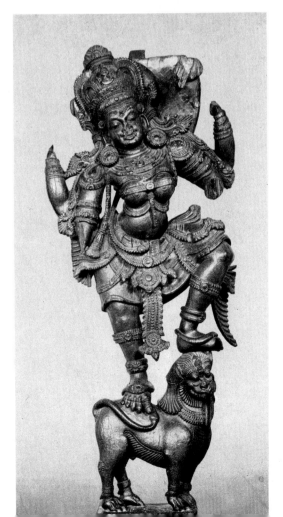
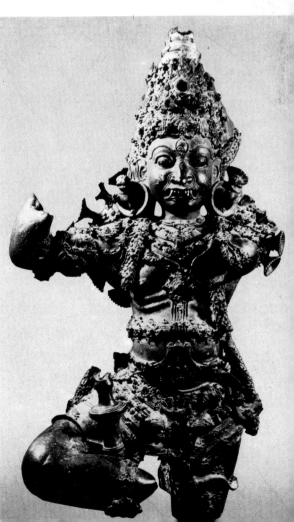

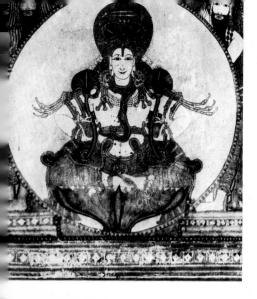

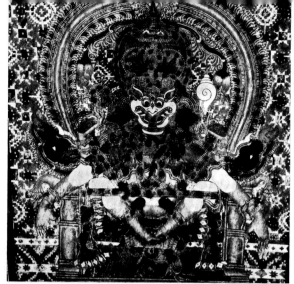

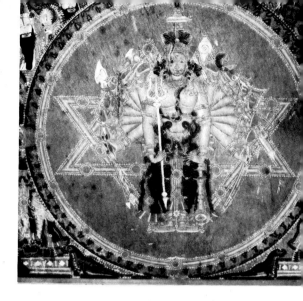

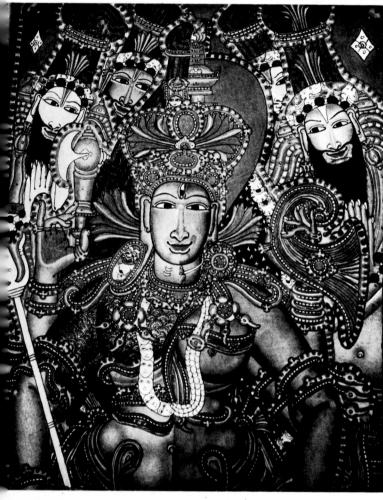

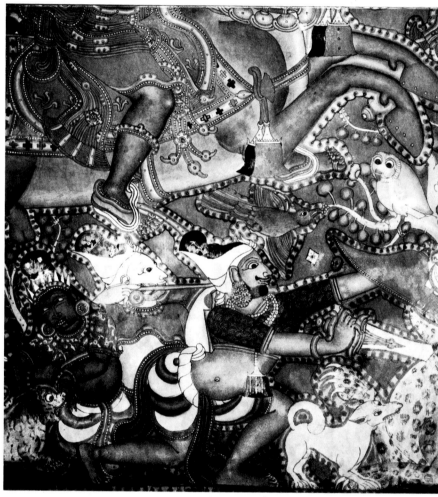

Left to right, top to bottom: Nos. 658, 659 and 660.

Mogul painting

and

sculpture

(FOR CAPTIONS SEE PAGE 432)

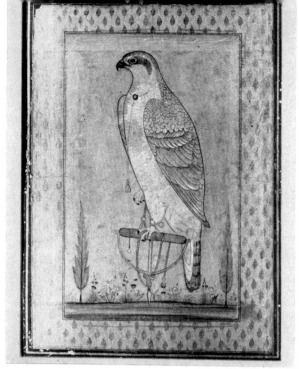

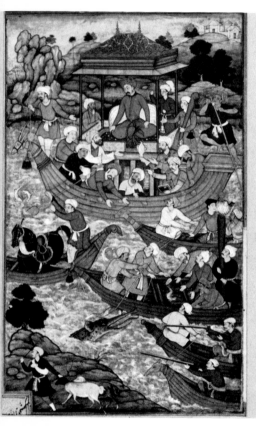

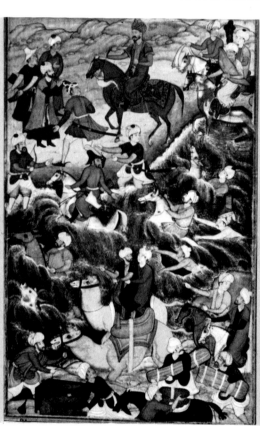

Left to right, top to bottom Nos. 659 through 666

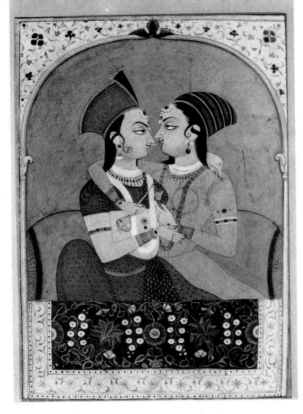
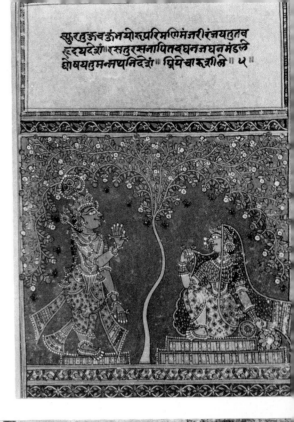
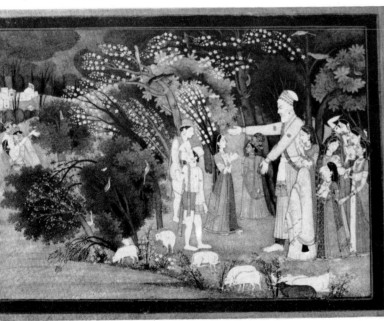
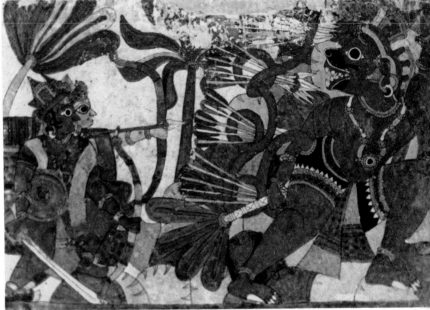

Left to right, top to bottom Nos. 667 through 673

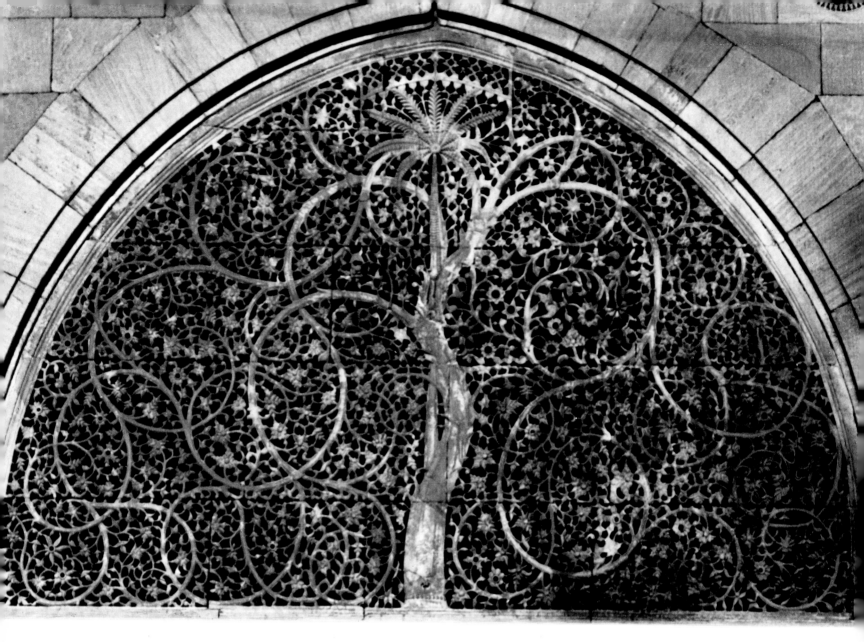

Left to right, top to bottom Nos. 674 through 677

LEGENDS

181. BUFFALO
Bronze from Mohenjo-Daro. 2500 B.C.
National Museum of India, New Delhi

182. CROCODILE HEAD
Bone from Mohenjo-Daro. 2500 B.C.
National Museum of India, New Delhi

183. MONKEY
Terra-cotta from Mohenjo-Daro. 2500
B.C. National Museum of India, New
Delhi

184. SEAL WITH TWO ANIMALS AROUND A
PIPAL TREE
Terra-cotta from Mohenjo-Daro. 2500
B.C. National Museum of India, New
Delhi

185. SQUIRREL
Faience from Mohenjo-Daro. 2500 B.C.
National Museum of India, New Delhi

186. BIRD
Terra-cotta from Mohenjo-Daro. 2500
B.C. National Museum of India, New
Delhi

187. MOTHER GODDESS
Terra-cotta from Mohenjo-Daro. 2500
B.C. National Museum of India, New
Delhi

188. PAINTED BOWL
Terra-cotta from Mohenjo-Daro. 2500
B.C. National Museum of India, New
Delhi

189. MONKEYS IN A TREE
Terra-cotta from Mohenjo-Daro. 2500
B.C. National Museum of India, New
Delhi

190. ELEPHANTS ADORING THE BODHI TREE
Detail of toran architrave. Satavahana,
2nd–1st century B.C. Sanchi

191. DOHADA
Red sandstone. Kushan, 2nd century.
National Museum of India, New Delhi

192. GODDESS CARRYING FOOD AND WATER
Kushan, 2nd century. Archaeological
Museum, Mathura

193. DAMSEL GATHERING FLOWERS
Red sandstone. Kushan, 2nd century.
Archaeological Museum, Mathura

194. HIMAVAN GIVING HIS DAUGHTER IN MAR-
RIAGE
Vakataka, 5th century. Elephanta

195. GANGADHARA
Vakataka, 5th century. Elephanta

196. HIMAVAN GIVING HIS DAUGHTER IN MAR-
RIAGE
Vakataka, 5th century. Ramesvara
cave, Ellora

197. GAJALAKSHMI AMID LOTUSES
Vakataka, 5th century. Ellora

198. YAMUNA
Rashtrakuta, 8th century. Kailasa
temple, Ellora

199. SARASVATI
Rashtrakuta, 8th century. Kailasa
temple, Ellora

200. GANGA
Rashtrakuta, 8th century. Kailasa
temple, Ellora

201–4 STORY OF GANGA
Pillar frieze. Western Chalukya, 8th
century. Pattadakal

201. GANGA GRANTING A BOON TO THE VASUS

202. BHAGIRATHA'S PENANCE. SHIVA RE-
CEIVES GANGA ON HIS LOCKS

203. BHAGIRATHA RECEIVING GANGA FROM
SHIVA AND FROM JAHNU

204. GANGA IN PATALA RECALLS THE EPISODE
OF KAPILA

205. GOVARDHANAGIRIDHARA
Chera, 17th century. Mattancheri
palace, Cochin, Kerala

206. COLUMN OF HELIODORUS
Brahmi script, 2nd century B.C. Besh-
nagar

207. FRAGMENT OF AN EDICT OF ASOKA
Brahmi script, 3rd century B.C. Nation-
al Museum of India, New Delhi

208. PEDAVEGI PLAQUES OF SALANKAYANA
NANDIVARMAN II
Brahmi script, 4th century. National
Museum of India, New Delhi

209. COLUMN OF SAMUDRAGUPTA
Brahmi script, 4th century. Allahabad

210. MANDASOR INSCRIPTION OF YASODHAR-
MAN
Nagari script, 6th century. National
Museum of India, New Delhi

211. BANSKHERA PLAQUE OF HARSHAVAR-
DHANA WITH ROYAL SIGNATURE
Nagari script, 7th century. State Mu-
seum, Lucknow

212. COPPER PLAQUE OF DEVAPALA OF
NALANDA
Nagari script, 9th century. National
Museum of India, New Delhi

213. INSCRIPTION ON STONE OF EASTERN
GANGA RULER ANANTAVARMACHOLA-
GANGA
From Urajam. Nagari script, 9th cen-
tury. Government Museum, Madras

214. DONATION PLAQUE OF VIJAYANAGAR
KING ACTUTARAYA
Nandinagari script, 16th century.
National Museum of India, New Delhi

215. FRAGMENT OF AN INSCRIPTION OF RAJA-
SIMHA PALLAVA
From Kanchipuram. Grantha script,
7th century. Government Museum,
Madras

216. COPPER PLAQUE OF PARANTAKA VIRA-
NARAYANA
From Dalavaipuram. Grantha-Tamil
script, 9th century. National Museum
of India, New Delhi

217. FRAGMENT OF AN INSCRIPTION OF NAN-
DIVARMAN PALLAVAMALLA

From Mambakkam. Grantha script,
8th century. Government Museum,
Madras

218. VIJAYANAGAR INSCRIPTION
Tamil-Grantha script, 15th century.
Government Museum, Madras

219. INSCRIPTION OF RAJARAJA
Tamil-Grantha script, 11th century.
Brihadisvara temple, Tanjore

220. EASTERN CHALUKYA INSCRIPTION
From Ghantasala. Telugu script, 7th
century. Government Museum, Ma-
dras

221. SEAL OF THE PONDURU DONATION
PLAQUES BEARING THE BOAR, A ROYAL
EMBLEM
From Ponduru. Telugu script, 10th
century. National Museum of India,
New Delhi

222. INSCRIPTION OF EASTERN CHALUKYA
RULER RAJARAJA
From Rajamahendravaram. Telugu
script, 11th century. Government Mu-
seum, Madras

223. HERO WITH INSCRIPTION OF EASTERN
CHALUKYA RULER VIKRAMADITYA
From Annavara Agrahara. Kannada
script, 7th century. Government Mu-
seum, Madras

224. DONATION PLAQUE OF THE WESTERN
CHALUKYA RULER PULAKESIN
From Kopparam. Kannada script,
early 7th century. National Museum
of India, New Delhi

225. WESTERN CHALUKYA INSCRIPTION COM-
MEMORATING A HUNT
Kannada script, 10th century. Mysore
Government Museum, Bangalore

226. APOLLODOTOS
Indo-Greek coin, 1st century B.C.
National Museum of India, New Delhi

227. YAUDHEYA
Brahmi coins, 1st century B.C. National
Museum of India, New Delhi

228. KANISHKA
Kushan coin. Brahmi script, 1st cen-
tury A.D. National Museum of India,
New Delhi

229. ASVAMEDHA
Gupta coin of Samudragupta. Brahmi
script, 4th Century. National Museum
of India, New Delhi

230. MUSICIAN
Coin of Samudragupta. Brahmi script,
4th century. National Museum of
India, New Delhi

231. SASANKA
Gauda coin. Nagari script, 7th century.
National Museum of India, New Delhi

232. VARAGUNAPANDYA
Pandya coin. Tamil-Grantha script,
9th century. National Museum of
India, New Delhi

233. GANGAIKONDACHOLA
Rajendrachola I coin. Nagari script,
11th century. National Museum of
India, New Delhi

234. PANDYA DHANANJAYA
Pandya coin. Nagari script, 13th century. National Museum of India, New Delhi

235. GANGEYADEVA
Kalachuri coin. Nagari script, 12th century. National Museum of India, New Delhi

236. AKBAR
Mogul coin. Persian script, 16th century. National Museum of India, New Delhi

237. JAHANGIR
Mogul coin. Persian script, 17th century. National Museum of India, New Delhi

238. JAHANGIR
Mogul coin. Persian script, 17th century; zodiac type (Taurus). National Museum of India, New Delhi

239. JAHANGIR
Mogul coin. Persian script, 17th century; zodiac type (Sagittarius). National Museum of India, New Delhi

240. JAHANGIR
Mogul coin. Persian script, 17th century; zodiac type (Libra). National Museum of India, New Delhi

241. JAHANGIR
Mogul coin. Persian script, 17th century; zodiac type (Aries). National Museum of India, New Delhi

242. NAGARAJA IN ADORATION
From Bharhut. Sunga, 2nd century B.C. Indian Museum, Calcutta

243. CHANDRA YAKSHI
From Bharhut. Sunga, 2nd century B.C. Indian Museum, Calcutta

244. KUBERA YAKSHA
From Bharhut. Sunga, 2nd century B.C. Indian Museum, Calcutta

245. GAJALAKSHMI
From Bharhut. Sunga, 2nd century B.C. Indian Museum, Calcutta

246. PRESENTATION OF JETAVANAVIHARA
From Bharhut. Sunga, 2nd century B.C. Indian Museum, Calcutta

247. SURYA IN HIS CHARIOT
Detail of a pillar. Sunga, 1st century B.C. Bodh Gaya

248. GAJALAKSHMI
Detail of a pillar. 2nd century B.C. Sanchi

249. GAJALAKSHMI
Detail of a pillar. 2nd century B.C. Sanchi

250. BUDDHA
Kushan, 1st–2nd century A.D. Archaeological Museum, Mathura

251. SKANDA WITH A PEACOCK
Gupta, 5th century. Bharat Kala Bhavan Museum, Benares

252. PARSVANATHA
Kushan, 2nd century. State Museum, Lucknow

253. EKAMUKHALINGA
Gupta, 5th century. Municipal Museum, Allahabad

254. MAHISHAMARDINI
Gupta, 4th century. Cave at Udayagiri

255. HEAD OF ARDHANARISVARA
Early Gupta, 4th century. Archaeological Museum, Mathura

256. YAMUNA ON HER TORTOISE
From Buxar. Gupta, 5th century. Indian Museum, Calcutta

257. GANESHA
From Bhumara. Gupta, 5th century. Indian Museum, Calcutta

258. GANGA ON HER CROCODILE
From Buxar. Gupta, 5th century. Indian Museum, Calcutta

259. NARASIMHA FIGHTING HIRANYAKASIPU
Vakataka, 5th–6th century. Dasavatara cave, Ellora

260. SHIVA, PARVATI, AND THEIR FAMILY
Vakataka, 5th–6th century. Dasavatara cave, Ellora

261. SESHASAYI PADMANABHA
Vakataka, 6th century. Dasavatara cave, Ellora

262. NATARAJA
Vakataka, 5th century. Elephanta

263. MADHU AND KAITABHA ATTACKING VISHNU PADMANABHA
Terra-cotta from Bhitargaon. Indian Museum, Calcutta

264. BRAHMA
Pallava, 4th century. Madugula

265. VISHNU
Early 4th century. Madugula

266. SHIVA AND THE BULL
Pallava, 4th century. Victoria Jubilee Museum, Bezwada

267. BHIKSATANAMURTI
Eastern Chalukya, 9th century. Temple of Golingesvara, Bikkavolu

268. LAKULISA
Eastern Chalukya, 9th century. Bikkavolu

269. LINGODBHAVA
Eastern Chalukya, 10th century. Victoria Jubilee Museum, Bezwada

270. SURYA ON HIS HORSE
Eastern Ganga, 13th century. Konarak

271. MANMATHA, RATI, AND PRITI
Eastern Ganga, 11th century. Temple of Uttaresvara, Bhuvaneshwar

272. VARUNA WITH A PASA
Eastern Ganga, 10th century. Rajarani temple, Bhuvaneshwar.

273. VRISHABHANTIKA AND DEVI
From Tiruvenkadu. Chola, 11th century. Art Gallery, Tanjore

274. NATARAJA
Bronze from Tiruvarangulam. Chola,

10th century. National Museum of India, New Delhi

275. SHIVA DANCING ON THE BULL
Bronze. Pala, 10th century. Melakkadambur temple near Chidambaram

276. BALARAMA
Bronze from Nalanda. Pala, 8th century. National Museum of India, New Delhi

277. VISVARUPAVISHNU
Bronze. Pala, 10th century. Bangiya Sahitya Parishad, Calcutta

278. HARAGAURI
Bronze from Kurkihar. Pala, 11th century. National Museum of India, New Delhi

279. SURYA
Bronze from Nalanda. Pala, 9th century. National Museum of India, New Delhi

280. VISHNU AND HIS CONSORTS
Bronze from Rangpur. Pala, 11th century. Indian Museum, Calcutta

281. MATSYAVATARA
Pala, 11th century. Dacca Museum

282. SURYA
From Kashipur. Pala, 10th century. Asutosh Museum of Indian Art, Calcutta

283. TRIVIKRAMA
From Badulla. Pala, 11th century. Dacca Museum

284. VISHNU VAIKUNTHA
From Kashmir. Utpala, 9th century. Sir Pratap Singh Government Museum, Srinagar

285. TRIVIKRAMA
From Nepal. 9th–10th century. Nepal Museum, Katmandu

286. LINGODBHAVA
From Rajasthan. Gurjara-Pratihara, 10th century. Rajputana Museum of Archaeology, Ajmer

287. SHIVA DANCING WITH THE MATRIKAS
From Abaneri. Gurjara-Pratihara, 9th century. Central Museum of Jaipur

288. MANMATHA, RATI, AND PRITI
Gurjara-Pratihara, 9th century. Abaneri

289. VARAHA
Chandella, 9th–10th century. Khajuraho

290. VISHAPAHARANA
Bronze. Pallava, 9th century. Government Museum, Madras

291. DURGA
Western Chalukya, 6th century. Temple of Durga, Aihole

292. NATESHA
From Poruppumettupatti. Early Pandya, 11th century. Government Museum, Madras

293. SARASVATI
Hoysala, 12th century. Halebid

294. NATESHA
Rashtrakuta, 8th century. Lankesvara cave, Ellora

295. VENUGOPALA
Hoysala, 12th century. Temple of Kesava, Belur

296. SESHASAYI
From Aihole. Western Chalukya, 6th century. Prince of Wales Museum, Bombay

297. GAJALAKSHMI
Pallava, 7th century. Varaha cave, Mahabalipuram

298. VAHARA
Pallava, 7th century. Mahabalipuram

299. MAHISHAMARDINI
Pallava, 7th century. Mahishamardini cave, Mahabalipuram

300. SESHASAYI VISHNU
Pallava, 7th century. Mahishamardini cave, Mahabalipuram

301. SHIVA DANCING
From Mahabalipuram. Pallava, 7th century. National Museum of India, New Delhi

302. SOMASKANDA
From Mahabalipuram. Pallava, 7th century. National Museum of India, New Delhi

303. DAKSHINAMURTI
Pallava, late 7th century. Kailasa temple, Kanchipuram

304. VISHNU
Chola, 9th century. Vijayalayacolisvara temple, Nartamalai

305. ARDHANARISVARA
Chola, 10th century. Nagesvaraswami temple, Kumbakonam

306. MATRIKA CHAMUNDA
Chola, 10th century. Musée Guimet, Paris. Collection Van Loo

307. BHIKSHATANA
Chola, 11th century. Brihadisvara temple, Tanjore

308. KALANTAKA
Chola, 11th century. Brihadisvara temple, Tanjore

309. NATARAJA
Chola, 11th century. Brihadisvara temple, Gangaikondacholaquram

310. CANDESANUGRAHAMURTI
Chola, 11th century. Gangaikondacholapuram

311. MARRIAGE OF PARVATI
Nayak, 17th century. Madura

312. DANCE OF SHIVA
Mural, 17th century. Ettumanur

313. YOGA NARAYANA SURYA
Gurjara-Pratihara, 9th century. Sardar Museum, Jodhpur

314. SOMASKANDA
From Nidur. Chola, 11th century. Government Museum, Madras

315. VISHNU AND AYUDHAPURUSHA
Gupta, 4th century. Cave at Udayagiri

316. NAVAGRAHA AND GANESHA
Pala, 11th century. Indian Museum, Calcutta

317. BHAIRAVA, GAJANTAKA, AND ANDEKANTAKA
Eastern Ganga, 9th–10th century. Indian Museum, Calcutta

318. VARAHA
Gupta, 5th century. Eran

319. SHIVA AND PARVATI
From Kosambi. Kushan-Gupta, 3rd–4th century. Indian Museum, Calcutta

320. TORSO OF A TIRTHANKARA
From Lohanipur. Maurya, 3rd century B.C. Patna Museum

321. DESCENT OF BUDDHA ON THE TRIPLE LADDER
From Bharhut. Sunga, 2nd century. Indian Museum, Calcutta

322. ADORATION OF THE WHEEL
From Amaravati. Satavahana, 2nd century. Government Museum, Madras

323. ADORATION OF BUDDHA'S BOWL BY THE CELESTIALS
From Amaravati. Satavahana, 2nd century. Government Museum, Madras

324. ADORATION OF THE STUPA BY NAGAS AND NAGINIS
From Amaravati. Satavahana, 2nd century. Government Museum, Madras

325. AYAGAPATA
Gift of Lonasobhika. Kushan, 2nd century. Government Museum, Madras

326. LALA BHAGAT COLUMN
Kushan, 1st century B.C.–1st century A.D.

327. STORY OF NANDA
From Nagarjunakonda. Ikshvaku, 2nd–3rd century. Nagarjunakonda Archaeological Museum

328. SUBJUGATION OF NAGA APALALA
From Nagarjunakonda. Ikshvaku, 2nd–3rd century. Nagarjunakonda Archaeological Museum

329. AYAGAPATA
From Mathura. Kushan, 2nd century. National Museum of India, New Delhi

330. AYAGAPATA SHOWING ARYA BHAGAVATI
Kushan, 2nd century. State Museum, Lucknow

331. VISIT OF INDRA
Kushan, 2nd century. Indian Museum, Calcutta

332. AHALYA FREED FROM A CURSE
From Deogarh. Gupta, 5th century. National Museum of India, New Delhi

333–34. KIRATARJUNA COLUMN
From Rajaona. Gupta, 5th century. Indian Museum, Calcutta

335. TRIPURANTAKA
Vakataka, 8th century. Cave 15, Ellora

336. SHIVA RESCUING MARKANDEYA
Vakataka, 6th century. Cave 15, Ellora

337–40. KIRATARJUNA
Eastern Chalukya, 9th century. Bezwada

341. SEATED HARAGAURI
Eastern Ganga, 7th century. Parasuramesvara temple, Bhuvaneshwar

342. NANDA, YASODA, AND KRISHNA AT THE CHURN
Eastern Ganga, 11th century. Lingaraja temple, Bhuvaneshwar

343. DURGA PUTTING ON HER ANKLET
From Abaneri. Gurjara-Pratihara, 9th century. Amber Archaeological Museum

344. NATARAJA
Gurjara-Pratihara, 9th century. Abaneri

345. SADASHIVA
Sena, 12th century. Indian Museum, Calcutta

346. MANMATHA, RATI, AND PRITI
Utpala, 9th century. Temple of Awantisvami, Awantipur

347. SARVAMANGALA
From Satna. Chedi, 10th century. Indian Museum, Calcutta

348. SHIVA AND PARVATI OBSERVING DANCERS
From Abaneri. Gurjara-Pratihara, 9th century. Nelson Gallery–Atkins Museum, Kansas City. Collection William Rockhill Nelson

349. KRISHNA CRUSHING ARJUNA TREES
Vijayanagar, 16th century. Penukonda.

350. RAVANA OFFERING SEVERED HEADS TO SHIVALINGA
Rashtrakuta, 8th century. Kailasa temple, Ellora

351. JATAYU FIGHTING AGAINST RAVANA
Rashtrakuta, 8th century. Ellora

352. MARRIAGE OF SHIVA AND PARVATI
Chera, 17th century. Mattancheri palace, Cochin, Kerala

353. ELEPHANT AND BULL
Chola, 12th century. Temple of Shiva, Darasuram

354. ELEPHANT AND BULL
Chola-Vijayanagar transition, 13th–14th century. Chidambaram

355. GANGA FLOWING FROM JAHNU'S EAR
Western Chalukya, 8th century. Pattadakal

356. BHISHMA ON A BED OF ARROWS
Western Chalukya, 8th century. Pattadakal

357. BHISHMA ON A BED OF ARROWS
12th century. Kiradu, Rajasthan

358. VARAHA RESCUING PRITHVI
Western Chalukya, 6th century. Mahakuta

359. PADMANIDHI
From Kaveripakkam. Pallava-Chola transition, 9th century. Government Museum, Madras

360. GIRL GATHERING SAL FLOWERS
Sunga, 1st century A.D. Bodh Gaya

361. ARAMADUSAKA JATAKA
From Bharhut. Sunga, 2nd century B.C. Indian Museum, Calcutta

362. PURNAKALASA
Western Chalukya, 7th century. Huchiyappa temple, Aihole

363. TIMID BRIDE AVOIDING HER HUSBAND'S EMBRACE
Sunga, 1st century B.C. Bodh Gaya

364. STORY OF ANGULIMALA
From Amaravati. Satavahana, 2nd century. Government Museum, Madras

365. SUJATA OFFERING RICE TO BUDDHA
From Amaravati. Satavahana, 2nd century. British Museum, London

366. RAHULA PRESENTED TO HIS FATHER
From Amaravati. Satavahana, 2nd century. British Museum, London

367. UDAYANA SHOOTING AT SAMAVATI
From Amaravati. Satavahana, 2nd century. Government Museum, Madras

368. FALL OF MANDHATA
Ikshvaku, 2nd–3rd century. Nagarjunakonda

369. VASANTASENA
From Mathura. Kushan, 2nd century. National Museum of India, New Delhi

370. GIRL COMING FROM HER BATH
Hoysala, 12th century. Belur

371. SMILING GIRL
Red sandstone from Mathura. Kushan, 2nd century. Archaeological Museum, Mathura

372. GODDESS CARRYING A DISH AND PITCHER
From Mathura. Kushan, 2nd century. Bharat Kala Bhavan Museum, Benares

373. GODDESS CARRYING A DISH AND PITCHER
From Mathura. Kushan, 2nd century. Archaeological Museum, Mathura

374. BIRTH OF KRISHNA
From Gwalior. Gupta, 5th century. Central Archaeological Museum, Gwalior

375. SHIVA ACCEPTING GANGA AS HIS CONSORT
Pillar from Rajaona. Gupta, 5th century. Indian Museum, Calcutta

376. VISVARUPA. THE MOVEMENT OF THE SUN AND THE MOON. A PROCESSION
Gupta, 5th century. State Museum, Lucknow

377. GANGADHARA
Vakataka, 5th century. Elephanta

378. SHIVA YOGI
Vakataka, 5th century. Elephanta

379. NATARAJA
Vakataka, 5th century. Elephanta

380. BHAIRAVA
Vakataka, 5th century. Elephanta

381. SHIVAGANAS PLAYING WITH NANDI
Vakataka, 5th century. Elephanta

382. FOUR DEER WITH ONE HEAD
Vakataka, 5th century. Ajanta

383. MAHISHAMARDINI DURGA
Eastern Chalukya, 9th century. Rajaraja temple, Bikkavolu

384. GANGADHARA
11th century. Temple at Patan, Nepal

385. GANGADHARA
10th century. Temple at Patan, Nepal

386. DAMSEL BEHIND A DOOR
Eastern Ganga, 9th century. Muktesvara temple, Bhuvaneshwar

387. SPRINGTIME CONCERT
Gurjara-Pratihara, 9th century. Abaneri

388. TWO HEADS WITH FOUR BODIES
Eastern Ganga, 9th century. Temple of Muktesvara, Bhuvaneshwar

389. SPIRIT OF DANCE
Eastern Ganga, 9th century. Temple of Muktesvara, Bhuvaneshwar

390. CELESTIAL BEINGS
From temple of Durga at Aihole. Western Chalukya, 6th century. National Museum of India, New Delhi

391. BEAUTY IMPORTUNED BY BEAST
Hoysala, 12th century. Kesava temple, Belur

392. TRIVIKRAMA
Ay, 8th century. Cave at Namakkal

393. ARDHANARISVARA
Pallava, mid-7th century. Mahabalipuram

394. NOONTIME RITUAL
Pallava, mid-7th century. Mahabalipuram

395. MADANANTAKA
Chola, 12th century. Darasuram

396. SURYA IN HIS CHARIOT
Satavahana, 2nd century B.C. Cave at Bhaja

397. COWHERD MILKING
Pallava, mid-7th century. Govardhana cave, Mahabalipuram

398. HEAD OF A PEASANT
From Sarnath. Maurya, 3rd century B.C. National Museum of India, New Delhi

399. DANSEUSE WITH SWIRLING SKIRT
From Bulandibagh. Maurya, 3rd century B.C. Patna Museum

400. HEAD OF AN ARISTOCRAT
From Sarnath. Maurya, 3rd century B.C. National Museum of India, New Delhi

401. ASOKAN CAPITAL
From Rampurva. Maurya, 3rd century B.C. Rashtrapati Bhavan, New Delhi

402. LION CAPITAL
From Sarnath. Maurya, 3rd century B.C. Sarnath Museum

403. MIGA JATAKA
From Bharhut. Sunga, 2nd century B.C. Indian Museum, Calcutta

404. SUVARNA KAKKARTA JATAKA
From Bharhut. Sunga, 2nd century B.C. National Museum of India, New Delhi

405. BODHI TREE
From Bharhut. Sunga, 2nd century B.C. Indian Museum, Calcutta

406. YAKSHA
From Patna. Sunga, 2nd century B.C. Indian Museum, Calcutta

407. WOMAN WITH ELABORATE COIFFURE
Terra-cotta. Sunga, 2nd century B.C. Ashmolean Museum, Oxford

408. YAKSHA
From Parkham. Sunga, 2nd century B.C. Archaeological Museum, Mathura

409. VESSANTARA JATAKA
Detail. Satavahana, 2nd–1st century B.C. North gate, Sanchi

410. THE GREAT RENUNCIATION
Satavahana, 2nd–1st century B.C. Sanchi

411. MARADARSHANA JATAKA
Satavahana, 2nd–1st century B.C. Sanchi

412. WAR OF THE RELICS
Satavahana, 2nd–1st century B.C. Sanchi

413. DREAM OF MAYA AND OTHER SCENES
Satavahana, 2nd–1st century B.C. East gate, Sanchi

414. SALABHANJIKA
Satavahana, 2nd–1st century B.C. East gate, Sanchi

415. YAKSHA CARYATIDS
Satavahana, 2nd–1st century B.C. West gate, Sanchi

416. DESCENT TO EARTH OF THE BODHISATTVA. MAYA'S DREAM
From Amaravati. Satavahana, 2nd century. Indian Museum, Calcutta

417. SHAKYA ADORING BUDDHA
From Amaravati. Satavahana, 2nd century. Archaeological Museum, Amaravati

418. MUSICAL SCENE
Cheta, 2nd century B.C. Rani Gumpha, Khandgiri-Udayagiri

419. CHHADDANTA JATAKA
From Amaravati. Satavahana, 2nd century. Government Museum, Madras

420. UDAYANA AND MAGANDIYA
From Amaravati. Satavahana, 2nd

century. Government Museum, Madras

421. STUPA
From Amaravati. Satavahana, 2nd century. Government Museum, Madras

422. GARLAND-BEARERS
From Amaravati. Satavahana, 2nd century. Government Museum, Madras

423. GARLAND FLOWING FROM A YAKSHA'S MOUTH
From Amaravati. Satavahana, 2nd century. Government Museum, Madras

424. VISIT OF AJATASATRU TO BUDDHA
BUDDHA RECEIVED IN A TOWN
BUDDHA SPEAKING WITH AN ASCETIC
From Nagarjunakonda. Ikshvaku, 2nd–3rd century. Nagarjunakonda Archaeological Museum

425. SNAKE CHARMER AND MONKEY
From Amaravati. Satavahana, 2nd century. Government Museum, Madras

426. VESSANTARA JATAKA
From Goli. Ikshvaku, 2nd–3rd century. Government Museum, Madras

427. SURYA
From Mathura. Kushan, 2nd century. Archaeological Museum, Mathura

428. KANISHKA
From Mathura. Kushan, early 2nd century. Archaeological Museum, Mathura

429. VIMA KADPHISES
From Mathura. Kushan, 1st century A.D. Archaeological Museum, Mathura

430. YAKSHI CARRYING WINE AND MANGOES
From Bhutesar. Kushan, 2nd century. Archaeological Museum, Mathura

431. MOTHER AND CHILD UNDER ASOKA TREE
From Mathura. Kushan, 2nd century. Archaeological Museum, Mathura

432. MOTHER AND CHILD
From Mathura. Kushan, 2nd century. National Museum of India, New Delhi

433. BODHISATTVA OF FRIAR BALA
From Mathura. Kushan, 1st century A.D. Sarnath Museum

434. ADORATION OF BUDDHA
From Mathura. Kushan, 2nd century. National Museum of India, New Delhi

435. BODHISATTVA OF FRIAR BALA
From Mathura. Kushan, 2nd century. Indian Museum, Calcutta

436. SALABHANJIKA
From Mathura. Kushan, 2nd century. Archaeological Museum, Mathura

437. VARAHA
From Mathura. Kushan, 1st century A.D. Archaeological Museum, Mathura

438. EKAMUKHALINGA
From Mathura. Kushan-Gupta tran-

sition, 3rd century. Archaeological Museum, Mathura

439. HERCULES AND THE LION
From Mathura. Kushan, 2nd century. Indian Museum, Calcutta

440. ARDHANARISVARA
From Mathura. Kushan-Gupta transition, 3rd century. Archaeological Museum, Mathura

441. EMACIATED BUDDHA
Gandhara, 2nd century. Central Museum, Lahore

442. BODHISATTVA
Gandhara, 2nd century. Chandigarh Museum

443. BODHISATTVA
Gandhara, 2nd century. Field Museum of Natural History, Chicago

444. SCENES FROM BUDDHA'S LIFE
Gandhara, 2nd–3rd century. Detroit Institute of Arts

445. MAN IN AGONY
From Ushkar. Gandhara, 3rd–4th century. National Museum of India, New Delhi

446. SURPANAKHA PUNISHED BY LAKSHMANA
From Deogarh. Gupta, 5th century. National Museum of India, New Delhi

447. AVALOKITESVARA WITH INSCRIPTION
From Sarnath. Gupta, 5th century. National Museum of India, New Delhi

448. DEVAKI GIVING KRISHNA TO VASUDEVA
From Deogarh. Gupta, 5th century. National Museum of India, New Delhi

449. BUDDHA
From Sarnath. Gupta, 5th century. Sarnath Museum

450. VISHNU WITH CROWN AND JEWELS
From Mathura. Gupta, 5th century. National Museum of India, New Delhi

451. BUDDHA
From Mankuwar. Gupta, 5th century. State Museum, Lucknow

452. BUDDHA WITH LARGE HALO
From Mathura. Gupta, 5th century. Rashtrapati Bhavan, New Delhi

453. MONKEYS BUILDING A BRIDGE BETWEEN SRI LANKA AND INDIA
Gupta, 5th century. Bharat Kala Bhavan Museum, Benares

454. COMBAT BETWEEN YUDHISTHIRA AND JAYADRATHA
From Ahicchatra. Gupta, 5th century. National Museum of India, New Delhi

455. HEAD OF A PRINCE
Terra-cotta from Akhnur. Late Gupta, 6th century. National Museum of India, New Delhi

456. CATURMUKHALINGA
Gupta, 5th century. Nachna

457. HEAD OF A RISHI
Terra-cotta from Akhnur. Late Gupta, 6th century. National Museum of India, New Delhi

458. INCLINING WOMAN
From Samalaji. Maitraka, 5th–6th century. National Museum of India, New Delhi

459. MOTHER AND CHILD
From Samalaji. Maitraka, 5th century. National Museum of India, New Delhi

460. CHANDRAGUPTA KUMARADEVI
Gupta, 4th–5th century. Bharat Kala Bhavan Museum, Benares

461. SHIVA AS THE SUPREME DANCER
Vakataka, 5th–6th century. Ramesvara temple, Ellora

462. GAJANTAKA
Vakataka, 5th–6th century. Cave 29 (Dumar Lena), Ellora

463. THE SEVEN BUDDHAS
Vakataka, 5th–6th century. Cave 12, Ellora

464. MAHISHAMARDINI
Vakataka, 5th–6th century. Cave 14, Ellora

465. RAVANA SHAKING MOUNT KAILASA
Vakataka, 5th–6th century. Cave 14, Ellora

466. THE SEVEN MOTHERS FLANKED BY SHIVA AND GANESHA
Vakataka, 5th century. Ramesvara cave, Ellora

467. DANSEUSE AND MUSICIANS
Vakataka, 5th century. Cave 7, Aurangabad

468. THE SEVEN DEVOTEES
Vakataka, 5th–6th century. Cave 3, Aurangabad

469. MATIPOSAKA JATAKA
Vakataka, 5th–6th century. Cave 17, Ajanta

470. VESSANTARA JATAKA
Vakataka, 5th–6th century. Cave 17, Ajanta

471. FLYING CELESTIALS
Vakataka, 5th–6th century. Cave 17, Ajanta

472. NYMPH PLAYING CYMBALS
Vakataka, 5th century. Cave 17, Ajanta

473–75. PAINTINGS ON CEILING OF CAVE I
Vakataka, 5th–6th century. Ajanta

476. PRINCE'S BATH
Mural. Vakataka, 5th–6th century. Cave 1, Ajanta

477. FLOWER HELD BY A BODHISATTVA
Detail of mural. Vakataka, 5th–6th century. Cave 1, Ajanta

478. BODHISATTVA PADMAPANI
Mural. Vakataka, 5th–6th century. Cave 1, Ajanta

479. LOVING COUPLE
Mural. Vakataka, 5th–6th century. Cave 1, Ajanta

480. MAHAJANAKA JATAKA
Mural. Vakataka, 5th–6th century. Cave 2, Ajanta

481. SHIPWRECK
Mural. Vakataka, 5th–6th century.
Cave 2, Ajanta

482. MARADHARSHANA
Vakataka, 5th–6th century. Cave 26,
Ajanta

483. NATESHA
Pallava, 6th century. Bhairavunikonda
cave

484. VISHNU AND AYUDHAPURUSHA
Fragment from Bombay region. Vaka-
taka, 5th–6th century. National Mu-
seum of India, New Delhi

485. VISHNU
Pallava, 6th century. Bhairavunikonda
cave

486. HORNED DOOR GUARDIAN
Vishnukundin, 6th century. Mogulra-
japuram cave, Bezwada

487. MONOLITHIC BUDDHA
3rd–4th century. Anuradhapura, Sri
Lanka

488. NAGARAJA
2nd–3rd century. Polonnaruva, Sri
Lanka

489. BODHISATTVA OR KING DUTTHAGAMINI
3rd century. Anuradhapura, Sri Lanka

490. KAPILA
7th–8th century. Isurumuni vihara
near Anuradhapura, Sri Lanka

491. NAGARAJA AS ENTRY GUARDIAN CAR-
RYING A WATERPOT
12th century. Anuradhapura, Sri
Lanka

492. TIRUJNANASAMBANDA
From Polonnaruva. 11th century.
Colombo National Museum, Sri Lanka

493. MAHARAJALILA
7th–8th century. Isurumuni vihara
near Anuradhapura, Sri Lanka

494. SHIVA VRISHABHANTIKA
Bronze. Chola, 11th century. Colombo
National Museum, Sri Lanka

495. BUDDHA
8th century. Barabudur, Indonesia

496. MONKEY ARMY BUILDING A DAM FOR
INVASION OF CEYLON
9th century. Prambanan (Indonesia)

497. FACADE OF TEMPLE OF SHIVA
9th century. Prambanan (Indonesia)

498. DETAIL OF TEMPLE SCULPTURE
8th century. Barabudur, Indonesia

499. RAMA AND HIS BOW
9th century. Prambanan (Indonesia)

500. RAVANA LIFTING MOUNT KAILASA
10th–11th century. Bantay-Srei, Ang-
kor

501. BEARDED ASCETIC
12th–13th century. Musée Guimet, Paris

502. BUDDHA PROTECTED BY THE SERPENT
KING

Cambodian bronze in the style of
Angkor Wat. 12th century. Cleveland
Institute of Art

503. SHIVA
11th–12th century. Bayon, Angkor

504. RAVANA
Eastern Chalukya, 9th century. Man-
davyanarayana temple, Bhimavaram
Samalkota

505. VISHNU
Eastern Chalukya, 9th–10th century.
Golingesvara temple, Bikkavolu

506. KAUMARI
Eastern Chalukya, 9th century. Goling-
esvara temple, Bikkavolu

507. GANESHA
Eastern Chalukya, 9th century. Goling-
esvara temple, Bikkavolu

508. NANDI
Eastern Chalukya, 9th–10th century.
Bhimesvara temple, Draksharama

509. LOKAPALA ON HIS MOUNT
Eastern Chalukya, 9th century. Goling-
esvara temple Bikkavolu

510. FRIEZE OF MUSICIANS
Eastern Chalukya, 8th–9th century.
Ruins of Jamidoddi temple, Bezwada

511. MUSICIANS
Eastern Ganga. 7th century. Parasura-
mesvara temple, Bhuvaneshwar

512. PILLAR
Eastern Chalukya, 10th century.
Bhimesvara temple, Draksharama

513. MAHISHAMARDINI
Eastern Ganga. 8th–9th century.
Vaitaldeul, Bhuvaneshwar

514. LINTEL
Eastern Ganga, 9th–10th century.
Mukhalingesvara temple, Mukhaling-
am

515. VRIKSHAKA
Eastern Ganga, 10th century. Rajarani
temple, Bhuvaneshwar

516. ARDHANARISVARA DANCING
Eastern Ganga, 7th century. Parasura-
mesvara temple, Bhuvaneshwar

517. GIRL PUTTING ON AN ANKLET
Eastern Ganga, 10th century. Rajarani
temple, Bhuvaneshwar

518. VISHNU WITH AYUDHAPURUSHA
Bronze. Pala, 8th–9th century. Patna
Museum

519. BUDDHA
Bronze from Nalanda. Pala, 8th–9th
century. Archaeological Museum,
Nalanda

520. BUDDHA PREACHING
Bronze from Kurkihar. Pala, 9th cen-
tury. Patna Museum

521. TARA
Bronze from Kurkihar. Pala, 9th cen-
tury. Patna Museum

522. PRINCE AND PRINCESSES ON ELEPHANT

Bronze. Pala, 8th century. Indian Mu-
seum, Calcutta

523. BIRTH OF BUDDHA
Pala, 8th century. National Museum of
India, New Delhi

524. MOTHER AND CHILD
Pala, 11th century. National Museum
of India, New Delhi

525. MANUSCRIPT COVER DEPICTING A PURA-
NIC EPISODE
11th–12th century. Bear Library, Kat-
mandu

526. MANUSCRIPT COVER DEPICTING VISHNU
TRIVIKRAMA
11th–12th century. Bear Library,
Katmandu

527. MANUSCRIPT COVER DEPICTING SHIVA-
DHARMA
11th–12th century. Bear Library,
Katmandu

528. HALOED CELESTIAL WITH FOLLOWER
From Nepal. 9th century. Los Angeles
County Museum of Art. Collection
Heeramaneck

529. BRAHMA DANCING ON HIS MOUNT
From Nepal. 16th–17th century. Boston
Museum of Fine Arts

530. VISHNU
From Nepal. 10th century. Brooklyn
Museum, New York

531. LAKSHMI NARAYANA ON GARUDA
Utpala, 10th century. Sir Pratap
Singh Government Musnum, Srinagar

532. KAUMODAKI (VISHNU'S CLUB)
Utpala, 9th–10th century. Sir Pratap
Singh Government Museum, Srinagar

533. NARASIMHA
Utpala, 9th–10th century. Sir Pratap
Singh Government Museum, Srinagar

534. SVACCHANDA BHAIRAVI
Chamba Utpala, 9th century. National
Museum of India, New Delhi

535. GANESHA DANCING
From Kanauj. Gurjara-Pratihara, 9th
century

536. DEVI
Gurjara-Pratihara, 9th century. Cen-
tral Archaeological Museum, Gwalior

537. WARRIOR DANCE
From Sikar. Gurjara-Pratihara, 9th
century. National Museum of India,
New Delhi

538. VISHNU AND GARUDA
Western Chalukya, 6th century. Tem-
ple of Durga, Aihole

539. VISHNU ON THE SERPENT SESHA
From the Huchiyappa temple, Aihole.
Western Chalukya, 6th century. Na-
tional Museum of India, New Delhi

540. VRISHABHANTIKA
Western Chalukya, 6th century. Tem-
ple of Durga, Aihole

541. SHIVA AND PARVATI
Western Chalukya, 6th century. Vais-
nava cave, Badami

542. COILED NAGA
Western Chalukya, 6th century. Cave
1, Badami

543. SHIVA AND PARVATI
Western Chalukya, 6th century. Vais-
nava cave, Badami

544. MITHUNA
Western Chalukya, 6th century. Lad
Khan temple, Aihole

545. SCENES FROM THE RAMAYANA
Western Chalukya, 8th century. Pa-
panatha temple, Pattadakal

546. SCENE FROM THE RAMAYANA
Western Chalukya, 8th century. Pa-
panatha temple, Pattadakal

547. KAMA AND RATI. VISHNU ON GARUDA
Rashtrakuta, 8th century. Kailasa
temple, Ellora

548. AMBIKA
9th century. Indrasabha, Ellora

549. ELEPHANT CARYATIDS
Rashtrakuta, 8th century. Kailasa
temple, Ellora

550. CELESTIAL DANSEUSE
Rashtrakuta, 9th century. Ceiling
painting of Indrasabha, Ellora

551. SHIVA DANCING
Rashtrakuta, 9th century. Indrasab-
ha, Ellora

552. DIKPALA YAMA
Nolamba, 9th century. Government
Museum, Madras

553. VOTIVE SCULPTURE SHOWING DEATH OF
KING SHIVAMARA
Western Ganga, 9th century. Mysore
Government Museum, Bangalore

554. CARVED PILLAR
From Hemavati. Nolamba, 9th cen-
tury. Government Museum, Madras

555. PARSVANATHA, DHARANENDRA YAKSHA,
AND PADMAVATI
Pandya, 9th century. Rock-cut temple,
Kalugumalai

556. MONOLITHIC GOMATESVARA
Western Ganga, 10th century. Sravana
Belgola

557. SURASUNDARI
Pandya, 8th century. Vattuvankoil,
Kalugumalai

558. NARASIMHA
Pandya, 8th century. Vattuvankoil,
Kalugumalai

559-60. SCENES OF MUSIC AND DANCE
Chera, 9th-10th century. Balustrade
of temple of Shiva, Trivikramangalam

561. SCENES FROM PALLAVA HISTORY
Pallava, 8th century. Vaikunthaper-
mal temple, Kanchipuram

562. SHIVA VRISHABHANTIKA AND PRINCELY
DEVOTEES
7th century. Arjuna ratha, Mahabali-
puram

563. PRINCE

Chola, 10th century. Temple of Kuran-
ganatha, Srinivasanallur

564. BRAHMA
Chola, 10th century. Museum of Fine
Arts, Boston

565. PRINCESS
Chola, 10th century. Temple of Nages-
varaswami, Kumbakonam

566. NATARAJA
Eastern Ganga, 11th century. Temple
of Markandesvara, Bhuvaneshwar

567. GANESHA
Eastern Ganga, 11th century. Temple
of Lingaraja, Bhuvaneshwar

568. MONOLITHIC ELEPHANT
Eastern Ganga, 13th century. Konarak

569. FEMALE MUSICIAN
Eastern Ganga, 13th century. Jagamo-
han ceiling, Konarak

570. HORSE
Eastern Ganga, 13th century. Konarak

571. WHEEL
Detail. Eastern Ganga, 13th century.
Temple of Surya, Konarak

572. NARASIMHA
From Konarak. Eastern Ganga, 13th
century. National Museum of India,
New Delhi

573. VARUNANI ON MAKARA
From Konarak. Eastern Ganga, 13th
century. National Museum of India,
New Delhi

574. VISHNU AND ATTENDANTS
From Konarak. Eastern Ganga, 13th
century. National Museum of India,
New Delhi

575. BIRTH OF KRISHNA
12th century. Chauhan, near Kutb,
New Delhi

576. VISHNU
Gahadavala, 12th century. National
Museum of India, New Delhi

577. PRINCE HUNTING A LION
Chandella, 11th century. Kandariya
Mahadeva temple, Khajuraho

578. SURASUNDARI
From Khajuraho. Chandella, 11th
century. Jardine Museum, Khajuraho

579. WALL SCULPTURES IN TEMPLE OF LAK-
SHMANA
Chandella, 11th century. Khajuraho

580. SCULPTURES IN TEMPLE OF LAKSHMANA
Chandella, 11th century, Khajuraho

581. VISHNU AND LAKSHMI
Chandella, 11th century. Parsvanatha
temple, Khajuraho

582. LOVERS
Chandella, 11th century. Parsvanatha
temple, Khajuraho

583-92. FRIEZES OF TEMPLE OF LAKSHMANA
Chandella, 11th century. Khajuraho

593. MOTHER AND CHILD

From Khajuraho. Chandella, 9th-10th
century. Indian Museum, Calcutta

594. FLUTE PLAYER
From Khajuraho. Chandella, 11th
century. Jardine Museum, Khajuraho

595. THE LOVE LETTER
From Khajuraho. Chandella, 10th-
11th century. Indian Museum, Cal-
cutta

596. HARAGAURI
Haihaya, 11th century. Municipal
Museum, Allahabad

597. GANESHA DANCING
Haihaya, 11th century. Municipal
Museum, Allahabad

598. NARASIMHI
From Satna. Haihaya, 11th century.
Indian Museum, Calcutta

599. SURASUNDARI
Haihaya, 11th century. Viratesvara
temple, Sohagpur

600. SARVAMANGALA
From Satna. Haihaya, 11th century.
Indian Museum, Calcutta

601. SURASUNDARI
Haihaya, 11th century. Viratesvara
temple, Sohagpur

602. GANGA
Haihaya, 11th century. Viratesvara
temple, Sohagpur

603. YAMUNA
Haihaya, 11th century. Viratesvara
temple, Sohagpur

604. BHAIRAVA
Haihaya, 11th century. Collection
Maharaja of Sohagpur

605. CEILING OF THE TEJAHPALA TEMPLE
13th century. Mount Abu

606. LIFE OF NEMINATHA
Corridor ceiling. 13th century. Mount
Abu

607. TORAN
Chalukya, 11th-13th century. Kapad-
vanj

608. TORAN
Chalukya, 11th-13th century. Dabhoi

609. NARASIMHA KILLING HIRANYAKASIPU
Chalukya, 11th century. Mount Abu

610. LOVING COUPLES
Gujarat, 11th century. Temple of
Surya, Modhera

611. DANCING TRIMURTI
Toran lintel from Warangal. Kakati-
ya, 12th century. National Museum of
India, New Delhi

612. SCULPTURE FROM TEMPLE OF BELUR
Hoysala, 12th century

613. PRINCESS WRITING PANEGYRIC ABOUT
VIKRAMADITYA
Western Chalukya, 12th century.
Dharwar

614. SARASVATI DANCING
Hoysala, 12th century. Hoysalesvara
temple, Halebid

615. SURYA
From Halebid. Hoysala, 12th century. Victoria and Albert Museum, London

616. BELLE WITH MIRROR
Hoysala, 12th century. Kesava temple, Belur

617. GIRL TALKING TO A PARROT
Hoysala, 12th century. Kesava temple, Belur

618. DANSEUSE WITH DRUM
Hoysala, 12th century. Kesava temple, Belur

619. NARASIMHA AND HIS QUEEN SANTALA AT COURT
Hoysala, 12th century. Kesava temple, Belur

620-24. SURASUNDARIS
Kakatiya, 12th-13th century. Ramappa temple, Palampet

625. CELESTIAL MUSICIANS AND DANCERS
Mural, 11th century. Brihadisvara temple, Tanjore

626. WIFE OF RAJARAJA ADORING NATARAJA
Mural, 11th century. Brihadisvara temple, Tanjore

627. RAJARAJA I AND HIS GURU
Mural, 11th century. Brihadisvara temple, Tanjore

628. HANUMAN
From Vadakkupanayur. Chola, early 11th century. Government Museum, Madras

629. LAKSHMANA
From Vadakkupanayur. Chola, early 11th century. Government Museum, Madras

630. RAMA
From Vadakkupanayur. Chola, early 11th century. Government Museum Madras

631. SITA
From Vadakkupanayur. Chola, early 11th century. Government Museum, Madras

632. CANDIKESVARA
From Okkur. Chola, late 10th century. Government Museum, Madras

633. NATARAJA
From Tiruvalangadu. Chola, early 11th century. Government Museum, Madras

634. DEVI
Chola, 10th century. Ahmadabad. Collection Gotam Sarabhai

635. AYYANAR ON ELEPHANT
From Togur. Chola, 12th century. Government Museum, Madras

636. JAMBHALA AND CONSORT
From Nagappattinam. Chola, 10th century. Government Museum, Madras

637. GANESHA
From Velankanni. Chola, 10th century. Government Museum, Madras

638. KARANA
13th century. Dance hall of Nataraja temple, Chidambaram

639. MAHISHAMARDINI
13th century. Gopura of Nataraja temple, Chidambaram

640. KARANA
13th century. Gopura of Nataraja temple, Chidambaram

641. CELESTIAL NYMPHS
13th century. Temple gopura, Tiruvarur

642. ACROBATS
chola, 12th century. Darasuram

643. KRISHNADEVARAYA AND HIS QUEENS
Vijayanagar, 16th century. Venkatesvara temple, Tirupati

644. NARASIMHA
Vijayanagar, 16th century. Kalyana-mandapa of Varadaraja temple, Kanchipuram

645. SUGRIVA AND ANGADA
Vijayanagar, 16th century. Kalyana-mandapa of Varadaraja temple, Kanchipuram

646. MOHINI
Vijayanagar, 16th century. Kalyana-mandapa of Varadaraja temple, Kanchipuram

647. GAJANTAKA
Vijayanagar, 16th century. Temple of Shiva, Perur

648. KURATTI
Nayak, 17th century. Pudumandapa of Minakshi temple, Madura

649. BRAHMA
Carved wood. Chera, 18th century. Napier Museum, Trivandrum

650. MAHISHAMARDINI
Carved wood. Chera, 18th century. Napier Museum, Trivandrum

651. DVARAPALA
Bronze from Tiruvanjikulam. Chera, 18th century. Archaeological Museum, Trichur

652-58. PALACE AT PADMANABHAPURAM
Murals. Chera, 18th century

659. NIMAT NAMA—SULTAN DRINKING IN THE HAREM

15th century. Indian Office Library, London

660. EAGLE
Miniature. Mogul, 16th century. Prince of Wales Museum, Bombay

661. DUCK
Miniature. Mogul, 16th century. National Museum of India, New Delhi

662. MINIATURE FROM THE BABAR NAMA
Mogul, 16th century. National Museum of India, New Delhi

663. MINIATURE FROM THE BABAR NAMA
Mogul, 16th century. National Museum of India, New Delhi

664. EPISODE FROM THE MAHABHARATA
Mogul, 16th century. Indian Museum, Calcutta

665. CAMELS IN COMBAT
Mogul, 17th century. National Museum of India, New Delhi

666. LION HUNT
Mogul, late 18th century. School of Kota. National Museum of India, New Delhi

667. SULTANA RAZIA AT THE HUNT
Mogul, 18th century. Red Fort Museum, New Delhi

668. TWO PRINCESSES
School of Jodhpur, 18th century. National Museum of India, New Delhi

669. ILLUSTRATION OF THEGITA GOVINDA
Orissa, 18th century. National Museum of India, New Delhi

670. ILLUSTRATION OF THE GITAGOVINDA
Kangra, 18th century. National Museum of India, New Delhi

671. ILLUSTRATION OF THE RAMAYANA
Paithan, 18th century. National Museum of India, New Delhi

672. MERCHANTS
School of the East India Company, 19th century. National Museum of India, New Delhi

673. GIRL WITH PARROT
Pat-Bengal painting, 19th century. National Museum of India, New Delhi

674. PIERCED WINDOW OF SIDDI SAYYID MOSQUE
17th century. Ahmadabad

675. DECORATIVE RELIEF ON MOSQUE
17th century. Ahmadabad

676. DECORATIVE RELIEF ON TAJ MAHAL
17th century. Agra

677. DECORATIVE RELIEF ON MOSQUE
17th century. Ahmadabad

PRINCIPAL ARCHAEOLOGICAL SITES

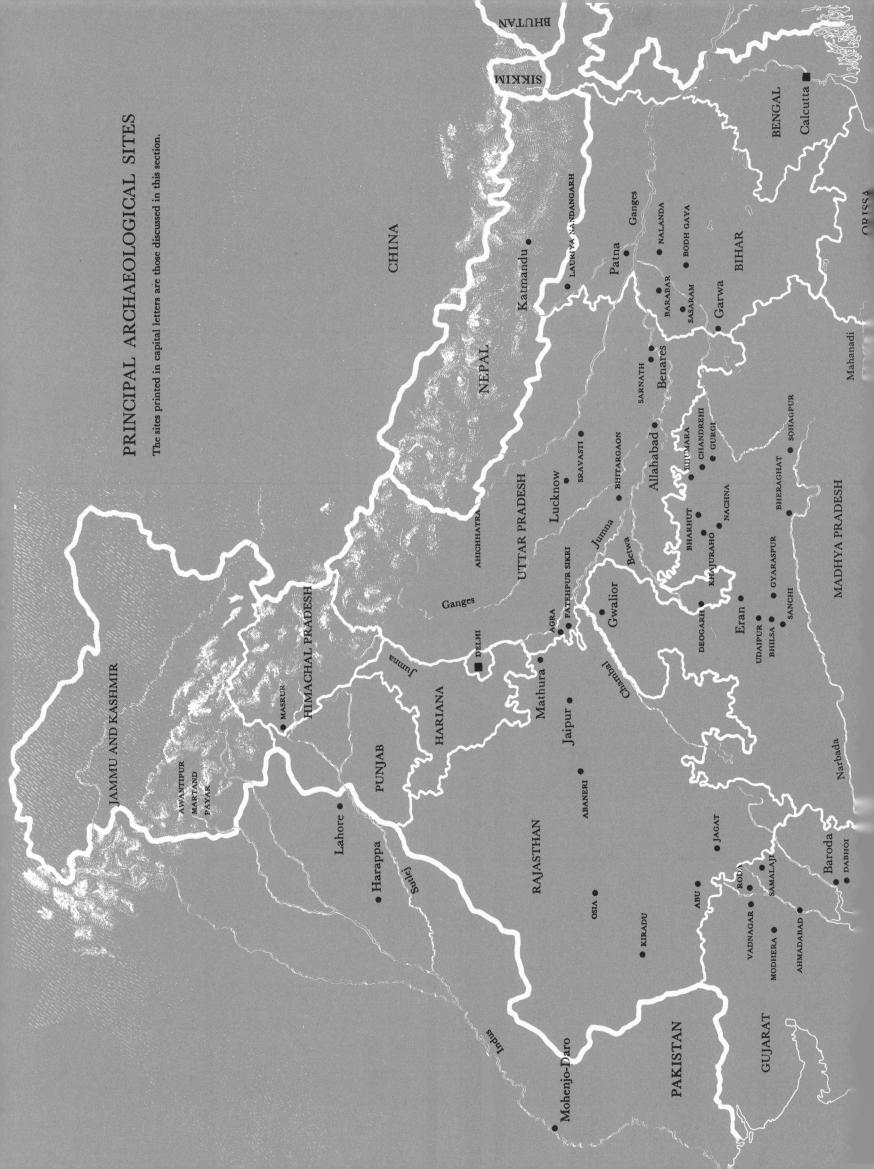

PRINCIPAL ARCHAEOLOGICAL SITES

The sites printed in capital letters are those discussed in this section.

BHUTAN

SIKKIM

CHINA

NEPAL

BENGAL

Calcutta

ORISSA

Mahanadi

Ganges

Katmandu

LAURIYA NANDANGARH

Patna
Ganges

NALANDA
BODH GAYA
BARABAR
SASARAM
Garwa

BIHAR

SARNATH
Benares

SRAVASTI

BHITARGAON

Allahabad

BHUMARA
CHANDREHI
GURGI
NACHNA

SOHAGPUR

Lucknow

AHICHHATRA

UTTAR PRADESH

BHARHUT
KHAJURAHO

BHERAGHAT

MADHYA PRADESH

Jumna

Betwa

DEOGARH

Eran

UDAIPUR
BHILSA
GYARASPUR
SANCHI

Ganges

FATEHPUR SIKRI

Gwalior

HIMACHAL PRADESH

MASRUR

DELHI

AGRA

Jumna

Chambal

Narbada

JAMMU AND KASHMIR

AWANTIPUR
MARTAND
PAYAR

HARIANA

Mathura

Jaipur

Sutlej

PUNJAB

Lahore

Harappa

RAJASTHAN

ABANERI

OSIA

KIRADU

ABU

JAGAT

RODA
SAMALAJI

VADNAGAR
MODHERA
AHMADABAD

Baroda
DABHOI

GUJARAT

Indus

PAKISTAN

Mohenjo-Daro

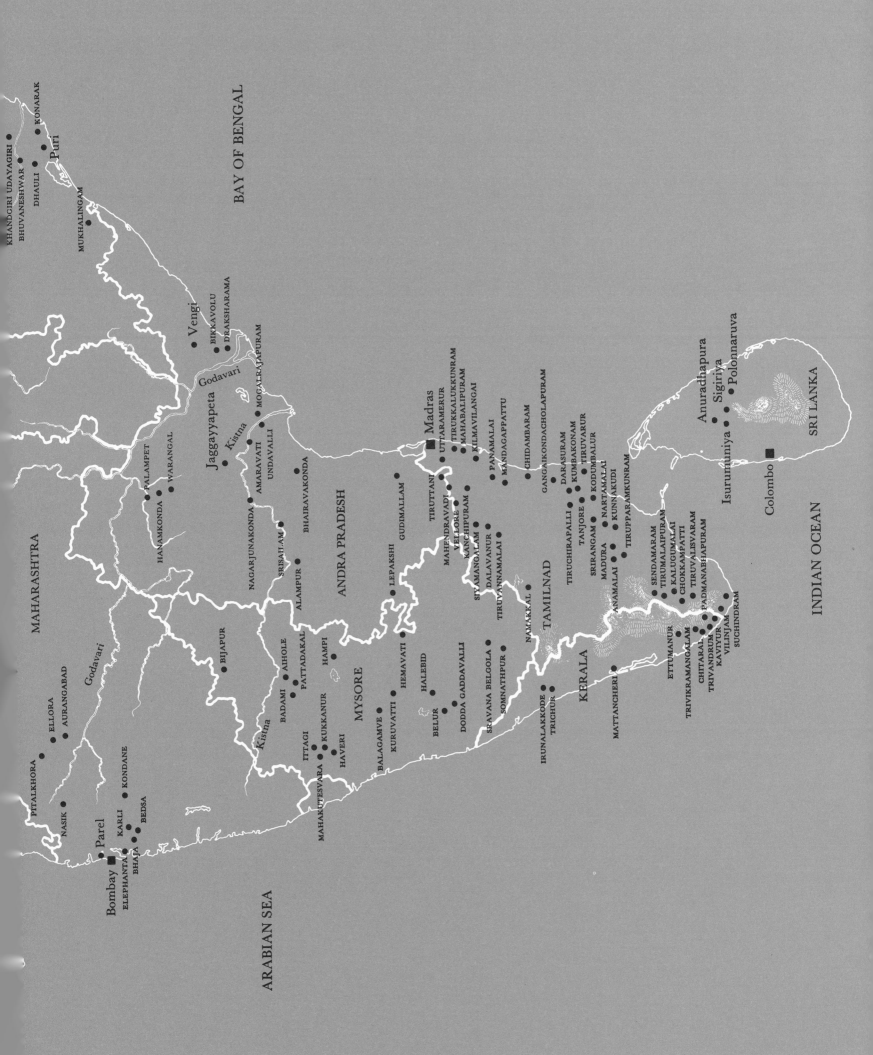

KHANDGIRI UDAYAGIRI
BHUVANESHWAR
DHAULI
KONARAK
Puri
MUKHALINGAM

BAY OF BENGAL

Vengi
BIKKAVOLU
DRAKSHARAMA

MOGALRAJAPURAM
Godavari
Jaggayyapeta
Kistna
AMARAVATI
UNDAVALLI

PALAMPET
HANAMKONDA
WARANGAL

MAHARASHTRA

NAGARJUNAKONDA
SRISAILAM
ALAMPUR
BHAIRAVAKONDA

ANDRA PRADESH

Madras
UTTARAMERUR
TIRUKKALUKKUNRAM
MAHABALIPURAM
KILMAVILANGAI

PANAMALAI
MANDAGAPPATTU
CHIDAMBARAM
GANGAIKONDACHOLAPURAM
DARASURAM
KUMBAKONAM
TIRUVARUR
KODUMBALUR
NARTAMALAI
KUNNAKUDI
TIRUPPARAMKUNRAM

GUDIMALLAM
LEPAKSHI
TIRUTTANI
MAHENDRAVADI
VELLORE
KANCHIPURAM
SIYAMANGALAM
DALAVANUR
TIRUVANNAMALAI

Godavari

BIJAPUR

AIHOLE
BADAMI
PATTADAKAL
HAMPI

MYSORE

HEMAVATI
HALEBID
BELUR
DODDA GADDAVALLI
SRAVANA BELGOLA
SOMNATHPUR

NAMAKKAL

TAMILNAD

TIRUCHIRAPALLI
TANJORE
SRIRANGAM
MADURA
ANAMALAI

SENDAMARAM
TIRUMALAIPURAM
KALUGUMALAI
CHOKKAMPATTI
PADMANABHAPURAM

ELLORA
AURANGABAD

PITALKHORA
NASIK
Parel
KARLI
KONDANE
BEDSA
BHAJA
ELEPHANTA
Bombay

MAHAKUTESVARA
ITTAGI
KUKKANUR
HAVERI

BALAGAMVE
KURUVATTI

Kistna

ARABIAN SEA

IRUNALAKKODE
TRICHUR

KERALA

MATTANCHERI

ETTUMANUR
TRIVIKRAMANGALAM
CHITARAL
TRIVANDRUM
VILINJAM
KAVIYUR
SUCHINDRAM
TIRUVALISVARAM

Anuradhapura
Sigiriya
Polonnaruva

Isurumuniya

Colombo

SRI LANKA

INDIAN OCEAN

ARCHAEOLOGICAL SITES

DELHI

Delhi is near the site of Indraprastha (some believe it to be actually on it), the capital built by the heroes of the *Mahabharata*. Certainly the city has a very long history; excavations near the sixteenth-century Purana Qila (Old Fort) have uncovered artifacts from the second millennium B.C.

According to the Asokan rock edicts, Delhi dates from the third century B.C. After a long and continuous history, Delhi became the capital of the Sultanate in the thirteenth century and the capital of the Mogul Empire in the seventeenth century. The city therefore has monuments representing every phase of ancient and medieval history. The important remains in Delhi, however, begin with early lotus-decorated pillars and beautifully carved sandstone lintels recovered from the tomb of Sultan Ghari (a fairly early Gupta temple may have existed at this site) that are now in the National Museum in Delhi. The most outstanding monument in Delhi is the Outb Minar, which not only served as a tower of victory but also as a minaret to the mosque known as the Quwwat-al-Islam (The Might of Islam). The foundation of the Kutb Minar was laid by Kutb-ud-din-Aibak, founder of the Delhi Sultanate, and it was added to by succeeding sultans. The architecture of the Kutb is of Islamic origin and is based on a prototype in brick in Ghazni. It is a credit to the Hindu craftsmen who built the tower that they could successfully create a monument so different from those of their own tradition. A statue of Vishnu in black chlorite recovered from near the Kutb Minar suggests that a twelfth-century temple of Vishnu may once have existed there, and the beautiful pillars with vase-and-foliage decoration also found in the vicinity were probably part of a hundred-columned hall of a Hindu temple that has since been destroyed.

The Quwwat-al-Islam mosque, near the Kutb in a large rectangular court, is the earliest mosque extant in India; it was begun in 1193 and completed in four years. The inscriptions of Kutb-ud-din Abika on the mosque's main eastern entrance state that its cloisters were constructed of the remains of more than twenty Hindu temples demolished by the Muslims. The large stone screen in front of the prayer hall, with borders composed of inscriptions and arabesque tracery, reveals the adaptability of the Hindu stonecutter, who could achieve perfection in ornamental Islamic calligraphy as well as in the scrollwork and figure carving of Hindu monuments. The mosque was extended and elaborated by Kutb's son-in-law, Shams-ud-din Iltutmish, whose tomb lies northwest of the mosque.

The beautiful iron pillar near the Kutb Minar, which stands on the hill sacred to Vishnu and named Vishnupada after him, is a memorial to a King Chandra (probably Chandragupta II, A.D. 376–415) and is not connected to either the Kutb Minar or the mosque. It was probably brought to this site by the Tomara king Anangapala in the middle of the eleventh century, when he made Delhi a feudatory of the Gurjara-Pratihara monarch. A single piece of iron more than twenty-three feet high, the pillar has never rusted—a remarkable fact attributed to the purity of the metal.

Shah Jahan, who transferred his capital from Agra to Delhi in 1648, laid the foundations of the imposing Red Fort. Known as Lal Qila, it is built entirely of red sandstone. The fort is an irregular octagon with its longest sides extending north to south. The famous Lahore and Delhi gates give access through the walls, within which are numerous palaces of white marble. Hamid and Ahmad were the master builders chosen to construct this imposing complex. The Naubat (Drum House) at the entrance of the palace area was for the playing of music at specific hours of the day; and here visitors dismounted from their elephants. After crossing a large courtyard, one reaches the Diwan-i-Am, or hall of public audience, which was originally wonderfully decorated with gilded stucco. A marble dais inlaid with gems supported the throne on which the emperor sat to receive complaints and petitions from his subjects. Some of the beautiful panels of the Diwan-i-Am, with their exquisite inlay work, are believed to have been done by a Florentine jeweler, Austin de Bordeaux.

Originally the Yamuna River seems to have flowed quite close to the fort, almost touching its moat. There were six main palaces along the riverfront and a museum is now housed in one of them, the Mumtaz Mahal.

The Rang Mahal (Palace of Color) has tiny pieces of mirror embedded in its walls and ceilings, giving it also the appellation Shish Mahal (Palace of Mirrors). In its center is a marble basin that served as a cool and refreshing fountain. The private palace, or Khass Mahal, was in three parts: Tasbih Khana, the chamber for worship; Khwabgan, the sleeping chamber; and Tosh Khana, the robe chamber. Adjacent to the private palace was the Muthamman Burj, the octagonal tower on which the emperor appeared each morning as a gracious gesture toward his people. The Diwan-i-Khass, or hall of private audience, was once inlaid in floral designs and gilded and painted with costly materials, but these were completely removed by plunderers. In its center is a marble pedestal on which stood the renowned Peacock Throne, which was carried away by the Persian conqueror Nadir Shah after he sacked Delhi in 1739. Above the north and south corner arches of this magnificent hall is the famous couplet of Shah Jahan, "If there be paradise on earth, it is this, it is this, it is this."

The Hammam, to the north of the Diwan-i-Khas, is composed of apartments separated by corridors where fountains filled with heated rose water allowed a most comfortable bath. To the west is the Moti Masjid (Pearl Mosque), a small mosque of dazzling white marble built by Aurangzeb for his own use. Its three bulbous domes with their finely tapering necks and metal-covered finials present a pleasing appearance. The garden in the rear, laid out in the usual pattern of Mogul gardens, was called the Hayat-Bakhsh Bagh (Life-Bestowing Garden).

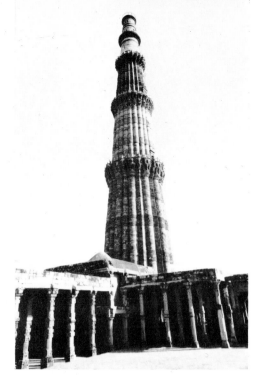

678. DELHI. KUTB MINAR

679. DELHI. IRON COLUMN OF KUTB MINAR

680. DELHI. REMAINS OF A TEMPLE MANDAPA

681. DELHI. DIWAN-I-KHAS

682. DELHI. DIWAN-I-AM

683. DELHI. TOMB OF HUMAYUN

Humayun's tomb on the Mathura Road, one of the earliest examples of Mogul architecture, was constructed by his widow, Hamida Banu Begum. The mausoleum is built of red sandstone and has a large central dome of white marble that is surrounded by pillared cupolas. It stands on a platform faced with a series of cells that have arched entrances, and on each of the tomb's four sides are three huge arches that lead to the octagonal central chamber. Black and white marble detailing is used extensively and breaks up any possible monotony of design. This noble building is situated within a vast enclosure entered by two imposing two-story gateways with large arches. In the large and pleasant garden the tasteful arrangement of water channels shows how the Moguls' love of gardens helped to make even their funerary monuments attractive and inviting.

Delhi is so full of monuments that it is difficult to describe all of the many tombs, palaces, and mosques, but among other noteworthy tombs are those of Sultan Ghari, Safdar Jang, Ataga Khan, Sultan Ghiyas-ud-din Balban, Mirza Najaf Khan, Mubarak Shah, Nizam-ud-din, and Ghalib. The tombs of Sikandar Shah and Mohammed Shah in the Lodi Gardens are also impressive monuments. There is also the ruined palace of Firuz Shah Tughlak, the famous Kotla Firuz Shah; because of his love for early monuments, Firuz Shah erected an Asokan column here. There are the mosques Bara Gumbad Masjid, Kalu Sarai Masjid, Khirki Masjid, and Begampuri Masjid, to mention only a few. Jami Masjid, built by Shah Jahan, is the largest mosque in India and is still in use.

Jantar Mantar is a fascinating observatory built by Maharaja Jai Singh II of Jaipur, who had a great interest in astronomy, in the eighteenth century. Similar ones were built at Ujjain, Jaipur, Benares, and Mathura, although only the ones at Delhi and Jaipur still exist.

ANDHRA PRADESH

ALAMPUR

Alampur, in the Kurnool District, is on the banks of the Tungabhadra River near its confluence with the Kistna. A cluster of eighth-century temples makes Alampur very important for the study of early Western Chalukyan architecture—these buildings are comparable in importance and style to the temples of the same period at Pattadakal. Some of the Alampur temples have shikaras that are entirely ribbed; other temples, in the southern style, have an octagonal shikara like that of the Virupaksha temple at Pattadakal. These southern towers are also crowned by ribbed amalakas, recalling the graceful curves of the tower-sanctuaries in Orissa. The fact that this Western Chalukyan territory was the meeting place of northern and southern styles explains the striking similarity in the architectural forms of the temples at Alampur and those at Pattadakal, particularly the Papanatha temple.

The nine temples here, although dedicated to Shiva, are all named after Brahma and are locally known as Bala Brahma, Kumara Brahma, Arka Brahma, Vira Brahma, Visva Brahma, Taraka Brahma, Garuda Brahma, Svarga Brahma, and Padma Brahma. This group of holy places has been held in great reverence, and Alampur is mentioned in the twelfth century by Palkuriki Somanatha in his *Panditaradhyacharitra*.

The general arrangement of these temples is similar. There is a shrine with an ambulatory, preceded by two pillared halls with elaborate carving on the sides of the columns and on the ceiling. The niches around the circumference of the temple, with their beautiful makara decoration, contain various representations of Shiva, particularly Gangadhara, Tripurantaka, Dakshinamurti, Kirata, and Nataraja, along with other deities. The figures guarding the door are very spirited. The representation of Shiva as Nataraja (Lord of the Dance) is found often here—Nataraja appears in the large horseshoe-shaped window of the vestibule at the side of the tower-sanctuary, and as on many temples at Pattadakal and in Orissa (for example, at Bhuvaneshwar), he is

684. ALAMPUR. GROUP OF TEMPLES

685. ALAMPUR. TEMPLE OF SVARGA BRAHMA

prominently featured on the facade of the temple. On the facade of the Vira Brahma temple, Nataraja is depicted with Devi and an entourage of musicians. A sixteen-armed Shiva in the warrior pose, as well as a figure of the same god in the lalita pose with celestials composing the orchestra, appears in the Svarga Brahma temple. The Garuda Brahma temple stresses the Gangadhara aspect of Shiva—Shiva who releases the heavenly Ganges but breaks the force of the mighty torrent, which would otherwise shatter the earth, with the matted locks of his hair.

A noteworthy feature in one of these temples is Shiva in one of his fierce forms—Virabhadra. He appears with a group of seven goddesses and a mother goddess, headless and nude, with a lotus in place of her head and with the genitals emphasized to indicate the creative source of all life.

The inscriptions incised here and there on the walls of these temples indicate clearly their close affinity with those of Vikramaditya II and Queen Trailokyamahadevi at Pattadakal. The entrances, the capitals of the columns, and the windows in the form of openwork screens are all typical of Western Chalukyan art.

The supposition that Vikramaditya II brought sculptors from the southern territory to Alampur as well as to Pattadakal is borne out by inscriptions found here noting that until that time the formal style had been the northern one. The northern style featured a curvilinear tower crowned by an amalaka, niches topped by a multiribbed elaboration of the trefoil canopy that is closely related to the Gupta-Vakataka tradition, and columns that continued the vase-and-foliage type.

Between the niches are large flat pilasters decorated with the loving-couple motif. In late Chalukyan temples these alternating shafts-and-niches take the place of vase-decorated pilasters and niches. The columned halls are like those at Aihole. The heavy, well-carved pillars separate the main hall into a nave with side aisles. There are as many as four entrances, and the longer east-west axis includes a large hall, vestibule, shrine, and ambulatory.

The museum at Alampur, maintained by the Archaeological Department of Andhra Pradesh, has a fine collection of sculptures from this area, some of them of high quality.

AMARAVATI

Amaravati, eighteen miles from Guntur, was once the eastern capital of the Satavahanas, who ruled from the second century B.C. to the second century A.D., with their main capital at Pratisthan. Amaravati was also known as Dhanyakataka and is so mentioned in inscriptions. A twelfth-century inscription mentions the temple of Amaresvara and the stupa of Amaravati as two monuments of the region. The stupa, the most important in southern India, was still intact in 1797 when Colonel Mackenzie saw it. But when he returned in 1816 to study it, he found it almost entirely devastated by villagers who had used the bricks and the sculptured marble as building material. He salvaged whatever he could. Subsequent excavations at this site brought to light a number of sculptures, some of which attracted the attention of the duke of Buckingham, then governor of Madras, who ordered them to be brought to the Madras Museum. But they were not displayed there for quite some time, and eventually some were sent to the British Museum in London and some to the Indian Museum in Calcutta. A large number of sculptures subsequently unearthed were taken to the Madras Museum and are displayed there.

The stupa at Amaravati was one of several built by Asoka throughout the country to enshrine the relics of Buddha. The earliest sculptures here date from the second century B.C. One of these, of which only the head and the legend explaining the sculpture survive, was of a yaksha named Chandramukha who lived in a flowering bakula tree. The stupa was originally decorated with a series of carved slabs that were replaced about A.D. 100 by a new series.

The monument rests on a five-foot-high platform with a circumambulatory passage so narrow as to allow room for only one person at a time except where there are projecting areas, each with five large inscribed pillars. Around the passage ran an exquisitely carved balustrade, composed of uprights, crossbars, and coping, with pairs of lions guarding the doorways at the cardinal points. On the inner side of the rail, a long, sinuous garland was carried by dwarf yakshas and pairs of well-proportioned youths and maidens. Lotus medallions were carved on the uprights and the crossbars. On the outer side were carvings illustrating scenes from the Jatakas and Buddha's life. This balustrade, created about A.D. 150, is considered to be the best sculpture of the early period, superior even to that at Sanchi. It is attributed to Nagarjuna, a close friend of successive Satavahana monarchs and a great master of Buddhism.

The fourth period (which follows the balustrade's period) shows an evolution toward stylization; the figures are more delicately sculptured and somewhat elongated. These four great periods of sculpture are affirmed by the study of inscriptions that accompany some of the sculptures. The third (or balustrade) period is famous for its magnificent sculptures—among them are the medallion illustrating the subjugation of Nalagiri; the story of Udayana and Samavati; the gifts of Prince Bandhuma; the tale of Buddha's former life as an elephant (*Chhaddanta Jataka*); and the division of the relics. One sculptured slab from Amaravati illustrates the worship of the Ramagrana stupa by the snakes. In the British Museum are magnificent sculptures depicting Buddha visiting his wife Yasodhara and his son Rahula, the crossing of the Neranjara, and the *Bhuridatta Jataka*. Apart from these, there is an important group of Amaravati sculptures from all four periods in the local site museum. The adoration of Buddha by the Sakyas, executed during the balustrade period, and the adoration of the stupa by celestial musicians from the first period are among the most noteworthy. There are also several inscribed pieces that show the development of script during the centuries of Satavahana rule. The large figures of Buddha, undoubtedly belonging to the third century A.D., were probably inspired by the Ikshvakus who fostered Buddhism though they themselves were Brahmanic in their faith.

(Figs. 97, 98, 322–24, 365–67, 416, 417, 419, 425)

686. AMARAVATI. VIEW OF THE SITE

687. AMARAVATI.
ADORATION OF THE DHARMACAKRA

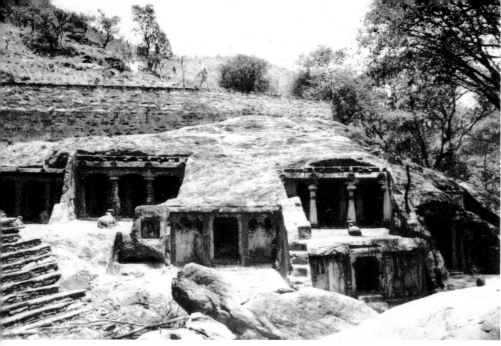

688. BHAIRAVAKONDA. VIEW OF THE CAVES

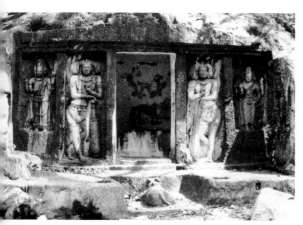

689. BHAIRAVAKONDA. CAVE ENTRANCE

690. BHAIRAVAKONDA. CAVE FACADE
WITH LION PILLARS

BHAIRAVAKONDA

Bhairavakonda in the Nellore District has a group of eight cave temples built into the scarp of a hill, from which the village takes its name. These temples are picturesquely situated on a stream, and although all three major gods are represented here, Shiva is given the principal place. The caves closely resemble Pallava rock-cut shrines of the Mahendravarman period.

Cave 1, facing north (unlike the rest which face east), appears to be the oldest and is the least ornamented. The small cell cut out of the rock enshrines a Shivalinga. Its entrance is flanked by guardians, each with only one pair of arms, their legs crossed, and one of their hands resting on a heavy club; their hair is arranged in *jaṭābhāra* ("mass of curls"). In two corners, beyond the guardians, are shrines for Brahma and Vishnu. Both are four-armed and their attributes recall early Pallava figures. Facing the Shivalinga is a bull in a roofless court. In the walls are niches depicting Shiva (seated and holding an ax) and Ganesha.

Cave 2, adjacent but on a slightly higher level, is very similar to Cave 1. The shrine has the Shivalinga figure, the guardians leaning on large clubs, and the statues of the seated Shiva and Ganesha in the walls of the court. There are a few small memorial shrines cut into the rock, with inscriptions that name them as Damodaresvara and Brahmesvara. As has been explained by Professor Jouveau-Dubreuil, the letters engraved in Pallava Grantha script between Caves 1 and 2 date from the reign of Mahendravarman I and record the names of Brahmesvaravishnu (shrines for Brahma, Isvara, and Vishnu) as in the inscriptions at Mandagappattu, thus indicating that this is the work of the early Pallavas, probably Simhavishnu Pallava himself.

Cave 3, similar to Cave 2, has a shrine for a Shivalinga and the usual large door guardians leaning on huge clubs. Here one of them wears horns on his head, as in the early Pallava rock-cut shrines. Shiva and Ganesha on the north wall are repeated on the terrace.

Cave 4 also closely resembles the others but remains unfinished. One of the huge guards has horns.

Cave 5, immediately above Cave 4, has a shrine for a Shivalinga which has a porch supported by two rock-cut pillars. There are four-armed images of Brahma and Vishnu in two corners; Nandi is portrayed in high relief on the terrace. The cornice of the facade, decorated with lions, imitates similar decoration at Mogalrajapuram. Ganesha and Shiva are carved on the north and south walls of the terrace.

Cave 6, closely resembling Cave 5, has a shrine for a Shivalinga; door guardians, one with horns, lean on clubs on either side of the entrance; and at the corners are Brahma and Vishnu. There are two square, clumsily carved pillars with tiny seated lions on top. On one wall of the terrace is Ganesha and on the other, Shiva.

Cave 7, which appears to be slightly later in date than Caves 1 through 4, displays large seated lions supporting the columns, recalling those of Narasimhavarman's time at Mahabalipuram. A long frieze of dwarfs, immediately under the cornice, is decorated with the lion-headed *kūḍu* motif above each column; above that is a long frieze of lions, again recalling those at Mahabalipuram. The shrine for the Shivalinga has large door guardians of the same type as in the other caves, and on either side of the entrance there are images of Brahma and Vishnu.

At Bhairavakonda there is also an early representation of a multiarmed dancing Shiva, which adds interest to the earlier representation of the theme at Mogalrajapuram and its reappearance at Siyamangalam in one of the early caves of Mahendravarman I. There is a stone carving of Nandi in high relief opposite the shrine on the terrace.

Cave 8, next to Cave 7, has the usual shrine with flanking guards, one with horns, and Brahma and Vishnu repeated at the corners. The two columns for the porch are exactly like those in Cave 7. Ganesha and Shiva are shown on either side on the walls of the terrace with the bull in the center.

BIKKAVOLU

Bikkavolu, midway between Samalkot and Rajahmundry, has some important temples of the early Eastern Chalukya period. The village is named after King Gunaga Vijayaditya III, who had the title Birudankabhima. There are three abandoned temples in the fields outside the village and three that are still in use in the village itself. One of the temples outside the town is larger than the others, but it is austere and lacks decoration, although its architectural features are the same as in the others. Even the niches are bare, and except for the two guardian figures on the doorjamb and Lakshmi on the lintel, there is not a single figure. Both guards have their legs crossed. They each carry a huge club and hold a snake in one of their hands with an air of wonder; each has a female attendant. The vimana immediately brings to mind the Pallava type that was the main source of inspiration both for the Pattadakal group and the famous Rashtrakuta temple at Ellora.

Nearer the village, another of the abandoned temples is in a sad state of disrepair but is enlivened by several statues. Two of the three niches on the sides contain figures of Surya and Vishnu, and there are several figures on the tiers of the temple representing iconographic forms of the deities and motifs such as the loving couple. The doorway is interesting because it is guarded by personifications of the Ganges and Jumna rivers on the jambs, a feature absent in other temples in this area. The personification of Ganga and Yamuna as guardians of a doorway is characteristic of the Gupta-Vakataka period and is known to have been brought, along with the Palidhvaja banner (a symbol of sovereignty), from the Jamuna-Ganges doab by the Western Chalukya king Vikramaditya of Badami—or more precisely, by his son Vinayaditya, who won victories there. These symbols were inherited by the Rashtrakutas, the successors of the early Western Chalukyas, who lost them when they were conquered by Gunaga Vijayaditya. The early date of this temple is evident from the images on the tiers of the facade (the same type occur on the seal of Gunaga Vijayaditya from Sataluru) and from the fact that Ganesha has a single pair of arms.

The third temple on the outskirts of the village closely resembles the others. It has niches on three sides, in one of which is a dancing Shiva. The floriated tails of the makaras on either side of the niche cannot but recall similar decoration in the Kailasanatha temple at Kanchipuram. The horseshoe-shaped window of the facade has a profusion of makara decoration. The amorous couples on one tier, resembling similar pairs from Orissan temples, remind us that Gunaga Vijayaditya was the overlord of Kalinga and that there was a close connection between his kingdom and Orissa. As at Mahabalipuram, a row of geese is seen under the eaves. The temple is mainly in the southern style though with several elements suggestive of northern influence, transmitted by way of Orissa.

The group of temples in the village itself, all dedicated to Shiva, are known as the Golingesvara, Raja-raja, and Chandrasekhara. They are all of the time of Gunaga Vijayaditya or slightly later and exhibit a greater profusion of sculpture than the temples outside the town. These temples have niches on three sides showing Ganesha, Kartikeya on his peacock, and Mahishamardini (the last is not depicted at the Chandrase-khara temple). The central shrine of the Golingesvara temple has a profusion of iconographic detail. On the interior walls and in the niches between pilasters there are figures of Surya, Vishnu, Vayu, Indra, Agni, Bhikshatana, Brahma, a naga with an auspicious vase, Skanda, a nagi, Ekapada, Ganga, Chamunda, Mahisha-mardini, Vrishabha, Kankala, and Ardhanarisvara.

The general arrangement of the Eastern Chalukya temples, with their niches, horseshoe-shaped gable windows, pilasters, gargoyles, and so forth, can be understood by studying the Golingesvara temple. Figures of amorous couples or celestial beauties carved inside the *kūḍu* were made in imitation of similar Orissan figures.

In the intermediate hall in the Golingesvara temple, there are two remarkable sculptures: Shiva and Parvati as Alinganachandrasekharamurti and a seated Ganesha. Shiva's upper pair of arms carry the trident, and one hand is in the *alapadma* dance position, suggesting a feeling of wonder. (This is unlike the southern representations of Shiva, where he holds an ax and deer). The sacred thread is a broad ribbon with a loose knot, a feature characteristic of late Pallava, Western Chalukya, and early Chola carvings. Shiva's topknot and Devi's conical crown are both in the southern tradition. Ganesha, however, wears the type of crown that at once proclaims the northern idiom. There is a garland of bells on the neck as well as on the feet. The stomach band (*udarabandha*) and the sacred thread composed of a snake (*nāgayajñopavita*) are prominent. The armlets (*keyūra*) are coiled. Of the four hands, one has a rosary (*akṣamālā*), one an ax (*paraśu*), and the others carry the broken tusk and a vessel filled with sweets. The halo (*prabhā*) behind the hair is another typically Chalukya form. Mahishasuramardini (Durga) in a niche of this temple is noteworthy for the two devas who flutter over her head and hold a huge crown—a very old motif also seen in the Gajendramoksha relief at Deogarh. Another excellent early example of this is a sculpture of the second century A.D., in which the celestials hold a crown above Siddhartha, honoring his renunciation of his princely status. Here Durga is not represented in the southern style—that is, standing on the head of a buffalo or, mounted on her lion, fighting the buffalo demon. In the style of the north, she assumes a warrior's attitude while trampling the animal and piercing him with her trident. In the figure of Vishnu, the hub of the wheel shoots forth flashes of lightning as in north Indian carvings, but his club rests on the ground with his hand on it as in the southern mode. And the conch is held with the spiral upward, which is characteristic of southern style. Western Chalukya and Orissan features can be observed in the belt (in the loop and the central tassel) as well as in the decorations that are composed of chainlike links. Surya is not bare-legged, as is usual in the south, but wears top boots as he does in Orissan sculpture. Chamunda, one of the seven mother goddesses, is also very much like the Orissan and Bengali types. Seated on a corpse being torn asunder by jackals, she makes a threatening gesture (*tarjani mudra*). Her face is wan and her body is skeletal; a scorpion on her shrunken belly suggests the pangs of hunger. Her hair is bound up and she is clad in the hide of an elephant like the Orissan from of Bhairava. Holding a weapon composed of thigh bone and skull, she is indeed terrifying.

The images of Bhikshatana and Kankala, each carrying a fan of peacock feathers, again recall Kalinga influences, as does the form of Ekapada adopted for Shiva, and the carving of Gomata, who has a bovine face, as her name suggests. Gomata is one of the sixty-four yoginis who have a famous temple near Cuttack in Orissa.

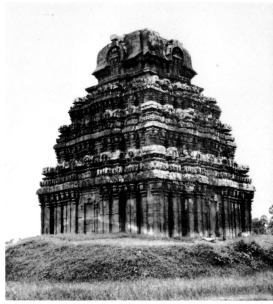

691. BIKKAVOLU. TEMPLE

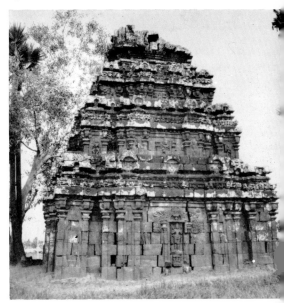

692. BIKKAVOLU. TEMPLE

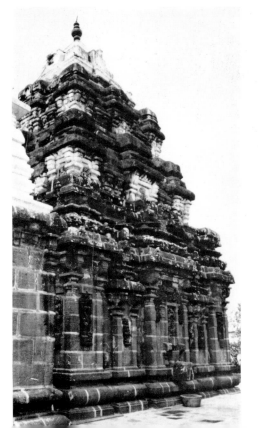

693. BIKKAVOLU. TEMPLE OF GOLINGESVARA

694. BIKKAVOLU. TWO-ARMED GANESHA

The yoginis are equally common in the Haihaya area, and it is known that the Eastern Chalukyas sometimes married Haihaya women. The Ardhanarisvara has one foot resting on a bull and the other on a lion—the mounts of Shiva and Devi. This posture and the arrangement of the masculine and feminine halves, including the varying hair styles, again show the admiration the Eastern Chalukya sculptor had for Kalinga motifs. There are also lovely representations of Skanda fondling the peacock and of Brahma on a lotus, supported by three dwarfish figures, probably the three Vedas personified. The youthful face of Brahma suggests an inclination toward the southern tradition. The graceful figure of the river goddess Ganga in one of the niches, peacock-feather fan in her left hand and a vessel in the other, shows the importance that Ganga began to assume in Eastern Chalukya sculpture.

Among the other sculptures in the temple is a Chamunda with fierce mien, seated on a corpse with a jackal tearing at it. She is decorated with a garland and a sacred thread of skulls, a reptile is her necklace, and snakes are her earrings. A huge mass of frizzled hair encircles her head. With her cavernous eyes, gaping mouth, and curved tusk, she is terrifying. Another of the seven mother goddesses, Kaumari, with her peacock mount most beautifully delineated, wears a conical crown and other ornaments; the sacred thread runs over her right arm as in early Chalukyan figures. The noose and thunderbolt are shown in her upper arms, and her face is charming. Virabhadra Shiva has his bull, Nandi, at his feet. His hair is arranged in the style of an ascetic, and he wears earrings, a stomach band, a ribbon-shaped sacred thread over his right arm, and *ananta* armlets—all characteristic attributes. The rosary and trident in his upper pair of arms, however, suggest the style of the north rather than the south, where the ax and deer are more commonly seen.

(Figs. 268, 383, 505–7, 509)

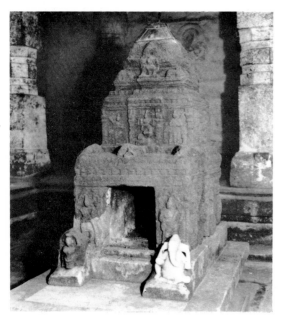

695. DRAKSHARAMA.
MINIATURE MODEL OF TEMPLE

DRAKSHARAMA

At Draksharama in the Godavari delta is the famous shrine of Bhimesvara, the deity named after the Eastern Chalukya king Bhima, one of the greatest warriors of his time and a patron of art and literature. A noteworthy sculpture in this temple is a miniature shrine prepared by the architect to show the king how the temple would look when finished. This model, covered with carvings, emphasizes the rishi theme on all sides of the plinth.

In the main enclosure of the temple itself, near the steps of the large tank, is a carving of the seven rishis —Atri, Bhrigu, Kutsa, Vasistha, Gautama, Kasyapa, and Angiras. Arundhati, the consort of Vasistha, is beside him. The depiction of the seven rishis together is very rare. In the center of the tank there is a pavilion for the spring barge festival, a feature in all south Indian temples.

In this temple there are miniature bracket figures for the pillars, a feature very common in Western Chalukyan, Hoysala, and Kakatiya temples. In the mandapa adjoining the principal shrine, the pillars themselves are decorated with carvings illustrating the enjoyment of music. The kolattam, a folk dance in which couples keep time with small wooden rods as they sway their limbs, is graphically portrayed. The large Nandi in the Shiva temple is excellent. In the Chalukyan fashion he wears a garland of bells on his neck.

(Fig. 512)

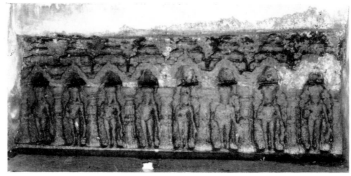

696. DRAKSHARAMA.
THE SEVEN SAGES AND ARUNDHATI

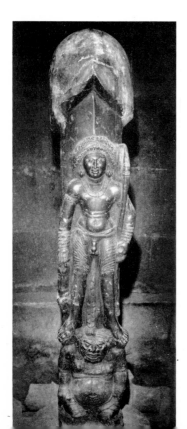

GUDIMALLAM

Gudimallam, a village six miles from Renigunta in Andhra Pradesh, is famous for its Shiva temple known as Parasuramesvara. Here is enshrined the famous *śivaliṅga* with Shiva shown against the shaft. This work is from the second century B.C., of the same period and style as the early carvings from Bharhut and Jaggayya-peta. Here Shiva looks almost like a yaksha, with a single pair of arms, an elaborate *ushniṣa* arranged like a turban over the head, heavy earrings, a wide necklace, and bracelets. His undergarment is tightly tied above the thighs and held in position by a waistband. In his right hand he holds a ram, the animal for sacrifice, and in his left an ax and a holy vessel for ghee. He stands on a dwarf yaksha.

The Gudimallam temple has an apsidal shrine with a vestibule and a pillared hall at the far end of which is the bull Nandi. The niches on the outer walls of the shrine have sculptures representing Shiva,

697. GUDIMALLAM. SHIVALINGAM

Brahma, Vishnu, Durga, and Ganesha. This temple was so often renovated in Pallava and Chola times that its original form has disappeared. There are Pallava, Chola, and Bana inscriptions, and a Chola inscription records that the temple was rebuilt in 1126 in the time of Vikramacholadeva. The apsidal portion has undoubtedly survived from Pallava times, in spite of the subsequent renovations; this explains its close resemblance to late Pallava shrines like Vadamallisvara at Oragadam near Chingleput.

HANAMKONDA

The temple at Hanamkonda, a typical example of Kakatiya work of the thirteenth century, has a high plinth with exuberantly carved friezes and a mandapa that is almost obscured in darkness by its numerous columns. The pillars are elaborately carved and provided with bracket figures so large that they appear almost to overwhelm the supporting shafts. These figures are particularly noteworthy for their portrayal of dance poses. The extremely elongated style, the pointed noses and chins, arched eyebrows, large breasts, and slim waists, the large earrings and other distinctive ornaments, and the almost impossible dance postures, single them out as special examples of the medieval Kakatiya style.

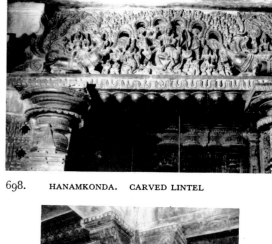

698. HANAMKONDA. CARVED LINTEL

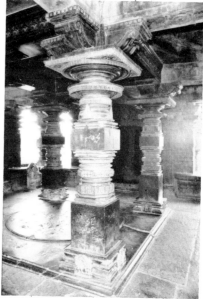

699. HANAMKONDA. PILLARED HALL

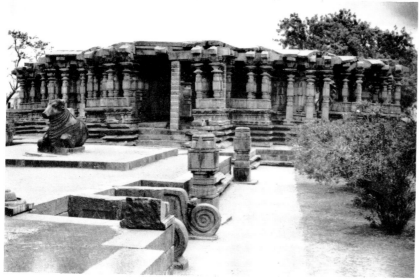

700. HANAMKONDA. TEMPLE

LEPAKSHI

Lepakshi in the Anantapur District of Andhra Pradesh, is nine miles from Hindupur. It was a center of trade and pilgrimage in the sixteenth century, when the brothers Viranna and Virupanna, Nayak chieftains under Achyutaraya, enlarged the shrine of Papanasesvara, situated on a small hillock known as Kurmasaila, into a fine temple. The inscriptions of Achyutaraya, carved on the walls of the new temple, mention a cluster of three shrines for Shiva, Vishnu, and Virabhadra. The last, a wrathful manifestation of Shiva, was the patron deity of the Nayak rulers. Virupanna, a treasurer of Achyutaraya, had vast resources at his disposal, and he spent huge sums on the construction of this large temple. It is composed of three shrines around a central pavilion, with an intermediary hall and a hall for ritual dance—all surrounded by a large open court entered from the east, with large gopuras to the north and west. A monolithic Nagalinga and Ganesha in the second interior court are especially noteworthy. A wonderful granite bull of gigantic dimensions a short distance from the temple enclosure is closely associated with the temple. It is probably the largest statue of this type in south India and is even larger than the famous one on the Chamunda Hill in Mysore.

 In the temple itself, the dance hall has imposing sculptures in half-relief on each of its granite pillars. These reliefs are of dancers, drummers, and divine musicians—Brahma playing the drum, Tumburu playing the vina, and Nandikesvara playing the *hudukka*. The nymph Rambha dances, and Shiva himself is shown dancing in the *ananda tandava* pose. In the intermediary hall there are three friezes, one of which is a long line of geese with lotus stalks in their beaks. In the central hall between the three shrines, there are elegant carvings of Gajantaka, Ganapati dancing, Durga, and a hermaphrodite.

701. LEPAKSHI. MONOLITHIC NANDI

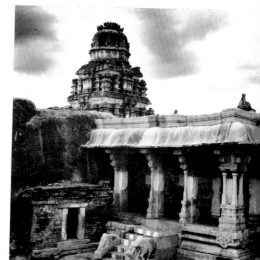

702. LEPAKSHI. MANDAPA SEEN FROM
INTERIOR COURTYARD

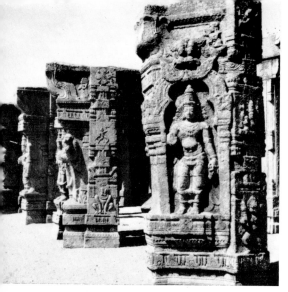

703. LEPAKSHI. MANDAPA WITHOUT ROOF

The Lepakshi temple is most celebrated for its paintings. To the southwest of the temple is a hall with paintings, unfortunately fragmentary, on the cornice of the facade. There are paintings in better condition on the walls of the small sanctum of Virabhadra and on the ceiling of the Raghunatha shrine, where the ten incarnations of Vishnu are represented. A colossal painting of Virabhadra is almost hidden in the darkness of the central hall between the three shrines. It is even larger than the Tripurantaka in the Chola series in the Rajarajesvara temple at Tanjore. But in the hall of dance and the intermediary hall are found the most colorful and well-preserved paintings. On the ceiling of the hall of dance, eight panels brilliantly illustrate legends from the Puranas: the marriage of Shiva and Parvati; Dakshinamurti; Rama's coronation; Krishna as a child lying on a banyan leaf; the story of Kiratarjuna; the toilet of Parvati; Shiva playing chess with his wife; and the famous story of the Chola king Manunitikanda, who loved to dispense justice even to an animal like the cow. From a historical point of view, the portraits, also in this hall, of Virupanna and Viranna with their followers, standing before Virabhadra and receiving sacred ashes from the priest, are especially noteworthy. The richest paintings and the best workmanship, however, are in the intermediary hall. The series of fourteen ceiling panels presents various iconographic forms of Shiva—Shiva rising from the lingam to assure protection to his devotees, Kalantaka protecting Markandeya, Shiva dancing on Kala, Dakshinamurti, Chandresanugrahamurti, Bhikshatana, Harihara, Kalyanasundara, and so forth.

(Fig. 153)

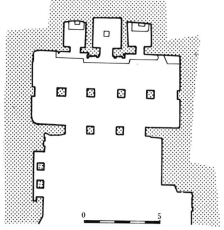

704. MOGALRAJAPURAM.
GROUND PLAN OF CAVE 4

MOGALRAJAPURAM

Mogalrajapuram, near Vijayawada, has important early cave temples, of which Cave 4 is very important for the study of the art of the Vishnukundins. Badly weathered as they are, the carvings are important as the only examples that have survived to show us the early medieval art of Vengi (modern Peda Vegi), near Ellora, the capital of the Vishnukundins in the fifth and sixth centuries. These sixth-century Vishnukundin caves are the precursors of the earliest cave temples of Mahendravarman Pallava near Kanchipuram in the south, which date from the beginning of the seventh century.

The style of columns, pilasters, and reliefs in the cave temples of the Vishnukundins served as a model for the early Pallava ones at Trichinopoly, Dalavanur, and elsewhere. The massive pillars in the caves of Mahendravarman clearly follow the Mogalrajapuram pattern. They are tripartite—cubical at the top and bottom and hexagonal in the middle. This arrangement and the lotus-medallion decoration recall the balustrade of Amaravati, whose uprights display similar lotus medallions and analogous triple fluting. The development of the horseshoe-shaped window from Vakataka monuments at Ajanta can be traced through the Vishnukundins to Pallava sculptors. Instead of ordinary human heads peeping through the windows, here there are definite faces of Trimurtis—Brahma, Shiva and Parvati, and Vishnu and Lakshmi. Above a long frieze of elephants, lions, and imaginary animals, there is a lovely but damaged multiarmed Shiva dancing on the demon of ignorance, Apasmara—a combination of the northern characteristic of the multiple arms and the southern theme of the trampling of the dwarfish demon. Behind the main hall there is a triple niche, as in early Pallava temples, intended for Brahma, Shiva, and Vishnu. At the ends of the cave, on either side of the entrance, there are guardians, one of them horned but otherwise quite naturalistic with a single pair of arms, resting a hand on a heavy club. They are precursors of later Pallava guardian figures.

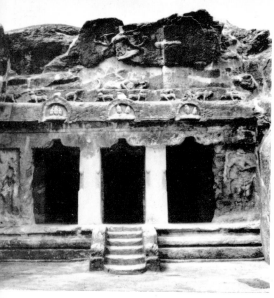

705. MOGALRAJAPURAM. FACADE OF CAVE 4

NAGARJUNAKONDA

Nagarjunakonda—or the hill of Nagarjuna—is closely associated with the great Buddhist philosopher of that name. From the early inscriptions found here we know that the adjoining hills, now known as Nallamalai, were called Sriparvata. Discovered in 1926, this important site was excavated in 1927–38 and 1954 and revealed a number of stupas, apsidal chaityas, monasteries, and other important remains of early Brahmanic temples; a large bathing ghat; a public assembly hall; and an imposing amphitheater.

A spacious, well-lit museum, built on one of the hilltops, displays scale models of the reconstructed architectural remains of Nagarjunakonda. (The entire excavated area was inundated by the waters of the Kistna River after construction of the giant Nagarjunasagar Dam and a reservoir for irrigation.) The museum's galleries contain casing slabs, semicircular doorsteps from shrines, āyaka slabs and pillars, relic caskets, sculptures, and reconstructed parts of the stupa.

Nagarjunakonda was at the peak of its glory during the time of the Ikshvaku rulers, who succeeded the Satavahanas toward the end of the second century A.D. and ruled in the following century. Inscriptions contain the names of Vasishthiputra Chamtamula, Mathariputra Virapurushadatta, and Vasishthiputra Ehuvala. Though the kings were followers of the Brahmanic faith and performed Vedic sacrifices, the princesses were Buddhists and generously supported Buddhist establishments. The inscriptions tell us that the Ikshvakus had marital connections with the Abhiras and Kshtrapas, both of western India. Chamtamula was a worshiper of Kartikeya or Skanda, the son of Shiva and Parvati, which explains why the finest and earliest statues of Kartikeya have been discovered here. Chamtamula's sister Chamtasiri, a fervent Buddhist, was responsible for the Mahachaitya temple (site 1). Temples, such as those of Shiva as Pushpabhadrasvamin and Nodagisvarasvamin,

of Vishnu as Ashtabhuja, and of Skanda, and several Buddhist monuments show the eclecticism of the Ikshvaku rulers. Although the Ikshvakus were successful and prosperous, the inscribed memorial columns with battle scenes carved on them give a vivid picture of the violent life of the time. Some of the columns allude to victories; others were raised in honor of soldiers who died gloriously in battle. With the emergence of the Pallavas as a political power in the fourth century, the might of the Ikshvakus dwindled and eventually disappeared.

The bathing ghat (site 34), a large assembly hall (site 71), and a hall for banquets and dance (site 37) point to a flourishing city with cultured citizens. The amphitheater (site 17), capable of seating a thousand spectators, is the only monument of this type to have been found by excavations in India. It closely resembles the Roman type, because in the early centuries of the Christian Era there was considerable contact between Rome and southern India.

Of the Brahmanic temples, that of Vishnu-Ashtabhujaswami had a wooden image, as mentioned in a third-century inscription on a stone pedestal; only the pedestal has survived. A conch shell was found here with the name of the deity inscribed in beautiful letters of an early style. The pillar with Garuda on top is lost. The inscriptions clearly reveal that both Pushpabhadrasvamin and Nodagisvarasvamin are forms of Mahadeva Shiva. Another Shiva temple is of Sarvadeva (site 99). Close to it was a temple of Kartikeya with a long pillared hall. At site 57, there was a cluster of three or four temples, all dedicated to Kartikeya; at site 39, one dedicated to his consort, Devasena.

The majority of the monuments at Nagarjunakonda, however, were Buddhist, the principal one being the Mahachaitya. Like the sage Nagarjuna who supervised the construction of the balustrade at Amarvati, the noted monk Ananda supervised the construction of this stupa, which is circular in plan with projecting pillared platforms. It contained some corporeal relics of Buddha. An apsidal stupa shrine and monastery with four wings was built close to it. The "Ceylonese monastery" (site 43) and the house of the Mahaviharavasins (site 38), a Theravadin sect from Ceylon, show the close connection that existed between the Buddhists of Ceylon and those in the Kistna Valley. On another hill, overlooking that of the Mahachaitya, stood a monastery (site 14). The apsidal shrine, containing a small stupa for images and an apse, appears to have been built later, as at sites 1 and 43. There are several other stupas which were simply for votive offerings. The Mahisasaka monastery (sites 7 and 8) was on another rise adjacent to the Nagarjuna Hill and included a stupa with a terracotta casket of relics. Several other smaller monasteries and sanctuaries were added so that it became a whole Buddhist complex.

The museum now houses a number of inscribed pillars found here and several other sculptures that adorned stupas and their projecting platforms. The memorial columns in honor of commanders and generals, including a unique memorial for a queen mother, are worth studying. The delightful sculpture here, which closely resembles the fourth and last period of art at Amaravati, illustrates many of the Jatakas. Along with the famous story of Mandhata and the well-known tales of Mahakapi, Vessantara, Hamsa, and Sibi, here one finds episodes rarely depicted—such as those of Mahapaduma, Dasaratha, Ghata, and Dighiti Kosala. Apart from the Pali text of the Jatakas, most of the sources of these stories are lost. Lost sources of still-surviving works such as the *Avadanakalapalata* of Kshemendra and the popular poems *Saundarananda, Avadanasataka,* and *Lalitavistara,* as well as the *Buddhacharita,* are illustrated here, as they are at Amaravati. The story of Muchalinda is a favorite here and at Amaravati. One finds that this tradition traveled to Cambodia and Champa.

(Figs. 74, 87, 328, 424)

PALAMPET

Palampet in Andhra Pradesh is famous for its Ramappa temple, built early in the thirteenth century by Recherla Rudra, a general of the Kakatiya king Ganapati, according to an inscription in the temple. The temple is a magnificent example of the exuberant decorative art of the twelfth and thirteenth centuries in this region. As in Hoysalan and later Chalukyan temples, it rises on a high platform and faces east with its long axis from

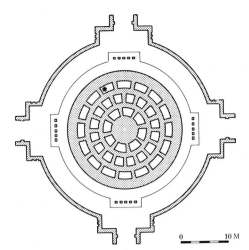

706. NAGARJUNAKONDA.
GROUND PLAN OF THE GREAT STUPA

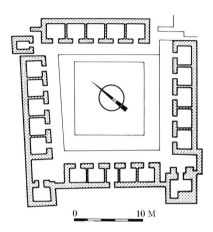

707. NAGARJUNAKONDA.
GROUND PLAN OF MONASTERY I

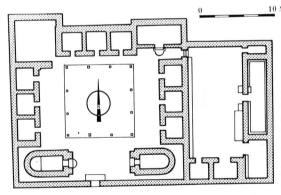

708. NAGARJUNAKONDA.
GROUND PLAN OF MONASTERY 2

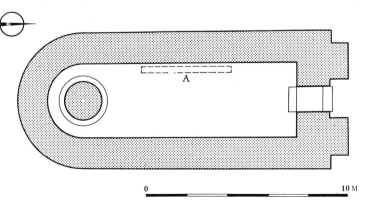

709. NAGARJUNAKONDA. GROUND PLAN OF TEMPLE I.
A—INSCRIPTIONS

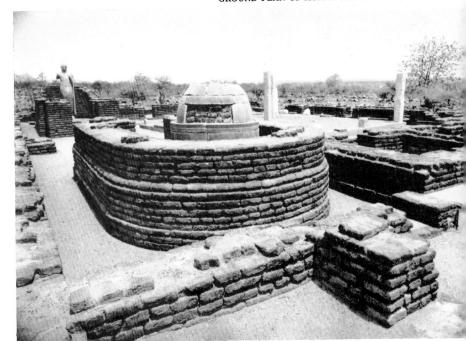

710. NAGARJUNAKONDA. VIEW OF TEMPLE

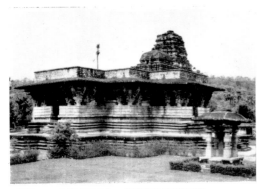

711. PALAMPET. VIEW OF TEMPLE

east to west. There are porches to the north, south, and east. The high plinth has a series of exquisitely carved friezes of processions, warriors, musicians, dancing figures, loving couples, and iconographic forms of deities. The friezes are separated by channels, which help to accentuate each course. The pillars that make the mandapa so beautiful are alternately square and circular, with intricate carving showing musicians and episodes from the Puranas—the Churning of the Ocean, the heroic combats of the *Mahabharata*, the sports of the youthful Krishna, and the like. Every inch is wonderfully carved, and the bracket figures, continuing an earlier tradition from Badami, add color to the ornamentation. The ceiling of the mandapa is again a profusion of intricately intersecting motifs surrounding the marvelous reliefs representing the dance of the *dikpālas* and that of Shiva. The entrance to the shrine, with openwork screens on either side and elaborate carving both on the jambs and on the lintel, where Shiva dances in the company of the mother goddesses and Ganesha, demonstrates the amazing skill of the Kakatiya sculptor. The walls of the shrine are embellished by pilasters and niches and are polished to the mirrorlike finish usual in Kakatiya temples. The bracket figures are prominent on the outer pillars and almost support the elaborately carved eaves of the mandapa. The shrine itself has the lingam and the bull Nandi with garlands of bells, which are typical of medieval Andhra work.

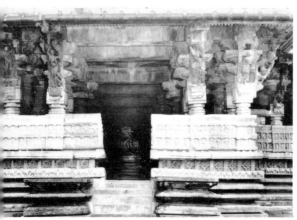

712. PALAMPET. ENTRANCE TO PILLARED HALL

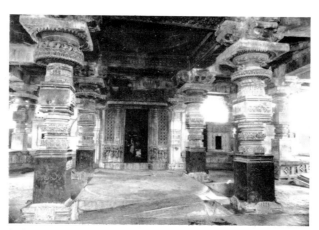

713. PALAMPET. PILLARED HALL LEADING TO THE SANCTUM SANCTORUM

714. PALAMPET. NANDI MANDAPA

715. SRISAILAM. INTERIOR VIEW OF TEMPLE

SRISAILAM

Srisailam, in the Nallamalai forest of the Kurnool District, is accessible only by a mountainous road from Dornal. The hill is known as Rishabhagiri and, as it was a great center of Shivaism, has been a famous place of pilgrimage. In the eighth century it was a favorite spot of Sankara, who described Mallikarjuna, the form under which Shiva is worshiped here. The temple also invokes the legend of Prabhavati, the daughter of the Gupta king Chandragupta II, who daily honored Shiva with garlands of jasmine flowers. A sculpture in the Chalukyan style in this temple is considered to be her portrait. The Chenchu, a tribal people living in the hills of this area, claim that Shiva is one of them, having married a beauty from one of their families. Thus they refer to him as Chenchu Malliah.

The temple is a very large one with an imposing boundary wall decorated with carvings illustrating incidents from the Shivite Puranas. There are inscriptions from the thirteenth and fourteenth centuries on—

716. SRISAILAM. EXTERIOR WALL OF TEMPLE

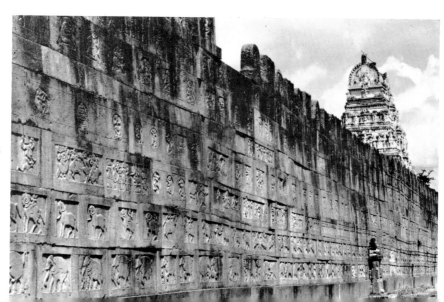

from the Kakatiya king Prataparudra and from the most illustrious emperors of the Vijayanagar dynasty such as Harihara, Praudhadevaraya, and Krishnadevaraya, all of whom had close association with this famous temple. In the center of the inner courtyard, surrounded by a cluster of minor shrines including a temple of Devi (here known as Bhramaramba) is the principal shrine of Mallikarjuna. Adjoining it is a pillared hall built by Harihara II early in the fifteenth century, in which the pillars, eaves, and ceiling are beautifully carved. Carvings in half relief on the walls of the court are a veritable narration of the epics. Here various panels depict the sports of Shiva, and portray him as Nataraja, Bhikshatana, Kalyanasundara, Kiratarjuna, Gajantaka, and Kalantaka and, most interesting of all, as Visvakarma, the architect of the universe.

717. UNDAVALLI. VIEW OF CAVES

UNDAVALLI

Very close to Bezwada but on the other side of the Kistna River are the multistoried Undavalli caves. The famous carvings on the pillars are significant as the precursors of the famous Pallava reliefs at Mahabalipuram. Particularly in the scene of Krishna lifting Mount Govardhana, it can be seen how closely the sculptor of Mahabalipuram has followed his model at Undavalli. Some of the details, such as the milkmaids carrying pots piled one on top of another, are repeated in the later work in almost identical, although more elaborate, manner. Narasimha and Trivikrama are represented in reliefs here in much the same manner as at Badami and Mahabalipuram. The Gajandramoksha relief reveals the ways in which the famous Gupta panel in Deogarh, the fame of which spread throughout the Vakataka domain, inspired sculptors. It should be remembered that the Vishnukundins were related by matrimony not only to the Pallavas, but also to the Vakatakas, who in turn were related to the Guptas.

718. WARANGAL. PRINCIPAL TORAN

WARANGAL

Warangal, or Orukallu as it was formerly known, is the famous Ekasilanagari—the capital of the Kakatiyas. Before Warangal's decline in the thirteenth century, the rulers here built lavishly. The excavations of the fort allow one to imagine the splendor of the city—a city that once was great as Vijayanagar. From the ruined temple of Shiva there remains the lintel of the entrance (now in the National Museum) with makara decoration at either end and Shiva dancing in the center, flanked by Brahma and Vishnu. It is a magnificent example of the best of Kakatiya art. Dance and music always gave great power of expression to the Kakatiya sculptural groups, and Sarasvati dancing on a swan with chowrie-bearers and Indra, Sakti, and other figures all around is an extremely attractive theme here. The beautiful ceiling panels, along with pillars that appear almost lathe-turned, now make up the mandapa that has been reconstructed in the Hyderabad Museum. This mandapa gives us an idea of the magnificence that it once shared with other examples of Kakatiya temple architecture throughout the territory in the twelfth and thirteenth centuries. The freestanding torans, as in medieval Gujarat examples from Ghumli and Dabhoi, show the survival of this form from Sanchi until the thirteenth and fourteenth centuries. The arched makara-decorated toran, such as that in Bhuvaneshwar in front of the Muktesvara temple, is an example of an intermediate stage. The toran at Warangal shows the last phase in the gateway's development before the Vijayanagar period.

(Fig. 611)

BIHAR

BARABAR

The Barabar caves are cut into granite hills on the bank of the Phalgu River, sixteen miles from Gaya. The largest, the Nagarjuni cave, is only a simple hall. The others are the Sudama cave, built in 252 B.C. in the time of Asoka; the Gopi (milkmaid) cave, dug in 214 B.C. in the time of Dasaratha, the grandson of Asoka; and the Lomas Rishi cave. Considering that there are no natural chaitya caves in Bihar, one must admire so bold an experiment as this—cutting a cave out of solid rock. They have been so fashioned as to imitate a construction in wood; however, no actual timber or frame was used, as in the early chaitya caves in western India. One explanation may be that in this area bamboo was the preferred building material rather than teak or other timber. The Lomas Rishi cave, though lacking an inscription, is architecturally important. Facing east so as

719. BARABAR.
ENTRANCE OF LOMAS RISHI CAVE

447

720. BODH GAYA. STONE BALUSTRADE AROUND THE BODHI TREE

to admit the morning light, it begins with a large rectangular hall which leads to a circular, or more precisely ovoid, space for the sanctuary. (The plan of this and the Sudama cave is identical.) It is not known why there was no freestanding chaitya in this space; probably a wooden or metal votive stupa was placed in the center for worship. The facade is most interesting. It is a large arch simulating the roof of a hut. The roof structure is meticulously copied, down to the last detail of the beams and even the overhang. There are large flat jambs on either side and between them a semicircular arch. The arch carries a semicircular relief of a row of elephants approaching from either side to worship stupas that are spaced at intervals among them. Above and below are plain bands of stone; above the upper band is an excellent simulation of bamboo trellis. This trellis is surmounted by a third plain band. A few feet behind the arch is a plain wall with a simple rectangular opening. The high polish on the walls of the Lomas Rishi cave is a clear indication of its early date, which is confirmed by inscriptions in the other caves.

BODH GAYA

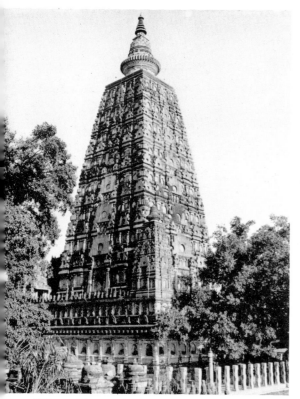

721. BODH GAYA. VIEW OF TEMPLE

Bodh Gaya, the ancient site of Uruvilva on the Niranjara River now called the Phalgu, is one of the great sacred spots associated with Buddha. It was here that he attained his enlightenment under the bodhi tree. This tree has been nurtured without interruption for about 2,600 years, and it is from here that a sapling was sent by Asoka to Ceylon. The story of how Asoka cared for the bodhi tree is narrated in sculpture both at Amaravati and at Sanchi. Under the tree there is the diamond throne, which has been renovated and reconstructed.

During the time of the Sungas a stone railing was erected around the tree, and a sculpture at Bharhut is supposed to represent the railing. This railing, part of which is still at Bodh Gaya itself and a few fragments of which are in the Indian Museum in Calcutta, is later in date than the celebrated balustrade of Bharhut and is done in a more advanced technique. The large uprights have a half-lotus at the bottom, a lotus medallion in the center, and at the top a semicircular relief illustrating the worship of the bodhi tree and scenes from Buddha's life. The long coping is made in pieces and is decorated with a frieze of running animals such as lions and bulls. Some of the uprights are cubical, having medallions on each side that illustrate a variety of subjects. There are sancturaries and palaces and scenes of the worship of the Wheel of Law; there are incidents from Buddha's life, such as his birth; there is the stupa that is symbolic of his attainment of Nirvana; and there is Gajalakshmi or Surya in his chariot drawn by four horses. There are even secular themes such as literary heroes and heroines, the coy and shy newly wedded wife, amorons musicians, one of them with a harp, and a damsel gathering asoka flowers and climbing a tree with the help of her lover, and so forth. Though the technique here is advanced, the exuberant spirit of Bharhut is absent here. The scene of the presentation of Jetavana, for example, is rather insipid. While the sculptor at Bharhut has taken great pains to be unambiguous about his themes by labeling them, there is scarcely a label here at Bodh Gaya. Nevertheless, some large sculptures, such as the yaksha with grass seeds in his hand, are well carved. While the railing is of the first century B.C., the stupa itself was rebuilt in the early medieval period and has all the features of medieval architecture.

It is a narrow truncated pyramid with four smaller pyramids at the corners of the large platform on which the monument rests. It is thus a *pañcāyatana*, an ensemble of five sanctuaries—the most imposing of all such monuments. Several votive tablets have immortalized its image, and pilgrims from all over Asia have visited Bodh Gaya; there are innumerable votive shrines that almost cover the area around the main stupa. Chinese inscriptions, put up by pious Buddhist pilgrims, have been discovered there. The stupa at Bodh Gaya has so inspired generations of Buddhists that it is found repeated in almost the same form in far-off Burma and even in Thailand.

(Figs. 360, 363)

NALANDA

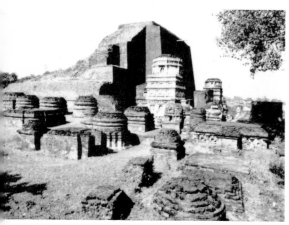

722. NALANDA. VIEW OF SITE

Nalanda, about fifty miles southeast of Patna and close to Rajagriha, is an important Buddhist site. Its name is derived from a local king—the Bodhisattva Nalanda, or the Buddha himself in an earlier birth—who gave "charity without intermission." It is also associated with Asoka, who is believed to have erected the vinara here, and with other important figures in Buddhist history. The disciple Sariputra was born here. The Buddhist philosophers Nagarjuna, in the second century A.D., and later Asanga and Vasubandhu are believed to have grown up and received their education here. But it was the Guptas who assured the prosperity of the center. Harshavardhana richly endowed the vihara and called himself the servant of the Nalanda monks. In the seventh century Hsüan Tsang resided here for some time while pursuing his Buddhist studies; he wrote a vivid account of life in the monastery at the time. The rulers of the Pala dynasty, who were themselves Buddhists, took special care to encourage such monasteries and centers of learning as Vikramsila and Nalanda. An important

copperplate engraving of Devapala, found in monastery site 1 during excavations, records the donation of five villages for the maintenance of the monastery, at the request of the Sailendra king Balaputradeva of Suvarnadvipa. Some of the inscriptions found here, such as the Gosrawan and the Nalanda stone inscriptions, refer to the time of Devapala and Mahipala I respectively. A manuscript in the Bodleian Library at Oxford, the *Ashṭasahasrikā-prajñāpāramitā*, was copied at Nalanda during the time of Ramapala. These documents date from the ninth to the twelfth century. An image of Tara and Vagisvari also mentions the regnal years of the Palas, during which it was prepared. Excavations by the Archaeological Department of the Government of India, begun in 1915–16 and carried on for several years, revealed some of the monuments here and established the importance of this site. The main temple, at site 3, is a huge structure in a large court with a number of small votive stupas around it, many of them built one on top of another during the centuries. The fifth and best-preserved temple has four corner towers. It was decorated with stucco figures of Buddhas and bodhisattvas in niches, which are excellent examples of fifth-century Gupta work. The shrine at the top probably contained a huge image of Buddha, of which only the pedestal remains.

To the east of the temple are remains of a number of monasteries. One of these, entered from the west, was provided with a large portico resting on pillars, followed by a vestibule in which were stucco statues that have now mostly perished. The monastery itself, as usual, was composed of a number of cells around a large quadrangular open court. There may have been several stories, but nothing remains of them. During the excavation of the site, another monastery was found beneath the more recent one visible on the surface. The remains of a colossal seated Buddha with crossed legs indicate the existence of a shrine in the earlier building, at the southwest of which was a square chapel with carved scrollwork and figures of flying dwarfs indicating the existence of an earlier Gupta temple. The inscription of Dharmapala (717–802) was found in a corner of the northern veranda of this monastery.

The monastery at site 4, to the north of monastery site 1, had two stories, as is indicated by an ancient flight of stairs and the remains of an old dormer window here above the lower landing. A coin of Kumaragupta, one of the earliest discovered in Nalanda, was recovered here. Other monasteries at sites 5, 6, 7, 8, 9, 10, and 11 indicate what a huge and flourishing establishment Nalanda was in the early medieval period. Charred wooden beams, doors, and images indicate that a conflagration destroyed Nalanda and sent the monks and students fleeing in panic.

Apart from the main temple in site 1, there are other temples at sites 12, 13, and 14, all with a square floor-plan and with traces of stucco figures of Buddha. Temple site 2, to the northeast of monastery site 7, is especially interesting for the variety of figures found here, including Shiva and Parvati, Kartikeya, Agni, Kubera, and Gajalakshmi; the scenes from Buddha's life, such as Gautama at school and the archery test, and Jataka scenes such as the tale of Kachchhapa; and the floral, geometric, and other decorative patterns. The terra-cotta plaques here cannot help but recall similar work from Pahadpur in East Bengal (now Bangladesh). The stonework on the base of the temple is so beautiful that it is nearer to Gupta work than to later idioms.

Excavations have brought to the surface several important images in stone, in addition to large and small bronze figures. The large number of Brahmanic images recovered here suggests that there was no great animosity between faiths. The Buddhist pantheon is wonderfully represented by such rare images as Aparajita, Vidyutjvala, Karali, Trailokyavijaya, and so forth; there are also Brahmanic images of Vishnu, Balarama, Surya, Haragauri, Ganesha, etc. Some of the Buddha figures here are very large and compare favorably with similar figures of the Kurkihar school now preserved in the Patna Museum.

The local museum, which is one of the most important site museums of the Archaeological Survey, contains fine examples of Buddhas and bodhisattvas, including Avalokitesvara, Kshasarpana, Lokesvara, Vajrapani, Arapachana, Jambhala, Tara, Prajnaparamita, Marichi, and Vasudhara. A number of works from Nalanda are also displayed in the Indian Museum in Calcutta and the National Museum in Delhi. Apart from the Devapala copperplate engraving, inscriptions on stone, including those of Yasovarman and Vipulasrimitra, are shown in the Nalanda Museum. A brick inscription discovered here is one of the most important of its kind, giving as it does a portion of the text of the *Nidanasutra* or *Pratityasamutpadasutra*. A number of seals and plaques discovered here bear the official seal of the Nalanda monastery with the legend *śri-Nālandā-mahāvihariyārya-bhikshusaṅghasya*, or "of the community of Venerable Monks of the Great Monastery at Nalanda."

(Figs. 212, 276, 279, 519)

LAURIYA NANDANGARH

Lauriya Nandangarh is famous for the imposing Asokan lion pillar that remains exactly as it was left by the original builders and sculptors. (It shares this distinction with another pillar—the one at Basarh, which also has a lion at its top.) Incised on the Lauriya Nandangarh pillar are six edicts of Asoka dated in the emperor's twenty-seventh year. This pillar is an excellent example of a Mauryan column. Fashioned out of a gray Chunar sandstone, it has a smooth, tall, circular shaft that gently tapers upward; its bell-shaped capital is decorated with lotus petals and topped by a circular abacus with a row of geese sniffing the ground with their beaks. The lion is seated atop the abacus. There is no other Asokan pillar with such elegant carving. The lion—his splendid mane, powerful, muscular body and limbs, prominent ears, and mouth open in the act of roaring (unfortunately mutilated)—is a triumph of the sculptor's art.

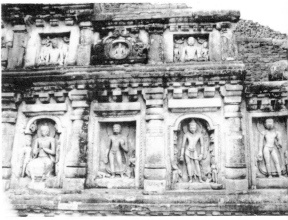

723. NALANDA. SCULPTURES IN NICHES

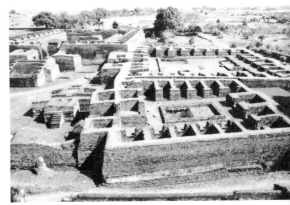

724. NALANDA. RUINS OF MONASTERIES

725. LAURIYA NANDANGARH. LION COLUMN OF ASOKA

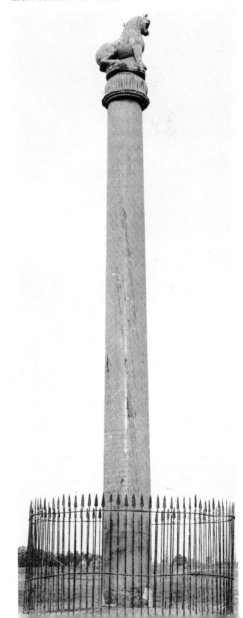

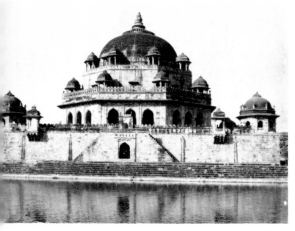

726. SASARAM. TOMB OF SHER SHAH SUR

SASARAM

Sasaram, in the Shahabad District, is especially noteworthy for the tomb of Sher Khan Sur, usually known as Sher Shah, who wrested the throne of Delhi from the Mogul emperor Humayun and held it for fifteen years. His father, Hasan Khan, had a fief from Sikandar Lodi in Sasaram, and Sher Shah, who had a fondness for the earlier imperial Lodi style of architecture, built his tomb here in 1540 as an imposing mausoleum of the octagonal variety—far more imposing than that of his father, also at Sasaram, built five years earlier. The mausoleum is situated on a high stepped platform in the center of a lake. Flights of steps lead upward from the large stepped plinth toward what appears to be parapet, but is really a very high terrace. Then begins a series of tiers: first, on the terrace, a large rectangular courtyard with large columned pavilions at its corners; and then the octagonal monument, rising level after level toward dome and finial on top. A causeway leading from the north shore of the lake to the monument is entered through a large guardroom, itself a beautiful architectural creation. The tomb of Sher Shah is one of the finest examples of the last stage of the Lodi style of architecture—simple, massive, but noble.

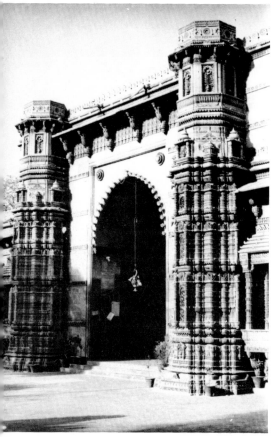

727. AHMADABAD.
ENTRANCE OF JAMA MASJID MOSQUE

GUJARAT

AHMADABAD

Under the Ahmad Shahi sultans Ahmadabad developed a provincial school of architecture in Gujarat that reached the height of its glory in the first half of the fifteenth century, when Ahmad Shah I imprinted his admirable personality on his monuments. Ahmadabad was named after him, and his reign was an era of great architectural activity.

Undoubtedly the most remarkable monument of this period is the Jama Masjid mosque, which was completed in 1423 and is justly considered the most beautiful in western India. The sanctuary, which is of great architectural beauty, is situated in a courtyard so spacious as to enhance the richness of the structure and give it a majestic appearance. A whole forest of pillars forms colonnades that support a cluster of domes. The play of light and shade created by the carved screens gives the whole edifice an aura of fantasy. In the interior, tiers of overhanging balconies alternate with groups of columns, which separate the nave from the side aisles, with a central rotunda of great solemnity. There is something here of the pillared halls of Gujarat, involuntarily introduced by sculptors faithful to an unforgettable tradition. The facade of the Jama Masjid is impressive: above the monumental arched gateway, flanked by two tall minarets, an overhanging balcony projects from a massive wall decorated on top with turrets.

The universal fame enjoyed by the Siddi Sayyid mosque, making this modest building a monument of great importance, derives from its exceptional openwork screens, depicting in beautiful tracery a banyan tree strangling a palm. So delicate is the carving, so sensitive, and so free from convention, so completely had the artist given himself up to his work, that these windows are almost a tribute to oriental plant life, achieved with exceptional skill in a medium that rarely admits of such grace, imitating in stone the softness of ivory carving. This monument of exceptional charm is among the last great creations of this school in western India.

(Figs. 674, 675)

DABHOI

Dabhoi, a few miles from Baroda, is famous for its remains of fortifications of the Chalukyan period. Massive ramparts, now mostly ruined, were built around the city like the wall around a temple court (*prākāra*). Because of their style of decoration, these fortifications are thought to be of the time of the Vaghela king Visaladeva in the mid-thirteenth century. According to the *Vastupalacharita*, Tejahpala, the brother of Vastupala, who was a minister of the Vaghela ruler Viradhavala, built this rampart as a protection against invading hordes. The kings who actually built the rampart, however, were Jayasimha Siddharaja and his ancestors.

The four gates at Dabhoi are exquisitely carved, very elaborate in treatment, and rather deep and wide. The most beautiful one is appropriately titled Hira, or the "diamond gate." The northern one is called the Moti gate, the southern one Nandod or Chandod, and the one to the west is the Baroda gate. Burgess feels that the principles of construction in wood have survived in stone architecture. These gates are proportioned in exactly the same way as temple architecture and at the same time could be the entrance to a palace—a freestanding entrance continuing the toran tradition. The pilasters are carved with figures of deities and scenes from the epics. Above the projecting brackets, the architraves terminate in exquisite sea monster (*makara*) decoration.

728. DABHOI. HIRA GATE

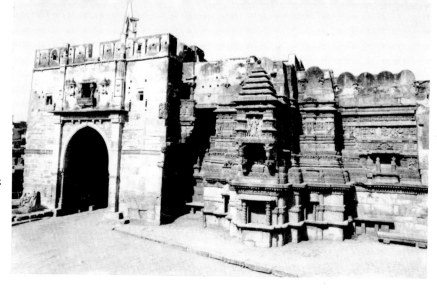

729. DABHOI. BARODA GATE

The scene of the churning of the cosmic ocean to obtain the elixir of immortality, already observed on a Gupta door lintel at Udayagiri, is repeated here. The fight between Sugriva and Vali, figures of the dancing Shiva, Bhairava, Devi living as an ascetic to obtain Shiva as her husband, Narasimha, Trivikrama, Narasimhi, and Surya are among other striking carvings at Dabhoi.

It is interesting to compare the gateway at Dabhoi with similar ones at Ghumli, Junagarh, Jhinjuvada, etc. The toran was such a popular form with medieval rulers of the twelfth and thirteenth centuries that it is given a prominent place even in Kakatiya architecture, as at Warangal in Andhra Pradesh. The toran became more and more elaborate until, in the late Chola period (about the thirteenth century), the gopura, sometimes with as many as eleven or twelve stories, began to appear in southern Indian temples, culminating in the immense gopuras of the Vijayanagar and Nayak periods.

(Fig. 608)

KHAMBALIDA

The Kshatrapas, who ruled from Ujjain in western India as contemporaries of the Satavahanas, are well known to history through their inscriptions and coins which bear a series of portraits on the obverse. The Girnar inscription records the double victory of Rudradaman over Satakarni, ruler of the Deccan, who was probably Vasishthiputra Pulumavi. This defeat probably avenged the early success of Gautamiputra Satakarni who had overcome Nahapana. Usavadata, son-in-law of Nahapana, is described in a long and interesting inscription from the Nasik cave. Rudradaman was a great patron of art and literature. The Uparkot and Talaja caves, though rather austere, have some figure carvings on the pillars, particularly in Uparkot, but have no large reliefs such as can be seen in the group of five caves at Khambalida in Saurashtra. One of these caves, though of no architectural importance, has richly carved panels on either side of the entrance. There are the asoka and kadamba trees laden with flowers; and the guardians of the garden gateway, with a large number of attendants around them, are prominently represented. The short dwarf caryatids supporting this composition remind one of similar ornamentation in the Nasik cave.

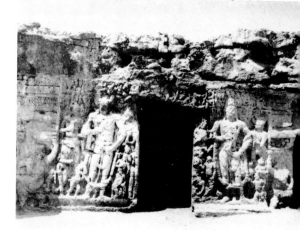

730. KHAMBALIDA. CAVE ENTRANCE

MODHERA

Easily reached by road from Ahmadabad, Modhera is today a lonely spot where the beautiful sun temple of the eleventh century is a veritable oasis in a desert. Among the sun temples in India, such as Martand, Konarak, and Suryanarkovil, Modhera ranks very high. An inscription on the back wall of the shrine indicates that it can be dated about 1026, during the time of Bhima I, and is contemporary with the Adinatha temple at Dilwara on Mount Abu, built by Vimala. The Modhera temple, though now in ruins, is an imposing one with a beautiful inner shrine with ambulatory, an adjoining covered pillared hall, and a larger assembly hall in

731. MODHERA. VIEW OF TEMPLE

732. MODHERA. TEMPLE AND SACRED POOL

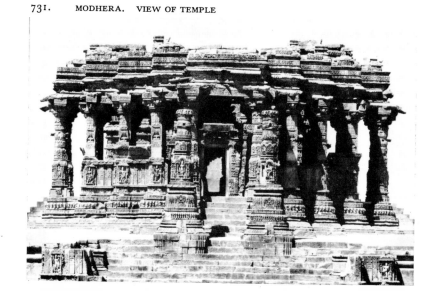

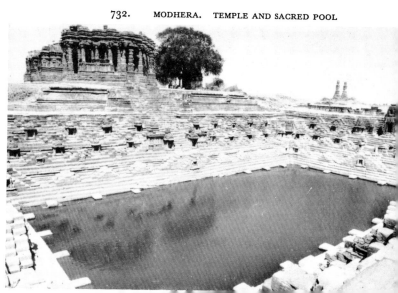

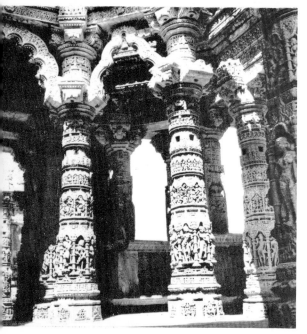

front. A huge stepped reservoir or tank called Ramakunda, one of the loveliest temple tanks in western India, is nearby. Small steps lead on from one terrace to another down to the water level. At intervals there are small pavilions enshrining different forms of Shiva, Vishnu, Devi, Surya, and other gods. It is believed that this beautiful tank with its numerous shrines served as a model for the one at Sahasralinga, built by Jayasimha.

The outer walls of both the columned hall and the inner shrine are exquisitely carved with bands of sculptures depicting iconographic forms of various deities, celestial beauties, dancing figures, rows of elephants, processions of people in different attitudes, decoration using the motif of the vase or the mask, and chaitya windows, all in addition to the main bands showing the deities of the Hindu pantheon, with emphasis on the forms of Surya, to whom the temple is dedicated. The entrance to the shrine has a beautiful carving of Surya surrounded by dancers and amorous couples. The assembly hall has exquisitely carved pillars, pairs of which support arches and are wonderfully decorated with groups of dancers and celestial beauties. The elaborate cusped arches, which are of two varieties, semicircular and triangular, begin at the brackets of the pillars and support the lintels and architraves. The brackets are equally charming with makara decoration. In front of the assembly hall there was once an arch of victory, of which only the pillars remain. The roof of the columned hall is in the shape of a stepped pyramid and the ceiling rises in tiers in a very artistic manner. With its imposing tank, the lovely columned hall, and the well-carved shrine, the sun temple makes a strong impression as a great monument now in ruins.

(Fig. 610)

733. MODHERA. MANDAPA PILLARS

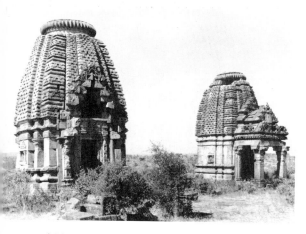

734. RODA. TWO TEMPLES

735. SAMALAJI. VIEW OF TEMPLE

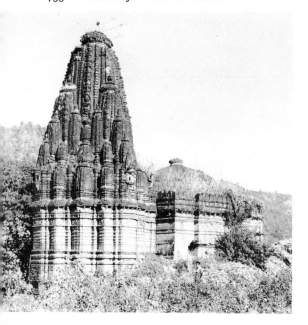

RODA

Roda, an obscure village in the former state of Idar, contains eight temples of about the tenth century. One is very simple, with an elaborately carved doorway and pillars at the corners, simple though ornamented with elegant carving, niches on three outer walls, and a roof decorated with a line of *kūḍus* whose upper portions are lost. Another temple is almost as simple but has a front porch with two pillars and two pilasters, almost entirely destroyed. A vestibule (*sukhanāsī*) in front extends over the porch. The vestibule is intact, as is the amalaka over the shrine roof. The third temple is equally simple and is intact, except for the porch and vestibule, both of which are lost. The doorway, decorated with elaborately carved rearing lions, honors several forms of deities in reliefs arranged one above the other on the jambs, and in a row in the miniature shrines arranged on the lintel. These iconographic forms include Ardhanarisvara, Vrishabhantika, Shiva, Vishnu with personified weapons, and Haragauri, among others. Another temple, very similar, is complete and intact and shows how the roof of the columned hall, continuing the vestibule, is gabled. In the niches are seated figures of Surya and other deities. Yet another temple has an elaborate closed porch leading to the main shrine. It, too, has niches on the sides with deities enshrined in them. All these temples bespeak a continuous architectural tradition from the time of the Maitrakas to that of the Paramaras.

Early sculptures discovered here are exquisite examples of their kind. A four-armed Ganesha, for example, with a lotus, ax, bowl of sweets, and sacred thread formed of a snake, is extremely well carved. A series of seven mother goddesses, including Parvati and Chamunda, is of an earlier date, probably the seventh century, and shows the beginnings of art in this region. Sculptures of the eighth and ninth centuries can be seen in the temple carvings, which include such magnificent specimens as Parvati arranging her anklets while seated on her vehicle, the lion, to prepare herself for a lasya dance with her consort Shiva, the dancer par excellence; and Parvati, seated in the lotus position, performing penance, holding a Shivalinga in one hand and Ganesha in another and a water vessel in a third. There are exquisite carvings of celestial beauties with attendants, holding lotuses or appreciating their beauty in the mirror with their garments fluttering and flying about them.

SAMALAJI

Samalaji, very close to Devani Mori, is on a hilly site surrounded by the Mesvo River. It is believed to have been a sacred spot of Vishnu in the form of Gadadhara, but there have also been finds that indicate Shivaite associations. Some of the mounds at Samalaji appear to be Gupta temples that have almost disappeared. In the ruins of these old Shiva temples, a beautiful Nandi bull was found and it is now in the Prince of Wales Museum. It is very early and belongs to the time of the Maitrikas who ruled this part of the country under the Guptas. The many large bricks that have also been found show that monuments of a very early date, probably Kshatrapa, once existed here.

The temple called Harischandrani Chori is approached through an exquisitely carved toran. The jambs of the toran have multifaceted well-carved bases, with niches topped by elaborate *kūḍu* arches and miniature shikaras enshrining celestial beauties and loving couples. The upper part of the shafts are more slender and have rich arabesque carving. The horn-of-plenty motif is prominently shown. Ribbed capitals support the lin-

452

tel, and a double-arched gateway issues from the gaping mouth of a pair of sea monsters. Portions of carving on both sides of this toran are now lost; nevertheless this is a superb example. The temple itself is on a fairly high platform and is approached by steps. A porch and a pillared hall lead to the vestibule and the inner shrine. The mandapa is domed, while the roof of the sanctum is a faceted truncated cone with large amalaka shikara which is clearly of the north Indian nagara type (it appears in a temple of the Paramara period of about 1000). The Kasi Visvesvara temple at Samalaji enshrines a single-faced Shivalinga that dates from about the seventh century. The main shrine, antarala, and mandapa of the temple of Surya are complete, but restored.

Samalaji is most famous for the early sculptures that have been discovered there and are now preserved in the Baroda Museum and the Prince of Wales Museum. In the Baroda Museum there is the standing Ganesha with a single pair of arms, naturalistic elephant head, and large halo and a curious-looking gana attendant devotedly standing close by. A lovely Shiva from Samalaji with circular earring on the left lobe and a different, tiny ear ornament on the right is now in the Prince of Wales Museum. Locks of hair nestle on the shoulder and are arranged delicately on the head against a large halo; a single strand of pearls lies around the neck; the upper hands carry the trident and the snake, the lower right hand holds a rosary, and the lower left rests on the hip; a tiger skin lies across the thighs; the bull Nandi stands next to the god. Also in the Prince of Wales Museum is Skanda Kumara with a peculiar turban on his head, a smile on his face, the spear in his right hand, a simple strand of pearls on his neck. In the National Museum there is a fragment of a mother and child; the mother has a wonderfully garlanded braid with a circular gem against it immediately above curls on her forehead. The leaves and blossoms hanging from the braid to the right indicate that she was part of a Matrika group. These and a host of other such figures as Kaumari, Indrani, Mahesvari, Vaishnavi, and Chamunda, all in the Baroda Museum, indicate what a fruitful place this was in the time of the Guptas.

It also should not be forgotten that one of the most magnificent Visvarupa forms of Vishnu was found at Samalaji. This must have had importance in earlier shrines such as the Ranchodaji and other ruined Vishnu temples.

(Figs. 60, 458)

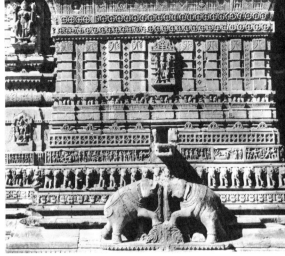

736. SAMALAJI. DETAIL OF TEMPLE FRIEZE

UPARKOT

The Kshatrapas, who ruled in western India in the early centuries of the Christian Era, are best known through their inscriptions, not many of their monuments having been discovered. The few that we do know, however, show this early dynasty's skill in creating dwellings and shrines in solid rock. In Uparkot near Junagarh are caves and inscriptions in Gujarati from the first and second centuries A.D. The caves are two-storied. Besides a bath on the second floor, there is a large chamber with six pillars apparently to support the roof, even though it is solid rock. The walls are divided into compartments and ornamented with the chaitya window motif. On the first floor there is an arrangement of chambers, corridors, and pillars to support the floor above. The chaitya window ornament is repeated on the walls. The pillars are almost circular in section but are actually polygonal. There is elaborate strand-of-pearl decoration on their stepped bases, while their circular capitals, carved with beautiful figures of humans and animals, are topped by a square abacus covered with decorative carving. The figures are composed of celestial women admiring their beauty in a mirror, loving couples, and other such well-known motifs all repeated in lush variety. On the bases there are also lions, horses, and human figures, in addition to floral designs such as the wish-fulfilling creeper.

The remains of some caves at Uparkot point to the existence here of a vihara. The halls, reached by way of a winding staircase, were probably long open verandas around the bath and were used as places of assembly.

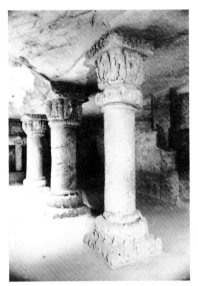

737. UPARKOT. INTERIOR OF SIX-PILLARED CAVE

VADNAGAR

Vadnagar in the north of Gujarat once had a beautiful temple, but today the most important remains here are of the toran or the *kirtistambha*. There are two torans outside the town walls to the north that are identical in dimensions and style. The more easterly is better preserved. There is the usual simple plinth with carving of rows of elephants, men, and other decoration. There are carved figures in panels on faces of the pillars, carved octagonal bands and corbels above, brackets with makara decoration, and semicircular arches and architraves. All these elements combine to make an imposing structure. The decorative work is very close to that of Modhera and it is of the same time period, the eleventh century. It is interesting to compare this with the torans at Kapadhvanj, Ghumli, and Dabhoi (which are slightly later in date) and the earlier Reva toran which is typical of Chedi work of the tenth century. At Vadnagar, an adjunct of the temple is a tank, with sculptural work all around and steps leading to the water level. Noteworthy among these sculptures are the Saptarishis (the seven sages) along with Arundhati (the wife of Vasishtha) and the celestial cow Kamadhenu. Representations of the Saptarishis in sculpture are quite rare, the other known instance being also near a tank—that of the Bhimesvara temple at Draksharama in Andhra Pradesh, which belongs to the time of the Eastern Chalukyas, about the tenth or eleventh centuries.

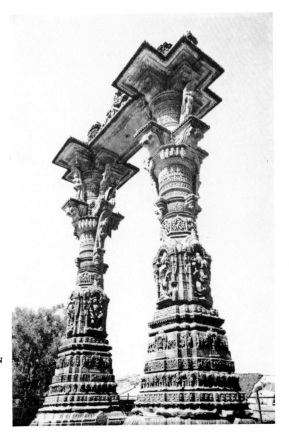

738. VADNAGAR. TORAN

HIMACHAL PRADESH

MASRUR

739. MASRUR. ROCK-CUT SANCTUARY

Masrur, in the Kangra District, is an important site in the Himalayan region. Of interest here are nine early medieval, freestanding temples cut out of the rock. Some are weathered and in ruins. Of these nine temples, only one has an interior shrine like the usual cave temples. The rest are solid freestanding structures; they have doorframes but these lead nowhere—the interior is solid rock. Though such temples abound in western India, in the Deccan, in Bihar, in Madhya Pradesh, in Orissa, and in the south, there are not many of this type in the north, and from this point of view these monuments at Masrur are of special interest. The temple with the finished interior, adorned with carvings of a high order, faces east and is aligned with but higher than the subsidiary shrines on either side. Because of its imposing position on the high point of the hill, its beauty is shown off to great advantage. In this temple the architect has arranged the shikaras so that the solid rock shrines blend softly in a contour that harmonizes their lesser height with that of the primary one. The main shrine has a small portico and a larger mandapa, most of which is lost. Yet its pillars and pilasters charm the spectator with their beautiful half-lotus and pot-and-foliage decoration. The roof of the mandapa and whatever remains of the rest of it have equally beautiful decorative work. Since modern images of Rama, Sita, and Lakshmana were enshrined here in recent times, the early carved figures in this shrine were discovered only after excavations. These earlier carvings include a central one of Shiva with flying demigods above holding a jeweled crown—a motif common in Gupta and medieval art, following a tradition already observed at Deogarh in the Gajendramoksha panel. The others are Vishnu, Indra, Ganesha, Skanda, and Durga. On the lintel of the east porch of the shrine are again seven deities with Shiva in the center, wearing a crown held up by rows of celestials converging from either side. On the doorway of the shrine at the southeast corner, Mahesvari, Indrani, and Varahi, among others, are easily recognized. Ganesha is the central figure, with a pair of celestials on either side, on the lintel of the porch of the shrine. Excavation has also revealed several other original images in the niches of the various shrines; most of them are part of the rock itself, but in some cases they are independent carvings. We find Shiva, Indra, Surya, Kartikeya, Ganesha, and Vishnu as Vaikuntha, with the central human face flanked by the face of the lion and the boar, a form common in this region and in Kashmir. It is surprising that carvings of Brahma and of the nine planets that usually adorn the lintel of the doorway are absent.

 As there are no inscriptions to give a clue to their date, the age of these monuments has to be estimated from their style. Since the carving is very pleasing and follows the Gupta idiom—though very much more advanced in style—this must be eighth-century work. They may be attributed to the Karkota dynasty of Kashmir, which then held this entire region.

JAMMU AND KASHMIR

AWANTIPUR

740. AWANTIPUR.

RUINS OF AWANTISVAMI TEMPLE

Eighteen miles on the main road from Srinagar is Awantipur. Here Avantivarman, the famed ruler of Kashmir of the Utpala dynasty (855–883), built two magnificent temples, of which only the ruins now exist to proclaim these gems of Kashmiri art. One temple is dedicated to Vishnu and is named Avantisvami after the king. It was nearly destroyed in the fourteenth century by Sikandar But-Shikan (the Idol-Breaker). As in the case of the Martand temple, there is a large paved courtyard enclosed by a colonnaded cloister. In the center are the main shrine and mandapa on a double platform. The entrance from the west, corresponding to the toran or gopura, is approached by steps. The side walls contain carvings of the four forms (caturvyūha) of Vishnu, as well as Manmatha, Rati, Priti, a flock of parrots, and Pradyumna with his consorts. This last is exceedingly well fashioned, even to the details of the sugarcane bow. Both the outside and inside walls of the entrance are decorated with sculpture, most of which is weathered and broken. Ganga and Yamuna on their mounts guard the chamber from either side. One of the large panels here represents the approach of a king with his queen and attendant followers with offerings for the deity. This is perhaps the king dedicating himself eternally to the service of the deity for whom he lovingly built the temple. A similar carving is also found on the opposite side. Between the main shrine and the gateway there appears to have stood the pillar surmounted by Garuda, the emblem of Vishnu, but it is now lost.

 All that is left of the central shrine is the plinth and its moldings. The decorations include a dentil course of ornamental masks, rows of geese, the alternating lotus-and-goose pattern, rows of beads between pairs of spirals, and so forth. The four miniature shrines at the corners of the courtyard proclaim this temple a *pañcarātna*

type. There are sixty-nine cloister cells around the courtyard. This important temple is mentioned by Kalhana in his *Rajatarangini*.

Half a mile away, also on the main road, is the Avantisvara temple that was also built by Avantivarman for Shiva. This is almost completely in ruins but a number of architectural fragments are strewn about. All vestiges of sculpture, except a fragment (exactly like the portrait of Avantivarman and his queens in a panel of the Avantisvami temple), have disappeared. The shrine is in the center of a large court on a high platform and was also probably like the Avantisvami temple in plan. It was doubtless once an imposing structure.

741. MARTAND. TEMPLE RUINS

MARTAND

Martand in Kashmir has the most famous monument in this area. The name Martand itself is from the sun-god Martanda, and when it was intact, it was probably the most monumental temple dedicated to the sun-god anywhere in the country except the one at Konarak. The temple was built by King Lalitaditya in the eighth century. The importance of the monument led Kalhana to mention it in his *Rajatarangini*. Even today the temple, situated in a valley abounding in groves, dotted by villages, and encircled by hills, presents a lovely appearance. The ruins are stately and rouse the imagination of the visitor to see more in them than actually exists. In a huge rectangular courtyard with cloistered sides, the temple is an imposing structure of monumental proportions. There is a large closed mandapa with its principal entrance to the west and side entrances to the south and the north and a smaller hall and a vestibule that lead to the shrine itself. In the vestibule near the entrance can be seen images of Ganga and Yamuna on their respective vehicles with attendants holding umbrellas over them. These, however, are weathered almost beyond recognition. There are figures of Vishnu of the Vaikuntha type with the lion and boar heads on either side and other carvings, mostly obliterated, of Surya with the charioteer Aruna guiding the seven steeds. The walls of the temple both inside and out have pedimented niches with iconographic representations of celestials, mainly those associated with Surya. The roof and its decoration is of the gable type, the usual style in Kashmir. The roof thus was pyramidal though most of it has disappeared and the sanctum is without its entablature. Everywhere the walls of the gateway as well as the sanctum and the mandapa have decoration both inside and out. There are long floral scrolls, elaborate arabesques, flocks of geese, and groups of figures—all arranged in panels and bands. Unfortunately most of it is in ruins, with projecting bits of pillars and columns scattered about.

PAYAR

At Payar, close to a stream that runs past the village, is a small but elegant temple of about the eleventh century dedicated to Shiva. With gable decorations and pyramidal roof surmounted by an amalaka, it is a typical example of a medieval temple of Kashmir. A porch no longer exists, though a projection of the plinth at the entrance suggests that there once was one. However, this projection may have been a pedestal for a Nandi bull that faced the shrine. The sanctum is open on all sides and is reached by a flight of steps on the east. Each of the rectangular entrances is topped by a trefoil that is enclosed by a pediment resting on pilasters decorated with pairs of geese on the capitals and crowned by seated bulls. Above the lintels in the niches formed by the trefoils there is Lakulisa on the eastern side and Bhairava on the northern; six-armed dancing Nataraja Shiva with musicians is on the west; and three-headed Shiva, with Bhairava and Devi on either side of the central calm face, is on the south. This is a theme that is also found at Elephanta, Gwalior, and Ellora and even in murals from far-off central Asia.

A double pyramid, one over the other, composes the roof, with gabled niches on all four sides, topped by a ribbed amalaka. The interior is domed and within the spandrels around the edge are winged figures with limbs outstretched supporting the roof. The temple enshrines the usual Shivalinga symbol of Shiva.

742. PAYAR. TEMPLE OF SHIVA

KERALA

CHITARAL

On the promontory at Chitaral, there is a large group of early carvings representing Tirthankaras, yakshas, and yakshinis which are similar to the Jain carvings at Kalugumalai. The seated Tirthankaras have triple umbrellas above and attendant figures behind their lion thrones. The Tirthankara seated in the lotus position with flanking figures, or chowrie-bearers, is the very picture of serenity. Of the standing Tirthankaras, the most imposing is Tirthankara Parsvanatha with the snake hoods over his head. This depicts Dharanendra Yaksha and Padmavati coming to his rescue as Kumatha tries to attack him. In another large niche a Tirthankara is seated with flanking chowrie-bearers behind the lion throne. Next to this, in another niche, is Yakshi Ambika and her children with her husband close by in the form of a lion.

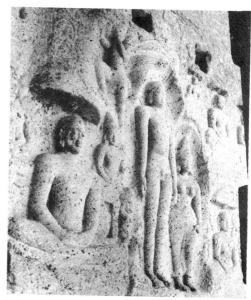

743. CHITARAL. TIRTHANKARAS

ETTUMANUR

According to the inscription on the gopura, the temple at Ettumanur, which is dedicated to Shiva, is an early building that was renovated in the sixteenth century. Although the entrance is large and imposing, the gopura itself has nothing in common with the lofty towers of the Tamil area.

The central shrine is circular with a conical metal roof, facing which is a square mandapa on a raised platform. A seated Nandi bull is situated in this mandapa, and the excellent wood carving on the ceiling is very interesting. An inscription on the base of the sanctum sanctorum mentions renovations and a consecration in the sixteenth century; to this period should be assigned the beautiful carvings in wood that decorate the cornice, brackets, and architrave all around the shrine. In the style of kathakali, in the decorative detail, and in the quality of the work in general, we see the Kerala carver at his best. The subjects are: a running narration of the story of Rama; the games of Krishna as described in the *Bhagavata*; Santanagopala; Krishna amidst the milkmaids; folk dances; an orchestra; Lakshmi being bathed by elephants; Shiva dancing in the company of his consort Shivakamasundari; and so forth. The wood carvings supplement the fine sculptural work here.

The murals in the temple are especially noteworthy as the two large panels on both walls inside the gopura date from the sixteenth century. On one side Shiva dances with celestials all around him, and on the other Padmanabha reclines on the serpent couch with his consort at his feet. These murals reveal a style resembling closely that of the paintings in the Mattancheri palace. More murals are found in the central shrine. The rectangular court surrounding the temple contains rows of metal lamps so arranged that they virtually screen the temple on all the sides. In the evening, with the lamps lit, the shrine becomes a festival of light.

(Fig. 312)

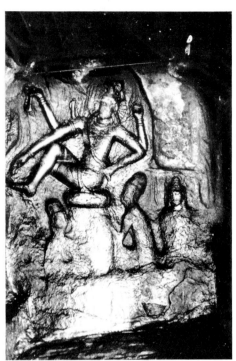

744. IRUNALAKKODE.
SHIVA DAKSHINAMURTI

IRUNALAKKODE

Irunalakkode is important because of a small cave temple that contains a carving of Dakshinamurti Shiva, four-armed, seated with legs crossed. His hair forms an elongated crown, and a cobra coils around his body, its hood raised above his left shoulder. It is interesting that the halo is visible, and the sacred cord, the anklet, and the armlets high up on the arm are noteworthy. It is also interesting that he has the book and the rosary in two of his hands, while one of his other two hands is beckoning and the other resting on his knee at ease. As is usual in representations of Dakshinamurti, there are four sages seated at his feet, humbly waiting to receive his elucidation of the highest truth. This figure is of the ninth century and is probably one of the most important early Dakshinamurtis in Kerala.

(Fig. 456)

KAVIYUR

At Kaviyur there is an eighth-century Chera cave temple dedicated to Shiva and built on the pattern of early Pallava caves. It faces west and is cut out of two massive pieces of rock. The cave is a few feet above ground level and is approached by a flight of steps. The temple is a simple rectangular hall, with the usual pairs of heavy pillars and pilasters, and beyond that a central shrine—a square cell. The cave has imposing figures guarding the entrance. One of them wears his hair in picturesque curls on his shoulder and leans heavily on a huge club entwined by a cobra; his adornment consists only of heavy earrings, necklace, and waistband. The other is the very personification of deference, with hands crossed in an attitude of reverential attention, a type often encountered in Gupta and other later medieval schools. Another carved figure is that of a sage standing with hair piled high upon his head. There is also a Ganesha, with a naturalistic elephant head and a proboscis that extends the entire length of the paunch, which resembles early Pallava and Pandyan representations.

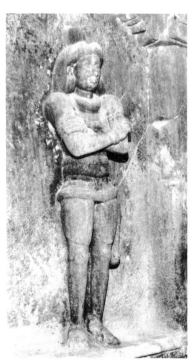

745. KAVIYUR.
DVARAPALA IN CHERA CAVE

MATTANCHERI

The Mattancheri palace was built and presented by the Portuguese to the ruler of Cochin in about 1555. Though originally known as the Dutch Palace, it is nevertheless the Kerala type in its design and execution. Set within a high boundary wall, the palace is a large rectangular structure with a large central courtyard. The second story commands a wonderful view of Cochin Harbor. There is a shrine in the center of the courtyard dedicated to the tutelary deity of the ruling family, Palayanur Bhagavati; in addition, there are temples for Vishnu and Shiva. The coronation hall, large bedrooms, and various other rooms are located on the upper floor. A very large and spacious dining hall and a kitchen are included in this palace, and there is a separate area for the harem.

Mattancheri is specially noteworthy for excellent murals representing a series from the *Ramayana* and the marriage of Parvati, in addition to other themes carefully executed by the painter in a style that antedates that of the murals at Padmanabhapuram. The *Kumārasambhava* scenes are delicately limned, and since color was never applied, they remain as interesting drawings that show that stage of the painter's work. The panel depicting attendant women adorning Parvati for her wedding is very impressive. Elsewhere, the dance of Mohini, Vishnu seated with Seshanaga hoods over his head, and several other themes are richly painted. In the halls of the upper story, to the left of the Darbar Hall, one finds a magnificent series of murals illustrating the story of Rama and the games of Krishna.

(Figs. 205, 352)

SUCHINDRAM

In Suchindram, eight miles from Cape Comorin, one finds one of Kerala's most interesting temples. Built in the seventeenth and eighteenth centuries, the Sthanumalayapperumal temple, as it is called, is dedicated to the Trimurti, then the principal gods of the Hindu pantheon: Shiva (as Sthanu), Vishnu (as Mal), and Brahma (as Aya). The temple's stately tower, which is imposing, well proportioned, and elegantly executed, is the finest in Kerala. The gods of the pantheon are well represented in the granite decorative panels on the tower's base and the upper parts are studded with plaster figures. Inside, the pairs of doorway guards on each floor throughout the tower arrest one's attention.

The dance pavilion, once used for the daily ritual of dance for the deity as well as various other performances, is now used as a hall of music. The prominent female figures at the base of the hall's eight imposing columns are believed to be the temple dancers who donated the pavilion. Attractive floral decoration adorns the ceiling.

Beyond the pavilion is a huge doorway with frightful figures of demons with blazing eyes, monstrous teeth, and ponderous bellies. Among the small shrines on either side of the doorway is a *Chidambareśvara,*

746. SUCHINDRAM. SOUTH CORRIDOR

747. SUCHINDRAM.
PAVILION FOR YEARLY REGATTA
WITH TEMPLE GOPURA IN
THE BACKGROUND

which contains an image of Nataraja. The doorway leads on to a portico that in turn leads to the *uñjal maṇḍapa,* or the pavilion for the swing. There, on a central raised platform, the *tirukkalyāṇa* festival is held. This is the celebration of the marriage of the deity to his consort and it is held on a swing suspended from the ceiling that is rocked gently to and fro to the accompaniment of music. In another hall the *vasanta maṇḍapa,* the festival of spring, is celebrated.

There are several smaller shrines here—dedicated to Kankalamurti, Kailasanatha, Sasta, Ramasvami, Subrahmanya, Jayantisvara, and Kalabhairava. As in several other temples of this late period, this one contains "musical pillars" near the Kalabhairava shrine. They produce musical notes when tapped. Close to them is the *Kulasekhara maṇḍapa,* which contains two exquisite royal portraits. The *citrasabhā,* with stately elephants decorating its flight of steps, glorifies the dance of Shiva by representing him in *ūrdhva tāṇḍava* against a pillar, with corresponding representations of Brahma, Vishnu, Patanjali Vyaghrapada, Karaikkalammaiyar, and the always-challenging Kali. Vallabha Ganapati in a niche here is also an excellent sculpture. The temple also has many other mandapas: *Chaṁpakarāman maṇḍapa, Vīra Pāṇḍyan Maṇimaṇḍapa, Udaya Mārtāṇḍa maṇḍapa, Ṛishabha maṇḍapa,* and *Sabhāpati maṇḍapa.* The *Ṛishabha maṇḍapa* contains a huge bull which, with its thin white coat of plaster, looks as if it were made out of rice flour. It is one of the largest Nandi bulls in southern India. The monolithic Hanuman close to the *citrasabhā,* about seventeen feet high, is another interesting image here.

The sanctum of Shiva is called the Vadakkedam, and here the holy water that bathes the Shivalinga in the sanctum is believed to flow by way of an underground channel all the way to Kanyakumari and to empty itself in the ocean.

It should be noticed that many features of this temple—the musical and other pillars; the large-proportioned, meticulously detailed decorative work—recall the late Nayak work in several temples of the Tirunelveli District.

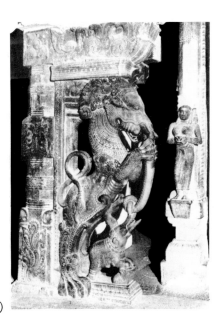

748. SUCHINDRAM. PILLAR DETAIL (YALI)

749. TRICHUR. TEMPLE OF VADAKKUNATHA

TRICHUR

In the town of Trichur there is a large and important shrine for Shiva—the temple of Vadakkunatha. Owing to its sanctity, this temple is sometimes called Tenkailasa, the "southern Kailasa." The main shrine of Shiva, Srikoil as it is known, faces west and is situated within a vast enclosure and is approached by prominent gopuras. Close to it there are several other temples including ones for Rama and Sankaranarayana. There are other smaller shrines dedicated to Krishna, Nandikesvara, Parasurama, and Sasta. All these, including the central one, are located in a quadrangular building of the Nalambalam style. This structure is made more impressive by the magnificent array of lamps which, when lit, illuminate the area with an almost celestial glow. Within the temple there is a large theater called Kuttambalam where the traditional drama of Kerala (*śākyar kūttu*) is performed. The exquisite ceiling of the Kuttambalam reveals the genius of Kerala wood-carvers. Though the shrine is an early one (it is even associated with Sankara, the great master of Advaita philosophy), the present structure dates only from the eleventh or twelfth century.

The wood carvings and the paintings are of great interest although they belong to the seventeenth century. Particularly interesting and important are the two large painted panels of Shiva as Nataraja and Vishnu as Seshasayi, both of which are very popular forms and are often shown together. One dynamic and the other static, they are expressions in art of the functions of the Almighty as creator, protector, and destroyer, the imposer of the veil of illusion, which he removes as his act of grace to vouchsafe salvation to the devotee.

750. TRIVIKRAMANGALAM. COURTYARD ENTRANCE

TRIVANDRUM

The Padmanabhaswami temple at Trivandrum is a happy blend of the Keralan style with that of the Vijayanagar, a union that is common from the Pallava period onward throughout the Tamil country. Like the early Chola gopuras, the tower of Padmanabhaswami is near a large tank; it is quite late, although it recalls an earlier style. Though the tower is imposing, it is shorter than other contemporary ones in the Tamil country. (The gopura at Madura, for instance, soars skyward.) There is a long colonnade—a corridor with terraced roof—from the vimana to the shrine inside. The pillars are decorated with fine carvings; of particular note is that of a damsel holding an oil pan. Beyond the corridor is the golden flagstaff with the symbol of Garuda on top. An impressive mandapa named after Kulasekhara follows the corridor and contains rich sculptural embellishments. Characteristic of Keralan temple architecture, the two-storied rectangular inner shrine is gable-roofed and the walls are covered with murals. The three doorways reveal the face, navel, and feet of the reclining figure of Seshasayi Vishnu, a magnificent representation of Padmanabha. Within the enclosure, there are minor shrines for Krishna, Kshetrapala, Sasta, Narasimha, Shiva, Ganesha, Rama, and Vyasa.

TRIVIKRAMANGALAM

Three miles east of Trivandrum is Trivikramangalam where there is an ancient temple of the eleventh century dedicated to Shiva. The shrine and the mandapa opposite are the usual Keralan type, but what is interesting here are the flights of steps that lead to the main shrine through the central entrance from either side. The side of the balustrade is decorated with a gaping makara head at the top and another at the bottom complete with floriated tail. Scenes of dance enliven the opposite panel on both sides. The danseuse and the instrumentalists sounding drum and cymbals form a well-composed group. Balustrade decoration is also found elsewhere in other similar early temples such as Kadangur, but this is one of the finest. Another noteworthy sculptural work here is a pair of granite door guardians of great elegance and movement.

(Figs. 559, 560)

751. VILINJAM. VIEW OF CAVE

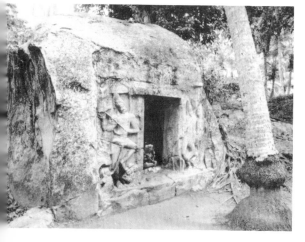

VILINJAM

Vilinjam, about twelve miles from Trivandrum, is the site of one of the oldest Chera rock-cut temples in Kerala. It is a small shrine, in the central cell of which is an independent sculpture of seated Vinadhara Dakshinamurti of about the tenth century. On two sides of this cell are unfinished panels representing Tripurantaka and Shiva dancing as Nataraja, with Shivakamasundari watching. Tripurantaka, carrying the bow and arrow in two of his four hands, is a fine example of eighth-century work. His left foot rests on Apasmara, the sacred cord runs over his right arm, the crown of hair is elegantly carved as a high headdress, and the necklet, earrings, waist cord, armlets, and bracelets make up the full gamut of ornamentation. One hand of dancing Shiva is in a gesture of protection; the other is across the chest, and the legs are crossed. The smile on the lips of Nataraja, a figure still half-carved, is very suggestive. It is interesting that the various forms of Tripurantaka had developed at such an early date. This representation, with the foot resting on a dwarf, is a precursor of a similar type in metal of the time of Rajaraja, who presented it to the Brihadisvara temple. It is now displayed in the Tanjore Art Gallery.

MADHYA PRADESH

BHARHUT

Bharhut in former Nagod State in central India is famous for the remains of the balustrade that once enclosed the stupa and the toran there. It was rescued by Sir Alexander Cunningham and brought to the Indian Museum in about 1875. The stupa itself disappeared long ago, and the largest section of the balustrade that was still intact was moved from here, but several more sculptures, uprights, crossbars, and coping pieces from it have been found here even in recent years and enrich a whole gallery of the Allahabad Museum. There was originally a great deal of sculpture that had been part of the balustrade, but villagers unknowingly used it as building material for their homes. It is these pieces that were recovered and dispersed to museums; they form an important source for the study of Sunga art. Some of the latest discoveries are in the National Museum in New Delhi and the Prince of Wales Museum in Bombay.

The Bharhut balustrade and the toran are both richly decorated, unlike some others. (At Sanchi, for instance, only the torans are embellished.) Bharhut sculpture has revealed several scenes from Buddha's life and the Jatakas and amply testifies to the early date and authenticity of Buddhist texts. The titles of the themes are sometimes at variance with what is known in the Jataka although the text is normally the same. This is particularly interesting since the variances are of the second century B.C.

Besides an inscription of Prince Dhanabhuti, made when the Sungas were the rulers of the realm, the date of this important monument is clearly indicated by the early archaic style of its sculpture—the representation of Buddha in symbolic form, of earlier Buddhas, each with his own individual tree, and of the visit to Buddha by prominent contemporary kings. The frontality in the carvings is noteworthy, as is the undeveloped and somewhat crude style of the local type that developed simultaneously with court art, which had advanced more rapidly (by the time of Asoka, a century earlier, it had incorporated foreign influences). The popular objects of worship we see, such as the chaitya tree, dryads, yakshas, and nagas, and the scenes of daily life make this monument from the earliest historical period most fascinating.

(Figs. 77–79, 95, 244–46, 321, 361, 405)

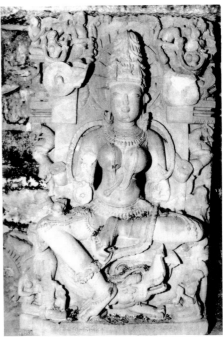

752. BHERAGHAT. YOGINI

BHERAGHAT

Bheraghat, thirteen miles from Jabbalpur, is famous for a curious, large tenth-century temple composed of a circular pillared series of cloistered mandapas that contain the sixty-four yogini figures. Yogini shrines are very common in this area, and the many figures here, enshrined on a running platform of the thick wall, make this an excellent example. Although the architectural features here are not of much significance, the sculptural excellence of the figures, typical of Chedi or Haihaya work, make it important for a study of this phase. The carved descriptions on the sculptures and other inscriptions here offer some clue to their date. While the labels on the sculptures look early, an inscription offers evidence of the existence of an original shrine that was rebuilt by Queen Alhanadevi during the reign of her son Narasimhadeva in about 1155, and discoveries of Kushan images indicate that as a temple for yoginis and Matrikas it was famous even earlier. At any rate, the present series should be thought of as tenth century. But some of the dancing figures are definitely dated before the many seated ones, which are replacements for an earlier series.

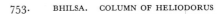

753. BHILSA. COLUMN OF HELIODORUS

BHILSA

Bhilsa, about five miles from Sanchi, is an ancient site representing Vidisa where Asoka was stationed as viceroy for some time. In the excavations conducted here by the Archaeological Survey, early Sunga sculptures were found such as the famous yakshi or Sri Lakshmi, the makara of a pillar opposite the temple of Kama (now lost), and the celestial tree that crowned a pillar opposite a temple of either Kubera or Lakshmi. All of these now are in the Indian Museum.

A large pillar in Beshnagar, not far from Bhilsa, is the Heliodorus column—here known as Khamb Baba. It stands on the northern bank of the Betwa River. It is especially important for its early Brahmi inscription describing it as a Garuda pillar set up by Heliodoros, a Greek who was greatly devoted to Vishnu and who had come to the court of King Bhagabhadra of Vidisa as an ambassador of Antialcidas, the king of Taxila. Heliodorus describes himself as a Bhagavata, and the pillar was set up in honor of Lord Vasudeva. Apart from

754. BHILSA. VIEW OF A CAVE

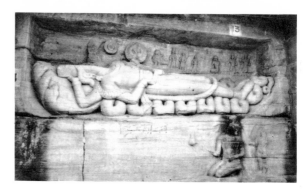

755. BHILSA.
VISHNU SESHASAYI
IN A CAVE

this inscription, there is a still more interesting piece of inscription that mentions three steps to immortality—sacrifice, control of senses, and alert exertion.

Also in the vicinity, in Udayagiri, there are early Gupta caves that are very interesting. Among these, some of which are Jain and others Brahmanic, there is one containing a large and monumental figure of Seshasayi Vishnu. The lintel of the entrance to another cave close to it has a pleasing carving of the gods and demons churning the ocean for ambrosia—Mount Mandara is the churning stick and Vasuki is the string. Another cave has door guardians on either side of its entrance: Vishnu with his hands resting on personified weapons of the earliest Gupta type with the *srivatsa* mark very prominent on the chest, and Mahishamardini Durga slaying the buffalo demon. Ganesha, with a single pair of arms and naturalistic elephant head in the utterly simple style of the fourth century, dates this entire group of carvings. An inscription here states that a minister of Chandragupta II was responsible for excavating the cave.

Most imposing, however, is the Varaha cave. It contains a representation of the therianthropic form of Vishnu as a gigantic Varaha in human form with animal head, raising Prithvi from the ocean. The ocean itself is suggested by ripples, and all the gods are assembled to witness the great event. The netherworld is suggested by the naga at the foot of the Varaha. Samudraraja, or the lord of the ocean personified, is represented four times to suggest the four seas. The goddesses Ganga and Yamuna in human form are shown standing on their respective vehicles against wavy lines composing the streams that commingle at Prayag and proceed farther to empty themselves into the sea.

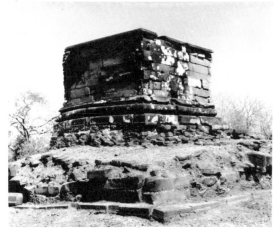

756. BHUMARA. RUINS OF A TEMPLE OF SHIVA

BHUMARA

At Bhumara, a village twelve miles west of Unchehra, are the remains of a famous Gupta temple of Shiva. In its present ruined state the temple, originally an elaborate one on a large platform, with a pair of smaller shrines on either side at its approach, gives us only a faint idea of its former glory. It has no second story; otherwise it is very similar to the so-called temple of Parvati at Nachna Kuthara. The inner shrine originally was enclosed by a circumambulatory passage and had a mandapa in front. A large number of carvings of Shivaganas in various comical attitudes were found here and are now in the Indian Museum in Calcutta and the Allahabad Museum. These undoubtedly once decorated the outer walls. The Ekamukhalinga that was enshrined in this charming temple is among the greatest masterpieces of Gupta art; there is only one other of its kind—in the Allahabad Museum. At the entrance to the shrine there are three elaborately carved horizontal bands. Two of them contain pleasing design patterns, while the central one contains a series of panels showing celestial beauties and other heavenly figures as well as loving couples at either end. With attendant figures holding an umbrella and celestials fluttering above, Ganga and Yamuna, on their vehicles, guard the gateway. A charming bust of Shiva with Vidyadharas flying toward him on either side with offerings is in the center of the lintel.

All that remains of the exquisite decorative work that once made this temple magnificent are circular windows with carvings of Indra, Brahma, Ganesha, Kubera, Kartikeya, Surya, Mahishamardini, and other deities; pieces of floral decoration and meandering wish-fulfilling creeper with figures of Ganas intertwined; and bits of arabesques, half-lotus medallions, and makaras. The pillars and pilasters with half-lotus and vase-and-foliage motifs, lion heads with pearl tassels issuing from their mouths, and other motifs eloquently proclaim the sculptor's enthusiasm. And the temple was not lacking in appropriate figurative sculpture. The pair of figures that originally guarded the shrine, now preserved in the Indian Museum, show Gupta art at its best. There is also a dainty carving of Ganesha in this shrine showing him with a single pair of arms, the circle of light, sacred cord, and garlands and anklets with tinkling bells.

(Fig. 257)

757. CHANDREHI. VIEW OF SITE

CHANDREHI

Chandrehi is noteworthy for a very early Shiva temple and a monastery. An inscription in the latter fixes the date of both. The inscription, which is by Prabodhashiva, a Shivaite ascetic of the Mattamayura clan and spiritual preceptor of the Chedi or Haihaya rulers, clearly states that the monastery was built "close to the house of the gods" by his spiritual preceptor. The monastery was complete in 972, so the temple should be dated some-

what earlier—about 947 according to R. D. Banerji. The temple, built on a high platform, is large. There is a circular sanctum, a mandapa in front, another enclosed hall, and a vestibule. It has an imposing ribbed shikara and the roof of the mandapa is pyramidal. The vestibule is very elaborate with a large, highly decorated chaitya window arch that enshrines a dancing figure of Shiva Nataraja in its niche. Although the carvings here are not the very best of the Haihaya, the early date of this monument helps us to understand the beginnings of this school, and therefore it is important.

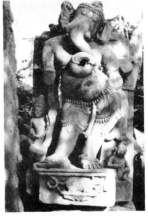

758. GURGI. GANESHA

GURGI

Gurgi, twelve miles from the town of Rewa, has enormous ruins that indicate how important a place it was during the height of the Haihaya period. A temple with a circular shrine as at Chandrehi is believed to have been built by Raja Karna of Dahala. An inscription found here mentions the spiritual genealogy of the ascetics of the Mattamayura clan who were brought to Dahala by the Chedi kings from western India to inspire Shivaism in their kingdom. As this inscription is closely related to the one at Chandrehi, this site should probably be dated tenth century. This temple, dedicated to Isvara or Mahadeva and close to a larger one also for Shiva built by Yuvarajadeva, is specifically mentioned as having been built by Prasanta Shiva. A number of images commissioned by Prasanta Shiva—such as Uma, Umamahesvara, Kartikeya, Ganapati, Sarasvati, and others—in the smaller temples close by are also described. The large mound here called Gurgaj has yielded monumental sculptures of Durga, Haragauri, and others.

But the most important of all is the great toran. Originally it was in front of the Shiva temple, but it now stands before the palace at Rewa. The inscription tells that Yuvarajadeva built a temple tall enough to rival the Kailas Mountains, and the toran is indeed worthy of such a temple. The toran is a magnificent one with polygonal elaborately carved jambs that support an equally elaborate lintel. The main theme of the second frieze (below the flying Vidyadharas) is the marriage of Shiva. We see a large procession of celestials on the march toward the Himalayas, the marriage of Shiva to the princess, and the return home to Shiva's own abode of the wedded pair on the back of the Nandi bull. The jambs on either side have repeated bands of elegant panels showing celestial beauties in various attitudes separated by slender circular pillars. Bands of sprightly caryatid dwarfs proudly support this lively burden. The topmost panels exhibit dancing Ganesha, Ardhanarisvara, Brahma, and other deities. The makaras on the lintel—arranged in four semicircular bands immediately below the long marriage procession and above a row of "face of glory" masks—are holding a charming streamer of pearl tassels in their mouths. The makaras are flanked by more celestial beauties and musical figures with equestrian carvings between.

759. GURGI. VIEW OF SITE

GYARASPUR

Halfway between Udaipur and Bhilsa is Gyaraspur, where the Maladevi temple, a very large and picturesque monument on the slope of a hill, is an arresting sight. It is a massive temple with an entrance porch, hall, and shrine with a circumambulatory walk. The lofty shikara is beautifully decorated. It was originally a temple for Devi as is clearly indicated by her image on the outer doorframe and other associated images all about. Although it is now converted into a Jain shrine, some of the figures of nymphs arranged in tiers on the outer side of this typical Pratihara monument are extremely beautiful.

(Fig. 91)

KHAJURAHO

Khajuraho, twenty-five miles north of Panna and twenty-seven miles east of Chhatarpur, is an important spot because of the exquisite temples built there by the Chandellas. The Chandellas—or Chandratreyas, as they are known from inscriptions—trace their origin to the moon through the legendary Chandravarman. Harshadeva, who ruled at the beginning of the tenth century, slowly built up his kingdom with centers at Khajuraho, Kalanjara, Mahoba, and Ajaigarh. The early Chandellas were devoted to their Pratihara sovereign and when, toward the end of the century, Mahipala was restored to the throne, the Chandellas enhanced their prestige. They commanded the respect of neighboring dynasties—such as the Chahamanas and the Kalachuris—who became allied with them. In the Rashtrakuta attacks against the Pratiharas, the Chandellas stood by their sovereign. In the time of Dhanga, who came to power in 950, the power of the Chandellas was at its zenith. It was then that the most beautiful and imposing treasures such as the Kandariya Mahadeva, Devi Jagadamba, Chitragupta, Visvanatha, Parsvanatha, and the Vamana temples, were built. (The Lakshmana and Chaturbhuja temples had been constructed earlier by Yasovarman.) Very liberal in outlook, Dhanga also had Jain temples constructed, including the ones of Parsvanatha which have an inscription of his time. In the beginning of the eleventh century, the Chandella king Vidyadhara was powerful enough to be a match for Mahmud of Ghazni. But by the middle of the eleventh century Devavarman, the grandson of Vidyadhara, was overcome

760. GYARASPUR. VIEW OF TEMPLE

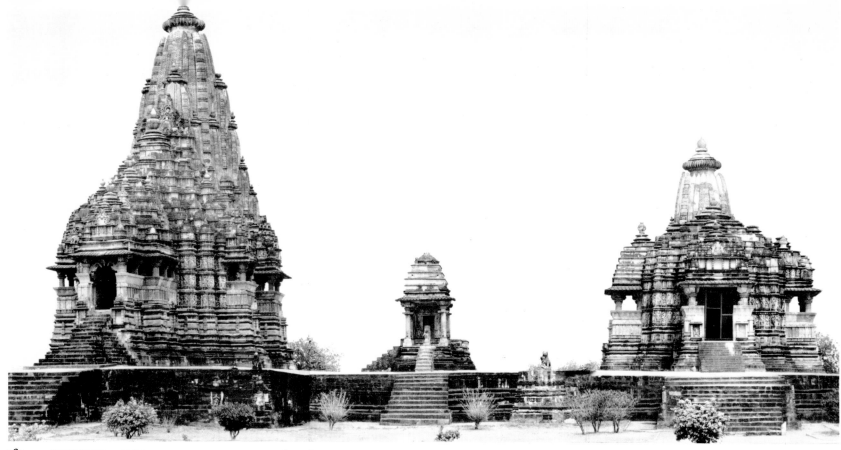

761. KHAJURAHO. KANDARIYA MAHADEVA TEMPLE (LEFT) AND DEVI JAGADAMBI TEMPLE (RIGHT)

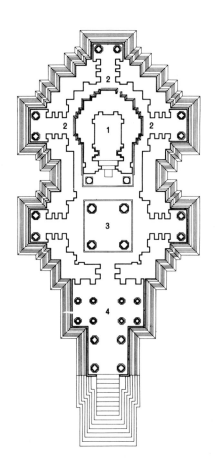

762. KHAJURAHO. GROUND PLAN
OF KANDARIJA MABADEVA TEMPLE.
*1—garbhagṛha; 2—pradakṣiṇapatha;
3—maṇḍapa; 4—ardhamaṇḍapa*

by his own brother Kirtivarman, who ruled for many years and to an extent consolidated power. Kirtivarman is especially remembered as the patron of Krishnamishra, the poet who wrote *Prabodhachandrodaya*, an allegorical Sanskrit play. Except for his son Sallakshanavarman, Kirtivarman's successors were of no great consequence, and Muslim inroads, including that of Mohammed of Ghor, crippled the dynasty. Viravarman was one of the last of the Chandellas, and the end of the thirteenth century brought the end of their power.

The Khajuraho temples are cruciform in plan with the long axis from east to west. Built of buff sandstone from the quarries of Panna, they have a soft texture and a most pleasing color. The temples usually rise on high terraces. They are composed of an inner shrine, an assembly hall or mandapa, and an entrance portico. There is also usually a circumambulatory passage. The pyramidal roofs of the main vimanas of the inner shrines leap upward with series of small turrets clustered around the main shikara to finally reach the large amalaka or ribbed ringstone, surmounted by the rain vase and finial. The entrances are to the east, and one approaches by way of long flights of steps that usually have intricately carved torans. Inside, the main halls with four pillars in the center have transepts on either side and the circumambulatory passage leads out onto several balconied openings. Each sanctum has the characteristic semicircular "moonstone" doorstep. Some of the temples at Khajuraho are a cluster of five shrines—the main temple surrounded by four others at each corner.

Evidence of the genius and magic of the sculptor is seen everywhere—in the iconographic detailing of the deities, in the sculptural record of the battles, marches, and festive processions of a thriving empire, in the innumerable depictions of love and passion, and in the delicate workmanship of the cusped and coffered ceilings. The nymphs, celestial beauties, loving couples, horned lions, and dwarf demigods are all examples of the best of medieval work.

KANDARIYA TEMPLE: To the north of the Chaunsat Yoginis, this is the most important temple here. The Kandariya temple is the largest and probably the best from the point of view of the study of Chandella architecture. It once had five shrines but the corner ones have disappeared; however, all the important parts remain. The toran at the entrance is most beautifully carved and enlivened by such themes as musicians, various forms of the deity, makaras, loving couples, and so forth. The ceilings of the mandapas are equally rich. The doorway of the sanctum has very fine carving in addition to the figures of Ganga and Yamuna on their vehicles. A Shivalinga is enshrined in the sanctum and on the outside wall of the sanctum are the guardian figures of the eight quarters. On the main outside wall there is a wealth of sculpture—various iconographic forms as well as nymphs, celestial beauties, loving couples. On the richly carved pillars, the brackets are celestial beauties.

MAHADEVA TEMPLE: Standing between the Kandariya and Devi Jagadambi temples, this temple is in ruins. Although the main shrine is lost, the richly carved portico is interesting for the figure of a lion being attacked by a prince—an emblem of the Chandellas.

DEVI JAGADAMBI TEMPLE: This is really not a temple of a goddess. It was originally dedicated to Vishnu, and his image is carved on the entrance. It has lost its original four subsidiary shrines and it lacks the surrounding passage. The decorations are not much different from those in the other important temples.

CHITRAGUPTA TEMPLE: A short distance from Devi Jagadambi is this temple dedicated to Surya, whose figure is still in the sanctum. He is shown wearing top boots and his chariot is drawn by seven horses. The presence of the Surya image on the lintel of the doorway is also an indication that it is a solar shrine. The

462

temple is most interesting as on its plinth there are fine representations of fighting warriors, processions of elephants and cavaliers, scenes of the hunt and the dance, and the playing of music. Of great interest in one of the niches is an image of Vishnu with eleven heads, each depicting one or another of the ten incarnations.

VISVANATHA TEMPLE: This temple is dedicated to Shiva and closely resembles the Kandariya. The feminine figures on the brackets of pillars in the mandapas, as well as other celestial nymphs carved on the outer wall of the sanctum, are exceedingly lovely. The most noteworthy of all is the woman playing the flute with her back to the spectator. Another fondles a child; a parrot rests on the wrist of a third. Also one of the most beautiful and colossal figures of Nandi is here in what is known as the Nandi shrine.

PARVATI TEMPLE: This temple, to the southwest of the Visvanatha, was originally intended for Vishnu, as one can tell from his figure on the lintel of the doorway to the shrine. The Ganga on the doorway is often mistaken for Parvati.

LAKSHMANA OR THE CHATURBHUJA TEMPLE: Similar to Visvanatha, this is a five-shrined temple with an elegant entrance toran. The sanctum houses an image of Vishnu in his Vaikuntha aspect, four-armed and three-headed. Lion and boar heads flank the main face. The inscription here records that it was built by Yasovarman (also known as Lakshmanavarman) in the time of Dhanga to house the image obtained from Devapala, the Pratihara king of Kanauj.

VARAHA TEMPLE: Located in front of Matangesvara, this temple holds a colossal monolithic representation of Varaha with the bristles of its body composed of such gods of the pantheon as Shiva, Vishnu, Brahma, the Navagrahas, the eight Dikpalas, Ganga, Sarasvati, and so forth.

CHAUNSAT YOGINI TEMPLE: This is the only temple at Khajuraho built entirely of granite and dedicated to the sixty-four yoginis—the goddesses who wait on Devi. A large courtyard surrounded by sixty-five cells enshrines the yoginis and the principal goddess.

Though there are several temples such as the Brahma, Vamana, and Javari that are of no great consequence, there are other interesting monuments in this great architectural center of the tenth, eleventh, and twelfth centuries. Duladeo, also dedicated to Shiva, has superb carvings of the flower-gathering-girl motif on

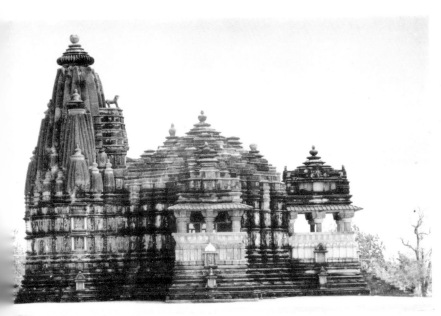

763. KHAJURAHO. TEMPLE OF CHITRAGUPTA

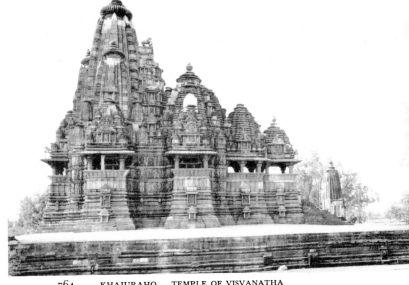

764. KHAJURAHO. TEMPLE OF VISVANATHA

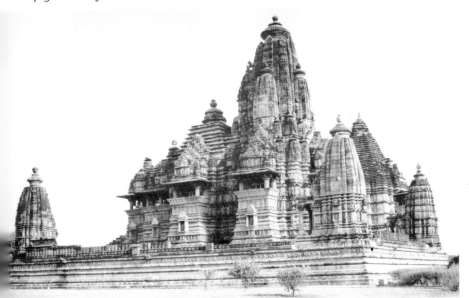

765. KHAJURAHO. TEMPLE OF LAKSHMANA

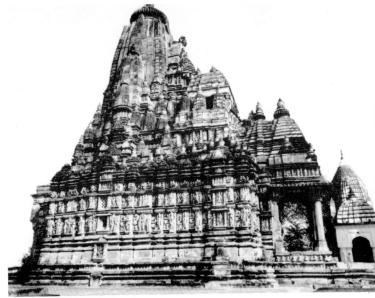

766. KHAJURAHO. TEMPLE OF PARSVANATHA

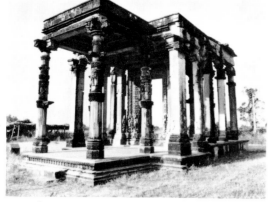

767.　KHAJURAHO.　TEMPLE OF GHANTAI

the capitals of the pillars in the transept and other strikingly conceived and executed carvings. The Jatkari, or Chaturbhuja, temple houses a large image of four-armed Vishnu, and has fine carvings of Narasimhi, Shiva seated on a bull, and Ardhanarisvara—the most striking of the themes in the long frieze on the outer walls.

Among the Jain temples situated to the southeast of Khajuraho, the Parsvanatha is the most important and has great sculptural wealth, particularly on the miniature balconies with sloping balustrades and in several friezes elsewhere. The Ghantai temple is so called because of the bell-and-chain ornament on its pillars.

A site museum recently opened here by the Archaeological Survey houses other examples of excellent Chandella art.

(Figs. 38, 143, 577–95)

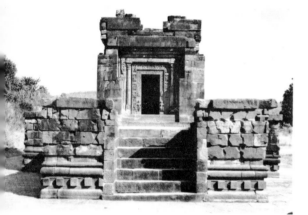

768.　NACHNA.　TEMPLE OF PARVATI

NACHNA

Nachna Kuthara is an important site famous for its so-called Parvati temple which, like other early Gupta temples, is simple and elegant. Though now in ruins, most of the original plan is there. The sanctum is square with a covered circumambulatory around it, dimly lighted by pierced windows on three sides. A porch in front is reached by steps. The Nachna temple has an exquisitely carved doorway as well as figure carving and interesting designs on the window frames and elsewhere. The pilasters exhibit the vase-and-foliage motif and half-lotus medallions on their cubical, octagonal, and polygonal sections. There are two broad bands on the inner framework of the doorway. The first presents guardian figures with frizzy hair arranged in the most pleasing fashion dropping toward one side as in most Gupta figures. They have only a single pair of arms and carry the trident. It is interesting that each is provided with a large halo and a dwarf attendant with hands crossed in reverence as a mark of respect and attention. Higher up, all along the jamb and continuing on the lintel is the wonderful floral decoration for which Gupta sculpture is famous. The motif is the celestial wish-fulfilling vine issuing from the navels of dwarfs undoubtedly intended for Sankha and Padma on either side of the jambs. In the second band, Ganga and Yamuna, umbrella held over them, stand on their respective vehicles. Above them are flying Gandharvas with panels above glorifying the loving-couple motif. The lintel shows Vinadhara Shiva seated in the center with Parvati beside him and various attendants and Vidyadhara pairs approaching reverentially. On the walls of the temple there are beautifully decorated bands of dwarf demigods and forms of Shiva—Vamadeva dancing, Ganesha, and other themes.

A special feature of this temple is the upper story, which is lacking in decoration. It is thus similar to the earliest temples in the Deccan, such as the Lad Khan, Kont Gudi, and Meguti at Aihole.

The other temple here is the Mahadeva which is also a square shrine with a very elaborate doorway—another magnificently carved framework composed of several richly sculptured bands projecting one beyond another. The first and simplest band is of a floral design with panels of loving couples on the jambs. In the second and more prominent band Seshashayi Vishnu is flanked on either side by figures of musicians. The final band contains several panels showing the various forms of Vishnu in his avatars such as Varaha, Narasimha, Vamana, and Trivikrama, and including many of the sports of Krishna.

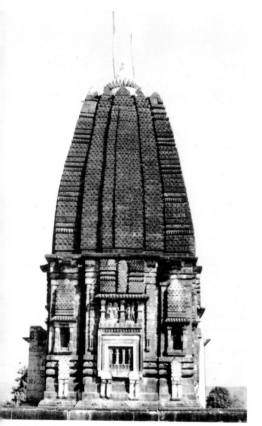

769.　NACHNA.　TEMPLE OF MAHADEVA

RAJIM

In Rajim, about thirty-two miles from Raipur on the banks of the Mahanadi, there is a beautiful temple for Vishnu, here called Rajivalochana—"the beautiful-eyed one." It is the most important among those here. By studying this temple one can better understand the architecture of Mahakosala, a region bordering on Orissa, where the Sarabhapura sovereigns ruled as feudatories of the Guptas and Vakatakas in about the sixth and seventh centuries. A Nala inscription of about 700 here mentions this early medieval dynasty.

The Rajivalochana temple is of the *pañcāyatana* type—the main shrine surrounded by subsidiary ones at the four corners. The main shrine is for Rajivalochana, the others for Badarinath, Vamana, Varaha, and Narasimha. The Rajivalochana shrine is composed of a sanctum facing west overlooking the river, a vestibule, and a mandapa at the front. Flights of steps from the north and the south lead to the mandapa through small but beautifully carved side entrances. The mandapa, which was originally open, is supported by twenty-four pillars in rows of six each. The central rows are left freestanding while those at the sides have been turned into pilasters by walls built between them. Most of the pillars as well as the pilasters are beautifully carved with lifesize figures of celestials, nymphs, and dryads. The *dohada* motif—the maiden causing a tree to flower out of season—is excellently delineated. The scrollwork and the arrangement of loops and tassels of pearls and other designs on the pillars is masterly. The large entrance to the shrine is imposing, with its three wide sculpture-covered bands. There is scrollwork as well as panels of the loving-couple motif and gracefully intertwined nagas. The top of the lintel is decorated with Vishnu as Garudarudha surrounded by musical figures and attendants. The original shikara of the temple is lost, and the present roof of the temple, along with some other additions including the doorways in the walls of the mandapa, must be dated later. The raised outer wall and a large entrance with Anantasayana Vishnu on the serpent couch adorning the lintel are also later additions.

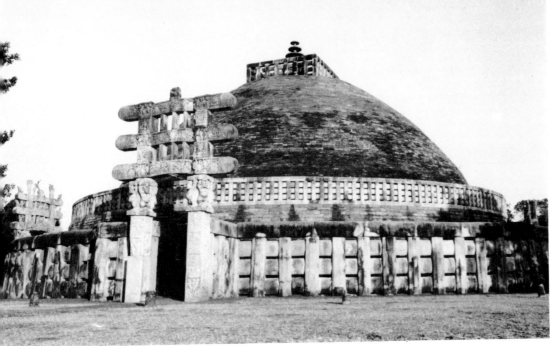

770. SANCHI. WESTERN TORAN OF STUPA

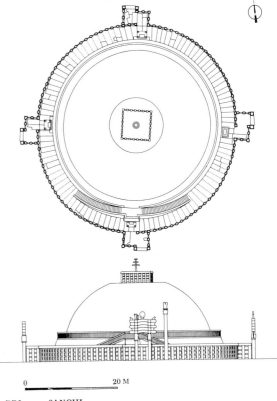

771. SANCHI.
GROUND PLAN AND ELEVATION OF THE GREAT STUPA

Among the magnificent sculptures in this temple that are contemporary with the original structure are: the famous Trivikrama with foot thrown into the mouth of Rahu and the great Sesha Naga adoring him from below; Vamana receiving a gift from the noble King Bali even against the wish of his preceptor Sukra; Yoga-narayana in meditation; and Narasimha destroying Hiranyakasipu.

SANCHI

Not far from Vidisa is Sanchi where one finds the most beautiful and best preserved of the early stupas—torans intact. From the very beginning Sanchi, at the confluence of the Betwa and Bes rivers, flourished as a center of trade. The early Gupta temple at Sanchi indicates that it was important during the palmy days of the imperial dynasty. Built by Asoka, Sanchi is not one of the major sites associated with Buddha, but it is noteworthy as the spot where Asoka, when viceroy at Ujjain, married the beautiful daughter of a merchant-prince and sired a son, Mahendra, by her. The principal stupa—No. 1, or the Great Stupa, as it is known—is a large hemispherical dome topped with a *harmikā* surmounted by three umbrellas. A double stairway on the south leads to a terrace forming a circumambulatory passage just above the base. On the ground level between the outside railing and the stupa itself is a wide processional path. A casing of stone was added to the original structure during the time

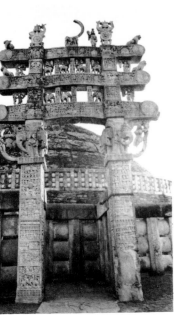

772. NORTHERN TORAN

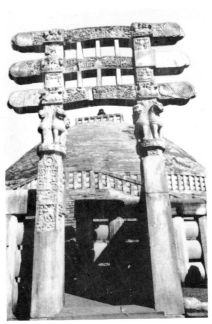

773. SOUTHERN TORAN

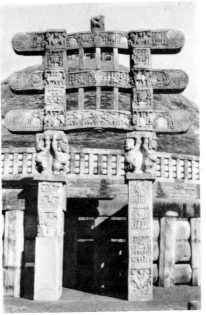

774. WESTERN TORAN

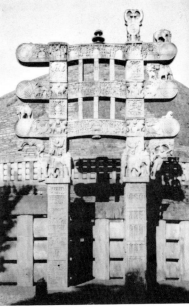

775. EASTERN TORAN

776. SANCHI. GUPTA TEMPLE

777. SANCHI. AMBULATORY

of the Sungas when stupas No. 2 and No. 3 were also built. A little later, the Satavahanas, who triumphed here, added elaborately carved torans to stupas No. 1 and No. 3. At stupa No. 1 the double flight of steps with balustrade, the processional path, the *harmikā* on top, and the umbrellas are all later additions as well.

The large railing all around the Great Stupa is severely plain and simple with all the artistic work concentrated on the torans. The ivory carvers of Vidisa, who formed a famous guild here and who are mentioned in an inscription on the southern toran, worked delicately in stone and ivory and produced a wonder of art. Each of the gateways has three curvilinear architraves set one above another, separated by cubelike blocks that are visually part of the square pillars on which the torans stand. There are also sets of three smaller supports between the architraves themselves. There are lovely bracket figures on either side immediately below the lowest architrave. The tops of the square pillars have magnificent caryatid figures of elephants, lions, riders, banners, and festoons that add richness to the overall design. The volutes and the panels depicting various themes on the architraves themselves—both outside and in—make them most interesting. There are scenes from the Jatakas and events from Asoka's life in addition to large sculptural representations of princely figures. Also imposing are representations of events such as Maya's dream, the Master's turban, and the offering of honey by a monkey at Vaisali. Mara's birth and his enlightenment, the turning of the Wheel of Law and the great disease, the worship of Siddhartha's temptation, the conversion of the Jatilas and some of the miracles performed by Buddha are also depicted with great zest. A royal procession is splendidly represented in the scene of Prasenajit's visit. Of events after Buddha's death, the incident of the Ramagrama stupa, which Asoka tried unsuccessfully to open, and the emperor's visit to the bodhi tree are especially noteworthy. All of the symbolic representations of Buddha here are worthy of special notice, since at this time Buddha had not yet been pictorially represented.

Not far away are the other stupas. No. 2 is interesting for the relief carvings on the pillars of its balustrade which clearly indicate an early date—second century B.C. There are fanciful animals such as the elephant with the fishtail, makaras, griffins, *kinnaris* with equine faces, yakshas, yakshis, horsemen, lions, and elephants—all carved in the early primitive style. Such symbols as the Wheel of Law and the bodhi tree are repeated. This stupa yielded the bodily relics of Buddhist masters such as Kasapagota, the teacher of all the Himalayas, Vachhiya-Suvijayata, and others. Stupa No. 3 is famous for the bodily remains that have been found in reliquaries inscribed with the names of Sariputa and Mahamuggarlana, the foremost disciples of Buddha. In addition there are four less important stupas and temples which show more work of the Gupta sculptor at this famous Buddhist spot.

(Figs. 2, 96, 190, 249, 411–15)

SIRPUR

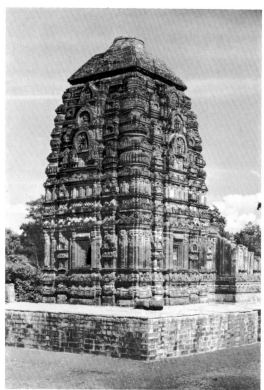

778. SIRPUR. LAKSHMANA TEMPLE

Sirpur, on the Mahanadi River in the Raipur District, is an important site because it was the capital of the kings of Sarabhapura and their successors in Dakshina Kosala. It was an important center of Buddhism from the sixth to the tenth centuries, and was visited by Hsüan Tsang, the seventh-century Chinese pilgrim-scholar. Excavations have revealed two brick temples of Buddha with an adjoining monastery that had cells arranged around a long, open central court. Both temples house enormous images of Buddha in the earth-touching gesture, flanked by Avalokitesvara and Vajrapani. An interesting feature of these large Buddha figures is that they are composed of individual carved blocks in much the same way as the carved panels at Borobudur. As they are made of delicate sandstone, many of the details have suffered from the wear and tear of centuries. The image of seated Manjusri—made of chlorite, a harder material—gives an idea of the delicacy of the carving of this period. This must be compared with a large number of bronzes here, very pleasing and probably the most interesting of their kind, cast in the lost-wax process in a distinctive style peculiar to this region. They rank with the best from Akota in western India or Nalanda and Kurkihar in eastern India, and the name of the sculptor Dronaditya in letters of the eighth century makes them all the more important.

But the most important monument of all at Sirpur is the large brick temple for Vishnu, known as the Lakshmana temple. Constructed by Vasata, the queen mother of Mahashiva Gupta toward the close of the seventh century, it ranks with other similar but earlier brick temples at Ahichhatra and Bhitargaon, and it shows that even in the time of the Vardhanas and still later this style continued. Although the amalaka is now lost and the shikara was reconstructed at a much later date, giving an incongruous appearance at the top, the temple—with pronounced vertical bands; carved bricks representing the chaitya arch, the brimming pitcher, and other motifs; stately *kūḍu* arches rising story after story, higher and higher; and horizontal undercut at various stages—is a stately monument. There are false windows of terra-cotta that decorate the temple on all sides, and the stone entrance to the sanctum is magnificent and monumental. It is composed of at least four bands, one with a rich decorative foliage design issuing from vases of plenty, another of loving couples and dwarfs. The lintel holds a magnificent Seshasayi Vishnu group with his consorts seated at either end, and beyond a band of a meandering wish-fulfilling creeper design the top lintel has a number of panels illustrating mighty heroes fighting. The mandapa in front, which originally had rows of pillars and pilasters dividing it into a nave flanked by aisles, has some remains of excellent sculpture. Among the original sculptures still preserved in the temple are Vishnu flanked by Ayudhapurushas and Krishna seated on a naga. Along with Vishnu on Garuda, now in the Gandharvesvara temple at Sirpur, these sculptures can be compared with the carvings in the Rajivalochana temple at Rajim, not only for their aesthetic quality but also for their workmanship.

779. SOHAGPUR. TEMPLE VESTIBULE

SOHAGPUR

Only two miles from Sahdol, Sohagpur in the former state of Rewa has a beautiful Haihaya temple dedicated to Shiva as Viratesvara that bears close resemblance to the Khajuraho temple. It has a square sanctum, a vestibule, and a large enclosed hall in front which originally had a beautiful pyramidal roof. (This type of roof is common in this part of the country and is seen in other temples as at Amarkantak and Chandrehi.) Standing on a very high and richly decorated plinth, with a dwarf wall running the whole length of the mandapa except where steps lead to the porch connected to the mandapa, the temple has an affinity with Chandella, Chauhan, and Paramara monuments. The vestibule here is elaborate as at Chandrehi. The dome of the mandapa rests on an architrave supported by eight double pilasters. From the projecting arms of corbeled capitals, there are charming caryatids of celestial figures. The dome rises in tiers, and the intricate design and workmanship add greatly to its character. On either side of the front hall openings lead into projecting windows that have seats and back rests. This temple has elegant carvings on the walls, which distinguish it as a monument worthy of study for the understanding of Haihaya sculpture. The doorway leading to the vestibule is elaborate and fully decorated. There are nagas and door guardians with attendant female figures in addition to representations of Sarasvati and Durga, Shiva and Brahma, and Ganga and Yamuna on either side prominently shown in their positions as attendants of Shiva. Shivaganas are carved above the moldings of the plinth of the inner shrine, and several loving-couple groups are found here as at Khajuraho. Among sculptures decorating the niches, one of multiarmed Shiva dancing is particularly interesting, as is seated Parvati in the niche immediately above. There are also many beautiful celestials here as elsewhere. One pulls a thorn from her leg, another decorates her braid; others apply crimson powder with a mirror in hand or indicate leisurely ease by the attitude of the arms together over the head. One has just emerged from the bath and draws her garments closer around her waist.

(Figs. 599–604)

780. SOHAGPUR. VIRATESVARA TEMPLE

TIGAWA

In Tigawa, about 150 miles from Sanchi, there is a very early Gupta temple that has greater vitality and probably higher architectural quality than the similar temple at Sanchi. While this one is Brahmanic and that at Sanchi is Buddhist, the same principles of architecture apply to both. As is usual in early Gupta temples, there is great simplicity and restraint; the dimensions are very modest. It consists of a characteristic flat-roofed sanctum with a porch in front—a hall with four pillars for the facade. At the left of the hall is a projecting wall which contains a large carved panel. The pillars themselves are rather simple and severe—cubical at the base, then octagonal and polygonal, with vase-and-foliage motif immediately below the cubical top. Horseshoe-shaped designs decorate the large abaci and atop them, supporting the architrave, are pairs of caryatid lions back to back, so arranged that the heads at the four corners are common to the eight bodies portrayed on the sides. The entrance is beautifully carved with floral design and prominently displays the personified river goddesses Ganga and Yamuna on their respective vehicles. There are pilasters against the front wall of the shrine itself, with a large entrance leading to the cell in the center.

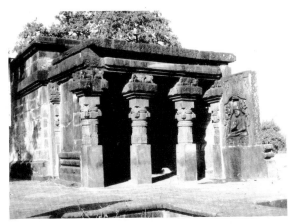

781. TIGAWA. VIEW OF TEMPLE

UDAIPUR

A little more than twenty miles from Bhilsa is Udaipur, where the great Udayesvara temple, built by the Paramara king Udayaditya between 1059 and 1080, stands. Like his predecessor Bhoja, a great artist and engineer who created the great Bhojasagara reservoir, Udayaditya also excavated a huge tank—the Udayasamudra. The temple of Udayesvara is named after him as is the city of Udaipur itself.

The temple is large with rectangular projections facing the cardinal points with parapets all around. There is a central cell, three entrance porches, and a long hall. On each side the entrance is reached by a flight of steps that have guardian figures; the original entrances on the other three sides are now closed. The large semicircular niche, decorated with the figure of multiarmed Shiva dancing, with panels below illustrating the dance of Sarasvati and Parvati, is a masterpiece of Paramara art and gives an imposing appearance to the vestibule projection on the facade of the vimana of the main shrine. The other carving on the temple's exterior, which is completely covered with decoration except for the main entrance, is also extremely interesting and

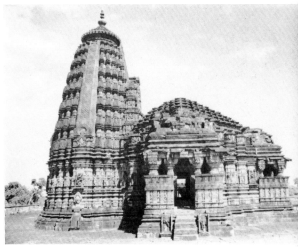

782. UDAIPUR. UDAYESVARA TEMPLE

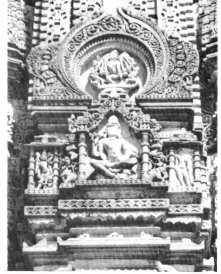

beautiful. There is a wealth of Brahmanic iconography, such as the Dikpalas, Ganesha, Kartikeya, Durga, Shiva, Brahma, and Vishnu, in addition to celestial beauties, loving couples, and other such themes. The pyramidal roof of the mandapa with the tall and imposing shikara of the main temple behind it produces a gorgeous effect. Near the shikara there is an interesting carving believed to portray the architect who planned the monument. It has also been thought to be the royal donor reaching for heaven—through such godly work as the construction of this temple.

There were originally eight smaller shrines around this temple, two of which are now completely lost while the rest are in a sadly ruinous state. The shrine in front of the main temple had a pyramidal roof and was probably intended for a Nandi which is now lost.

MAHARASHTRA

AJANTA

The famous monastery and temple caves of Ajanta are sixty-seven miles from Aurangabad and about thirty-four miles from Jalgaon. Dug from living rock, there are about thirty altogether, in different stages of completion—some unfinished, others covered with finicky detail and completely embellished with wall paintings.

The earliest, Caves 9 and 10, are contemporary with early caves like Bhaja and Pitalkhora in western India. The rest of the caves are Vakataka. The group as a whole, carved into the semicircular scarp with a stream running by, is a very impressive sight.

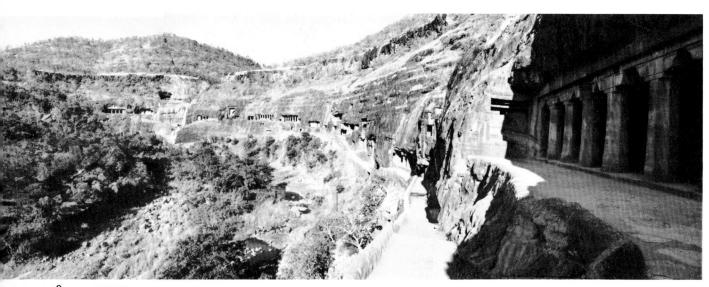

784. AJANTA.
VIEW OF CAVES FROM CAVE 2

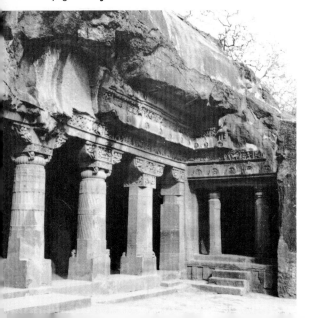

785. AJANTA. CAVE 2

Cave 1 is a fine vihara. Its pillars are exquisitely carved, with decorative fluting and brackets rich with figure sculpture including caryatid dwarfs. Under the cornice there is a long frieze of elegantly grouped men and animals. Among the sculptures here are those representing the four incidents that turned the mind of Siddhartha away from worldly pleasures. There is also a sculptural fantasy of a group of four deer with one common head. In this cave, there are also several large wall paintings. One of them is the famous Bodhisattva—or Siddhartha as he should be correctly called, since with him is his consort Yasodhara with a lotus in her hand. And there is the large and beautiful fresco of the temptation of Mara. The miracle of Sravasti—to which Prasenajit, the king of Kosala, was a witness—is also here, as is the conversion of Nanda. Other Jatakas are also represented, such as *Sibi Jataka*, a tale of sacrifice; *Sankhapala Jataka*, the story of a Naga prince who was patience incarnate; *Mahajanaka Jataka*, about a prince who gave up worldly pleasures in spite of his queen who tried to entice him; and *Champeya Jataka*, about another Naga prince who practiced restraint. Also in this cave is the famous bullfight painting and what is believed to be a scene of the Persian embassy received by Pulakesin, the Chalukya king.

Cave 2 is also a vihara with a richly carved doorway and well-executed pillars. Here are the famous monumental sculptures of Panchika and Hariti. Among the paintings are those of the *Hamsa Jataka*, the search for the golden goose to discourse on the law; the *Vidhurapandita Jataka,* the wise minister of the king of Indraprastha, Vidhurapandita, from whose lips the Naga queen desired to learn about dharma; the *Ruru Jataka*, a story of a kindhearted and self-sacrificing golden deer; and the *Purnavadana*, a story from the *Divyavadana* narrating how Buddha converted Purna. There are also scenes from Buddha's life such as the dream of Maya, the birth of Siddhartha, and others.

Cave 3 is an incomplete vihara.

468

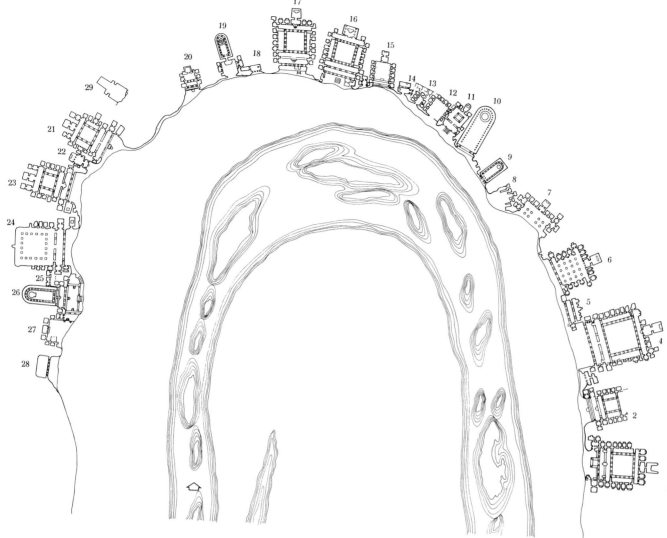

786. AJANTA. GROUND PLAN OF CAVES

Cave 4 is a large but unfinished vihara. It is supported by eight pillars and the main door has beautiful carvings of loving couples and young girls gathering sal blossoms. A colossal image of preaching Buddha flanked by the bodhisattvas Vajrapani and Padmapani is in the main shrine, along with other monumental figures of Buddhas. The wall paintings, however, have disappeared except for traces here and there.

Cave 5 is an unfinished vihara.

Cave 6 is a two-storied vihara. There is a makara toran above the door of the shrine. The wall paintings that originally adorned this cave have all disappeared; the cells at either extremity of the veranda enshrine Buddha. In the main shrine beyond the hall, Buddha is depicted expounding dharma.

Cave 7 is another vihara with its pillars resembling those of Cave 2. There are three cells, each enshrining a Buddha; there are also other standing Buddhas. The incident of the Naga Muchalinda and the miracle of Sravasti are carved here.

Cave 8 is a ruined domicile for monks.

Cave 9 is an apsidal chaitya with a long colonnade of twenty-three pillars creating a central nave with aisles on either side. In the apse is a carved stupa. This is an early cave with traces of wall paintings of about the first and second centuries B.C.

Cave 10 is also a chaitya with the usual votive stupa at the end of the apse. This cave is early and has an inscription mentioning the gift of the facade by Vasithiputa Katahadi. The important frescoes here are of the worship of the bodhi tree; the *Sama Jataka*, a touching story of a boy who supported his blind parents before they were killed, accidentally, by a king; and the *Chhaddanta Jataka*, a popular story of a kindly elephant that offered its tusks even to the wicked hunter who sought its life.

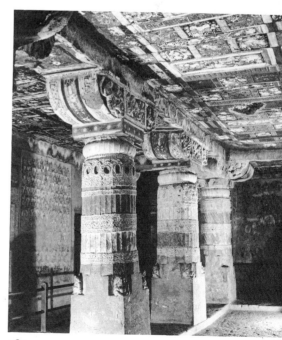

787. AJANTA. INTERIOR OF CAVE 2

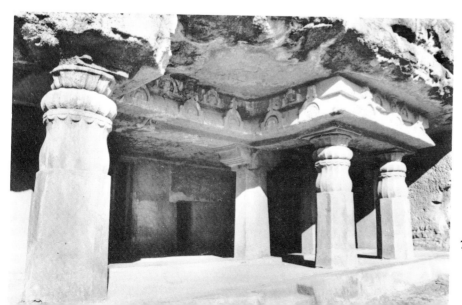

788. AJANTA. CAVE 7

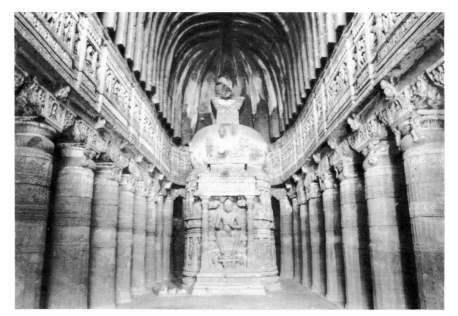

789. AJANTA. INTERIOR OF CAVE 26

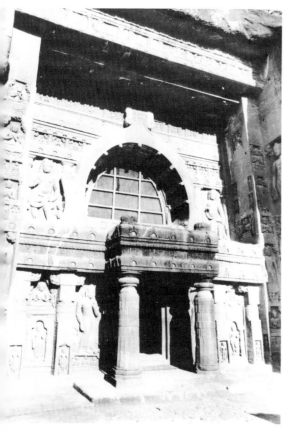

790. AJANTA. CAVE 19

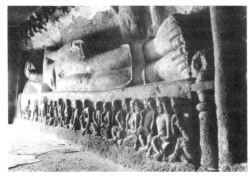

791. AJANTA. PARINIRVANA OF BUDDHA

Cave 11 is a somewhat ruined vihara and in its shrine there is a carving of preaching Buddha against an unfinished stupa. Among the damaged paintings here the one worthy of special notice is a rendering of a sculptural version of the quadruple deer fantasy found painted in Cave 1.

Caves 12 and 13 are *sangharamas* with cells, while Caves 14 and 15 are viharas. Cave 16 is a very beautiful vihara, not only elegantly executed but also important for an inscription mentioning Varahadeva, the minister of the Vakataka king Harishena, who built this cave. This revealing inscription describes the cave as being adorned with windows, doors, beautiful picture galleries, carvings of celestial nymphs, ornamental pillars and stairs, a shrine, and a large pool. The brackets of the elaborately carved pillars are adorned with celestial couples. The shrine has a monumental figure of preaching Buddha flanked by chowrie-bearers. The paintings here represent the story of the conversion of Nanda and the tragedy of his beautiful wife Sundari at her toilet; the miracle of Sravasti; the offering of Sujata; the incident of Trapusha and Bhallika; the plowing festival; the visit of sage Asita to see the newborn babe; Prince Siddhartha at school; and the dream of Maya. Among the Jatakas, the *Hasti Jataka, Mahamugga Jataka,* and *Sutasoma Jataka* are depicted.

Cave 17 is also a beautiful vihara containing an inscription of a feudatory of King Harishena. The pillars and doorway are elaborately carved and the capitals of the pillars are attractive. The murals here represent the seven former Buddhas. There is a series of Jatakas and *Avadanas* depicted here, all of which eulogize the great quality of sacrifice of the bodhisattva. The *Simhala Avadana* is a very impressive story that is narrated with skill here.

Cave 19 is a beautiful chaitya with the votive stupa at the far end. The pillars are elaborately carved with bracket figures of the girl gathering sal blossoms. The facade of the cave is exquisitely wrought with a lovely portico and a large and dominating chaitya window, with several Buddhas arranged all around. The most beautiful sculpture here is the seated Nagaraja with his consort attended by a female chowrie-bearer. Among the paintings is the famous Buddha with his begging bowl standing before Rahula and Yasodhara.

Caves 20, 21, 22, 23, 24, 28, and 29 are viharas while 26 is a chaitya. Cave 26 contains the elaborate and famous sculptures of the temptation of Buddha and his death and entrance into Nirvana. An inscription here mentions the monk Buddhapada, a friend of the minister who donated the temple.

The caves at Ajanta offer a unique opportunity to study Vakataka architecture, sculpture, and particularly painting.

(Figs. 108–14, 382, 469–82)

AURANGABAD

Aurangabad has a number of Buddhist caves in its vicinity, all of which belong to the Vakataka period except Cave 4, which is of the time of the Satavahanas, the second century A.D.

Cave 1, with its ruined and lost portico, has a veranda with eight beautiful pillars. Some have square bases and polygonal shafts surmounted by the pot-and-foliage motif and intricately carved capitals with rounded corbels. Others are square at the top and bottom, polygonal in the middle, with richly carved lotus medallions, half-medallions, and half lotus-and-foliage, clearly indicating their derivation from balustrade pillars of

the late Satavahana periods such as those found at Amaravati. Exquisite figure drawings, makaras with floriated tails, dwarfs and nymphs, loving couples, floral designs, and lions with riders are some of the other themes here. The vase-and-foliage motif is particularly well done. The center doorway on the veranda's rear wall shows the river goddesses Ganga and Yamuna at the top of the jambs and a naga and nagini at the base. The windows are decorated with carvings of loving couples. On the left wall on the outside of the veranda is a row of seven Buddhas, including the six predecessors of Gautama; inside is a seated Buddha with chowrie-bearers Avalokitesvara and Vajrapani. On the right wall of the veranda Buddha and his attendants are again found between the door and windows. To the left there is a Buddha seated on a lotus supported by nagas.

Cave 2 is a chaitya with a badly damaged front. Behind the veranda is a hall with beautifully carved square pillars and pilasters. The hall contains a shrine with a processional path around it. The entrance to the shrine has a frieze of miniature temples enshrining Buddha flanked by chowrie-bearers. At the base of the jambs are the personified treasures, Sankha and Padma. The magnificent guardian figures on either side are nearly double human size. One has a crown of matted hair and an antelope skin over one shoulder; the other wears a crown and is stately and regal in appearance. The chaitya on the crown indicates that he is Bodhisattva Manjusri while the other, with a Dhyanibuddha in his hair, is Avalokitesvara. There are rows of Buddhas, preaching or in the attitude of meditation, each flanked by chowrie-bearers. In the processional path, one

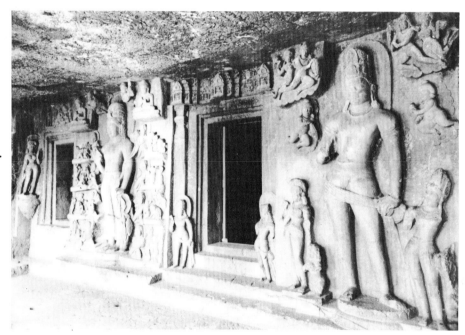

792. AURANGABAD. CAVE ENTRANCE

sees more figures of Buddha. On the left wall of the veranda is a large panel of seated Dhyanibuddha flanked by chowrie-bearers.

Cave 3 is a very fine example of a vihara. A large veranda which once had four pillars leads onto another veranda. The large wall beyond has twelve beautiful minutely carved pillars with square bases, polygonal shafts, and capitals with rounded corbels. The loving-couple scenes in the roundels on the capitals are interesting as is the figure carving on the bases. The entrance to the shrine is decorated with the Ganga and Yamuna motif at the top of the jambs and nagas at the base. The shrine itself has a huge carving of Buddha seated on a lion throne with his hands in the attitude of preaching. He is flanked by the chowrie-bearers Avalokitesvara and Manjusri. Pairs of celestials carrying garlands of flowers hover above.

Cave 4 is an early apsidal chaitya of the time of the Satavahanas with a barrel roof and seventeen octagonal pillars, most of which have fallen into decay. An interesting feature is that the rafters of the roof are all carved out of the rock to imitate wood. There is a solid but mutilated chaitya also carved out of rock, which once probably had a wooden umbrella crowning it. The great chaitya window, which would have given the facade an imposing look, is unfortunately now lost.

Cave 5 is a chaitya in poor condition, but the shrine and processional path have survived along with some carved panels of Buddha on a lotus supported by nagas. The shrine contains a large Buddha seated on a lion throne in the attitude of preaching.

Cave 6 has a number of monk cells and shrines. The veranda is damaged and all its four pillars are lost except for a fragment. The hall beyond has a cell at either end. The processional path enclosing the shrine has three cells on the right, three on the left, and two chapels to the back. These chapels are flanked by guardian

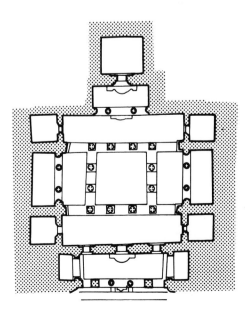

793. AURANGABAD. GROUND PLAN OF CAVE 3

figures. One, with a chaitya on his headdress, is Manjusri, and the other, holding a thunderbolt, is Vajrapani. Within the chapels, there is a seated Buddha in dhyana in one and expounding the dharma in another.

Off the entrance hall which leads to the main shrine, there is a small antechamber with two pillars and pilasters whose back wall shows Ganga and Yamuna on either side with the treasures Sankha and Padma personified below them. There are also monumental guardians on either side with attendant figures and flying celestial figures with garlands above. On the back wall of the main shrine is a large seated Buddha turning the Wheel of Law, flanked by Avalokitesvara and Manjusri. The sculptures, though of excellent workmanship, are unfortunately worn.

Cave 7 is the most distinguished of all. In conception and execution it is similar to Cave 6. There is an entrance porch with four pillars and two pilasters and a veranda beyond two chapels on either side, each with two square pillars and pilasters. In one of them are Hariti and Panchika, flanked by chowrie-bearers, the former with a child on her lap. In the other are a Buddha, a bodhisattva, and six Taras. The back wall of the veranda has a central entrance and flanking windows with the Gajalakshmi motif carved on them. The entrance is flanked by seated personified treasures Sankha and Padma and two large beautiful panels of Avalokitesvara and Manjusri, the former wearing a crown of hair, the ends of the locks resting on his shoulder. Four tiers of worshipers adore him and a preaching Buddha is at the top with flying celestials. Manjusri wears a crown and is flanked by male and female attendants and dwarfs. Flying couples and a dwarf greet him from above. The main shrine has a very large figure of Buddha seated on a lion throne in the attitude of turning the Wheel of Law. The seated Buddha motif is repeated on either side. On the left wall of the shrine is a dance scene—a female dancer surrounded by a bevy of women playing musical instruments—one of the most beautiful carvings of Aurangabad.

Cave 8 is a half-finished cave that is in ruins. There is a hall with a large representation of Buddha's death and entrance into Nirvana. The pillared hall leads to three chapels; on the wall are Tara with attendants and Avalokitesvara. The entrance to the shrine again has flanking figures of Avalokitesvara and Manjusri and also the treasures Sankha and Padma. In the shrine itself is a preaching seated Buddha. The pillars and pilasters are well decorated with lotus medallions.

(Figs. 467, 468)

BEDSA

At Bedsa, five miles east of Bhaja, there is a small group of caves, the most important of which are the apsidal chaitya and the vihara with monk cells. The chaitya cave has a stupa at the end near the apse. At the entrance are two massive octagonal pillars and two similar pilasters. A veranda or porch then leads to a long hall. The pillars here are the artistic treasure of this cave. There are twenty-four in all, separating the central nave from aisles on the sides and continuing around behind the stupa. Each is an octagonal shaft rising from the mouth of a pot on stepped pyramidal base and crowned by an inverted ribbed pot—the Persepolitan type—with a fluted circular cushion in an open square frame, surmounted by a stepped square abacus on which pairs of horses, elephants, bullocks, and sphinxes with male and female riders are executed in a most realistic fashion. The absence of the image of Buddha against the chaitya is an indication of the early date of this cave. It is only a little later than Bhaja and Kondane.

The vihara cave with eleven cells, all with doorways surmounted by chaitya arches and a continuous balustrade pattern running between them, is an interesting example of its kind.

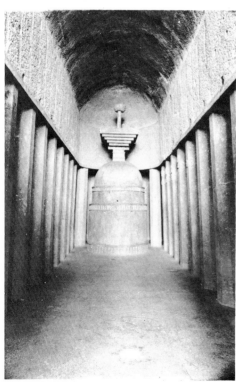

794. BEDSA. CAVE INTERIOR

795. BEDSA. CHAITYA INTERIOR

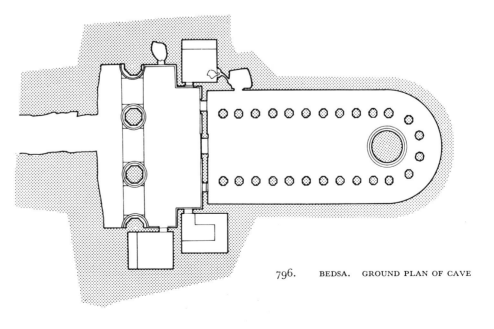

796. BEDSA. GROUND PLAN OF CAVE

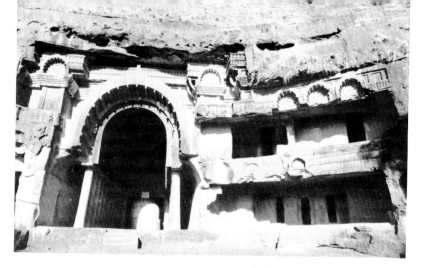

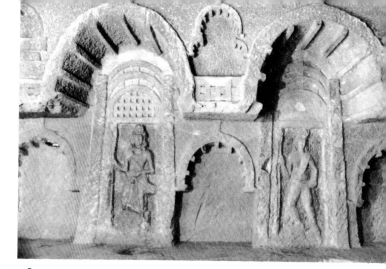

797. BHAJA. CAVE FACADE 798. BHAJA. MONK'S CELL

BHAJA

In the village of Bhaja, two miles south of Karli, is the famous chaitya cave that is among the oldest in western India. Large portions of the facade of this interesting cave are broken and lost, but what remains is impressive. The huge horseshoe-shaped arch with rock beams that imitate wood, the simulated balustrades, the pierced-window designs, and the small chaitya arches all make up an imposing facade, giving the appearance of a multistoried, balconied structure. The long apsidal hall ending in a rock-cut chaitya with twenty-seven plain octagonal shafts dividing the nave from the aisles on either side make it a very interesting example of early Buddhist architecture. The stupa is topped by a stepped *harmikā* with *kūḍu* ornaments on the sides. The arched roof is ribbed as at Karli and elsewhere. The figure carving in the chaitya is almost completely lost except for a few other heads looking out from chaitya windows and a very badly worn female figure.

By the side of the chaitya is a vihara with a very badly damaged facade. There are several other viharas close by, oldest and most important of which is small and irregular in plan. The outer pillars are broken or lost. There are two reliefs at the east side of the veranda on either side of a doorway leading to a cell. There is a difference of opinion as to the iconography of these two reliefs. One theory is that the figure riding in the chariot drawn by four horses is Surya attended by women carrying an umbrella and a fly whisk, driving away darkness in the form of a huge demon. On the elephant is Indra, riding in his celestial garden. It is also held that these reliefs narrate the story of Mandhata as told in the *Divyavadana*. If this is so, the figure on the elephant is Mandhata as the supreme emperor moving along to Uttarakuru; and the other is Mandhata in his aerial car aiding Sakra, the lord of the celestials, by overcoming the forces of the demons, depicted below by a single monstrous figure. Close to this and to the right of the pierced window is an archer carrying a bow and quiver. Another long frieze in the veranda shows a group of figures: animals and men, two of them caryatids; a cavalier and humped bulls; and what appears to be a pair of camels. All of these are in the archaic style, pointing to the early date of this vihara. Two doorways and a pierced window in the veranda's wall lead to an inner hall with a number of cells around it. The roof of the hall is of the barrel type. At the west end, between the cells and the veranda, there is a pilaster and a pillar with a frieze. The pillar is surmounted by a capital supporting pairs of fantastic animals with bovine bodies except for their human-female breasts.

(Fig. 57)

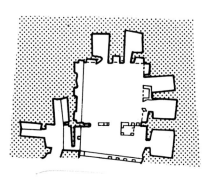

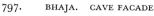

799. BHAJA. GROUND PLAN OF ORIGINAL VIHARA

ELEPHANTA

The island of Elephanta, in Bombay Harbor about seven miles from the city and easily reached by motor-launch ferry, got its name from the Portuguese who landed here and discovered a colossal stone image of an elephant. This sculpture subsequently was dismantled and reconstructed in Victoria Gardens in Bombay. There are a number of caves at Elephanta, but the principal and most imposing one is Cave 1.

The Vakatakas, who ruled in the Deccan as the contemporaries of the Guptas and had such a strong tradition of art and literature, built this cave. It will be remembered that most of the caves at Ajanta are also of this dynasty. This enormous cave—it is 130 feet wide—is on the western hill of the island at a considerable height and is reached by a long series of steps. The central hall has four aisles or vestibules. On the three sides, there are porticoes fifty-four feet long and over ten feet wide. There are six rows of columns, six in each row, that appear to function as supports for the "roof." They are beautifully shaped and fluted and have detailed decorations and bulbous fluted capitals. They recall those in similar caves at Ellora. Each of the porticoes has two pillars and two pilasters. The height of the ceiling in the cave varies from sixteen to seventeen feet.

As we enter, the first two great panels we see are of Nataraja, the Lord of the Dance, and Shiva in meditation. These huge and very impressive panels are about eleven feet square, each set in quite a deep recess. Nataraja with eight arms, holding several attributes such as the ax and the snake, is in the *catura* pose. Parvati, to his left, watches with dismay the orchestral group seated at her feet. To the right of Shiva is a pretty carving of Ganesha represented in the earliest style—two-armed and with elephant head, holding an ax and a broken tusk. The figure of Bhringi, emaciated and skeletonlike, who dances with Shiva, is interesting as is the seated figure of a musician, probably Tandu who taught Bharata the art of dancing. There are a number of flying figures above including Brahma carried aloft by swans, Vishnu on Garuda, Indra on his elephant Airavata, and so forth. It is probably the most important early carved panel in the entire Deccan.

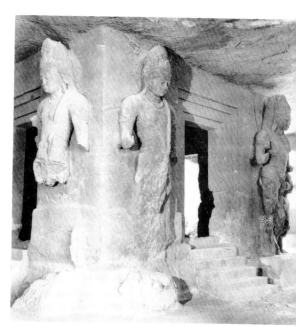

800. ELEPHANTA.
CENTRAL SANCTUARY OF CAVE

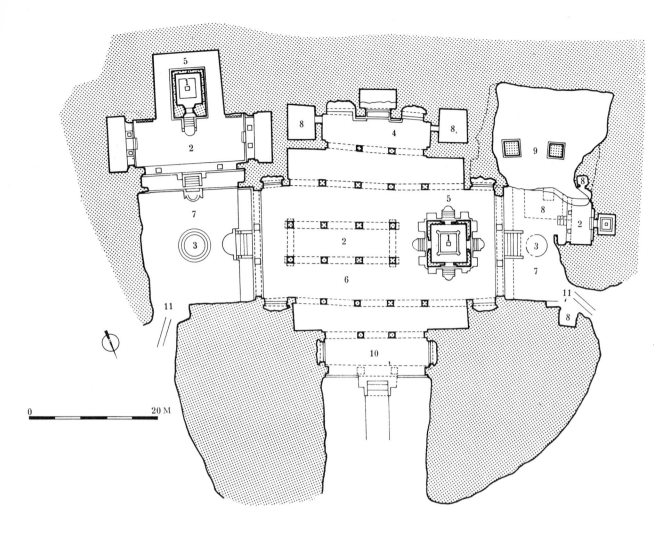

801. ELEPHANTA.
GROUND PLAN OF CAVES.
1—sanctum sanctorum; 2—man-dapa; 3—Nandivedi; 4—antarala (covered passage); 5—circular passage; 6—great hall; 7—interior court; 8—cells; 9—tanks; 10—portico; 11—drainpipe

0 20 M

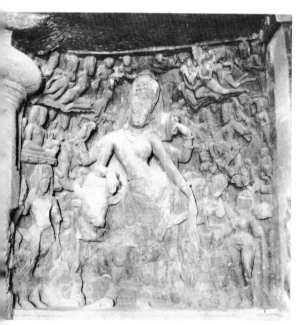

802. ELEPHANTA. ARDHANARISVARA

The next panel shows Andhakasamharamurti Shiva destroying the demon of darkness. This is one of the most spirited panels at Elephanta, and the devas above holding a crown suggest the great achievement of Shiva in overcoming so mighty a demon. He is not only piercing Andhaka with his trident but is also holding aloft the hide of an elephant which he has killed. The knitted brow and the anger on the face suggest Shiva's Bhairava aspect as well.

This panel is not far from the Shiva shrine that forms the central feature of this cave—a cubical cell with four entrances, each with a flight of steps and each with monumental fifteen-foot guardian figures, most with dwarf attendants. Their hairdos, sacred cords, other ornamentation, and general appearance suggest a very early date—about the fifth or sixth century. Near the water cistern to the south of the courtyard is another small shrine for Shiva with sculptured panels as decoration. Here again Shiva's violent dance is prominent, as well as Lakulisa as a teacher holding a club or a rod.

Back again in the main part of the cave, there is a large panel of the marriage of Shiva as Kalyanasundara, a majestic figure holding the hand of his shy bride Parvati, given away in marriage by Himavan, the Lord of Mountains, with his queen Mena beside him. A group of celestials flutter above. The one with the crescent, indicating that he is the moon, is Chandra holding a large vessel of the ambrosia of which he is composed.

The next panel of Gangadhara is also a very handsome one and is especially noteworthy for depicting several aspects of Ganga—pouring down on Shiva's locks as the triple stream, as the river of the celestials, as the stream following Bhagiratha on earth, and as purifying the ashes of the sons of Sagara in the netherworld. Parvati is shown, slightly discomfited at the prospect of having a co-wife.

The most magnificent sculpture of all these is the one nearby showing Shiva in his threefold aspect—terrible Bhairava, auspicious and peaceful Shiva, and the feminine Ardhanari Parvati. This colossal bust, usually called Trimurti or Mahesamurti, combines the three aspects of Shiva: the creator as the mother, the protector as the peaceful one, and the destroyer. The guardians and dwarfs on either side of the niches are exceedingly well carved.

Farther along is another panel of Ardhanarisvara showing Shiva combining masculine and feminine aspects, thus forming the parents of the universe. The contrasting contours—charming feminine and the majestic masculine—are noteworthy. The next panel shows Shiva and Parvati at rest on Mount Kailasa attended by the celestials and sages.

A flight of steps leads on to a mandapa, beyond which more huge figures guard another Shiva shrine where sculptures of Ganesha, the Matrikas, and Virabhadra make up an interesting group.

Returning to the main section again, there is another panel representing Ravana shaking Kailasa, a popular theme most graphically represented here.

The other smaller caves at Elephanta either are not especially noteworthy or are badly mutilated.

(Figs. 194, 195, 262, 377–81)

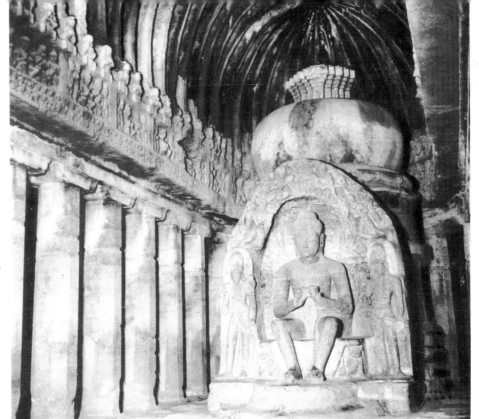

803. ELLORA.
CHAITYA IN CAVE 10

ELLORA

Ellora, twelve miles from Aurangabad, has a highly interesting series of cave temples that extends for more than a mile in the scarp of a hill. The first group of caves is Buddhist, the second Brahmanic, and the last Jain. They contain exquisite examples of architectural and sculptural work. Most of the paintings here are nearly destroyed and in any case cannot compare with those from Ajanta, which are better preserved and older. But what paintings there are at Ellora are important for they are the only examples of Rashtrakuta art.

Buddhist Caves

Cave 1, the earliest cave at Ellora, is a Buddhist vihara with three pillars at the entrance and cells cut in the rear and right-hand walls. Its sculpture, however, is of little interest.

Cave 2, which is reached by steps, has a mutilated facade. On the left side of the veranda that leads to the hall there is a large carving of Jambhala, the god of wealth, with a money bag in his hand. On the other side the figure, who may have been Hariti, is broken and lost. The female chowrie-bearer is still preserved. The entrance to the cell on the rear wall of the veranda is flanked by a number of images of Buddha with bodhisattvas. The doorway itself has huge guardian figures on either side representing Avalokitesvara and Vajrapani. There are twelve beautifully carved massive pillars supporting the central hall, each with seated dwarfs at the corners of the square bases. Above the base there is an octagonal band; the fluted shaft rises beyond this. The vase-and-foliage design decorates slender pillars on both sides of the hall against the raised lateral galleries which exhibit large images of seated Buddha turning the Wheel of Law, always flanked by bodhisattvas (several of which are unfinished). A huge carving of Buddha seated on a lion throne again turning the Wheel of Law is the main figure in the shrine beyond the rear wall of the hall. He is flanked by the bodhisattvas Avalokitesvara and Manjusri, the former wearing matted locks of hair and the latter a jeweled crown.

The facade of Cave 3, a vihara, is ruined. The main hall is supported by twelve pillars—several of them unfinished—that have the vase-and-foliage design. There are eight cells on the sides and two on the back wall flanking the entrance to the main shrine that is guarded by huge bodhisattvas. Within the shrine is a seated Buddha flanked by Avalokitesvara and Vajrapani.

Cave 4, again a vihara, is double-storied with the passage between the two levels destroyed. The upper level has two cells and a shrine, the entrance of which is flanked by bodhisattvas. Buddha seated in European fashion is enshrined here with Avalokitesvara to his left. On the left wall of the shrine is a large carving of Tara with a lotus and rosary. The ground floor is sadly mutilated but between the hall and the antechamber are two pillars and a pair of pilasters leading to a shrine and two cells in the back wall. At one end of the antechamber a seated Avalokitesvara wears the deerskin sacred thread. Once again we find a monumental Buddha seated in

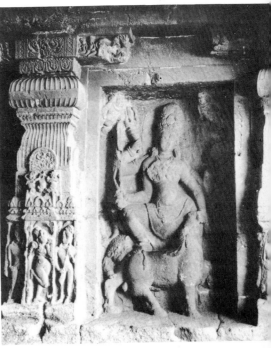

804. ELLORA. MAHISHAMARDINI
PANEL IN CAVE 14

475

the European manner, turning the Wheel of Law with chowrie-bearers on either side—they are Avalokites-vara and Maitreya. On the right wall of the shrine is a figure of Tara.

Cave 5 is a large vihara, the face of which presents four pillars and two pilasters. The pilasters provide more beautiful examples of the full- and half-lotus motifs. The hall is divided into a nave and aisles by two rows of pillars. The walls on all the sides have cells—twenty in all—with the central shrine at the far end cut into the back wall. Huge bodhisattvas guard its doorway. Enshrined here is a large preaching Buddha seated as usual and flanked by the chowrie-bearers Avalokitesvara and Maitreya.

Cave 6 is a vihara with a ruined facade. Cut in the wall are cells. The figure of a lovely celestial, appre-ciating her beauty in a mirror and with dwarf attendants beside her, is a bracket decoration on one of the front pillars. Our imagination must supply the others that have now disappeared. Elegantly carved pillars, with vase-and-foliage design and dwarf musicians at the corners of the square bases, separate the nave from the aisles. The pillar brackets are decorated with rearing griffins. The central cell once again enshrines a preach-ing Buddha flanked by Avalokitesvara and Maitreya who are also repeated as guardians of the entrance. Mahamayuri, the goddess of learning, is on the right wall of the cell and facing her is Tara who holds a long-stalked lotus in her hand. The doorway to the shrine has beautiful moldings, and the top terminals of the jambs present Ganga and Yamuna, a feature also observed in several of the Ajanta caves.

Cave 7 is an unfinished monastery.

Cave 8 is both a chaitya and a vihara. A porch leads to a long chaitya hall where a number of cells are carved into the side walls. A raised chamber on the left enshrines Buddha seated in European fashion turning the Wheel of Law and flanked by bodhisattvas. There are large carvings of Avalokitesvara wearing the deerskin sacred thread and locks of matted hair, standing with a lotus and waterpot in his hand. Tara also holds a lotus here. Cut into the wall at the end is a shrine surrounded by a perambulatory passage. The entrance is flanked by Avalokitesvara and Maitreya. To the left of the latter is a beautiful female attendant with elaborate headdress. A sculpture of Mahamayuri, as in Cave 6, is very interesting. On the rear wall of the shrine is the principal figure—a large seated Buddha flanked by chowrie-bearers, kneeling worshipers, and Tara. On the outside wall of the cave are Panchika and Hariti with a child in her lap.

Cave 9 is approached through pillars and pilasters of the vase-and-foliage type, with the loving-couple motif decorating their square bases. This cave's principal image is also of Buddha turning the Wheel of Law. He is seated in a central niche in the rear wall with bodhisattva figures on either side, one wearing the deerskin sacred thread and matted hair and the other a jeweled crown. Both are flanked by female attendants. The architrave of the interesting facade of this cave is decorat d with small panels showing alternately Buddha and Avalokitesvara and attendants. Also depicted here is Tara flanked by six dangers—among them the snake, sword, elephant, and shipwreck—from which her grace assures protection.

Cave 10 is both a chaitya and a vihara. This is popularly known as the Visvarkarma cave. A high partly damaged screen wall leads on to a nicely laid-out court. The veranda on three sides of the court is decorated with square pillars of the vase-and-foliage type; their upper portions are round and fluted. At either end of the veranda is a shrine. The apsidal hall with long rows of pillars has a chaitya at the far end against which Buddha is seated, flanked by bodhisattvas and with adoring c lestials above. The ribbed roof imitates wood-work. There are three bands of frieze immediately above the pillars that show repeated panels of Buddha, his attendants, and dwarfs in musical and dance attitudes. This cave, with its beautiful facade, its imposing balcony with a long balustrade, and its beautifully carved panels and friezes, also has its rear wall exquisitely decorated with a trefoil pattern flanked on top by flying figures. This resembles a large window and corre-sponds to the early semicircular chaitya windows at Bhaja, Karli, and Ajanta. There is also a multifoil pattern on either side of this that substitutes for a large horseshoe-shaped *kūḍu*. The beauty of the loving-couple figures in a long row of arched niches forming the decoration of the architrave immediately under the roof of the veranda is matched by the lovely flying figures flanking the trefoil window. This window is the most imposing architectural feature of any individual cave at Ellora and offers a beautiful view of the chaitya.

Cave 11, Do Tala as it is usually called, is however a three-storied monastery. A pierced window wall that serves as a screen leads to an imposing court. The ground floor which is rather crude has a number of pillars and on the back wall of the veranda is the shrine with seated Buddha turning the Wheel of Law and flanked by bodhisattvas. On the floor above is yet another shrine for Buddha who is again flanked by bodhisatt-vas. A damsel offering food is Sujata, who fed Buddha before nis enlightenment. On one side of the shrine's entrance is Jambhala and on the other is Tara. In the shrine beyond the veranda there is a Buddha flanked by Padmapani and Vajrapani. Flying celestials carry garlands and offerings. On the next floor there is a vestibule which is supported by four pillars and a hall beyond with eight square pillars. The main shrine is for Buddha. Among the sculptures on this floor Prajnaparamita, Jambhala, and Chunda are noteworthy.

Three-storied Cave 12, known as Tin Tala, is again a chaitya and a vihara in one. The facade is impressive though unadorned, and the interior is a rich trove of sculpture. Of the eight pillars that face the visitor in the court, only the central pair are decorated; they are of the vase-and-foliage type. The others are square and unadorned. Three rows of eight pillars support the hall on the ground floor. On the rear wall of the hall is a long row of bodhisattvas. In the main shrine is the usual large Buddha turning the Wheel of Law but flanked by two naga chowrie-bearers. On the second floor is a long veranda, an antechamber with four pillars, a large sixteen-pillared hall, anotner antechamber with another pair of pillars, and finally the main shrine at the rear. There are cells in several places around the hall. An interesting feature here is the rows of Buddhas, bodhisattvas, and Taras. The seven Manushi Buddhas—Vipasyi, Sikhi, Visvabhu, Krakuchchanda, Kanakamuni, Kasyapa, and Sakyasimha—are seen in human form—a repetition of the theme that was executed at Bharhut in symbolic style as early as in the second century B.C. There are, similarly, the Buddha figures re-presenting Vairochana, Akshobhya, Ratnasambhava, Amitabha, Amoghasiddhi, Vajrasattva, and Vajraraja with umbrellas and celestial worshipers. Forms of Tara and other Buddhist goddesses, such bodhisattvas as Maitreya, Sthirachakra, Manjusri, and others join the other rows of Buddha and Tara to create a veritable Buddhist pantheon in these last two caves of the Buddhist group at Ellora.

Cave 13 is an unimportant rectangular cave without any decoration.

Cave 14, called Ravana Ka Khai, has a large hall supported by sixteen pillars. The walls to the north and the south have panels between the pilasters. The panels begin with one of four-armed Durga, her right foot on the lion. The second is Gajalakshmi seated on a lotus with celestial attendants holding pitchers of water for her as elephants pour a stream over her head. The third is Varaha raising up Prithvi as a naga and naginis at his feet adore him. Next is Vishnu seated at ease fondling his consorts Sri and Bhudevi. Personified weapons are also shown here including the club Kaumodaki. The fifth panel is Vishnu seated with Sridevi as Sriyahpati, and again the personified weapons appear. Beyond this is the shrine, with guardian figures on either side as well as graceful representations of Ganga, Yamuna, and two dwarfs representing the principal *nidhis*. Then the wall panels continue. The first shows Shiva as Virabhadra, beginning the Saptamatrika series. It continues with Brahmi, Mahesvari, Kaumari, Vaishnavi, Varahi, and Chamunda, each shown with her own vehicle—the bull, peacock, kite, boar, elephant, and owl, respectively. At the end Ganesha completes the group. The next panel is of Shiva as Andhankantaka destroying the demon of darkness. In the next, Shiva and Parvati are seated on Mount Kailasa while fearless Ravana makes it tremble. The panel beyond this represents Nataraja dancing in the *catura* pose to the accompaniment of music by ganas. Next is a panel showing Shiva and Parvati in a gay mood playing dice. In the long frieze below are ganas surrounding the Nandi bull and playfully pulling his tail and ears. The final panel is of Mahishasuramardini fighting the buffalo demon.

Cave 15, called Dasavatara, is very important. An inscription here mentions the visit of the Rashtrakuta king Dantidurga upon the occasion of its completion; thus we can date it as eighth century. On the ground floor of this two-storied cave are fourteen square, plain, undecorated pillars. In the antechamber of the shrine one finds a two-armed figure of Parvati; a carving of Vishnu with his four attributes; a panel depicting Trimurti; and a carving of Ganesha. The hall in the center of the courtyard is on a raised plinth, with Ganga and Yamuna on either side of the entrance, as well as a number of beautiful celestials and loving couples in different attitudes. All are considerably weathered and have lost the fine details that once made them masterpieces. The second floor has a large hall supported by forty-eight pillars arranged in eight rows of six. All are plain, except those in the first row, which carry the vase-and-foliage theme. On the walls we once again find large panels illustrating different forms of the deity. They begin with Andhakari Shiva dancing; the next illustrates Shiva's dance; the third is a Shivalinga; in the fourth Shiva and Parvati play dice. A frieze below shows the Nandi bull teased by dwarfs. The next panel elaborately illustrates the marriage of Shiva as Kalyanasundara; the following one depicts Ravana shaking Kailasa. The first panel on the back wall illustrates Shiva blessing Markandeya while destroying Yama as Kalantaka. The second is Gangadhara. Then the long stretch of wall is broken by the antechamber of the shrine. There are guardians on either side of the entrance and on the walls of the antechamber are carvings of Ganesha, Sarasvati, Gajalakshmi, Kartikeya, Lingodbhava, and Tripurantaka. A Shivalinga is enshrined in the cell. In the main hall once again the panels continue, showing various forms of Vishnu in his avatars—six-armed Krishna raising Mount Govardhana (with an emphasis on his godly aspect); Seshasayi, with the lotus from his navel supporting Brahma and with Lakshmi at his feet attended by personified weapons; Vishnu as Garudarudha; Varaha raising Prithvi with Seshanaga at his feet; Trivikrama with the dwarf Vamana at his feet; and Narasimha fighting Hiranyakasipu. The final panel is the most imaginative of all, with the legs of god and demon interlocked and the latter defying Narasimha with a look of disdain.

Temple 16 is the Kailasa temple, one of India's greatest architectural treasures. This famous freestanding shrine was carved out of solid rock by the Rashtrakuta king Krishna.

Outside the entrance there is a small gopura, characteristic of the age and always seen at Pallava temples. On either side of the entrance the eight guardians of the quarters are on their vehicles. As he enters this complex the visitor is awed by enormous panels on either side. In one of them Gajalakshmi is being bathed by elephants in a huge lake covered with lotuses. In another Shiva is embraced by Parvati on Mount Kailasa during the quaking caused by Ravana. Even her attendants run helter-skelter in dismay. There is personified treasures—Sankha and Padma—signifying royal prosperity. The outer wall has other interesting sculpture— four-armed Krishna raising up Govardhana, Rati and Manmatha, Vishnu on Garuda, Tripurantaka, among others. Moving on, the shrine of the triple streams shows the personified Ganga, Yamuna, and Sarasvati. This is a glorification of the great confluence at Prayag. The huge *dhvajastambha* cut out of rock is most imposing and effective.

The Lankesvara temple here is reached through the *nandigrha*—a beautiful elevated platform crowned by a shrine to house just the Nandi bull. This one is exceedingly well carved and provided with door guardians. The main temple—Lankesvara—is also on a very high platform. It is interesting that this entire temple has been conceived as a mountain resting on rows of caryatid elephants and lions and topped by a lotus shikara. Ganga and Yamuna are shown on their vehicles on the left and right of the door. Behind the lingam in this shrine is Shiva in his triple aspect (as also seen at Elephanta)—the principal face serene, the face of Uma to the left, that of Bhairava the destroyer to the right. Besides this there are other beautiful carvings here including well-known iconography such as Ravananugraha, Nataraja, Ardhanarisvara, Mahishamardini, and others, in addition to famous episodes from the epics such as Jatayu fighting Ravana.

The main mandapa of the Kailasa shrine, supported by sixteen well-carved pillars, is again delightfully designed and decorated with motifs of celestial gnomes, mythological animals, and floral designs. Remnants of painting illustrate battle scenes, processions, elephants in a lotus pool, Shiva as Nataraja, Lingodbhava, and so forth. The *Ramayana* and the *Mahabharata* are narrated in a series of miniature panels that form long reliefs on the plinth of the mandapa. This temple provides an almost encyclopedic text in stone of the various sports of Shiva and of his many forms. There is Umasahita, Lingodbhava, Bhairava, Shiva as a *brahmacarin* before Parvati, Tripurantaka, Ardhakari, Kalyanasundara, Kalantaka, and so forth.

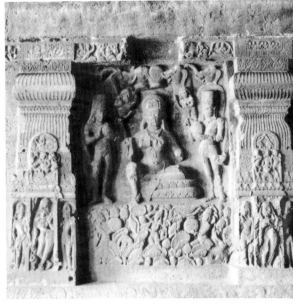

805. ELLORA.
SRI LAKSHMI PANEL IN CAVE 14

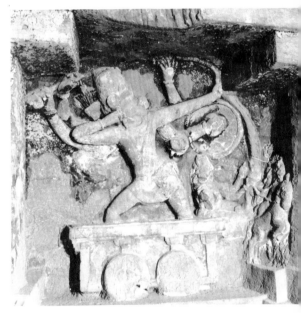

806. ELLORA.
TRIPURANTAKA IN CAVE 15

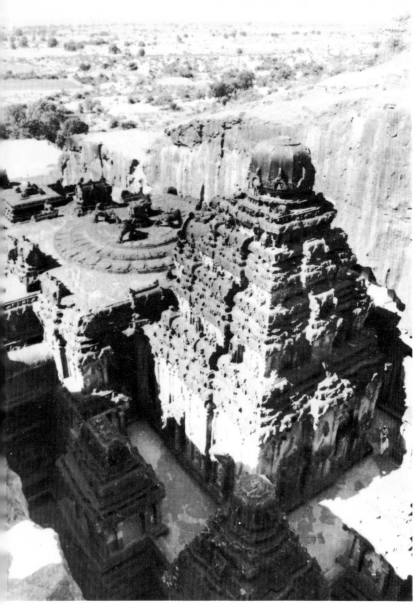

807. ELLORA. KAILASA VIMANA
WITH LOTUS-TOPPED MANDAPA

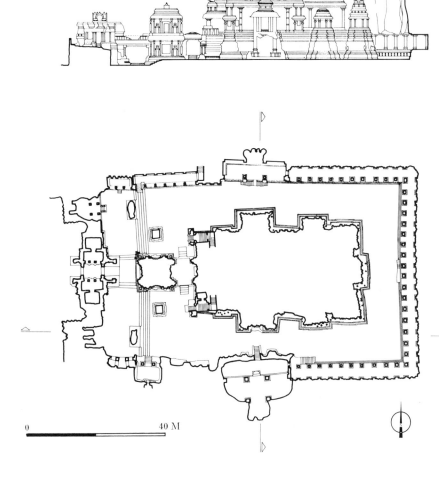

808. ELLORA. GROUND PLANS AND
ELEVATIONS OF THE KAILASA TEMPLE

0 40 M

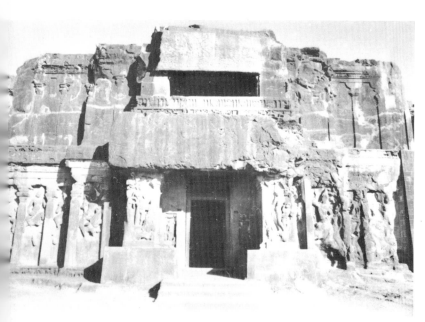

809. ELLORA. FACADE OF THE KAILASA
TEMPLE WITH GUARDIANS OF THE QUARTERS

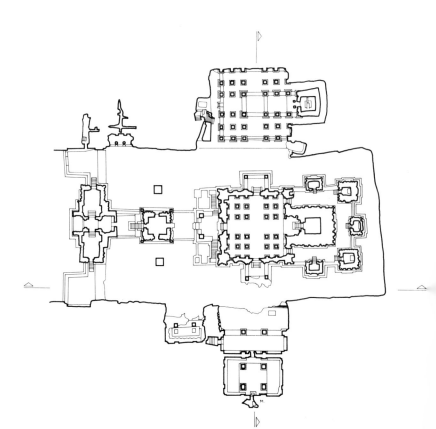

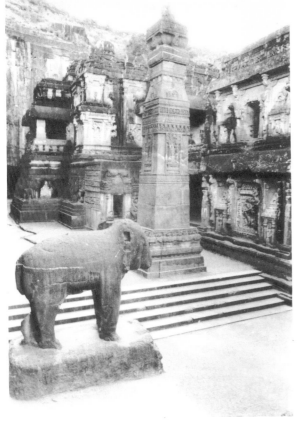

810. MONOLITHIC ELEPHANT IN THE COURTYARD

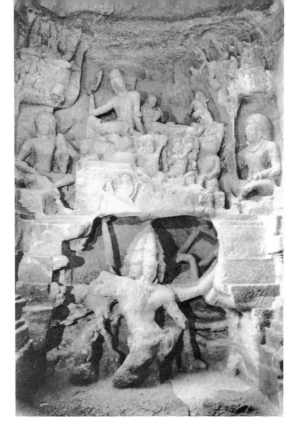

811. RAVANA SHAKING MOUNT KAILASA

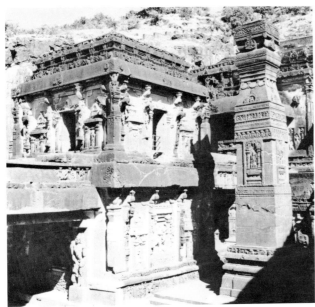

812. NANDIMANDAPA

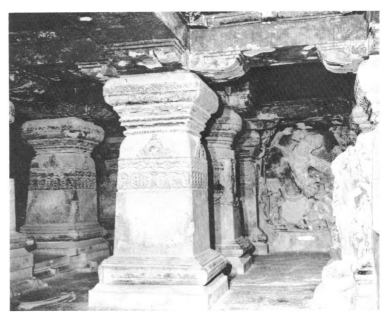

813. LANKESVARA CAVE WITH NATARAJA IN THE REAR

Beyond the court that surrounds the temple, there are cloister cells that contain more panels illustrating incidents from the Puranas and the epics. Here are interesting panels such as Ravana offering a garland of his severed heads to Shiva; Umamahesvara; Shiva as Yogi; Shiva playing dice with Parvati; Ravananugraha; and Markandeyanugraha. Particularly noteworthy are the cell containing Lingodbhava, the one occupied solely by a huge lingam with Shiva issuing from it, and the ones where Vishnu and Brahma are found. There are also sculptures of the Saptamatrikas and Ganesha in appropriate places, and the loving-couple motif has been freely utilized. There are also several forms of Vishnu such as Trivikrama, Garudarudha, Varaha, Kaliya-Krishna, among others. The imposing elephant near the *dhvajastambha* is a tribute to the genius of the sculptor.

Cave 17, with its four-pillared facade, begins with a veranda that leads to a hall supported by eight pillars. Although the cave is half-finished, the carvings on both the pillars and the walls are excellent. Carvings of Vishnu and Brahma on either side just near the entrance, Mahishamardini, and the four-armed Ganesha, who holds a rosary and an ax and wears a lotus in place of crown (indicating an early date), are all

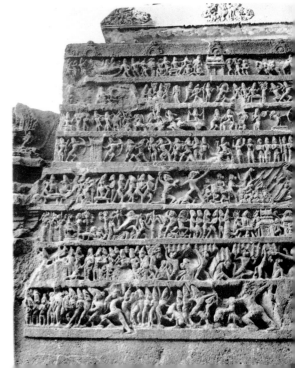

814. ELLORA.
SCENES FROM THE RAMAYANA

479

exceptional works. The doorway of the shrine with its attendants is also attractive. The pillars are interesting for the figure carvings that compose the brackets and for the panels on the fluted surface above the square base.

While Caves 18, 19, and 20 are of no consequence, Cave 21—the Ramesvara—is extremely beautiful. The Ramesvara cave is on a high platform and has a low parapet wall with a long frieze of gracefully grouped elephants. Above the wall the squat pillars have exquisite bracket figures—representations of the various river goddesses. Placed immediately below the delicately carved capitals, these figures are nearly as tall as the shaft of the pillars.

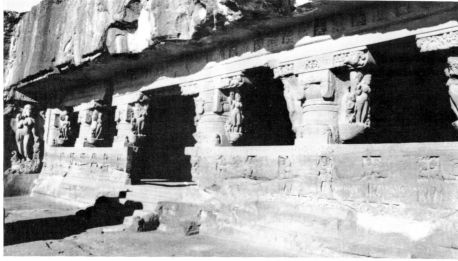

816. ELLORA. GROUND PLAN OF RAMESVARA CAVE

815. ELLORA.
FACADE OF RAMESVARA CAVE

On the walls of the hall, there is an effective narration of the various scenes preceding the marriage of Parvati and Shiva—Brahma and the rishis requesting Parvati's hand on behalf of Shiva, Himavan and his consort Mena, the penance of Parvati, the appearance of Shiva in the form of a young scholar to test Parvati, and finally the joyous wedding. There are two other panels here—one of Shiva playing dice with Parvati and another showing the dance of Shiva in the *katisama* pose—that are probably the most magnificent at Ellora.

Cave 22, known as Nilakantha, has a square hall supported by ten pillars. Two more pillars in the antechamber have interesting bracket figures of loving couples. Ganesha and Kartikeya appear on the left and right walls; Lakshmi is represented on either side of the shrine on the rear wall. In a chamber to the right the Saptamatrikas are shown in a chamber flanked by a Ganesha and Virabhadra.

Caves 23, 24, 25, 26, 27, and 28 are of little consequence. Cave 29, Sita Ka Nahani or Dumar Lena as it is known, is important. This cave, which is a shrine for Shiva, in plan is almost like the one at Elephanta, how-

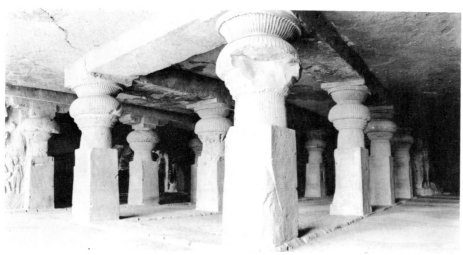

817. ELLORA. DUMAR LENA CAVE

ever aesthetically this one is inferior. The large panels on the walls are almost lifeless, stolid, and mediocre. As at Elephanta, there are two roaring lions on either side of the steps. There are two pillars and two pilasters on the facade and there is a row of pillars in the interior of the hall. There are panels that illustrate Shiva as Nataraja, Lakulisa, Kalyanasundara, and Shiva playing dice with Parvati. The large shrine in the center has a spacious ambulatory and is guarded on all four sides by huge guards exactly as at Elephanta.

There are a few more caves in this section—the Ganesha caves as they are known—but they are of no consequence.

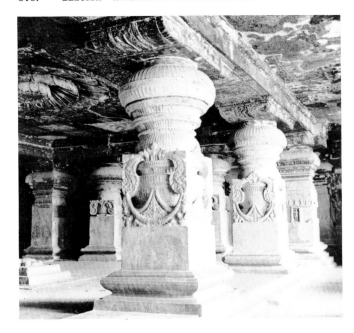

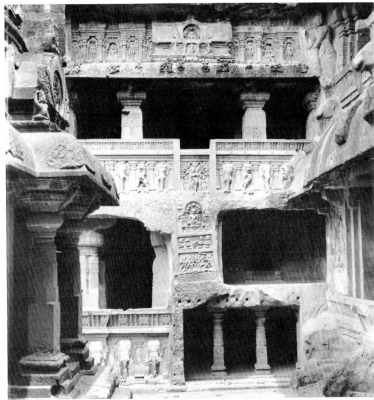

819. ELLORA. INDRASABHA CAVE

Jain Caves

Among the Jain caves, Cave 30—popularly called Chota Kailasa, or "little Kailasa"—is a smaller edition of the larger and more imposing temple. Again it is carved out of the rock as a freestanding shrine. The small gopura here is unimposing, but on its walls are carvings of Tirthankaras with attendant figures and adoring celestials. Chakresvari on the left wall is an attractive figure. The portico of the temple is supported by a pair of pillars and two pilasters and is decorated with dancing figures at the top where there is a long parapet wall decorated with a floral design. On either side of the entrance inside the portico are guardian figures. There are vestiges of paintings on the ceiling. The main hall beyond is supported by sixteen pillars and is decorated with carvings of seated Tirthankaras. The toran in front of the shrine is attractive, and on either side are Parsvanatha and Gomatesvara.

Cave 31 is small with a four-pillared hall and a shrine beyond the rear wall. Here are carvings of Parsvanatha and Dharanendra protecting the Tirthankara with snake hoods held over him. Gomatesvara with his legs entwined by creepers and overgrown by an anthill is shown on the right wall of the hall.

Cave 32, known as Indrasabha, dates from the ninth or tenth century and is the most beautiful of the Jain caves. There is an emblem-crowned pillar here, as at Kailasa, all cut from stone. The shrine on a high platform is modeled after the Kailasa one. A beautiful lotus is carved on the ceiling of the shrine, and a very interesting panel to the right illustrates Parsvanatha protected by Dharanendra to overcome Kumatha—the Mara of Jain mythology. This is matched by the equally well-fashioned Gomatesvara to the left flanked by his sisters and recalling the famous monolith at Sravanabelagola. The Matanga Yaksha on his elephant and Ambika on her lion under the mango tree are also magnificent carvings. It is interesting that the inscription here in the Nagara script of the period mentions the image as carved by the sculptor Nagavarma. An inscription below the carving of a Tirthankara explains the fact that the image of Santinatha was caused to be made by Sohila. There are vestiges of beautiful paintings on the ceiling of the mandapa. A staircase leads to a second floor where again on the walls are Parsvanatha and Gommatesvara with Matanga and Ambika repeated. Here also the ceiling has beautiful paintings.

Caves 33 and 34 are comparatively uninteresting.

(Figs. 35, 59, 75, 139, 140, 196–200, 259–61, 294, 335–40, 350, 351)

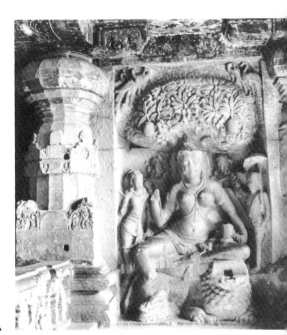

820. ELLORA. YAKSHI AMBIKA

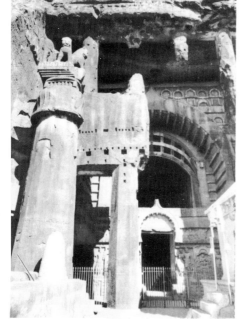

KARLI

Karli is located thirty-five miles from Poona. Here there are four caves of particular importance for the study of Satavahana architecture of about A.D. 100.

Cave 1 is a chaitya and is the largest and the best preserved one here. To the left of the entrance is an imposing pillar topped by four lions that recall the animals on the Asokan pillar of Sarnath. The shaft of the pillar, which is inscribed, mentions a Maharathi who was responsible for its creation. The Maharathis, as we know from the Nanaghat cave, were closely related to the Satavahana monarchs. The magnificent facade makes this cave one of the most beautiful monuments in western India. A porch once stood before this facade. It is now gone, but the end walls still have large carvings of caryatidal elephants standing on a long railing. This rail motif is repeated higher up, interrupted at intervals by panels depicting Buddha in meditation, preaching, and in other attitudes. The wall of the facade has sculptural panels showing Buddha and bodhisatt-vas and the loving-couple motif repeated over and over again. These may be portraits of the wealthy donors responsible for the cave. There is a row of ends of stone beams that resemble wood above this and there are more panels of Buddha and bodhisattvas. Then there is a long parapet with a long balustrade of simple uprights, crossbars, and coping. Above this, almost covering the entire area, is a large chaitya window through which the semicircular roof of the chaitya itself can be seen. There is elaborate carving of beams and rafters in imitation of wood construction that suggests the beginnings of Buddhist temple architecture. On either side of this arch are *kūḍus* doorways, and panels representing loving couples reverentially moving around toward the central chaitya. The inner screen-wall has three doorways topped by chaitya arches, the central one leading to the long apsidal hall where two stately rows of columns divide the nave from the side aisles. The pillars, fifteen on each side, are octagonal with a fluted capital surmounted by kneeling elephants carrying pairs of male and female riders. On the capitals, facing the aisles, there are pairs of horses, each with a single rider. These imposing pillars rise from large circular pots; the figures on the capital are exceedingly well carved.

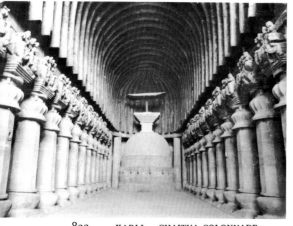

821. KARLI. CAVE ENTRANCE
WITH ARCHED WINDOW IN REAR

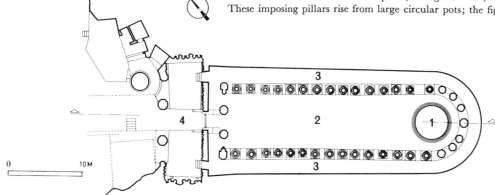

822. KARLI.
GROUND PLAN OF BUDDHIST CHAITYA.
1—stupa
2—central nave
3—lateral naves
4—vestibule

Inscriptions on some of these pillars mention donors from the flourishing city of Dhenukakata, others from Yavanas, and even foreigners from the West, probably Ionia. The chaitya carved from solid rock at the end of the apse is surmounted by a stepped *harmikā*. No discussion of this chaitya is complete without mentioning the excellent loving-couple figures on the wall. They are as fine as any works of art in the world.

Several inscriptions here make this cave as interesting historically as it is sculpturally. There is one about Ushavadata, the son-in-law of the Kshatrapa king Nahapana, who donated a village to the monks living in the caves at Valuraka—the ancient name for Karli. There is another about a Maharathi during the reign of Pulumavi, the famous Satavahana king. At the left side of the porch, above the elephant and a frieze of Buddha, is an important inscription proclaiming that "this rock mansion, the most excellent in Jambudvipa [India], has been completed by the banker Bhutapala from Vaijayanti [an ancient subsidiary capital of the Satavahanas]." The other inscription here mentions a relic given by a monk from Supara, an important port in western India.

Cave 2 is a ruined three-storied vihara. Four monk cells are on each side and five are at the back of the central hall. On the rear and right walls are carvings of Buddha that are seventh-century additions. The front wall has pierced openings.

Cave 3 is a two-storied vihara with monk cells, water cisterns, and a small chaitya. An inscription here tells that it was donated by Harapharna during the reign of Pulumavi, and therefore it should be dated the middle of the second century A.D. To the right of the chaitya cave is an unfinished vihara where the only notable carving is of a seated Buddha; his feet rest on a lotus, and he is flanked by bodhisattvas as chowrie-bearers.

823. KARLI. CHAITYA COLONNADE

KONDANE

Four miles from the Karjat station is a group of caves of which a vihara and a chaitya are the most important. The vihara is entered through a veranda supported by five pillars with two pilasters at the entrance. This opens on to a large court which has rows of pillars on either side and across the back. There are eighteen cells for monks on the three sides, but most are in ruins.

The chaitya cave, a large one, is apsidal. It has a stupa and the usual rows of pillars separating the nave from the aisles. There are thirty pillars altogether, nearly all of which have decayed and almost disappeared.

The facade of this cave with its grand arch and rafters carved to imitate wood closely resembles those of Bhaja and Pitalkhora and probably once had a wooden screen. The barrel roof and the great horseshoe window are characteristic of early western Indian caves where the decorative pattern consists of bands of railing and tiers of miniature chaitya windows mimicking wood construction. An inscription here in early characters of the second century B.C. (close to the sculpture of a figure of which all but the headdress is lost) gives the name of the sculptor as Balaka, a pupil of Kanha. The figure sculptures in the panels of a band just beneath the great arch of the facade reveal youthful warriors wielding bows, clubs, and other weapons. In the company of damsels in a mood of abandon they recall similar early sculpture at Bhaja and Pitalkhora.

There are two other caves here. They are viharas, each with nine monk cells and mostly in ruins.

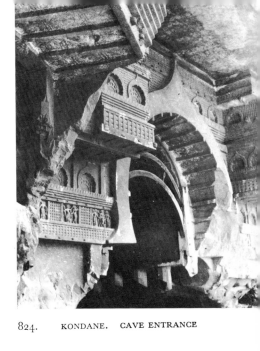

824. KONDANE. CAVE ENTRANCE

NASIK

The group of caves at Nasik is about four miles outside the town itself. The important ones are Cave 3, the Gautamiputra Vihara; Vihara 10, the chaitya cave; and Cave 8, the Nahapana vihara. The chaitya cave, or Pandulena, with its facade closely resembling the Bedsa and Kondane type, has a small horseshoe arch with a rectangular entrance below it and a series of architraves carved in relief so that it closely resembles the facade of the Lomas Rishi cave. Close to the entrance is a yaksha guardian and an inscription stating that the villagers of Dhambika paid for the carving over the doorway. As at Karli and Kondane at the second-story level there is a huge arched chaitya window that allows light into the hall. There is a large balcony-rail pattern on either side and a row of pilasters above with *kūḍu* decoration and yet another balcony. The third story is decorated with medium-sized chaitya window pattern and latticework decoration and is topped by a shovel-headed *kūḍu*. This is all very elaborate and similar to what is found in many facades of early Buddhist chaitya halls. The apsidal hall beyond has a long series of pillars on either side that meet behind the rocket-shaped stupa at the far end. Set in pots supported by stepped pyramidal bases, these pillars are octagonal. The ribs and beams worked on the ceiling of the curvilinear roof imitate a wooden structure. This is an early cave—about the second or first century B.C.

Nahapana vihara (Cave 8) is of about the same time. This vihara has a large central court reached by a long entrance porch in which there are four pillars and two pilasters of the usual early type in this part of the country—octagonal shaft issuing from a pot resting on a stepped pyramidal base. They are surmounted by bell-shaped capitals topped by a fluted cushion encased in an open frame with an inverted pyramidal base. On it there are figures of elephants, lions, bulls, and mythological animals with riders. (A row of pillars of this type also forms the facades of Cave 10 and Cave 18.)

Cave 3, the Gautamiputra vihara, is noteworthy for several reasons. The pillars here, two of which are broken and lost, are excellent examples of the type seen at Karli and Bedsa. It is particularly interesting to see that the bell-shaped portion below the bulbous cushion above the shaft is almost like an upturned pot with flaring mouth. All along the base of the pillars is a low wall carved to suggest latticework. Along the bottom of the wall six hefty yakshas seem to be emerging from the earth to support the entire structure on their shoulders. It is therefore like the moving palace of Ravana carried by Rakshasas that is described in the *Sundarakanda*.

The doorway to the cave itself is elaborately carved and has rather primitive guardian figures on either side. On the jambs and on the lintel there is a narration of a story of a pair of lovers. The lintel is embellished with half-lotus medallions, complete medallions, and undulating necklaces as well as panels depicting the worship of the bodhi tree, the stupa, and the Wheel of Law. Inside the cave there are twenty cells on three sides of the large rectangular hall.

This cave is also very important for the inscription of Balasiri, the mother of Gautamiputra Satakarni who, it says, dedicated the cave to the monks of the Bhadrayaniya order in the nineteenth year of her grandson Pulumayi. The inscription also has a spirited description of the glory and grandeur of the great king Gautamiputra Satakarni of the Satavahana dynasty.

The Nahapana cave contains eighteen cells for monks on three sides of a large court reached by a veranda to that of Cave 3. The pillars are of the type already seen except that here there are other features such as the human heads of the mythological animals and the beaked sphinxes. The inscription on the rear wall of the veranda is in very beautiful script and records the construction of the cave by Ushavadata, son-in-law of the Kahaharata king Nahapana. It also describes various projects of his, including the building of rest houses, the establishment of free river ferries, and other good works. Other inscriptions record such incidentals as arrangements for providing the monks with medicines and agreements with the weavers' guild to provide garments for the twenty monks residing in the cave during the rainy season.

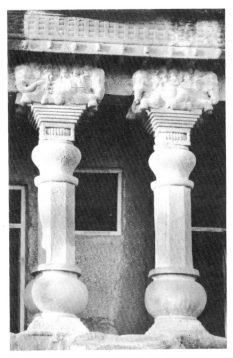

825. NASIK. NAHAPANA MONASTERY

826. NASIK. GROUND PLAN OF VIHARA 3.
1—*veranda*; 2—*cells*; 3—*pool*

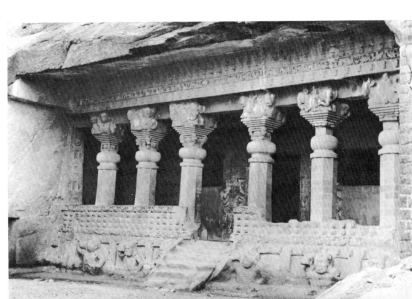

7. NASIK.
ADE OF GAUTAMIPUTRA
NASTERY

PITALKHORA

Pitalkhora has a group of caves, of which a chaitya and a vihara are especially noteworthy. The chaitya, the front of which is mostly in ruins, has suffered from the disintegration of the rock. It is the usual apsidal temple with a stupa. There is not much left of the twenty-five pillars. Even the chaitya itself has disappeared. The vaulted roof once had wooden ribs fixed in the mortises as at Karli and Bhaja. The chaitya was painted with figures of Buddha in different attitudes with a triple umbrella over his head. The paintings are most probably contemporary with those of Ajanta, although the cave itself is very old—of the second century B.C.

This vihara is interesting for the several cells, each with an arched entrance. The pilasters between the arches are decorated with mythological animals on their capitals. There are winged horses, lions, elephants, and bulls very much like those in the first period of Amaravati and at Jaggayyapeta. Sculptural form at Pitalkhora is very similar to that at Bhaja, and excellent examples of carving from this cave are now in the National Museum in New Delhi and the Prince of Wales Museum in Bombay. The roofs of the cells are curved with stone rafters meticulously made to look like wood.

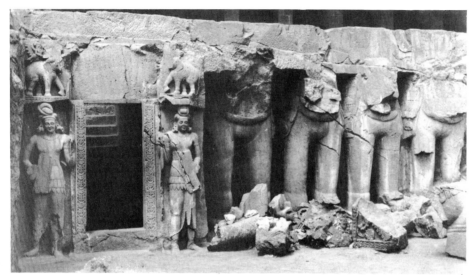

828. PITALKHORA. CAVE ENTRANCE

MYSORE

AIHOLE

Aihole—originally known as Ayyavola or Aryapur—in the Bijapur District twelve miles east of Badami, was an important center of the early Western Chalukyas. Though now a neglected village, it contains superb examples of Chalukyan temple architecture.

THE MEGUTI: This Jain temple was built, according to its inscription, in 634 by Ravikirti, under Pulakesin II. It contains a famous inscription describing the military glory of the king. Long and rectangular, it is composed of a square shrine with a mandapa in front; inside, the circumambulatory passage is dimly lighted by pierced windows and in the shrine is a large image of a Tirthankara. The most important sculpture here, however, is that of Yakshi Ambika seated on a lion and with two children, one of them on her lap. It is an exquisitely carved image. Except for small figure carvings in panels running the length of the shrine on the plinth and two images, a male and a female, to the west of the temple, all the niches are empty. The word Meguti— or Megudi—connotes a temple high up, and actually it stands on the hill and commands a view of the village. Just below is a ruined two-storied temple.

LAD KHAN: This is the oldest temple at Aihole. It is approached by a porch with twelve square pillars. In the first row, the ends show Yamuna on one side and probably Ganga on the other, now hidden. On the other two are loving couples. On the low parapet walls between the pillars on either side one sees the vase of plenty and other auspicious designs. There are pierced windows on the outer walls of the temple to the north, south, and east. An interesting design of fish converging toward a central lotus rather like the spokes of a wheel toward its hub is found here. It is similar to a design in the ceiling at Badami; here it forms a pierced window. While the porch is open with a low parapet between the outer pillars, the overall plan of the temple is of concentric squares, each formed by several massive square pillars. The outer wall is solid except for the lattice windows between some of the pillars. Toward the western side is a shrine with the figure of Garuda at the entrance. This was originally intended for Vishnu but now it houses a Shivalinga. Facing it is a large Nandi in the center of the pillared hall. There is a rectangular shrine on the roof on the three sides of which are the images of Vishnu, Surya, and Devi.

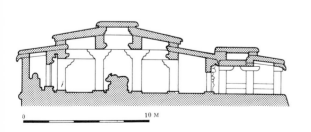

829. AIHOLE. GROUND PLAN AND ELEVATION
OF LAD KHAN TEMPLE

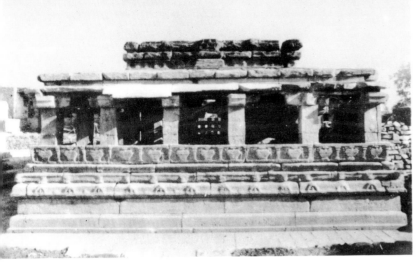

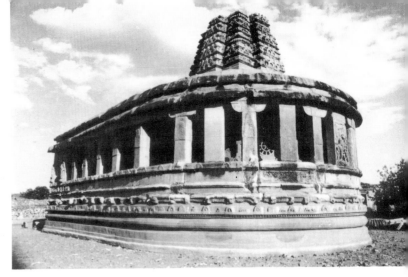

830. AIHOLE. LAD KHAN TEMPLE

831. AIHOLE. DURGA TEMPLE

KONTAGUDI (Temple of the Trident): Kontagudi is another flat-roofed temple with massive square pillars. The roof once again slopes gently toward the heavy outside walls, but here there is a shikara with carving on its four sides. We see Shiva dancing, Varaha, Bhairava, and Vamana. Inside, the ceiling immediately beneath the shikara has a carving of the guardians of the eight quarters and Brahma in the center. The entrance to the shrine has a Garuda on the lintel, indicating that the temple was originally dedicated to Vishnu. The pillars here, though massive and clumsy in shape, are better carved than the ones in the Lad Khan temple. On the ceiling near the shrine are delicately carved representations of Shiva seated with Devi, Brahma on a lotus, and Narayana on his serpent couch. Guardian figures on pillars flank the door to the shrine.

DURGA TEMPLE: The Durga temple—so named even though it has no connection with Parvati's terrible aspect—is one of the finest in Aihole. As in Buddhist chaityas, there are two rows of columns that divide the hall into a central nave with side aisles. The pillars though still square and heavy are more elegant than in the Lad Khan or Kont Gudi and have excellent figure carvings. The temple itself is on a fairly high plinth that contains several molding courses topped by a long frieze of dwarfs in amusing attitudes. The entablature above also has sculptured figures. Toward the apsidal end of the building there is a shikara which should have an amalaka of the northern or nagara style, but it is now lost. The presence of Garuda on the lintel of the shrine doorway indicates an association with Vishnu. As one goes around the ambulatory, the outer walls of the shrine show carved figures of Narasimha, Mahishamardini, Varaha, Vishnu, Ardhanari, and Shiva. At intervals light filters through the pierced windows in pleasing patterns.

HUCHCHIMALLI GUDI: Huchchimalli Gudi is a temple with a shikara over its shrine in the northern style, the facade showing a prominent semicircular chaitya *kūḍu* with a dancing Shiva in it. There is a severely plain porch with heavy square pillars leading to a large, walled flat-roofed mandapa encircling the main shrine. Two of the four pillars in the center of the mandapa have a pierced stone screen between them. The top of the shrine is decorated with carving and on the ceiling of the porch we see Kartikeya on his peacock with attendant figures. Otherwise this temple is almost bare.

HUCHCHAPPAYYA TEMPLE: In the countryside to the southwest of Aihole is another massive temple. The shrine has a northern-style shikara. There are niches on three sides, two of which contain carvings (of Narasimha and Bhairava) while the third is empty. The walled-up mandapa, with a flat rectangular roof and sloping entablature on either side, has massive pillars as in the Huchchimalli Gudi temple. The architrave above the pillars carries carvings of ganas and patterns of creepers. The lintel of the shrine's doorway shows Garuda, but the guardian figure to the left against the pilaster carries the trident, snake, and club, thus indicating Shivaite associations. It is not unlikely that this shrine was dedicated to Harihara. Above the frieze of dwarfs on the lintel are exquisite representations of the guardians of the eight quarters with their consorts on their respective vehicles as well as Narasimha and Varaha depicted in a spirited fashion. The ceiling was once decorated with sculptures of Shiva and Parvati, Seshasayi Vishnu, and Brahma on a lotus, all with devotees around them. Fortunately these panels are now preserved in the Prince of Wales Museum. They are excellent examples of early Western Chalukyan art.

Another early temple in the countryside has an archaic shikara in the northern style, a mandapa with a flat sloping roof, and heavy square pillars. The doorway to the shrine here also has a Garuda and flanking figures of Ganga and Yamuna. The architraves, though decorated with the lotus-pattern design, lack the usual frieze of dwarf ganas. On the ceiling there was originally a sculpture of the complete trinity, but only Brahma—seated cross-legged on his goose—is left. On the pilaster near the shrine to the south is a guardian figure with four arms.

Temple 7 is similar in plan to the preceding ones. A walled mandapa leads to a shrine with pillars at intervals decorated with carvings of the loving couple motif; the pillars and their capitals are massive. On the ceiling there are sculptures of the trinity with their attendants—Brahma seated astride his goose (strangely enough shown here as a peacock), and Vishnu, not lying on the serpent couch but seated on the coils of Sesha. The shrine door shows Garuda as usual. Here again the pillars divide the central nave from the aisles. The shikara on top of the shrine has completely disappeared.

There are four other similar small temples in front of the Lad Khan temple. And a small shrine built in the southern style with a beautiful carved entrance doorway stands in front of Temple 11. It is a massively walled square structure with four heavy pillars in the center. The doorway is adorned with the figures of Ganga and Yamuna and is decorated by makaras with elaborately floriated tails.

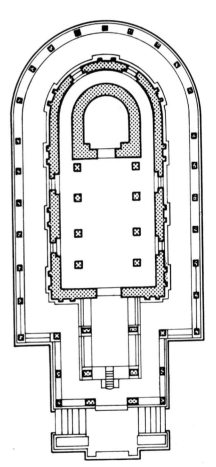

832. AIHOLE.
GROUND PLAN OF DURGA TEMPLE

485

RAWALPADI: This is a small cave composed of a hall with two square pillars and shrines on the sides and at the rear. Toward the corners there are sculptures on the wall of, among others, Ardhanarisvara; Gangadhara with Ganga as the river flowing in the three regions—celestial, terrestrial, and the netherworld—and Bhagiratha as an emaciated ascetic. The ceiling has a pleasing lotus pattern. The main shrine has a small antechamber with its doorway in ruins. On the wall of the shrine to the left there are carvings of ten-armed Shiva dancing with Parvati; Ganesha; and the Seven Mothers, all with peculiar dress and ornamentation and unusually high headgear.

There is a Jain cave to the southwest of Aihole which is composed of a veranda leading to a mandapa with decorative carving on the ceiling. A seated Tirthankara is found in the central shrine; large guardian figures with dwarf attendants flank the entrance to this shrine. On the walls of the veranda are Parsvanatha with serpent hoods over his head and Gomatesvara standing in penance between his sisters.

(Figs. 128, 296, 362, 390, 538–41)

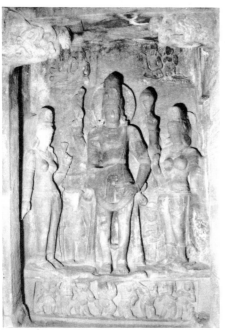

833. BADAMI. HARIHARA BETWEEN LAKSHMI AND PARVATI (CAVE 1)

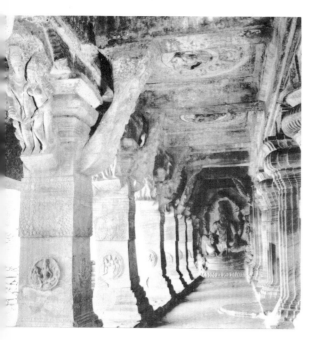

834. BADAMI. MANDAPA INTERIOR OF CAVE 4

BADAMI

Originally known as Vatapi, capital of the early Western Chalukyas, Badami is in the Bijapur district. It is in the scarp of a hill in the vicinity of a large water reservoir known as the Bhutanatha tank. From an inscription on a pillar in Cave 4—the Vaishnava cave—it is clear that the group of caves here was excavated during the time of Mangalesa about A.D. 578.

Cave 1 is a temple for Shiva and this is probably the earliest. The approach is through a veranda with four pillars and two pilasters. The veranda is reached by a flight of steps at the base of which is a long frieze of dwarfs in various amusing attitudes. The first sculpture to greet the visitor is a Nataraja with eighteen arms, dancing on a pedestal; Nandi, Ganesha, and a gana holding a pair of drums are nearby. The canopy that once topped the sculpture's shallow niche is broken and lost. The square pillars of the veranda have beautiful carved medallions, and the corbels of the brackets are decorated with a central band as in Pallava caves. On the walls at either side are recesses that form shrines containing large carved panels. In one panel, beside the bull accompanied by Bhringi, is Shiva as Ardhanarisvara with a vina in his hand. Curiously enough, Devi stands next to him, suggesting that she still has her own individuality. Opposite this is Harihara flanked by Parvati and Lakshmi. Below both panels there are long friezes of beautiful bhutaganas. A vigorous Mahishamardini piercing the buffalo with a trident, as well as a guardian figure, is found against the wall on one side. (The motif of the fused elephant and bull composing a small panel on the pedestal for the guardian is an interesting sculptural puzzle.) The makaras with floriated tails in the medallions of the front pillars of the veranda are very spirited. The hall beyond has the same type of pillars as the veranda. These eight pillars are decorated with panels illustrating Shiva and Parvati in different situations, Ganesha, loving couples, dwarfs dancing, and so forth. There are also carvings on the lintels above the pillars at the front of the veranda—a long narration of Shiva's marriage to Parvati.

Cave 2 is a Vishnu shrine. It is reached by a flight of steps cut into the rock with a frieze of dwarfs on its base as in Cave 1. Guardian figures watch over the entrance to the veranda, which is again supported by four pillars and two pilasters. On either end of the veranda are two well-carved panels. We see Varaha on one side raising Prithvi from the ocean and Trivikrama with his feet raised skyward. Bali is shown offering a boon to the dwarf Vamana—a beggar—at the foot of Trivikrama. The lintels above the pillars of both the veranda and the hall beyond have carvings composing a long frieze illustrating the churning of the ocean by the gods and the demons for the immortal elixir. Here also are various deities, such as Indra on Airavata, Vishnu on Garuda, Skanda on his peacock, Shiva on Nandi, Brahma on his swan, and Lakshmi on her lotus, as well as Durga as Mahishamardini overcoming the buffalo demon, Vishnu as Mohini apportioning nectar among the gods, the severing of Rahu's head by the use of the chakra, and elaborate scenes of the sports and life of Krishna, beginning with his birth and including such scenes as the killing of Putana, the kicking of the cart, and the felling of the twin trees. The ceiling of the mandapa has excellent design patterns, including the swastika into which Vidyadhara pairs are sometimes fitted, and a ring of fish converges toward a central lotus.

Cave 3 is relatively unimportant except for a few carvings including Bodhisattva Padmapani.

Cave 4, with a series of steps leading to it and with a long frieze on either side of the base, is probably the most important one here. The long veranda has six pillars and two pilasters with brackets decorated with rampant lions supported by dwarfs. At either side of the veranda, Vishnu is seated on Sesha Naga and Trivikrama. The dwarf Vamana is shown begging from Bali at the foot of Trivikrama. The other sculptures here are Varaha, Narasimha, and Harihara. The ceiling of the veranda is wonderfully worked with motifs of pairs of Vidyadharas, naga couples, and so forth, as well as a Nagaraja with his coils encircling him. The mandapa here is the most beautiful of any cave temple in this part of the country. The carving on the ceiling, elegantly chiseled, shows Vishnu on Garuda, Indra on Airavata, Shiva on Nandi, Brahma on his swan, Varuna on a makara, and so forth. In the main hall the ceiling has reliefs of Agni, Brahma, Varuna, Yama, Indra,

Kartikeya, and others. The shrine beyond the mandapa is empty. The pillars have beautiful brackets illustrating such themes as Ardhanarisvara, Manmatha and Rati, Rati under the Asoka tree, and an eager wife adorning herself with the aid of a mirror. The lintel above these brackets has a long frieze that illustrates various themes—the Churning of the Ocean; the fight of Krishna with Indra for Parijata; the story of Kadru and Vinata and their progeny; the snakes and Garuda; the battles of the gods and the demons; the sports of Krishna; and others.

Next to the Vaishnava cave is a small Jain cave of about the same time. Here, however, the workmanship is not as elegant as in the others. There are four pillars at the front of the veranda and then another row of two pillars and pilasters. The principal carving here is of Mahavira seated on a lion throne with chowrie-bearers flanking him. On the walls toward the end of the veranda are Gomatesvara and Parsvanatha with attendants; there are some other minor carvings of Tirthankaras.

MALEGITTI-SHIVALAYA: This very early Chalukyan temple is picturesquely perched on a rocky overhang. Malegitti-Shivalaya means "the Shiva temple of the female garland-maker." It is in the southern style and resembles the Meguti at Aihole. It is a simple shrine that one enters by way of a porch with four square, nearly decoration-free pillars that have rounded corbels on heavy brackets. Although the molding on the base of the building is simple, the series of reliefs that forms an almost continuous frieze of guardian figures is very interesting. The entrance to the antechamber is quite plain, but inside there is a sculptural representation of Krishna killing Kesi, the equine demon. There also are more pillars, and again they are heavy and simple. The ceiling of the nave shows Vishnu on Garuda. The Garuda on the doorway of the shrine indicates the temple is dedicated to Vishnu. The light in the interior enters through windows on two sides of both the shrine and the mandapa. In relief panels between the windows on the outer wall of the shrine one finds Vishnu to the north and Shiva to the south. The former is flanked by personified clubs and wheels and the latter by two dwarf followers.

THE BHUTANATHA GROUP OF TEMPLES: Close to the lake, there is a cluster of shrines dedicated to Shiva as Bhutanatha. These temples are of different periods. The main temple, with massive pillars resembling those of Malegitti-Shivalaya and with perforated windows with geometric patterns, is distinctly earlier than the ones that surround it. It was originally for Vishnu, then later used by Jains, and finally converted into a Shivaite shrine by the Lingayats.

(Figs. 130–32, 541–43)

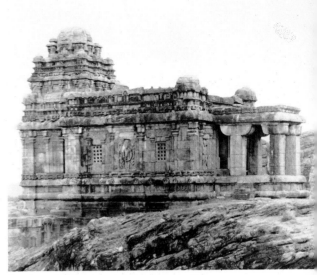

835. BADAMI. MALEGITTI-SHIVALAYA TEMPLE

BALAGAMVE

Fourteen miles southwest of Hire Kerur is the village of Balagamve, which has some fine Hoysala temples. The temple of Kedaresvara is the best preserved here. Like many other Hoysala temples, it is made up of three separate star-shaped shrines with a common mandapa which is also in three parts, each larger than the preceding one. In *sarvotobhadra* fashion it has median projections on all the sides. On top of the main shrine there is a fine sculpture of Sala, the founder of the dynasty, fighting a tiger. The decorative work, particularly in the large horseshoe-shaped windows with lion-head motif, exhibit excellent arabesque carving. Along the soffit of the arch there are carved guardians of the quarters on their mounts. The mandapa for the three shrines has, in the first section, six large pillars; the main part beyond has sixteen pillars; in the extension on three sides there are twenty-two. In all, it is a magnificent series. It is noteworthy that the ceiling of the open hall has an intricately carved panel of the guardians of the quarters and their attendants, with a dancing multiarmed Shiva in the center. This is a common feature of Chalukyan and Hoysala temples.

Another temple here is of Tripurantaka, which, though somewhat ruined, is noteworthy for a number of its features. On the elaborate entrance there is an exquisitely carved naga couple, entwined in coils on the pierced screen. The nagas are flanked by two goddesses, one under a celestial tree and the other under a celestial creeper; obviously they are Ganga and Yamuna, though without their vehicles. The lintel has an elaborate arrangement of the trinity—Brahma, Shiva as Gajantaka, and Vishnu. The hosts of attendant gods and goddesses make this a large and interesting group. To the north of the mandapa is the pair of perforated windows with a wonderful arabesque of creeper design meandering about to form rows of circles in which musical and dance figures are cleverly entwined. Another unusual feature here is a narrow frieze in low relief around the exterior of the temple illustrating erotic *mithuna* figures that are rarely seen in Chalukyan temples, although they are found in Orissan, Chandella, and other northern monuments. Also unusual are a number of large sculptures around the base of the building, held by mortises and tenons between the projecting upper edge and the lower course. Unfortunately, many of these interesting groups have been removed, but among those left is a spirited representation of the Hoysala fighting a tiger—their hounds snarling, barking, and prepared to bite. The fearful claws of the tiger proclaim that the sculptor's study of nature included animals. The prancing horse and the trumpeting elephants in this carving are equally forceful.

In this village is also a tall column on the abacus of which is the mythical bird *gandabherunda*—double-headed and, like a Garuda, almost anthropomorphic. Other ruins and inscriptions, including one which mentions a Buddhist vihara and a college attached to the temple of Kedaresvara, indicate that Balagamve, a center of learning and religion, had Brahmanic, Jain, and Buddhist associations during the Chalukyan period.

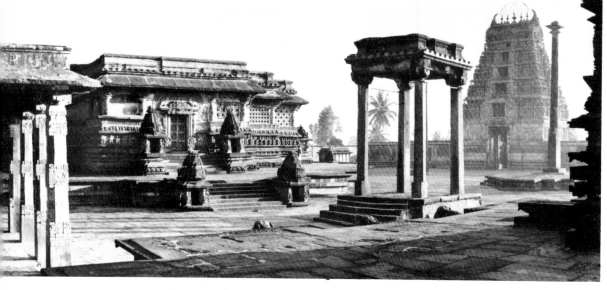

836. BELUR.
TEMPLE SEEN FROM THE COURTYARD

BELUR

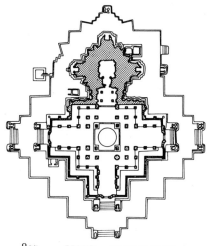

837. BELUR. GROUND PLAN
OF CHANNAKESAVA TEMPLE

At Belur in the Hassan District is a lovely temple of cruciform plan, with three star-shaped shrines. The high plinth has exquisite bands of carvings of elephants, makaras, lions, processions of cavaliers and so forth. Above it, there are exquisite carvings of celestial beauties and iconographic forms covering a vast range of the Indian pantheon. This temple dedicated to Channakesava was built by Vishnuvardhana, the famous Hoysala king who, originally known as Bittiga, was converted from Jainism by Ramanuja. It was built with the utmost devotion by the king and his learned queen Santala who, although a Jain, was enthusiastically involved in this project. The interior of this temple hall is very attractive. The large guardian figures and the makara toran are great masterpieces of the Hoysala workman, and the pierced stone windows are exquisite works of art. One also finds here a wonderful portrait of the devoted king and his art-loving queen. The wonderful workmanship of the ceiling of the mandapa, with the usual guardians of the quarters, is magnificent. Just under the eaves the pierced windows are enhanced by bracket figures or nymphs in various lively attitudes. They are among the best known in Hoysala sculpture. Labels announce the names of many of the sculptors of the period. Among particularly good individual sculptures here are those of Krishna as Venugopala, Govardhanadhari, and the Narasimha pillar.

(Figs. 295, 370, 391, 612, 616–19)

BIJAPUR

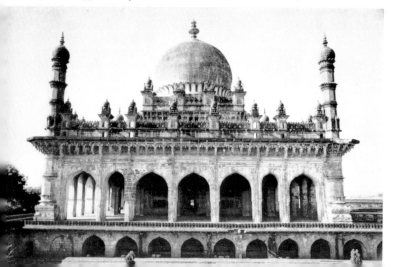

838. BIJAPUR. JAMA MASJID

Bijapur, now a ruined town, was one of the most flourishing cities of the Deccan in the sixteenth and seventeenth centuries, as its remains eloquently testify. The Adil Shahis who ruled Bijapur broke away from the Bahmini kingdom toward the end of the fifteenth century, and until it fell to the Moguls in 1686 and then to the Marathas, the Adil Shahi Sultanate held its power.

Though Bijapur is studded with many monuments, the most important are the Jama Masjid, Ibrahim Rauza, and Gol Gumbaz. One of the earliest buildings is the Jama Masjid, built by Adil Shah I. It is a vast and imposing mosque with a huge courtyard and is a fine example of the simple, elegant, and restrained architecture that continued the Bahmini style. Although it was never finished—two minars are lacking, and its entrance doorways were installed a century later by Aurangzeb—it nevertheless is an impressive building. The arches on the three sides and the square arcaded clerestory over the sanctuary, supporting an imposing dome with the crescent on the finial (a symbol of the Turkish origin of the Adil Shahis), give a distinct personality to the monument.

Ibrahim Rauza is the tomb of Ibrahim Adil Shah (1580–1627). Built toward the beginning of the seventeenth century, it is noted for its elaborate tomb and mosque. The architect rightly chose to build on a relatively small scale and was thus able to lavish on it all his skill and still complete it, rather than attempting a larger structure that might have remained unfinished.

The mosque has the usual dome and tall turrets at the corners. The treatment of the arches eloquently

839. BIJAPUR. IBRAHIM RAUZA

840. BIJAPUR. GOL GUMBAZ

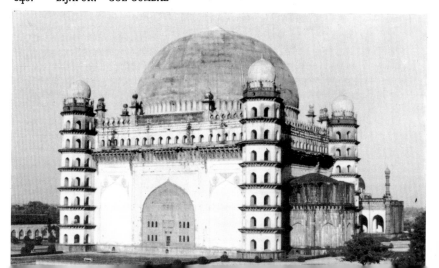

proclaims the building's superior architectural plan and its execution. Within the walled enclosure the tomb and the mosque face each other with an ornamental pool and fountain between. The carving of inscriptions, the arabesques, and the designs appropriately incorporating new forms—all are skillfully created and executed.

Gol Gumbaz, "the round dome," is an architectural wonder, if only for its sheer size. The dome is probably the largest in the country and perhaps in the world. The mausoleum of Mohammed Adil Shah, the building itself is a monstrous cube, crowned by the enormous dome, with minarets at the four corners. Under the dome the slightest whisper is magnified and repeated again and again, making this one of the strangest "whispering galleries" in the world. The interior space is totally harmonious; the elegant large arches below the dome create an atmosphere of great charm. The arches, arcade, foliated parapet, and large and imposing dome with its turrets amaze the spectator.

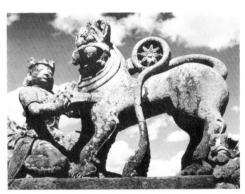

841. DODDA GADDAVALLI. MAHALAKSHMI TEMPLE

DODDA GADDAVALLI

Dodda Gaddavalli, a village twelve miles from Hassan, has a temple of Mahalakshmi built in 1113 by a prosperous merchant named Kullahana Rahuta and his wife Sahajadevi during the reign of the Hoysala king Vishnuvardhana. This is a complex of five temples, four of them connected by a large common hall (mandapa) supported by sixteen pillars. Each of the shrines is composed of an inner shrine with a vestibule extending from the tower and surmounted by the Hoysala crest of Sala fighting a tiger. The large court that surrounds this cluster has shrines at the corners which together make up nine towers—or vimanas in the Hoysala style. The eastern shrine of the central cluster is of Mahalakshmi, the western one of Bhutanatha Shiva as a Shivalinga, the southern one of Bhairava. The northern one was originally dedicated to Vishnu, as one can tell by the mark of Garuda on the pedestal that now houses Kali. The outer walls have several niches, each flanked by double or single pilasters and smaller pilasters crowned by miniature shikaras. The tiered roof contains elaborate horseshoe-shaped decorations topped by lion heads. The Mahalakshmi shrine has dancing Shiva on the lintel; the Kali shrine has Yoganarasimha; and the Bhutanatha shrine has Gajalakshmi. On both sides of the west doorway of the middle hall of the Kali shrine there are exquisite door guardians wearing Vishnuite emblems. The Kali looks contemporary with the temple itself, but the figure of Mahalakshmi seems to be of a much later date. A carving of the *vetala* in the temple of Kali, looking almost like a skeleton, appears to follow the tradition of the earlier style of the theme that is seen at Mahakutesvara. In an inscription, the architect of this temple is called "Malloja Maniyoja, resplendent with the creative skill of Visvakarma, the architect of the gods."

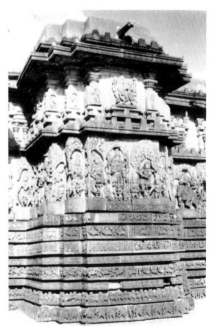

842. DODDA GADDAVALLI. HOYSALA EMBLEM

HALEBID

Halebid—literally "old house"—is the ancient city of Dvarasamudra, the capital of the Hoysalas, and here they built one of their finest and largest temples. It is a double temple and a superb example of this dynasty's workmanship. The usual high plinth is more elaborately carved here than anywhere else. The star shape of the vimanas has lent itself to the exhibition of a large number of forms of the deities. As one enters the temple, the doorway with its elaborate makara toran attracts attention. A fine dancing figure of multiarmed Ganesha is on the outer wall of the temple, while within the courtyard near the temple is an exquisite monolithic seated Ganesha. The inner mandapas with their lathe-turned pillars and impressive ceilings (guardians of the quarters on their vehicles with dancing Shiva in the center is the theme in each) are most imposing and attractive. The seated humped bull with rows of bells and other trappings facing the Shivalinga is exquisitely carved. The mandapa for the bull is a striking pillared pavilion, and its guardians are carved with such elaborate decoration and care of detail that each is itself a masterpiece. Every detail in this temple, including the bracket figures on the lathe-turned pillars, makes the spectator marvel that art in the late medieval period remained so vital alive despite excessive ornamentation that nearly overcomes the figures.

(Figs. 148, 293, 614, 615)

843. HALEBID. HOYSALESVARA TEMPLE

HAMPI

Hampi, on the Tungabhadra River in the Hospet Taluk of Bellary District of Mysore, was once the site of the Vijayanagar capital. It is a vast expanse of ruins indicating the glory of the Vijayanagar emperors. This is also believed to be Pampa, the place where Rama spent a rainy season in the company of Sugriva. In the fourteenth century under the spiritual blessing of Vidyaranya, Harihara and Bukka established a kingdom here as the nucleus of a great Hindu empire that would challenge the Muslim hordes. The Jain temples on the Hemakuta Hill are pre-Vijayanagar, but the main temple—the large Virupaksha temple for Shiva—is a Vijayanagar structure. (Virupaksha, also known as Pampapati, is the deity invoked in Vijayanagar copperplate grants.) Facing east, the Virupaksha temple overlooks the broad road that was the main market area. Its imposing gopura is typically Vijayanagar. The ceiling of the large pillared hall is completely covered with

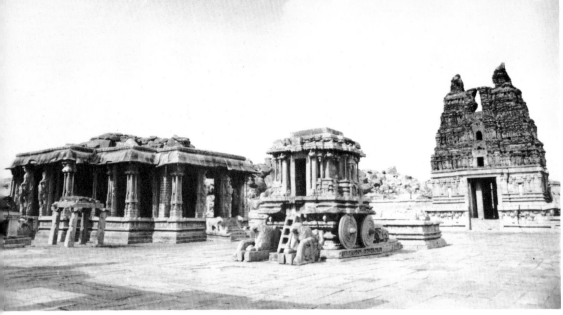

844. HAMPI. VITHALA TEMPLE AND MONOLITHIC CHARIOT

murals, and there one sees a gorgeous procession of Vidyaranya in a palanquin; Arjuna shooting the fish; the marriage of Draupadi; Tripurantaka; Kamari; and more. Beyond the mandapas there is a circumambulatory court and then the main shrine itself.

The Vithala temple, though unfinished, is exquisite—one of the finest examples of Vijayanagar architecture. The monolithic chariot with running elephants in front, is indeed most imposing. The pillars—there are fifty-six—in the large mandapa are decorated with warriors and horses and other creatures. There is also the mandapa for the weddings of gods, a festival hall, and a lofty lamp pillar. As usual, the temple has a large ambulatory court and a holy of holies. Here, in the Vijayanagar style, on the walls of the shrine are niches and recessed pilasters and rows of mythological lions and dwarf demigods. There are arches with a lion's head at the top and balustrades decorated with elephants and mythological animals. The pillar capitals have the plantain flower as decoration.

The Krishna temple, with an inscription dating it 1513, was built by Krishnadeva Raya to enshrine a seated baby Krishna that he brought as a war trophy from Udayagiri. Here again, the shrine is in the center with an ambulatory court, small half-hall, and larger mandapa.

The Hazara-Ramaswami temple is a dainty little one and is especially noteworthy for its carvings of scenes from the *Ramayana*. The two great monolithic sculptures of Narasimha and Ganesha belong to the time of Krishnadeva Raya. The Narasimha is about twenty-two feet tall and is dated 1528—it is a perfect example of Vijayanagar work. The monumental figure of Ganesha is ironically styled a "mustard seed," *Sasivikallu Gaṇeśa*. It is about eight feet tall and is also in the best Vijayanagar tradition.

845. HAMPI. TULABHARA (BALANCE)

There are other monuments at Hampi like the Queen's Bath, with its elaborate stucco work and projecting balconies. It is a blend of Hindu and Islamic architecture, making it a very pleasant structure. There is also a massive stone platform—called Mahanavami Dibba—built for the Navaratri festival, the celebration of Krishnadeva Raya's victory over the Gajapati of Orissa. A large pillared hall once stood on this platform, and even in its ruined state one can see the friezes showing processions of elephants, horses, dancers, and musicians. From the great height of the platform one can imagine what is lost.

Similarly, on the base of the king's palace there is another such frieze that hints at former splendor. Of the king's audience hall, only a large base remains, with flights of steps and a balustrade of green chlorite decorated with lotus medallions.

The Lotus Mahal, its configuration resembling the spread petals of the lotus, is a two-storied pavilion with twenty-four square pillars on the ground floor carrying recessed and floriated arches—a happy blend of Islamic and Hindu motifs.

In the zenana enclosure, the watchtower, the Queens' Palace, the women guards' quarters, and the elephant stables are all excellent examples of the adaptation and blending of Islamic motifs and Hindu elements. They speak volumes about the catholic outlook of the Vijayanagar emperors, particularly Krishnadeva Raya.

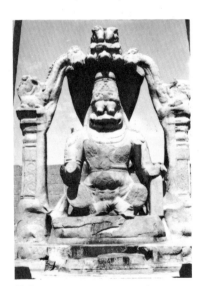

846. HAMPI. MONOLITHIC NARASIMHA

847. HAMPI. LOTUS MAHAL

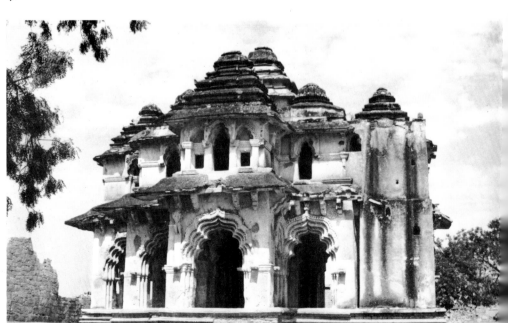

HAVERI

The shrine of Siddhesvara at Haveri in the Dharwar District closely resembles the temples of Siddharamesvara at Niralgi, Muktesvara at Chudadampur, and Somesvara at Haralhalli and is typical of late Chalukyan work. This shrine faces west unlike most of these temples, which normally face east, and it rises on a fairly high base, as is usual in Chalukyan temples, encircled by a sloping parapet. The sculpture of Shiva, carefully carved in front of the vimana above the roof of the mandapa, suggests that the temple may have been originally dedicated to him. The sculptures in the niches of the subshrine have been removed, probably because over the centuries the temple was used by Jains and others. At the front there is an antechamber that leads to a large mandapa with pillared projections on all sides, making the entire temple cruciform in plan. All the pillars are beautifully carved and polished, suggesting lathework in some cases, with elaborate figure carving, polygonal design, and floral work. The brackets are typically Chalukyan. The doorway of the antechamber has representations of the trinity—Brahma, Shiva, and Vishnu—which is again characteristically Chalukyan. (A superb example of this feature is the lintel from Hampi in the National Museum.) Ganesha and Kartikeya on either side of the trinity are another indication that the temple was originally intended for Shiva. On either side of the antechamber, there are pierced screens of excellent workmanship that admit light. The ceiling of the mandapa is decorated with a number of panels around the central one of Shiva, where instead of the usual guardian figures we find the theme of the eight mothers dancing. The guardians of the quarters are reliefs on one of the pillars. The association of Trimurti with Surya is emphasized by the repetition of the trinity and Surya on the four sides at the bottom of one of the pillars. Several freestanding sculptures in and around this temple are examples of typical twelfth-century style. Particularly noteworthy are the naga couple with snake hoods above them and their coils entwined to form a lovely pattern. A fine example of Chalukyan work is the bust of Devi with ringlets on her forehead and an elaborate crown and other ornamentation.

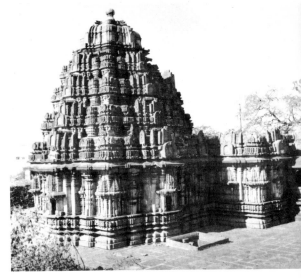

848. HAVERI. SIDDHESVARA TEMPLE

HEMAVATI

Hemavati, originally known as Henjeru, the ancient capital of the Nolambas, is in the Madakasira Taluk of Anantapur District on the northern border of Mysore. The Nolambas, who were feudatories under the Western Gangas and the Rashtrakutas, had a keen aesthetic sense. While Nolamba art follows the Chalukyan idiom, their temples are more simple than either Chalukyan or Rashtrakuta ones. Their finest temples are at Hemavati, and the three main ones lie beyond the village. A number of groups of the Seven Mothers and several elegant Nandi bulls lie scattered about, but the most important feature in all these temples is the vase-of-plenty motif seen on either side of the doorways, symbolically representing Ganga and Yamuna, as in early Chalukyan temples at Aihole. The *asta mangalas*—the eight auspicious objects—or the *sodasa mangalas*—sixteen auspicious objects—with Gajalakshmi in the center on the lintels are also interesting. Pierced windows with loving couples, celestial beauties, personified Ganga and Yamuna, or musicians and dancers, all entwined with "wish-fulfilling" creepers, enliven these temples further. The Doddappa temple has particularly excellent examples of pierced s one windows. Here they softly light the hall of the mandapa leading to the shrine. The Mallikarjuna temple has a magnificent doorway where one again sees the heavenly creepers twining around several figures. The mandapa pillars at Hemavati are so exquisite and so full of diverse themes revealing the fertile imagination of the sculptor that the Chola emperor Rajendra carried several of them away to his capital as trophies.

(Fig. 554)

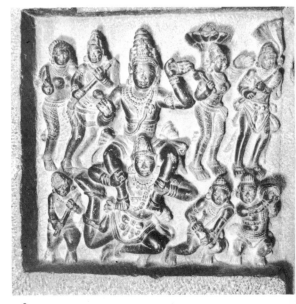

849. HEMAVATI. CEILING PANEL
FROM MALLIKARJUNA TEMPLE

ITTAGI

Ittagi, a village twenty-two miles from Gadag, has a beautiful temple dedicated to Mahadeva Shiva. The vimana has cusped niches in the center of each tier, always crowned by miniature Chalukyan-style shikaras. The top tiers and the crowning shikara are now lost. As is characteristic of Chalukyan architecture, the horizontal lines of the vimana are more prominent than the vertical. The base of the temple, which would also be elaborate, is now embedded in a mass of accumulated earth. In the moldings of the tower, there are many interesting motifs, such as a lively group of monkeys. The filigree wreaths that one sees in the recesses of the walls are in two cases pierced to form windows. The closed mandapa in front has a doorway on each of its four sides, the one on the east leading to a large open hall and the one on the west into the shrine. The doorways have rich decorative detail, and the ceilings are elaborately ribbed with lotus-petal decoration. At one time there were bracket figures on the outside pillars of the porches which unfortunately are now lost. To have an idea of them one can look at those still intact at Kuruvatti. Some of the empty niches also proclaim that fine sculptures have been removed. The great hall has twenty-six large pillars—some round, some square but all elaborately carved—and a number of smaller ones resting on the elevated bench that carries the sloping eaves. An inscription here from 1112, the time of Vikramaditya VI, describes the creation of this temple by Mahadeva, the commander in chief. It is interesting to note that this temple is praised in one of the inscribed verses as "an emperor among temples."

850. ITTAGI. MAHADEVA TEMPLE

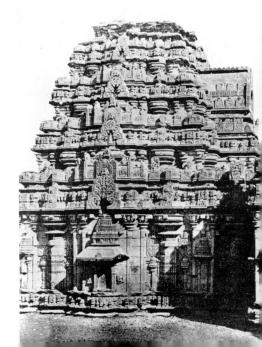

KUKKANUR

Four miles north of Ittagi and not far from Gadag is Kukkanur, where one finds the Mahamaya temple which has late additions of the Vijayanagar period. More interesting is a group of nine earlier shrines clustered together and called the Navalinga temple. There are four large pillared mandapas contiguous with the nine shrines around them. The pillars of the mandapas show an advance in style over that found in the early Chalukya ones at Pattadakal. The cubical parts have panels illustrating scenes from the epics and the Puranas and elaborate circular moldings toward the top and capitals with large flat abaci. The seated Devi is probably not Lakshmi but Sarasvati, since the left hand holds a book and the upper hands a noose and a goad. There is a similar goddess on either gateway. When we consider these representations in the context of the inscriptions found here, which are coeval with the sculptures themselves (about the eleventh or twelfth century) and mention grants to different temples dedicated to Ganga, Kalika, Mahamaya, Sarasvati, and Chamunda, the Navalinga shrine is probably not for Shiva but for the goddesses in various aspects, even though today there are Shivalingas enshrined in the cells with Nandis facing them in their mandapas. The makaras with wonderful floriated tails and dwarf riders make the torans attractive and are of the typical later Chalukyan style so frequently seen in the medieval temples in this region. The inferior stone used here accounts for the vast deterioration in the carving on the outside walls of the shrine. There is also a large tank with flights of steps leading down to the water's edge.

 Another temple at Kukkanur is known as Kallesvara. Though it is Chalukyan, it also has Dravidian features. On each of the tiers of the vimana, the cornice contains the horseshoe-shaped *kūḍu* decoration. On the tower there is a prominent representation of Shiva dancing. The walls, with their pilasters that flank niches crowned by miniature shikaras, follow the type in the Virupaksha temple at Pattadakal. However, there is very little figure sculpture, and the decoration is characteristic of medieval Chalukyan architecture. The central square shrine has an antechamber in front leading to a large mandapa with four main pillars and many pilasters. There is Nandi in the open porch outside, and the pillars of the mandapa have round·shafts and capitals and square bases. The large hall has six pierced windows that admit light. There are two remarkably well-carved images of Brahma and Shiva placed against the wall on either side of the entrance of the antechamber. They are typical of late Chalukyan work, with elaborate tracery that has been greatly mutilated.

851. KUKKANUR. EXTERIOR OF NAVALINGA TEMPLE

KURUVATTI

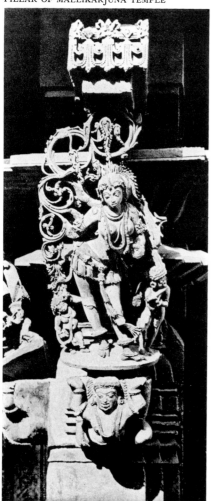

852. KURUVATTI. PILLAR OF MALLIKARJUNA TEMPLE

Kuruvatti, a village on the Tungabhadra River twenty miles from Harihara, has an old temple (Mallikarjuna) belonging to the late Chalukyan period. The outer walls have extremely beautiful sculptural work. The niches on the wall cease to be mere niches and are rather miniature shrines with elaborate towers over their lintels. Encircling the vimana of each niche-shrine is an elaborate toran which proceeds upward from the gaping mouth of a makara on either side. The elegant scrollwork of the tails forms graceful cusped arches each surmounted by a lion's head. The pilasters between the niches are elegant though simple and are characteristic of the Chalukya style. The pillars of the porch have bracket figures of young women, so delicately and richly carved that one almost wonders how it was possible to render them in stone. Encircling the main figures and their flanking dwarf musicians and drummers is a delicate floral pattern. Perforated stone screens and delicate carvings make this one of the most elegant of later Chalukyan temples.

MAHAKUTESVARA

Three miles from Badami is a small group of temples, the principal one being dedicated to Shiva as Mahakutesvara. Like the ones at Aihole and Pattadakal, these are early temples. On either side of the entrance to the large enclosure are lifesize guardian figures of fearful appearance, resembling Bhairava and Chamunda. Within the enclosure is a large masonry tank—the lotus pool for Vishnu—containing a small central pavilion with a five-faced lingam in it. To the north of the tank is the Mahakutesvara temple, to the south Mallikarjuna. Mahakutesvara is in the southern style, while the other shrines are of the nagara or northern type. The Mahakutesvara has a small porch with four square pillars almost devoid of decoration, a mandapa, and a shrine. There are niches on the walls containing fine sculptural work. Particularly noteworthy are the Ardhanarisvara, Varaha rescuing Prithvi, and the guardians. There are also pierced windows characteristic of these Chalukya temples. The Nandi here with long garlands of bells and prominent hump is very beautiful indeed. A sandstone pillar made to celebrate righteous victory was found here with a long inscription describing the wealth and glory of Mahakutesvaranatha.

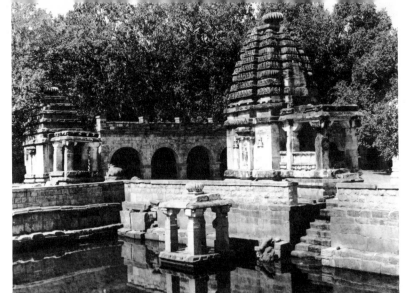

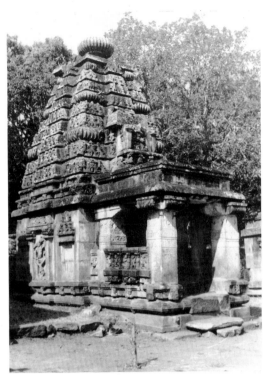

853. MAHAKUTESVARA. TEMPLE AND SACRED POOL

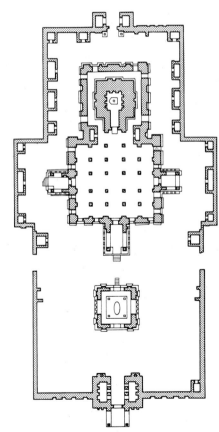

854. MAHAKUTESVARA. TEMPLE OF SHIVA

PATTADAKAL

Like Badami, which is about ten miles away, and Aihole, Pattadakal is noteworthy for its beautiful early Western Chalukyan temples. They belong mainly to the time of Vikramaditya II (whose art-loving queen Trailokyamahadevi reverently named the deity Lokesvara after herself as indicated in inscriptions). The inscription on the eastern porch says that the architect Sutradhari Gunda constructed the Virupaksha temple for Lokamahadevi, sister of Trailokyamahadevi, to commemorate the conquest of Kanchi by Vikramaditya II. The inscriptions on the east facade of the Papanatha temple eulogize a sculptor named Chattara-Revadi-Ovajja, who is described as one who "made the southern country" (that is, who built southern temples as a member of the architects' guild of Sarvasiddhi). This confirms that Vikramaditya II brought famous sculptors and architects from Kanchipuram and created temples resembling the Kailasa temple in his own city.

VIRUPAKSHA TEMPLE: Constructed toward the middle of the eighth century, the Virupaksha temple has a large court and a fine hall for Nandi, Shiva's bull, which is ornamented with an effigy of the goddess Ganga. On the east side it has a porch with two pillars decorated with the loving-couple motif. Flanking the entrance are two large door guardians, three-eyed and crowned with a trident to suggest their association with Shiva, and the personified treasures Sankhanidhi and Padmanidhi. The ceiling of the porch has an elaborate carving of Surya in his chariot, with Usha and Pratyusha at his side, shooting arrows to dispel darkness. The pillared hall has a coiled naga on its ceiling like the one at Badami. The columns have splendid bas-reliefs of anecdotes from the *Ramayana* and the *Mahabharata*. Particularly interesting here are the stories of the elixir of immortality, the descent of Ganga, the purification of the sins of Sagara by the efforts of Bhagiratha, the loves of Indra and Ahalya, the capture of cattle as a ruse to provoke war as described in the *Virataparva*, the churning of the ocean to obtain ambrosia, and many other tales. At the entrance to the main shrine, two figures once again guard the door.

On the south side is another porch, with an exceptionally beautiful guardian holding a huge club with a snake coiled around it. An inscription tells us that this figure was carved by Baladeva, son of Suggi-acharya. Here, too, are scenes from the epics: Hiranyakasipu fighting Narasimha, and Ravana shaking Mount Kailasa. The north porch has an imposing bas-relief of the Gajendramoksha incident, Vishnu on Garuda rescuing the elephant, and an eight-armed Shiva dancing. The walls of the shrine have beautiful sculptural representations of the four-armed Nataraja standing on the dwarf Apasmara with the bull standard; Tripurantaka seated in the warrior pose; Trivikrama; Lingodbhava; Jatayu fighting Ravana; Shiva with a staff in the form of Lakulisa; Ardhanarisvara; and Vrishabhantika with Parvati. The large mandapa for Nandi has a beautiful Ganga image.

MALLIKARJUNA TEMPLE: The Mallikarjuna temple is adjacent to the Virupaksha temple and resembles it so closely as to be almost its twin. This temple—dedicated to Shiva and called Trailokyesvara after Trailokyamahadevi, the younger sister of Lokamahadevi and junior consort of Vikramaditya II—was also erected to commemorate her husband's victory at Kanchi. It, too, faces east and is modeled after the Kailasa temple in Kanchi. As in the Virupaksha temple, the large hall beyond the porch has eighteen columns on which beautiful bas-reliefs illustrate the *Ramayana*, *Mahabharata*, Krishna's sports, and stories from the *Panchatantra*. Rows of geese, flying Gandharvas, elephants, lions, and other motifs, appear in a frieze under the eaves. The shrine itself is decorated with beautiful bas-reliefs of Gajantaka, Lakulisa, Harihara, Karivarada rescuing the elephant, and so forth. The ceiling of the antechamber near the shrine has sculptures of Shiva and Parvati. There are several loving couples of exceptional quality in this temple.

KASIVISVESVARA TEMPLE: The Kasivisvesvara temple, near the Mallikarjuna temple, faces east. It is in the northern style, but the Nandi mandapa is ruined and the shikara is lost. In its horseshoe-shaped chaitya window high on the facade is Shiva dancing, with Parvati watching. The columned hall in front has a doorway with the river goddesses Ganga and Yamuna on either side as well as pious nagas with their hands

855. PATTADAKAL. GROUND PLAN OF VIRUPAKSHA TEMPLE

joined. The motif of swans above the doorway is particularly pleasing. Horned guardian figures with three eyes indicate that the temple is dedicated to Shiva. A beautiful central relief on the ceiling shows Shiva, Parvati with the baby Skanda in her arms, and Nandi, surrounded by guardians of the quarters as is usual in Chalukyan temples. The marvelous sculptures on the columns illustrate scenes from the *Ramayana*, the sports of Krishna, and diverse forms of Shiva and Parvati, such as the Ardhanarisvara, Kalyanasundara, and Tripurantaka. Beyond the hall is the antechamber leading into the shrine.

SANGAMESVARA TEMPLE: This temple, built in the early part of the eighth century, is a little away from the Kasivisvesvara temple. Shiva in this temple is known as Vijayesvara, after the builder of the temple, Vijayaditya. Of large proportions, this temple is rather simple but effective. Though the sculptures are massive, they look unfinished and indicate that the structure was left incomplete for some unknown reason. There is a main shrine surrounded by an ambulatory, two secondary shrines, and a columned hall.

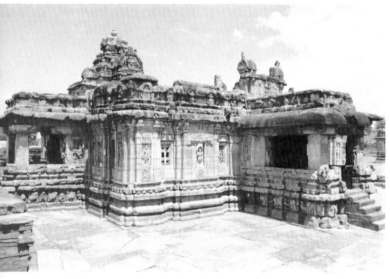

856. PATTADAKAL. VIRUPAKSHA TEMPLE

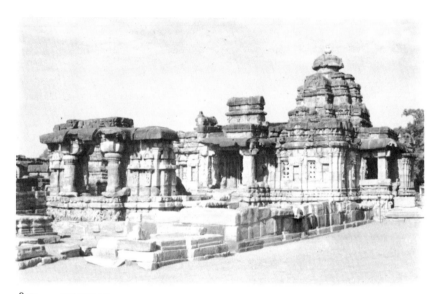

857. PATTADAKAL. MALLIKARJUNA TEMPLE

The ambulatory is lighted through beautiful pierced windows. The usual figures flank the entrance and proclaim it a temple of Shiva, as is corroborated by the inscription that names the deity Shiva Vijayesvara. The unfinished carvings on the walls of the main shrine represent Varaha, Gajantaka, Vrishabantika, and others. Under the eaves there are rows of exquisitely carved dwarf followers of Shiva in various poses resembling those of caryatids. The name of the sculptor Paka who fashioned two of the columns is mentioned in an inscription.

CHANDRASEKHARA TEMPLE: A little to the left of the Sangamesvara temple is the Chandrasekhara, the shikara of which is in ruins. The shrine and the mandapa are rather simple and plain. The guardian figures with tridents on their heads indicate that it is a temple of Shiva. The niches are now empty and examples of sculpture are hence few.

GALAGANATHA TEMPLE: Nearby is the Galaganatha temple, which is in the northern or nagara style. Simple but grandiose, the temple has towers at its four corners and in the center, on which the ribbed amalaka and *kūḍu* motifs are repeated at every level, with a large ribbed amalaka as the crowning piece. The lintel over the doorway is carved with a dancing Shiva, and there once were probably figures of Ganga and Yamuna on the jambs. There is an ambulatory around the main shrines and an antechamber, but no mandapa. The image of Ardhakasamharamurti, carved in a small porch on the south wall of the temple, is quite effective.

JAMBULINGA TEMPLE: At the rear of the Galaganatha temple is the Jambulinga, also facing east and also in the nagara style though the amalaka is missing. It is a shrine with a small mandapa whose ceiling is lost, but whose well-carved entrance remains. The facade of the vimana immediately above the entrance shows Shiva dancing, watched by Parvati and Nandi.

KADASIDDHESVAR TEMPLE: This is another temple near Galaganatha, with Shiva and Parvati on the lintel of the doorway. The figures guarding the shrine are mutilated, and the mandapa in front of it has lost its roof. Ganga and Yamuna are depicted on the jambs of the doorway. The sculptures on the outer walls of the shrine are Shiva on the south; Harihara on the west; and Ardhanarisvara, with his hands resting on Nandi, on the north.

PAPANATHA TEMPLE: The temple of Papanatha is a little to the south of the Virupaksha temple. Also facing east, it was built toward the end of the seventh century, or even later, in the northern style. It is known from inscriptions that the sculptors Baladeva and Changamha constructed the temple along with Revadi-Ovajja, a disciple of the architect Sarvasiddhi. The temples were probably originally intended to be

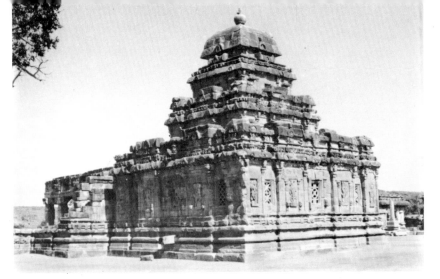

858. PATTADAKAL. TEMPLE

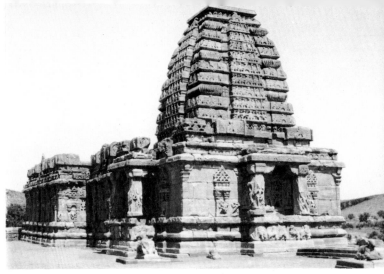

859. PATTADAKAL. PAPANATHA TEMPLE

dedicated to Vishnu, who appears on the ceiling of the Nandi mandapa as Seshasayi, but were later turned over to Shiva. The Nandi mandapa has sixteen columns with splendid *mithunas*, some of them as musical couples, carved on the pilasters and on the walls. The temple also consists of walls, a porch, a columned hall, an antechamber adjoining the main shrine, and an ambulatory. The figures guarding the hall are severely damaged. The lintel of the mandapa doorway shows not only Gajalakshmi under a makara gateway, but also Shiva and Parvati with Nandi above. The ceiling panels and beams of the mandapa are richly decorated with diverse designs. The doorway of the shrine is guarded by figures with tridents over their heads. On the ceiling of the antechamber there is a naga, encircled by his coils as at Badami, and a Nataraja in the company of Parvati, carved with great taste. The lintel of the doorway to the sanctuary shows Gajalakshmi with Indra, Vishnu, Surya, and Shiva. The outer walls of the shrine have a wealth of sculpture, identified in cartouches. The south wall in particular illustrates incidents from the *Ramayana*, among them the Putrakama sacrifice by Dasaratha, the birth of Rama, Sita choosing her husband, the incidents in the forest including Surpanakha's intrusion, Kharadushana's attack, and the golden deer. There are also sculptures illustrating the Kiratarjuna incident on the north wall and Gajantaka on the west wall.

The old Jain temple here is of about the ninth century and is in the southern style, with a shrine, an ambulatory, a secondary shrine, and a small columned porch. The makara decoration on the lintel of the door to the shrine and the elephants with riders are superbly carved; the personified treasures Sankhanidhi and Padmanidhi, along with the auspicious vases symbolically representing the river goddesses Ganga and Yamuna on the door jambs, are also noteworthy.

(Figs. 37, 201–4, 355, 356, 545, 546)

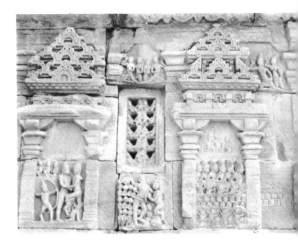

860. PATTADAKAL. SCENES FROM THE RAMAYANA (PAPANATHA TEMPLE)

SOMNATHPUR

Twenty miles from Seringapatam is a temple in miniature, in typical late Hoysala style, exquisitely planned and executed. It is a triple shrine with three star-shaped vimanas radiating from a long pillared hall to make the temple look cruciform in plan. As usual in Hoysala temples, it is set on a high podium with richly carved friezes of swans, elephants, cavalry, makaras, and so forth. The star shape of each shrine, with its innumerable indentations, lends itself to the placing of decorative figures all around the circumference of the temple, many of them almost facing each other. A cella is dedicated to Kesava in the main shrine; Venugopala is honored in one of the other two. The front hall has twelve pillars, while the central hall has four, all of them bright, polished, and lathe-turned.

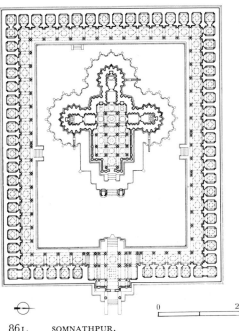

861. SOMNATHPUR.
GROUND PLAN OF KESAVA TEMPLE

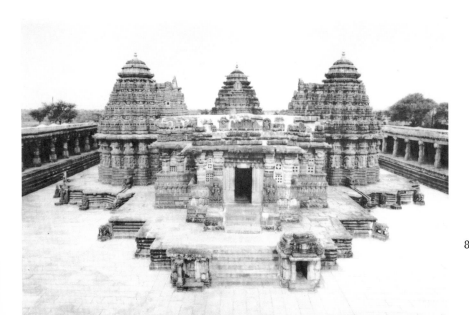

862. SOMNATHPUR. KESAVA TEMPLE

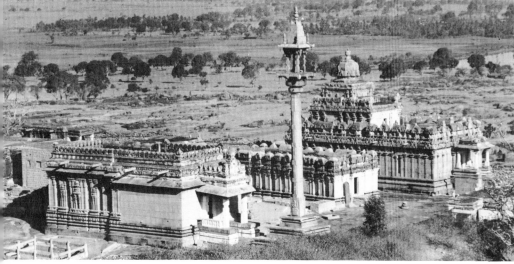

SRAVANA BELGOLA

About fifty miles northeast of Mysore is Sravana Belgola, a spot which is sacred to the Jains; it is here that Bhadrabahu, the spiritual master of Chandragupta Maurya, starved himself to death according to the Jain tradition of *sallekhana*. The belief that a number of Jains from the north migrated here in the company of Chandragupta Maurya and Bhadrabahu would seem to be confirmed by the fact that even today it continues to be a Jain stronghold.

Of the cluster of monuments here, the most important is a colossal image of Gomatesvara, the saintly son of Adinatha, the first Tirthankara, who is better known as Rishabhadeva. Although similar colossal figures exist at Karkala and Enur on the west coast in the Kanara District, these are respectively forty and thirty-five feet high, while the colossus of Sravana Belgola reaches a height of over fifty-six feet. It is undoubtedly the finest example of tenth-century Western Ganga work. The prince is represented standing in a rigid attitude, completely oblivious of the anthills springing up between his feet and of the dense growth of creepers twining around his legs.

A large reservoir presents a picturesque appearance against two adjacent hills. An open court honoring Gomatesvara, situated on the hillside, though of no architectural importance, does have the advantage of providing a foundation for the colossus, which was created by Chamundaraya, the minister of the Western Ganga king Rachamalla II, in about 983. There are also a number of temples called *basati* (or *basadi*) of which the larger and finer ones are of the time of Chamundaraya, though some of the buildings date from the twelfth century.

At Sravana Belgola there is also a typical Jain freestanding pillar opposite the main entrance of the temple of Parsvanatha. Resting on a high stepped base, this huge pillar is square at the bottom and then becomes circular and fluted higher up, with lateral bands at regular intervals. At the top, a fluted auspicious vase supports an abacus with griffins under the corners. The whole is crowned by a miniature four-pillared mandapa.

ORISSA

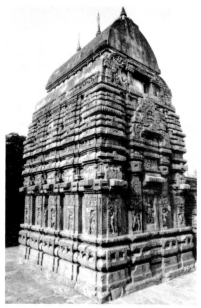

BHUVANESHWAR

PARASURAMESVARA TEMPLE: The Parasuramesvara temple is among the oldest in Orissa, dating from the eighth century A.D., as is revealed by its relatively short, square tower—or *deul*—above the cella with simple projections at the corners and in each face. The *deul* curves in toward the top, and the amalaka sits on its narrow neck. On the lower part there is a series of circular niches one above the other, in one of which is found a multiarmed Shiva Nataraja. The rectangular anteroom before the cella has a plain flat double roof, but the outside walls are profusely carved; its most noteworthy embellishment is a pair of elegantly carved pierced windows. Here musicians playing flutes, drums, and cymbals form an orchestra for the dancers, whose limbs are bent and stretched into graceful dance poses. Inside the anteroom are two rows of columns, creating a nave and side aisles.

VAITALDEUL: This is an unusual temple with a barrel-vaulted roof and somewhat resembles the gopuras in the south—a peculiarity it shares with the Teli-ka-Mandir at Gwalior. The Vaitaldeul has a prominent central projection on the facade, on which Nataraja dances in a circular niche with a massive *kūḍu*. On the top of the tower are three miniature amalakas with small flame-shaped shikaras on top. The porch, or anteroom, is again double-roofed with clerestory windows for ventilation. It is at a later stage that the pyramidal porch appears. In fact, the Vaitaldeul probably dates from the end of the ninth or beginning of the tenth century; the sculptural decoration in its niches is in a rather early style. The principal niches enshrine

the more important deities, such as a very impressive Mahishamardini killing the demon, and the smaller niches have delicately executed loving couples.

MUKTESVARA TEMPLE: The Muktesvara temple at Bhuvaneshwar is a miniature temple of supreme elegance on which the sculptor has lavished all his skill in executing delicate individual figures and groups and floral motifs interspersed with animals and birds. The freestanding toran has makara heads at the terminals of a lovely arch. The porch with its slightly pyramidal roof is a worthy companion to the elegant tower behind it, which is crowned by a large amalaka. Large screens on either side of the porch narrate age-old fables such as those of the monkey and the crocodile, the tortoise and the swans, and so forth. A whole series of sculptures embellishes the walls: naga columns with nagarajas and naginis, their coils wound round the shafts, who hold objects for worship of the deity—a garland, a crown, a conch full of water, an incense burner, etc.; statues representing Shiva, Durga, Ganesha and other deities; one of the traditional themes, such as a woman impatient for the return of her husband, an amorous pair, and a young beauty talking to her parrot, or adorning herself, or peeping from a half-open door. All this exquisite carving embellishes the most charming temple in Orissa, a miniature one with all adjuncts complete, including a paved court with a pool reflecting the beauty of the lovely structure.

LINGARAJA TEMPLE: The largest and most important temple at Bhuvaneshwar—one that ranks with those at Konarak and at Puri—is the Lingaraja temple, also known as Krittivasa, built about 1000. The exact date of this temple and the name of its builder are not clear, though it is sometimes attributed to the Somavansi king Mahabhavagupta Janamejaya. There is a cluster of smaller edifices around the central one. In addition to the porch or audience hall there are a dance pavilion and a refectory which were added to the main shrine during the time of Narasimha and Anangabhima. The Lingaraja is the most imposing temple surviving in Orissa—since the largest tower, the one at Konarak, has collapsed. As graceful in its contours as it is mighty in its proportions, this temple is one of the major works of architecture in India. Though the main temple is built of pinkish sandstone, there are fine chlorite images of Ganesha, Parvati, and Skanda in large niches. Both the choice of motifs and their execution are exquisite: the guardians of the eight quarters, the deities of the Hindu pantheon, the fantastic animals and birds entwined in creepers, the amorous couples, the celestial beauties, and the poetic heroines are all most interesting. Vertical ribs dominate the tower from bottom to top, while horizontal dividing lines dominate the pyramidal roof of the porch with its bell-shaped top. Interspersed here and there are stylized seated lions with gaping mouths and uplifted right paws. At some moments the whole ensemble takes on the appearance of a magical vision.

RAJARANI TEMPLE: Completely exotic in its concept and execution, the Rajarani temple is unlike any other in Orissa and comes closer to such central Indian ones as Khajuraho. What distinguishes this temple from others are miniature shikaras that cluster around the central tower and taper upward to various levels. This special type of ornamentation, in which the miniature shikaras and amalakas are crowned by a large amalaka at the summit, determines the star-shaped plan of the structure. The porch has, however, the normal pyramidal roof. The entrance is adorned by two remarkable columns around which are coiled nagarajas. The decorative sculpture all around (guardians of the quarters, deities, celestial beauties, and so forth) adds great color to this dainty monument.

(*Figs. 144, 271, 272, 341, 342, 386, 388, 389, 511, 513, 515–17, 566, 567*)

865 BHUVANESHWAR. PARASURAMESVARA TEMPLE

866. BHUVANESHWAR. MUKTESVARA TEMPLE

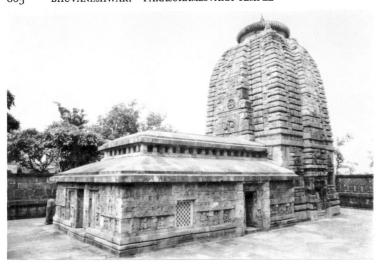

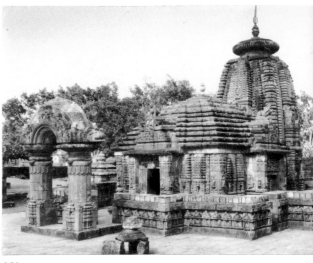

867. BHUVANESHWAR. LINGARAJA TEMPLE

868. BHUVANESHWAR. RAJARANI TEMPLE

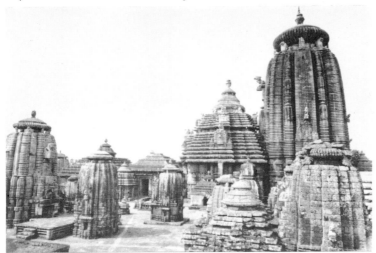

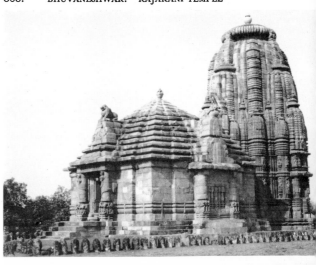

869. DHAULI. MONOLITHIC ELEPHANT

DHAULI

Within a few miles of Bhuvaneshwar, on what was a highway in Mauryan times, are carved the famous rock edicts of Asoka at Dhauli. Close by, cut out of the living rock and almost appearing to emerge from the hillock, stands a famous elephant, a sculptural marvel of the third century B.C. It is interesting that here a figure in very high relief takes the place of the Gajatama—the elephant par excellence and thus the symbol of Buddha who descended into his mother's womb in the form of an elephant. (Gajatama also appears as a figure drawing at Kalsi in close association with the edicts of Asoka there.) Nobility and wisdom are characteristic of the elephant; the sculptor sought to emphasize these qualities in Buddha, just as the noble elephant in the *Chhaddanta Jataka* ultimately succeeded in becoming the Enlightened One.

 Dhauli is especially important for one of the most important achievements of the Mauryan sculptor's art, especially during the time of Asoka himself. A look at the row of elephants carved over the entrance of the Lomas Rishi cave in the Barabar Hills is sufficient to demonstrate the Mauryan sculptor's mastery over animal form. In India there has never been a period when the elephant, the lotus, and the swan have not been portrayed to their best advantage. It must, however, be borne in mind, in following the development of an indigenous school, that Bharhut is not necessarily the first to develop the rudiments of art. In Mauryan art itself, there is great vitality and strength and a free acceptance of foreign motifs and techniques. This can be observed in the Iranian tinge in both style and technique, combined with an innate vigor of execution—one characteristic imported, the other indigenous. In the carving of the elephant, the Iranian element is totally absent; it is a purely indigenous type of work with a native vitality, made possible by real anatomical knowledge. The animal seems to live and breathe and move. It is massive and monumental and has the stately appearance of the royal elephant. As the edicts at Dhauli are of the twelfth year of the reign of Asoka, or about 257 B.C., the carving should be assigned to that date.

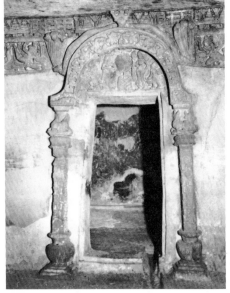

870. KHANDGIRI UDAYAGIRI.
CELL ENTRANCE IN ANANTA CAVE

KHANDGIRI UDAYAGIRI

The most outstanding group of early monuments in Orissa are the caves in Khandgiri Udayagiri. Kharavela, the powerful emperor who was a contemporary of the great Pushyamitra Sunga of Magadha and Demetrius of Gandhara, has left a clear picture of himself and his achievements in the Hathigumpha inscription which describes in detail all his enterprises, year by year. He and his queens, devoted Jains, built these caves for the use of the Jain monks.

 Like the Buddhist monasteries, these caves were elaborately planned and executed. The ornamentation of the rock veranda and cells tends to confirm what we know from other Buddhist monuments of the glory of the second and first centuries B.C. The entrances to the various cells have jambs in the form of pilasters whose cubical shafts are decorated with lotus motifs rising from brimming pitchers. The capitals have pairs of natural or winged animals, reclining back to back and supporting an arched frame decorated in different ways—sometimes with a row of geese carrying lotus stalks in their beaks, sometimes with animals like bulls and lions in combat with heroes. The arch itself is surmounted by a prominent symbol from which three-hooded cobras emerge on either side, almost encompassing the width of the arch. The semicircular niche immediately above the entrance and below the arch is enhanced with such decorative themes as the worship of the sacred tree, associated at the edge with a Tirthankara, or Lakshmi amidst lotuses and holding lotuses in her arms while being sprinkled by elephants flanking her, or Surya in his chariot with attendant figures. These sculptures recall similar ones at Bharhut, Bodh Gaya, and Sanchi. The Ananta cave at Khandgiri is especially distinguished.

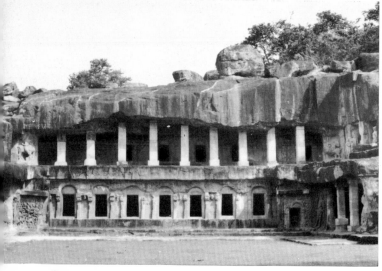

871. KHANDGIRI UDAYAGIRI. RANI GUMPHA

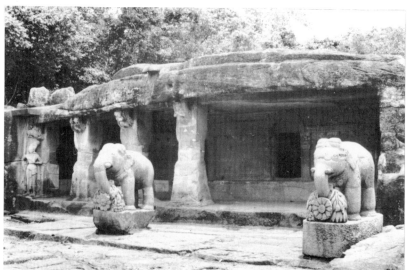

872. KHANDGIRI UDAYAGIRI. GANESHA GUMPHA

In these caves a veranda and rock-cut cells open off a large courtyard. There are several huge sentinels; these guardians, bearing their weapons, are turbaned and garbed in the full military panoply of the period. The sculptor has also created a group of elephants in a lotus pond; in this impressive composition the females reach out and offer flowers to the noble chief of the herd.

In the Rani Gumpha and Ganesha Gumpha caves at Udayagiri, a long frieze decorates the veranda wall over the cell entrances. This frieze vividly depicts groups of musicians and scenes from the royal court and hunting expeditions. There are also illustrations of Jain legends, many of which remain unidentified. One section, however, clearly shows the well-known story of Udayana, the prince of Kausambi and a celebrated vina player, who abducted Vasavadatta, the most beautiful princess of her time, from Ujjain.

At Udayagiri in the Manchapuri cave (also called Vaikunthapura, Svargapura, or Patalapura) is seen another superb frieze. A procession of elephants advances toward the lotus-decorated arch above the entrance to the monks' cells. These splendid animals vividly recall earlier representations of elephants—the Sanchi portals are especially remarkable, although the more ancient Mauryan works in Barabar Hills are also noteworthy.

(Figs. 80, 418)

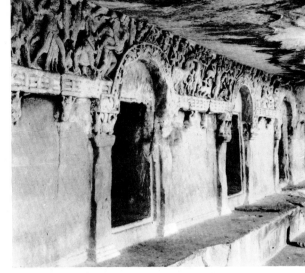

873. KHANDGIRI UDAYAGIRI.
FRIEZE OF MANCHAPURI CAVE

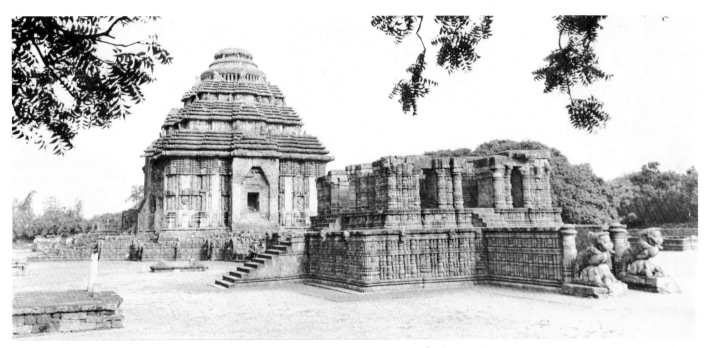

874. KONARAK.
JAGAMOHAN AND NATAMANDIR

KONARAK

The huge and imposing audience hall with the ruins of the tower (*deul*)—the stately height of which one can only try to imagine, in the absence of most of the structure—the dance hall, and the subsidiary shrines in the large court around the stupendous monument are the only remains of what was once the most enormous temple in Orissa. This huge structure, with its tower still standing in 1837, was called the Black Pagoda by the earliest wonder-struck European visitors. The temple faces east, and on the lintel of the doorway is the most imposing "nine planets" slab anywhere in India. The several tiers on the pyramidal roof of the audience hall carry large figures of lovely damsels playing a variety of musical instruments, rivaling the smaller figures in a multitude of dance poses in the *natamandir* a short distance away. Together, they almost conjure up a festival of music and dance for the rising sun. The large niches on the three sides of the shrine contain lovely figures of Surya in various forms (one of them on horseback), which reveal the meticulous care taken to glorify the solar deity. On one of the tiers, one encounters one of the more rare solar aspects of Shiva—the Martanda Bhairava dancing in the boat which allows him to cross the ocean of the sky. The drummer, the cymbal-player, the trumpeter, and the girl strumming the lute, attest not only to the sculptor's talent but also to his knowledge of perspective and optical effects, since he has varied the proportions of his figures' upper and lower limbs, so as to make the composition more comprehensible to the spectator viewing it from below.

One must imagine how the tower and the hall originally stood on a sort of platform, which represented the chariot of Surya. The chariot wheels—originally twenty-four like the hours of the day—were drawn by rows of horses representing the seven steeds of the sun in his journey across the heavens. Some of the wheels have been lost, yet one is still overwhelmed by the intricate carving of the stone, especially on the rims and spokes of the wheels, into a profusion of designs—creeper, animal, bird, and man, all freely intermixed. This is a treasure-

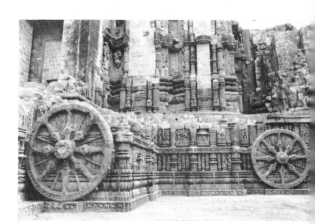

875. KONARAK. WHEELS OF THE SUN TEMPLE

house of art: whole rows of elephants in a long frieze on the plinth, rows of geese and other birds, innumerable representations of erotic couples and dancing girls, bas-reliefs of the guardians of the quarters, and numerous historical scenes drawn from the life of Narasimha, the builder of the temple.

The audience hall here is not unlike those of the Lingaraja temple at Bhuvaneshwar or the Jagannatha temple at Puri. This was considered to be a place sacred to Surya, where Samba, a son of Krishna, was cured of a disease. Though there is a tradition that the temple was never used for worship because the tower collapsed almost immediately after construction, it cannot be denied that it was long in use as a place of worship and the collapse was probably comparatively recent.

(Figs, 149, 150, 270, 568–74)

MUKHALINGAM

The temple of Somesvara at Mukhalingam is one of the early structures erected by the Eastern Gangas, who ruled from their capital at Dantapura, not far away. This temple is square in ground plan and curvilinear toward the top, with a central projection on each side that rises to the summit, and a large amalaka above a narrow neck. Here one can note the beginning of the tower (*deul*), which gradually increased in height and size over two or three centuries. The central projection incorporates the entrance on one side; on the other three sides an elaborate niche is flanked by two smaller niches, all containing images. In the second story there is only one niche. The top of every niche is decorated with an elaborate arch within a *kūḍu*. All the niches are wonderfully decorated with intricate foliage patterns and elegantly arranged celestial groups. They are exquisite examples of the early Kalinga style. The principal statues are of Ganesha, Skanda, and Mahishamardini; Ardhanarisvara, Lakulisa, and other deities occupy the subsidiary niches. The porch (*jagamohan*) is absent here.

Another Eastern Ganga temple, the Mukhalingesvara, which is dedicated to Shiva, is situated within a large court. More developed than the Somesvara and entirely covered with elegant sculptural decoration, it can be assigned to the tenth century. The entrance doorway has elaborate carvings narrating the story of a prince or chieftain, probably associated with the temple, whose identity is not clear. The niches around the main shrine contain elegant carvings, among which the twelve-armed Nataraja is particularly noteworthy. The rather circular face, with large eyes and raised brows, and the peculiar shortened crown of matted hair (*jaṭāmakuṭa*), richly bejeweled and surmounted by a crescent moon, are very characteristic of an earlier phase of sculpture in Orissa. Also important is the Lakulisa, the form of Shiva which takes the place of Dakshinamurti in Orissan shrines. A standing Ganesha flanked by attendants is another interesting sculpture. The rosary and ax as attributes of Ganesha are also noteworthy, as is the crown of hair arranged in curls, almost like a beehive (conforming to an early Orissan style). The trunk is peculiarly curled, in a manner not to be observed anywhere else in India. In another niche, Indra is interesting both for the type of crown that he wears and for the thunderbolt in his hand, as well as for the sacred thread composed of pearls. Mahishamardini Durga tramples and kills not a mere buffalo, but a full-sized warrior with a human body and buffalo head, as at Mahabalipuram and Ellora. The combination of a crown and an ostentatious braid, joined to her hair almost like a wig, gives an appropriately Amazonian touch to Durga. The gargoyle, which drains water from the inner cell of the temple, is in the form of a multihooded Nagaraja, holding in his hands a large pitcher, from the mouth of which pours the water.

The temple of Bhimesvara is rather plain, in spite of statues of Brahma, Dakshinamurti, and Narasimha inserted in niches on the outer wall of the sanctuary. Except for a few inscriptions mentioning the names of Aniyanka Bhima, after whom this temple is named, it is unimportant.

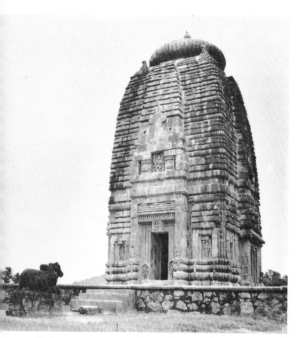

876. MUKHALINGAM. SOMESVARA TEMPLE

877. MUKHALINGAM.
ENTRANCE OF SOMESVARA TEMPLE

878. ABANERI. LARGE POOL

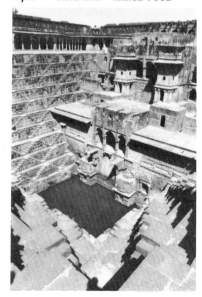

RAJASTHAN

ABANERI

Abaneri, or Abhanagari, in the Jaipur District is justly famous as the site of a beautiful early Gurjara-Pratihara temple that fell to ruins and is now lost. The original temple dedicated to Harshatmata no longer exists. The present structure is a completely renovated one, and it gives no idea of what once was a lovely temple; however, the exquisite architectural fragments that lie strewn about give us an idea of its splendor. The renovators incorporated a large number of these earlier sculptures in the new shrine when they rebuilt. A large tank here is probably the old one which was close to the temple. It too was tampered with in later times. Nevertheless the sculptures still hold great interest. The pot-and-vase motifs on pilasters flanking panels of relief figures are exquisite. One also sees Nataraja dancing; a whole row of Matrikas flanked by Virabhadra and Ganesha dancing; a frieze illustrating the three celestials of luck; Manmatha, the lord of love, with his consorts Rati and Priti and his friend Madhu, the spring season personified; celestial beauties holding a large pitcher as a gargoyle; and several long architraves and various fragments of delicate floral and geometric patterns. One can tell from these remains that the exterior of the inner shrine of this temple was once covered with magnificent carving.

(Figs. 61, 288, 344, 348, 387)

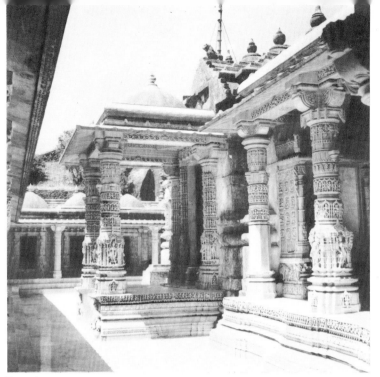

879. ABU. VIMALA TEMPLE

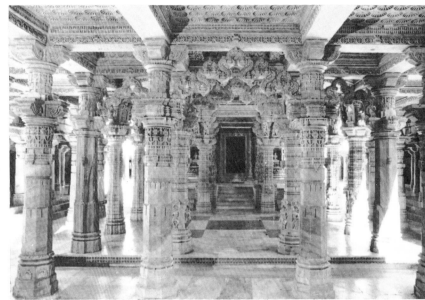

880. ABU. TEJAHPALA TEMPLE

ABU

Mount Abu is famous for its group of Jain temples, the earliest of which is the Adinatha temple built at Dilwara by Vimala, a commander in chief of King Bhima I, about 1032. This beautiful temple is composed of a central shrine, a smaller adjoining hall, and a larger outer mandaga or assembly hall. It has a perambulatory passage and smaller shrines around it in a vast courtyard. The temple, which is on a higher level than the mandapas, has rich figure carving on its exterior. Inside, the pillars, the brackets, and the arches, as well as the ceiling of the assembly hall, are also wonderfully worked with bands of friezes. The dome of the mandapa itself rests on eight pillars arranged in an octagon. On the sixteen brackets here we see Vidyadevis, the goddesses of learning: Rohini, Prajnapti, Vajrasrinkhala, Vajramkusi, Apraticakra, Purushadatta, Kali, Mahakali, Gauri, Gandhari, Sarvasra, Mahajvala, Manavi, Vairotya, Achupta, Manasi, and Mahamanasi.

 A later temple, Luna Vasahi, enshrines Neminatha. It was built in the thirteenth century by Tejahpala. The dancing figures on the molding of the base above the first bracket are very interesting; the ceiling has, among its many carvings, illustrations of the lives of Tirthankaras. The exquisite carving here, considering its date, compares favorably with the earlier Vimalavasahi temple. The filigreelike ceiling of the assembly hall is a marvelous example of marble work and the pillars, brackets, and side porches all have wonderful miniature carving. The Renunciation of Neminatha, depicted in a long narrative frieze, is among the best medieval sculpture in Gujarat and Rajputana.

(Figs. 147, 152, 606, 609)

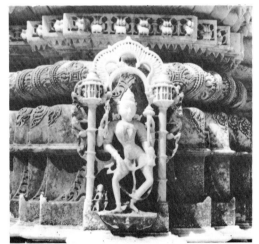

881. ABU. SCULPTURE IN TEJAHPALA TEMPLE

JAGAT

Jagat, a village twenty-seven miles from Udaipur, has a lovely tenth-century temple built by Sampura. Though the inscription mentions its construction during the reign of the Guhilas of Mewar, this temple is actually from the Gurjara-Pratihara period. The temple closely resembles the Khajuraho type—built on a high platform, it has an inner shrine and assembly hall with carved pillars and projections on the four sides; flights of steps lead to the porch entrance. The joyous-damsel figures in various pleasing attitudes and the dancers, musical groups, and amorous couples (some in quite pronounced erotic attitudes) arranged around the exterior of the temple follow a tradition common in all the medieval temples in this part of India, those in the central part, and even those in Orissa. The many carvings of Devi here point to this temple's importance as a shrine for that goddess; this also accounts for the temple's name.

882. JAGAT. VIEW OF TEMPLE

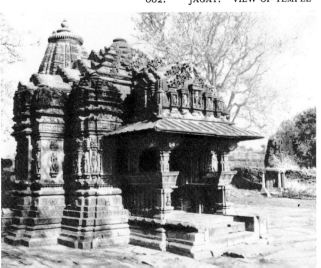

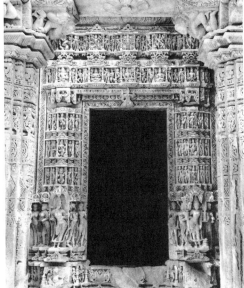

883. KIRADU.
ENTRANCE OF SOMESVARA TEMPLE

KIRADU

Kiradu, sixteen miles from Barmer, is noteworthy for a group of temples, most of which are in ruins. There is one, however—Somesvara—that still is intact enough to be understood as a temple. It is composed of an inner shrine with its vestibule, a large audience hall (with an elaborate domed roof built upon eight tall pillars with prominent makara bracket decoration), and an outer porch. The intricate reliefs on the facets of the pillars of the hall are extremely attractive miniature carvings of deities, celestial beauties, masks of glory, and the rope-of-pearl motif. The platform of the temple itself is wonderfully decorated with rows of elephants, horses, men, and masks of glory. On the entrance doorway are carved images of Brahma, Vishnu, and Shiva. (In all medieval representations of any one of the trinity, the other two are never left out.) It is interesting that Surya here has sixteen arms, combining the attributes of each of the trinity in addition to his own. There is a strong Gupta influence here, and Somesvara must be assigned to the eleventh rather than the twelfth century. The other temples in Kiradu also have exquisite carvings, but they are in such a dilapidated condition that they are beyond reconstruction.

OSIA

Osia is about thirty-two miles north of Jodhpur and is famous for some badly ruined but exquisite temples of the Gurjara-Pratihara period, many of which are sacred to Vishnu. The ones dedicated to Sachiyamata and Mahavira are the most well known and most popular. The Sachiyamata temple is surrounded by five temples of Vishnu, one of them sacred to Harihara. This too is a multishrine type with the subsidiary ones on all four sides, one completely ruined and the others in only a slightly better state. All of them have a small porch in front. The porches are supported by typical early medieval pillars with elaborate carving and heavy stepped capitals that project out on all four sides to support the lintel above. The front of the vimana is ruined and fallen though the amalaka shikara is intact.

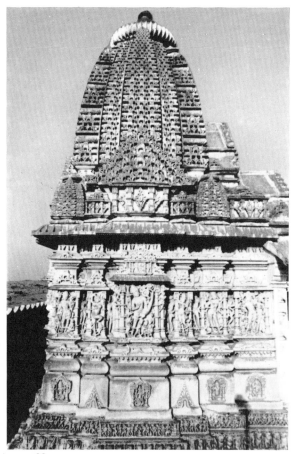

884. OSIA. SACIYAMATA TEMPLE

Another Harihara temple is on a very high platform, beautifully decorated with designs and an elaborate frieze broken up by projecting niches that are topped by an elaborate multifoil design. Unfortunately, the top of the shrine including the amalaka is broken off and lost. The walls also have niches enshrining figures of various deities. The elaborate pillared mandapa in front is approached by a porch supported by more pillars. A low encircling wall with projecting animal carvings makes it attractive in a quaint way. Here also, there are smaller shrines at the corners that are mostly in ruins.

The exquisite nature of the carving here can be judged by the elaborate doorways of these subsidiary shrines where one sees coiled nagas on either side with their hands folded encompassing the door frame. Below are Ganga and Yamuna on their respective vehicles. The roundels of the pillars, the pot-and-foliage motifs, and the pearl tassels held by dwarfs all testify to the mastery of the Pratihara sculptor. The entrance to the sanctum of the temple has all these features in addition to several reliefs of loving couples on the jambs. Garudavahana Vishnu is in the center bottom of the lintel above which five delicately carved niches enshrine Ganesha, Brahma and Sarasvati, Lakshminarayana, Umamahesvara, and Kartikeya. Further up, beyond other decorative details, there is a row of *navagrahas*. On the outer side, besides deities such as Shiva, Vishnu, Revanta, Surya, Sankarshana, Nataraja, Umamahesvara, and Kalyanasundara, there are also guardian figures such as Indra, Agni, Varuna, Kubera, Nirriti, and Vayu, facing in their assigned directions.

In another temple of Harihara only the lower portion of the main shrine and the entrance are elaborately decorated. The mandapa has balconylike projections on three sides, the main one at the entrance reached by steps. The curvilinear roof, topped by three square slabs which are crowned by a fluted knob, presents an imposing appearance. The carvings on the main shrine are simple and effective, but it is the large reliefs at the top and at the bottom immediately above the plinth and in a long frieze on the outer wall that make this temple so attractive. And there are sculptures in five niches on each side, the central one at the back representing Trivikrama with one of his legs raised; one sees Narasimha and Harihara on the other two sides. These are good examples of the charming simplicity found in early Pratihara sculpture.

The ruined temple beyond consists only of a shrine and its porch. In the principal niches on its outer walls, Trivikrama, Vishnu, and Narasimha are shown on three sides, and the rather plain doorway presents the *navagrahas*. Next there is a temple of Surya. Here the shrine, the mandapa, and the porch are present, but in a dilapidated condition. The shrine's door has the coiled naga decoration and a Garuda on the lintel. At the top of the lintel one sees Ganesha, Brahma, Vishnu, Shiva, and Kubera in miniature niches, and above them is a frieze of *navagrahas*. The niches on the outer side of the shrine show Ganesha, Surya, and Mahishamardini in addition to the eight guardians of the cardinal points, each in his proper place. The pillar of the porch is very tall and is fluted except for the vase of plenty at its base. The terrible aspect of Shiva is seen on the four sides, and the overflowing vase is repeated at the top immediately below the capital. There are beautiful carvings in the moldings of the plinth.

There is one temple close by dedicated to Shiva that is too plain to comment on, but another, that of Pipladevi, has wonderful carved pillars and pilasters in the inner hall. The lintel of the doorway has a row of *navagrahas*. The shrine itself houses three large sculptures—Mahishamardini in the center flanked by Kubera and Ganesha.

The last temple in this group is the Jain one mentioned earlier which is dedicated to Mahavira; it must be assigned to the tenth century. With the same elaborately carved pillars and decorative details as the Dilwara temples, this temple already existed during the reign of Vatsaraja toward the end of the eighth century but had extensive renovations in the tenth century. Very recently also there seems to have been tampering with the original structure.

Unlike the rest, the Sachiyamata temple is on the hill. It is composed of the main shrine with an ambulatory passage, an assembly hall, and a porch. This is an elaborate temple with half-shikaras attached to the main one of the shrine, along with a small domelike covering for the mandapa resting on a series of pillars. The pillars have dancing celestial beauties for bracket figures. A twelfth-century inscription here mentions a banker, Gayapala, who donated carvings of Chandika, Sitala, Sachchika, Kshemankari (or Mahishamardini), and Kshetrapala to the temple. Close by are a number of other temples similar to the Pipladevi temple described earlier.

TAMILNAD

ANAMALAI

Anamalai, eight miles from Madura, is a hill resembling a seated elephant with its trunk stretched forward. According to the *Tiruvilayadalpuranam*, a huge elephant was invoked by spells of Jain ascetics to destroy the city of Madura but was petrified by Shiva when he hit it with an arrow. This hill is that elephant. Besides some caverns and early Jain inscriptions in Brahmi, in the Anamalai Hill there is a cave temple dedicated to Narasimha. A Sanskrit and Tamil inscription written in Grantha and Vatteluttu letters records the construction of the temple in 770 by the chief minister of the Pandyan king Jatila Parantake Nedunjadayan. Before it could be completed, Marangari or Madhurakavi, as the minister was known, died, and his brother Maran Eyinan consecrated it. The multipillared mandapa and gopura are later additions. The main shrine is a cave with two massive pillars and a pair of pilasters. The cell is beyond the mandapa as in the Tirupparamkunram temple.

In the vicinity is another shrine locally known as the temple of Ladamuni. It is of the same period as the Narasimha cave but is dedicated to Subrahmanya and his consort. A flight of steps on either side leads to the usual mandapa with two massive pillars and pilasters with the main cell beyond. Two dwarf demigods support the cornice as caryatids. The doorway of the cell is flanked by a peacock and a cock. There are also two well-carved devotees offering garlands to the deity. These take the place of usual door guardians. The deity is seated at ease with his consort Devasena, the army of the celestials personified.

CHIDAMBARAM

886. ANAMALAI.
ENTRANCE OF SUBRAHMANYA CAVE

Chidambaram, the holy spot of Nataraja in the South Arcot District, is an important place of great antiquity. Adavallan, as Dancing Shiva is known, was the favorite deity of the Chola kings, who once maintained a palace close to this shrine. Tradition has it that a Hiranyavarman, who was probably connected with the Pallava family built the original temple here. It began as a miniature temple, and later the *kanakasabha*—the golden dance hall—and the great temple hall were added. The great Shivaite devotees during Pallavan times glorified Nataraja. The dance hall of the Chidambaram temple was covered with gold by the Chola king Parantaka I at the beginning of the tenth century. Gandaraditya, a pious king, later sang his *Tiruvisaippa* to the lord of Chidambaram. Rajaraja himself was a great devotee of this form of Shiva, and the deity Rajarajesvara of Tanjore was also called Adavallan. The great Shivaite work *Periyapuranam* was composed in the thousand-pillared hall here at Chidambaram during the time of Kulottunga II in the first half of the twelfth century.

The temple at Chidambaram has been so often renovated by the wealthy merchant class of Nattukkottai chettis that the description of even Fergusson is no longer applicable to all that is found around the sanctum of this great temple complex. There are four courts, each with large gopuras. As can be seen from their architecture and sculptures as well as from inscriptions, these gopuras belong to the late Chola, late Pandya, Vijayanagar, and even later periods. The west and south gopuras are of the time of Maravarman Kulasekhara Pandya in the thirteenth century. The east gopura is also of the thirteenth century. The gopura on the north is sixteenth century, having been built by the Vijayanagar emperor Krishnadevaraya, whose portrait is found carved on it. Also found here are sculptures of the architects. As might be expected in a temple devoted to the Lord of Dance, there are scenes of the dance here illustrating all 108 dance poses. They are in small panels arranged on the inner walls on either side of the gopura entrance. On the west gopura, these panels have

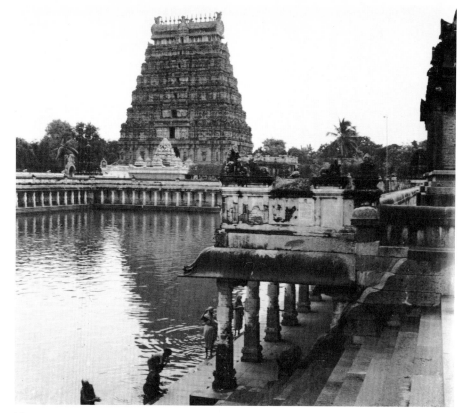

887. CHIDAMBARAM. SHIVAGANGA POOL AND GOPURA

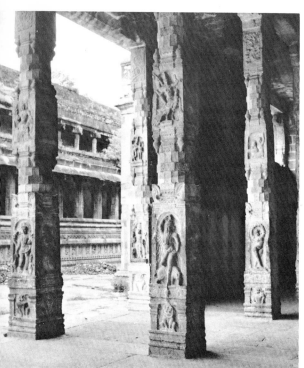

888. CHIDAMBARAM. COURTYARD
SEEN FROM THE MANDAPA

explanatory text from the *Natyasastra* in early Grantha characters. The panels are superior to similar ones in the gopuras to the north and south. Larger individual decorative sculptures are exceedingly beautiful, especially those on the west gopura—particularly Shanmukha fighting Taraka, Durga in combat, Vishnu on Garuda, and Kalyanasundara. On the east gopura, Shiva dancing, Somaskanda, Gangadhara, Dakshinamurti, and Gajantaka are interesting, and Kama is worth attention in the south gopura.

In the third court is the large stepped Shivaganga tank with the temple of Devi—Shivakamasundari—close to it. In the mandapa, the ceiling is entirely covered with paintings of the Nayak period. In this same court is the thousand-pillared hall on one side of the tank and the hundred-pillared hall on the other. The third court also has a long double-storied pillared cloister that is in bad repair. In the innermost enclosure is a shrine of Vishnu as Govindaraja—the reclining lord. It is a pavilion with a barrel roof. Close to it and also facing east is the dance hall of Nataraja with two interconnected structures known as *citsabhā* and *kanakasabhā*, one for the visible form of Nataraja and the other for the invisible form. This is the most sacred spot in the temple and presents the *ākāśaliṅga*, the lingam of ether (i.e., the void). The workmanship and the delicate carving places these in the late Chola period. This date is confirmed by the fact that the theater of this temple features the wheel-and-horse motif, as at Darasuram. They were built at a time when this motif was a popular Chola theme. In spite of the frequent additions and renovations, parts of the hundred-pillared and thousand-pillared halls still have late Chola work. The inscriptions that abound in this temple tell us that the Chola kings described themselves as "bees at the lotus-feet of Natesha," their beloved "family deity."

CHOKKAMPATTI

At Chokkampatti, twelve miles from Tenkasi, is an early rock-cut temple. It has all the characteristics of the early caves—heavy pillars, pilasters, mandapa, and so forth. On the sides, where there are usually pilasters, there are niches showing a prince in one and a princess in the other. The prince is probably a royal youth of the Pandyans. He wears a sacred thread of pearls over his right arm and holds a lotus in his right hand as an offering for the god, while his left hand rests on a sword. His crown is topped by a three-headed snake. Though the lower portion of the figure is unfinished, the looping waist cord is present. The princess on the other side carries an offering for the deity in her right hand; the left rests on her waist. The modeling of the torso is exceedingly well done. Guarding the doorway of the cells are pairs of guardians that show more advanced workmanship than in other early Pandyan cave temples. The horseshoe-shaped *kūḍu* decoration in the upper part of the roof is supported by dwarf caryatid figures in amusing postures, while their faces peep through the *kūḍu* recalling similar Pallava decoration.

504

DALAVANUR

Ten miles from Gingi, in the South Arcot District at Dalavanur, there is a typical rock-cut temple sacred to Shiva. It is excavated in the southern face of a small hill locally known as Panchapandavamalai. The facade, facing south, has two pillars, square in section at base and top and octagonal in the center. Lotus medallions are seen in the square parts, above which runs a makara toran against the heavy corbels. The makaras at the ends are wonderfully carved, with floriated tails and gaping mouths and each with a rider on its back. In the center is a double makara face topped by a seated dwarf. There are pilasters at either end and beyond them are two guardians in shallow niches. Above the pillars there is a cornice decorated with five horseshoe-shaped *kūḍus* with shovel-headed tops. In each a beautiful head peeps out. The shrine for Shiva in this cave faces east and is cut in the western wall of the mandapa. There are guardian figures at the entrance both with hand on the hip and the other raised in adoration. The Shivalinga here is cylindrical and not fluted as it became later. There are pillars in front of the shrine with corbel capitals, the lower half cubical and the upper octagonal. An inscription on the pilaster of the facade to the left says: "In this rock the temple of Satrumallesvara has been excavated by the king Satrumalla, who has subdued royal foes by conquest."

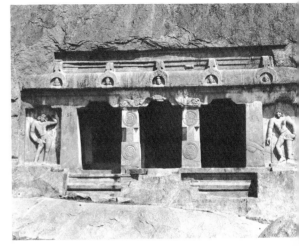

889. DALAVANUR. CAVE FACADE

DARASURAM

The temple at Darasuram, three miles south of Kumbakonam, was built during the time of Rajaraja II (1150–73), whose title Rajagambhira is recorded on its mandapa. The growing Shivaite zeal of the Chola dynasty is clear from the stories that are told in sculpture here. The upper part of the large gopura at the entrance of the temple is damaged and lost, but it is more than made up for by what remains. The carvings here on the gopura—the lovely Apsaras, Shivaganas and other motifs—are most interesting, and the lotus decoration of the large offering receptacle beyond the gopura is noteworthy. Just behind a large Nandi, an interesting quaint-looking dwarf, conceived and executed with great artistic taste, is blowing a conch. Long narrow friezes of miniature figures dancing in lovely poses provide the keynote in this temple—*nityavinoda*, perpetual entertainment. The mandapa at the entrance is reached by a flight of steps that have beautifully decorated balustrades. The personified treasures, on the back of an elephant, are important as part of the balustrade decoration. The eight outer pillars of the mandapa, supported by seated hybrid-animal monsters with curled trunks, have lotus-petal capitals. The prominent tips of the petals are characteristic of this period. The capitals show the beginnings of the type of decoration that, in the late Chola and Vijayanagar periods, develops into a lotus decoration. The cobra-hood motif as decoration for the pillar has not yet developed; here it is still a decorative pattern of double geese. There are small reliefs on the pillars illustrating mythological episodes such as the attack of Manmatha, the penance of Parvati, the birth of Kumara, Shiva's marriage, and so forth. The front of the base of this mandapa's extension is decorated with panels showing Tripurantaka, Kalantaka, Kamari, Virabhadra, Agni, Indra, Brahma, Vishnu, and Vayu, reverently attending Shiva. The main mandapa has extremely fine carvings. Here one finds a pair of dwarf yakshas representing the personified treasures and pillars and ceilings filled with decorative patterns, musicians, dancers, various forms of the deities, and so forth. The next mandapa has niches containing Kannappa, seated Sarasvati, Devi with a lotus and a pot of gems, and Nandikesvara standing with hands in adoration.

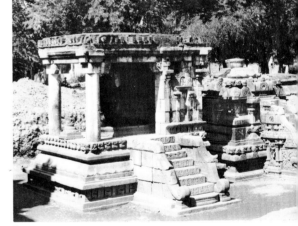

890. DARASURAM. MINIATURE MANDAPA

The narrow hall leading to the shrine itself is approached by long flights of steps from the north and south, and it houses a Nandi. The guardians here are four-armed, furious, and carry huge clubs. The garland decoration of their sacred threads recalls Chalukyan ones. The niches in the walls of this hall as well as of the main shrine are mostly empty of their original images; occasionally poor substitutes in brick and plaster take their place. Among the noteworthy Chola works are a fine Ardhanarisvara with eight arms and three faces; a four-armed Nagaraja; the dwarf sage Agastya seated; dancing Martanda Bhairava; Shiva as Sarabha, the destroyer of Narasimha; standing Ganesha; Dakshinamurti under a tree, expounding the highest truth to sages

891. DARASURAM. MANDAPA
WITH THE WHEEL AND HORSE MOTIFS

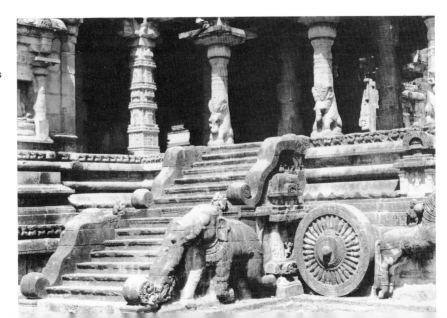

around him; Lingodbhava flanked by Brahma and Vishnu; eight-armed Durga standing on the severed head of the buffalo demon; Bhuvanesvari with a noose and goad in two of her hands; Tripurantaka carrying the bow and an ax; multiarmed Gajantaka destroying the elephant demon and dancing against the spread-out hide of the animal; and six-armed Bhairava and Mahesamurti with three heads and four arms. There are miniature decorative carvings below two rows of hybrid-animal monsters, which are in turn immediately below niches illustrating scenes from the life of the Shivaite saints. Many of them have explanatory labels in Tamil. Separating these panels are miniature figures of dancers, Shiva, or Devi. Around the main shrine is a broad granite-paved strip with a low wall beautifully decorated with a lotus pattern and seated Nandis. The drains that one sees indicate that at one time this was a pool, assuring a cool atmosphere around the temple in summer. The gargoyle on the north of the main cell is decorated with the lion-head motif. It discharges water into a large reservoir that has figures of dancers and dwarfs on the sides. The gargoyle is supported by a caryatid dwarf almost like one at Tanjore. The cloisters around the paved courtyard have been enlarged to form a mandapa, with carvings on the pillars as well as on the ceiling. This mandapa is the dance theater of the temple. To the east is a sacrificial chamber, where the king and queen we see are probably Rajaraja II and his consort. In the cloistered hall to the west is a remarkable sculpture group that tells the story of Shiva as Kankala being offered alms by the wives of the sages of Darukavana, who are astonished at his beauty. The garments of one wife are shown sliding away, while her finger on her lip indicates passion and wonder. Kankala fondles a deer, a dwarf demigod holds up a large begging bowl, the women carry ladles to offer food to the divine beggar. All in all, it is a Chola masterpiece.

The shrine of Devi is adjacent to and contemporary with the main temple. The hybrid-animal monsters with riders on the balustrades on either side as one enters the shrine are fine works of art as are the lattice-window carvings. The gargoyle on the cell is also a wonderful piece. From the innumerable figures in this temple that stress themes of dance and music, the visitor receives an idea of the popularity of Bharata's *Natyasastra*.

(Figs. 353, 642)

GANGAIKONDACHOLAPURAM

Gangaikondacholapuram, now a deserted village about twenty-two miles from Kumbakonam, was once the capital of the Cholas. It was established by the emperor Rajendra, who conquered not only the whole of India, excluding the Punjab and Kashmir, but also a considerable portion of Southeast Asia. The emperor built the temple in gratitude to Shiva for his successes. The only tribute Rajendra exacted from the defeated monarchs was the sacred waters of the Ganges, which he brought here and poured into a long tank which then constituted a sort of liquid horizontal pillar of victory. The temple, more graceful in its contour than the Brihadisvara temple at Tanjore, is nevertheless imposing, but if the temple at Tanjore is masculine in its might, the temple at Gangaikondacholapuram is feminine in its grace.

There are several badly vandalized gopuras surrounding the large courtyard. Two flights of steps, on the northern and southern sides as at Tanjore, lead to the first entrance of a long closed mandapa made up of several pillared sections leading to the main temple. The guardian figures seen at intervals are colossal ones. In the niches to the south one finds dancing Ganesha, Ardhanarisvara beside the bull, Harihara, and Nataraja. The sides of the niches in early Chola temples have carvings that further elaborate the main theme of the niche. Thus, Nataraja's dance is further illustrated here by Vishnu playing a drum, Ganesha and Kali approaching on their vehicles, Devi watching with her hand resting on the bull beside her, and so forth. On the western wall, in the niche where Gangadhara appeases Devi, the whole story of Bhagiratha's penance is narrated on the sides. We see Lingodbhava, Vishnu and consorts, and Indra and Umasahita, the last being adored by Vishnu, who offers his eyes as a flower. On the northern wall is a niche for Kalantaka, with the story of Markandeya on the sides. One sees eight-armed Mahishamardini; Brahma with Sarasvati and Savitri; and eight-armed Bhairava

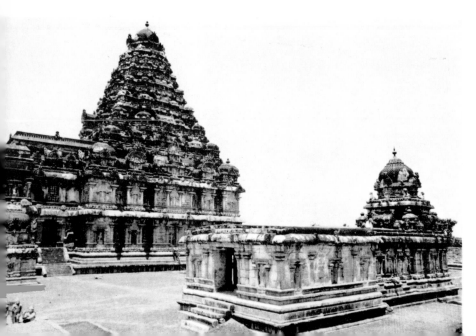

892. GANGAIKONDACHOLAPURAM. TEMPLE OF SHIVA

and Madanantaka reducing Madana to ashes as all the devas and Rati intercede on his behalf. There is a remarkable delineation of Shiva as Chandesanugrahamurti and of Sarasvati in two other niches.

A fine large carving of Chandikesvara adorns a shrine dedicated to him to the north of the main temple. To the southwest of the temple is a small shrine with a large image of Ganesha, his proboscis curling around the sweet that he holds, a popular delineation in early Chola art. Beyond the shrine of Chandikesvara is one of Mahishamardini. Further up is a large representation of a lion, through the body of which runs a flight of steps leading to the "lion tank." A slab with the nine planets and the sun, symbolized here as a lotus, is a noteworthy piece, as it combines northern and southern elements of the nine-planet concept. It is an example of Rajendra's cosmopolitan knowledge and taste.

(Figs. 309, 310)

893. KALUGUMALAI. ROCK-CUT TEMPLE

KALUGUMALAI

Fifteen miles east of Sankaranainarkoil is the rock cut temple of Kalugumalai, a magnificent monolithic monument of the early Pandyas. Here, as at Ellora, an entire hill was fashioned into a temple. This is a particularly remarkable achievement since it was carved from the top downward. From some reason, however, this project was never completed. It is locally known as Vattuvankoil—the sculptor's temple—and there is a legend that tells of a rivalry between the temple's sculptors, a father and son. The only ornamentation on the front porch consists of two long friezes of dwarfs in various poses related to dance and music. They are exceedingly well done figures—the smiling faces beam with enthusiasm. In the music frieze the drummers almost seem to create sound as others nod their heads in time to the beat. The flutist is lost in his music as a drummer provides syncopation. The limbs of the dancers in the other frieze sway in ecstasy, and the hands of two of them are held in the position that expresses ecstatic joy.

One's eye cannot help being arrested by the excellent decoration here. The *kūḍus* or chaitya windows have either shovel-head or lion-head tops. Just under the eaves of the vimana four figures face the quarters—to the east are Shiva and Parvati; to the south is Dakshinamurti with his feet on Apasmara; to the west Narasimha; and to the north is Brahma seated on a lotus supported by a pair of elephants. The Nandis at the corners are exquisite. Facing the east and seeming almost the guiding spirit of the entire monument is Umasahita—Shiva seated with Parvati—in an exceedingly fine rendering representing Shiva with the ax and deer in his hand. He has heavy ornaments that sit well on his body, a prominent stomach band, and armlets. The figures closely resemble late Pallava and early Western Chalukya carvings. The waist cord, the decorated coiffure, and the contours of the hips and breasts of Devi proclaim the sculptor a great master. Dakshinamurti's hair is arranged in a fine display of ringlets, and his face wears an ecstatic smile. The peculiar feature is that he does not play the vina, but instead sounds a drum of the *ankya* type, holding it in position with a shoulder strap.

The seated Narasimha recalls the colossal one in the Badami cave, whose face is naturalistic but leonine. The crown shaped like a lotus bud on the head is a feature common in both.

Brahma wears the sacred thread and the usual ornaments, carries a rosary and a water vessel, and has a smile on his lips. He is charmingly youthful, as he is usually in southern representations, and lacks the beard suggesting the early Pitambha or "grandfather of the gods," a type occurring in northern sculpture. The frieze of horned lions on the topmost tier is very interesting. Also on this level there are nymphs, dwarf demigods, and lovers in significant attitudes. The usually frolicsome dwarfs here sometimes wear a grave countenance as they converse with wise men, with whom they seem to be discussing great philosophic tangles. And the figures of the female celestials are charming: One holds a toilet box, her garment almost slipping away, another holds a lotus by a long stalk, while yet another is just returning from her bath, holding her wet locks in her hand to dry them before perfuming the braid.

In the next and final tier, there are miniature pavilions as well as elongated barrel vault designs. On this tier are Dakshinamurti to the south, seated Vishnu to the west, seated Shiva holding a snake in his hand to the north. This temple is really a simpler version of the magnificent Kailasanatha at Ellora, but the top portion resembles the Dharmarajaratha at Mahabalipuram.

Close by is a large relief carving with beautiful Jain figures that closely resemble the figures of the temple. Some panels depict Tirthankaras flanked by attendants seated on thrones, each under his own tree. A panel represents Dharanendra Yaksha and Padmavati. The standing Parsvanatha with hooded snakes over his head in another panel is a jewel of early Pandyan art.

(Figs. 134, 555, 557)

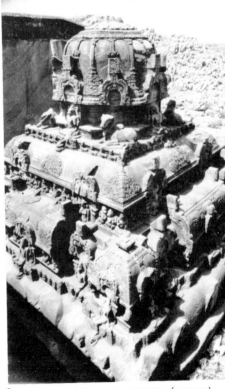

894. KALUGUMALAI. VIMANA (DETAIL)

895. KALUGUMALAI.
JAIN SCULPTURES

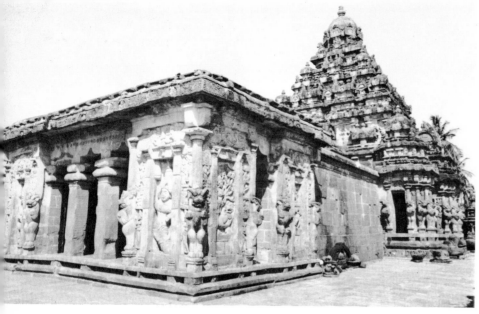

896. KANCHIPURAM. KAILASANATHA TEMPLE

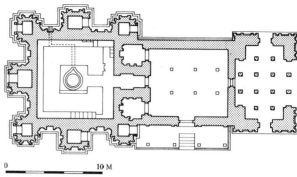

897. KANCHIPURAM. GROUND PLAN OF KAILASANATHA TEMPLE

0 10 M

898. KANCHIPURAM.
INTERIOR OF VAIKUNTHAPERUMAL TEMPLE

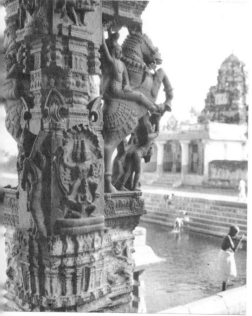

899. KANCHIPURAM.
VARADARAJA TEMPLE AND POOL

900. KANCHIPURAM. KALYANAMANDAPA
OF VARADARAJA TEMPLE

KANCHIPURAM

Kanchipuram, forty-seven miles southwest of Madras, is famous as an ancient capital of the Pallavas. This is one of the oldest and best-known of cities in southern India. Patanjali mentions it in the second century B.C., and Vishnugopa, the Pallava king, was in power here when Samudragupta invaded the south. The city had a great university in the early centuries of the Christian Era, and the founder of the Kadamba family, Mayurasarman, studied here. Asoka is believed to have built a stupa at Kanchi, and Hsüan Tsang noted a flourishing Buddhist population with Buddhist monasteries, viharas, and stupas. The Jains also had a stronghold here as is evidenced by the remains of temples at Tiruparuttikunram a few miles from Kanchi.

Kanchipuram is studded with early Pallava monuments, the most famous of which are the Kailasanatha temple (built by Rajasimha, who was Narasimhavarman II) and the Vaikunthaperumal temple. Built by Nandivarman II in the eighth century and sacred to Vishnu, the Vaikunthaperumal, in three stories, is a perfect example of late Pallava architecture.

The Kailasanatha temple is approached through a tiny gopura. First one sees the Nandi mandapa, and beyond it the cloistered court forming a perambulatory passage all around and containing a number of cells. The central shrine, pyramidal in shape and surmounted by an octagonal sikhara, has an enclosed mandapa and a small porch in front. All around the plinth of the cloistered cells, there are inscriptions in flowery Nagari giving hundreds of elegantly worded appellations of the king. The grandeur of the temple and the devotion of the king are recorded in verse in Grantha characters on the plinth of the main shrine. The wall niches that abound are surmounted by artistic makara torans and enshrine interesting forms of Shiva. Unfortunately, an inferior grade of sandstone was used here, and as a preservation measure a coating of plaster was clumsily applied in the early decades of this century. Thus the effect of most of these lovely early Pallava sculptures is lost. There are traces of wall painting in many of the cells. Particularly noteworthy and almost intact is Somaskanda, a pair of Kinnaras, and a figure of a prince.

The Vaikunthaperumal temple has a series of pillars supported by squatting lions, and the main outer walls of the long perambulatory walk around the principal shrine has interesting reliefs of Pallava history tracing

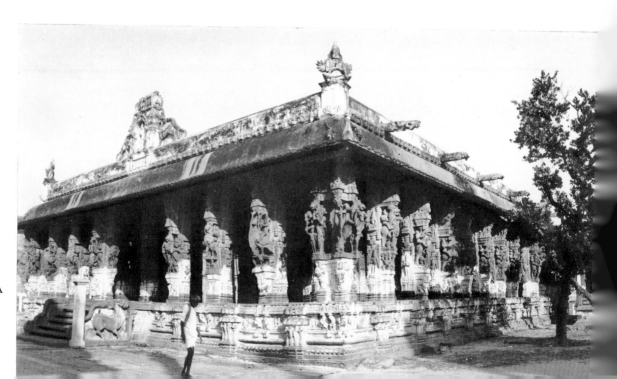

the royal genealogy from its mythical origins and recording the birth of the first Pallava on tender shoots of leaves. Battles are fought, victories won, cities built, sacrifices performed, temples constructed, coronations celebrated—all with explanatory labels in Tamil. The central shrine contains the standing, seated, and reclining forms of Vishnu.

There are other temples at Kanchipuram. The Ekambaresvara temple, with imposing gopura towers, sacred tank, subsidiary shrines, and pillared halls including one with a thousand columns, is the largest one here. Another, which is early and much renovated but with many original vestiges, is the Kacchapesvara. Others are the Airavatesvara, Matangesvara, and Iravanesvara. All are Pallava and all have pyramidal roofed shrines with enclosed mandapas and vestibule with niches filled with lovely representations of the deity.

Three miles from Shivakanchi—or the Kanchipuram of Shiva temples—is Vishnukanchi, where there is a large temple of Vishnu on an elevated mound known as Hastigiri. Karivarada, who protected the elephant in distress, is represented here on the hill. It is an ancient shrine which was extensively renovated during the Chola and Vijayanagar times. It has one of the largest courts of any temple in this area and has a very imposing mandapa for the marriage of the deity with exquisitely carved pillars decorated with prancing horses and hybrid animal monsters mounted by riders. This "horse court," as it is called, bears a close resemblance to a similar one in Srirangam and in Vellore. A large tank for the barge festival is a feature here as well as in the Ekambaresvara temple. The central shrine is large but is dwarfed by the imposing gopuras on all sides.

(Figs. 215, 303, 561, 644, 645)

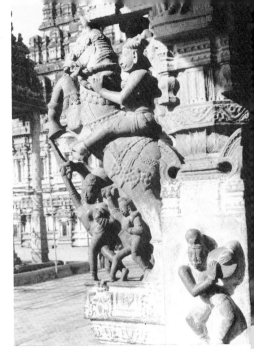

901. KANCHIPURAM.
PILLAR IN KALYANAMANDAPA

KILMAVILANGAI

Kilmavilangai, in the South Arcot District seven miles from Tindivanam, has a small rock-cut shrine dedicated to Vishnu that belongs to the very early Mahendravarman period of Pallava art. Known as Mukaraperumal temple, the five-by-three-foot cell is cut into the northern face of a rock. A rather heavy and crude image of Vishnu appears in high relief on one wall; the guardians on the jambs of the entrance are only sketched into the rock in a primitive fashion. Each holds a flower. The conch and wheel of Vishnu lack the decorative flames, thus indicating a very early date. The lofty headdress, thick sacred cord, heavy lower garment, and other ornamentation are all characteristic of the period.

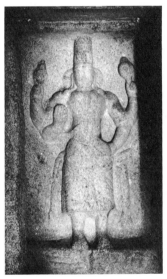

902. KILMAVILANGAI. VISHNU

KODUMBALUR

Kodumbalur, in the Tiruchirapalli District, is famous for its lovely early Chola temples. In an inscription, the creation of these temples is attributed to Bhutivikramakesari whose date is controversial but is probably ninth or tenth century. The temple—Muvarkovil—is a fine example of the smaller early type which eventually culminated in the grand styles of Rajaraja and Rajendra at a much later period. The Muvarkovil was a group of three shrines, of which only two have survived, a half-mandapa, a common connecting mandapa, of which the upper part is lost, and a Nandi mandapa with only the base intact. There are also the remains of an offering receptacle and an emblem-crowned pillar. The base of the central shrine has elegant moldings including a long frieze of hybrid monsters. Gaping makara heads appear at the ends with human figures issuing from them. In the wall on each of the three sides is a niche topped by a makara toran. Ardhanarisvara is in one, Chandrasekhara in another, and the third is empty. Gangadhara, Chandrasekhara, and Vinadhara are enshrined in the niches of the southern shrine. In the corresponding tiers of the vimana roof of the central shrine the niches contain Umamahesvara, Sukhasana, and Dakshinamurti and in the topmost tier, Indra, Sukhasana, and Vinadhara. Kalari, Sankaranarayana, and Nataraja appear in the southern one as do Andhakari and Gajantaka. All are exquisite examples of tenth-century Chola workmanship. Equally interesting are the long courses of dwarfs and friezes of mythological animals as well as the *kūḍus* above the cornice and the almost animated Nandis facing the corner on the topmost tier beneath the shikara. Overall it is an excellent example of the simplicity and elegance of Chola art in its earliest phase.

The Aivarkoil, or Arantali as it is known, was a temple that once existed to the south of Muvarkovil. It must have been a five-shrine type so common in the north but very rare in the south. Only the bases remain to give us an idea of what once existed here.

903. KODUMBALUR. RUINS OF AIVARKOIL TEMPLE

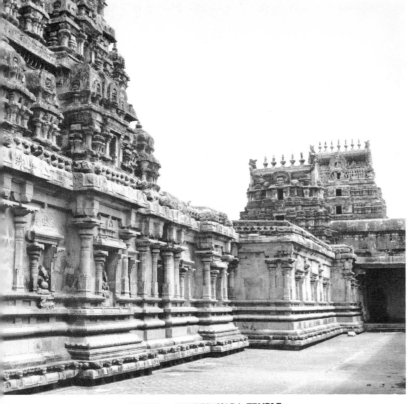

904. KUMBAKONAM. KUMBESHVARA TEMPLE

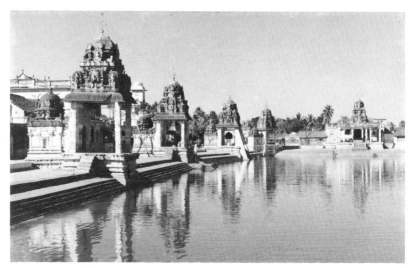

905. KUMBAKONAM. LARGE POOL OF KUMBESHVARA TEMPLE

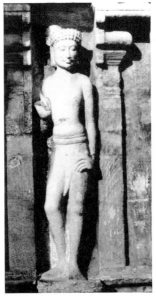

906. KUMBAKONAM.
SUPPOSED FOUNDER OF TEMPLE

KUMBAKONAM

Kumbakonam is a city famous for its many temples; however, the Nagesvaraswami temple is by far the most important.

With a comparatively late gopura and a twelfth-century mandapa similar to those at Chidambaram and Darasuram, with running elephants, horses, and wheels, the appearance of the Nagesvaraswami temple is misleading. In fact, the central shrine is a very early Chola one, probably of the time of Aditya, though it has several inscriptions of later kings as well—Parantaka, Rajaditya, Uttamachola, and others. Originally the temple was built facing east to allow the rays of the sun to fall on the Shivalinga, but it is now all changed, with the mandapas and other structures that were added over the years. A *bilva* tree, the leaves of which are used in Shiva worship, is associated with this sacred spot. The temple is in two stories, and the niches have excellent carvings, many of them portraits of princes, princesses, or noblemen. The sculptures of Ardhanarisvara, Brahma, Bhikshatana, Durga, and Dakshinamurti are all characteristic of the elegance of the earliest phase of Chola art. The portrait figures, particularly of the princesses or nymphs, are excellent. With their sophisticated dress, their coiffures, their jewelry, and their tasteful, elegant demeanor, they speak of an era of great fashion. The simple but effective side view of Agni, with an indication of the flame on the crown, is another triumph. A nobleman, with a fine beaded headpiece and with an otherworldly expression on his face, gives an idea of the outlook on life in the ninth century in the realm of the Cholas. The miniature carvings here of stories from the *Ramayana* are among the most important pictorial representations of the epic of Valmiki. These are on the plinth of the shrine, very close to the hybrid-animal carvings that vie with the exquisite Bhutaganas just below the cornice.

At the approach to the shrine, there is a small and separate cell for Ganesha, which is totally different from any other Chola sculpture. It is of Eastern Ganga workmanship and is a war trophy brought by Rajendra from Orissa after his conquest there.

The famous temple after which the town takes it name, Kumbeshvara, is a large and imposing one with huge gopuras on all sides. These gopuras are a regular feature in all temples of any importance in the south from the late Chola period onward. In the heart of the town and close to the temple is a large stepped tank with small mandapa pavilions along its sides for receiving the deities from the different temples at Kumbakonam on the holy days of the *Mahamakha*. Once in twelve years the water in this tank is believed to attain special sanctity by an invisible confluence of the Ganges in it. Like another tank at Madura (which is tremendously large and is impressive for its barge festival) this one here at Kumbakonam is famous for the crowds it attracts on that sacred day. The various pavilions are attributed to Govinda Dikshita, the prime minister of the Nayak king of Tanjore. In their construction he used an amount of gold weighed against the person of the king himself.

The Sarangapani temple is also a beautiful one. On its gopuras are illustrated in beautiful reliefs the dance positions of Bharata's *Natyasastra*. Krishna is shown demonstrating the correct form of each pose. The central shrine here is a very beautiful one. The sculptures of the gopuras and the shrine belong to the late Chola period. This is the period when it became the style to add wheels and galloping horses to mandapas and vimanas to make them seem almost like chariots soaring in the sky. The central shrine itself was constructed in

907. KUMBAKONAM. RAMASVAMI TEMPLE

510

this style, and elephants as well as horses appear to pull it. Sarngapani, the lord with the *sárnga* bow (Vishnu), rides an aerial chariot like the sun in the firmament. The large temple tank here associated with the sage Hema has special sanctity.

The temple of Ramasvami is one of the gems of Nayak architecture in southern India. It was built in the sixteenth century by Raghunatha Nayak, king of Tanjore. The main shrine houses the seated figures of Rama and Sita, Hanuman reading out a philosophic text as Bharata, Lakshmana, Satrughna, Vibhishana, and Sugriva attend the royal couple. It is the most imposing group of sculpture in a sanctum anywhere in India. The carved pillars of the mandapa in front of the shrine are particularly noteworthy for their delicacy and feeling. The Abhisheka of seated Vishnu with Sridevi and Bhudevi, episodes from the *Ramayana,* an imposing Trivikrama panel, and Rama embracing Hanuman on his return from Lanka are all exquisite.

The temple for Chakrapani, where the glory of the wheel of Vishnu, Sudarsana, is especially emphasized, is another important one.

(Figs. 305, 565)

908. KUMBAKONAM. MANDAPA
OF RAMASVAMI TEMPLE

KUNNAKUDI

Eleven miles west of Karaikkudi is Kunnakudi, which has an early cave temple resembling early Pallava shrines. The guardian figures here have one arm resting on a huge club with serpent entwining it, the other on the waist cord. Their necklaces are large, their earrings are heavy, and the sacred thread is massive, but their appearance is pleasing rather than frightful. In a niche in the wall, Vishnu is represented resting his hand on Garuda, reminiscent of a similar figure at Mahabalipuram. Garuda, with his hands crossed in an attitude of devotion, is the very picture of loyalty to Vishnu. Vishnu's long cylindrical crown, the wheel and the conch on his fingers, his warrior's crossband, as well as the mode of the undergarment and the looping waist cord are all reminiscent of the Pallava style.

In another cave temple here, there is an eight-armed Nataraja dancing. It resembles to an extent the Nallur Nataraja in bronze which is late Pallava. Two dwarf demigods on either side keep time. Since the carving is covered with stucco, it is impossible to see the original Pandyan features. The guardians, however, are free from the plaster coat and reveal all the characteristic features of the early Pandyan school. They lean heavily on huge clubs, wear sacred threads composed of pearls, and have their hair arranged in matted locks. Loops and tassels characterize their waistbands just as in Pallava figures. The horns on the one to the right recall similar Pallava guardians or even earlier ones in the cave at Mogalrajapuram.

The figure with matted locks of hair, thick waist cord, and beaded garland, which is seated in the lotus position on the outer side of the cave, is Shiva or perhaps his distinguished disciple Parasurama.

MADURA

Madura, the ancient Pandya capital, has also been known as Halasyapura, Alavay, and Uragakhyapura. One of India's most beautifully planned towns, its streets were laid out with the temple always in the center. The entire city was supposed to have been circular because the snake Adisesha, according to legend, coiled itself around the site. This was where the ancient conferences of scholars were held to promote Tamil literature. Sundaresvara is here the beautiful lord as the bridegroom. His dance form in the "silver hall," as it is known, is the reverse of the normal one (such as in the golden hall at Chidambaram), for here the right foot is raised instead of the left. (The best example of this form of Shiva is the Pandya work from Poruppumettupatti, now in the Madras Museum.)

The large and imposing gopuras that greet the visitor to the temple of Minakshi-Sundaresvara are of the most recent historic phase of the city—the time of Tirumala Nayak in the seventeenth century—but the four courts are obviously earlier. The central shrine, with its Nandi mandapa and its narrow pillared hall forming the inner sanctuary, has a court completely covered up by gopura entrances on the east and the west. The vimana of the sanctum rises above the flat roof. Beyond this is a larger rectangular court with four larger gopuras. Adjacent to this on the southern side is the shrine of Devi which has a large gopura to the west and a smaller one to the east.

Opposite the shrine of Minakshi, surrounded by a colonnade, is the large rectangular "tank of the golden lily." Beyond it is a large open court to the north of which is the large thousand-pillared hall. Immediately through the very large gopura of the outermost court, there are smaller gopuras to the north, south, and west. There is a long cloister arrangement of pillared halls and chambers all along the southern, western, and northwestern part of the temple. The growth of this complex has been gradual, and there have been so many additions and extensions that it is a bewildering maze of pillared halls, subsidiary shrines, granaries, storerooms, sacrificial halls, kitchen, and on and on. The pillared hall in front of the Minakshi shrine is known as the *astasakti*

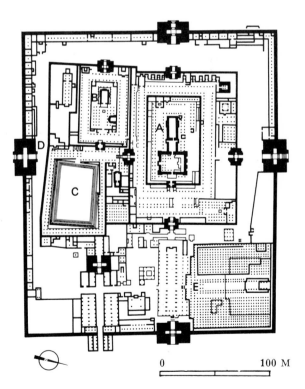

909. MADURA. GROUND PLAN
OF MINAKSHI-SUNDARESVARA TEMPLE.
A—*Sundaresvara sanctuary*
B—*Minakshi sanctuary*
C—*sacred pool*
D—*south gopura*
E—*thousand-pillared hall*

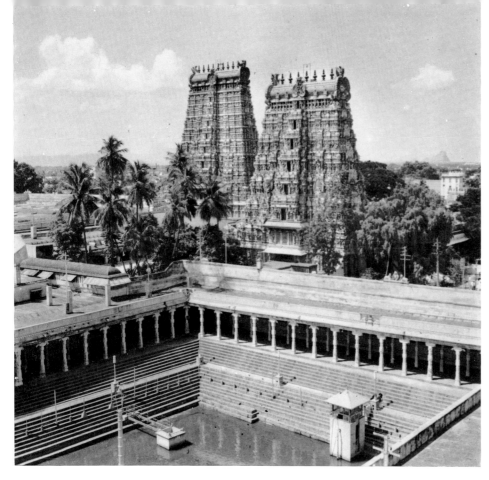

910. MADURA. MINAKSHI TEMPLE
AND SACRED POOL

911. MADURA. CORRIDOR NEAR THE POOL

mandapa and has fine carvings of the eight goddesses that symbolize power. Close to this is the *yāli* mandapa with rearing griffons against its pillars. The *kiḷikaṭṭi* mandapa, or "parrot pavilion," has votive offerings of parrots in cages hung from its ceiling. Opposite the eastern gate of the Sundaresvara is the Tirumalai choultry, a pillared hall of exquisite workmanship. The portrait of Tirumalanayak and his wives against a pillar in this hall is probably the very best representation of the ruler. The outermost towers of the Minakshi-Sundaresvara temple are among the largest and the most imposing in southern India.

Here is also a shrine for Karaikkalammaiyar, the beautiful woman who chose to become ugly and who was absorbed in her devotion to Shiva and in the enjoyment of his celestial dance. Opposite the temple of Sundaresvara is the very beautiful and exquisitely carved pillared hall known as the *pudumaṇḍapa*, also called *vasanta* mandapa. The inner row of pillars here contains portrait carvings of the Nayak kings of Madura with their queens. The outer rows of pillars show various iconographic forms of Shiva, including the marriage of Kalyanasundara and Matribhuta Shiva who, out of compassion for the little orphaned piglets, took the form of a sow and suckled them. The corridor around the tank has fine panels depicting the sixty-four sports of Shiva. These paintings are of the most recent phase, having been restored and repainted a little over one hundred years ago.

Three miles east of this temple is a stepped tank—the largest of its kind in southern India—where the barge festival usually takes place. In the center of the tank, there is a large vimana rising above a pillared hall with four similar smaller structures at the corners of a large rectangular court around it, which is itself a lovely little garden. This is known as the *teppakulam*. The famous Tirumalanayak Palace is a beautiful mahal with large and spacious courts and halls and a veranda. The huge pillars supporting a very high ceiling with intricate stuccowork on its domes and arches provide an excellent example of a blend of Hindu and Islamic architecture. The palace of Mangammal, which is partly ruined, is also an impressive one.

(Figs. 157, 160, 161, 311, 648)

912. MADURA. PUDUMANDAPA PILLARS

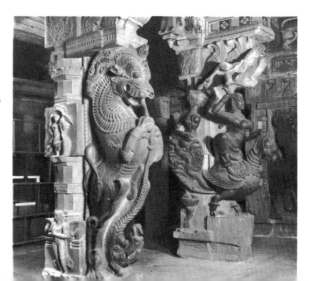

MAHABALIPURAM

Thirty-five miles south of Madras, Mahabalipuram is picturesquely situated close to the sea and is a place of great artistic wealth. Every phase of Pallava architecture and sculpture is represented here.

As a famous port, Mahabalipuram was well known to an anonymous Greek navigator of the first century A.D., who wrote a periplus of the Erythraean Sea. In the following century the Greek geographer Ptolemy mentions it, and it is known that the Romans traded with the town since Roman coins have been found here. In the seventh century the Chinese traveler Hsüan Tsang visited here, but he wrongly refers to it as Kanchi. The name Mahabalipuram is derived from Mamallapuram—"the city of Malla"—a title of Narasimhavarman I (c. 630–670), the greatest of the Pallava rulers, who built most of the rock-cut temples and carvings here. The Vaishnava holy man Tirumangaialvur refers to it as Kadalmallai and describes large ships laden with treasure anchored in the harbor. This was also the birthplace of Bhutattalvar, another Vaishnava sage. It is believed that a cluster of temples, originally on the shore, are now under the sea; local fishermen would have us believe that the spires of submerged temples can occasionally be seen beneath the waves.

The three major styles of architecture at Mahabalipuram are: (1) that of the time of Mahendravarman I (600–630), a contemporary of Pulakesin and Harsha and a great polymath, poet, engineer, artist, and musician; (2) that of the time of his son Narasimhavarman, also a contemporary of Pulakesin and Harsha, who defeated and reduced the power of the Western Chalukyas and with his navy restored his friend Manavarman to his throne in Ceylon; and (3) that of the time of Rajasimha (Narasimhavarman II), whose cultured queen Rangapataka helped him in his architectural and sculptural endeavors. There is also a minor phase represented here by the work of Nandivarman (717–779), who also built the Vaikunthaperumal temple at Kanchipuram.

The Mahendra style, which is the earliest and simplest, is found in a rock-cut temple with its sanctum composed of a triple cell and a front porch with massive pillars. The pillars are divided into three parts, the upper and lower being square in section and the middle octagonal. The bracket is either cut at a forty-five-degree angle or is rounded, often with a wavy ornament on either side of a smooth band. The horseshoe-shaped window is simple with a human head looking out of it and has a finial shaped like the head of a spade. The doorkeepers flanking the entrance to the sanctum are monumental and carry heavy clubs. One of a pair is horned. The sacred thread runs over the right arm. They have a single pair of arms and pleasant countenances unlike their fierce-looking counterparts of a later date, who also have an additional pair of arms. Human sculpture displays well-rounded limbs, a somewhat elongated face, double chin, somewhat inconspicuous nose, and rather thick lips. Weapons are held by deities in a realistic fashion. There are two or three heavy or broad loops below the waistband. The sacred thread is ribbonlike, with a fastening over the left breast.

In the Mamalla-style cave temples the pillars are slender, have more ornamentation, and are supported by squatting lions. The *kūḍu* window is simple, as in the Mahendra style. The pavilion ornament is shaped like a thatched hut with a simulated railing below. The niche has a toran-arch decoration at the top, with makaras on its ends that flourish floriated tails. The door guardians are no different from those of the earlier period, but the other figures, though still heavy, are slimmer than the Mahendra ones. Also during the Mamalla period freestanding monolithic temples were built. The most interesting of these are at Mahabalipuram.

In the Rajasimha period, masonry temples were favored. They have slender pillars, supported not by docile squatting lions but by rampant ones. The *kūḍu* retains the spade-head finial but now this topknot is more ornamented. And the niche also develops greater ornamentation. The doorkeepers have many decorative elements, and the human and other figures are conceived and executed with great taste and delicacy. There is greater exuberance and larger groupings of figures. Miniature panels also multiply and are characteristic of this period. The central vimana is given great emphasis, and the gopura entrance beyond the courtyard—a new feature—is tiny. The representation of Somaskanda behind the Shivalinga becomes a regular feature in this phase of Pallava art and architecture.

Monolith 1 (Dharmarajaratha): The name of this monolith (and those of the others) has no relevance to the five Pandavas of the *Mahabharata*. All the monoliths belong to the time of Narasimhavarman I. Monolith 1 is the southernmost and the largest temple of the group. Pyramidal in structure and on a square base, it has a series of tiers, each with a row of miniature barrel-vault pavilions above bands of horseshoe-shaped *kūḍu* windows. Each tier is supported by brackets and pilasters, which form rows of niches. The niches contain relief panels of great iconographic and aesthetic value. In the lowest row are various representations of Shiva including the Ardhanarisvara form, Narasimha, and a portrait of Narasimhavarman himself, with his titles Sri-Megha and

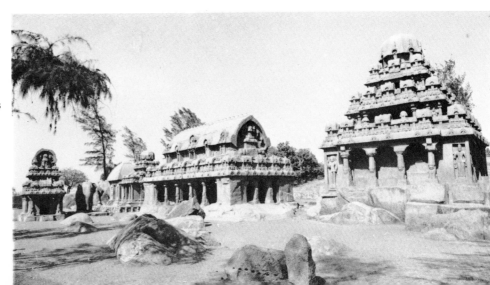

913. MAHABALIPURAM. VIEW OF THE FIVE RATHAS

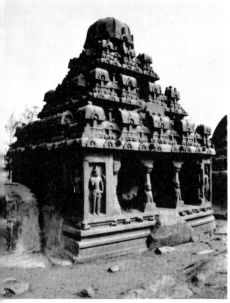

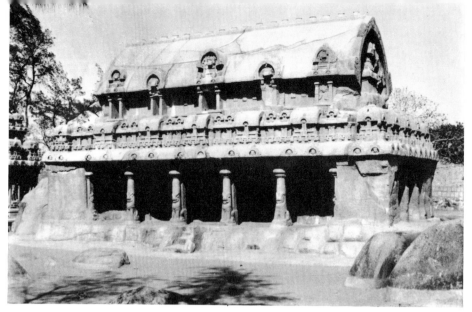

914. DHARMARAJARATHA 915. BHIMARATHA

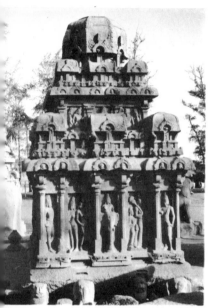

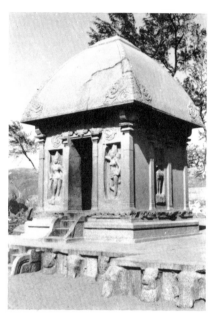

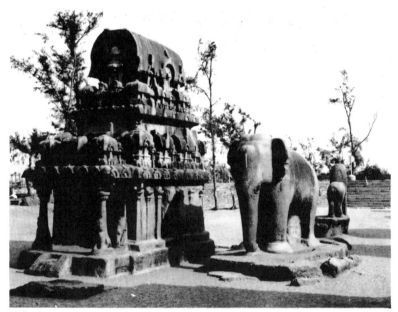

916. ARJUNARATHA 917. DRAUPADIRATHA 918. NAKULA-SAHADEVA-RATHA

919. MAHABALIPURAM.
GROUND PLAN OF VARAHAMANDAPA 13

Trailokya-vardhana-vidhi inscribed in Grantha characters. Harihara, Brahma, Skanda, and Gurumurti are at the corners. In the central tier, there are such forms of Shiva as Gangadhara, Nataraja, Vrishabhantika, Kirata, Chandesanugraha, and Vinadhara, in addition to Vishnu as Garudantika and Kaliya-Krishna. In the top tier are Surya, Shiva, Somaskanda, Brahma, and Vishnu.

MONOLITH 2 (Bhimaratha): This has a roof shaped like a covered wagon, is on a rectangular base, and is supported by three pillars and two pilasters. We see horseshoe windows and miniature pavilions similar to those of Dharmarajaratha. The curvilinear roofs of this and Monolith 4 suggest that they were inspired by the thatched hut.

MONOLITH 3 (Arjunaratha): This is a smaller edition of the Dharmarajaratha. There are five panels on each of three sides. The principal carvings are of Shiva leaning on Nandi, Indra on Airavata, and Vishnu on Garuda. In the upper tier there are beautiful carvings of the amorous couple and a frieze of geese; at the base elephants and lions act as caryatids. Again the horseshoe-window decoration and miniature barrel-roofed pavilion are repeated. A portico at the entrance, supported by two lion pillars, and a flight of steps are all part of the monolith. The row of dwarfs one sees below some horseshoe-shaped windows is artistic and laughter-provoking. In the cell one finds a head crowned by horns or trisula, obviously intended for Shiva. Behind the building is a colossal monolithic couchant bull.

MONOLITH 4 (Draupadiratha): Draupadiratha is supported by corner pilasters and there are large niches on three sides; the entrance is watched over by female guardians. Both the niches and the doorway lintel are decorated with makara torans. The niches contain representations of Durga, who is found again inside the cell flanked by worshipers ready to decapitate themselves and give their heads as an offering to the goddess. In front of the structure is a standing lion.

MONOLITH 5 (Nakula-Sahadeva-ratha): Named after Nakula and Sahadeva, it is apsidal and the

514

smallest of the group. It has a porch supported by two lion pillars but lacks figure carving. The fascinating monolithic elephant that stands next to it suggests the form of the temple.

CAVE 1 (Varaha cave): Located behind the Mahishamardini cave, the Varaha cave has a large hall with a front row of four pillars and two pilasters, all supported by lions. There is a cell in the center of the back wall with a carved panel of Varaha raising the earth from the ocean. The walls of the veranda contain other relief panels where one sees Gajalakshmi bathed by elephants, eight-armed Mahishamardini, two representations of Shiva, and Gangadhara and Brahma. There are also interesting royal portraits, one of Simhavishnu seated on a throne flanked by his two queens, another of Mahendravarman I leading his two queens toward his father. These portraits have identifying labels in Grantha-Pallava characters of the seventh century.

TEMPLE 1 (Olakkanatha temple): This temple, built on top of the rock in which the Mahishamardini cave is cut, belongs to Rajasimha's time. The top is unfortunately lost. The rampant lions and the sculptures on the sides of Dakshinamurti, Ravananugrahamurti, and Alidhanrittamurti are exceedingly well done.

CAVE 2 (Mahishamardini cave): The cave is a long hall with a triple cell in the center. There are four polygonal pillars and two pilasters each with a cushion-type capital on a square abacus. The pillars, squatting lions as bases, support a small mandapa projecting from the cell. The cell is flanked by guardians, and the cornice of the mandapa is decorated with a frieze of geese. In the central cell there is the usual representation of Somaskanda. There are two large panels on the side walls representing Seshasayi Vishnu and Mahishamardini. Seshasayi Vishnu is a picture of repose in deep slumber while the demons Madhu and Kaitabha brandish their weapons in agitation. The weapons of Vishnu, the discus and sword, are personified as youths, the club as a charming amazon, and the conch as a dwarf. All are preparing to attack. Eightarmed Mahishamardini riding her lion and surrounded by hosts of dwarfs and amazons, pulls the bowstring up to her ear to discharge arrows. The umbrella held over her and her opponent indicate their importance. The Mahishasura suggests great power and animation; the enthusiasm of the dwarfs is in contrast to the despair of the demons. This remarkable sculpture inspired a similar one at Ellora.

CAVE 3 (Dharmaraja mandapa): Triple-celled and with massive pillars, this cave is typical of Mahendravarman's time.

CAVE 4 (Krishna mandapa): Cut out of a large piece of rock, this cave vividly presents the story of Krishna lifting Mount Govardhana to protect the cowherds and milkmaids from a storm raised by Indra. Krishna and Balarama are depicted in monumental size with one of the hands of the former in the boon-conferring attitude. These are charming scenes—a cowherd milks a cow that fondly licks her calf, a milkmaid holds a pile of milk-pots on a rope string and balances a bundle of fodder on her head, a woodcutter idly rests his ax on his shoulder, a mother holds a little child in her arms, a cowherd plays a flute. Everything is depicted in a marvelously natural fashion, making this one of the most magnificent carvings at Mahabalipuram.

CAVE 5 (Panchapandava mandapa): This large cave has six lion pillars and pilasters at either end. The brackets over the capitals are decorated with lions and griffins with human riders.

ARJUNA'S PENANCE: This is the most remarkable sculptural group anywhere in India. Two large boulders, with a narrow fissure between, have lent themselves to the sculptor to represent celestials such as the moon, the sun, pairs of singers, Siddhas, nymphs, and so forth moving towards the cleft, where a sage is deeply engaged in penance and rewarded for it by four-armed Shiva in the company of dwarfs. There is even a cat engaged in penance—with mice gathered around it unafraid. Gracefully carved nagas and naginis with hands in adoration stand out against the cleft. In the vicinity of a temple of Vishnu, there are several sages in yoga meditation. Their disciples are depicted bathing, carrying water in a pot, wringing out a wet cloth, or engaged in a peeping at the sun through their fingers (this last ritual indicates that it is midday). Fearless deer near the sages suggest the peace and tranquillity that persist in the vicinity of holy men. The figures in the upper part of this group suggest the celestial sphere, the central section with the temple and the sages suggests the terrestrial sphere, and the lower area with the two large elephants—the elephants of the quarters—is meant tobe the netherworld. The cleft represents the river Ganges, on the banks of which, according to the story, Arjuna performed penance to obtain the weapon from Shiva.

MONKEY GROUP: This is a tiny but delightful carving of a family of monkeys—father, mother, and child.

MONOLITH 6 (Ganesharatha): This is one of the finest monoliths here. It is similar in style to the Bhimaratha, but of better workmanship and is more finished. The gable ends of the roof each have a finial with a human head that wears trident-shaped headgear. The small pavilion and horseshoe-shaped ornamentation is found here again. The roof line has nine vase-shaped finials. This type of finial is actually the beginning of

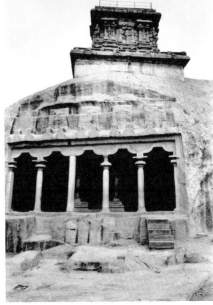

920. MAHABALIPURAM. MAHISHAMARDINI CAVE AND OLAKKANATHA TEMPLE

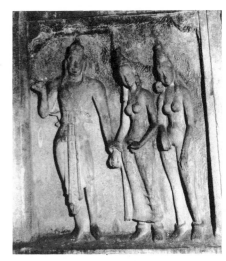

921. MAHABALIPURAM. MAHENDRAVARMAN AND HIS QUEENS (VARAHA CAVE)

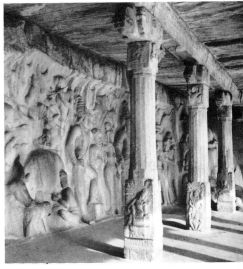

922. MAHABALIPURAM. GOVARDHANA CAVE

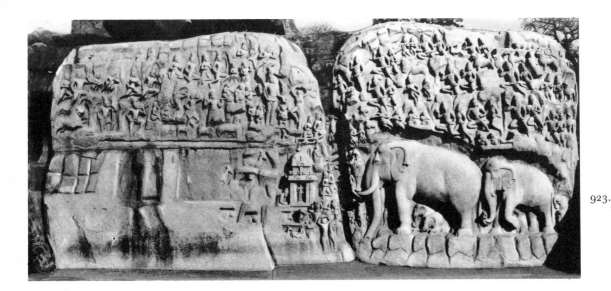

923. MAHABALIPURAM. PENANCE OF ARJUNA

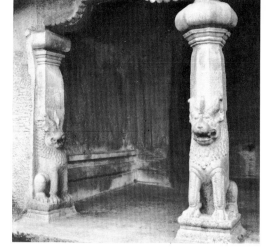

924. MAHABALIPURAM. VARAHA CAVE 2

925. MAHABALIPURAM. TRIMURTI CAVE

926. MAHABALIPURAM. SHORE TEMPLE

what developed into the gopura. There are two lion pillars and two pilasters at the front; the cell beyond the hall once held a Shivalinga.

ELEPHANT GROUP: A little beyond the Ganesharatha toward the north is a small unfinished group of animals—elephants, a peacock, and a monkey. This is a lovely study of animals and birds.

CAVE 6 (Varaha cave 2): Very near the Ganesharatha is the Varaha mandapa where again one finds two lion pillars and pilasters in the front hall. Beyond is the cell. The four reliefs here are: a spirited depiction of Varaha raising the earth from the ocean, a fine Gajalakshmi seated on a lotus and bathed by elephants, a four-armed Durga, and multiarmed Trivikrama overcoming the demon king Bali. The modeling of the snout of the boar is remarkable, and Surya, Brahma, and the other adoring figures are interesting. The naga king Sesha near the feet of Varaha is shown against lotus leaves, flowers, and ripples suggesting water. All this suggests his abode—the netherworld—from which the earth was rescued. The Gajalakshmi relief is simple but effective. The two nymphs fetching water for her bath and the elephants emptying waterpots over her head are fine examples of figure carving. The contours of the elephant's trunk and the natural folds of the ears indicate the sculptor's mastery of detail. In the Trivikrama panel, Jambavan at the top, beating a drum and rejoicing, and Trisanku, in midair (suggesting the celestial region) and touched by Vishnu's foot, are very appealing.

CAVE 7 (Ramanuja mandapa): This triple-celled Shivaite cave with two pillars and two pilasters has been ruined by vandals.

PALACE SITE AND LION THRONE: Where once the palace probably stood is a monolithic lion. The animal's back was flattened to provide a large rectangular seat for the king.

CAVE 8 (Kotikai mandapa): This small cave temple sacred to Durga has massive pillars that closely resemble those of the Mahendra period. Beyond the front hall is a cell guarded by female doorkeepers on either side of the entrance. An inscription gives the epithet of King Sri Vamankusa.

CAVE 9 (Koneri mandapa): This is a crude unfinished cave temple with four pillars supported by couchant lions and flanked by pilasters.

CAVE 10: A five-celled rock-cut temple, this cave has pillars that look quite finished and that have an attenuated shape. These features along with the form of the door guardians and the more advanced architecture indicate the Mamalla period. The row of horseshoe-shaped windows along the cornice with faces peeping through them and the row of geese below are typically early Pallavan.

STONE CISTERN: The "milkmaid's churn," as this is known, is a large circular cistern cut out of the rock.

CAVE 11 (Trimurti cave): This is a triple-celled cave for Brahma, Vishnu, and Shiva. The entrance of each cell is flanked by guardians and toward one end, in a niche topped by a makara toran, one sees Durga on the severed head of Mahishasura. The three deities are shown in their respective cells.

SHORE TEMPLE: Close to the sea, this double temple is an example of the masonry work of Rajasimha's time. The main shrine faces east, with a small gopura leading on to it; there is a perambulatory passage between the temple and the outer wall. The vimana is narrow and elongate. An emblem column is perched on a boulder opposite the gopura and is constantly lashed by ocean waves. Behind the temple and connected to it is a cell without a superstructure enshrining Seshasayi Vishnu. Adjoining this and facing west is another shrine, similar to the main one and also devoted to Shiva. The Somaskanda panel can be seen on the back wall of the cell inside. Some distance opposite this is an offering receptacle and a pedestal for another emblem column.

A large courtyard enclosed by a low wall decorated with rows of Nandis makes the whole complex picturesque. Near the entrance and in the vicinity of the shrine facing west is a large sculpture of Durga's lion with the goddess seated on the right hind leg and a miniature likeness carved in a tiny square niche on the chest.

MAHISHASURA ROCK: A short way to the north of the shore temple is a large boulder close to the sea with a shrine of Durga cut in it. On the back wall of the cell is an eight-armed rendering of the goddess. There are female doorkeepers and lion pilasters on either side of the entrance. On the far side of the rock Durga's lion is shown attacking Mahishasura.

CARVED ROCKS: These are somewhat to the south of the shore temple. One of the carved rocks is fashioned into a rampant lion and has a niche containing Durga. The rock opposite this resembles a recumbent lion and contains a shrine facing east dedicated to Indra. At one end is a carving of a trotting horse and worshipers.

TIGER CAVE: Three miles north, in the hamlet of Saluvankuppam, there is a rock-cut shrine of Durga with a small portico in front flanked by two pilasters supported by rampant lions. This cave is of the time of Rajasimha.

927. MAHABALIPURAM. TIGER CAVE

ATIRANACHANDA CAVE: This is a shrine with intriguing features. There are massive pillars, simple corbel capitals, and door guardians with early features. But the inscriptions here mention King Atiranachanda, a surname of Rajasimha, so this cave must be of his time.

CAVE 12 (Valayankuttairatha): This resembles the Arjunaratha, though it is smaller in size. It is one of a group of three.

CAVES 13 and 14: These two unfinished rock-cut shrines are known as Pidarirathas.

(Figs. 8, 138, 300–302, 394)

928. MAHABALIPURAM.
GROUND PLAN OF MAHISHASURAMANDAPA 15

MAHENDRAVADI

In Mahendravadi, a village three miles from Sholinghar in the North Arcot District, there is a rock-cut temple on the eastern side of a large boulder. An inscription on the pilaster to the left reads: "Excavation of this rock was commissioned by Gunabhara. This large and prominent temple of Murari, known as Mahendravishnugriha, in the vicinity of the Mahendra tank in the city of Mahendra, is of great quality and beautiful to the eyes of the people to behold." The facade has two square pillars. They have an octagonal central section and rounded corbeled capitals. There is a pilaster at either end. This series is repeated in the mandapa hall which leads on to a central cell for Vishnu. The doorkeepers of the shrine are elegantly carved but are of heavy build; though a little worn they are excellent examples of very early Pallava work of Mahendravarman's time. There is no sculpture in the shrine, and the carving of Narasimha placed here is a late one.

MANDAGAPPATTU

In the South Arcot District, twelve miles from Vilupuram and six miles from Dalavanur, is the village of Mandagappattu, where a very important Pallava temple of the time of Mahendravarman is found in the north face of a small granite outcrop. An inscription here proclaims that the temple, built "not of bricks or wood or metal or mortar but created by King Vichitrachitta," was dedicated to Brahma, Vishnu, and Isvara. As usual in Pallava cave temples the facade is simple with two heavy pillars that are square in section at the top and bottom and octagonal in the middle, with the capital composed of rounded corbels. Beyond similar pilasters on either side are rather heavy and clumsily carved guardian figures in shallow niches. The one to the right leans heavily on his club, one of his legs crossed against the other, in almost three-quarters view. The other stands almost erect, resting his left hand on his club and the right on his hip and facing the spectator. Serpents entwine the clubs, and the figures wear a heavy wiglike hair and lofty crowns. In the mandapa beyond, the pillars and pilasters are repeated; still further back there are three shrines, the central one obviously for Shiva. All three are empty.

929. MANDAGAPPATTU. CAVE FACADE

NAMAKKAL

Namakkal in the Salem District is famous for two rock-cut temples both sacred to Vishnu. In one of them the principal deity is Ranganatha and in the other it is Lakshminarasimha. The cave for Ranganatha, in the eastern scarp of the hill and facing east, is a simple one composed of a sanctum and a mandapa. It is on a raised platform reached by steps. Here is the usual pair of pillars and pilasters. Modern additions in the form of a wall in line with the outer pillars that completely blocks the cave have ruined the facade. The cave can be visited only once a year; the openings in the walls are otherwise kept closed. Ranganatha on his serpent couch is close to the western wall of the cave on which are carved Tumburu, Narada, and other minstrels. Brahma is depicted seated on a lotus issuing from the navel of Ranganatha. The demons Madhu and Kaitabha approaching Vishnu are carved on the north wall. Chandra and Surya are shown on the northern and southern walls respectively. The weapons of Vishnu are seen on the base of the couch (bringing to mind the famous Seshasayi at Mahabalipuram). On the south wall is another relief of Trivikrama, with Mahabali at his feet granting a boon to Vamana. Jambavan is depicted at the top with other celestials.

The Lakshminarasimha temple, which is composed of a central shrine, three cells, and the usual pair of pillars and pilasters for the mandapa in front, has a raised platform with pillars to enshrine Narasimha in the seated-hero pose, with a number of celestials such as Surya, Chandra, Sanaka, Sanandana, Brahma, and Rudra around him. In one of the other cells one sees Narasimha tearing open the entrails of Hiranyakasipu as he holds

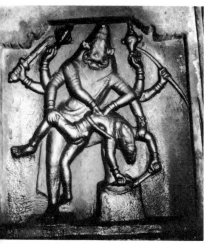

930. NARASIMHA

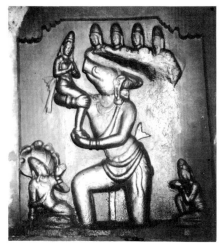

931. VARAHA

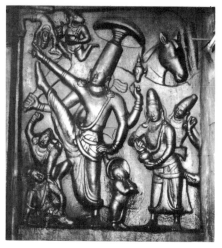

932. TRIVIKRAMA

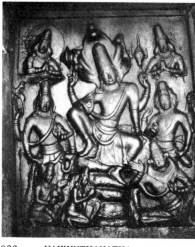

933. VAIKUNTHANATHA

him across his thigh. In the other Varaha lifts Bhudevi on his right arm. There is Seshanaga at the feet to suggest the netherworld from which the earth is rescued, and there are celestials above the clouds at the top. Though this cannot compare with the Varaha at Mahabalipuram for grace and charm, it is nevertheless an early piece of considerable importance. In niches on the north and south walls Trivikrama, with his foot raised as he grows from the dwarfish Vamana, is being welcomed by Bali, and Vishnu is seated on a serpent couch with Shiva and Brahma on either side, as Bhudevi and Garuda stand in adoration. In this panel it is interesting to note Trisanku falling, as at Mahabalipuram, head downward near the upraised foot to suggest the celestial region which the foot has reached. (Trisanku had his own special celestial sphere created for him by Visvamitra.)

The inscriptions in the Ranganatha cave reveal that they were built by an Atiya king called Gunasila. The cave was therefore called Atiyendra-Vishnugriha following the Pallava tradition of naming a temple after the king and his family. Pallava influence is obvious here; the cave is of the eighth century.

NARTAMALAI

Ten miles from Pudukkottai, Nartamalai is important for its variety; early structures of several different dynasties are found here. There is here a cave cut in the rock, popularly known as Samana-kudagu (Cave of the Jains). At one time it may indeed have been Jain but it is now Brahmanic, with a shrine and a mandapa, and a whole row of Vishnu images, each over six feet tall, placed on either side of the doorway of the central cell. These carvings are simple but elegant and imposing and the attributes of *śaṅkha* and *cakra* have very early features.

There is another cave to the south of this that is a temple for Shiva. This is of the time of the Pallava king Nripatunga in the ninth century and was later enlarged by the daughter of a chieftain. She added a narrow pillared hall and a mandapa for the Nandi bull. Opposite the cave are the stone structures of a Shiva temple complex—a main shrine surrounded by eight subsidiary ones—from the earliest phase of the Chola period. It is the creation of Vijayalaya, the founder of the Chola dynasty, and as an inscription states the central shrine is called Vijayalaya Cholisvaram. Lacking the usual niches that house deities, this complex is almost austere. But the few figures one does see, such as the dancers over the front of the vimana as well as a Vinadhara, a Dakshinamurti, and a Umasahita, are exquisite. The doorkeepers are also elegant, slim, and imposing. The miniature pavilions on the vimana have graceful horseshoe-shaped *kūḍus* on them, and the mandapa in front of the shrine is austere but in harmony with the rest of the plan. Built in the third quarter of the ninth century, this is an excellent example of the beginnings of Chola architecture.

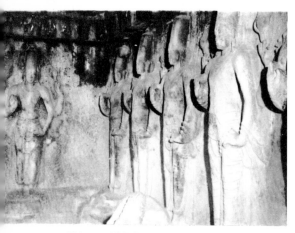

934. NARTAMALAI.
ROW OF VISHNU FIGURES

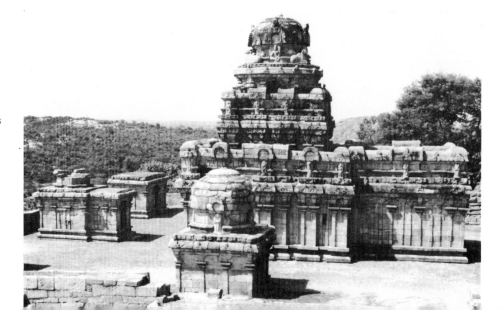

935. NARTAMALAI. TEMPLE AND PAVILIONS

PADMANABHAPURAM

It is well known that the earliest structures in India, both secular and religious, were constructed of wood, such as the exquisitely carved palace of Chandragupta. This tradition was continued in many places throughout Kerala, and the Padmanabhapuram palace, the oldest parts of which date from the mid-fourteenth century, is a fine example in which local architectural features are very well represented. The gabled roofs, dormer windows, and long corridors are all characteristic of the Keralan architectural style—simple yet elegant. The important parts of the palace are: the entrance hall, the council chamber, the theater hall, the hall of worship, the shrine of Sarasvati, and the rulers' bedrooms on the top floor. Also on the top floor of this four-storied building is a series of well-preserved eighteenth-century murals that form a rich heritage of late medieval painting in this part of the country. The faces of figures are somewhat elongated, and the masterly draftsmanship is combined with a riot of color. Here one finds paintings depicting popular themes—Padamanabha reclining on the serpent couch with the lotus from his navel holding Brahma; Venugopala amid the milkmaids playing the flute; multiarmed Shiva dancing as Nataraja; Gajalakshmi bathed by elephants; Rama's coronation; and other similar incidents from the sacred books. In a panel illustrating the worship of Ganesha, it is interesting to notice the scenes of day-to-day life in that period in Kerala, which remain almost unchanged in our own time. One sees domestic and religious activities, the modes of dress, the everyday belongings of the people, and the simplicity of life, which was so completely in tune with nature. The "lamp tree" has all its branches lit; troops of musicians play the pipes, beat the drum, blow the conch, and clang cymbals. Plantain and jackfruit, sweet cakes, and pots filled with rice cooked in milk—all are lovingly offered to the elephant-headed deity. It is indeed an impressive scene.

The wood carving in this palace is also important. A long and continuous tradition of such carving in Kerala accounts for such lovely work as the *Ramayana* panels in the Ramasami temple here and the intricate workmanship of the wooden cots in the ruler's sleeping chamber. The capitals of the pillars, which in the Padmanabhapuram palace have the plantain-flower pattern (a favorite in the Vijayanagar period) and the serpent-hood motif, are good examples of the intricate decorative work of Kerala. On the vast grounds of the palace is the Nerapura, a separate house built completely of wood. Every part of this structure—pillars, ceilings, doorways, architraves, stairs, balustrades—is an excellent example of the carver's art. The large dining halls and spacious corridors, as well as the several domestic shrines within the boundary of the palace, make this an impressive example of domestic architecture. There are also a number of the hanging lamps for which Kerala is famous.

936. PADMANABHAPURAM. PALACE ENTRANCE

PANAMALAI

The village of Panamalai in the South Arcot District is fourteen miles from Villupuram. Here, on a small hill close to a large irrigation tank, is an important Shiva temple of the time of Rajasimha. According to Dubreuil, inscriptions indicate that this temple is a contemporary of the Kailasantha at Kanchipuram. The temple faces east and is simpler than the Kailasanatha. From the plinth to the cornice it is of stone construction; the superstructure is brick and plaster. Square in plan, the little sanctum has a narrow processional path, a small entrance porch, and a large mandapa. The Shivalingas in niches on the outside walls of the sanctum are fluted, indicating their date, and on the rear wall of the shrine is a representation of Somaskanda as one would expect in a temple of this period. As at Kanchipuram there are rampant lions against pilasters at every corner of the shrine. The cornice has horseshoe-shaped decoration and there are courses of horned lions and miniature pavilions continuing up the pyramidal shrine. In one of the side shrines to the left a faint outline of Shiva dancing has survived. A bit more distinct is Devi watching the dance. She stands on one foot, the other leg bent to rest against the wall, with an umbrella over her. Despite their damaged condition the paintings are extremely charming. Such murals once covered much of the interior of this temple, but the rest are lost.

(Fig. 133)

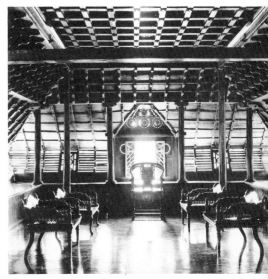

937. PADMANABHAPURAM. COUNCIL HALL

PULLAMANGAI

Very close to Pasupatikoyil is one of the earliest Chola structures still retaining the Pallava tradition—the Brahmapurisvara temple. The gopura of this temple is small and was a later addition. The central vimana (about twenty-five feet square) and the porch are the components of the original shrine. Square and rectangular miniature pavilions decorate the roof of the porch and under the eaves there is a frieze of Bhutaganas. The niches, which are topped by richly embellished makara arches, are flanked by pilasters with large abaci and bracket figures of rearing mounted lions. The doorkeepers have single pairs of arms and are quite normal-looking, lacking the fierce mien that became the fashion at a later date. Ganesha, in a niche, has a graceful trunk that clutches a sweet. A number of exquisite dwarfs are gathered around him on the sides of the niche, a feature that continues in Chola shrines. Bracket carvings in the form of dancers and musicians are seen on many pillars and pilasters. The Manmatha and Rati on a chariot here is a forerunner of a similar group at Darasuram. There are some exquisite small reliefs at the bases of the pilasters. Of these, Nataraja, Gajantaka, Kalari, and Varaha, are noteworthy, and they recall similar figures at Srinivasanallur. Floral festoons, elaborate horseshoe windows, and a frieze of griffins around the base also adorn this lovely temple. Among the outstanding sculptures are: a delicately carved Brahma; a Lingodbhava flanked by Brahma and Vishnu; and a charmingly posed Durga.

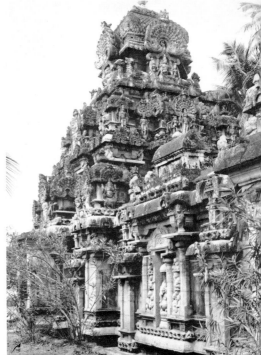

938. PULLAMANGAI. BRAHMAPURISVARA TEMPLE

SENDAMARAM

At the foot of the Virasigamani Hill in Sendamaram, twenty miles from Sankaranayanarkoil, is an early rock-cut temple with heavy pillars. In this cave, there is a carving of a sage that is badly worn except for the face, which is serene and full of devotion. This figure is particularly interesting as this is the region of Agastya. The guardians flanking the central cell of Shiva have all the characteristics of the early schools. One of them leans against his huge snake-entwined club, and his matted hair, thick sacred thread, armlet, and looped waist cord are all characteristic of the period. His companion on the other side resembles a holy man, similar to one at Mahabalipuram, who comes to adore the deity.

SIYAMANGALAM

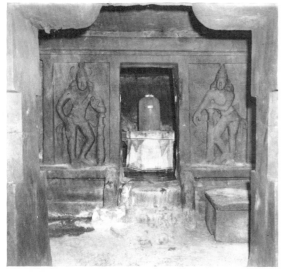

Siyamangalam (more correctly Simhamangalam), is a village in the North Arcot District in Wandiwash taluk. The rock-cut temple here is unfortunately obscured by a series of mandapas that were added to it. From the inscription here, it is clear that it was built by Mahendra himself. It states: "By the king Lalitankura, this shrine, known as Avanibhajanapallavesvaram, was caused to be made as a receptacle of the immortal elixir of precious gems—namely his own good deeds." The cave is simple with two cubical pillars and pilasters in the facade and two more in the middle of the mandapa. At the back is the shrine with a cylindrical lingam. The entrance of the shrine has doorkeepers closely resembling those at Vallam with all the peculiarities noted there. But more interesting are the fierce warriors brandishing swords and shields on either side of the facade under a double-arched makara toran. It is also interesting that on one of the pillars on the facade there is a representation of a lion with the looped tail, a lotus medallion below, and an inscription in the central portion.

What is most important, however, is that on one of the cubical pilasters Shiva is shown dancing and carrying fire and an ax. His hair whirls around. It is noteworthy there is no Apasmara here, but a snake with raised hood listens to the music of the dwarfs that beat the drum and sound the cymbals for the dance.

939. SIYAMANGALAM. CENTRAL SHRINE
WITH DOOR GUARDIANS

SRIRANGAM

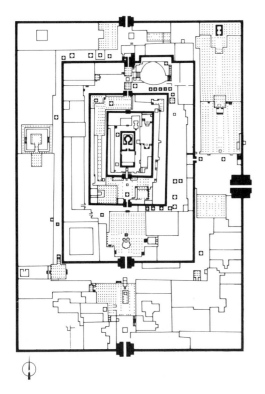

Srirangam, a great center of Vishnuism, is mentioned in early literature as a sacred spot; however, except for Chola inscriptions here and there all vestiges of the original structure are lost. It is well known that the early Vaishnava Alvars favored this city-temple, and Ramanuja was associated with it in the twelfth century. In the thirteenth century the Pandyas, particularly Jatavarman Sundara Pandya, renovated the shrine and covered it with gold. There were Muslim invasions in the fourteenth century, and Srirangam was overrun when Madura became the headquarters of a province of Mohammad Tughlak. But early in the Vijayanagar period the temple was again restored to its original condition. The Nayaks of Tanjore and Madura also greatly admired the Srirangam temple and they made further renovations.

There are seven concentric courts, each with gopuras in its walls, and nearly the entire city is contained within these courts. The southern gateway, where one enters, is actually only the base of an incomplete gopura. The names of the courts or enclosures—the sixth is named after Kaliyugaraman, one of the Pandya kings; the fifth is called Trivikrama *tiruvidi* after Vikramachola of the twelfth century; and the fourth Akalankan *tiruvidi* after Vikrama Chola, the son of Kulottunga I—indicate how successive dynasties had their hand in the additions and renovations.

The main shrine is elliptical—the most felicitous design, according to the Pancharatragama—with a row of four shikaras at the top. The vestibule projection has a similar arrangement of shikaras, and the large arch that forms its facade is surmounted by a lion's head with makara terminals at the bottom and has Vishnu standing against it. With its projecting roof in front, this vimana suggests the mystic syllable *Om*. The mandapa leading up to the shrine, approached by steps from both the east and the west, has five rows of six pillars with the plaintain-flower corbels that are characteristic of Vijayanagar style. There are several mandapas and smaller shrines. The most imposing of the mandapas are the thousand-pillared hall and the Seshagiriraya mandapa in the fourth enclosure near the Vellai gopura. The Unjal mandapa contains the swing; the Kili mandapa has

940. SRIRANGAM.
GROUND PLAN OF THE CITY-TEMPLE

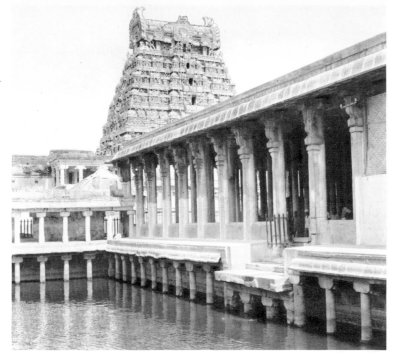

942. SRIRANGAM. THOUSAND-PILLARED HALL

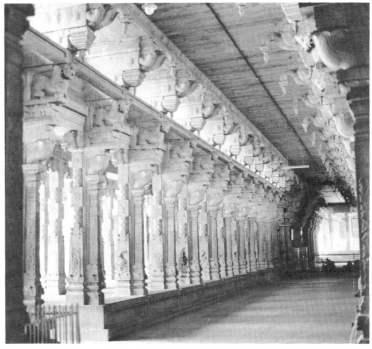

942. SRIRANGAM. THOUSAND-PILLARED HALL

parrots in cages as votive offerings. There are shrines for Krishna, Vishvaksena, Dhanvantari, Pattabhirama, Kodandarama, and Sriranganachiyar, the consort of Ranganatha. There are also shrines dedicated to wise men such as Udayavar, Alavandar, Nammalvar, and others and there is a special mandapa for Garuda. One also sees stately portrait sculptures of Nayak kings. In the shrine of Nachiyar one image is believed to represent Chokkanatha Nayak who lived in the seventeenth century. A sculptural decoration in the Venugopala shrine, though late Nayak, is nevertheless interesting. The prancing horses in the Seshagiriraya mandapa are exceedingly well executed and the portraits of Chokkanatha and his brothers on the pillars of the Garuda mandapa are noteworthy. Even the eighteenth-century nobleman Lala Todar Mal, a general in the army of the nawab of the Karnataka, is portrayed here.

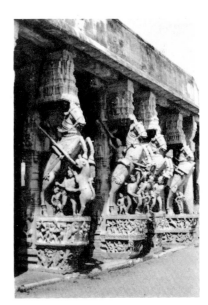

943. SRIRANGAM.
KALYANAMANDAPA

TANJORE

Tanjore, two hundred miles southwest of Madras, is famous for the most important Chola monument of all, the Brihadisvara temple. It was built by Rajaraja (985–1012), the great Chola emperor, who was a military genius as well as a patron of art and literature. The Brihadisvara temple, along with the similar one at Gangai-kondacholapuram built by Rajendra (Rajaraja's son, who almost eclipsed the glory of his father), presents the acme of Chola art. Built of granite, it has a central shrine 150 feet square and a vimana 200 feet high. The huge shikara atop the vimana, believed to weigh eighty tons and popularly thought to have been brought from a place known as Sarapallam about four miles away, is an imposing piece. The platform of the vimana contains several inscriptions giving details of Rajaraja's exploits and his gifts to the temple that provide a fascinating glimpse of Chola life and culture. Immediately above the plinth, there is a long freize of griffins that is interrupted at the corners and other intervals by makara heads with warriors issuing from their gaping mouths. Niches and

944. TANJORE.
GROUND PLAN OF BRIHADISVARA TEMPLE.
A—sanctum sanctorum; B—ardhaman-dapa; C—mahamandapa; D—Nandim-andapa; E—gopura; F—Subrahmanya sanctuary

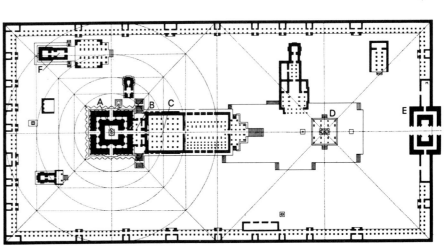

0 40 M

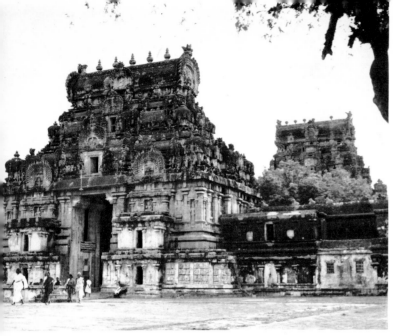

945. TANJORE. ENTRANCE GOPURAS OF BRIHADISVARA TEMPLE

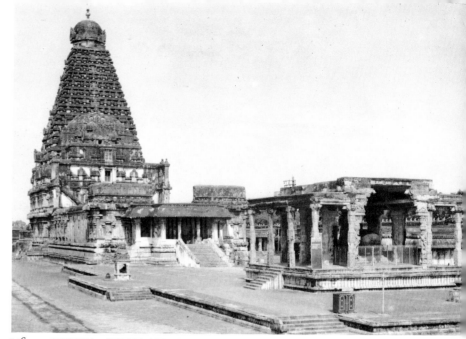

946. TANJORE. VIMANA AND NANDIMANDAPA

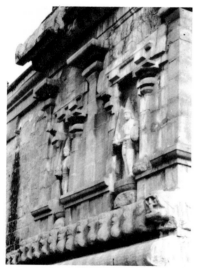

947. TANJORE.
NICHES ON THE TEMPLE WALLS

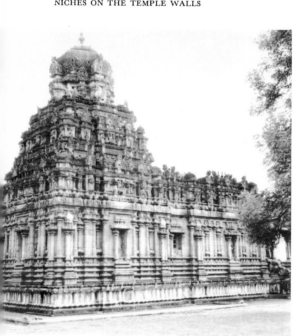

948. TANJORE. SUBRAHMANYA TEMPLE

pilasters decorate the vimana above the plinth. They are surmounted by curved moldings decorated with pairs of horseshoe-shaped *kūḍus* which are in turn topped by lion heads. The niches of the southern wall show Ganesha, Vishnu, Lakshmi, Vishnuvanugrahamurti, Bhikshatana, Virabhadra, Dakshinamurti, Kalantaka, and Natesha; to the west are Harihara, Ardhanarisvara, Chandrasekhara; on the north are Ardhanarisvara, Gangadhara, Virabhadra, Alingana-Chandrasekhara, Sulapahi, Sarasvati, Mahishamardini, and Bhairava. The huge inner courtyard is 250 by 500 feet and is surrounded by a cloister. There are two gopuras widely separated from each other that constitute the entrance to the courtyard. The monolithic guardian figures here are huge and imposing. With their four arms, fiery eyes, and terrifying countenance, they are the later medieval type, so different from the naturalistic figures in the early Pallava shrines. In honor of the deity at Chidambaram whom the Cholas greatly revered, they called the Shiva at Tanjore Adavallan—"one who can dance well." Like other large Chola temples, a long flight of steps leads to the platform where one enters the sanctum. The balustrade is massive, curled at the ends, and decorated on the outside. The perambulatory walk around the cell was in recent centuries covered over to create a dark passage. This area originally contained wall paintings which were done during the time of the Nayaks. The original paintings have been exposed mainly on the western and northern walls. There is a huge panel of Shiva as Dakshinamurti seated on a tiger skin in a yogi's pose watching the dance of two celestial nymphs while Vishnu, dwarfs, and other celestial musicians play on a drum and other instruments. Sundara and Cheraman, two famous saints, are shown hurrying to the scene on an elephant and a horse. Up and further away is a depiction of an early Chola-style temple with Nataraja enshrined in it being adored by a princely devotee, probably Rajaraja himself. The story of Sundaramurti's marriage and Shiva claiming the bridegroom as his own slave is also vividly portrayed. The scene showing the preparations in a kitchen is a part of the marriage festivity. Beyond this on the other side of the wall is a large figure of Nataraja in the golden hall at Chidambaram. Rajaraja and his three queens and some followers are shown at the shrine. Further up, there is a panel of Rajaraja and his guru Karuvur Devar. Beyond this there is a group of five beautiful heads. The northern wall almost is completely covered with a monumental Tripurantaka—Shiva on a chariot fighting the Tripura demons. Kartikeya on his peacock, Ganesha on his mouse, and Kali on her lion are all shown helping the deity while Brahma acts as charioteer. The eight-armed Shiva in the warrior pose with knitted brow and a determined look is a masterpiece. The artist has succeeded in depicting power, grandeur, and rhythm. It is interesting that Rajaraja, himself a great warrior and conqueror, frequently repeated this theme in the sculpture of the temple. On the inner wall of the first floor of the vimana is a fine series—some unfinished—of the 108 dance poses of Shiva. These are interesting as the predecessors of the labeled dance poses on the gopura at Chidambaram created in the twelfth and thirteenth centuries.

The Nandi mandapa, the temple for Devi, and the delicately carved Subrahmanya temple are all later additions. The temple of Devi was added in the thirteenth century and the Nandi mandapa and the Subrahmanya shrine in the twelfth century.

(Figs. 141, 142, 180, 219, 307, 308, 625–27)

TIRUCHIRAPALLI

On the crest of the famous Rock of Tiruchirapalli (Trichinopoly) is the fortified Uchipillayar temple dedicated to Ganesha. At its approach is a temple sacred to Shiva in his form as Matribhutesvara around which is engraved *Saundaryalahari*, a hymn to Devi by Sankara.

Built into the rock on its southern face is an excellent example of a cave temple of the time of Mahendravarman I with inscriptions to verify its date. The cave is austere. One sees the usual cubical and octagonal pillars, decorated with lotus medallions at top and bottom, and the usual corbeled capitals. The main shrine, which is empty, is dug into the east wall of the mandapa. On the wall opposite the shrine is a magnificent relief of Shiva as Gangadhara—Ganga pouring down onto locks of his hair, his right foot resting on a dwarf. One of Shiva's four arms rests on his hip, another carries a snake, a third holds the locks. There are four adorers, both human and celestial. The former kneel on the ground, and the latter float through the air; all have one hand on a hip and the other raised in adoration. The entrance to the shrine is watched over by two elegantly carved but heavily built guardians, each leaning on a club. Above the doorway, the long cornice is decorated by horseshoe-shaped *kūḍus* with faces peering through them.

There is another unfinished cave temple at the foot of the rock below the first one, and a little farther south is another about which there is divided opinion as to its date. There are no verifying inscriptions here, but it probably is of the time of Narasimhavarman Mamalla (rather than that of Mahendra) as it shows an advance in style. The temple is composed of a large mandapa with an unfinished shrine at either end. On the rear wall there are five large reliefs with carvings of Ganesha, Shiva, Durga, Surya, and Brahma. Doorkeepers guard the doorways of both shrines. The shrine to the left has a pillared portico with its cornice decorated with *kūḍus*. The pillars here have cushion capitals with corbel brackets similar to those in the Varaha temple at Mahabalipuram. The facade of the main shrine has four similar pillars and a frieze of Shivaganas below the cornice.

(Fig. 34)

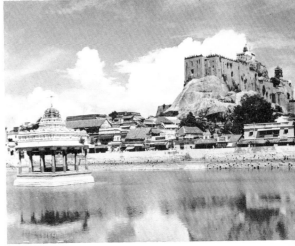

949. **TIRUCHIRAPALLI. UCHIPILLAYAR TEMPLE**

TIRUKKALUKKUNRAM

Six miles from Mahabalipuram and nine miles from Chingleput is Tirukkalukkunram which is famous for the hill here known as Vedagiri—"the hill composed of the Vedas." The curious thing about this hill is that two kites arrive here every day at noon from Rameswaram on their way to Benares. Each day they are fed at the appointed time.

There are two shrines on the hill—one a cave temple (known as Orukal mandapa) and the other a late Pallava temple. The first belongs to the time of Mahendravarman in the seventh century. It is composed of a shrine and a veranda supported by four pillars and four pilasters on the sides that conform exactly to the dimensions and style of pillars in other early Pallava shrines. The doorkeepers are large and imposing. There are also relief figures of Brahma and Vishnu on one wall. On the top of the hill, where the kites are fed, the structural temple closely resembles the vimana of Kailasanatha at Kanchi. There are carvings here of Somaskanda flanked by Brahma and Vishnu, Ardhanarisvara, and Dakshinamurti with sages at his feet. This temple belongs to the time of Rajasimha, the end of the seventh century.

The large temple at the foot of the hill is of Bhaktavatsala. The shrine here is dwarfed by large gopuras and a high enclosing wall. The thirteenth-century inscription tells us that this temple was constructed, consecrated, and endowed by the Pandyan monarch Jatavarman Sundara. The original apsidal shrine, a late Pallava structure, is now an adjunct of the temple.

950. **TIRUKKALUKKUNRAM. BHAKTAVATSALA TEMPLE**

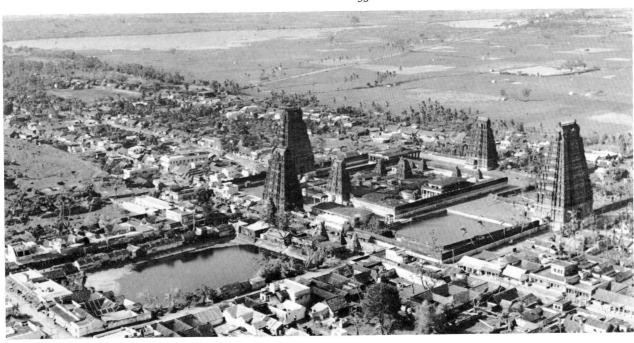

951. TIRUMALAIPURAM. TEMPLE FACADE

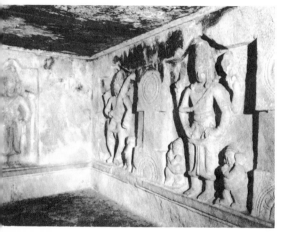

952. TIRUMALAIPURAM. CAVE INTERIOR
WITH THREE DIVINITIES IN NICHES

TIRUMALAIPURAM

This is an early Pandyan cave a short way from Kadayanallur. The cave of the Pallava king Mahendravarman was a model for all later caves in southern India, and this Pandyan one at Tirumalaipuram closely resembles the Pallava type. The facade presents two massive pillars and pilasters with lotus medallions arranged exactly as in a Pallava cave, and the elephant fish with floriated tail that replaces the lotus medallion on two pillars has a parallel in Pallava art. The guardians flanking the cell toward one end of the mandapa have a single pair of arms and a mass of hair arranged like a large wig under the crown. They wear heavy armlets and heavy girdles with ribbonlike waist cords. The figures are of heavy build and closely resemble their Pallava counterparts. In the main wall, there are three niches showing seated Ganesha, standing Vishnu, and dancing Shiva. Ganesha wears a crown resembling a pile of pots on his head, and his trunk, curled at the end to hold a sweet, rests on his paunch. Two of his four arms hold the usual attributes, the noose and the goad. He also closely resembles the Pallava type. Vishnu—heavy, rigid, and with simple ornamentation—carries the conch and the wheel in the upper pair of arms and has his other pair resting almost on his hips. The sacred thread goes over his right arm, a halo encircles his face, and the heavy ear ornaments rest on his shoulders. The lower garment is arranged so as to resemble the curled trunk of an elephant. The dwarfs on either side of Vishnu have their hands clasped in adoration.

The dancing figure of Nataraja has his head slightly tilted to the left. His upper hands hold what are probably a drum and a book, the other right hand is in the *mrgasisa* attitude, the other left is thrown up in ecstasy. The ear ornaments are heavy as are also the waist loop and the sacred thread. He is flanked by two dwarfs, one of whom is playing a primitive musical instrument resembling the vina. Standing Brahma in a fourth panel carries a book, a water vessel, and a rosary. The hair is elaborately arranged, the ear lobes are without jewels, the lower garment is in the *kaccha* fashion, and the jewelry—including the sacred thread and the anklet—are heavy.

Originally the cave contained murals, but many of them are now lost. The paintings were discovered in 1935 by Jouveau-Dubreuil. The colors used are yellow, vermilion, red, black, blue, and green. The outline was drawn first with red and then with black. There are dancing dwarfs painted on the ceiling with a drummer reminding us of a similar one in the Brihadisvara temple at Tanjore. There are also figures of bearded men in the company of women and sages in amorous pursuits. (The court of the Pandyan kings included men and women who belonged to the cult of Astarte and indulged in bacchanalian orgies.) There are white lotuses against an indigo background in a simple and effective manner.

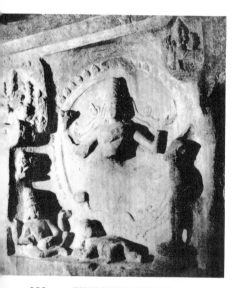

953. TIRUPPARAMKUNRAM.
NATARAJA

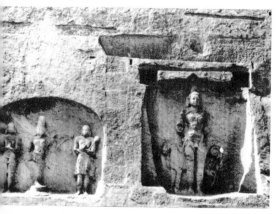

TIRUPPARAMKUNRAM

The Tirupparamkunram cave is five miles to the southwest of Madura. Although the present temple belongs to the Nayak period, the main shrine behind the modern structure is an early cave shrine with the usual large and heavy pillars and pilasters. The tripartite cell (against the main wall facing the mandapa) and two side cells have carvings of deities in them. In the triple cell one finds Skanda, Durga, and Ganesha, while Vishnu and Shivalinga face each other from the cells on the sides. These figures have been covered with plaster, completely hiding the original carving which, with the early Pandyan characteristics, would have been very beautiful. The outside wall of the cell with the Shivalinga in it has two reliefs on the theme of Shiva's dance that are free from the plaster coat. Just above the gargoyle, Shiva dances on the dwarf Apasmara. Here he is four-armed with his right hand in the attitude of teaching and the left across his chest. In the other hands, he holds the banner topped with a bull as he does at Pattadakal. His hair is elaborately dressed and heavy ornaments hang from his ears. In the adjacent panel a seated drummer plays the *ürdhva*, and several dwarfs keep time while another plays the flute. Devi stands beside a short-horned bull, resting her right hand on the head of a dwarf attendant, watches Shiva with rapt attention. The waist cord, sacred thread, armlet, anklet, and other ornaments are clearly visible. Her undergarment with the knot at the waist makes it an interesting study. Beyond the clouds above, three devas watch the dance; the first is Brahma, the second is Vishnu, and the third is probably Indra. All are usually associated with Shiva's dance.

A mile away is another cell cut into the rocks. Here there are carvings of Nataraja and Shivakamasundari, Heramba Ganapati and Skanda, dancing Jnanasambandar and Sundaramurti, and Bhairava with his dog. These late medieval carvings have no connection with the early Pandyan cave at Tirupparamkunram.

954. TIRUPPARAMKUNRAM. ROCK-CUT SANCTUARY
OF NATARAJA AND OTHER DIVINITIES

TIRUTTANI

Very close to Arkonam, Tiruttani is important because of the Virattanesvara temple here that belongs to the time of Aparajita, the last of the Pallavas. This is a fine ninth-century temple illustrating the final phase of the Pallava style of architecture and sculpture. The temple is composed of an inner shrine and a vestibule hall. The mandapa added as a porch is later and ruins the appearance of the structure. The shrine is of the apsidal type and the side and rear walls each have a niche between pilasters. An exceedingly fine frieze of Shivaganas may be seen under the eaves above the pilasters. The horseshoe-shaped *kūḍus* at intervals on the roof have the lion's head decoration and at the corners there are Nandis. At the top of the imposing apsidal vimana there is a long frieze of geese, and though most of the niches are empty, the one in the facade depicts seated Shiva and Parvati. The sculptures in the hall include doorkeepers, the Seven Mothers, Ganesha, Shiva, Surya, and Chandikesvara and are all typical examples of the period. The walls of the porch have niches in which one sees Dakshinamurti and Ganesha to the south, Vishnu to the west, Brahma and Durga to the north.

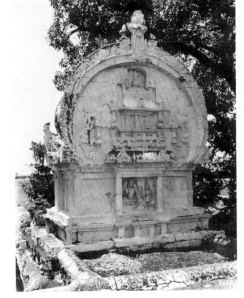

955. TIRUTTANI. VIMANA FACADE

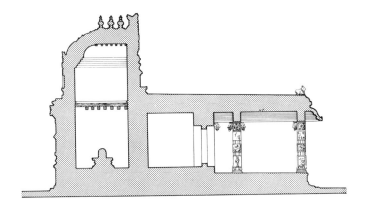

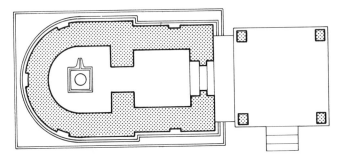

956-57. TIRUTTANI.
TEMPLE ELEVATION AND GROUND PLAN

TIRUVALANJULI

The temple of Kapardisvara, a few miles from Kumbakonam, was originally built by Parantaka in the tenth century and rebuilt by Rajaraja in the beginning of the eleventh century. This is clear from inscriptions on the central shrine. The temple has a mandapa and a perambulatory passage around the shrine. Close by is a shrine for Bhairava built by Rajaraja's queen Lokamahadevi. Tiruvalanjuli is also famous for a beautiful carved temple of Ganapati.

The temple of Kapardisvara with its subsidiary shrines for Kshetrapala and Ganesha (here these assume greater importance than Shiva himself) is particularly noteworthy for its seventeenth-century Nayak paintings. Here we see Nataraja's dance witnessed by celestials—Brahma keeping time, Vishnu sounding the drum, Indra playing the flute, and so forth, as well as other themes such as Skanda explaining the significance of the mystic syllable *Om* and other well-known incidents from the Puranas.

TIRUVALISVARAM

Tiruvalisvaram, about thirty miles from Tirunelveli, has an early Chola temple dedicated to Shiva. It is called Valisvara and was built toward the end of the tenth century. It is an early structure of the time of Rajaraja, whose inscriptions are found here. As usual in the case of these Chola temples, the Devi shrine is a late addition of about the twelfth or thirteenth century. Here the large hall is also a later addition. The shrine itself is of the medium-sized vimana. It was later in Rajaraja's great Brihadisvara temple at Tanjore (and almost immediately again in the temple at Gangaikondacholapuram and in later ones such as that at Tribhuvanam) that the style of an immensely large vimana as the sanctum was set. The one here, nevertheless, is one of the early Chola period's most pleasing, with its beautiful pilasters and niches, its carvings, its simple but effective miniature pavilions, and its lifelike Nandi bulls. In this temple one also sees Shiva in various forms: as Vrishabhantika with Devi; as Gangadhara, trying to appease Parvati by caressing her even as he receives Ganga on his locks; as Nataraja dancing; as Vrishbharudha seated on the bull; as Ardhanarisvara with two arms and a single one on the male and female side respectively in suggestive curves and proportions; as Dakshinamurti, the teacher par excellence, with Apasmara under his foot to suggest the chasing away of illusion. These are excellent examples of early Chola work.

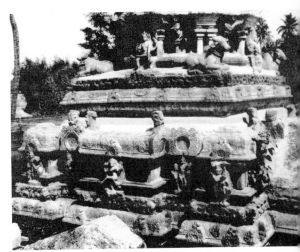

958. TIRUVALISVARAM. VALISVARA TEMPLE

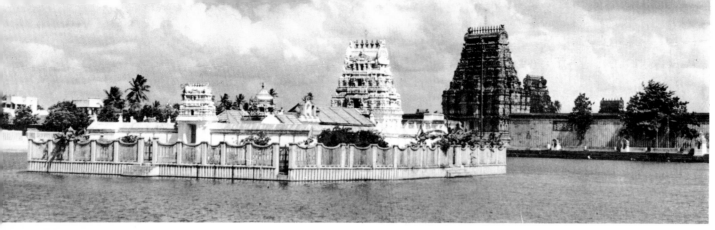

959. TIRUVARUR. TYAGARAJA TEMPLE
AND KAMALALAYA POOL

960. TIRUVARUR. TYAGARAJA TEMPLE
SEEN FROM THE COURTYARD

TIRUVARUR

Tiruvarur was one of the secondary capitals of the Cholas. The Somaskanda form of Shiva at Tiruvarur—along with Nataraja of Chidambaram—was the most honored deity of the Cholas. This is the holiest of Shivaite places—even to be born here was considered to be a sure sign of Shiva's favor. The earliest saints, such as Appar and Jnanasambandar glorified the Lord of Tiruvarur, and the temple here—with its huge Kamalalaya tank which itself has a shrine in the middle of its waters—is among the largest religious monuments of southern India. There are five large temple courts, and all the courts have their own towers, the largest of them being on the final or outside wall. The innermost sanctum is dedicated to Shiva as Tyagaraja and there are several subsidiary shrines. In the second court is the Achalesvara shrine. The original temple here was constructed in brick by Sembian Mahadevi; the walls of the inner shrine as well as the inner and outer mandapa have beautiful sculptures in their niches of Ardhanarisvara, Durga, Bhikshatana, Brahma, Lingodbhava, Dakshinamurti, Agastya, and Nataraja.

The story of Muchukunda—a legendary early Chola king who brought from heaven the bronze image of Somaskanda, the Tyagaraja of Tiruvarur—is narrated in a series of paintings in the thousand-pillared hall, where also Sundara is believed to have sung his famous *Tiru-tondat-togai*, the basis for the *Tirut-tondar-puranam*. There is also a shrine for Sundara and his consorts, as this seer is closely associated with the Tiruvarur deity. The name of the deity here, Tiru-Ara-neri-isvarar, evokes the legendary Chola king Manunitikanda, who meted out justice in the most unswerving manner. The story is told that the bell of justice was sounded by a cow when her calf was killed by the chariot of a reckless prince. The Chola monarch himself drove over the prince, his son, to mete out justice, but Shiva blessed and restored both the calf and the prince to life. This legend is a favorite theme in sculpture and painting not only in the Tamil country but elsewhere. On the northeastern side of the outer court is a late Chola representation of a chariot with the cow and the calf caught under the wheel.

(Fig. 641)

TIRUVANNAMALAI

The celebrated Arunachalesvara temple at Tiruvannamalai is well known for its imposing gopuras; it is a magnificent sight when viewed from the nearby hill. Here Shiva is honored as Lingodbhava, issuing from a column of flame. Each year on the festival day a great fire is lit in his honor on the summit of the hill. Its flames are visible for days and sometimes weeks.

Originally the temple had three large courtyards, one inside the other. The gopuras marking the four cardinal points are very imposing, particularly the exterior ones. The Cholas and the Vijayanagars developed and constructed these lofty gopuras that over the centuries grew higher and higher, almost minimizing the importance of the central sanctuary, the vimana. During this period many impressive pillared halls, with hundreds and indeed thousands of columns, were built. Tanks or reservoirs (*pusakarini*) also assumed great importance. Both these tanks and the pillared halls enhanced the beauty of the temple.

The interior gopura, called the parrot tower (*kili gopura*), was built by Vira Rajendra, the Chola ruler. The three other gopuras of the intermediate courtyard were built in the mid-fourteenth century by the Hoy-

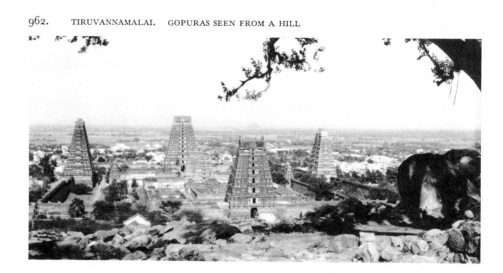

962. TIRUVANNAMALAI. GOPURAS SEEN FROM A HILL

961. TIRUVANNAMALAI. POOL AND GOPURA

sala king Ballala III, better known as Maharaja Vallala. (One of these is called the Vallala gopura in an inscription.) The western gopura in this courtyard is very high and is therefore called a melgopura. The famed Vijayanagar emperor Krishnadevaraya was responsible for the construction not only of the immense thousand-columned hall (*āyarakal maṇḍapa*), but also of the gopura on the western exterior. The gopura on the eastern exterior was built in the seventeenth century by Sevappa Nayak of Tanjore. The gopura on the northern exterior was built in the late eighteenth or early nineteenth century by a wealthy devotee.

It is interesting to compare these gopuras with those at Chidambaram. Here the beautiful series of dance poses (108 in all) are represented in rows, as at Chidambaram, in a thirteenth-century Chola series, on three of the gopuras, and on the gopura built by Krishnadevaraya.

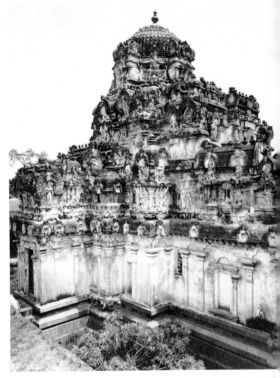

963. UTTARAMERUR.
SUNDARAVARADA TEMPLE

UTTARAMERUR

Uttaramerur, fifty miles from Madras, is famous for its ninth-century temple of Sundaravarada—a late Pallava temple of the time of Dantivarman whose inscription is found here. It and the Vaikunthaperumal temple at Kanchi, which it resembles, are probably the most important of the later Pallava temples. The inner shrine is on a high plinth and has three stories. It is said to be built according to the *Vaikhanasagama* and is a very important Vaishnava sacred place. As one walks around the temple, there are three important niches. Proceeding clockwise, one first sees, on the north wall, Valli Devi Sarasvati bathed by elephants. This closely resembles the Pallava type of Gajalakshmi bathed by elephants, but here is not a Lakshmi but a Sarasvati. This is a most unusual and magnificent representation of the goddess. Next, on the western wall Rati and Manmatha are very beautifully portrayed. The sacred thread of Manmatha runs over the right arm, and between the couple is a long banner with the crocodile emblem on top. In the third niche, on the south, is a seated figure of the sage Bhrigu depicted as a youthful sage. The makara toran over the niche is gorgeous. On the second floor, Krishna and Arjuna are shown in the niche to the south, Yoganarasimha to the west, and Lakshminarayana to the north. The main figure on top, corresponding to Sundaravarada down below, is Anantarangaraja or Ranganatha. There is a large court all around, but it is the main temple which is most interesting.

VALLAM

In the eastern face of the hill in this small village two miles from Chingleput, there are three cave temples. The largest and most important of these, it is learned from inscriptions, was excavated by Skandasena, son of Vasantapriyaraja, a vassal of King Mahendra Potaraja. Flanking the facade of the largest cave are a beautiful carved image of Ganesha and a rather worn figure of Jyestha. Jyestha, the goddess of bad luck, continued to be popular till the end of the Pallava period, and her presence here in this early temple is indeed interesting. The cave is very simple, with two heavy cubical pillars that have the octagonal central part, the usual angled corbel capital, and corresponding pilasters at either end. The main shrine at the back is dedicated to Shiva, represented by a cylindrical lingam that is not fluted. The entrance of the shrine is guarded by hefty doorkeepers, each leaning heavily on a club entwined by snakes. The large mass of hair below the high-topped crown, the prominent horns, the large cylindrical earrings, heavy sacred thread, stomach band, bracelets, and other accessories all are indicative of the period. The sculpture on the whole is not inelegant.

Of the other two caves, one is unfinished and the other, dedicated to Vishnu, has the usual doorkeepers each with a hand raised in adoration, a stylistic mannerism usual in this period.

964. VALLAM. CAVE FACADE

VELLORE

The chief city of the North Arcot District, Vellore is justly famous for one of the best-preserved medieval fortresses in India. This large and imposing fort with its gateway, large well-kept moat, and pleasing towers and turrets was once the pride of Chinna Bomma Nayak, one of the great Nayak kings under the Vijayanagar emperors. This king was also the patron of the great Shivaite polymath of the sixteenth century, Appayya Dikshita.

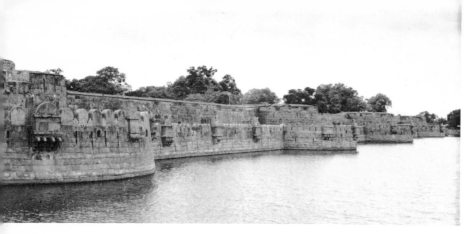

965. VELLORE. FORT WITH MOAT

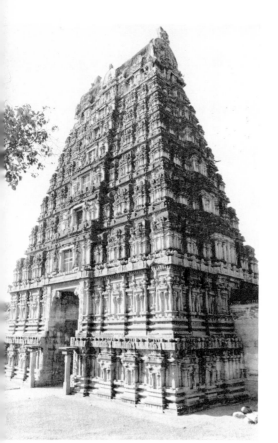

966. VELLORE. TEMPLE GOPURA

967. AHICHHATRA. RUINS OF TEMPLE OF SHIVA

The beautiful temple inside the fort is a gem of Vijayanagar architecture. The elaborate guardians in front of the large gopura at the entrance are typical of work in this style. The carving of Ganga on a makara and the meandering creeper that forms circles against the jambs are exceedingly well done. The main shrine, the mandapas, and the subsidiary shrines are all elegantly placed, but the most beautiful and arresting of all is the large *kalyanamandapa* where the principal deity is ceremonially brought during the annual festival. Here there is a long row of pillars decorated with carvings of rearing horses, lions, and mythical animals, each with a rider on its back, all in various attitudes of the hunt. The wildly galloping animals (each surrounded by a number of attendants), the fury of the wounded beast, the riders rushing forward with uplifted weapons—all make this mandapa the finest example of this kind of pillared hall. The other pillars also have wonderful carvings of various forms of deities and capitals that carry the plantain-flower motif. The intricate workmanship of the ceiling in the center of the pillared hall is another remarkable feat of the sculptor.

The overall arrangement of niches with miniature pavilion tops, *kūḍus* with their lion heads, and flamboyant pilasters known as *kumbhapañjaras* between the niches both on the gopura and on the walls of the vimana, exhibits the very best of the Vijayanagar tradition.

Eight miles from Vellore is Virinchipuram where the temple of Shiva as Margasahaya is famous for its beautiful typically Vijayanagar temple. It closely follows the design of the one at Vellore and it also is a noble Vijayanagar structure.

(Fig. 162)

UTTAR PRADESH

AHICHHATRA

Ahichhatra, once the capital of North Panchala, is mentioned in such inscriptions as the Pabhosa and the Banskhera. Because of its numerous mounds, the town attracted the attention of archaeologists, and Cunningham worked here as did Führer. In 1940–44 the Archaeological Survey made some excavations and laid bare portions of the fortified wall of the city as well as some houses and two temples. The temples were terraced, like the famous Buddhist stupas of Pahadpur and Barabudur. The larger one, dedicated to Shiva, is rectangular and of the Gupta period. It was built over an earlier Kushan structure and is probably the most notable of the brick temples of the Guptas. The large terra-cotta figures of Ganga and Yamuna, which were found here and are now preserved in the National Museum, are the largest adornment of any ancient brick temple in India so far discovered. A great number of terra-cotta plaques have also been found here, although there probably were many more originally, covering the walls of the upper terrace in friezes. There appear to have been three terraces with steps leading to the sanctum at the top where a colossal Shivalinga is still in place. The terra-cotta plaques are exceedingly interesting as they depict the sports of Shiva and incidents from the epics. One also sees the terrifying form of Bhairava with the *triśūla* in his hand, the hair flying, the eyes flaring. In stark contrast is Dakshinamurti, the Lord of Wisdom. Quietly seated, he is the very embodiment. of grace. He holds the banyan sapling in a pot, instead of being under the spreading branches of the tree, as is usual in later renderings, particularly in the south. There are here several other interesting scenes such as the one of the discomfiture of Daksha. Daksha performed a sacrifice without inviting Shiva. A plaque illustrates the story of Vikrama and Urvasi; another shows the fight of Yudhishthira and Jayadratha. The dwarfs then taught a lesson to all the celestials who had encouraged him to oppose Shiva. The temple also seems to have had a shrine for the Seven Mothers, as several large mutilated busts, including one of Chamunda in her typical emaciated form, have been found. With the temple at Bhitaragaon and the later one at Sirpur, this is one of India's most important terra-cotta Gupta structures.

(Figs. 33, 58, 454)

BHITARGAON

Bhitargaon, twenty miles south of Kanpur, is an out-of-the-way village, reached by a difficult journey. Once there, however, one is rewarded by a look at one of the oldest (and not altogether ruined) examples of early Gupta brick architecture in India. It has a simple, basically square, design—a porch leading to a sanctum. Wide extensions on all four sides create recessed corners. The first story is enhanced by a series of pilasters that flank rectangular panels; miniature horseshoe-shaped arches and larger forms decorate the upper tiers. This temple was originally crowned by an amalaka, in the manner of the Sirpur temple, but that part no longer exists. The eastern face, where the entrance is, has a vestibule, but the porch itself has disappeared. The pilasters are cubical and octagonal with circular bands and brimming-pitcher decoration. The most interesting aspect of this temple, however, is its abundance of large terra-cotta reliefs. The panels depict such themes as: Gajalakshmi; Trivikrama; Narasimha; Varaha; Mahishamardini; Vishnu slaying Madhu and Kaitabha; Seshasayinarayana; Ganesha crawling along with a container of sweets, playfully refusing to give any to the dwarf who pursues him; and various sports of Krishna. The heads that peep through the chaitya windows are typical and pleasing. The terra-cotta panels of Ganga and Yamuna on the walls of the porch, though unfortunately very deteriorated, are excellent and of higher quality than, for instance, the renditions of the same subject found at Ahichchhatra, that are now preserved in the National Museum. The simple but effective modeling in the reliefs reveals the early Gupta potter's skill as well as his freedom from later conventions. Vogel does not exaggerate when he says that the terra-cottas he collected at Bhitargaon are the finest he had ever seen in India.

968. BHITARGAON. BRICK TEMPLE

DEOGARH

Deogarh, seven miles from Jakhlaun and about twenty miles from Lalitpur, has an important Gupta monument—the Dasavatara temple. This fifth-century temple of Vishnu, on the right bank of the Betwa River, is built on a large square plinth and is reached by flights of steps on all four sides. The small shrines which originally stood at the corners of the plinth are now lost, although their ground plan can still be seen. At the top of the plinth between the pilasters there was a row of relief panels that told the story of Rama and Krishna. Some of these are still in place, but others that have either fallen off or been removed are preserved in museums. Above these were moldings and a frieze that created a parapet all around the terrace of the central shrine. The shrine itself has three magnificent panels on its walls and an exceedingly well executed, typically Gupta doorway. The jambs have Ganga and Yamuna at the top and a doorkeeper who is attended by two females and a dwarf. Vishnu, seated on Ananta and sheltered by hooded snakes, is the principal sculpture on the lintel. Loving couples, dwarfs, and wish-fulfilling creeper all appear in moldings around the doorway. The roof of the temple is in very bad condition. A cantilevered canopy has disappeared as well as many details and carvings. But the main relief panels in the temple are a sculptural paradise. One sees a magnificent narration of the story of Naranarayana who, seated under the badari tree, disseminates knowledge through his silence and makes peace even among the animals. And by creating the peerless nymph Urvasi from the thigh of Vishnu as an ascetic, he shames the ravishing nymphs sent by Indra to disturb their meditation.

969. DEOGARH. DASVATARA TEMPLE

On the rear wall there is a rendering of Vishnu on his serpent couch in ecstatic slumber with Bhudevi and Garuda at his feet. Brahma is on a lotus that issues not from his navel but from behind the serpent Sesha. The demons Madhu and Kaitabha approach, as personified weapons such as the club (depicted as an amazon), the discus (with the wheel on his head), the bow, and the sword prepare to attack the intruders. At the top Shiva and Parvati on the bull, Kartikeya on his peacock, and Indra on his elephant Airavata witness the scene.

There is a panel on the northern wall that illustrates the Lord's compassion for even the humblest beast as he hastened to rescue an elephant whose legs had become entwined in the coils of a powerful serpent in a lotus pool. The animal offers lotuses to Vishnu in his uplifted trunk in grateful appreciation of the succor given him. This achievement of Vishnu is signified by the elaborate crown held by a pair of flying celestials.

(Figs. 1, 89, 104, 332, 446, 448)

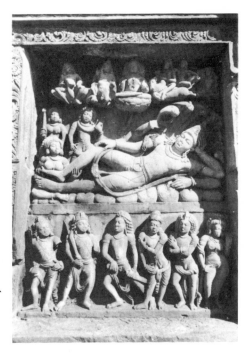

970. DEOGARH. VISHNU ANANTASAYANA

971. SARNATH. DHAMEKH STUPA

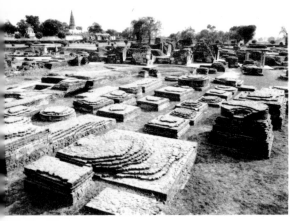

972. SARNATH. VIEW OF THE RUINS

SARNATH

Four miles from Benares is Sarnath, an archaeological site that is the sacred place where Buddha first taught. This is where the story of *Nyagrodhamriga* (seen at Bharhut) took place—the self-sacrifice of the bodhisattva born as a deer who offered himself in the place of a young pregnant doe. The incident so moved the king of Benares that he declared a herd of deer sacred and protected from all harm. Sarnath is a shortened form of Saranganatha—"lord of the deer"—the name of Shiva in a nearby temple. A late Kushan inscription here partially tells this story. Sarnath is one of the places visited by Fa-Hien and Hsüan Tsang; their writings contain descriptions of the stupas and monasteries in their heyday.

An Asokan pillar here is crowned by four lions; this is the original of the motif that was adopted as India's national emblem. It is the most valuable antiquity of the site and is now in the local museum. The Dharmarajika stupa was also erected here by Asoka—the emperor built many monuments at important places connected with Buddha's life and teachings. Other Mauryan fragments found here include heads of a plebeian and a patrician now in the National Museum, a headless female torso, and some railing pillars from a Sunga railing that is now lost. There is also a magnificent and colossal bodhisattva in red sandstone of the Mathura school of the third year of Kanishka's reign. These are all in the local museum. To the Gupta period belongs the noble Dhamekh stupa here that is encased in intricately carved stone pieces.

As this is one of the "eight great places," a new shrine for Buddha prominently showing eight scenes from his life was added here in the beginning of the eleventh century. And as late as the twelfth century, Kumaradevi, the wife of Govindachandra, built a large monastery here, the Dharmacakra Jina Vihara.

When the Asokan stupa was pulled down in 1794 to collect building material, a marble casket—a reliquary—was discovered inside the tomb, and in 1835–36 Sir Alexander Cunningham excavated and found several sculptures and other antiquities. In 1851–52 Major Kittoe unearthed more monuments near the hamekh stupa, and in 1907 Sir John Marshall's excavations uncovered the remains of three monasteries of the Kushan period below the one built by Kumaradevi. Further excavations in 1915 revealed valuable inscriptions of Kumaragupta II and Budhagupta.

The Dhamkh stupa is mentioned in an inscription on a twelfth-century clay sealing, which reads *dhamaka jayatu*—"victory to the *dhamaka*." This should probably be connected with the wheel, or *dharmacakra*, of which word *dhamaka* is a corruption. The most valuable sculptures found here are the monumental inscribed standing Buddha; the Asokan pillar capital; Bodhisattva Lokanatha; a stela illustrating Buddha's birth, enlightenment, first sermon, and death; another stela that depicts the "eight important events" from the Master's life; and the famous and exquisite Gupta image of preaching Buddha, with the large characteristic halo with a scrollwork border and a pair of celestials above. The medieval sculptures in the local museum include some Brahmanic ones.

(Figs. 6, 398, 400, 402, 447, 449)

973. SRAVASTI. JETAVANA MONASTERY

SRAVASTI

Sravasti, eleven miles from Balarampur near the Rapti River in Uttar Pradesh, is now known as Saheth Maheth. It was named after King Sravasta, according to the legend in the *Mahabharata*, and it has long been a famous spot with both Buddhist and Jain associations. When Fa-hien and Hsüan Tsang visited the town they found to be most prosperous. The great miracle that Buddha performed here is one of the important events in his life. And Prasenajit, king of Sravasti, observed Buddha descending from Heaven on the jeweled ladder after preaching to his mother. This incident is often seen in painting and sculpture—for instance, the second-century rendering at Bharhut and the Vakataka painting at Ajanta. Also, the famous merchant of Sravasti who was called the "giver of alms to the needy" is immortalized both at Bharhut and Bodh Gaya in medallions that record the presentation of his gift to the Jetavana vihara. A sculpture of Prasenajit's visit to Buddha is seen at Bharhut.

Sravasti is also famous for associations with Mahavira, the last of the Tirthankaras, who had a large following here. Friar Bala presented a monumental statue of Buddha to the Jetavana vihara in the time of Kanishka, and as late as the twelfth century Kumaradevi, the consort of Govindachandra, made liberal gifts to the Jetavana. In 1863 Sir Alexander Cunningham visited Sravasti and wrote about it, and excavations were carried on here under Sir John Marshall in 1907–8, 1910, and 1911. Several stupas and temples, a large monastery, and the remains of a huge city wall and gates have been laid bare here. A large collection of terra-cotta plaques that originally decorated the Gupta edifice here have been recovered. These terra-cottas ilustrate scenes from the *Ramayana* and indicate the existence of Brahmanic temples as well as Jain ones.

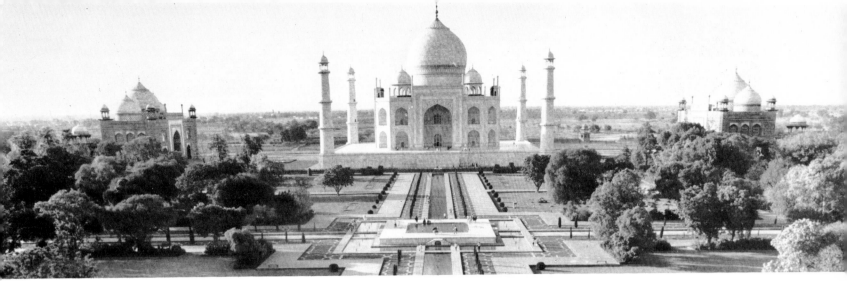

974. AGRA. TAJ MAHAL

AGRA

Agra is mainly famous for the Taj Mahal which is of course a masterpiece, but that is not the only attraction in this city. The Red Fort is equally important. Begun by Akbar in 1556, the fort is huge, and its high massive wall is covered with turrets, battlements, windows and balconies, and mighty gateways flanked by gigantic guard rooms. Within this vast enclosure are exquisite architectural creations. The Moti Masjid and the palaces of Akbar and Shah Jahan command particular attention. The main entrance is on the north through the Delhi Gate. Inside this there is a secondary gate called Hathi Pol—the elephant gate—so called because of the lifelike carvings of elephants that it once had. These were removed, however, by Aurangzeb whose religious zeal would not permit such idolatrous material. At the other side of the fort to the south is the Amar Singh Gate.

The Moti Masjid, or the Pearl Mosque, is rather plain and unpretentious but it is remarkable for the harmony of its design and its execution. The Diwan-i-Am—in a large and extensive quadrangle—is the large and resplendent hall of public audience. It is all of red sandstone that has been covered with polished stucco and then painted and gilded. The throne of the emperor is here in an alcove of inlaid marble. It is connected with the royal apartments and beyond it, beautifully laid out in marble with water channels and fountains, is the Machhi Bhavan, or fish square. The Diwan-i-Khas, modest in proportions but nicely decorated with the best of Persian art, adjoins it. On the terrace of the Diwan-i-Khas is the marble throne from which Jahangir enjoyed the sight of the Yamuna River. The Samman Burj—or jasmine tower—close to the Diwan-i-Khas is a lovely pavilion built by Jahangir. Adjacent to this is the Khas Mahal, the elaborate apartments of the zenana. The portraits of Mogul emperors that once filled the niches in the walls have now disappeared. Beyond a large quadrangle in front of Khas Mahal, where a Mogul garden with lovely arcades on three sides was laid out, are the elegant marble pavilions of the Jahangiri Mahal, the palace of Jahangir (although it was actually built by Akbar and is typical of his virile style of architecture).

The Taj, however, is the most outstanding monument of Agra. It was built by Shah Jahan as the eternal resting place of his beloved wife Mumtaz Mahal, and there are many stories about how the best artists of the day from India, Persia, and Arabia were employed in its construction. It is told that even an Italian had a hand in it. The domed and delicately decorated white marble palace stands on a great terrace; four stately minarets are at the corners. Its central shrine and tomb hold the remains of Mumtaz within a casket of exquisite pierced marble. The inscription on it reads: "The illustrious sepulcher of Arjumand Banu Begam, called Mumtaz Mahal. Died in A.H. 1040 [A.D. 1630]." The long marble promenade before the Taj is equally beautifully executed, with rows of cypress trees and flower beds adding charm and color to this singular monument. The gateway is splendid. In a large quadrangle its proportions have a dignity that excels even those of Akbar's tomb at Sikandra. A quotation from the Koran on this arch "invites the pure of heart to enter the Gardens of paradise."

(Figs. 164, 676)

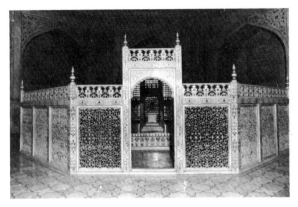

975. AGRA. TOMB OF MUMTAZ

976. AGRA. DIWAN-I-KHAS

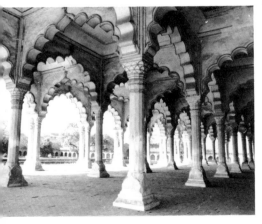

977. AGRA. DIWAN-I-AM

978. AGRA. KHAS MAHAL

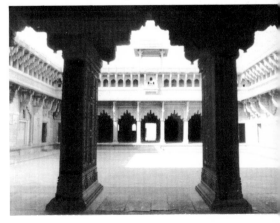

979. AGRA. JAHANGIRI MAHAL

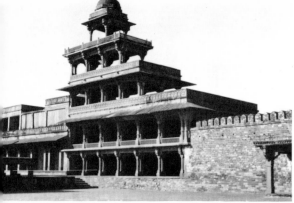

980. FATEHPUR SIKRI. PANCH MAHAL

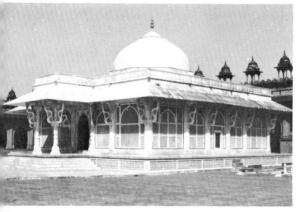

981. FATEHPUR SIKRI. TOMB OF SALIM CHISHTI

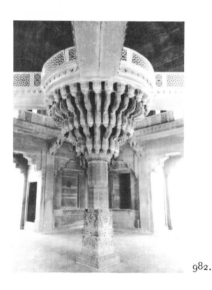

FATEHPUR SIKRI

About twenty-five miles from Agra, Akbar built his famous capital, Fatehpur Sikri. The emperor's main attraction to this place was its association with Sheikh Salim Chishti who, he felt, blessed him with a long-sought heir —the son who later became the emperor Jahangir. Fatehpur means "town of victory." Within the short span of fifteen years, this hilly tract blossomed into a glorious city with smiling gardens, imposing palaces, and lovely pavilions. Its glory was, however, short-lived, for scarcity of water gave this beautiful city a life of only seventeen years. After Akbar's death the capital was shifted back to Agra.

The long wall around the city was pierced at intervals by several gates—the Lal Gate, the Delhi Gate, the Birbal Gate, and the Chodanpol Gate, the Gwalior Gate, the Tehra Gate, the Chor Gate, and the Ajmer Gate. Today Fatehpur Sikri is entered by the Agra Gate which in turn has an inner entrance, the Naubat Khana, or "music house." On one side of the quadrangle of the Diwan-i-Am was the palace of Akbar—the Mahal-i-Khas—a two-storied building with the Kwabgah, or sleeping apartment, on the roof. The ornamentation here is mainly Persian with some Chinese elements. A part of the palace quadrangle to the north was made into a large chessboard (called Pachisi) where Akbar amused himself by playing the game with beautiful women as living chess pieces. To the northeast of the palace quadrangle was the Turkish sultana's house with its charming dado panels of trees, flowers, birds, and animals.

Farther up, the Diwan-i-Khas (hall of private audience) is an excellent example of the virile yet restrained style of Akbar. In contrast is the soft, delicate, and almost feminine Shah Jahan. This two-storied building houses a single magnificent column in the center of the chamber. This column, with its incredibly elaborate capital, supported Akbar's throne. Ministers and nobles attended the emperor from the four corners of the gallery.

The cloistered Diwan-i-Am (hall of public audience) is to the east of the palace court and nearly opposite it is the Panch Mahal, a five-storied pavilion. Mariam's Kothi, the palace for Akbar's wife Mariam Zamani, has fragments of frescoes that have been variously interpreted. Some think there are even Christian themes such as the Annunciation in the fragments that have survived. In any case, there is a marked Hindu feeling in the building. The Mahal of Jodh Bai, also called the Jahangiri Mahal, was the palace of the Hindu consort of Akbar who gave birth to Jahangir. The emperor's tolerant spirit is evident in the Hindu temple that exists within this spacious palace. Constructed and decorated in purely Rajasthani style, the structure combines the best of Hindu and Saracenic styles. A pavilion attached to this palace is the Hava Mahal. Through the pierced stone screens one has a grand and elegant view of the distant hills and lakes. There is a tower known as the Hiran Minar, and the two-storied house of Raja Birbal, a poet of great reputation at the court and close friend and entertainer of Akbar, is more Persian than Hindu.

But the most important monument of all here is the Jami Masjid—the great mosque—said to be modeled after the one at Mecca. With broad flights of steps and a majestic gate called Buland Darwaza, or "high gate for the emperor," and three domed chapels, it was built mainly in honor of Sheikh Salim Chishti who lies buried close by in a shrine of white marble in a large courtyard. The delicate stone trelliswork vies with the ivory carving.

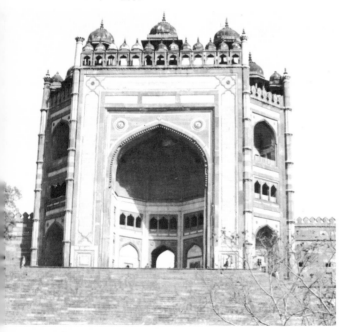

982. FATEHPUR SIKRI. PILLAR IN THE DIWAN-I-KHAS

983. FATEHPUR SIKRI. BULAND DARWAZA

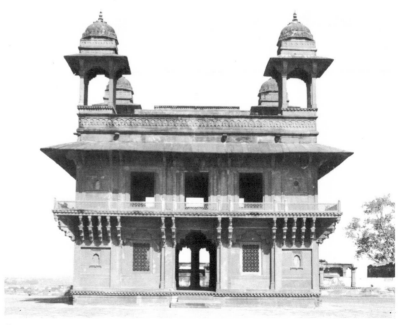

984. FATEHPUR SIKRI. EXTERIOR PAVILION OF THE DIWAN-I-KHAS

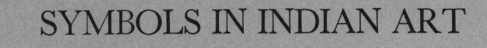

SYMBOLS IN INDIAN ART

BHRŪSŪTRA (eyebrow)

NETRASŪTRA (eye)

ADHAROSHTHASŪTRA (lip)

MUKHAPARYANTASŪTRA (face)

KARNASŪTRA (ear)

BĀHUPARYANTASŪTRA (arm)

AKSHISŪTRA (corner of the eye)

NĀSĀGRASŪTRA (bridge of the nose)

HANVAGRASŪTRA (chin)

HIKKĀSŪTRA (neck)

VAKSHASTHALASŪTRA (breast)

KAKSHASŪTRA (armpit)

NĀBHISŪTRA (navel)

MEDHRA or LIṄGAŚIRASSŪTRA (sexual organs)

JĀNVADHASSŪTRA (calf)

JĀNUMŪRDHA (knee)

POSITIONS OF THE HANDS AND FINGERS (MUDRĀS AND HASTAS)

a

b

c

d

a. abhaya: assuring protection

b. varada: bestowing a favor

c. ahāyavarada: beckoning to bestow

d. kaṭakāmukha: holding a flower such as the lotus or lily

e. kartarimukha: holding the fingers open like a pair of scissors to grasp a weapon between them

f. katyavalambita: making a gesture, a little below the waist, to signal the easing of suffering and sorrow

g. lola: going freely

h. suchī or tarjanī: designating by name or inspiring terror

i. vismaya: suggesting astonishment

j. cinmudrā or vyakhyanamudrā: indicating instruction by silence or contemplation

k. añjali: adoration

l. daṇḍahasta or karihasta: gesture of Nataraja that indicates that the devotee should seek refuge and protection under his lifted foot

m. ardhachandra: holding fingers like the crescent moon; characteristic gesture of Nataraja who holds the burning flame in his upper left hand

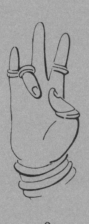

e

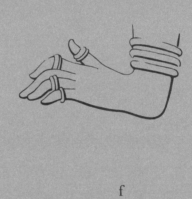

f

g

h

i

j

k

l

m

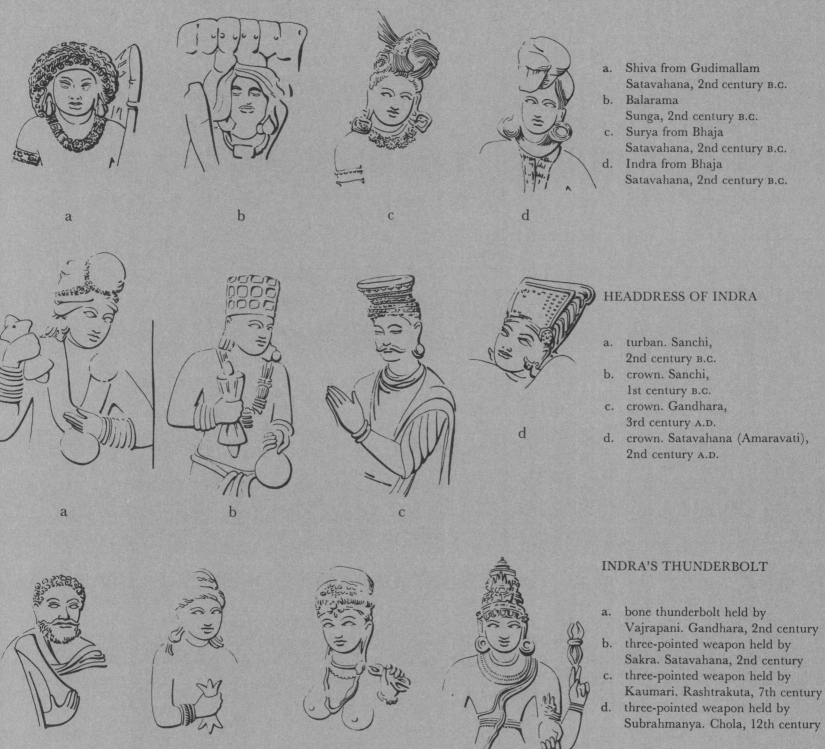

USHNISA (TURBAN) OF THE EARLIEST DIVINITIES

a. Shiva from Gudimallam
 Satavahana, 2nd century B.C.
b. Balarama
 Sunga, 2nd century B.C.
c. Surya from Bhaja
 Satavahana, 2nd century B.C.
d. Indra from Bhaja
 Satavahana, 2nd century B.C.

a b c d

HEADDRESS OF INDRA

a. turban. Sanchi,
 2nd century B.C.
b. crown. Sanchi,
 1st century B.C.
c. crown. Gandhara,
 3rd century A.D.
d. crown. Satavahana (Amaravati),
 2nd century A.D.

a b c

INDRA'S THUNDERBOLT

a. bone thunderbolt held by
 Vajrapani. Gandhara, 2nd century
b. three-pointed weapon held by
 Sakra. Satavahana, 2nd century
c. three-pointed weapon held by
 Kaumari. Rashtrakuta, 7th century
d. three-pointed weapon held by
 Subrahmanya. Chola, 12th century

a b c d

BUDDHA—VARIETIES OF USHNISA

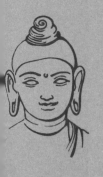
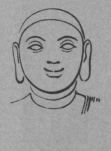

a. simple curl. Kushan,
 2nd century A.D.
b. shaved head. Kushan,
 1st century A.D.
c. braided hair. Gandhara,
 3rd century
d. curls of hair. Gupta,
 5th century
e. flame atop curls of hair. Chola,
 11th century

a b c d e

RIVER GODDESSES PERSONIFIED AS THE MOTHER WHO GIVES WATER AND NOURISHMENT IN ABUNDANCE

a. From Mathura. Kushan, 2nd century A.D.
b. From Amaravati. Satavahana, 2nd century A.D.

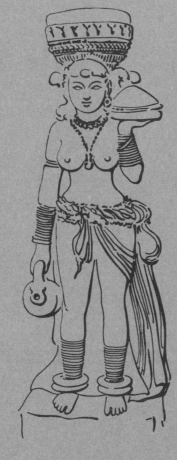

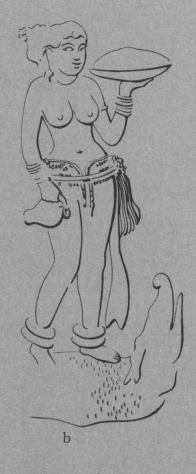

a

b

ATTRIBUTES OF BRAHMA

a. holding a book and a water vessel; mounted on a flock of geese. Vakataka, 5th–6th centuries

ATTRIBUTES OF SARASVATI

b. holding a book and wearing a rosary. Kushan, 2nd century A.D.

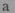

a

b

UDAREMUKHA

Motif of grimacing heads on the stomachs of the *rākṣasas* ("demons"). Inspired by the *Ramayana*.

a. Satavahana, 2nd century A.D.
b. Ikshvaku, 3rd century
c. Vakataka, 5th century
d. Early Western Chalukya, 6th century
e. From Prambanan, Indonesia. Srivijaya, 9th century

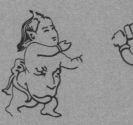

a

b

c

d

e

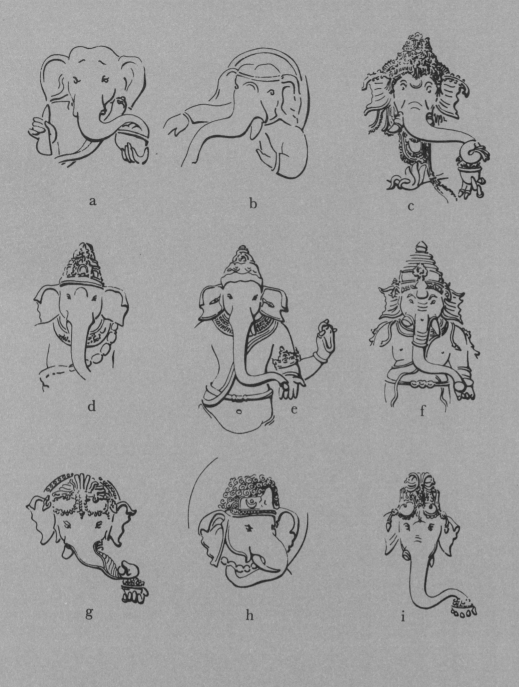

GANESHA—VARIETY OF TRUNKS AND
CROWNS

a. Gupta, 5th century
b. Early Western Chalukya, 6th century
c. Western Chalukya, 12th century

d. Early Chola, 11th century
e. Early Chola, 12th century
f. Vijayanagar, 17th century

g, h. Eastern Ganga, 9th–10th centuries
i. Pala, 11th century

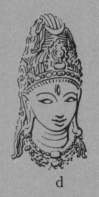

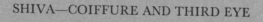

SHIVA—COIFFURE AND THIRD EYE

JAṬĀBHĀRA (Mass of Locks)
a. Shiva as Dakshinamurti. Chola, 12th centu:

JAṬĀJAVĀLĀ (Flamelike Coiffure)
b. Shiva as Bhairava. Chola, 12th century

THIRD EYE
c. Kushan-Gupta transition, 4th century
d. Gupta, 5th century

SHIVA—VARIETY OF FORMS

a. southern India—holding the ax and the deer
b. northern India—holding the trident and the serpent

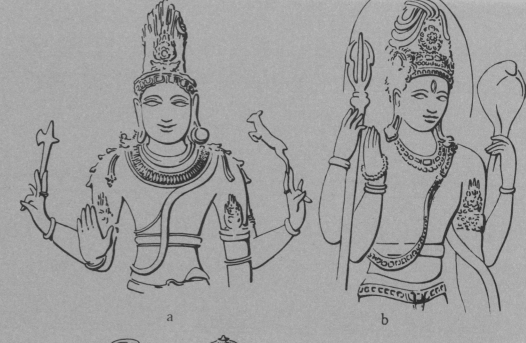

a

b

SHIVA—VARIETY OF CROWNS

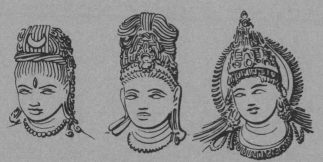

Gupta, 5th century
Early Western Chalukya, 10th century
Hoysala, 12th century

Pallava, 7th century
Early Chola, 12th century

Gurjara-Pratihara, 9th century
Pala, 11th century

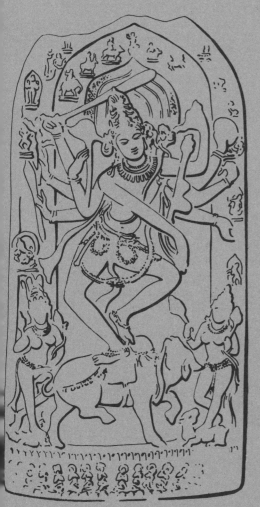

Shiva dancing on the sacred bull, flanked by Ganga and Uma, his consorts. Pala, 11th century.

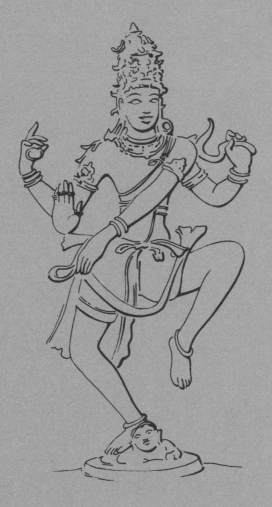

Shiva dancing in the *ūrdhvajānu* style with his knee lifted.

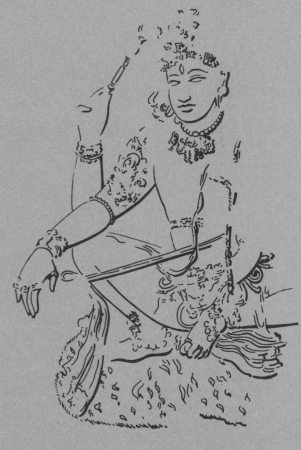

Shiva seated as Dakshinamurti, with the cincture of meditation (*yogapaṭṭa*) about his legs.

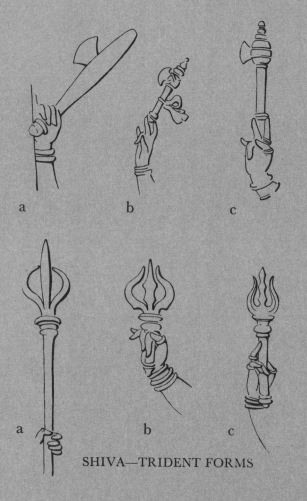

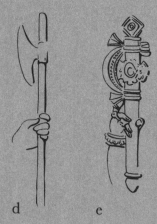

SHIVA—AX FORMS

a. Pallava, 7th century
b. Early Chola, 11th century
c. Vijayanagar, 16th century
d. Early Western Chalukya, 6th century
e. Late Western Chalukya, 12th century

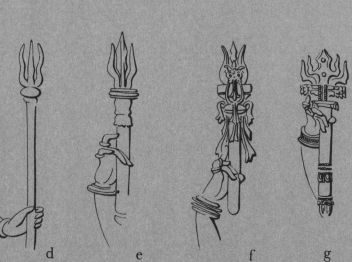

SHIVA—TRIDENT FORMS

a. Pallava, 7th century
b. Chola, 11th century
c. Vijayanagar, 16th century

d. Early Western Chalukya, 6th century
e, f, g. Late Western Chalukya, 12th century

VISHNU—WHEEL FORMS

a. Gupta, 5th century
b. Early Western Chalukya, 6th century
c, d. Late Western Chalukya, 12th century
e. Pallava, 7th century
f. Early Chola, 11th century
g. Late Chola, 13th century
h. Gurjara-Pratihara, 10th century
i. Gahadavala, 12th century
j. Pala, 11th century

VISHNU—FORMS OF CLUB

a. personified club. Gupta, 5th century
b. natural and personified forms. Early
 Western Chalukya, 6th century
c, d. Late Western Chalukya, 12th century
e. natural and personified forms. 7th century
f. Early Chola, 11th century
g. Vijayanagar, 15th century
h. Gurjara-Pratihara, 9th century
i. j. Pala, 11th century

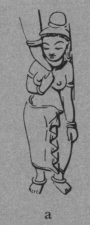

a

b

c

d

e

f

g

h

i

j

VISHNU—FORMS OF CONCH

a. Early Western Chalukya, 6th century
b, c. Late Western Chalukya, 12th century
d. Pallava, 7th century
e. Early Chola, 11th century
f. Pala, 11th century
g. Vijayanagar, 15th century

a

b

c

d

e

f

g

VISHNU—FORMS OF ŚRĪVATSA

a. Gupta
b. Chola, 11th century
c. Gahadavala, 11th–12th centuries
d. Vijayanagar, 16th century
e. *śrivatsa* on the chest of a Tirthankara. Kushan, 2nd century A.D.
f. Gahadavala, 12th century

EVOLUTION OF THE ŚRĪVATSA IN THE SOUTH

a. Pallava, 8th century
b. Early Chola, 11th century
c. Vijayanagar, 16th century

FORMS OF NARASIMHA

a. Early Western Chalukya, 6th century
b. Chalukya, 12th century
c. Chola, 12th century
d. Vijayanagar, 16th century
e. Gahadavala, 12th century
f. Sena, 12th century

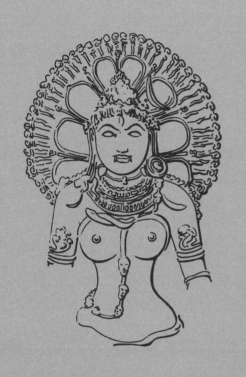
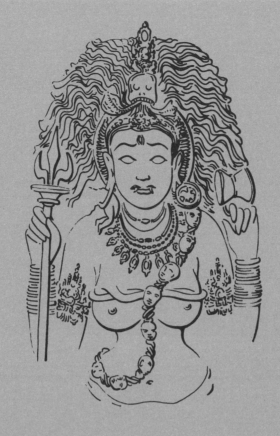
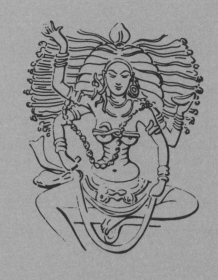

ATTRIBUTES OF CHAMUNDA

- sacred thread composed of severed heads
- band of serpents across chest
- corpse in earring
- flamelike coiffure

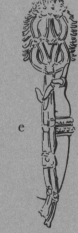

a b c

ELEPHANT GOADS

a. Chola, 11th century
b. Vijayanagar, 16th century
c. Chalukya, 12th century

a b c d e

FORMS OF NOOSE

a. Chola, 11th century
b. Late Chola, 12th–13th centuries
c. Vijayanagar, 16th century
d. Early Western Chalukya,
 6th–7th centuries
e. Late Western Chalukya, 12th century

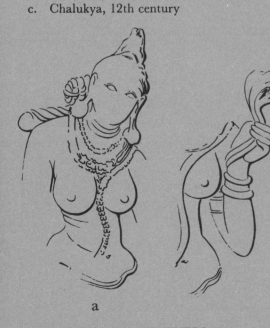
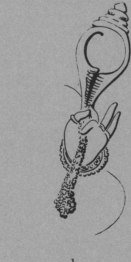
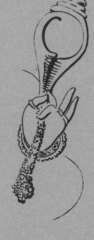

a b

LOTUS AND CHANK SHELL

a. lotus held in its usual position.
 Chalukya, 7th century

b. chank shell held in tripatāka.
 Chalukya, 12th century

MANNER OF HOLDING A WEAPON

a. *nāgapaśa* (noose in cobra form) held in usual
 fashion. Pallava, 8th century
b. ax held in kartarīmukha. Chola, 11th century

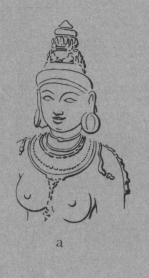
a

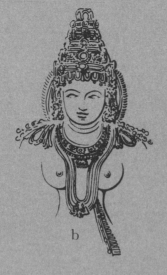
b

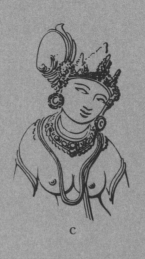
c

CROWNS (Makuṭa)

a. karaṇḍamakuṭa: crown resembling a pile of pots. Early Chola, 11th century
b. ratnamakuṭa: crown covered with jewels. Western Chalukya, 12th century
c. makuṭa and dhammilla. Pala, 11th century

a

b

c

ORNAMENTAL COIFFURES (Dhammilla)

a. Early Chola, 11th century
b. Western Chalukya, 11th century
c. Gurjara-Pratihara, 9th century

a

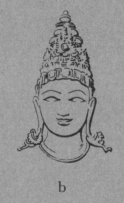
b

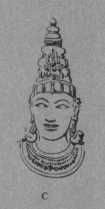
c

CROWNS (Karaṇḍamakuṭa)

a. Pallava, 8th century
b. Chola, 12th century
c. Vijayanagar, 16th century

SACRED THREAD—FABRIC
(Vastrayajñopavīta)

a

b

a. Sunga, 2nd century A.D.
b. Pallava, 8th century

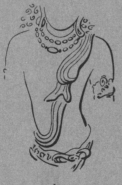
c

SACRED THREAD—DEERSKIN
(Ajinayajñopavīta)

c. Gupta, fifth century

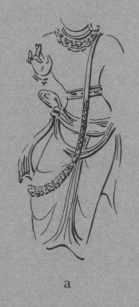

a

b

c

SACRED THREAD—PEARLS
(Muktayajñopavita)

a. Satavahana, 2nd century
b. Iksvaku, 3rd century
c. Gupta, 5th century
d. Early Western Chalukya, 6th century
e. Pallava, 8th century

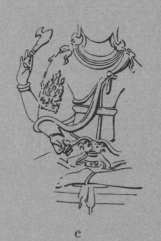

d

e

SACRED THREAD—GARLAND OF FLOWERS WORN BY DOOR GUARDIANS

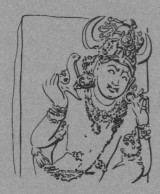

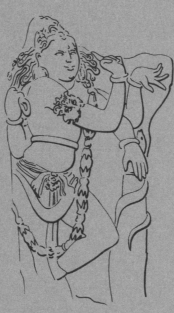

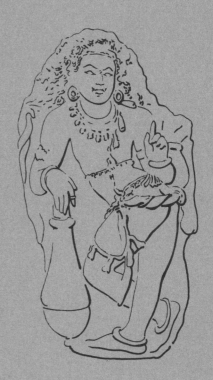

Pallava, 8th century
Early Eastern Chalukya, 7th century

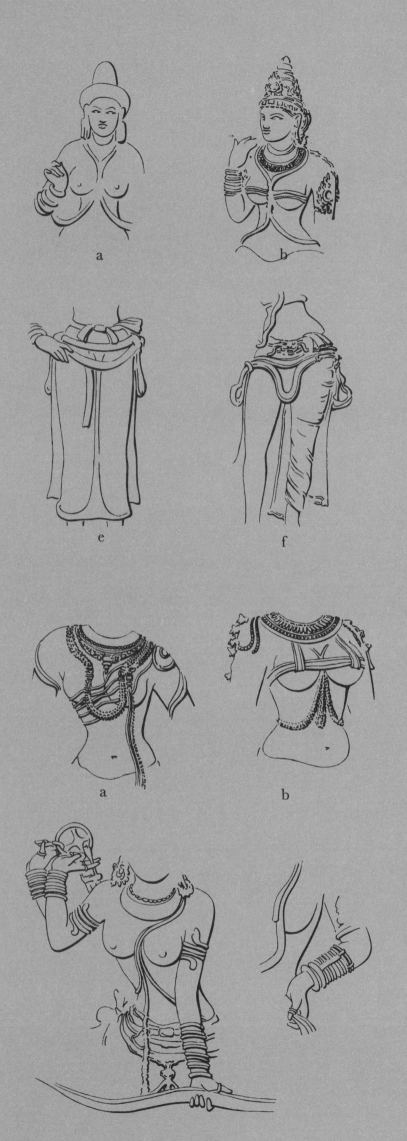

JEWELS AND ORNAMENTS

a. Pallava, 7th century
b. Chola, 11th century
c. sacred thread in the form of a thick piece of fabric. Pallava, 7th century
d. sinuous sacred thread. Chola, 11th century
e. kaṭisūtra: semicircular belt. Pallava, 7th century
f. kaṭisūtra: knotted belt. Chola, 11th century

BREASTBANDS

a. stanottariya: breast ornament seen in sculptures from northern India. Pala, 11th century
b. kuchabandha: breastband worn by a goddess. Chola, 11th century

ARMLETS OF DEVI

Kakatiya, 12th century

TYPICAL GUPTA DOORWAY WITH
ELABORATE CARVING. THE GODDESSES
GANGA AND YAMUNA ARE THE
FLANKING GUARDIANS.

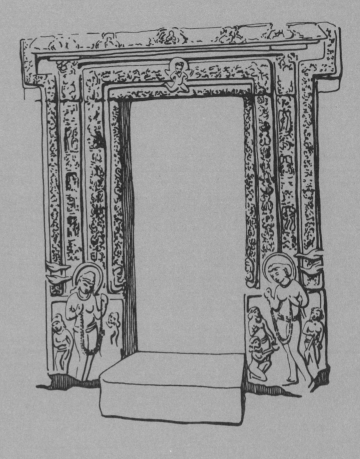

ENTRANCE GUARDED BY THE RIVER
GODDESSES SYMBOLIZED BY THE VASE
OF ABUNDANCE. The seated figures
represent the personified treasures,
Sankha and Padma.

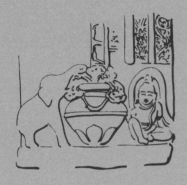 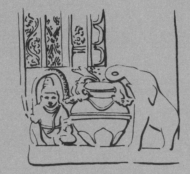

a b c d e

EVOLUTION OF THE HORSESHOE
WINDOW (Kūḍu)

a. Early Satavahana, 1st century A.D.
b. Vakataka, 5th century
c. Early Western Chalukya, 6th century
d. Vishnukundin, 6th century
e. Pallava, 7th century

PILLAR BRACKET

This motif evolved from the toraṇaśālabhañjikā.
It appears in all the temples of the 5th and 6th
centuries and is seen later in the temples of the
13th and 14th centuries. This is a 12th-century
Kakatiya bracket.

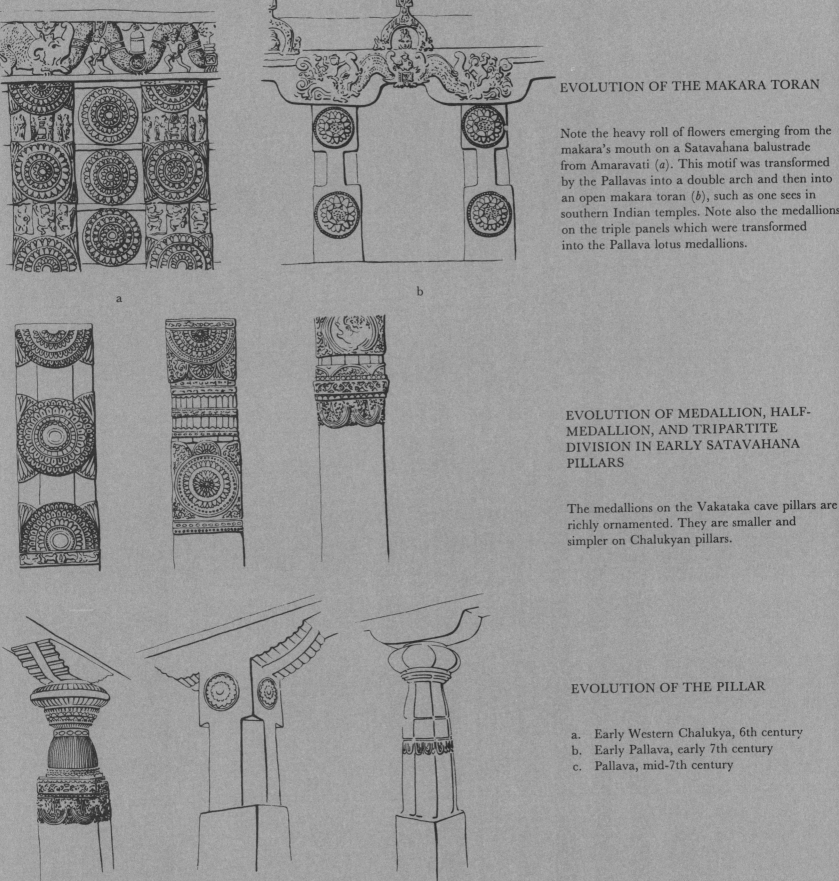

EVOLUTION OF THE MAKARA TORAN

Note the heavy roll of flowers emerging from the makara's mouth on a Satavahana balustrade from Amaravati (*a*). This motif was transformed by the Pallavas into a double arch and then into an open makara toran (*b*), such as one sees in southern Indian temples. Note also the medallions on the triple panels which were transformed into the Pallava lotus medallions.

a

b

EVOLUTION OF MEDALLION, HALF-MEDALLION, AND TRIPARTITE DIVISION IN EARLY SATAVAHANA PILLARS

The medallions on the Vakataka cave pillars are richly ornamented. They are smaller and simpler on Chalukyan pillars.

EVOLUTION OF THE PILLAR

a. Early Western Chalukya, 6th century
b. Early Pallava, early 7th century
c. Pallava, mid-7th century

a b c

These drawings were done by Jean Mazenod and are based on the author's sketches.

GLOSSARY

A

abhaya	hand gesture of protection and reassurance
abhisārikā	girl hurrying to the place of tryst
ācāri, ācārya	master craftsman; learned one
āḍavallan	the supreme dancer, i.e., Shiva as Nataraja
adbhuta	wonder, surprise
adhika	figure of speech in which the contained is larger than the container
ādi kāvya	the first poem, i.e., the Ramayana
agamanga	ritual dance performed in temples
āhārya	costume, makeup
āhuyavarada	hand gesture—beckoning to confer a boon
aitihya	belief or tradition
ajinayajñopavīta	sacred thread composed of deerskin
ājya	sacrificial ghee (clarified butter)
ājyapātra	sacrificial gheepot
ākāśaliṅga	the lingam of ether; in other words, the void
akṣamālā	rosary
akṣaralatitacārya	expert in engraving beautiful letters
alambana vibhava	principal factor indicating the emotional flavor (rasa) of a work of art
alaṁkāra	figure of speech (literally, "ornament")
alaṁkāra maṇḍapa	hall for decoration of deity
alapadma	hand gesture in dance
alasakanyā	young girl of joyous demeanor
āliḍha	warrior pose, with the right leg bent forward and the left drawn back
āmalaka	the fluted cushion-shaped member at the top of the north Indian shikara or spire (literally, the fruit of the myrobalan)
amṛta	ambrosia; elixir of immortality
amṛta-manthana	churning of the cosmic ocean by the gods and demons to extract ambrosia
ānanda	bliss
ānanda tāṇḍava	dance pose
ananta	variety of armlet
aṇḍa	hemispherical portion of the stupa
aṅgada	armlet
aṅgahāra	gyration in a dance pose
añjali	hands clasped in adoration or salutation
aṅkusa	goad
aṅkya	drum placed on the lap
antarāla	vestibule; antechamber to a shrine or cell
antariya	lower garment
anubhava	means of showing the emotional flavor of a work of art, such as perspiration, tears, specific gestures, etc.
aparṇā	name for Parvati (literally, "devoid of leaves")
apsarasa	nymph
āraṇyakas	Vedic texts studied in the forest
ardhamaṇḍapa	small hall connecting the shrine and the large pillared hall (mandapa)
ardhamattalli	dance pose expressive of joy
ārṣa	pertaining to a sage

āsana	seated pose, or a seat
asambhava	impossible, a figure of speech
aśoka	flowering tree
aṣṭadikpāla	guardians of the eight quarters
aṣṭa maṅgala	eight auspicious symbols
aṣṭa mātrikā	eight mothers
aṣṭamūrti	eight forms of Shiva
aṣṭaśakti maṇḍapa	hall of eight goddesses
asura	demon
aśvamedha	royal horse sacrifice
aśvamukhi	horse-headed celestial damsel
Atharva-Veda	see Veda
avadānakalpalatā	name of a book of stories of former lives of the Buddha
Avadanas	stories of the Buddha's life and deeds
avatāra	descent of a deity, usually Vishnu, to earth incarnated as a human or animal
āyāgapaṭṭa	sculptured plaque for worship
āyaka	platforms each surmounted by five pillars, projecting from the four cardinal points of Buddhist stupas in the Kistna Valley
ayudhapurusha	personified weapon

B

bakula	flowering tree
bālalīlā	juvenile sport or play, as of Krishna
bālipīṭha	raised, flat, circular receptacle for offerings in a temple
baniya	trader
bārāmāsā	theme of the twelve months vividly represented in paintings
basadi, basati	Kanarese temple
bhāgavata	devotee of Vishnu
bhaktavastsala	love of god for his devotees
bhakti	devotion to a personal god
bhāmaṇḍala	halo or circle of light
bharatanāṭya	classical dance of India, as expounded by sage Bharata
bhāva	mood represented in a work of art
bhavayojanā	infusion of emotions
bhayānaka	horror, terror
bhikṣā	alms
bhogamaṇḍapa	refectory of an Orissan temple
bhramaraka	ringlets of hair
bhrānti	delusion, a figure of speech
bhujaṅgāñcita	dance pose
bhujataruvana	forest of arms spread out like trees
bhukti	fiscal division in a kingdom
bhūmisparśa	earth-touching gesture of Buddha as he calls the earth to witness all his good deeds
bhūmukham	entrance hall
bhūrja	long, tough leaf used as a writing material in ancient India
bhūtagaṇa	dwarfish follower of Shiva

bībhatsa	disgust, loathing
bilva	tree whose leaves are used for Shiva worship
bimba	red fruit
biruda	title
bodhi tree	tree under which Buddha attained enlightenment
bodhikā	capital of a column
brahmacārin	young scholar initiated into Vedic studies
brahmahatyā	sin of killing a Brahman
Brāhmaṇas	commentaries on the Vedas
Buddhapāda	feet of Buddha

C

caitravana	celestial garden of Indra
caitya	sanctuary in the form of an apsidal hall
caityagṛha	shrine
caityamandira	shrine for worship
caityavṛkṣa	tree of sanctuary
cākkiyārkūttu	dance-drama performed by professional actors in Kerala
cakra	wheel
cakravikrama	rare Gupta coin showing the triumphant emperor adoring the personified wheel
cāmara	fly whisk, chowrie
camaradhāriṇī	female bearer of fly whisk
camarī	deer
campū	composition in prose and poetry
cāṇḍālavallakī	folk type of lute
candraśilā	moonstone; the semicircular doorstep before a shrine
cankama	promenade of the Buddha at Bodh Gaya
catura	dance pose
caturmukha	four-faced one, i.e., Brahma
caturmūrti	four forms, as of Vishnu
caturvyūha	array of four Vishnu forms: Vasudeva, Sankarshana, Pradyumna, and Aniruddha
caula	tonsure ceremony
caumukha	four images placed back to back, with the four faces looking toward the four cardinal points
caurī	fly whisk, chowrie
channavīra	bandolier
chatra	umbrella held over honored figure
citrakārapuli	title of the Pallava king Mahendravarman (literally, "tiger among painters")
citrasabhā	picturesque pillared hall
citraśālā	picture gallery
citsabhā	dance hall of Nataraja
cūḍāmaṇi	crest jewel

D

dabrasabhā	miniature temple hall
dagoba	stupa enshrining relics
dakṣiṇāpathīśvara	lord of the south
daṇḍa	stick, staff
daṇḍahasta	hand across the chest in dance
daśāvatāra	ten incarnations of Vishnu
deśi	folk style
deul	in Bengal and Orissa, generic name for a temple as a whole; also signifies the sanctuary (cella) and its tower (vimana)
deva	god
devadāsī	temple dancer (literally, "slave of the deity")

devakoṣṭha	niche to house an image of a deity
devakula	temple
devālayacakravarti	foremost among temples
devamātṛkā	rain-fed area
devasabhā	assembly of gods
devatā	celestial being, god
devi	goddess
dhamma	merit; ethical way of life
dhammilla	woman's hair style consisting of a decorated braid
dharma	merit; ethical way of life
dharmacakra	Wheel of Law
dharmacakrapravartana	first turning of the Wheel of Law by Buddha at Sarnath
dharmajayastambha	column celebrating righteous victory
dharmaprajā	offspring desired mainly for propagation of dharma, or the ethical code of life
dharmaśāstra	elaborate direction on the ethical way of life
dharmasūtra	directions on the ethical way of life
dharmavijaya	righteous conquest devoid of territorial cupidity
dharmayuddha	righteous warfare
dhvajastambha	emblem-crowned pillar in front of a temple
dhvani	suggestive expression
dhyāna	meditation
dhyānaśloka	meditative hymn
dhyāni Buddha	Buddha in meditation
digambara	naked (literally, "the quarters as clothes")
diggaja	elephant of the four cardinal points
dikpāla	guardian of the four cardinal points
dipalakṣmī	auspicious lamp-bearing damsel
Diwāli	festival of lights
dohada	a tree flowering out of season
Dussehra	nine-day autumn festival celebrating the victory of good over evil
dvārapāla	door guardian
dvārapālikā	female door guardian
dvitala	two stories

E

ekamukhaliṅga	Shivalinga with a single face of Shiva carved on it
ekāvali	single strand of pearls

G

gadā	club of Vishnu
gajapṛṣṭhākāra	shaped like an elephant's back; apsidal
gajathara	elephant frieze molding
gajavṛṣabha	motif of the fused elephant-and-bull
gaṇa	demigod follower of Shiva, usually a dwarf
gaṇacatuṣṭaya	four-dwarf motif on pillar
gaṇḍabherunda	mythical double-headed eagle
gandhakuṭi	special cell of the Buddha in a monastery
Gaṅgā	sacred river (Ganges)
Gaṅgaikoṇḍacoḷa	Chola ruler who triumphantly obtained water from the Ganges
gaṅgāvataraṇa	dance pose
garbhagṛha	inner shrine, the most sacred part of a temple
garuḍadhvaja	pillar surmounted by Garuda
garuḍamaṇḍapa	small hall for Garuda in a Vishnu temple
ghāṭ	steps on a riverbank, used for bathing
ghaṭikā	university

gokula	village of cowherds
gomukha	gargoyle
gopi	milkmaid
gopura	imposing tower over the entrance to temples in southern India
gopuravāśal	open entrance in southern Indian gopuras
graha	planet
Grantha	southern Indian script (literally, "knot of the cord of a manuscript")
gṛhasta	householder
gṛhyasūtra	directions for the ritualistic life of a householder
guru-śishya bhāva	mutual attitude of master and disciple

H

hallīsa	folk dance performed by several in a circle or ring
hamsaśreṇi	flight of sacred geese (often translated "swans")
harmikā	box-shaped structure on top of a stupa in which the shaft of the symbolic umbrella is set
hasta	hand position in dance
hastiśauṇḍika	mode of wearing the lower garment to suggest the contour of the elephant's trunk
hāsya	comic or humorous
hīra	diamond
Holī	joyous spring festival in which powdered colors or colored water are freely thrown on friends and neighbors
huḍukka	small hand drum

I

ihāmṛga	mythical animal like a horned lion
itihāsa	epic legend or story

J

jagamohan	audience hall or anteroom, preceding the sanctuary of an Orissan temple
jalavartma	sea route
japa	holy utterance in counting beads
jaṭā	matted locks of hair of an ascetic
jaṭābhāra	mass of locks of hair
jātakarma	ceremony of naming a newborn child
Jātakas	stories of former incarnations of Buddha
jaṭāmakuṭa	crown of locks of matted hair
jumma masjid	mosque
jyotiṣa	astronomy

K

kaccha	style of dress in which the cloth is finely folded and tucked
kaccvilaṅgam perumāl	the great lord who restored Kanchi
kaḍāramkoṇḍa	the prince who overcame Burma
kākapakṣa	sidelocks usually worn by children
kalaśa	rain vase
kalpa	ritual
kalpavallī	celestial wish-fulfilling creeper
kalpavṛkṣa	celestial wish-fulfilling tree
kalyanamaṇḍapa	pillared hall for the festival of the marriage of a deity
kāma	pleasure, desire

kāmadevayātana	temple of Kama
kanakasabhā	golden dance hall (of Natesha at Chidambaram)
kaṇṭhāśaleṣa	neck embrace
kapikuñjara	noblest of monkeys (literally, "elephant among monkeys")
karaṇa	dance pose
karaṇḍa	receptacle
karaṇḍamakuṭa	crown resembling a pile of pots
karihasta	hand across the chest in dance
karma	causality; the effect of former deeds on one's present and future condition
karmabhūmi	earth (literally, "the spot for deeds")
karuṇa	compassion
kathak	style of dance in northern India
kathakali	colorful and vigorous dance-drama from Kerala
katisama	dance pose
katisūtra	waist cord
kaustubha	rare gem worn by Vishnu
kavirāja	king among poets
kāvya	poetic composition
kāyotsarga	rigid standing posture of the Tirthankaras
kesara	flowering tree
keyūra	armlet
khaḍga	sword
khaṇḍitā	wronged wife
khatvāṅga	Shiva's club, composed of a skull and thigh bone
kiḷikaṭṭi maṇḍapam	hall for caged parrots, which were hung as votive offerings in the Minakshi temple in Madura
kiḷimaṇḍapa	hall for parrots
kinnara, kinnarī	divine singer
kirātārjuna	grouping of Shiva (as hunter) and Prince Arjuna
kirīṭa	crown
kīrtimukha	"face of glory"; an ornamental mask, representing the terrible aspect of Shiva, of great antiquity in Indian art
kīrtistambha	"pillar of glory"; freestanding pillar in front of a temple
kīrtitoraṇa	victory arch
kolāṭṭam	folk dance; performers dance in a ring while sounding small wooden rods
koṣṭha	niche
koṣṭhapañjara	niche with decoration on top
kṛṣṇāṣṭami	festival of the birthday of Krishna
kṣetra	sacred place
kucupuḍi	folk dance of Andhra Pradesh
kuḍakūttu	pitcher dance
kūḍu	horseshoe-shaped gable window
kula	family
kulanāyaka	family deity
kulaparvata	one of the seven hills protecting the Indian people and making them into a family
kulaśekhara maṇḍapa	pillared hall named after Kulashekhara
kumbha	motif resembling a vase
kumbhapañjara	recessed pilaster decorated with a vase motif
kumbhī	sculpture-decorated portion of an outer wall adjacent to a long frieze of elephants, horses, etc.
kuṇḍala	ear ornaments
kuravaka	flowering tree
kuśa	grass seeds
kūṭa	miniature pavilion
kūṭāgāra	domed roof

kuṭhāra	ax
kuṭila	crooked
kuṭilākṣara	crooked letters; crooked writing
kuṭilalipi	crooked letters; a cursory script
kūṭṭambalam	theater hall of Kerala
kūṭṭu	dance drama of Kerala

L

lalāṭatilaka	dance pose
lalita	dance pose
lāsya	soft and delicate dance of Shiva
lāvaṇyayojana	endowing the figures of a picture with iridescence
līlā	sport, prank
liṅga	phallic symbol of Shiva
lipi	script
lipikara	scribe
lokapāla	celestial guardian of the four cardinal points

M

madanakai	voluptuous beauty
mahal	palace
mahāmakha	bathing festival held every twelve years
mahāmaṇḍapa	large enclosed hall in front of main shrine; also transepts
mahāpuruṣa	great personage
mahāpuruṣalakṣaṇa	characteristics of a great personage
mahārājalīlā	seated at ease with the hands resting on the knees
maitrīkalyāṇaguṇa	great quality of peace with the whole world
makara	sea monster; crocodilelike mythical animal
makaradhvaja	makara standard
makaramukhapraṇālī	gargoyle with makara motif
makaratoraṇa	makara-decorated gateway
makarī	makara decoration
mākkālai	bull fashioned out of rice flour
makuṭa	crown
Malayamāruta	southern breeze from the Malaya Mountains
mānastambha	emblem-bearing column in front of a temple
maṇḍala	circular diagram representing a Buddhist hierarchy of cosmology
maṇḍapa	porch or pillared hall
maṅgala kalaśa	auspicious vase
mantra	textual hymns of the Vedas; phrases believed to have magical or religious power
mantraśālā	council chamber
masjid	mosque
mātaṅganakra	elephant fish
mātṛkā	one of the Seven Mothers
mayūrapiccha	peacock-feather fan
mihrab	alcove in a mosque, oriented toward Mecca
Mīmāmsā	one of the six schools of Hindu philosophy
mimhar	pulpit
minār	turret
mithuna	loving pair
modaka	sweets
mokṣa	salvation; release from transmigration
mṛdaṅga	deep and sweet-sounding south Indian drum
mṛdu varṇa	soft and delicately cut letters
mṛgaśirṣa	hand gesture in dance
mugdhā	shy, coy bride
mukhaliṅga	Shivalinga with the face of Shiva carved on it

mukhamaṇḍapa	narrow hall connecting the ardhamaṇḍapa or the mandapa with the shrine
muktābharana	pearl decoration
muktāyajñopavīta	sacred thread composed of pearls
mūlamañjari	main shikara on top when subsidiary miniature shikaras in a cluster below make up the deul
mūlasthāna	sanctum sanctorum
muṇḍamālā	garland of severed heads
muni	sage

N

nādasvara	reed instrument
nādatanu	Shiva shown as a body of musical notes
nadīmātṛka	river-fed area
nāgā	snake spirit
nāgabandha	cobra-hood motif at the corners of a square pillar
nāgaraka	sophisticated connoisseur (literally, "townsman")
nagaram	council of the elders of the town
Nagarī	script in which Sanskrit and modern Hindi and Marathi are written, used mostly in northern India
nāgayajñopavīta	sacred thread composed of a snake
nāgeśvara	Shiva as Lord of Snakes
nālambalam	quadrangular building including smaller shrines
nāmakaraṇa	ceremony of naming a child
nandi	sacred bull
nandidhvaja	bull standard
nandigṛha	hall for reclining bull in a Shiva temple
nandimaṇḍapa	miniature hall for reclining bull in a Shiva temple
nandipāda	auspicious symbol
narathara	molding on the base of a temple
nāsī	frontal projection of a vimana
naṭa	dancer
nāṭaka	drama; heroic comedy
nāṭakaśālā	theater hall
naṭamaṇḍapa	hall of dance
naṭamandir	dance hall
nāṭya	dance
nāṭyahasta	dance gestures
nāṭyamaṇḍapa, nāṭyasabhā	dance hall
navagraha	nine planets
navaraṅga, navaraṅgamaṇḍapa	middle or central hall of a temple
navarātrimaṇḍapa	pillared hall for the nine-day autumn festival
nāyaka	hero of a poem or play
nāyikā	heroine of a poem or play
nāyikā nāyaka bhava	posture of lovers
nidhi	mythical treasure
nirapura	house built entirely of wood
nirukta	Vedic etymology
Nirvāṇa	death of Buddha; extinction of separate selfhood and escape from transmigration
nityavinoḍa	perennial entertainment
nivibandha	knot of a garment on a woman's waist
nṛtta	rhythmic dance
nṛtyavinodavaḷanāḍu	fiscal division of a kingdom named after gaiety in dance
nūpura	anklet
nūpuraśiñjita	tinkling sound made by an anklet
Nyāya	logic, one of the six schools of Hindu philosophy

O

omkāra	*the mystic syllable Om*
orutāṅgi	*caryatid dwarf under a gargoyle*
oṣadhi	*herb*
oṭṭantuḷḷal	*violent style of dance in Kerala*

P

pādasvastika	*crossed legs in dance*
padma	*lotus; molding having the curves of the lotus petal*
padmanidhi	*mythical treasure*
padmāsana	*meditative pose (lotus position); seated with the legs crossed and soles of the feet turned upward*
paiśāca	*variety of barbarous language*
palāśa	*flowering tree*
pañcakṛtya	*fivefold act of God—creation, sustenance, destruction, posing illusion, and final deliverance*
pañcamukha	*five faces*
pañcarātna	*temple composed of five shrines, four at the corners around the central one*
pañcarātrāgama	*book on Vishnuite temple ritual*
pañcāyatana	*temple consisting of a group of five shrines*
paṇḍit	*scholar*
paṇḍitacoḷa	*epithet of a Chola king (literally, "scholarly Chola")*
paṇḍitavatsala	*epithet of a king (literally, "fond of scholars")*
pāṇḍyadhanañjaya	*title of a Pandya ruler comparable to the hero Arjuna*
pāṇigrahaṇa	*holding hands in marriage*
parasu	*ax, usually associated with Shiva*
parinirvāṇa	*Buddha's death and final entry into Nirvana*
paryaṅkabandha	*cloth tied across waist and right knee*
paryāyokta	*indirect expression, a figure of speech*
pāśa	*noose*
paśu	*animal for sacrifice*
patrakuṇḍala	*ear ornament shaped like a scroll*
paṭṭī	*outer wall*
payas	*water, milk*
perambalam	*great temple hall*
phalabhariśvara	*name of Shiva in one of his temples in southern India*
phalakahāra	*necklace composed of strands and plaques*
pīṭha	*base, foundation*
prabhā	*halo*
prabhā maṇḍala	*circle or ring of flames and light*
prabhāvali	*large halo, sometimes with projecting flames*
pradakṣiṇā	*clockwise circumambulation of a sacred spot*
pradakṣiṇapatha	*vedika, processional passage or ambulatory*
pradakṣiṇaprākāra	*court for clockwise perambulation*
pradakṣiṇavīthī	*perambulatory passage*
Prajñāpāramitā	*Buddhist goddess of learning (literally, "gone to the other shore of learning")*
prākāra	*outer wall of a temple court*
pralambapāda, pralambapādāsana	*seated in European fashion with feet resting on the ground*
praṇava	*the mystic syllable Om*
prāsāda	*palace; shrine*
prasādhikā	*toilet attendant*
praśasti	*panegyric inscription*
pretāsana	*corpse on which Chamunda is seated*

priyaṅgu	*vine*
proṣitabhartṛka	*wife separated from her lover*
pudumaṇḍapa	*new mandapa*
pūjāmaṇḍapa	*hall of worship*
pumsavana	*ceremonial prayer for the birth of a boy*
puṇyasalilā	*holy water or stream*
Purāṇas	*sacred books of mythology and epic*
pūrṇaghata	*vase of plenty; "vase and foliage" capital in style of northern India*
pūrṇakumbha	*brimming-pitcher motif*
puruṣa	*ideal man*
puruṣarṣabha	*foremost among men (literally, "a bull among men")*
puruṣottama	*most magnificent among puruṣas*
puṣakariṇī	*sacred pool or tank*
puṣpabodhikā	*pillar capital decorated with plantain-flower motif*

R

rāgā, rāgiṇī	*musical melody-structure upon which a musician improvises (literally, "color" or "mood")*
rājagambhīra	*princely dignity*
rājalekhaka, rājalipikara	*royal scribe*
rākṣasa	*demon*
Rāmanavamī	*festival celebrating the birthday of Rama*
rasa	*flavor or essence; the emotional character of a particular work of art*
rāsalīlā, rāsamaṇḍala	*folk dance in a ring; the dance of Krishna with the Gopis*
ratha	*chariot; temple shaped like a celestial chariot*
rathakāra	*wood carver (literally, "chariot maker")*
ratnamakuṭa	*jeweled crown*
raudra	*wrathful, wild*
rāyagopura, rāyalagopura	*temple entrance tower attributed to the Vijayanagar king Krishnadevaraya*
ṛk	*hymn of the Rig-Veda*
ṛṣabha	*bull like Shiva's bull*
ṛṣabha maṇḍapa	*pillared hall for Nandi, the bull of Shiva*
ṛṣi	*sage*
ṛta	*righteousness*
ṛtvik	*sacrificial priest*
rudrākṣa	*dark berries of a tree sacred to Shiva*
rudrākṣamālā	*necklace of rudrākṣa beads*
rūpaka	*metaphor, figure of speech*
rūpākṛti	*prince charming; a type of Gupta coin*

S

sabhā	*assembly*
sabhāmaṇḍapa	*assembly hall*
sabhāpati maṇḍapa	*hall of the Lord of the Assembly (Natesha)*
ṣaḍaṅga	*having six parts*
sādṛśya	*resemblance*
sahakāra	*mango tree*
śālā	*hall; long hall with barrel-vaulted roof in a southern Indian temple*
śālabhañjikā	*statuette (literally, a sculpture representing a girl gathering sal flowers)*
sallekhana	*Jain's fast unto death*
sāma	*hymn from the Sama-Veda*
samabhanga	*erect pose*
samarakesarī	*lion on the battlefield*

samāsokti	figure of speech that brings to one's mind an unmentioned idea
samāvartana	completion of studies or entering upon a householder's life
sambhoga	love in union
Samhitā	text of the Vedas; collections of hymns, prayers, and sacrificial formulas
samskṛta	refined or bejeweled, as the Sanskrit language
sandhyā	ablutions and worship at sunrise, noon, and sunset
saṅgam	conference of Tamil scholars
saṅgha	Buddhist order of monks
saṅghārāma	Buddhist monastery
sanghāṭī	Buddhist monk's robe
saṅkalpa	determination or resolve
śaṅkha	conch, usually associated with Vishnu; one of the mythical treasures
Sāṅkhya	one of the six schools of Hindu philosophy
śānta	tranquil
saparṇā	luscious with leaves
saptapadī	bride and groom walking seven steps together during the marriage ceremony, symbolizing that they are to be companions in life
saptasvaramaya	the seven musical notes
śaratalpa	bed of arrows
śārdūla	horned lion
śārīraka	relics; a stupa built over relics
śārṅga	bow of Vishnu
sārvabhauma	emperor
sarvatobhadra	decorative and architectural pattern
śāstra	scientific text
śata	innumerable (literally, "hundred")
sātvikabhāva	evanescent, fleeting effects like perspiration, gooseflesh, tears, etc.
śayana	bed
śayanacitraśālā	art galleries in the rooms for sleeping
śeṣagirirāya maṇḍapa	hall named after Seshagiriraya
śikhā	tuft
śikhara	in northern India, a spire or tower; in southern India, a flame-shaped ornament atop a tower
śikṣā	phonetics
simhakaṇar	lion tank
simhalalāṭa	lion head
simhamukha	lion face
simhaparākrama	valorous like a lion; a type of Gupta coin
simhāsana	lion throne
sindūra	red saffron powder
siraścakra	circular decoration or halo behind the head
Śivalīlā	sport of Shiva
Śivaliṅga	phallic emblem of Shiva
Śivarātri	festival of Shiva's sacred night
smaśāna caitya	temple in the burial ground
smṛti	memorized texts on code of conduct; traditional authority
ṣoḍaśamaṅgala	the sixteen signs of good fortune
somavāra maṇḍapa	pillared hall used on Mondays
sphuṭākṣara	clear, well-cut letters
śrauta	ritual pertaining to Vedic rites
śrī	prosperity, another name for Lakshmi; title of respect
śrīvacca, śrīvatsa	mark or symbol of Lakshmi on Vishnu's chest
śṛṅgāra	erotic
śrotriya	Vedic scholar
sruk	sacrificial ladle
śruta	learning acquired by hearing
śruti	the Vedas learned by hearing; revealed knowledge
sthalavartma	land route
sthalavṛkṣa	sacred tree associated with a place deity
sthāna	place
sthāṇu	image combining Shiva's human and columnar form
sthapati	master craftsman
stotra	hymn
stūpa	hemispherical funerary mound built over the remains of distinguished persons
stūpī	finial of a Hindu temple
subhaga	beautiful woman
sugānam rāje	during the reign of the Sungas
sukhanāsī	Chalukyan temple vestibule
śūla	trident, usually associated with Shiva
suranāyika	celestial damsel
surasundarī	celestial beauty, nymph
śuruḷyāḷi	motif of the mythical animal yāli on a balustrade
sūryopasthāna	adoration of the sun
sūtra	aphorism, pithy religious text
suvarṇavaikakṣaka	golden jewel shaped like a bandolier
svabhāvokti	natural expression, a figure of speech
svahasta	(one's own) signature
svarga	heaven
svargabhūmi	celestial sphere
svastika	auspicious symbol
svayamvara	choice of her marriage partner by the bride herself

T

takṣa	carpenter
tala	unit of measurement for images
talakāḍukoṇḍa	one who overcame Talakad, the capital of the Western Gangas
talao	tank
tāṇḍava	fierce, violent dance of Shiva
tapa	penance
tarjanī	threatening hand gesture
tavil	drum with a muted sound
teppakuḷam	pond for barge festival
tevāram	hymns of the Shivaite saints
tirukkalyāṇa	marriage festival of a temple deity
tiruvāymoḷi	hymns of the Vishnuite saints
tiruvīdi	large streets around the temple and tank
toraṇa	gateway of the enclosure of a Buddhist stupa
toraṇaśālabhañjikā	damsel under sal tree as a bracket for an ornamental toran
trayīvidyā	lore of the three Vedas
trikūṭāchala	Chalukyan triple shrine or three-celled temple
Tripathagā	the river Ganges flowing through three regions
triratha deul	structure having three pilasters on the facade
triratna	the three gems: Buddha, Dharma, and Sangha
triśaṅku svarga	heaven of Trishanku which is between heaven and earth; thus meaning in an uncertain position, neither in heaven nor on earth
triśūla	trident, usually associated with Shiva
triveṇisaṅgama	confluence of three streams

U

udarabandha	stomachband

555

udaya mārtāṇḍa maṇḍapa	*pillared hall named after Udaya Martanda*
uddīpana	*factors that arouse moods, such as moonlight and spring for śṛṅgara rasa*
ullāsa	*merit or defect of one compared with another, a figure of speech*
uñjal maṇḍapa	*hall of the swing*
upanayana	*sacred thread ceremony, symbolic of a boy's commencing Vedic studies*
Upaniṣads	*esoteric and philosophical portions of the Vedas*
ūrdhva	*variety of drum*
ūrdhvajānu	*dance mode*
ūrdhvaliṅga	*erect phallus, signifying great control of senses*
ūrdhvatāṇḍava	*dance mode*
ūrṇā	*curl of hair between the eyebrows of the Buddha*
uruśṛṅga	*half-shikara like a turret attached to the main shikara or spire*
ushṇīṣa	*turban; cranial protuberance of the Buddha*
utsavamaṇḍapa	*festival hall*
utsavavigraha	*metal processional image*
uttara mantrī	*chief minister*

V

vadhū	*newly wedded bride*
vāhana	*mount of a deity*
Vaiśeṣika	*one of the six schools of Hindu philosophy*
vajra	*thunderbolt*
vajrāsana	*adamantine throne*
vaḷanāḍu	*division of area in the Chola kingdom, similar to a modern district*
vāmanikā	*dwarfish female attendant*
vanamālā	*sweet-smelling flower garland worn by Vishnu*
varada	*hand gesture of conferring a boon*
varṇikābhaṅga	*mixing of colors*
vāsakasajjikā	*eager wife*
vasanta maṇḍapa	*hall for spring festival*
vastrayajñopavita	*sacred thread made of cloth*
vaṭapatraśāyi	*Vishnu as a child resting on a banyan leaf on the waters of the deluge*
vaṭavṛkṣa	*banyan tree*
Veda	*the four books of early Aryan scripture, containing hymns and formulas for Brahmanic priestly ritual; they are the Rig-Veda, Sama-Veda, Yajur-Veda, and Atharva-Veda*
vedāṅga	*six accessory branches of knowledge (literally, "limbs") of the Vedas*
Vedānta	*philosophical section of the Vedas; one of the six schools of Hindu philosophy*
vedikā	*railing or fence protecting a sacred enclosure*
vellai gopuram	*white temple-entrance tower*
velliambalam	*silver hall (for the dance of Shiva at Madura)*
veśavāsa	*courtesan's abode*
vetāla	*vampire*
vetradaṇḍa	*cane staff*
vicitracitta	*title of the Pallava king Mahendravarman (literally, "a curious-minded one")*
vidyadhara	*class of celestials*
vihāra	*Buddhist monastery*

vimalākṣara	*immaculate letters without a blemish*
vimāna	*small square cell or shrine*
vīnā	*stringed instrument resembling a lute*
vipralambha	*love in separation*
vīra	*hero, or the heroic*
vīrapāṇḍyan maṇi maṇḍapam	*jeweled pillared hall named after Vira Pandya*
vīrāsana	*hero's seated pose*
virāṭpuruṣa	*all-pervasive form of the Lord*
viṣādana	*disappointment, a figure of speech*
viṣama	*inconsistency, a figure of speech*
vismaya	*wonder*
vismayamudrā	*hand gesture of wonder*
Viṣṇumāyā	*the illusion of Vishnu*
Viṣṇupāda	*sky; the mount of Vishnu*
viśvam	*universe*
viśvarūpa	*omnipresent being*
vivāha	*marriage*
vīthī	*gallery*
vrālu	*signature*
vṛkṣa	*tree*
vṛṣbhadhvaja	*bull banner*
vṛttāyata	*elliptical structure*
vyabhicāribhāva	*transient moods such as despair, doubt, fatigue, etc.*
vyāghranakha	*tiger claw (adornment for children)*
vyākaraṇa	*grammar*
vyakhyānamaṇḍapa	*hall for exposition*

Y

yāga	*sacrifice*
yāgapaśu	*sacrificial animal*
yāgaśālā	*sacrificial hall*
yaj	*worship*
yajamāna	*one who sacrifices*
yajñopavīta	*sacred thread worn by all upper-caste Hindus*
yajus	*hymn of the Yajur-Veda*
yakṣa, yakṣī	*semidivine being, nature spirit*
yakṣagāna	*folk dance in Andhra Pradesh*
yālam	*row of yāli heads*
yāli	*hybrid monster, part lion, part horse, and part elephant, used in the ornamentation of Chalukyan temples*
yālimaṇḍapa	*hall with yāli decoration for pillars*
yamalārjuna	*pair of Arjuna trees felled by the infant Krishna as he crawled between them*
yamapāśamudrā	*a gesture using the fingers to form an aperture through which to see the solar disc*
yoga	*disciplined meditation; one of the six schools of Hindu philosophy*
yoganidrā	*meditative slumber of Vishnu*
yogapaṭṭa	*band for binding the legs in a pose of meditation (paryaṅkabandha)*
yogi	*ascetic*
yoginī	*one of the sixty-four mother goddesses*
yogīśvara	*lord of ascetics (i.e., Shiva)*
yūpa	*sacrificial pole*

CHRONOLOGY OF STYLES

DYNASTY	DATE	PRINCIPAL MONUMENTS AND REMAINS
MAURYA	320–185 B.C.	Elephant of Dhauli; lion and bull capitals of Rampurva; lion capital of Sarnath; lion pillar of Lauriya Nandangarh; yakshi of Didarganj.
SUNGA	185–72 B.C.	Balustrade and torans at Bharut; balustrade at Patna; balustrade at Bodh Gaya; Sankarshana now in Lucknow Museum; yaksha of Parkham; yakshi of Beshnagar; Kalpadruma capital.
CHETA	180–100 B.C.	Caves at Khandgiri and Udayagiri.
SATAVAHANA	200 B.C.–A.D. 200	Torans at Sanchi; caves at Bhaja, Karli, Kondane, Bedsa, and Nasik; Cave 10 at Ajanta; remains of the stupa at Amaravati.
INDO-GREEK	200 B.C.–A.D. 200	Remains at Taxila, Charsada, Jamal Garhi, Loriyan Tangai, Sahrī Bahlol, Shahbaz Garhi, Hadda.
KUSHAN	A.D. 78–200	Statue of King Kaniska; yakshi from Bhutesar; Jain Ayagapata; Katra Buddha; bodhisattvas from Maholi, Sravasti, and Sarnath; bacchanalian scene; statues of Lakshmi and Kubera.
IKSHVAKU	175–200	Stupa and remains at Nagarjunakonda and Goli.
VAKATAKA	275–550	Caves at Ajanta, Ellora, Elephanta, and Aurangabad; Shiva from Parel (Bombay).
GUPTA	320–510	Temples and remains at Tigawa, Nachna, Kuthara, Udayagiri, Bhumara, Bhitargaon, Ahicchatra, and Deogarh.
PALLAVA	325–897	Caves at Bhairavakonda, Dalavanur, Mandagapattu, Trichinopoly, Sittannavasal, and Mahabalipuram. Temples and remains at Kanchipuram and Bahur.
WESTERN GANGA	450–985	Remains at Talakad; huge Jain saint at Sravana Belgola.
MAITRAKA	475–766	Remains at Samalaji, Kotyarka, Karvan, and Roda.
VARDHANA	500–648	Remains at Thanesar, Kanauj, and Gwalior.
EARLY WESTERN CHALUKYA	543–755	Caves, temples, and remains at Aihole, Badami, Pattadakal, and Mahakutesvara.

DYNASTY	DATE	PRINCIPAL MONUMENTS AND REMAINS
PANDYA	590–920	Caves at Tirumalaipuram, Tirupparamkunram, Kunakudi, and Kalugumalai.
KARKOTA	600–850	Temples and remains at Lalitpura, Parihasapura, and Martand.
EASTERN CHALUKYA	624–1061	Temples and remains at Vengi, Vijayawada, Bikkavolu, and Draksarama.
CHERA	700–850	Caves at Vilinjam, Kaviyur, and Talakat.
EASTERN GANGA	750–1250	Temples and remains at Mukhalingam, Bhuvaneshwar, Jaipur, and Konarak.
PALA	765–1175	Remains at Nalanda, Vikramasila, Uddandapur, and Paharpur.
NOLAMBA	800–1150	Temples and remains at Hemavati and Henjeru.
PRATIHARA	805–1036	Temples and remains at Osia, Kanauj, Bundelkhand, Abaneri, Kotah, Sikar, Jagat, and Bikaner.
CHOLA	846–1173	Temples and remains at Nartamalai, Srinivasanallur, Tanjore, Gangaikondacolapuram, Darasuram, Tribhuvam, Chidambaram, and Tiruvarur.
UTPALA	855–939	Temples and remains at Awantipur.
CHEDI OR HAIHAYA	895–1150	Temples and remains at Bundelkhand, Chandrehi, Bheraghat, Sohagpur, and Gurgi.
CHALUKYA	941–1197	Temples, torans, and remains at Somanath, Sidhpur, Modhera, Gumli, Abu, Vadnagar, and Dabhoi.
PARAMARA	949–1088	Temples and remains at Dhara and Udaipur.
CHANDELLA	950–1203	Temples and remains at Mahoba and Khajuraho.
LATE WESTERN CHALUKYA	973–1200	Temples and remains at Kuruvatti, Kukkanur, Haveri, and Gadag.
GAHADAVALA	1080–1184	Temples and remains at Delhi and Bikaner.
SENA	1095–1206	Remains at Lakshmanavati and Mahanad.
HOYSALA	1100–1300	Temples and remains at Belur, Halebid, Somnathpur, Arsikere, and Dodda Gaddavalli.
KAKATIYA	1110–1326	Temples, torans, and remains at Warangal, Hanamkonda, Tripurantakam, Palampet, and Pillalmarri.
YADARA	1187–1312	Temples and remains at Devagiri, Lonar, Satgaon, and Mahkar.
PANDYA	1190–1310	Temples at Madura, Srirangam, Tiruvannamalai, and Chidambaram.
MAMLUK	1206–1290	Kutab Minar; tomb of Sultan Ghari at Delhi; Arahai din ka Jhompra at Ajmer.
KHALJI	1290–1321	Alai Darwaza.
TUGHLAK	1321–1414	Tomb of Ghiyas-ud-din Tughlak; Kotla Firuz Shah; tomb of Firuz Shah Tughlak.
VIJAYANAGAR	1335–1600	Temples and remains at Hampi, Lepakshi, Vellore, Gingi, Tadpatri, Virinchipuram, Srirangam, Tiruvannamalai, and Madura.

DYNASTY	DATE	PRINCIPAL MONUMENTS AND REMAINS
SAYYID	1414–1444	Tomb of Mubarak Shah Sayyid.
LODI	1451–1526	Shish Gumbaz; Moti Ki Masjid.
GUJARAT SULTANATE	1459–1550	Sidi Sayyid mosque at Ahmadabad.
BIJAPUR	1490–1686	Ibrahim Rauza; Gol Gumbad; Jami Masjid.
SUR	1538–1555	Tomb of Sher Shah at Sasaram.
MOGUL	1526–1707	Tomb of Chisti; Buland Darwaza; Panch Mahal and other remains at Fatehpur Sikri; tomb of Akbar at Sikandra; the Red Fort and the Taj Mahal at Agra; the Red Fort and the tomb of Humayun at Delhi; Bibi ka Maqbara at Aurangabad.

CATALOGUES

GODS
AND LEGENDARY HEROES

ARCHITECTS,
SCULPTORS,
AND PAINTERS

PHILOSOPHERS
AND AUTHORS

GODS AND LEGENDARY HEROES

Hindu mythology underwent certain transformations over the centuries. The Vedic gods who personified the elements—such as Indra (air), Agni (fire), and Vayu (wind)—gradually gave way to other gods. The Hindu trinity, composed of Brahma, Vishnu, and Shiva, forms the nucleus of post-Vedic mythology. These gods appear in a number of forms and are usually shown with objects or ornaments that represent their particular powers. And the heroes of classical literature came to hold an important place in Hindu mythology.

AGASTYA
Sage who is reputed to have written several hymns in the Rig-Veda.

AJA
Prince of the Solar Dynasty; husband of Indumati and father of Dasaratha, thus grandfather of Rama.

AMBIKA
Sister of Rudra; sometimes identified with Uma.

ANGADA
1. Son of Lakshmana.
2. Son of Gada, brother of Krishna.
3. Son of Bali, the monkey-king.

APARNA
Daughter of Himavan and Mena who devoted herself to asceticism. As Uma, she is also the spouse of Shiva.

ARJUNA
The third of the five Pandava brothers, he is a valorous warrior and possesses divine weapons. He heeds his charioteer, Krishna, when he exhorts him to act in the war against the Kauravas. This call to action is the celebrated chant of the Bhagavadgita.

ARUNDHATI
The morning star; personified as the spouse of the sage Vasistha, who is the model of the perfect wife.

BHAGAVATA
Epithet of Vishnu or Krishna.

BHAGIRATHA
Descendant of Sagara. As a reward for his asceticism, Shiva allowed Ganga to descend to earth.

BHAGIRATHI
One of the names of Ganga; given because her descent to earth is made possible by the asceticism of Bhagiratha.

BHARATA
Son of Dasaratha and Kaikeyi; half-brother of Rama.

BHIMA
"The Terrible"; the second of the five Pandava brothers; the son of Vayu, the god of the winds.

BHISMA
Son of King Santanu, he vowed to leave the throne to his brother's descendants. He took part in the war between the Pandavas and the Kauravas.

BHRIGU
Vedic sage; founder of the Bhargava people.

BRAHMA
First god of the Hindu trinity; creator of the world.

CHITRA or CHITRANGADA
Daughter of King Chitravahana of Manipur and wife of Arjuna.

DEVAKI
Wife of Vasudeva and mother of Krishna. Sometimes considered an incarnation of Aditi.

DEVI
"The Great Goddess." Daughter of Himalaya and spouse of Shiva, she represents the śaktī ("energy") of the Almighty. In her loving form she is called Uma ("light"), Gauri ("the sparkling one"), Parvati ("goddess of the mountain"), Haimavati ("the golden one"), Jagan-mata ("mother of the world"), and Bhavani. In her terrible form she is called Durga ("the inaccessible one"), Kali and Shyama ("the black one"), Candi and Candila ("the cruel one"), and Bhairavi ("the terrible one").

DRAUPADI
Daughter of Drupada; spouse of the five Pandava brothers.

DURGA
The terrible form of Shiva's spouse. See Devi.

DURYODHANA
Eldest son of King Dhritarastra and leader of the Kauravas.

DUSYANTA
Prince of the Lunar Dynasty; descendant of Puru, spouse of Sakuntala, and brother of Bharata.

DVARAPALA
Name of several yakshas.

GAJALAKSHMI
Epithet of Lakshmi.

GAJANTAKA
"He who has killed an elephant"; epithet of Shiva.

GANESHA
Son of Shiva and Parvati. The god of wisdom, he removes difficulties, and he is invoked before any important enterprise. He is represented with an elephant head, four hands, and a prominent belly.

GANGA
Goddess who is the personification of the river Ganges.

GANGADHARA
One of Shiva's names; given because he receives Ganga on his locks and thus saves the earth from the shock of her fall.

GARUDA
Sacred bird who is half man and half bird and serves as Vishnu's mount.

GAURI
See Devi.

GAURIGURU
Father of Gauri (Parvati), the spouse of Shiva.

HANUMAN or HANUMAT
Counselor of Sugriva, the monkey-king, he helped Rama recover his wife Sita and conquer Lanka.

HARIHARA
Combination of the names of Vishnu and Shiva, representing the union of these two deities in one.

INDRA
God of the air. He holds an important place in the Vedas, but in later mythology, he is a secondary deity. In the Puranas he is Krishna's rival.

JAGADAMBA
"Mother of the World"; epithet of Durga. See Devi.

JAHNU
The sage whose meditation was disturbed by Ganga. He drank her up in one sip, but she was later released through his ear (whence her name Jahnavi).

JAHNUTANAYA
"Daughter of Jahnu"; name of Ganga. See Jahnu.

JATAYU
King of the vultures. He flew to help Sita, who had been abducted by Ravana, and was killed.

JAYADRATHA
Prince of the Lunar Dynasty; king of Sind. He abducted Draupadi and was punished by Bhima.

KAMA
God of love. Reduced to ashes by the wrathful eye of Shiva, he was reborn as Pradyumna, son of Krishna and Rukmini.

KARTIKEYA
God of war.

KAUMODAKI
Club of Vishnu and Krishna, given by Agni during the battle against Indra.

KRISHNA
Incarnation of Vishnu as a shepherd. Son of Devaki, he was raised by Yasoda in order to escape the persecution of his uncle Kamsa. The most popular Indian divinity, he is venerated under several forms—as an infant; as a young shepherd playing the flute; as the master of maya; and as lover of the milkmaids (their love symbolizes the love of the soul for the Almighty, the means of attaining salvation).

KUBERA
God of abundance and wealth; one of the guardians of the world. Brahma gave him a celestial chariot called Puspaka.

KUMARI
"The young girl," epithet of Sita and sometimes of Durga.

LAKSHMANA
Son of King Dasaratha and his spouse Sumitra. Half-brother of Rama, he accompanied him in his exile and is portrayed as a valiant warrior.

LAKSHMI
The goddess of wealth; also called Sri. Spouse of Vishnu and mother of Kama, she is particularly venerated during Dewali, the festival of lights that marks the beginning of the Hindu year. Born from the ocean foam, she holds a lotus in her hand.

LOKAPALA
Guardians of the eight directions (the four cardinal points and four intermediate points).

MADHU KAITABHA
Two demons who issued from the ear of Vishnu and were killed by him.

MAHAVIRA
"The Great Hero"; epithet of Vishnu.

MAHISHAMARDINI
"She who crushes Mahisha"; epithet of Durga.

MANDHATA
"Creator," "architect"; epithet of Brahma.

MANMATHA
One of the names of Kama, the god of love.

MATSYAVATARA
Incarnation of Vishnu as a fish.

MENA
Spouse of Himavan and mother of Uma, Ganga, and Mainaka; appears in the Puranas.

MOHINI
Alluring feminine form assumed by Vishnu to mislead the demons.

NALA
King of Nisada; spouse of Damayanti and hero of a famous love story recounted in the Mahabharata.

NANDA
Shepherd; adoptive father of Krishna.

NARANARAYANA
Name of two early sages, the sons of Dharma and Ahimsa; sometimes refers to Krishna and Arjuna.

NARASIMHA
Incarnation of Vishnu in the form of a lion.

NARAYANA
"Moving in the waters"; epithet of Vishnu.

NATESHA (NATARAJA)
Shiva as the king of dance.

PADMANIDHI
One of the nine treasures of Kubera; sometimes designates Kubera himself.

PARAMESHA
Name of the Supreme Being, most particularly Vishnu.

PASUPATA
Name of a weapon given to Arjuna by Shiva.

PATALA
The netherworld.

PATALAGANGA
One of the names of Ganga; given when she flows toward the netherworld.

PRITHVI
The earth goddess.

PRITI
One of the two consorts of Kama.

RADHA
Favorite milkmaid of Krishna, who symbolizes the human soul.

RAMA
King of the Solar Dynasty; son of Dasaratha, king of Ayodhya. He is the seventh incarnation of Vishnu. The story of this hero is the subject of a great Sanskrit epic by Valmiki.

RATI
"Love"; the goddess of love, spouse of Kama.

RATNAKARA
"Source of Pearls"; human form of the ocean.

RAVANA
Demon-king of Lanka. Having become invulnerable through asceticism, he spread terror and carried away Sita, the spouse of Rama.

RUDRA
This god has a destructive and terrible aspect and a benevolent aspect. He is also called Bhava, Sarva, Isana, Pasupati, Bhima, Ugra, and Mahadeva.

RUKMINI
Spouse of Krishna who carried her off from Sispula, the king of Cedi.

SADASHIVA
One of the forms of Shiva.

SARASVATI
Goddess of learning and of language; patroness of literature and art. Personification of the Saraswati River.

SASANKA
Name given to the moon.

SATYABHAMA
Daughter of Satrajita, one of the spouses of Krishna.

SHIVA
Third divine aspect of the Hindu trinity. God who is simultaneously destructive (as Bhairava) and creative (as Linga). He is often represented dancing (Nataraja). He is seen seated with a third eye on his forehead and his matted locks symbolizing the fall of Ganga. He is usually accompanied by Nandi, the sacred bull.

SITA
Daughter of Janaka and spouse of Rama; the goddess of agriculture (her name means "furrow").

SRI
One of the names of Lakshmi.

SUBRAHMANYA
One of the names of Kartikeya.

SUGRIVA
"He who has a beautiful neck." The king of the monkeys, he helped Rama who then aided him in reconquering his kingdom from Bali.

SURPANAKHA
Sister of Ravana.

SURYA
Sun-god; one of the three principal Vedic deities.

TARA
1. Wife of the monkey-king Bali and mother of Angada. After the death of Bali, she married his brother Sugriva.
2. Wife of Brihaspati.

TRIPATHAGA
"She who flows through the sky, the earth, and the netherworld"; one of the names of Ganga.

TRIVIKRAMA
Epithet of Vishnu; given because he crosses the universe in three steps.

UDAYANA
Prince of the Lunar Dynasty; king of Vatsa; spouse of Vasavadatta, princess of Ujjain.

UMA
"Light"; spouse of Shiva (see Devi). Also called Umamahesvara.

USA
"Dawn"; daughter of the sky; deity who is benevolent to humans.

VAIKUNTHANATHA
"Ruler of paradise"; epithet of Vishnu.

VANADEVATA
Forest goddesses.

VARAHA
Incarnation of Vishnu in the form of a boar.

VARUNA
The supreme god in the Vedas. He then became Lord of the Waters, a god similar to Neptune.

VAYU
God of the wind; father of Bhima and Hanumat; often associated with Indra.

VENUGOPALA
Epithet of Krishna.

VISHNU
Second divine aspect of the Hindu trinity; preservative power. He is incarnated in ten avatars, the principal of which are Krishna and Rama. His spouse is Lakshmi, and his mount is the sacred bird Garuda. He is often represented asleep on the serpent Sesha (Seshasayi).

VISHNUPADI
"Flowing from the foot of Vishnu"; name given to Ganga.

VISVANATHA
"God of the Universe"; epithet of Shiva.

YUDHISTHIRA
Oldest of the Pandava brothers; son of Dharma, god of justice. Married to Draupadi, he decided to share his wife with his brothers.

ARCHITECTS, SCULPTORS, AND PAINTERS

THE architects, sculptors, and painters in this list are limited to those mentioned in the text.

ARCHITECTS

BHOJA (1018–60)
Paramara sovereign, renowned for his encyclopedic spirit. Architect and engineer, he created the great reservoir that bears his name—Bhojasagara. Several temples are attributed to him.

GOBHANADEVA
Built the temple of Satrunjaya during the thirteenth century under the Chalukya dynasty.

MAHENDRAVARMAN I
Pallava sovereign. Poet, painter, and musician, he was also an architect and engineer. He built a rock-cut temple at Mandagapattu.

MALLOJA MANIYOIA
Thought to be the architect of the temple of Mahalakshmi at Dodda Gaddavalli, which was completed in 1130.

SARVASIDDHI
His name is mentioned in an inscription in the Virupaksa temple at Pattadakal. His disciple Revadi Ovajja worked on the sculptural decoration of the Papanatha temple which was built at the end of the seventh century at Pattadakal.

SUTRADHARI GUNDA
An inscription on the eastern portico of the Trailokyesvara temple at Pattadakal (eighth century) cites him as the architect of this temple.

USTAD ISA
Persian architect who is thought to be the builder of the Taj Mahal which Shah Jahan had erected at Agra during the seventeenth century.

SCULPTORS

BALADEVA
Son of Suggi-acharya. According to an inscription, he created the guardian figure that is one of the most beautiful sculptures from the portico of the Virupaksa temple at Pattadakal (built in the eighth century). He also worked on the nearby temple of Papanatha.

BALAKA
His name is inscribed in second-century characters on a sculpture from the shrine at Kondane.

CHANGAMHA
He worked on the sculptures of the Papanatha temple at Pattadakal (late seventh century).

DRONADITYA
Eighth-century sculptor whose name is known from an inscription on a statue in a Buddhist temple in Sirpur.

KANHA
Sculptor whose disciple was Balaka.

NAGARVARMA-SRIBAGAVARMAKRITA PRATIMA
Sculptor of the Yaksha Matanga and the Yakshi Ambika, masterpieces of Cave 32 at Ellora (ninth–tenth centuries).

PAKA
Creator of two pillars in the Sangamesvara temple at Pattadakal, built in the eighth century.

RAVI
Celebrated sculptor who built the Tiruvottiyur temple during the reign of Rajendra Choladeva I.

REVADI OVAJJA
Disciple of the architect Sarvasiddhi, he worked on the sculptures for the Papanatha temple at Pattadakal (late seventh century)

SOHILA
Sculptor mentioned on the base of a sculpture from the assembly hall of Cave 32 at Ellora (ninth-tenth centuries).

SOVARASI
Eleventh-century sculptor noted for his calligraphic skills. He incorporated animal forms in the letters he carved.

MOGUL PAINTERS

BASAWAN
Collaborated on the illustration of the Razm-Nameh, the Persian translation of the Mahabharata commissioned by Akbar. He was one of the first Mogul artists whose miniatures show a knowledge of European techniques.

BIHZAD
He was the protégé of the emperor Humayun, a great art lover.

BISHNANDAS
Painter at the court of Jahangir.

DASWANT
Son of a palanquin-bearer, he was apprenticed to the painter Abdus Samad and became one of the noted

artists at the court of Akbar. His signature appears on about a dozen of the miniatures for the Razm-Nama.

FARUKCHELA
Painter at the court of Akbar.

HARBANS
Painter mentioned in the Ain-i-Akbari (Institutes of Akbar), written in about 1595 by Abu-l Fazl, histo-

riographer of the emperor Akbar.

KESAVLAL and KHEMKARAN
Painters mentioned in the Ain-i-Akbari.

MADHU
Painter at the court of Akbar; known for his portraits and for several illustrations for Akbar Namah, a history of Akbar's reign written by Abu-l Fazl.

MANCHAR
Painter at the court of Akbar.

MANSUR
Animal painter; the best-known artist from the court of Jahangir, whose memoirs he illustrated.

MUKUND
Painter mentioned in the Ain-i-Akbari.

PHILOSOPHERS AND AUTHORS

From the second millennium B.C. through the first centuries of the Christian Era, religious texts formed the philosophical and literary heritage of India. Because of the ancient oral tradition, most of the works cannot be assigned to a single author.

VEDIC AND BRAHMANIC TEXTS
(20th–4th centuries B.C.)

The VEDA (Revelation) is divided into four collections of hymns and rituals (Samhitas): the RIG-VEDA (hymns); the YAJUR-VEDA (sacrificial formulas); the SAMA-VEDA (hymns); and the ATHARVA-VEDA (cosmology, magical formulas).

BRAHMANAS. Eight principal works. Speculations, cosmologies, and rituals, notably in the *Satapathabrahmana*.

ARANYAKAS. Forest treatises.

UPANISHADS. Exposition of the philosophy of the universal soul.

SUTRAS. Texts of Vedic rituals; civil code (DHARMASUTRA).

PANINI (6th century B.C.)
Author of the first Sanskrit grammar.

BUDDHISM AND JAINISM
(6th century B.C.–6th century A.D.)

SIDDHARTHA GAUTAMA, THE BUDDHA (563?–?483 B.C.)
Founder of Buddhism. His preaching was the basis of the canonical texts.

SUTTA. Collections of numerous texts in Pali. The Pali canon is divided into three sections (*pitaka*): VINAYA-PITAKA (monastic rules); SUTTA-PITAKA (book of sermons); and ABHIDAMMA-PITAKA (book of dogma).

JATAKAS. Collection of five hundred stories that form the basis of Buddhist iconography.

ASVAGHOSA (c. 1st century A.D.)
Dramatist and poet who wrote a life of Buddha (*Buddhacaritam*).

BUDDHAGHOSA (5th century), MAHANAMA (5th century), HARIBHADRA (10th century), DHAMMAKITTI (13th century). The major Buddhist commentators and biographers.

MAHAVIRA (d. 527 B.C.)
The principal founder of Jainism.

HALA (2nd–3rd centuries A.D.)
King who is thought to be the author of *Gathasaptasti*, a group of seven hundred hymns.

CLASSICAL PERIOD
(2nd century B.C.–10th century A.D.)

RAMAYANA (c. 4th century B.C.–1st century A.D.)
"The March of Rama." Verse epic by Valmiki which has seven books and tells episodes from the life of Prince Rama, an incarnation of Vishnu.

MAHABHARATA (4th century B.C.–4th century A.D.)
Epic tale of the great war of the Bharatas; contains many philosophic sections, notably the *Bhagavadgita* (the quintessence of Hindu thought).

VYASA
Compiler of the *Mahabharata*.

The Jain texts are usually written in one of the Prakrits, particularly that of Bihar, or in Sanskrit.

The PURANAS, or "ancient tales," are eighteen in number and were composed between the fourth and ninth centuries. They are divided into three groups—those dealing with Brahma, those with Vishnu, and those with Shiva. One of the most famous, the *Bhagavata Purana*, contains the story of Krishna, an incarnation of Vishnu.

PATANJALI (2nd century B.C.)
Author of the *Mahabhasya* (Great Commentary).

JAIMINI (c. 1st century A.D.)
Author of the *Mimamsasutras*.

DHARMASHASTRAS, "treatises on correct order." Eighteen fundamental texts, one of which is the *Manavadharmasastra* (Institutes of Manu).

SUDRAKA (4th century)
Author of the famous play *Mricchakatika* (The Little Clay Cart).

KALIDASA (4th–5th centuries)
Lyric and epic poet, author of *Kumarasambhava* (about the birth of Kumara, Shiva's son), *Raghuvamsa* (The Family of Raghu); *Meghaduta* (The Cloud Messenger), and *Rtusamhara* (The Round of the Seasons). Among his dramas are *Sakuntala* and *Vikramorvasi*.

VARARUCI (c. A.D. 500) and HEMACANDRA (1088–1172)
Authors of Prakrit grammars.

BHARAVI (6th century)
Author of the *Kiratarjaniya*, an epic telling of the combat of Arjuna and Shiva.

HARSADEVA (c. 606–648)
King-poet, author of *Nagananda* (The Happiness of Serpents), *Priyadarsika* (The Beautiful Lover), and *Ratnavali* (The Pearl Necklace).

BANA (7th century)
Author in Sanskrit of a prose tale (*Kadambari*) and of a history of King Harsha.

DANDIN (7th century)
Author of the *Adventure of Ten Princes*, a portrait of city life of the period.

APAR (7th century)
Tamil Shivaite saint.

BHARTRIHARI (7th century)
Author of three poems of one hundred verses each—*Sringara sataka* (On Love), *Niti-sataka* (On Ethics), and *Vairagya-sataka* (On Renunciation).

BHAVABHUTI (late 7th century)
Author of a poem inspired by the *Ramayana* and the court comedy *Malati-Madhava*.

SANKARA (8th century)
Most celebrated commentator on the *Vedanta* and on nondualist metaphysics.

MAGHA (early 8th century)
Author of the *Sisupalavadha*, which tells of the destruction of the demon Sisupala by the god Krishna.

ALVAR (6th–9th centuries)
Group of Vishnuite saints; authors of devotional texts in Sanskrit and Tamil.

RAJASEKHARA (c. 900)
Author of works on Sanskrit rhetoric and of six dramas.

THE MIDDLE AGES
(10th–18th centuries)

Beginning in the eleventh century the vernacular languages of the different regions of India tended to gradually supplant the Prakrits and Sanskrit as literary languages.

RAMANUJA (11th century)
Commentator on nondualistic philosophy.

SOMADEVA (11th century)
Author of the *Kathasaritsagara*, a collection of folk tales based on a Kashmiri version of the *Brihatkatha*.

JAYADEVA (12th century)
Author of the *Gitagovinda*, a poem in late Sanskrit telling of the loves of Krishna.

NIMBARKA (12th–13th centuries)
Philosophical commentator.

VALLABHA (1479–1531)
Commentator on nondualistic philosophy.

HINDI

CAND BARDAI (1159–92)
Author of a long poem, the *Prithvi Raj Raso*, which celebrates the exploits of King Prithviraj.

RAMANAND (1400–?70)
Renowned religious leader; author of Hindi hymns.

KABIR (1440–1518)
Poet and preacher whose oral teaching was collected by his disciples in three main works—*Bijak*, *Ramaini*, and *Sabda Sakhi*.

NANAK (1469–1538)
Disciple of Kabir and founder of the Sikh sect. His verse work, the *Japji*, is a prayer to the glory of God.

MIRABAI (1498?–1547)
Poetess devoted to Krishna; author of *Pada*, short religious poems.

SURDAS (1483–1563)
Blind poet of Agra; author of the *Sursagar*, hymns honoring Krishna.

MALIK MUHAMMAD JAYASI
Muslim poet. Author of the epic poem *Padmavata*, which is based on the historic episode of the seige of Chittor (1303).

TULSIDAS (1532–1623)
Author of numerous verse works. His principal work, the *Ramcaritmanas*, is based on the *Ramayana*.

DADU (1544–1603)
Founder of a religious sect based on the doctrine of Kabir.

BIHARI LAL
Author of the *Satsai*, a poetic tour de force in seven hundred stanzas.

URDU

MUHAMMAD KULI QUTUB SHAH (d. 1611)
King of Golconda; author of odes and elegiac poems.

VALI (b. 1638)
Author of lyric and narrative poems.

MIRZA MUHAMMAD RAFI (1713–80)
Poet also called Sauda.

BENGALI

RAMAI PANDIT (11th century)
Poet during the reign of King Dharmapala; author of the six *Sunya Puranas*.

KRITTIVASA (15th century)
Author of a Bengali version of the *Ramayana*.

CHANDIDAS (end of 15th century)
Authors of the religious songs *Sri Krsna kirtan*.

CAITANYA (15th–16th centuries)
Great mystic poet devoted to Krishna.

Until the beginning of the nineteenth century Bengali literature was composed of songs, or *mangala*.

MARATHI

GYANADEVA (1275–97)
Author of a commentary on the *Bhagavadgita*.

NAMADEVA (1270–1350)
Taught the bhakti doctrine as the road to salvation.

EKNATHA (15th century)
Author of works based on the *Bhagavata Purana* and of a summary of the *Ramayana*.

MUKTESVARA (1599–1649)
First author of secular works.

RAMDAS (1608–?)
Taught a religion free of all dogma and fought against foreign domination.

TUKARAM (1609–49)
Taught the doctrine of bhakti through kirtan.

GUJARATI

SOMASUNDARA (1374–1446)
Author of religious works in verse and prose.

PADMANABHA (15th century)
Descendant of the hero who is the subject of his narrative poem, the *Kanhadadeprabandha*.

NARASIMHA MEHTA (16th century)
Author of the *Srngaramala* (The Rosary of Love), a collection of short religious poems honoring Krishna.

ASSAM

SANKARA DEVA (1449–69)
Vishnuite reformer; disciple of Caitanya; author of kirtans.

BHATTA DEVA (15th–16th centuries)
Prose writer; author of the *Kathagita*.

TAMIL

Early Tamil literature (from the time of Sangam) is found in three collections: *Pattuppattu* (ten idylls); *Ettuttogai* (eight collections); and *Patinekilkkankku* (eighteen didactic poems).

TIRUVALLUVAR (fl. 800–1000)
Author of a didactic poem, the *Kural*, fostered Shivaism in southern India.

TIRUTTAKKADEVAR (11th century)
Jain ascetic; author of the *Cintamani* (Book of Marriages).

MAYKANDAR (beginning of 13th century)
Author of a brief Shivaite treatise.

TELUGU

NANNIAH (11th century)
Translator of the *Mahabharata*.

SRINATHA (1365–1440)
The greatest Telugu poet; the themes of his works are taken from Sanskrit literature.

VEMANA (second half of 15th century)
Advaita Shivaite; advocated worship without rituals and images.

PINGALA SURANA (16th century)
Author of celebrated kavyas, notably *Raghava-Pandaviya*.

RAMARAJA-BHUSANA
Disciple of Pingala Surana; wrote *Vasu Caritra*.

KANNADA

PONNA
Jain author of the *Santi Purana*.

RANNA (10th century)
Author of Jain Puranas.

BASAVA (12th century)
Shivaite author of folk works in prose.

NEMI CANDRA (12th century)
Author of first known novel, *Lilavati*, which is written in *campū* style (alternating passages of verse and prose).

SARVAJNA MURTI (17th century)
Author of a very popular poem, the *Sarvajnapadagalu*.

BHATTAKALENDEVA (17th century)
Jain sage; published the first grammar of the Kannada language.

INDIAN RULERS

ARYAN PERIOD

(1600–600 B.C.)

PARIKSIT, first king of the Kuru. Semilegendary, he was the successor of Yuddhisthira (Mahabharata).

JANAMEJAYA (c. 1400 B.C.), associated with the serpent cult.

BIMBISARA (late sixth century B.C.), founder of the Magadha Empire.

UDAYANA (sixth century B.C.), king of Vatsa, whose capital was Kausambi near Allahabad.

FROM THE MAURYAS TO THE SATAVAHANAS

(fourth century B.C.–third century A.D.)

CHANDRAGUPTA (c. 313 B.C.), founder of the Maurya dynasty. He entered into battle against Alexander the Great, defeated his general Seleucus Nicator, and gained control of a vast territory bounded by Afghanistan, Bengal, and the Narbada River.

BINDUSARA (third century B.C.), son and successor of Chandragupta.

ASOKA (268–233 B.C.), Mauryan emperor who gained control of Orissa and converted the empire to Buddhism. His numerous inscriptions are a valuable source of information.

MAHENDRA (first century B.C.), brother of Asoka, responsible for the spread of Buddhism in southern India, especially in the Chola kingdom, and in Ceylon.

VIKRAMADITYA (c. 57 B.C.), renowned king of Ujjain who founded the Vikrama Era. He fought against the Saka and established his authority over northern India.

KANISHKA (A.D. 78–101), ruler of the Kushan Empire (northwest India and several provinces of eastern Turkestan). He began the Saka Era (A.D. 78) and converted to Buddhism.

GAUTAMIPUTRA (c. 106–125), the most important king of the Satavahana (or Andhra) dynasty. He conquered the Saka, the Indo-Greeks, and the Pallavas and established the power of the Satavahana kings.

CLASSICAL PERIOD

(fourth–sixth centuries)

CHANDRAGUPTA I (320–?330), the first Gupta king. With the disintegration of the kingdoms established in the Punjab (Kushan), Gujarat (Saka), and Malwa, he gained control in Oudh (Allahabad and Magadha).

SAMUDRAGUPTA (330–375), son and successor of Chandragupta I. Noted for his conquests, he extended the Gupta Empire from the Himalayas in the north to the Narbada River in the south and from the Brahmaputra River in the east to the Jamuna and Chambal rivers in the west. He was also a poet and an accomplished musician.

MEGHAVARNA (352–379), king of Ceylon who established diplomatic relations with Samudragupta.

CHANDRAGUPTA II (375?–413) expanded the empire westward through Gujarat and Saurashtra, thus gaining control of several ports that traded with the West and the holy city of Ujjain. During his reign literature and art achieved their full flowering.

KUMARAGUPTA I (413–455) maintained the geographical boundaries of the empire and established a strong administrative structure.

SKANDAGUPTA (455–467) repelled the invading Huns and achieved glorious victories. However, by the end of his reign the Gupta Empire had begun to disintegrate.

JAYAVARMAN (484–?541), contemporary of the Guptas and the first king of the Eastern Ganga dynasty.

KASSAPA I (fifth or sixth century), king who is depicted in the famous frescoes in Sigiriya, Ceylon.

YASODHARMAN (?–540), conqueror of the Huns. He opposed the Gupta emperor and carved out a vast empire in northern India.

PULAKESIN I (sixth century), first Chalukyan king. He founded this dynasty in 566 in the Deccan, and his capital was Vatapi (now Badami).

KIRTIVARMAN I (sixth century), son of Pulakesin I. Through his conquests, he extended the political influence of the Chalukyas into Maharashtra, Mysore, and Madras.

SIMHAVISHNU (second half of sixth century), king of the Pallava dynasty (the rivals of the Chalukyas). He controlled southern India as far as Ceylon and is depicted on a bas-relief from Mahabalipuram.

HARSHAVARDHANA (606–647), king of northern India. Several successful military campaigns made him the most powerful monarch in northern India and the rival of Pulakesin II. He maintained cordial relations with China.

MAHENDRAVARMAN I (600–630), Pallava king. After renouncing Jainism and adopting Shivaism, he built a number of celebrated temples in southern India.

NARASIMHAVARMAN I (?–645), the most illustrious of the Pallavas. The conqueror of Pulakesin II at Badami, he succeeded in invading Chalukyan territory.

PULAKESIN II (608–642), the most illustrious king of the Chalukya dynasty. One by one he defeated the Pallavas, the Gangas, the Alapas of Mysore, and the Mauryas of Konkan. His power extended from the Gulf of Oman to the Bay of Bengal. He built several temples at Aihole.

DURLABHAVARDHANA (seventh century), founder of the Karkota or Naga dynasty of Kashmir.

VIKRAMADITYA I (655–680), the youngest son of Pulakesin II. He overcame his brothers and restored the prestige of the Chalukya monarchy. He supported Jainism.

PARAMESVARAVARMAN I (?–695), Pallava king. The grandson of Narasimhavarman I, he was the great rival of Vikramaditya I.

VIKRAMADITYA II (733–746), Chalukya king. He fought against the Pallavas, especially Nandivarman II, and conquered Kanchi.

CHANDRAPIDA (first half of eighth century), king of the Naga dynasty.

LALITADITYA (eighth century), younger brother and successor of Chandrapida. He extended his control to the Cauvery River in the east, the Dwaraka River in the west, and the mountainous regions of the northwest.

THE MUSLIM INVASIONS AND
THE KINGDOMS OF CENTRAL AND SOUTHERN INDIA

(eighth–tenth centuries)

DANTIDURGA (?–757), son of the Rashtrakuta leader Indra I. The vassal of Vikramaditya II, he repelled the Muslim invasion of Gujarat in 738.

NANDIVARMAN II PALLAVAMALLA (696–782), Pallava king. Ascending the throne at the age of twelve, he opposed the joint forces of the Chalukyas and the Pandyas.

KRISHNARAJA I (second half of eighth century), Rashtrakuta king. He decisively conquered the Chalukya king Kirtivarman. He then attacked the Gangas and occupied their capital, Manyapuram. He built the monolithic temple of Kailasa at Ellora.

DHRUVA (second half of eighth century), Rashtrakuta king who gained control of the entire Deccan.

VATSARAJA (second half of eighth century), Pratihara king of Gujarat. He ascended the throne about 778.

DHARMAPALA (770–802), ruler of Bengal. He extended his kingdom to Kanauj despite

sometimes successful opposition from the Pratiharas and Rashtrakutas. A great patron of Buddhism, he founded many monasteries.

GOVINDA III (793–814), son of Dhruva. He controlled the Deccan to Kanchi and received the submission of Dharmapala.

DANTIGA (early ninth century), son of Nandivarman III, Pallava king of Kanchi.

NAGABHATTA II (first half of ninth century), Pratihara king. Son of Vatsaraja, he occupied Kanauj.

AMOGHAVARSA I (814–?877), Rashtrakuta king. He engaged in frequent wars against the Eastern Chalukyas, the kings of Vengi, and the Gangas.

VIJAYALAYA (?–871), founder of the Chola dynasty at Tanjore; vassal of the Pallavas.

NANNUKA (early ninth century), founder of the Chandella dynasty in Bundelkhand.

MIHIRA BHOJA (836–882), Pratihara king of Kalanjara. Defeated by Devapala, he later gained an impressive victory over Narayanapala and conquered a large part of his territories.

ADITYA I (871–?907), son and successor of Vijayalaya.

NRIPATUNGAVARAM (872–?913), son of Nandivarman III of the Pallava dynasty. He is noted for his victories over the Pandyas.

KRISHNARAJA III (939–?968), last great king of the Rashtrakuta dynasty. At several times he controlled Kanchi and Tanjore.

MAHENDRAPALA I (890–?907), son of Bhoja of the Pratihara dynasty. He was a patron of literature and the arts, and the poet Rajasekhara, the author of the *Karpuramanjari*, was a member of his court.

THE GHAZNEVID AND CHOLA ERA

(tenth–eleventh centuries)

MAHIPALA (910–940), Pratihara ruler. He controlled a large kingdom whose capital was Kanauj and which extended to Multan in the west and the Rashtrakuta kingdom in the south.

PARANTAKA (?–953), son of Aditya I of the Chola dynasty of Tanjore. He held Madura and defeated the Pandya king Rajasimha II and his Ceylonese allies at Vellore in 915.

YASOVARMAN (?–960), son of King Harsha; contemporary and rival of the Pratihara king Devapala.

MULARAJA (962–995), founder of the Solanki dynasty (962), a branch of the Chalukya dynasty. He annexed Saurashtra and Cutch.

JAYAPALA (?–1001), king of the Punjab.

DHANGGA (950–1002), Chandella king, the son of Yasovarman. He inherited the large kingdom conquered by his father. He built several temples at Khajuraho.

RAJARAJA I CHOLA (985–1014), Chola ruler who is called Rajaraja the Great. He conquered the Chera kingdom and the greater part of southern India, including Ceylon.

MAHMUD OF GHAZNI (997–1030), Muslim sultan called the "Idol Smasher." He invaded India seventeen times and made the Punjab an outlying province of his Afghan kingdom.

GANGEYADEVA VIKRAMADITYA (?–1041), Kalacuri king.

BHOJA (1000–1060), Paramara king of Malwa who extended his kingdom into Konkan and to the Godavari River.

KIRTIVARMAN (second half of the eleventh century), Chandella king.

TURKISH DOMINATION

(tenth–thirteenth centuries)

RAJENDRACHOLADEVA I (1014–1035), son of Rajaraja I Chola. He extended his kingdom while overcoming the Pandya kings and the rulers of Kerala and Ceylon. He was a great patron of Vedic and philosophical studies.

KULOTTUNGA I (1070–1120), ruler also known as Rajendra II. He belonged to both the Chalukya and Chola dynasties and sought to unite their two kingdoms.

VIKRAMADITYA VI (1075–1125), Chalukya ruler. He attacked the Cholas and took Kanchi in about 1085.

JAYASIMHA SIDDHARAJA (eleventh–twelfth centuries), Chalukya ruler of Gujarat.

PARAKRAMABAHU (?–1186), king of Ceylon. Through his mother he was a member of the Ganga dynasty of Kalinga.

PRITHVIRAJ (?–1192), last Rajput king of Delhi and Ajmer; killed at Battle of Tarain (1192) by Mohammed of Ghor.

SOMESVARA IV (?–1200), last Chalukya king.

MOHAMMED OF GHOR (1173–1206), most important ruler of the Ghuri dynasty of Persia. Founder of Muslim power in India, he defeated the Ghaznevids and took possession of the Punjab and Rajasthan after defeating Prithiviraj.

VIRA BALLALA I (1173–1220), Hoysala king. The son and successor of Vijaya Narasimha, he fostered Jainism.

BHIMADEVA II (twelfth–thirteenth centuries), Chalukya king.

NARASIMHA II (?–1234), Hoysala king. He fought against the Yadavas and the Pandyas.

THE SULTANATE OF DELHI

(twelfth–fifteenth centuries)

ILTUTMISH (1211–36), third and greatest sultan of Delhi of the Slave Dynasty. Born a slave, he conquered almost all the Hindu kings who opposed him.

SINGHANA (?–1247), Yadava king. He attempted to establish his sovereignty over all of the Deccan but was successfully opposed by the Hoysala kings.

JATAVARMAN SUNDARA PANDYA I (?–1268), Pandya king. He succeeded in defeating the Cheras, Hoysalas, Cholas, and Yadavas and reigned in northern Ceylon.

BALBAN (1266–87), penultimate king of the Slave Dynasty. He succeeded in reconstituting the Sultanate of Delhi.

RAMACANDRA (thirteenth century), Yadava king of Devagiri.

ALA-UDDIN (1295–1315), second king of Khilji dynasty in India. Suzerain of Allahabad, he conquered the Deccan and then took the throne of Delhi. His great power was based on a strong administrative structure. He conquered a large part of the western and southern kingdoms. Many forts and mosques were constructed during his reign.

GHIYAS-UD-DIN TUGHLAK (1321–25), founder of the Tughlak dynasty, also known as Tughlak Shah. During his short reign he restored the power of the Delhi throne.

VIRA BALLALA III (?–1327), Yadava king. He defended his kingdom against his Hindu rivals, the Pandyas, and against the Muslims.

MALIK KAFUR (?–1316), Hindu slave converted to Islam. He extended the Muslim domination through southern India.

HARIHARA and BUKKA I (first half of fourteenth century), two brothers who founded the city of Vijayanagar in 1335 and the kingdom of the same name.

ALAUDDIN BAHMAN SHAH (1291–1358), founder of the Bahamani kingdom (Deccan), of which the capital was first Gulbarga and then Bidar.

MOHAMMED SHAH (1358–75), second king of the Bahamani dynasty. He waged war against the Vijayanagar kingdom.

MOHAMMED TUGHLAK (1325–51), second Tughlak sultan of Delhi. He extended his kingdom to Madura. An eccentric man, intelligent but without political sense, he provoked bloody revolts by his tyranny.

FIRUZ SHAH III (1351–88), third king of the Tughlak dynasty. Although victorious in Orissa, he could not prevent the progressive disintegration of the Sultanate and the weakening of the army.

HARIHARA II (1377–1404), Vijayanagar king who fought successfully against the Bahamanis.

DEVARAYA I (1406–22), third Vijayanagar king. He battled against the Bahamanis, the Velamas, and Gajapati, the king of Orissa.

FIRUZ SHAH (1397–1422), eighth Bahamani sultan. He led many campaigns against the Vijayanagars with varying success. He built many beautiful mosques in his capital, Gulbarga.

DEVARAYA II (1425–46), Vijayanagar ruler. He extended his kingdom from the Kistna River to Ceylon and gained control of Kerala. A warrior-king, he was also a great patron of literature and the arts.

RANA KUMBHA (1431–69), sovereign of Mewar who fought against the Muslim rulers of Malwa and Gujarat.

SIKANDAR SHAH LODI (1489–1517), second sultan of the Lodi dynasty.

IBRAHIM LODI (1517–26), third sultan of the Lodi dynasty. He was defeated and killed by Babar at Panipat.

RANA SANGA (1482–1528), king of Mewar. He also defeated Ibrahim Lodi.

KRISHNADEVARAYA (1509–20), Vijayanagar king. He defeated the sultan of Bijapur, and after a hard campaign he concluded a treaty with Gajapati, the king of Orissa.

THE MOGUL EMPIRE

(sixteenth–eighteenth centuries)

BABAR (1506–30), king of Kabul, born of a Turkish father and Mogul mother. He conquered Samarkand in 1511 and the Punjab in 1523. Victorious at Panipat (1526), he occupied Delhi and then Agra. He defeated Rana Sanga and the Afghan rulers of Bihar and Bengal.

SHER KHAN (1540–45), Afghan ruler. He gained control of Bengal and then conquered Delhi, the Punjab, Rajputana, Malwa, and Bundelkhand, thus forcing Humayun to flee into Persia.

HUMAYUN (1530–56), son of Babar. Forced to flee by Sher Khan, he reconquered his kingdom and occupied Delhi and Agra in 1555.

AKBAR THE GREAT (1556–1605), son of Humayun. Gifted with a remarkable intelligence, strength, and personality, he conquered all of northern India, from west to east, and southern India to the Narbada River. Tolerant and a good administrator, he abolished discrimination against the Hindus and allowed them to share in the administration of his kingdom.

RANA PRATAP (1540–97), king of Mewar. He mounted a fiery resistance against the Moguls and prevented the complete conquest of Mewar by Akbar.

JAHANGIR (SALIM) (1605–27), son of Akbar and a Rajput princess of Amber. Crowned emperor in 1605, he married the celebrated Nur Jahan, who greatly influenced him.

AMAR SINGH (1597–1620), son of Rana Pratap. After a fierce war he regained his territories from Jahangir.

SHAH JAHAN (KHURRAM) (1627–58), son and successor of Jahangir. He married the beautiful Mumtaz Mahal. During his reign art and literature flourished; and to him we owe the Red Fort of Agra and the admirable Taj Mahal.

SIVAJI (1627–80), founder of the Maratha power in India. He defied the Mogul emperors and founded an independent Maratha kingdom.

AURANGZEB ALAMGIR (1659–1707), last of the great Mogul kings. He was forced to wage war constantly to preserve the integrity of his empire. His religious intransigence caused numerous revolts, and the corruption of his administration was a sign of the empire's decadence.

MUAZZIM or BAHADUR SHAH I (1707–12), son and successor of Aurangzeb.

TIPU SAHIB (1782–99), sultan of Mysore. Son of Haider Ali, he held the English at bay, thanks to his energy and military genius.

HISTORICAL CHRONOLOGY

From 2500 B.C. to A.D. 1750

According to traditional Indian sources, the history of India begins in the third millennium B.C. This date is confirmed by the archaeological finds at Mohenjo-Daro and Harappa—the remains of the vanished Indus Valley civilization. However, recorded history in a true sense begins only with the invasion of India by Alexander the Great.

2500 B.C.	Date of seals discovered in the Indus Valley
527	Death of Mahavira, the founder of Jainism
483?	Death of Buddha
327	Invasion of India by Alexander the Great
313?	Chandragupta Maurya begins reign
268–233	Reign of Asoka
185	The Maurya dynasty is succeeded by the Sunga dynasty
57	Beginning of the Vikrama Era
78–120 A.D.	Beginning of the Saka Era and of the reign of Kanishka
226	Establishment of the Sassanidae dynasty in Persia
320	Beginning of the Gupta Era
413–455	Kumaragupta I
455–467	Reign of Skandagupta
533	Yasodharman repels the Huns
c. 566	Accession of the Chalukya king Kirtivarman I
606–647	Reign of Harshavardhana
608	Crowning of Pulakesin II
629–645	Travels of Hsüan Tsang in India
634	Inscription at Aihole referring to Kalidasa and Bharavi
637	First Arab invasion of Sind
645	End of reign of the Pallava ruler Narasimhavarman I
710–713	Second Arab invasion of Sind; Arab capture of Multan
753	Beginning of the Rashtrakuta dynasty
c. 778	Accession of Vatsaraja, first king of the Pratihara dynasty
871–?907	Aditya I, son of Vijayalaya and founder of the Chola dynasty of Tanjore
962	New branch of the Chalukya dynasty founded by Mularaja
985–1014	Reign of Rajaraja I Chola
997	Accession of Mahmud of Ghazni, who gained control of Kanauj and plundered the temple at Sarnath

1175	Invasion of the Punjab by Mohammed of Ghor
1192	The Rajput king Prithviraj conquered by Mohammed of Ghor at Tarain
1200	Muslim conquest of Bihar and Bengal
1211	Iltutmish begins the Delhi Sultanate
1221	Invasion of Genghis Khan
1296	Ala-Uddin Khilji gains control of the Delhi throne
1302	Capture of Chittor by Ala-Uddin Khilji
1321	Beginning of the Tughlak dynasty
1335	Establishment of the Vijayanagar kingdom
1347	Establishment of the Bahamani kingdom in the Deccan
1398	Invasion of Tamerlane
1420	Niccolò de' Conti visits the Vijayanagar kingdom
1431–69	Reign of Rana Kumbha in Mewar
1451	The Delhi throne passes from the Lodi dynasty to the Tughlaks
1469	Birth in the Punjab of the first Sikh guru, Nanak (d. 1538)
1489–90	Sultanates of Bijapur and Ahmadnagar become independent
1497–98	First voyage of Vasco da Gama
1506	Albuquerque becomes viceroy of Portuguese lands in Asia
1510	Goa is captured by the Portuguese
1526	First Battle of Panipat. Barbar gains the throne of Delhi and establishes Mogul power in India.
1530	Babar is succeeded by Humayun
1533	Second capture of Chittor by Bahadur Shah
1540	Sher Khan defeats Humayun at Kanauj
1555	Humayun regains the Delhi throne and dies the following year
1561	Akbar, Humayun's successor, conquers Malwa
1564	Abolition of the tax levied on non-Muslims
1565	Destruction of the city of Vijayanagar after the defeat of Talikota
1571	Akbar founds the city of Fatehpur Sikri
1579	Promulgation of decree of infallibility by Akbar
1586	Akbar annexes Kashmir
1591	Akbar annexes Sind
1592	Akbar annexes Orissa
1595	Akbar annexes Baluchistan
1600	Charter granted to the East India Company by Elizabeth I of England
1609	Establishment of a Dutch factory at Pulikat
1605	Death of Akbar, accession of Jahangir
1611	Marriage of Jahangir and Nur Jahan
1612	English factory established at Surat
1615	Arrival of Sir Thomas Roe in India
1627	Birth of Sivaji, founder of the Maratha power
1627	Shah Jahan is proclaimed emperor
1631	Death of Mumtaz Mahal, wife of Shah Jahan

1639	English establish Fort Saint George in Madras
1651	Establishment of a Dutch factory at Hughli
1657	Shah Jahan's illness precipitates a war of succession
1659	Crowning of Aurangzeb
1661	Closing of the port of Bombay to the English
1664	Sivaji sacks Surat; the French Compagnie des Indes Orientales is established
1668	Aurangzeb promulgates anti-Hindu edicts
1669	Revolt of the Jats
1674	Establishment of Pondicherry
1677	Victories of Sivaji in Karnatak
1686–87	Aurangzeb conquers Bijapur and Golconda
1689	Execution of Sambuji, son and successor of Sivaji
1692	Renewal of Maratha attacks
1689	Beginning of major territorial acquisitions by the English East India Company
1707	Death of Aurangzeb
1739	Sack of Delhi by the Persian Nadir Shah
1742	Maratha invasion of Bengal
1744–48	French-English war in Karnatak

BIBLIOGRAPHY

ACHARYA, P. K. *Indian Architecture According to Manasara Silpasastra*. Oxford, 1921.

———. *A Dictionary of Hindu Architecture*. London, 1927.

———. *Architecture of Manasara*. London, 1933.

———. *Manasara on Architecture and Sculpture*. London, 1933–34.

AGRAWALA, VASUDERA S. *Guide to the Archaeological Sections of the Provincial Museum, Lucknow*. Allahabad, 1940.

———. "The Terracottas of Ahichchhatra." *Ancient India*, no. 4. Bulletin of ASI (1947–48).

———. "Gupta Art." JUPHS (1948).

———. "Catalogue of the Mathura Museum." JUPHS (1948–52).

———. "A Catalogue of the Brahmanical Images in Mathura Art." JUPHS 22 (1949).

———. *Sarnath*. New Delhi, 1957.

———. *Indian Miniatures: An Album*. New Delhi, 1961.

AIYANGAR, P. T. S. *Bhoja-Raja*. Madras, 1931.

AIYAR, V. NATESA. "Trimurti Image in the Peshawar Museum." Annual Report of ASI (1913–14).

ALLAN, J. *Catalogue of the Coins of the Gupta Dynasties*. London, 1914.

———. *Catalogue of the Coins of Ancient India*. London, 1936.

ANDREWS, F. H. *The Influence of Indian Art*. London, 1925.

———. *Wall Paintings from Ancient Shrines in Central Asia*. London, 1948.

ANNIGERI, A. M. *A Guide to the Pattadakal Temples*. Dharwar, 1961.

ANUJAN, ACHAN P. "The Marriage Scene of Uma as Depicted on the Walls of the Mattancheri Palace." JISOA 3 (1935).

———. "Two Scenes from the Ramayana Paintings on the Walls of the Mattancheri Palace." JISOA 4 (1936).

ARAVAMUTHAN, T. G. *South Indian Portraits in Stone and Metal*. London, 1930.

———. *Portrait Sculpture in South India*. London, 1931.

———. "A Fragment of an Ancient Painting in the Dekhan." JOR 13 (1939).

ARCHAEOLOGICAL SURVEY OF INDIA. *Annual Reports*. Calcutta, 1904–5, 1907–8, 1908–9, 1909–10, 1910–11, 1911–14, 1915–16, 1916–17, 1917–18, 1922–23.

———. *Ajanta Murals*. 1969.

ARCHER, WILLIAM G. *Indian Painting in the Punjab Hills*. London, 1952.

———. *Indian Painting*. London, 1956.

———. *Indian Miniatures*. London, 1960.

ARTHASASTRA. Edited and translated by R. Shama Sastri. Mysore, 1924.

ARTHAUD, J., AND GROSLIER, B. *Angkor*. New York, 1957.

ARUNACHALAM, SIR P. "Polonnaruva Bronzes and Siva Worship and Symbolism." JRAS 24 (1917): 68.

———. "Ancient Bronzes of the Colombo Museum." *Spolia Zeylanica* 6.

ASHTON, SIR LEIGH. *The Art of India and Pakistan: Catalogue of the Exhibition at the Royal Academy of Arts*. London, 1947–48.

AUBOYER, JEANNINE. *Arts et Styles de l'Inde*. Paris, 1935.

———. "Composition and Perspective at Ajanta." *Art & Letters: India and Pakistan*, New Series 22 (1948).

———. *Daily Life in Ancient India (from 200 B.C. to 700 A.D.)*. London, 1961.

AYMONIER, E. *Le Cambodge*. 3 vols. Paris, 1900–1904.

AYYAR, P. V. JAGADISH. *South Indian Shrines*. Madras, 1922.

AYYAR, V. VENKATASUBBA. *South Indian Inscriptions*. Vol. 12. Madras, 1943.

BACHHOFER, LUDWIG. *Early Indian Sculpture*. 2 vols. New York, 1929.

———. "The Influence of Early Indian Sculpture into Funan." JGIS 2 (1935).

BALASUBRAHMANYAM, S. R. *Early Chola Art*. London, 1966.

———. *Early Chola Temples (A.D. 907–985)*. New Delhi, 1971.

BANERJEA, JITENDRA NATH. "Surya (Adityas and the Navagrahas)." JISOA 16 (1948).

———. *The Development of Hindu Iconography*. 2d. ed., rev. Calcutta, 1956.

BANERJI, R. D. "The Temple of Siva at Bhumara." MASI, no. 16 (1924).

———. "Bas-reliefs of Badami." MASI, no. 25 (1928).

———. "The Haihayas of Tripuri and Their Monuments." MASI (1931).

———. *The Age of the Imperial Guptas*. Benares, 1933.

———. "The Eastern School of Medieval Sculpture." ASINIS (1933), New Delhi.

BANERJI-SASTRI, A. "The Lomas Rishi Cave Facade." JBORS 12 (1926).

BARNETT, LIONEL DAVID. *Antiquities of India*. London, 1913.

BARRETT, DOUGLAS E. *Sculptures from Amaravati in the British Museum*. London, 1954.

———. *A Guide to the Karla Caves*. Bombay, 1957.

———. *A Guide to the Buddhist Caves of Aurangabad*. Bombay, 1957.

———. *The Temple of Virattanesvara at Tiruttani*. Bombay, 1958.

———. *Hemavati*. Bombay, 1958.

———. *Ter*. Bombay, 1960.

———. "A Group of Bronzes from the Deccan." *Lalit Kala*, nos. 3–4.

———. *Early Chola Bronzes*. Bombay, 1965.

BARRETT, DOUGLAS E., AND DIKSHIT, MORESHWAR G. *Mukhalingam Temples, Sirpur and Rajim Temples*. Heritage of Indian Art, vol. 2. Bombay, 1960.

BARRETT, DOUGLAS E., AND GRAY, BASIL. *Paintings of India*. Treasures of Asia Series. Lausanne, 1963.

BARUA, BENIMADHAB. *Gaya and Bud-dha-Gaya.* 2 vols. Calcutta, 1931–34.
——. *Bharhut.* 3 vols. Calcutta, 1934–37.

BERNET KEMPERS, AUGUST J. *The Bronzes of Nalanda and Hindu-Javanese Art.* Leiden, 1933.
——. *Cultural Relations between India and Java.* Calcutta University Readership Lectures, 1935. Calcutta, 1937.
——. *Ancient Indonesian Art.* Cambridge, 1959.

BEYLIE, L. DE. *L'Architecture hindoue en Extrême-Orient.* Paris, 1907.

BHANDARKAR, D. R. "Jaina Iconography." Annual Report of ASI (1905–1906).
——. "The Temples of Osia." Annual Report of ASI (1908–1909).
——. "Excavations at Besnagar." Annual Report of ASI (1913–14; 1914–15).
——. "The Architectural Remains and Excavations at Nagari." MASI, no. 4 (1920).
——. "Some Temples in Mt. Abu." *Rupam* 3 (1920).
——. *Lectures on Ancient Indian Numismatics.* Calcutta, 1921.

BHANDARKAR, R. G. *Vaishnavism, Saivism and Minor Religious Systems.* Poona, 1938.

BHARUCHA, SILLO. "The Sun Temple at Modhera." *Marg* 5.

BHATTACHARYA, BENOYTOSH. *Buddhist Iconography.* London, 1924.

BHATTACHARYA, B. C. *Indian Images.* Calcutta, 1921.
——. *The Jaina Iconography.* Lahore, 1939.

BHATTASALI, N. K. *Iconography of Buddhist and Brahmanical Sculptures in the Dacca Museum.* Dacca, 1929.

BHISHAM PAL, H. *The Temples of Rajasthan.* Jaipur, 1969.

BHOOTHALINGAM, MATHURAM. *Movement in Stone.* New Delhi, 1969.

BHUSHAN, J. B. *Indian Jewellery, Ornaments and Decorative Designs.* Bombay, 1964.

BIDYABINODA, BINODA BIHARI. "An Illustrated Note on an Indian Deity Called Revanta." *Journal of the Asiatic Society of Bengal* (1909).
——. "Varieties of the Vishnu Image." MASI, no. 2 (1920).

BINYON, LAWRENCE. *Examples of Indian Sculpture at the British Museum.* London, 1910.
——. *The Court Painters of the Grand Moghuls.* Oxford, 1921.

BIRDWOOD, SIR G. *Industrial Arts of India.* London, 1880.

BLOCH, T. "Excavations at Lauriya." Annual Report of ASI (1906–1907).
——. "Notes on Bodh Gaya." Annual Report of ASI (1908–1909).

BOISSELIER, JEAN. *La Statuaire khmère et son évolution.* 2 vols. Saigon, 1955.
——. *La Statuaire du Champa: Recherches sur les cultes et l'iconographie.* Publications de l'École française d'Extrême-Orient, vol. 54. Paris, 1963.

BOSE, N. K. *Canons of Orissan Architecture.* Calcutta, 1932.

BOSE, P. N. *Indian Teachers of Buddhist Universities.* Madras, 1923.
——. *Principles of Indian Silpasastra.* Lahore, 1926.
——. *The Indian Colony of Champa.* Madras, 1936.

BROWN, J. C. *The Coins of India.* London, 1922.

BROWN, PERCY. *Picturesque Nepal.* London, 1912.
——. *Indian Painting.* Oxford, 1918.
——. *Indian Painting Under the Mughals.* Oxford, 1924.
——. *Indian Architecture (Buddhist and Hindu Periods).* Bombay, 1942.
——. *Indian Architecture (Islamic Period).* Bombay, 1942.

BUHLER, G. *Specimens of the Jaina Sculptures from Mathura.* London, n.d.
——. "Votive Inscriptions of the Sanchi Stupa." EI 2 (1894).

BUHOT, J. "La Découverte récente de peintures murales Pallava, par M. Jouveau-Dubreuil." *Bulletin des Amis de l'Orient* 10 (1931), Paris.

BURGESS, JAMES. *The Rock Temples of Elephanta or Gharapuri.* Bombay, 1871.
——. "Antiquities of Kathiawar and Kutch." ASI 2 (1876).
——. *Rock Temples of Ellora.* Bombay, 1877.
——. *Report on the Antiquities in the Bidar and Aurangabad Districts.* London, 1878.
——. "Notes on the Buddhist Rock Temples of Ajanta and the Paintings of the Bagh Caves." ASI 9 (1879), Bombay.
——. *Notes on the Amaravati Stupa.* Madras, 1882.
——. "Report on the Buddhist Cave Temples." ASINIS 4 (1883), London.
——. "Report on the Ellora Cave Temples." ASINIS 5 (1883), London.
—— *The Buddhist Cave Temples and Their Inscriptions.* London, 1883.
——. *The Buddhist Stupas of Amaravati and Jaggayyapeta.* London, 1887.
——. *The Ancient Monuments, Temples and Sculptures of India.* 2 vols. London, 1897–1910.

——. "The Gandhara Sculptures." JIAI 8 (1900), London.
——. "Mohammaden Architecture of Ahmedabad." ASI 7 (1900).

BURGESS, JAMES, AND COUSENS, HENRY. *Antiquities of the Town of Dabhoi in Gujarat.* London, 1888.
——. *Mohammaden Architecture of Gujarat.* London, 1896.
——. "Architectural Antiquities of Northern Gujarat." ASI 9 (1903), London.

BUSSAGLI, M. *Paintings of Central Asia.* Geneva, 1963.

CHANDA, RAMAPRASAD. "Archaeology and Vaishnava Tradition." MASI (1920).
——. "Medieval Sculptures in East India." Calcutta University, *Journal of the Department of Letters*, no. 3 (1920).
——. "The Mathura School of Sculpture." Annual Report of ASI (1922–23).
——. "Beginnings of the Sikharas of the Nagara (Indo-Aryan) Temple." *Rupam* 17 (1924).
——. "The Beginnings of Art in Eastern India with Special Reference to Sculptures in the Indian Museum, Calcutta." MASI, no. 30 (1927).
——. "Notes on the Ancient Monuments of Mayurbhanj." JBRS (1927).
——. "Exploration in Orissa." MASI (1930).
——. *Medieval Indian Sculpture in the British Museum.* London, 1936.

CHANDRA, MOTI. *Jain Miniature Paintings from Western India.* Ahmedabad, 1949.
——. *Sarthavaha (Hindi).* Patna, 1953.
——. "An Illustrated Set of Amarusataka." *Bulletin of the Prince of Wales Museum* (1953), Bombay.
——. *Mewar Painting in the Seventeenth Century.* Lalit Kala series of Indian Art, no. 3. New Delhi, 1957.

CHANDRA, PRAMOD. *Bundi Painting.* New Delhi, 1959.
——. *A Guide to the Elephanta Caves.* Rev. ed. Bombay, 1964.

CHATTERJEE, BIJAN R. "India and Java." JGIS 5 (1933).

CHHABRA, B. CH. *Expansion of Indo-Aryan Culture during Pallava Rule (as Evidenced by Inscriptions).* New Delhi, 1965.

CHITRA, V. R. AND SRINIVASAN, T. N. *Cochin Murals.* 3 vols. Bombay, 1940.

CODRINGTON, K. DE B. *Ancient India from the Earliest Time to the Guptas.* London, 1926.

————. *An Introduction to the Study of Medieval Indian Sculpture.* London, 1929.

CODRINGTON, K. DE B.; GRAY, BASIL; AND IRWIN, JOHN. *The Art of India and Pakistan, a Commemorative Catalogue of the Exhibition Held at the Royal Academy of Arts.* London, 1947–48.

COEDÈS, GEORGE. *Les Bas-reliefs d'Angkor Vat.* Paris, 1911.

————. "Le Royaume de Srivijaya." BEFEO (1918).

————. *Bronzes khmers.* Ars Asiatica, vol. 5. Paris and Brussels, 1923.

————. "New Archaeological Discoveries in Siam." *Indian Art and Letters* 4 (1930).

COHN, WILLIAM. *Indische Plastik.* Berlin, 1921.

————. *Buddha in der Kunst des Ostens.* Leipzig, 1925.

COMBAZ, GISBERT. *L'Évolution du Stupa en Asie.* Louvain, 1933–37.

COOMARASWAMY, ANANDA KENTISH. *Medieval Sinhalese Art.* London, 1908.

————. *The Aims of Indian Art.* Broad Campden, 1908.

————. *The Indian Craftsman.* London, 1909.

————. "Mahayana Buddhist Bronzes from Ceylon and Java." JRAS (1909).

————. *Indian Drawings.* 2 vols. London, 1910–12.

————. *Arts and Crafts of India and Ceylon.* London, 1913.

————. *Bronzes from Ceylon Chiefly in the Colombo Museum.* Memoirs of the Colombo Museum, no. 1. Colombo, 1914.

————. *Visvakarma.* London, 1914.

————. *Rajput Painting.* 2 vols. Oxford, 1916.

————. *Buddha and the Gospel of Buddhism.* London, 1916.

————. "Chitralakshana (Sri Kumara, Silparatna)." In *Sir Asutosh Mukerjee Silver Jubilee Volumes,* vol. 3. Patna, 1921–27.

————. *Portfolio of Indian Art.* Boston, 1923.

————. *An Introduction of Indian Art.* Madras, 1923.

————. *Catalogue of the Indian Collections in the Museum of Fine Arts, Boston.* 5 vols. Boston, 1923–26.

————. *The Dance of Shiva.* New York, 1924.

————. "The Frescoes of Ellora." *Ostasiatische Zeitschrift,* N.F. 3 (1926).

————. "The Indian Origin of the Buddha Image." JAOS 46 (1926).

————. *History of Indian and Indonesian Art.* London, 1927.

————. "The Origin of the Buddha Image." *Art Bulletin* (1927), New York.

————. *Yakshas.* 2 vols. Washington, D.C., 1928–31.

————. *Aesthetic of the Sukranitsatra.* Paris, 1932.

————. "Vishnudharmottara (III)." JAOS 52 (1932).

————. "The Technique and Theory of Indian Painting." *Technical Studies in the Field of the Fine Arts* 3 (1934): 2.

————. *Transformation of Nature in Art.* Cambridge, Mass., 1934.

————. *Elements of Buddhist Iconography.* Cambridge, Mass., 1935.

————. *La Sculpture de Bodhgaya.* Ars Asiatica, vol. 18. Paris, 1935.

————. "One Hundred References to Indian Painting." AA 4.

————. "An Early Passage on Indian Painting." *Eastern Art* 3.

————. "Abhasa." JAOS 52.

CORAL-RÉMUSAT, G. DE. *L'Art khmer: Les grandes étapes de son évolution.* Paris, 1940.

COUSENS, HENRY. "Chalukya Temples." *Journal of Indian Art* 2 (1888).

————. "Ter Tagara." Annual Report of ASI (1902–1903).

————. "The Ancient Temples of Aihole and Pattadakal." Annual Report of ASI (1907–1908).

————. "Bijapur and Its Architectural Remains." ASIIS 37 (1916), Bombay.

————. *The Architectural Antiquities of Western India.* London, 1926.

————. "Chalukyan Architecture of the Kanarese Districts." ASI 42 (1926).

————. "Medieval Temples of the Dakhan." ASIIS 48 (1931), Calcutta.

————. "Somanatha and Other Medieval Temples in Kathiawar." ASI 45 (1931).

CUNNINGHAM, SIR ALEXANDER. *The Bhilsa Topes.* London, 1854.

————. *Archaeological Survey of India Reports.* 23 vols. London, 1862–1887; and Calcutta, 1871–1887.

————. *The Stupa of Bharhut.* London, 1879.

————. *Coins of Ancient India.* London, 1891.

————. *Mahabodhi or the Great Buddhist Temple at Bodh Gaya.* London, 1892.

————. *Coins of Medieval India.* London, 1894.

DAS, P. K. *Temples of Tamilnadu.* Bombay, 1964.

DE BARY, WILLIAM T., JR. *Sources of Indian Tradition.* New York, 1958.

DENECK, M. M. *Indian Sculpture.* London, 1962.

DESAI, MADHURI. *The Gupta Temples of Deogarh.* Bombay, 1958.

DESHPANDE, M. N. "The Rockcut Cave at Pitalkhora in the Deccan." *Ancient India,* no. 15 (1959).

DEVA, K. "The Temples of Khajuraho in Central India." *Ancient India,* no. 15 (1959).

————. "Krishnalila Scenes in the Lakshmana Temple, Khajuraho." *Lalit Kala,* no. 7 (1960), New Delhi.

————. *Khajuraho.* New Delhi, 1965.

DEVAKUNJARI, D. *Hampi.* New Delhi, 1970.

DEVENDRA, D. T. *Classical Sinhalese Sculpture.* London, 1958.

DEYDIER, H. *Contribution à l'étude de l'art du Gandhara.* Paris, 1950.

DHAMA, B. L., AND CHANDRA, S. C. *Khajuraho.* New Delhi, 1953.

DIKSHIT, K. N. *Pre-Historic Civilization of the Indus Valley.* Madras, 1939.

DUPONT, PIERRE. "An Exhibition of Dravidian Bronzes in Paris." JISOA 4 (1936): 2.

————. "La Statuaire preangkorienne." AA Supplementum 15 (1955).

DUROISELLE, CHARLES. "Pictorial Representations of Jatakas in Burma." Annual Report of ASI (1912–13).

————. "The Stone Sculptures of the Ananda Temple, Pagan." Annual Report of ASI (1913–14).

————. "Ananda Temple of Pagan." MASI, no. 56.

ELLIOT, W. "Coins of Southern India." *International Numismatic Orientalia* 3 (1886), London.

FERGUSSON, JAMES. *Tree and Serpent Worship.* London, 1868.

————. *History of Indian and Eastern Architecture.* London, 1910.

FERGUSSON, JAMES, AND BURGESS, JAMES. *The Cave Temples of India.* London, 1880.

FINOT, LOUIS, AND GOLOUBEW, VICTOR. "Le Fan-Tseu T'a de Yunnafou." BEFEO (1925).

FINOT, LOUIS; PARMENTIER, HENRI; AND GOLOUBEW, VICTOR. *Le temple d'Icvarapura (Banta Srei, Cambodge).* Mémoires Archéologiques de l'École française d'Extrême-Orient, vol. 1. Paris, 1926.

FLEET, J. F. "Gupta Inscriptions." CII 3 (1888), Calcutta.

————. *The Dynasties of the Kanarese Districts of the Bombay Presidency.* Bombay, 1899.

FOUCHER, ALFRED. *Étude sur l'iconographie bouddhique de l'Inde.* 2 vols. Paris, 1900–1905.

———. *L'Art gréco-bouddhique du Gandhara.* 3 vols. Paris, 1900–23.

———. *The Beginnings of the Buddhist Art.* London, 1917.

———. *Les Représentations de Jâtaka dans l'art bouddhique.* Paris, 1919.

———. "Preliminary Report on the Interpretation of the Paintings and Sculptures of Ajanta." *Journal of the Hyderabad Archaeological Society for 1919–20* (1921), Bombay.

———. "The Influence of Indian Art on Cambodia and Java." In *Sir Asutosh Mukerjee Silver Jubilee Volumes,* vol. 3, part 1. Calcutta, 1922.

FOURNEREAU, L. *Les Ruines khmères.* Paris, 1890.

———. *Le Siam ancien.* Paris, 1908.

FRÉDÉRIC, L. *L'Inde, ses temples, ses sculptures.* Paris, 1959.

FRENCH, J. C. *The Art of the Pala Empire of Bengal.* London, 1928.

———. *Himayalan Art.* London, 1931.

GANGOLY, ORDHENDRA COOMAR. *South Indian Bronzes.* Calcutta, 1914.

———. "Notes of the Origin of Hindu Javanese Art." *Rupam* 17 (1924).

———. "The Mithuna in Indian Art." *Rupam* 22–23 (1925).

———. "Vasanta Vilasa, New Document of Indian Painting." *Ostasiatische Zeitschrift,* N.F. 2 (1925).

———. "The Cult of Agastya and the Origin of Indian Colonial Art." *Rupam* 25 (1926).

———. *Rajput Painting.* Calcutta, 1926.

———. *The Art of Java.* Little Books on Asiatic Art. Calcutta, 1928.

———. *Ragas and Raginis.* 2 vols. Calcutta, 1934.

———. "Cola Painting." *Indian Art and Letters* (1935).

———. "Relations between Indian and Indonesian Culture." *JGIS* 7 (1940): 51–69 (cf. Frederik D. Bosch, *"Local Genius" en oud-Javaanse kunst.* Amsterdam, 1952).

———. *Konarak.* Calcutta, 1956.

———. *The Art of the Chandellas.* Calcutta, 1957.

———. *The Art of the Pallavas.* Calcutta, 1957.

GANGOLY, ORDHENDRA COOMAR, AND GOSWAMI, A. *The Art of the Rashtrakutas.* Calcutta, 1958.

GANGULY, D. C. *The History of the Paramara Dynasty.* Dacca, 1933.

———. *The Eastern Chalukyas.* Benares, 1937.

GANGULY, MANOMOHAN. *Orissa and Her Remains, Ancient and Medieval.* Calcutta, 1912.

———. *Handbook to the Sculptures in the Museum of the Bangiya Sahitya Parishad.* Calcutta, 1922.

GARDE, M. S. *Guide to the Archaeological Museum at Gwalior.* Gwalior, 1928.

GARDNER, PERCY. *Catalogue of the Coins in the British Museum, Greek and Scythian Kings of Bactria and India.* London, 1886.

GETTY, ALICE. *The Gods of Northern Buddhism.* Oxford, 1928.

———. *Ganesa.* Oxford, 1936.

GHOSE, A. "A Comparative Study of Indian Painting." *IHQ,* June, 1926.

GHOSH, A. *Nalanda.* New Delhi, 1965.

GHOSH, D. P. "The Development of Buddhist Art in South India." *IHQ* 3 (1927).

———. "The Development of Buddhist Art in South India." *IHQ* 4 (1927).

———. "Early Art of Srivijaya." *JGIS* 1 (1934): 31–38.

———. "Sources of the Art of Srivijaya." *JGIS* 3 (1936): 50–56.

GHURYE, G. S. *Rajput Architecture.* Bombay, 1968.

GLAIZE, M. *Les Monuments du Groupe d'Angkor.* Saigon, 1944.

GOETZ, HERMANN. "The Relations between Indian Painting and Literature." *Bulletin of the School of Oriental Studies* 3–4 (1925), London.

———. *The Art and Architecture of Bikaner State.* Oxford, 1950.

———. "The Kailasa of Ellora and the Chronology of Rashtrakuta Art." *AA* 15 (1952).

———. *The Early Wooden Temples of Chamba.* Leiden, 1955.

———. *India.* Art of the World. New York, 1959.

GOLOUBEW, VICTOR. *La Descente de la Ganga sur Terre.* Ars Asiatica, vol. 3. Paris, 1921.

———. *Documents pour servir à l'étude d'Ajanta: Les peintures de la première grotte.* Ars Asiatica, vol. 10. Paris and Brussels, 1927.

GOLOUBEW, VICTOR; RODIN, A.; AND COOMARASWAMY, ANANDA KENTISH. *Sculptures Civaïtes de l'Inde.* Ars Asiatica, vol. 3. Paris and Brussels, 1921.

GOPALACHARI, S. "Some South Indian Metal Images and Their Dhyanas." *JISOA* 6 (1938).

GOPALAN, R. *History of the Pallavas of Kanchi.* Madras, 1928.

GOPALA RAO, AMANCHARLA. *Lepakshi.* Hyderabad, 1969.

GOPINATHA RAU, T. A. "Buddha Vestiges in Kanchipura." *IA* 44 (1915).

———. *Elements of Hindu Iconography.* Vol. 1, pts. 1 and 2; Vol. 2, pts. 1 and 2. Madras, 1914–16.

———. "Talamana or Iconometry." *MASI* 3 (1920).

GOVINDASWAMI, S. K. "On His Discovery of Cola Painting." *Hindu,* 11 April 1931.

———. "On His Discovery of Cola Painting." *Madras Mail,* 16 April 1931.

———. "Cola Painting." *JISOA* 1 (1933): 2.

———. "Cola Painting." *Journal of Annamalai University* 2 (1934).

———. "Discovery of Chola Paintings in the Brihadisvara Temple, Tanjore." *JISOA* (1934).

GRAVELY, FREDERIC H. *Outline of Indian Temple Architecture.* Madras, 1936.

———. *The Gopuras of Tiruvannamalai.* Madras, 1959.

GRAVELY, FREDERIC H., AND RAMACHANDRAN, T. N. "Catalogue of Metal Images in the Madras Government Museum." *Bulletin of the Madras Government Museum* 1 (1932): Part 2.

———. "Three Main Styles of Temple Architecture." *Bulletin of the Madras Government Museum* 3 (1934): Part 1.

GRAVELY, FREDERIC H., AND SIVARAMAMURTI, C. *Illustrations of Indian Sculpture.* Madras, 1939.

GRAY, BASIL. *Rajput Painting.* London, 1948.

GRAY, BASIL, AND BARRETT, DOUGLAS E. *Painting of India.* Treasures of Asia Series. Lausanne, 1963.

GRIFFIN, SIR LEPEL. *Famous Monuments of Central India.* London, 1886.

GRIFFITHS, JOHN. *The Paintings in the Buddhist Cave Temples of Ajanta.* 2 vols. London, 1896–97.

GRISWOLD, ALEXANDER B. "Dated Buddha Images of Northern Siam." *AA* Supplementum 16 (1957).

GRISWOLD, ALEXANDER B.; CHEWON, KIM; AND POTT, PETER H. *Burma, Korea, Tibet.* Art of the World. London, 1964.

GROSLIER, BERNARD-PHILIPPE. *The Art of Indochina.* Art of the World. New York, 1962.

GROSLIER, GEORGE. *Danseuses cambodgiennes.* Paris, 1913.

———. "Étude sur la psychologie de l'artisan cambodgien." *Arts et Archéologie khmers* 1 (1921; 1923).

————. *Angkor.* Paris, 1924.
————. "L'Art hindou au Cambodge: Le Buddha khmer: Asram Maha Rosei." *Arts et Archéologie khmers* 2 (1925).
————. "Introduction à l'étude des arts khmers." *Arts et Archéologie khmers* 2 (1925).
————. *La Sculpture khmère ancienne.* Paris, 1925.
————. "Note sur la sculpture khmère ancienne." *Études Asiatiques* (1925).
————. *Les Collections khmères du Musée Albert Sarraut à Phnom-Penh.* Ars Asiatica, vol. 16. Paris, 1931.

GROUSSET, RENÉ. *India.* Civilizations of the East, vol. 2. New York, 1931 (reprinted as *The Civilization of India*, New York, 1939).
————. *In the Footsteps of the Buddha.* London, 1932.

GROUSSET, RENÉ, AND AUBOYER, JEANNINE. *De l'Inde au Cambodge et à Java.* Monaco, 1950.

GRÜNDWEDEL, ALBERT. *Buddhist Art in India.* London, 1901.

GUPTA, S. N. *Catalogue of Paintings in the Central Museum, Lahore.* Calcutta, 1922.

GUPTE, R. S. *The Art and Architecture of Aihole.* Bombay, 1967.

GUPTE, R. S., AND MAHAJAN, B. D. *Ajanta, Ellora and Arangabad Caves.* Bombay, 1962.

HACKIN, JOSEPH. *Les Scènes figurées de la vie du Bouddha.* Paris, 1916.
————. *Guide Catalogue du Musée Guimet, Collections Bouddhiques.* Paris, 1923.
————. *La Sculpture indienne et tibétaine au Musée Guimet.* Paris, 1931.
————. *Recherches archéologiques à Begram.* 2 vols. Paris, 1939.
————. "The Colossal Buddhas at Bamiyan: Their Influences on Buddhist Sculpture." *Eastern Art* 1.

HACKIN, JOSEPH, AND CARL, JEAN. *Nouvelles Recherches archéologiques à Bamiyan.* Paris, 1933.

HALDAR, A. K. "The Buddhist Caves of Bagh." *Burlington Magazine* (1910–11).
————. "The Paintings of the Bagh Cave." *Rupam* 8 (1921).

HARGREAVES, HAROLD. "The Excavations at Sarnath." Annual Report of ASI (1914–15).
————. "The Monolithic Temples of Masrur." Annual Report of ASI (1915–16).
————. *The Buddha Story in Stone.* Calcutta, 1914.
————. *Handbook to the Sculptures in the Peshawar Museum.* Calcutta, 1930.

HARI RAI, V. N. *The Srirangam Temple.* Tirupati, 1967.

HARLE, JAMES C. *The Brahmapurisvara Temple at Pullamangai.* Bombay, 1958.
————. *Temple Gateways in South India.* Oxford, 1963.

HEINE-GELDERN, ROBERT. "The Archaeology and Art of Sumatra." In *Sumatra*, edited by Edwin M. Loeb. Vienna, 1935.

HERRINGHAM, LADY CHRISTIANA. *Ajanta Frescoes.* London, 1915.

HOPKINS, EDWARD W. *Epic Mythology.* Strasbourg, 1915.

HULTZSCH, E. "Asoka Inscriptions." CII 1 (1925), Oxford.

HUMPHREYS, CHRISTMAS. *Buddhism.* Harmondsworth, 1951.

HURLIMANN, M. *India.* London, 1967.

IRWIN, JOHN. "Masterpieces of Oriental Art, II: South Indian Figure Sculpture." JRAS (1948).
————. "The Amsterdam Nataraja." *Marg* 4: 2.

JAIN, HIRALAL. *Shatkhandagama.* Vol. 2. Amraoti, 1941–58.

JAYASWAL, K. P. "Statues of Two Saisunaka Emperors." JBORS 5 (1919).
————. "A Hindu Text on Painting." JBORS 9 (1925).

JOUVEAU-DUBREUIL, GABRIEL. *Archéologie du sud de l'Inde, Architecture et Iconographie.* Paris, 1914.
————. *Pallava Antiquities.* 2 vols. London, 1916; and Pondicherry, 1918.
————. *The Pallavas.* Pondicherry, 1917.
————. *Dravidian Architecture.* Madras, 1917.
————. *Ancient History of the Deccan.* Translated by V. S. Swaminatha Dikshitar. Pondicherry, 1920.
————. *The Pallava Painting.* Pudukottai, 1920.

KAK, RAM CHANDRA. *Handbook to the Archaeological and Numismatic Sections of the Sri Pratap Singh Museum, Srinagar.* London, 1923.
————. "Ancient and Medieval Architecture of Kashmir." *Rupam* 24 (1925).
————. *Ancient Monuments of Kashmir.* London, 1933; and New Delhi, 1971.

KALA, SATISH CHANDRA. *Sculptures in the Allahabad Municipal Museum.* Allahabad, 1946.

KALIDASA. *Kumarasambhava.* Commentary by Mallinatha. Bombay, 1919.
————. *Meghaduta.* Commentary by Mallinatha. Edited by M. R. Kale. Bombay, 1926.

KANAKASABHAI, V. *The Tamils Eighteen Hundred Years Ago.* Madras, 1904.

KAR, CHINTAMONI. *Classical Indian Sculpture.* London, 1950.
————. *Indian Metal Sculpture.* London, 1952.

KATS, J. *The Ramayana as Sculptured in Reliefs in Javanese Temples.* Batavia, 1925.

KHANDALAVALA, KARL J. *Indian Sculpture and Painting.* Bombay, 1938.
————. *Pahari Miniature Painting.* Bombay, 1958.
————. *Kishangarh Painting.* New Delhi, 1958.
————. "Masterpieces in South Indian and Nepalese Bronzes in the Collection of Mr. S. K. Bhedwar." *Marg* 4: 4.
————. "Brahmapuri." *Lalit Kala*, no. 7.

KRAMRISCH, STELLA. "The Contact of Indian Art with the Art of Other Civilisations." Calcutta University, *Journal of the Department of Letters* 10 (1923).
————. *The Vishnudharmottara (pt. 3): A Treatise on Indian Painting and Image-Making.* 2d ed., rev. Calcutta, 1928.
————. *Pala and Sena Sculpture.* Calcutta, 1929.
————. *Indian Sculpture.* Calcutta, 1933.
————. "Paintings at Badami." JISOA 4 (1936): 1.
————. "Dakshina Chitra." JISOA 5 (1937).
————. *Survey of Painting in the Deccan.* London, 1937.
————. *The Hindu Temple.* 2 vols. Calcutta, 1946.
————. *Dravida and Kerala in the Art of Travancore.* Ascona, 1953.
————. *The Art of India.* London, 1954.
————. *The Art of Nepal.* New York, 1964.

KRAMRISCH, STELLA; COUSINS, JAMES H.; AND VASUDEVA PODUVAL, R. *Arts and Crafts of Travancore.* London, 1948.

KRISHNADASA, RAI. *Moghul Miniatures.* New Delhi, 1958.

KRISHNASWAMI AIYANGAR, S. "The Antiquities of Mahabalipuram." Ind. Ant. 45 (1917).

KROM, NICOLAS J. *De Buddhistische bronzen in het Museum te Batavia.* Batavia, 1913.
————. "L'Art ancien de Bali." *Revue des Arts Asiatiques* (1924).
————. *L'Art javanais dans les Musées de Hollande et de Java.* Ars Asiatica, vol. 8. Paris, 1926.
————. *The Life of Buddha on the Stupa of Barabudur.* The Hague, 1926.

KROM, NICOLAS J., AND ERP, T. VAN. *Barabudur: Archaeological Description.* 2 vols. The Hague, 1927.

LANE-POOLE, STANLEY. *Medieval India under Mohammedan Rule 712-1764.* New York, 1903.

LE COQ, ALBERT VON. *Buried Treasures of Chinese Turkestan.* London, 1928.

LEE, S. E. *A History of Far Eastern Art.* New York, 1964.

LEGGE, JAMES. *A Record of Buddhist Kingdoms, Being an Account by the Chinese Monk Fa-Hien of His Travels in India and Ceylon.* Oxford, 1886.

LE MAY, REGINALD. "Le Temple d'Angkor Vat." *Mémoires archéologiques of l'École française d'Extrême-Orient* (1930-32), Paris.
———. *A Concise History of Buddhist Art in Siam.* Cambridge, 1938.

LEVI, SYLVAIN. *Le Nepal.* 3 vols. Paris, 1905-1908.
———. "The Art of Nepal." *Indian Art and Letters* 1-2 (1925).

LOHUIZEN-DE LEEUW, JOHANNA E. VAN. *The Scythian Period.* Leiden, 1949.
———. *The Dikpalas in Ancient Java.* Leiden, 1955.

LONGHURST, A. H. "Ancient Brick Temples in the Central Provinces." Annual Report of ASI (1909-10).
———. *Hampi Ruins.* Madras, 1917.
———. "Pallava Architecture." MASI: Part I, no. 17 (1924), Simla; Part II, no. 33 (1928), Calcutta; Part III, no. 40 (1930), Calcutta.
———. *Sittannavasal Painting, Pudukkottai State.* Annual Bibliography of Indian Archaeology for 1930. Leiden, 1931.
———. "The Sittannavasal Paintings, Pudukkottai State." *Indian Art and Letters* 6 (1932).
———. *The Story of the Stupa.* Colombo, 1936.
———. "The Buddhist Antiquities of Nagarjunakonda, Madras Presidency." MASI, no. 54 (1938).

MACDONELL, ARTHUR A. *Vedic Mythology.* Strasbourg, 1897.
———. "Early Hindu Iconography." JRAS (1917).
———. "The History of Hindu Iconography." *Rupam*, no. 4 (1920).

MACKAY, ERNEST J. H. "Sumarian Connections with Ancient India." JRAS (1925).
———. *Further Excavations at Mohenjodaro.* 2 vols. London, 1937.
———. *The Chanhu Daro Excavations.* New Haven, 1943.
———. *Early Indus Civilisations.* 2d. ed., rev. London, 1948.

MAISEY, F. C. *Sanchi and Its Remains.* London, 1892.

MAITRA, A. K. "Mauryan Art." IHQ 3.
———. "Origin of the Bell-Capital." IHQ 3.

MAJUMDAR, A. K. *Chalukyas of Gujarat.* Bombay, 1956.

MAJUMDAR, B. *A Guide to Sarnath.* New Delhi, 1937.

MAJUMDAR, NANI GOPAL. *A Guide to the Sculptures in the Indian Museum.* 2 vols. New Delhi, 1937.

MARCHAL, HENRI. *Les Temples d'Angkor.* Paris, 1955.

MARSHALL, SIR JOHN H. "Excavations at Charsada." Annual Report of ASI (1902-1903).
———. "Buddhist Gold Jewellery." Annual Report of ASI (1902-1903).
———. "Excavations at Sarnath." Annual Report of ASI (1904-1905).
———. "Rajagriha and Its Remains." Annual Report of ASI (1905-1906).
———. "Excavations at Sahet Mahet." Annual Report of ASI (1910-11).
———. "Excavations at Bhita." Annual Report of ASI (1911-12).
———. "Excavations at Taxila." Annual Report of ASI (1912-13).
———. "Excavations at Sanchi." Annual Report of ASI (1913-14).
———. "The Monuments at Sanchi." Annual Report of ASI (1913-14).
———. "Excavations at Taxila." Annual Report of ASI (1915-16).
———. *A Guide to Taxila.* Calcutta, 1918.
———. *A Guide to Sanchi.* Calcutta, 1918.
———. "The Monuments of Ancient India." In *India,* Cambridge History of India, vol. 1. Cambridge, 1914.
———. *Catalogue of the Museum of Archaeology, Sanchi.* Calcutta, 1922.
———. *Mohenjodaro and the Indus Civilisation.* 3 vols. London, 1931.
———. *Taxila.* 3 vols. Cambridge, 1951.

MARSHALL, SIR JOHN H., AND FOUCHER, ALFRED. *The Monuments of Sanchi.* 3 vols. London, 1940.

MARSHALL, SIR JOHN H.; GARDE, M. B.; VOGEL, JEAN PHILIPPE; HAVELL, E. B.; AND COUSINS, JAMES H. *The Bagh Caves.* London, 1927.

MARSHALL, SIR JOHN H., AND KONOW, STEN. "Sarnath." Annual Report of ASI (1906-1907).
———. "Excavations at Sarnath, 1908." Annual Report of ASI (1907-1908).

MARTIN, A. C. *Iconography of Southern India.* Paris, 1937.

MARTIN-DUBOST, PAUL. "Notes sur la statuaire au pays Cera." *Arts Asiatiques* 23 (1971).

MEHTA, N. C. "Indian Painting in the Fifteenth Century." *Rupam* 22-23 (1925).
———. *Studies in Indian Painting.* Bombay, 1926.
———. "Two Pahari Painters of Tehri-Garhwal: Manaku and Chaitu." *Rupam* 26 (1926).

MEHTA, R. J. *The Handicrafts and Industrial Arts of India.* Bombay, 1960.

MINAKSHI, C. "Tandantottam Bronzes." QJMS 28: 2.

MIRASHI, V. V. *Vakataka Inscription in Cave XVI at Ajanta.* Hyderabad Archaeology Series, no. 14 (1941).

MISHRA, V. "A Unique Painting in Tulja Caves at Padali (Junnar)." JIH 38 (1960).

MITRA, DEBALA. *Ajanta.* New Delhi, 1964.
———. *Sanchi.* New Delhi, 1965.
———. *Bhubaneswar.* New Delhi, 1966.
———. *Konarak.* New Delhi, 1968.

MITRA, J. N. *The Ruins of Vishnupur.* Calcutta, 1940.

MITRA, PANCHANAN. *Prehistoric India.* Calcutta, 1927.

MITRA, RAJENDRALALA. *Antiquities of Orissa.* 2 vols. Calcutta, 1875-80.
———. *Bodh Gaya.* Calcutta, 1878.

MITRA, S. K. *The Early Rulers of Khajuraho.* Calcutta, 1958.

MOOKERJI, RADHAKUMUD. *The Gupta Empire.* Bombay, 1947.

MUKERJEE, RADHAKAMAL. *The Culture and Art of India.* London, 1959.

MUNSHI, K. M. *The Saga of Indian Sculpture.* Bombay, 1957.

MUS, PAUL. *Barabudur.* Hanoi, 1935.

NAGASWAMI, R. "Rare Bronzes from Kongu Country." *Lalit Kala,* no. 9.

NAIR, T. B. "Three South Indian Metal Images—A Study." *Journal of Annamalai University* 3.

NARASIMHACHARYA, RAMANUJA-PURAM. *The Kesava Temple at Somanathapur.* Mysore Archaeological Series, no. 1. Bangalore, 1917.
———. *The Kesava Temple at Belur.* Mysore Archaeological Series, no. 2. Bangalore, 1919.
———. *The Lakshmidevi Temple at Dodda Gaddavalli.* Mysore Archaeological Series, no. 3. Bangalore, 1919.
———. *Inscriptions at Sravana Belgola.* 2d ed., rev. Epigraphia Carnatica, vol. 2. Bangalore, 1925.

NARASIMHAN, V. M. "Some Pallava Icons." *Lalit Kala,* no. 7.

NILAKANTA SASTRI, KALLIDAI-KURICHI A. *The Pandyan Kingdom*. London, 1929.

——. *History of Sri Vijaya*. Madras, 1949.

——. *South Indian Influences in the Far East*. Bombay, 1949.

——. *The Colas*. 2d ed., rev. Madras, 1955.

——. *A History of South India from Prehistoric Times to the Fall of Vijayanagara*. Madras, 1958.

OERTEL, F. O. "Excavations at Sarnath." Annual Report of ASI (1904–1905).

PARAMASIVAN, S. "An Investigation into the Methods of the Mural Paintings." JISOA 7 (1939).

PARANAVITANA, SENARAT. "The Stupa in Ceylon." MASI 5, Ceylon, Colombo.

——. *Art and Architecture of Ceylon Polonnaruva Period*. Bombay, 1954.

——. *Ceylon: Paintings from Temple, Shrine and Rock*. UNESCO World Art Series, no. 8, Greenwich, Conn., 1957.

PARKER, HENRY. *Ancient Ceylon*. London, 1909.

PARMENTIER, HENRI. "Catalogue du Musée khmer de Phnom Pen." BEFEO (1912).

——. "L'Art d'Indravarman." BEFEO (1919).

——. *Les Sculptures chames au Musée de Tourane*. Ars Asiatica, vol. 4. Paris, 1922.

——. "History of Khmer Architecture." *Eastern Art* (1931).

——. *L'Art khmer classique*. 2 vols. Paris, 1940.

PATTABIRAMIN, P. Z. *Trouvailles de Nedoungadon, Tandavas de Siva*. Pondicherry, 1956.

PEPPE, W. C., AND SMITH, VINCENT A. "The Piprahwa Stupa Containing Relics of Buddha." JRAS (1898).

PIGGOTT, STUART. *Ancient Cities of South India*. Calcutta, 1945.

——. *Prehistoric India*. London, 1953.

PILLAY, K. K. *The Sucindram Temple*. Madras, 1953.

PODUVAL, R. V. "Note on Paintings and Sculptures in Travancore." JISOA 5 (1937).

PRZYLUSKI, JEAN. *La Légende de l'Empereur Asoka*. Paris, 1923.

——. "La Légende de Rama dans les bas-reliefs d'Ankor-Vat." *Arts et Archéologie khmers* 1 (1923): 4, Paris.

PURI, K. N. *Le Civilisation de Mohenjo-daro*. Paris, 1938.

RAGHAVAN, V. "Some Sanskrit Texts on Painting." IHQ 9 (1933).

——. "Two Chapters on Paintings in the Narada Silpa Sastra." JISOA 3 (1933): 1.

——. *Bhoja's Sringara-Prakasa*. Madras, 1939.

RAJU, VENKATARANGA. "Chola Temples in Pudukkottai." JISOA (1937).

RAMACHANDRAN, K. V. "Paintings from Tiruvanjikulam." *Triveni* 4 (1931), Madras.

RAMACHANDRAN, T. N. "Tirupparuttikunram and Its Temples." *Bulletin of the Madras Government Museum* 1 (1930): 3.

——. "The Royal Artist Mahendravarman." JOR 7 (1933), Madras.

——. "Tirupparuttikunram Temples." *Bulletin of the Madras Government Museum* (1934).

——. "Cave Temples near Tirumalaipuram and Their Paintings." JISOA 4 (1936).

——. "Nagarjunakonda 1938." MASI, no. 71 (1953), New Delhi.

——. "Sittannavasal Paintings." *Lalit Kala* 9 (1961), New Delhi.

——. "Find of Tempera Paintings in Sitabhinji." AA 14.

——. "Bronze Images from Tiruvengadu-Svetaranya (Tanjore)." *Lalit Kala*, nos. 3–4.

RAMAKRISHNA AYYAR, V. G. "The Chidambaram Temple" *Journal of Annamalai University* 1 (1933).

RAMA RAO, M. *Eastern Chalukyan Temples of Andhra*. Andhra Pradesh Government Archaeological Series, no. 19. Hyderabad, 1964.

——. *Early Chalukyan Temples of Andhra Desa*. Andhra Pradesh Government Archaeological Series, no. 20. Hyderabad, 1965.

——. *The Temples of Srisailam*. Andhra Pradesh Government Archaeological Series, no. 23. Hyderabad, 1967.

——. *Select Andhra Temples*. Andhra Pradesh Government Archaeological Series. Hyderabad, 1970.

RAM RAZ. *Essays on the Architecture of the Hindus*. London, 1834.

RANDHAWA, M. S. *Kangra Valley Paintings*. New Delhi, 1955.

——. *The Krishna Legend in Pahari Painting*. New Delhi, 1957.

RAO, P. R. R. *The Art of Nagarjunakonda*. Madras, 1956.

——. *Pallava Sculpture*. Madras, 1957.

RAPSON, EDWARD JAMES. *Indian Coins*. Strasbourg, 1898.

——. *Catalogue of the Coins of the Andhra Dynasties*. London, 1908.

——. *Ancient India*. Cambridge History of India, vol. 1. Cambridge, 1914.

RAWLINSON, H. C. *Intercourse between India and the Western World*. Cambridge, 1926.

RAWSON, P. S. *Indian Painting*. Paris and New York, 1961.

RAY, H. C. *Dynastic History of Northern India*. Calcutta, 1931.

RAY, NIHAR RANJAN. *Mauryan and Sunga Art*. Calcutta, 1945.

RAYCHAUDHURI, HEMCHANDRA. *Political History of Ancient India*. 4th ed. Calcutta, 1938.

REA, ALEXANDER. "South Indian Buddhist Antiquities." ASINIS (1894), Madras.

——. "Chalukyan Architecture." ASI (1896), Madras.

——. "Excavations at Amaravati." Annual Report of ASI (1905–1906; 1908–1909).

——. "Pallava Architecture." ASI (1909), Madras.

RICE, BENJAMIN LEWIS. *Mysore and Coorg from the Inscriptions*. London, 1909.

ROCKHILL, WILLIAM W. *The Life of the Buddha and the Early History of His Order*. London, 1884.

ROWLAND, BENJAMIN. "A Revised Chronology of Gandhara Sculpture." *Art Bulletin* 18 (1936) and other articles in *Art Bulletin* and *American Journal of Archaeology*, 1940.

——. *Gandhara Art from Pakistan*. New York, 1962.

——. *The Art and Architecture of India*. Pelican History of Art, 3d ed., rev. Baltimore, 1967.

ROWLAND, BENJAMIN, AND COOMARASWAMY, ANANDA KENTISH. *The Wall-Paintings of India, Central Asia and Ceylon*. Boston, 1938.

SAHNI, DAYA RAM. "Excavations at Rampurva." Annual Report of ASI (1907–1908).

——. "Avantipur Temple" Annual Report of ASI (1912).

——. "Excavations at Avantipura." Annual Report of ASI (1913–14).

——. *Catalogue of the Museum of Archaeology at Sarnath*. Calcutta, 1914.

——. "Pre-Mohammaden Monuments of Kashmir in the ASI." Annual Report of ASI (1915–16).

——. *Guide to the Buddhist Ruins of Sarnath*. 5th ed. New Delhi, 1933.

SALMONY, A. *Sculpture in Siam*. London, 1925.

————. "Bronzes of India and Greater India." AA 19.

SANKALIA, H. D. *The Archaeology of Gujarat (Including Kathiawar)*. Bombay, 1941.

SARASWATI, S. K. *Early Sculptures of Bengal*. Calcutta, 1937.

————. *A Survey of Indian Sculpture*. Calcutta, 1957.

SARASWATI, S. K., AND SARKAR, K. C. *Kurkihar, Gaya and Bodhgaya*. Rajshahi, 1936.

SARKAR, G. "Some Aspects of the Buddhist Monuments at Nagarjunakonda." *Ancient India*, no. 16 (1962), New Delhi.

SARKAR, H., and MISRA, B. N. *Nagarjunakonda*. New Delhi, 1966.

SASTRI, H. "Excavations at Kasia." Annual Report of ASI (1911–12).

————. "Recently Added Sculptures in the Provincial Museum, Lucknow." MASI 11 (1926).

SASTRI, H. K. *South Indian Images of Gods and Goddesses*. Madras, 1916.

SCHALTERNA, J. F. *Monumental Java*. London, 1912.

SENART, E. "The Inscriptions in the Caves at Karla." EI 7 (1902).

SEN GUPTA, R. *A Guide to the Buddhist Caves of Ellura*. Bombay, 1958.

SHAH, PRIYABALA. *Vishnudharmottara-Purana*. 2 vols. Gaekwad's Oriental Series, nos. 130, 137. Baroda, 1958–61.

SHAH, UMAKANT PREMANAND. *Akota Bronzes*. Bombay, 1959.

————. *Sculptures from Samalaji and Roda (North Gujarat) in the Baroda Museum*. Baroda, 1960.

SHARMA, D. *Early Chauhan Dynasties*. New Delhi, 1959.

SHARMA, Y. D. *Delhi and Its Neighbourhood*. New Delhi, 1964.

SHASTRI, HIRANANDA. *A Guide to Elephanta*. New Delhi, 1934.

————. *Indian Pictorial Art as Developed in Book Illustrations*. Baroda, 1936.

SIRCAR, DINESHCHANDRA. "The Sakta-Pithas." Reprint from JRAS (1948).

SIVARAMAMURTI, CALAMBUR. *Amaravati Sculptures in the Madras Government Museum*. Madras, 1942.

————. *Sculpture Inspired by Kalidasa*. Madras, 1942.

————. "Epigraphical Echoes of Kalidasa." MASI (1944), Madras.

————. *Numismatic Parallels of Kalidasa*. Madras, 1945.

————. *Indian Epigraphy and South Indian Scripts*. Madras, 1948.

————. *Royal Conquests and Cultural Migrations in South India and the Deccan*. Calcutta, 1955.

————. "Sanskrit Literature and Art: Mirrors of Indian Culture." MASI, no. 73 (1955).

————. *Mahabalipuram*. New Delhi, 1955.

————. *Early Eastern Chalukyan Sculpture*. Madras, 1957.

————. *Directory of Museums in India*. New Delhi, 1959.

————. *Chola Temples: Tanjavur, Gangaikondacholapuram and Darasuram*. New Delhi, 1960.

————. *Le Stupa du Barabudur*. Paris, 1961.

————. *Indian Sculpture*. New Delhi, 1961.

————. *Kalugumalai and Early Pandyan Rockcut Shrines*. Bombay, 1961.

————. *Indian Bronzes*. Bombay, 1962.

————. *South Indian Bronzes*. New Delhi, 1963.

————. *Nolamba Sculptures in the Madras Government Museum*. Madras, 1964.

————. *South Indian Paintings*. New Delhi, 1968.

————. *Some Aspects of Indian Culture*. New Delhi, 1969.

————. *Indian Painting*. New Delhi, 1970.

————. *Masterpieces of Sculpture in the National Museum*. New Delhi, 1971.

————. *Art of India*. Smeets, 1971.

————. *Bhagavatpada Sri Sankaracharya*. New Delhi, 1972.

————. *The Amaravati Mode of Sculpture*. Madras, 1972.

————. *Nataraja in Art, Thought and Literature*. New Delhi, 1974.

————. *Expressive Quality of Literary Flavour in Art*. Dharwar, 1974.

————. "Fresco-Painting in Sivatatvaratnakara." *Triveni* 6 (1932), Madras.

————. "Frescoes of the Cholas." *Triveni* 6 (1932), Madras.

————. "Kalidasa and Painting." JOR 7 (1933), Madras.

————. "Painting and Allied Arts as Revealed in Bana's Works." JOR 6–7 (1933), Madras.

————. "Sri Harsha's Observation on Painting with Special Reference to Naishadhiyacharita." JOR 6–7 (1933), Madras.

————. "Chitrasala." *Triveni* 7 (1934): 2, Madras.

————. "The Artist in Ancient India." JOR 8 (1934), Madras.

————. "Conventions in the Art of Painting." JOR (1934), Madras.

————. "Artist's Jottings from the Nalachampu of Trivikrama." JOR 8 (1934), Madras.

————. "Sanskrit Sayings Based on Painting." JISOA (1934).

————. "A Passage of Painting-Process from Nannechoda's Kumarasambhava." In *Mahamahopadhyaya Kuppuswami Sastri Commemoration Volume*. Madras, 1935.

————. "Fragment of Painting from the Kailasanatha Temple." JOR (1935), Madras.

————. "Vijayanagara Paintings from the Lepakshi Temple." In *Vijayanagara Sexcentenary Commemoration Volume*. Dharwar, 1935.

————. "Artist's Material." *Calcutta Oriental Journal* 2 (1935).

————. "A Note on the Paintings at Tirumalaipuram." JISOA 4 (1936).

————. "Art Titbits from Ratnakara's Haravijaya." In *Dr. S. Krishnaswami Aiyangar Commemoration Volume*. Madras, 1936.

————. *The Indian Painter and His Art*. Cultural Heritage of India, vol. 3. Calcutta, 1936.

————. "Paintings from Lepakshi." JISOA 5 (1937).

————. "Early Western Chalukya Paintings from Badami." *Lalit Kala* (1959).

————. "Geographical and Chronological Factors in Indian Iconography." *Ancient India*, no. 6 (1952), Kanpur.

————. "Andhra Art Centres and Trends." In *Encyclopaedia of World Art*, vol. 1. New York, 1959.

————. "Dravidian Art Centres and Trends." In *Encyclopaedia of World Art*, vol. 4. New York, 1961.

————. "Ajanta." In *Buddhist Encyclopaedia*. Colombo, 1960.

————. "Art Notes from Dhanapala's Tilakamanjari." *Indian Culture* 2, Calcutta.

————. "Painter's Proverbs." QJMS 26, Bangalore.

————. "Paintings from the Kailasanatha Temple." JOR 11, Madras.

————. "Some Recent Acquisitions in National Museum." *Lalit Kala*, nos. 1–2.

SMITH, E. W. *Mughal Architecture of Fatehpur Sikri*. 4 vols. Vol. 18 of ASI series. Allahabad, 1896.

SMITH, VINCENT A. *Asoka: The Buddhist Emperor of India*. Oxford, 1901.

————. *The Jaina Stupa and Other Antiquities of Mathura*. Allahabad, 1901.

————. "Persian Influence on Maurya India." IA (1905).

————. *Catalogue of the Coins in the Indian Museum, Calcutta*. Vol. 1. London, 1906.

————. "The Monolithic Pillars of Asoka." *Zeitschrift der Deutschen morgenländischen Gesellschaft* (1911).

————. *A History of Fine Art in India and Ceylon*. Oxford, 1911. Revised by K. de B. Codrington, Oxford, 1930.

————. "Sculpture of Ceylon." *Journal of Indian Art* (1914).

————. "Indian Sculpture of the Gupta Period, A.D. 300–650." *Ostasiatische Zeitschrift* (1915).

————. *The Early History of India, from 600 B.C. to the Muhammedan Conquest.* 4th ed., revised by S. M. Edwards. Oxford, 1924.

SOUNDARA RAJAN, K. V. *Architecture of the Early Hindu Temples of Andhra Pradesh.* Hyderabad, 1965.

SPEAR, T. G. P. *Delhi, Its Monuments and History.* Oxford and Bombay, 1945.

SPOONER, D. B. "Excavations at Saheth-Maheth." Annual Report of ASI (1907–1908).

————. "Excavations at Shah-ji-ki-Dheri." Annual Report of ASI (1908–1909).

————. "Excavations at Sahri Bahlol." Annual Report of ASI (1909–10).

————. *Handbook to the Sculptures in the Peshawar Museum.* Bombay, 1910.

————. "Vishnu Images from Rangpur." Annual Report of ASI (1911–12).

————. "Mr. Ratan Tata's Excavations at Pataliputra." Annual Report of ASI (1912–13).

————. "Excavations at Basarh." Annual Report of ASI (1913–14).

————. "Terracottas from Pataliputra and Bronzes from Nalanda." Annual Report of ASI, pt. 1 (1917–18).

SRINIVASAN, P. R. "Sculptures in the Two Rockcut Vaishnava Cave Temples of Namakkal." AA 24: 2

————. "Rare Sculptures of the Early Chola Period." *Lalit Kala*, no. 5.

STEIN, SIR MARK AUREL. "Zoroastrian Deities in Indo-Scythian Coins." IA 17 (1888).

————. *Rajatarangini of Kalhana.* London, 1900.

————. *Sand-burned Ruins of Khotan.* London, 1903.

————. *Ancient Khotan.* Oxford, 1907.

————. "Excavations at Sahri-Bahlol." Annual Report of ASI (1911–12).

————. *Ruins of Desert Cathay.* 2 vols. London, 1912.

————. *Serindia.* 4 vols. London, 1921.

STRZYGOWSKI, JOSEF ET AL. *The Influences of Indian Art.* London, 1925.

STUTTERHEIM, W. *Rama-Legenden und Rama-Reliefs in Indonesien.* Munich, 1924–25.

————. "Archaeological Research in Java and Bali." *Indian Art and Letters* (1927).

————. "The Meaning of the Kala-makara Ornament." *Indian Art and Letters*, no. 3 (1929): 25–52.

————. "The Meaning of the Hindu-Javanese Candi." JAOS 51 (1931): 1–15.

————. *Indian Influences in Old-Balinese Art.* London, 1935.

SWARUP, BISHAN. *Konaraka.* Cuttack, 1910.

SWARUP, SHANTI. *The Arts and Crafts of India and Pakistan.* Bombay, 1957.

TAGORE, ABANINDRANATH. *Some Notes on Indian Artistic Anatomy.* Calcutta, 1914.

————. *Sadanga, ou les six canons de la peinture hindoue.* Paris, 1922.

TARN, W. W. *The Greeks in Bactria and India.* Cambridge, 1938.

TAYLOR, MEADOWS. *Architecture of Dharwar and Mysore.* London, 1886.

THOMSON, D. V. "Preliminary Notes on Some Early Hindu Paintings." *Rupam* 26 (1926).

TRIPATHI, RAMA SHANKAR. *History of Kanauj to the Moslem Conquest.* 2d ed. New Delhi, 1959.

26TH INTERNATIONAL CONGRESS OF ORIENTALISTS, ORGANIZING COMMITTEE. *Archaeological Remains, Monuments and Museums.* 2 vols. New Delhi, 1964.

VAIDYA, CHINTAMANI V. *History of Medieval Hindu Art.* Poona, 1921–26.

VALMIKI. *Ramayana.* Edited by M. M. S. Kuppuswami Sastri et al. Madras, 1933.

VATS, MADHOSARUP. *Excavations at Harappa.* 2 vols. Calcutta, 1940.

————. "The Gupta Temple at Deogarh." MASI, no. 70 (1952).

VATSYAYANA. *Kamasutra.* Commentary by Jayamangala. Chaukhamba Skt. Series, Benares.

VENKATARAMAYYA, M. *Sravasti.* New Delhi, 1956.

VENKATASUBBIAH, A. *The Kalas.* Madras, 1914.

VERNEUIL, M. P. *L'art à Java: Les Temples de la période classique Indo-Javanese.* Paris and Brussels, 1927.

VISSER, H. F. E. "Indian Influence on Far Eastern Art." In *The Influences of Indian Art.* London, 1925.

VISVANATHA. *Sahityadarpana* (The Mirror of Composition). Translated by J. R. Ballantyne and Pramadadasa Mitra. Calcutta, 1875.

VOGEL, JEAN PHILIPPE. "Inscribed Gandhara Sculpture." Annual Report of ASI (1903–1904).

————. "Buddhist Sculptures from Benaras." Annual Report of ASI (1903–1904).

————. "Notes on Excavations at Kasia." Annual Report of ASI (1904–1905; 1905–1906).

————. "Ancient Monuments of Kangra." Annual Report of ASI (1905–1906).

————. "The Mathura School of Sculpture." Annual Report of ASI (1906–1907; 1909–10).

————. "Excavations at Saheth-Maheth." Annual Report of ASI (1907–1908).

————. "The Garuda Pillar at Besnagar." Annual Report of ASI (1908–1909).

————. "Naga Worship in Ancient Mathura." Annual Report of ASI (1908–1909).

————. *Catalogue of the Bhuri Singh Museum at Chamba.* Calcutta, 1909.

————. "The Temple of Bhitargaon." Annual Report of ASI (1908–1909).

————. *Catalogue of the Archaeological Museum at Mathura.* Allahabad, 1910.

————. "The Sacrificial Posts of Isapur, Muttra." Annual Report of ASI (1910–11).

————. "Iconographic Notes on the Seven Pagodas." Annual Report of ASI (1910–11).

————. "Antiquities of Chamba State." ASINIS 26 (1911).

————. "Naga Worship at Mathura." Annual Report of ASI (1911–12).

————. "Exploration at Mathura." Annual Report of ASI (1911–12).

————. "Facts and Fancies about the Iron Pillar of Old Delhi." *Journal of the Panjab History Society* 9 (1923).

————. "Ganga et Yamuna dans l'iconographie bouddhique." *Études asiatiques* (1925).

————. "The Relations between the Art of India and Java." In *The Influences of Indian Art.* London, 1925.

————. *Indian Serpent-Lore or the Nagas in Hindu Legend and Art.* London, 1926.

————. *Bagh Caves in Gwalior State.* London, 1927.

————. "The Woman and Tree, or Salabhanjika in Indian Literature and Art." *Acta Orientalia* 7 (1929).

————. "Le Makara dans la sculpture de l'Inde." *Revue des Arts Asiatiques* (1930).

————. *La Sculpture de Mathura.* Ars Asiatica, vol. 15. Paris, 1930.

————. *The Discovery of Frescoes in South India Temples.* Annual Bibliography of Indian Archaeology for 1931. Leiden, 1932.

————. *Buddhist Art in India, Ceylon and Java.* Oxford, 1936.

VORETSCH, E. A. "Indian Art in Siam." *Rupam* (1920).

VREDENBERG, E. "The Continuity of Pictorial Tradition in the Art of India." *Rupam* (1920).

VYASA. *Mahabharata.* Edited by P. C. Roy. Calcutta, 1887–91.

WADDELL, L. A. *Report on Excavations at Pataliputra*. Calcutta, 1903.

WALES, H. G. QUARITCH. "A Newly Explored Route of Ancient Indian Cultural Expansion." *Indian Art and Letters* 9 (1935).
————. *Towards Angkor*. London, 1937.
————. *The Making of Greater India*. London, 1951.

WANGER, F. A. *Indonesia*. Art of the World. New York, 1959.

WARMINGTON, E. H. *The Commerce between the Roman Empire and India*. Cambridge, 1928.

WATTERS, THOMAS. *Yuan Chwang*. 2 vols. London, 1904.

WAUCHOPE, R. S. *Buddhist Cave Temples of India*. Calcutta, 1933.

WHEELER, SIR R. E. MORTIMER. *Five Thousand Years of Pakistan*. London, 1950.
————. *The Indus Civilisation*. Cambridge, 1953.
————. *Early India and Pakistan*. London, 1959.

WHITEHEAD, R. B. *Catalogue of the Coins in the Punjab Museum, Lahore*. Oxford, 1914.

WINSTEDT, SIR RICHARD, ED. *Indian Art*. London, 1947.

WITH, KARL. *Java*. The Hague, 1920.
————. *Java: Brahmanische, Buddhistische und eigenlebige Archetektur und Plastik auf Java*. Hagen, 1922.

YAZDANI, GHULAM. "Paintings from Ellora, Pillalamarri and Anagondi." Annual Report of the Archaeological Dept. of H. E. H. the Nizam's Dominions for 1927-28.
————. *Ajanta*. 4 vols. Oxford, 1930-58.
————. "The Rockhewn Temples of Aurangabad." *Indian Art and Letters* 11 (1937): 1.
————. *The Early History of the Deccan*. London, 1960.

YAZDANI, GHULAM ET AL. *History of the Deccan*. Vol. 1. Oxford, 1952.

ZANNAS, ELIKY, AND AUBOYER, JEANNINE. *Khajuraho*. The Hague, 1960.

ZIMMER, HEINRICH. *Myths and Symbols in Indian Art and Civilization*. New York, 1946.
————. *Philosophies of India*. New York, 1951.
————. *The Art of Indian Asia*. 2 vols. New York, 1955.

PRINCIPAL
ABBREVIATIONS OF
THE BIBLIOGRAPHY

AA. Artibus Asiae, Artibus Asiae Publishers, Ascona

ASI. Archaeological Survey of India, Calcutta

ASIIS. Archaeological Survey of India, Imperial Series

ASINIS. Archaeological Survey of India, New Imperial Series, Calcutta

BEFEO. Bulletin de l'École Française d'Extrême-Orient. Hanoi and Maisonneuve, Paris

CII. Corpus Inscriptionum Indicarum, Calcutta

EI. Epigraphia Indica, Government of India, Calcutta

IA. Indian Archaeology, Government of India, Bombay and New Delhi

Ind. Ant. Indian Antiquary, Popular Prakashan, Bombay

IHQ. Indian Historical Quarterly, Calcutta

JAOS. Journal of the American Oriental Society, Yale University, New Haven

JBORS. Journal of the Bihar and Orissa Research Society, Bankipore

JBRS. Journal of the Burma Research Society, Rangoon

JGIS. Journal of the Greater India Society, Calcutta

JIAI. Journal of India Art and Industry, Government of India

JISOA. Journal of the India Society of Oriental Art, Umakhant P. Shah, Calcutta

JMBAS. Journal of the Malayan Branch of the Asiatic Society, Singapore

JOR. Journal of Oriental Research

JRAS. Journal of the Royal Asiatic Society of Great Britain, London

JUPHS. Journal of the Uttar Pradesh Historical Society, Lucknow

MASI. Memoirs of the Archaeological Survey of India

QJMS. Quarterly Journal of Mythic Society

INDEX

Page numbers followed by an asterisk (*) refer to the principal discussion of the subject.
Numbers in *italic type* refer to illustrations.

HARIHARA II, 447, 571
HARINAIGAMESA, 159
HARISCHANDRANI CHORI, 452–453; *735*
HARISHENA, 176, 470
HARITI, 228, 468, 472, 475, 476
HARIVAMSA, 67
HARMIKA, 465, 466
HARSHA (HARSHAVARDHANA), 60–62, 211, 221, 226, 259, 448, 569; *211*
HARSHA (hill), 231
HARSHACHARITA, 175
HARSHADEVA, 461, 565
HARSHATMATA, 500
HASTIGIRI, 509
HASTI JATAKA, 470
HASYA RASA, 134, 135
HATHIGUMPHA, 498
HATHI POL, 531
HAVA MAHAL, 311, 532
HAVERI, 491; *848*
HAWK COIN, 66
HAYAT-BAKHSH BAGH, 437
HAZARA RAMASWAMI, 287, 490
HEAVEN, 112–114
HELIODORUS, 459; *206, 753*
HEMA, 511
HEMACANARA, 565
HEMACHANDRA, 262
HEMADPANTI, 264
HEMADRI, 264
HEMAKUTA, 489
HEMAVATI, 223, 224, 260, 491*; *849*
HENJERU, 491
HERAMBA GANAPATI, 524
HERCULES, 159; *439*
HIMACHAL PRADESH, 454
HIMALAYAS, 35, 466
HIMAVAN (GAURIGURU), 41, 78, 129, 176, 474, 480, 562; *194, 196*
HIMAVATI, 41
HINDI LITERATURE, 566
HINDOLA RAGA, *166 (color)*
HIRA, 450; *728*
HIRAHADAGALLI, 75
HIRAN MINAR, 532
HIRANYAKASIPU, 76, 214, 263, 465, 477, 493, 517–518; *259, 609*
HIRANYAVARMAN, 503
HOLI, 37; *174 (color)*
HORNED ANIMALS, 177; *19 (color), 22 (color), 486*
HORSE, *570, 891*
HOYSALA, 63, 65, 77, 83, 129, 224, 264–265*, 287, 442, 487–489, 495, 526–527, 559; *148 (color), 293, 295, 370, 391, 612, 614–619, 842*
HOYSALESVARA, *614, 843*
HRISHIKESA, 228
HSÜAN TSANG, 448, 466, 508, 513, 530
HUCHCHAPPAYYA, 485
HUCHCHIMALLI GUDI, 485
HUCHIYAPPA, 220; *362, 539*
HULI, 63
HUMAYUN, 310, 312, 438, 572; *683*

IBRAHIM ADIL SHAH, 311, 488
IBRAHIM LODI, 572
IBRAHIM RAUZA, 311, 488; *839*
IKSHVAKU, 158, 176, 195, 439, 444–445*, 558; *74 (color), 87 (color), 327, 328, 368, 424, 426*
ILAMS, 266
ILTUTMISH, 310, 571
INDOCHINA, 196–197
INDO-GANGETIC PLAIN (riverine plain), 35, 41, 62
INDO-GREEK, 64, 558
INDONESIA, 197–198*, 266
INDRA, 74, 76, 83*, 84, 112, 131, 133, 154,

156, 173, 195, 219, 221, 223, 231, 441, 447, 454, 460, 473, 486, 487, 493, 495, 502, 505, 506, 509, 514–516, 524, 525, 529, 536, 562; *57 (color), 331*
INDRAKILA, 221, 222
INDRANI, 453, 454
INDRAPRASTHA, 468
INDRARAJA III, 62
INDRASABHA, 223, 481; *140 (color), 548, 550, 551, 818, 819*
INDRAVARMAN, 63
INDUS VALLEY CIVILIZATION (Harappan civilization), 26
INSCRIPTIONS, 58–64
IONIA, 482
IRALAGUPPA, 263
IRAN (PERSIA), 195, 309, 310, 312, 498, 532; *see also* PERSIAN SCRIPT
IRANANESVARA, 509
IRINJALAKKUDA, 218
IRUNALAKKODE, 456; *744*
ISANA, 77
ISLAM (Muslim), 259, 287, 309–311, 490, 512, 520, 569
ISURUMUNI VIHARA, *493*
ISURUMUNIYA, 196
ISVARA, 440, 461, 517
ITIHASAS, 74
ITTAGI, 491; *850*
IYER, K. V. SUBRAMANIA, 59

JABALPUR, 261
JAGADAMBA, 562
JAGAMOHAN, *569, 874*
JAGANNATHA, 114, 258, 500; *145 (color)*
JAGAT, 501; *882*
JAGGAYYAPETA, 156, 442, 484; *88 (color)*
JAHAN, SHAH, *see* SHAH JAHAN
JAHANGIR, 66, 310, 312, 531, 532, 572; *167 (color), 237–241*
JAHANGIRI MAHAL (JODH BAI MAHAL), 310, 531, 532; *979*
JAHNAVI (Jahnutanaya), 42, 133, 563
JAHNU, 42, 133, 563; *203, 355*
JAHNUTANAYA (Jahnavi), 42, 133, 563
JAIMINI, 565
JAIN, 74, 77, 84, 112, 159, 217, 218, 220, 221, 227, 261, 262, 313, 455, 460, 461, 464, 481, 482, 484, 486–489, 491, 495, 496, 498, 499, 501, 503, 507, 508, 530, 565; *140 (color), 151(color), 895*
JAIPUR, 82, 225, 258, 311, 438, 500
JAI SINGH II, 438
JAJALLADEVA, 65, 264
JALHANA, 264
JAMA MASJID, 438, 450, 488, 532; *727, 838*
JAMBAVAN, 516, 517
JAMBHALA, 268, 449, 475, 476; *636*
JAMBUKESVARAM, 269
JAMBULINGA, 494
JAMIDODDI, 221; *510*
JAMMU, 174, 313, 454*; *171 (color)*
JAMUNA, 311
JANAMEJAYA, 568
JANANESVARA, 264
JANTAR MANTAR, 438
JAPAN, 199
JARA, 74
JARS, PAINTED, *27 (color)*
JATABHARA, 538
JATAJAVALA, 538
JATAKAMALA, 157
JATAKARMA, 38
JATAKAS, 45, 66, 135, 154–159, 173, 176, 195, 198, 228, 361, 403, 404, 409, 411, 426, 439, 445, 449, 459, 466, 468–470, 480, 565; *95 (color), 109 (color)*
JATAMAKUTA, 81, 83

JATAVARMAN SUNDARA PANDYA I, 520, 523, 571
JATAYU, 223, 477, 493, 563; *351*
JATILA, 466, 503
JATKARI, 464
JAVA, 129, 131, 198, 225, 227; *124 (color)*
JAVARI, 463
JAYA, 63
JAYACHANDRA, 259
JAYADEVA, 258, 289, 566
JAYADHAVALA, 265
JAYADRATHA, 173, 528, 563; *454*
JAYANTISVARA, 457
JAYAPALA, 570
JAYASIMHA, 258, 266, 452
JAYASIMHA SIDDHARAJA, 262, 450, 571
JAYAVARMAN, 569
JETAVANA, 154, 155, 448, 530; *973*
JETAVANAVIHARA, 246
JINA, 84, 112, 174
JINJI, 287
JIRJINGI, 63
JIVANTASWAMI, 174
JNANASAMBADNAR, 524, 526
JODH BAI (JAHANGIRI MAHAL), 310, 531, 532; *979*
JODHPUR, 313; *668*
JOGIMARA, 223
JONES, SIR WILLIAM, 58
JOUVEAU-DUBREUIL, G., 440, 519, 524
JUMNA, 42, 43, 441
JUNAGARH, 62
JYESTHA, 527

KABIR, 313, 566*
KACCHAPESVARA, 509
KACCVILANGAM PERUMAL, 65
KACHCHHAPA, 449
KADALMALLAI, 513
KADAMBA, 63, 508
KADANGUR, 218, 458
KADARMKONDA, 65
KADA SIDDHESVAR, 494
KADRU, 487
KAILASA (mount), 79, 113, 115, 175, 197, 223, 461, 474, 477, 493; *59 (color), 465, 500, 811*
KAILASA (temple), 82, 196–198, 216, 222, 223, 477, 493; *139 (color), 198–200, 303, 350, 547, 549, 807–810*
KAILASANATHA, 60, 62, 63, 133, 211, 212, 218, 441, 457, 507, 508, 523; *896, 897*
KAILASA VIMANA, *807*
KAITABHA, 76, 174, 515, 517, 529, 563; *263*
KAKAPAKSAS, 83
KAKATIYA, 62, 63, 265*, 442, 443, 445–447, 451, 559; *611, 620–624*
KAKUCHADA, 154–155
KAKUSTHAVARMAN, 63
KALA, 444
KALABHAIRAVA, 457
KALACHURI, 259, 461; *235*
KALAGNIRUDRA, 77
KALAKACHARYAKATHA, 313
KALAKAKUTTAM, 289
KALANJARA, 260, 461
KALANTAKA, 266, 308, 444, 447, 477, 505, 506, 522
KALARI, 509, 519
KALASAN, 195
KALHANA, 455
KALI, 268, 457, 489, 501, 506, 522
KALIDASA, 40–42, 45, 46, 67, 112, 128, 130–133, 157, 195, 219, 223, 225, 261, 565
KALIKA, 492
KALINGA, 62, 63, 78, 215, 222, 257, 265–267, 441, 442, 500